THE
PARTHENON
ENIGMA

JOAN BRETON CONNELLY is a classical archaeologist who has excavated throughout Greece, Kuwait, and Cyprus, where she has directed the Yeronisos Island Excavations since 1990. The author of two previous books, *Portrait of a Priestess: Women and Ritual in Ancient Greece* and *Votive Sculpture of Hellenistic Cyprus*, she has held visiting fellowships at All Souls College, Magdalen College, New College, and Corpus Christi College at Oxford University and at the Radcliffe Institute for Advanced Study, Harvard University, and has been a member of the Institute for Advanced Study in Princeton. Joan Breton Connelly is currently a Professor of Classics and Art History at New York University.

ALSO BY JOAN BRETON CONNELLY

Portrait of a Priestess: Women and Ritual in Ancient Greece

Votive Sculpture of Hellenistic Cyprus

THE
PARTHENON
ENIGMA

THE PARTHENON ENIGMA

A JOURNEY INTO LEGEND

Joan Breton Connelly

First published in in the United States in 2014 by Alfred A. Knopf, a division of Random House LLC, New York.

First published in the UK in 2014 by Head of Zeus Ltd

This paperback edition first published in the UK in 2017 by Head of Zeus Ltd

9 7 5 3 1 2 4 6 8

A CIP catalogue record for this book is available from the British Library.

ISBN (TPB): 9781781859605
ISBN (E): 9781781859421

Printed and bound by CPI Group (UK) Ltd, Croydon, CR0 4YY

Head of Zeus Ltd
First Floor East
5–8 Hardwick Street
London EC1R 4RG

www.headofzeus.com

For Louise, Thomas, and Peter

Contents

Prologue

NEVER BEFORE in human history has there been a structure that is at once so visible to the world, so celebrated, so examined, so invested with authority, and yet, at the same time, so strangely impenetrable at its core. After centuries of study and admiration, the Parthenon remains, in so many ways, an enigma.

The past three decades have brought perhaps the most intensive period of scrutiny the Parthenon has seen since its construction nearly twenty-five hundred years ago (447–432 B.C.). The monumental work of the Acropolis Restoration Service in the conservation and analysis of the building has revealed a wealth of new information about how the Parthenon was planned, engineered, and constructed. Surprises, like newly revealed traces of bright paint on architectural moldings set high within the west porch, hint at the original, radiant decoration of the temple. At the same time, freshly emerging evidence from Greek literature, inscriptions, art, and archaeology has broadened our understanding of the world in which the Parthenon was built. The myths, belief systems, ritual and social practices, cognitive structures, even the emotions of the ancient Athenians, are now under rigorous review. But much of what has been discovered in recent years does not fit into the sense we have had of the Parthenon for the past two and a half centuries. Why?

Our contemporary understanding of the Parthenon and the symbolism that has been constructed for it from the Enlightenment on has everything to do with the self-image of those who have described and interpreted it. There is a natural tendency to see likeness to oneself when

approaching a culture as foreign as that of Greek antiquity. How much more so this is when looking at a monument that has become the icon of Western art, the very symbol of democracy itself. With these labels comes a projection onto the Parthenon of all our standards of what it means to be civilized. In looking at the building, Western culture inevitably sees itself; indeed, it sees only what flatters its own self-image or explains it through connection to the birthplace of democracy.

This association has been reinforced again and again by the adoption of Parthenonian style for civic architecture beginning with the neoclassical movement and culminating in the Greek Revival. From the early nineteenth century on, financial and governmental institutions, libraries, museums, and universities have reproduced classical architectural forms to communicate a set of values, implicitly aligning themselves with the flowering of democratic Athens. One need only look at the Second Bank of the United States in Philadelphia (1811–1824), the British Museum (1823–1852), the U.S. Custom House on Wall Street (1842) (page 341), Founder's Hall at Girard College in Philadelphia (1847), the U.S. Treasury Building in Washington, D.C. (1836–1869), the Ohio State Capitol (1857), the Philadelphia Museum of Art (1928), or the U.S. Supreme Court Building (1935) to recognize quotations from the iconic form of the Parthenon.[1] Ironically, these unequivocally secular civic structures have appropriated what is, fundamentally, a religious architectural form. Preoccupied with the political and the aesthetic, we have become all too comfortable with the constructed identity of Parthenon as icon, neglecting its primary role as a deeply sacred space.

Any views that depart from the well-established contemporary understanding of the Parthenon, and its association with civic life as we know it, have been effaced, like the traces of paint and intricate detail that once adorned the surface of the temple itself. Criticism of the conventional creed is taken as an attack on an entire belief system. The long-standing association of the Parthenon with Western political ideology has, indeed, caused new interpretations to meet with enormous resistance. But there is much more to the Parthenon and the people who created it than flatters and corresponds to our sense of ourselves. To recover it, we must begin by trying to see the monument through ancient eyes.

Viewing the Parthenon as synonymous with the Western democratic system of government began in the eighteenth century, when the art

historian Johann Winckelmann first linked the emergence of individual liberty to the development of high classical style. In his influential book, *Geschichte der Kunst des Alterthums* (*History of the Art of Antiquity*, 1764), Winckelmann argued that the rise and decline of artistic styles followed developments in the political sphere. The peak of Greek art, he maintained, coincided with the democratic form of government.[2] Nine years later his student Johann Hermann von Riedesel took this model a step further, proclaiming the Parthenon to be "the supreme product of Athenian democracy."[3]

This sentiment was robustly embraced during the Greek War of Independence (1821 to 1830) and the period that immediately followed it. As the modern Greek nation was forged, the European powers that helped to shape it constructed narratives through which they could trace their own political systems back to the epicenter of the Athenian Acropolis. On August 28, 1834, the newly designated king of Greece, Otto, son of King Ludwig of Bavaria, officially inaugurated the Parthenon as an ancient monument. In a carefully orchestrated pageant conceived in the very image of Periklean Athens, King Otto rode on horseback with his regents, court, and bodyguards while soldiers from the National Guard led a procession of citizen elders, teachers, guild officers, and other notables.[4] Sixty Athenians marched with olive branches in hand, while on the Acropolis, Athenian maidens, dressed in white and carrying bows of myrtle, unfurled a banner displaying the image of Athena.[5] Upon reaching the citadel, King Otto was presented with keys to its gate and escorted into the Parthenon by the neoclassical architect Leo von Klenze. There, the king was enthroned upon a chair covered in laurel, olive, and myrtle. Klenze delivered a rousing patriotic address, advocating the restoration of the Parthenon and the obliteration of every trace of Ottoman Turkish building on the Acropolis. "All the remains of barbarity will be removed," Klenze proclaimed. He then bade King Otto to sanctify the first marble drum to be restored to the "reborn Parthenon." The king obliged, tapping three times on the white marble column segment set before him.[6] Klenze's vision of a barbarian-free Acropolis was fully realized in his "ideal view" of the Acropolis (following page), painted in 1846 and acquired by King Otto's father, Ludwig I, some six years later.[7]

In the century that followed, the growth of archaeology and an ever-increasing recognition of classical Greece as the cradle of Western civi-

lization elevated classical cultural production to a whole new level.[8] In 1826 work began on a replica of the Parthenon atop Calton Hill just east of Edinburgh. Designed as the National Monument of Scotland to memorialize Scottish soldiers and sailors lost in the Napoleonic Wars, it would become, people hoped, the final resting place for a host of Scottish notables. The structure was never completed, and the single façade that stands today is marked with an inscription that reads, "A Memorial of the Past and Incentive to the Future Heroes of the Men of Scotland."[9] Meanwhile, just above Regensburg in Bavaria, King Ludwig I built his own Parthenon (1830–1842), designed by the same Leo von Klenze of the ceremony on the Acropolis. Named Walhalla, "the Hall of the Dead" (facing page), the Bavarian Parthenon was furnished with portrait busts and inscribed plaques commemorating more than a hundred famous individuals across eighteen hundred years of German history. By 1897 the United States could boast of its own Parthenon, built in Nashville, Tennessee, for the state's Centennial Exposition of 1896–1897. The wooden structure was rebuilt in concrete in 1920–1931 and remains a prized landmark of the city to this day (page xiv).[10]

By the twentieth century, Ernst Gombrich would hail the "Great

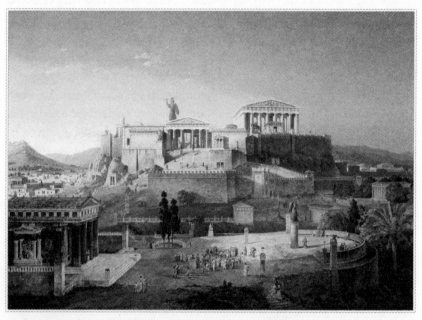

Leo von Klenze, *Ideal View of the Acropolis and the Areopagus in Athens*, 1846.

Walhalla memorial, Regensburg, Bavaria, 1830–1842, Leo von Klenze, architect.

Awakening" in Greek art as a product of the dawn of democracy. He viewed the "summit of its development" in the high classical period as a direct reflection of the "new freedom" experienced by artists working within the new political system.[11] This positivist construct was perpetuated in a blockbuster exhibition of Greek art that traveled across the United States in 1992, celebrating the twenty-five hundredth anniversary of the birth of democracy. The show, titled *The Greek Miracle: Classical Sculpture from the Dawn of Democracy,* treated viewers in Washington, D.C., and New York City to the very finest of surviving Greek art.[12]

The tendency to see oneself in ancient artistic masterpieces is not, however, limited to the adherents of any particular political ideology. Cecil Rhodes viewed the Parthenon as a manifestation not of democracy but of empire. "Through art, Pericles taught the lazy Athenians to believe in Empire," he maintained.[13] Karl Marx, also attracted to Greek art, preferred to understand classical monuments as products of a society not at its peak but in its infancy. "The charm of [Greek] art," Marx argued, "was inextricably bound up" with "the unripe social conditions under which it arose."[14] The splendor of high classical art in general, and the Parthenon in particular, would hold irresistible attraction for

Nashville Parthenon, Centennial Park, Nashville, Tennessee, 1920–1931.

the fascist regime of Hitler's Germany, which readily appropriated it in the service of its ideological, cultural, and social agendas.[15]

Should we be surprised that Sigmund Freud's response to the Parthenon was one of guilt? He was tortured by the fact that he had been privileged to see a masterpiece that his own father, a wool merchant of modest means, could never have seen or appreciated. Indeed, Freud was riddled with guilt at the thought of having surpassed his father in this good fortune.[16]

In 1998, the editor Boris Johnson, now mayor of London, published in *The Daily Telegraph* an interview with a senior curator at the British Museum. Johnson quoted the curator as saying that the Elgin Marbles are "a pictorial representation of England as a free society and the liberator of other peoples."[17] Thus, the Parthenon serves as both magnet and mirror. We are drawn to it, we see ourselves in it, and we appropriate it in our own terms. In the process, its original meaning, inevitably, is very much obscured.

Indeed, our understanding of the Parthenon is so bound up with the history of our responses to it that it is difficult, if not impossible, to separate the two. When the object of scrutiny has been thought so matchlessly beautiful and iconic, a screen for meanings projected upon it across two and a half millennia, it is all the more challenging to

recover the original sense of it. What is clear is that the Parthenon matters. Across cultures and centuries its enduring aura has elicited awe, adulation, and superlatives. Typical of the gushing is that of the Irish artist and traveler Edward Dodwell, who spent the years 1801–1806 painting and writing in Greece. Of the Parthenon he declared, "It is the most unrivaled triumph of sculpture and architecture that the world ever saw."[18] This same sentiment inflamed Lord Elgin, less a man of words than of action. In fact, during the very years of Dodwell's stay in Athens, Lord and Lady Elgin and a team of helpers were busy taking the temple apart, hoisting down many of its sculptures and shipping them off to London, where they remain to this day.

Even the removal of its sculptures, however, could not dull the building's allure. In 1832, the French poet Alphonse de Lamartine, last of the Romantics, declared the Parthenon to be "the most perfect poem ever written in stone on the surface of the earth."[19] Not long thereafter, the neo-Gothic architect Eugène Emmanuel Viollet-le-Duc proclaimed the cathedral at Amiens to be "the Parthenon of Gothic Architecture."[20] Even the great arbiter of twentieth-century modernism Charles-Édouard Jeanneret, later known as Le Corbusier, upon first seeing the Parthenon proclaimed it "the repository of the sacred standard, the basis for all measurement in art."[21]

And so the Parthenon's larger-than-life status has had a profound effect on the ways in which it has been scrutinized, what questions have been asked of it, and, more interesting, what questions have been left unasked. Too revered to be questioned too much, the Parthenon has suffered from the distortions that tend to befall icons. The fact that so few voices from antiquity survive to tell us what the Athenians saw in their most sacred temple has only enlarged the vacuum into which postantique interpreters have eagerly rushed.

IT HAS NOT HELPED the effort to recover original meaning that beginning in late antiquity, long after Athens had lost its independence, the Parthenon suffered a series of devastating blows. Around 195 B.C., a fire consumed the cella, the great room at the eastern end of the temple. At some point during the third or fourth century A.D., under Roman rule, there was an even more ruinous fire. Some scholars have pointed to the attack by the Germanic Heruli tribe in A.D. 267 as the cause of

this destruction, while others have attributed it to the Visigoth marauders under Alaric, who plundered Athens in 396.[22] Whatever the cause, the Parthenon's roof collapsed, destroying the cella. The room's interior colonnade, its eastern doorway, the base of the cult statue, and the roof had to be entirely replaced.[23]

The Parthenon's days as a temple of Athena were now numbered. Between A.D. 389 and A.D. 391, the Roman emperor Theodosios I issued a series of decrees banning temples, statues, festivals, and all ritual practice of traditional Greek polytheism. (It was Constantine who legalized Christianity, but it was Theodosios who outlawed its competition, making it the state religion.) By the end of the sixth century and possibly even earlier the Parthenon was transformed into a Christian church dedicated to the Virgin Mary. This conversion required a change in orientation, with a main entrance now smashed open at the western end of the structure and an apse added at the east (page 337). The westernmost room became a narthex, while a three-aisled basilica stretched toward the east in what had been the temple's cella. A baptistery was introduced at the building's northwest corner.[24] By the late seventh century this church had become the city's cathedral under the name of the Theotokos Atheniotissa, the "God-Bearing Mother of Athens." When, in 1204, Frankish forces of the Fourth Crusade invaded, they converted the Greek Orthodox cathedral into a Roman Catholic one, renaming it Notre-Dame d'Athènes. A bell tower was added at its southwest corner. With the fall of Athens to the Ottoman Turks in 1458, the Parthenon was rebuilt once again, now as a mosque, complete with a mihrab, a pulpit, and a soaring minaret on the very spot where the bell tower had stood.

Having survived largely intact for more than two thousand years, the Parthenon suffered a catastrophic explosion on September 28, 1687. A week earlier, the Swedish count Koenigsmark and his army of ten thousand soldiers had landed at Eleusis, just fourteen kilometers to the northwest. There they joined the Venetian general Francesco Morosini for the siege of Athens, but one front in the larger Morean War, also known as the Sixth Ottoman-Venetian War, which lasted from 1684 to 1699. As the Venetian army advanced upon Athens, the Ottoman Turkish garrison defending the city barricaded itself on the Acropolis. The Turks had, by now, torn down the temple of Athena Nike at the western tip of the citadel and replaced it with a cannon platform. They stock-

piled live ammunition within the walls of the Parthenon itself. Over six days, the Venetians blasted an estimated seven hundred cannonballs at the Parthenon, shooting from the nearby Museion Hill. Finally, Count Koenigsmark's men scored a direct hit. The Parthenon erupted in a violent explosion that sent its interior walls, nearly a dozen columns on its north and south flanks, and many of its decorative sculptures flying out in all directions. Three hundred people died that day on the Acropolis. The battle would rage on for another twenty-four hours before the Turkish troops capitulated.[25]

The sacred space of the Acropolis was thus forever changed, now acquiring a new iconic status as "ruin."[26] By the early eighteenth century, a small square mosque was built within the rubble of what had been the Parthenon's cella. Made of brick and reused stones, the domed structure (with a three-bayed porch facing northwest; see page 338) sat within the fallen framework of the Parthenon's colonnade until it was damaged in the Greek War of Independence and subsequently removed in 1843.[27]

IN SOME SENSE our bias toward seeing the Parthenon in political terms can be put down to a success of scholarship: the political sphere of Athens in the fifth century B.C. is the one we know best. The survival of a relative wealth of literature and inscriptions by, for, and about classical Athenians provides access to the world of Perikles, the general and politician who so shaped what is known today as the golden age of Greece, with which the flourishing of democracy is very much bound up. Yet there is much more to Athenian culture than democracy and more to its conception of democracy than what can be perceived by viewing it through a modern lens. For one thing, the Athenian notion of politics transcends our own. *Politeia* is difficult to translate in English; in fact, the word embraces all the conditions of citizenship in its widest sense. Ancient *politeia* extended far beyond the parameters of modern politics, embracing religion, ritual, ideology, and values. Aristotle intimates that the primacy of the "common good" played a definitive role in *politeia,* observing that "those constitutions that aim at the common good are in effect rightly framed in accordance with absolute justice."[28]

At the very core of Athenian *politeia* lies the culture's fundamental understanding of itself and its origins, its cosmology and prehistory—

a nexus of ideas that defined the values of the community and gave rise to a complex array of ritual observances of which the Parthenon was the focal point for nearly a thousand years. Until now, the Parthenon has received relatively little consideration in this light. And yet without such understanding it is impossible to say satisfactorily just what the Parthenon is beyond a supreme architectural achievement or a symbol of a political ideal as understood by essentially foreign cultures in the remote future. If we are to recover the primordial and original meaning of the Parthenon, we must endeavor to see it as those who built it did. We must see it through ancient eyes, an effort that involves the archaeology of consciousness as much as of place.

This aim of discovering the ancient reality of the Parthenon has been advanced by recent archaeological and restoration efforts on the Acropolis as well as by fresh anthropological approaches that are ever widening our understanding of the ancient past. Concrete archaeological discoveries made by the Greek Ministry of Culture's Acropolis Restoration Service in its meticulous autopsy of the building have revealed new information on the materials, tools, techniques, and engineering employed in the Parthenon's construction.[29] We now know many changes were introduced in the course of building the Parthenon, which may have included the pivotal addition of its unique and magisterial sculptured frieze. It has now been established that this frieze originally wrapped around the entire eastern porch of the temple. Two windows, on either side of the Parthenon's east door, allowed extra light to flood in upon the statue of Athena. Traces of a small shrine with an altar have been discovered in the temple's northern peristyle, marking the place of a previously unknown sacred space that predates the Parthenon.[30] This opens the way for a new understanding of pre-Parthenon cult ritual and raises questions concerning the continuity of sacred space from deep antiquity to the age of Perikles.

The last decades have seen much more than the proliferation of new data on the design and evolution of the Parthenon as a building. They have also brought sweeping shifts in scholarship that allow us a view of the Parthenon in its more immaterial dimensions. New questions are being asked of the ancient evidence, with new research models and methods deployed to ask them, drawing on the social sciences and religious and cultural history. These have generated a fresh approach to monuments viewed within the fullness of a whole variety of ancient

contexts.[31] The study of Greek ritual and religion has burgeoned over the past thirty years.[32] The embeddedness of religion in virtually every aspect of ancient Greek life is now fully recognized. The study of ancient emotions and also cognition is under way, revealing the effects of language, behavior, and multisensory experience on feeling and thinking in the ancient world.[33] We are in a better position than ever before to get inside the heads of those who experienced the Acropolis in Greek antiquity.

Ongoing studies of reception, projection, and appropriation have exposed the ways in which aesthetic, ideological, and nationalist agendas have shaped interpretative frameworks over the past 250 years.[34] Modern Western nostalgia for a link with the classical past, one that affirms the West's own political and cultural aspirations, is now recognized as a controlling force in the construction of narratives that have long dominated our understanding of the monuments. An awareness of an "other Acropolis" is emerging, one that seeks to build a multi-temporal and multisensory appreciation of the site and its buildings, including the Parthenon itself.[35] Both of these forces—the discovery of new evidence and the development of new questions and methods through which it can be examined—are at work in forging the new paradigm for understanding the Parthenon that is proposed in this book.

The more we have discovered, the more enigmatic the Parthenon has come to seem, and the more inadequate appear the simplistic meanings ascribed to it by later cultures. As a vastly complex world of cult ritual and spiritual intensity reveals itself, it still remains to be asked of the structure at the very heart of so much strange, dark practice, "What exactly is the Parthenon?"

Of all the physical remains surviving from the classical period, the Parthenon's sculptured frieze is the largest and most detailed revelation of Athenian consciousness we have. This virtuosic triumph in the carving of marble, this moving portrayal of noble faces from the distant past, this "prayer in stone," the largest, most elaborate narrative tableau the Athenians have left us, provides a critical and essential way in. Just what is represented by the nearly four hundred figures carved upon it is a question of the utmost importance.

Since the fifteenth century A.D., the Parthenon frieze has been viewed as a snapshot of fifth century B.C. Athenians, and, from the seventeenth century, they have been understood to be marching in their

Panathenaic, or all-Athenian, procession, a key event within the annual festival of Athena.[36] But this reading places the frieze outside the standard conventions for Greek temple decoration, which regularly drew its subject matter not from contemporary reality but from myth. And so this astonishing ring of stone carving presents us with an enigma within that of the Parthenon itself.

In the pages that follow, I argue for a new interpretation of the frieze, one that stands in sharp contrast to what has become the orthodox view.[37] My interpretation starts with religion, not politics, and through pattern recognition within the iconographic, textual, and ritual evidence I propose an understanding that challenges how we see both the Parthenon and the people who built it.

I argue that we are looking not at contemporary Athenians marching in their annual Panathenaic procession but at a scene from the mythical past, one that lies at the very heart of what it means to be an Athenian. A tragic saga unfolds, revealing a legendary king and queen who, by demand of the Delphic oracle, are forced to make an excruciatingly painful choice to save Athens from ruin. This choice requires nothing less than the ultimate sacrifice. Based on the lives of the founding king and his family, the charter myth manifest on the Parthenon frieze suggests a far darker and more primitive outlook than later cultures and classicists have been prepared to face. This harrowing tale provides a critical keyhole into Athenian consciousness, one that directly challenges our own self-identifications with it.

The Parthenon thus leads us toward an understanding remote from the Renaissance and Enlightenment stereotypes of philosophers and rhetoricians that we have become accustomed to imagine. In fact, Athenians were a far more foreign people than most feel comfortable acknowledging today. Theirs was a spirit-saturated, anxious world dominated by an egocentric sense of themselves and an overwhelming urgency to keep things right with the gods. Much of each day was spent asking, thanking, and honoring gods in an attempt to keep balance, reciprocity, and harmony with the all-powerful beings who could play with human fate. After all, Athenians were continuously threatened by war, violence, and death.

Spirit shadows, divinities, and heroes from the mythical past were a constant presence, fully inhabiting the landscape at every turn. Life was fragile, uncertain, never consistently happy, and full of surprises, except

for the looming certainty of death.[38] Calendars and the timing of cult rituals, religious festivals, athletic games, and theatrical performances were set by long-established tradition and regulated by the observance of the movement of celestial bodies in the night sky. Cosmology, landscape, and tradition bound ancient Athenians together within an ordered cycle of religious observance, remembrance, and ritual practice.[39]

The profound, compulsive religiosity of the Athenians, an aspect that earned them a reputation for being among the most "deisidaimoni-acal," or "spirit-fearing," people in all of Greece, stands in contrast to our idealizing vision of a city inhabited by philosophical rationalists.[40] That some Athenians might call out the name "Athena!" upon hearing the hoot of an owl, avoid stepping on gravestones or visiting women about to give birth, and kneel to pour oil on smooth stones at crossroads to avert their power may come as a surprise to the modern reader.[41] That he or she might stick pins in dolls fashioned from wood, clay, wax, or lead to place curses or erotic spells on rivals, legal adversaries, or love targets may be more surprising still.[42] Perikles, an avowed rationalist, was not beyond tying a charmed amulet around his neck when he fell ill with the deadly plague.[43] Riveting accounts of Athenians engaged in love magic, the casting of spells, the inscribing of curses, and the con-sulting of oracles, dream interpreters, and bird-omen readers (remain-ing ever vigilant for signs that might portend the future) bring us closer to the experience of actual lives lived. Our own separation of the philo-sophical from the spiritual greatly obscures our comprehension of the Athenians as they were.

Notwithstanding dark practices, the Athenians aspired, above all, to be "the most beautiful and noble," *to kalliston,* a concept that domi-nated their worldview. This ideal motivated them toward heightened excellence but, at the same time, reveals a certain unease, an apprehen-sion of the possibility that fortunes can suffer sudden reversals. The conviction that they must be "the best" utterly governed the Athenians' sense of their own being, absolutely and in relation to everyone else. It also profoundly informed their relations to one another.

ENGAGING WITH a new paradigm, we aim for a deeper, more authentic realization of the ancient Athenian experience of the monument than we've had for the past two hundred years, seeking an answer not only to

the question "What is the Parthenon?" but to the larger one: "Who were the Athenians?" That question's answer has also been rendered obscure and reductive by the effort of subsequent peoples to seize the ancient mantle. Above all else, the Parthenon—the epicenter of an urgent and spiritually charged civic life—is the key to how Athenian identity was shaped and sustained.

At the same time, the Parthenon was first and foremost a religious building, a temple among temples. Its status as a masterpiece of Western art has long discouraged questions that have been asked of other temples built in places and at times that we know less well than those of Periklean Athens. In this book, I examine the Parthenon in relationship to sacred buildings on the Acropolis and elsewhere throughout the Greek world. I focus on foundation and genealogical succession myths that define local identity and on the signs and symbols that communicate a common origin for the Athenian citizenry. I look at local heroes and gods, at the relationship between their tombs and temples, and at the rituals that built bridges between the two. Such monuments enabled citizens to come into direct contact with their ancestors, reminding them of the values upon which their communities were founded. For a culture without media, without a sacred text, the centrality of a great architectural work in forging this solidarity cannot be overstated. For the Athenians, the Parthenon was a very special nexus in which sacrifice, ritual, memory, and, yes, democracy were closely intertwined.

We shall begin with the natural environment of the Acropolis, its cosmology, and the myth tradition that so shaped Athenian consciousness. We'll consider the ways in which local myth grew out of local landscape, examining the inseparability of the Parthenon from its natural surroundings, memory structures, and belief systems that derive from its unique setting. We'll go on to track the transformation of the Acropolis from Mycenaean citadel to sanctuary of Athena, focusing on the shrines and temples that preceded the Parthenon and the cosmic myth narratives of their sculptural decoration. We then turn to the Persian devastation of the Acropolis in 480 B.C. and the comprehensive Periklean rebuilding program that followed some thirty years later. Here, we'll take a close and culminating look at the Parthenon sculptures, above all the frieze, which provides such a critical aperture into the core meaning of the building.

In later chapters, we shall examine the implications of this reading

for our understanding of the Athenians themselves, through a better sense of their rituals, festivals, and games and the legacy of the Parthenon and Acropolis cults. Central in this is the relationship of dead heroes and heroines to rites of remembrance at the Panathenaic festival, the preeminent and defining celebration of Athenian identity, when the Athenians were, so to speak, most intensely, consciously, ecstatically Athenian. Finally, we'll consider the Athenians' earliest self-styled imitators, to take an oblique look at the Athenians through the eyes of those who observed them contemporaneously. Though hardly more immune to the sort of distorting reverence that shapes impressions of Athens in the Renaissance and the Enlightenment, the princes of Hellenistic Pergamon were at least not so separated from their ideal by the alienating effect of two millennia. As we consider the legacy of the Parthenon in the invention of heroic narratives and founding myths at the sanctuary of Athena Polias Nikephoros at Pergamon, we shall endeavor to keep close to the ancient experience, especially to the landscape that shaped local memory and to the narratives of earth, water, and the heavens that dominated local sensibilities. In the evocative words of Christopher Wickham, "Geography, like grace, works through people."[44] This is especially true of the Athenians, who were first and foremost a people of sea and land, of trade and agriculture—in short, of Poseidon and Athena.

But let us start at the beginning, the scene upon which the great, mysterious, and ultimately defining building of the Athenians was created. Then, as now, location was the key to appreciating all real estate, and so let us first explore the Acropolis and its environment.

THE
PARTHENON
ENIGMA

1

THE SACRED ROCK

Myth and the Power of Place

"THE EASIEST THING to do is to walk right in the stream; this way, we'll also get our feet wet, which is very pleasant, especially at this hour and season," Phaidros suggests as he and Sokrates pass beyond the city walls. He'd been in search of a quiet place on the banks of the Ilissos River where he could memorize an oration he'd just heard delivered by the speech writer Lysias. On his way out of Athens, Phaidros bumped into Sokrates, who was happy to join him to discuss the speech, one devoted to the nature of homoerotic love.[1]

Crossing the Ilissos, the two friends stop at a place by the foot of the Ardettos Hill, near where the Panathenaic Stadium stands today. Sokrates is delighted with the spot and extols the loveliness of its natural surroundings. Plato, who recounts this story in his *Phaidros* around 370 B.C., places on the lips of Sokrates what is perhaps the most vivid surviving description of the sights, sounds, smells, and touch of the classical Athenian landscape:

It really is a beautiful resting place. The plane tree is tall and very broad; the chaste-tree, high as it is, is wonderfully shady, and since it is in full bloom, the whole place is filled with its fragrance. From under the plane tree the loveliest spring runs with very cool water—

our feet can testify to that. The place appears to be dedicated to Acheloös and some of the Nymphs, if we can judge from the statues [of girls, *korai*] and votive offerings [*agalmata*]. Feel the freshness of the air; how pretty and pleasant it is; how it echoes with the summery, sweet song of the cicadas' chorus! The most exquisite thing of all, of course, is the grassy slope: it rises so gently that you can rest your head perfectly when you lie down on it.

Plato, *Phaidros* 230b–c²

In this intimate portrait of Sokrates enjoying the simple pleasure of lying with his head deep in the summer grass, Plato evokes not only the humanity of the philosopher, who was his teacher, but also the idyllic natural environment that blessed the city of Athens.

As they'd approached the shade of the river's edge, Phaidros's thoughts had turned immediately to myth. "Tell me, Sokrates, isn't it from somewhere near this stretch of the Ilissos that people say Boreas [the North Wind] carried Oreithyia away? . . . Couldn't this be the very spot?" he inquires. "No," Sokrates replies, that place is "two or three hundred yards farther downstream, where one crosses to get to the district of Agra. I think there is even an altar to Boreas there." Looking up at the doll-like figurines placed here by worshippers, Sokrates surmises that this must be a spot sacred to the river god Acheloös and the nymphs. Before long, he feels the effects of the mythically charged location: "There's something truly divine about this place, so don't be surprised if I'm quite taken by the Nymphs' madness as I go on with the speech. I am on the edge of speaking in dithyrambs."³

Sokrates might be forgiven for his spontaneous mouthing of those ecstatic hymns to Dionysos. For these passages from the *Phaidros* reveal how inseparable were myth, landscape, memory, and the sacred within Athenian consciousness—and also what collective power they exerted on the emotions.⁴ With signs and symbols of local piety and ritual abounding, Sokrates's own short bout of nympholepsy (in his day, an agitation induced by proximity to actual nymphs) makes palpable for us the power of place.⁵ The presence of the gods is real to Sokrates and Phaidros, men of the highly educated elite of the city. While Sokrates may be loath to speculate on the myth of Boreas and Oreithyia (daughter of the mythical king Erechtheus and his wife, Praxithea), he is happy enough to accept common opinion on the setting for the story.⁶ The

ancient landscape bristled with such localities charged with meaning, natural landmarks experienced with an intensified awareness by generations of Athenians, privileged and humble, educated and unschooled alike.

We begin our examination of the Parthenon with its broader natural surroundings, the landscape that so shaped Athenian consciousness of place and time, of reality itself (below). It is out of Attica—the greater territory surrounding Athens—that the forces of nature and divinity, of human drama and history, issued. To commemorate their favorable resolution required nothing less than what the Parthenon would be: the largest, most exquisitely planned and constructed, lavishly decorated, and aesthetically compelling temple that the Athenians would ever build. It would also be a monument steeped in carved images retelling vibrant stories from the city's mythical past. For in the Greek view, mythos (a "saying" or "story" without rational claim to truth) and history (the empirical search for truth about the past)[7] were often indistin-

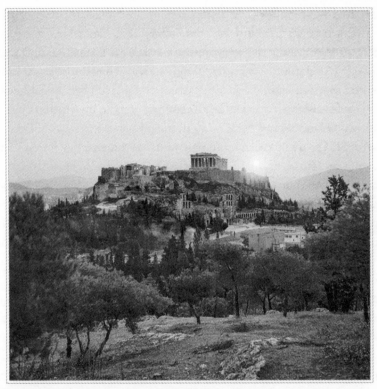

Acropolis at dawn from west. © Robert A. McCabe, 1954–1955.

guishable; both were inscribed in epic and genealogical narratives set in a landscape thought to have existed since the world was created out of chaos. Places of memory within this landscape held special meaning for generations of inhabitants who passed age-old narratives down to their children.

The Greeks comprehended their distant past according to certain fixed "boundary catastrophes" that punctuated and divided time into distinct eras.[8] Cosmic battles, global deluge, and epic wars are chief among the catastrophes that marked the succession of one period by another: in the early chapters of this book we shall consider the power of each sort of upheaval. (All show influence from the ancient Near East, some of it direct, but much via Syro-Palestinian and Phoenician sources.)[9] But of the three disruptive forces, none, of course, could have done more to shape the landscape or the culture's awareness of it than the ebb and flow of water. The recurrence of floods and deluges became a definitive means for dividing time into eras, the division between the antediluvian and the diluvian being as important to the Greeks as to the Sumerians and Hebrews.

The recounting of ancient narratives that describe era-defining floods, clashes among the gods, and epic battles of Greeks against exotic "others" (Amazons, Centaurs, Trojans, and Thracians) was utterly essential to Athenian paideia (education) and piety. That these phenomena played out in an ancient landscape still visible to Athenians of the historical period bound them to a mythic past in a way scarcely imaginable to us; for them the remote past was not remote but immanent in everything. The meaning of the Parthenon—the sense of its design and decoration, no less than its location—cannot be understood without wading into the spring of associations from which it issues. To do so, we must start at ground level with the ecology and topography of the ancient city.

ATTICA COMPRISES a triangular peninsula of some 2,400 square kilometers (927 square miles) that juts into the Aegean Sea at the very southeast corner of the Greek mainland (facing page).

It is bordered on the northwest by the Kithairon Mountains, some 104 kilometers (65 miles) distant, a range that separates it from the neighboring territory of Boiotia. Mounts Parnes and Aigaleos rise to the

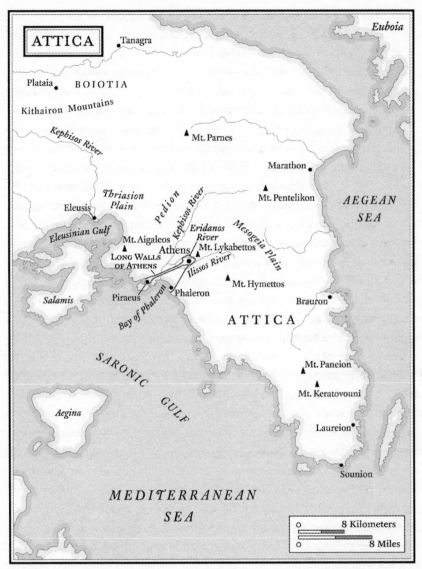

Map of Attica.

north and west of Athens; Mounts Pentelikon and Hymettos lie to its
northeast and east. Mounts Keratovouni and Paneion sit to the south-
east of the city, near Laureion. In between these mountains stretch four
valleys and three great plains: the Mesogeia Plain to the east of Mount
Hymettos, the Pedion (literally, "Plain") to the northwest of Athens,
and the Thriasion Plain between Athens and Eleusis. The Acropolis

(literally, "Peak or High Point of the City") is one of a series of smaller hills that rise within Athens itself (facing page).[10] The Areios Pagos, or Areopagus ("Hill of Ares"), sits just beside it at the west, with the Kolonos Agoraios to the northwest skirting the ancient marketplace, or Agora. Farther to the west rise the Pnyx and the Hill of the Nymphs, while at the southwest sits the Mouseion Hill. Ardettos Hill rests to the southeast of the Acropolis beyond the city walls, and farther away at the northeast we find Mount Lykabettos and Strefi Hill. Even farther north rises the ancient Anchesmos ("Sharp-Peaked") Hill, later called Lyko-vounia (Wolf Mountains) and, today, Tourkovounia (a more recent reference to Ottoman times). At the south, Attica opens onto the Saronic Gulf through a series of excellent harbors and bays (previous page). It has been estimated that by the 430s B.C., Attica had a population of between 300,000 and 400,000 people. About half of these are believed to have lived in Athens and the area immediately surrounding it.

It is difficult to grasp today, given the density and overdevelopment of modern Athens, just how diverse the ecosystems of ancient Attica were. Already in Plato's time, there was a sense that the countryside had changed dramatically over the preceding millennia. In the *Kritias,* he tells us that the Attic landscape once had mountains with high arable hills, fertile plains deep with loamy soil, and thick forests all around.[11] Still, even in his day, the countryside was rich with olive and plane trees, oaks and cypresses, Aleppo pine, cedar, laurel, willow, poplar, elm, almond, walnut, and mastic as well as the evergreen bushes myrtle and oleander. Fruit-bearing trees kept Athenians happy with figs, pears, apples, plums, cherries, pomegranates, and more. Vines and vineyards provided grapes for eating, for drying as raisins, and for making wine. No doubt, vine-entwined arbors provided shade for outdoor living much as they do today. Giant fennel grew wild, along with broom, eglantine, ivy, buckthorn, hemlock, akanthos, and celery.[12] Vegetable gardens provided garlic, onions, and prickly lettuce as well as broad beans, lentils, chickpeas, and other legumes. A host of herbs, including thyme, sage, oregano, and mint, enlivened the local cuisine.

The fertile fields of the Attic countryside (*chora*) fed thriving agricultural ventures that produced olives, cereals, and vines (page 5). Barley and (to a lesser extent) wheat were grown as mainstays of the diet under a system of crop rotation that left half the land fallow in any given year.[13] Above all else, Athenians valued the self-sufficiency that these

farms, fields, plantations, and groves brought to their extended families.[14] Indeed, the greatest product of Athenian agriculture was the sense of autonomy and independence it brought the people, a citizenry based on landownership. Of course, during the Peloponnesian War, Athens's survival depended on foreign food imports, especially grain, to supplement local production.[15] Nonetheless, Athens prided itself on being an

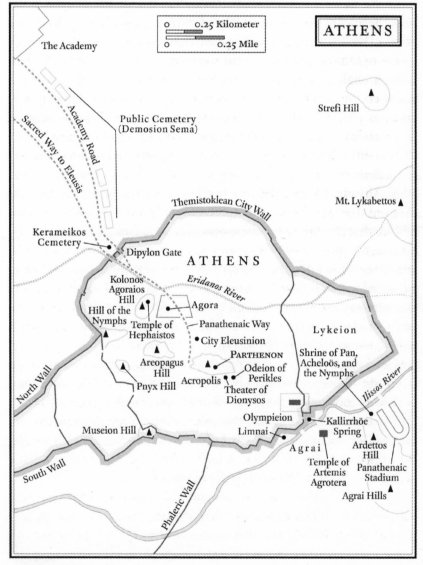

Map of Athens.

autarkestate polis (a "self-sufficient city"), an ideal held up by Aristotle as a shining virtue of the state.[16]

In so many ways the stability and security brought by these private farms created the conditions for the unprecedented rise of democracy—and eventually undemocratic excesses as well. The population boom of the eighth century and subsequent scarcity of land, increasingly concentrated in the hands of a superrich aristocracy, would threaten this agrarian stability until, around 594 B.C., the statesman (and poet) Solon was authorized to introduce reforms.[17] His measures helped the peasantry by banning slavery for debt, limiting the amount of land one family could hold, and greatly increasing the number of free, landholding citizens. Still, one's level of civic participation and representation in government remained commensurate with one's landholdings. In the new scheme of social census classes introduced by Solon's reforms, citizens of the uppermost rank, the *pentakosiomedimnoi* (named for the fact that they owned enough land to produce five hundred measures of grain a year), were eligible for the highest offices of treasurer and eponymous archon (chief magistrate). The next class, the *hippeis* (named for those who could afford to maintain a horse and thus participate in the cavalry), held property that produced three hundred measures of grain per year. Next came the *zeugitai*, or teamsters (named for those who maintained a pair of oxen that could be yoked for plowing), whose land produced two hundred measures a year. The lowest class belonged to the *thetes*, or common laborers, who owned no land whatsoever and could participate only in the assembly (of all citizens) and, importantly, as jurors on law courts. Ownership of land and the cultivation of grain thus rested at the very heart of Athenian civic engagement. Indeed property came to define Athenian belonging almost as much as genealogy, both being hereditary privileges. By the fourth century, the "Ephebic Oath," in which young men reaching the age of eighteen pledged to defend the state, spoke as much of agricultural as religious patrimony:

> I will honor the religion of my fathers.
> I call to witness the gods . . .
> The borders of my fatherland,
> The wheat, the barley, the vines,
> And the trees of the olive and the fig.[18]

Attica was also a land bedecked with flowers. We can picture hyacinths, crocuses, anemones, narcissi, cyclamen, asphodels, irises, roses, lilies, hellebore, larkspur, and a multitude of other species beautifying streets, gardens, and open spaces.[19] A kind of greenbelt flourished along the edges of Athens, inside and outside the city walls (page 9). Groves and gardens were planted close to natural water sources. And many of these came to be regarded as hallowed, associated with local shrines and divinities. At the northwest of the city, a twenty-minute walk beyond its walls and not far from the Kephisos River, grew twelve trees consecrated to Athena in an area called Akademos. The place took its name from the Arkadian hero who showed Kastor and Polydeukes where Theseus had hidden their sister Helen, having stolen her away to Athens. This is the same leafy setting where Plato established his school in 387 B.C., called the Academy after the eponymous place-name.[20] The Academy grove was believed to have developed from offshoots of the original sacred olive tree planted by Athena on the Acropolis. A curse hung over anyone who dared cut down the Academy olives, a crime punishable by death or banishment. Oil from the olives of these trees filled the prize amphorae given to winning athletes at the Panathenaic Games. By the 470s B.C., when Athens was recovering from the Persian Wars and enjoying the growth of its young democracy, the aristocratic statesman and general Kimon, as part of his enormously generous public works program (aimed at consolidating political support), built a wall around the Academy and diverted the waters of the Kephisos to irrigate it. He constructed an aqueduct 2 kilometers (1.25 miles) long to bring even more water from the northwest corner of the Agora out to Academy groves, where he planted many more olive and plane trees. Set outside the city walls and in the valley of the Kephisos, the natural setting of the Academy, with its gardens, walkways, and trees, offered Plato and his pupils the perfect place for contemplation and discussion. By the time Plutarch wrote of it in the second century A.D., the Academy was the most wooded spot in all of Athens.[21]

Philosophers similarly gravitated to a tree-filled retreat at the northeast of Athens known as the Lykeion (page 9), presumably after a sanctuary of Apollo Lykaios ("Wolf God") located somewhere nearby.[22] Groves sacred to Apollo are found at his sanctuaries throughout the Greek world, and the trees of the Lykeion may well have originated as

a wood connected with Apollo's worship.[23] A gymnasium for sporting activities was already established here in the sixth century. We know from Plato that the Lykeion was a favorite haunt of Sokrates's (the Platonic dialogue *Euthydemos* is set here, and, in the *Lysis*, Sokrates is en route from the Academy to the Lykeion when he gets distracted, ending up at a new palaistra). Aristotle would establish his own philosophical school at the Lykeion in 335 B.C., upon returning from Macedonia, where he taught the young Alexander the Great. It was around this time that the leader and visionary Lykourgos, scion of one of the oldest and noblest Athenian families, the Eteoboutadai, came to power as steward of the financial administration. He allocated funds for the planting of many more trees at the Lykeion.[24] Aristotle's custom of strolling and talking with his pupils under the shade of the Lykeion's covered walkways and colonnades (*peripatoi*) led to their being called the Peripatetics. Upon Aristotle's exile from Athens in 322, his successor, Theophrastos, took up, among other things, the study and organization of botany while working in the Lykeion's leafy setting.[25]

Somewhere beneath the Acropolis, in the direction of the Ilissos River, a grove of two hundred olive trees grew within the shrine of Kodros, Neleos, and Basile.[26] Kodros belonged to the period called the Dark Ages (ca. 1100–750 B.C.) when kings ruled Athens; he was the last of them, and Neleos was his son.[27] An inscription of Roman date, found to the southeast of the Acropolis, claims to be the epitaph for Kodros's grave monument.[28] It tells us that the body of the king (who valiantly gave his life to save the people from an advancing Dorian army) was embalmed by the Athenians and buried at the foot of the Acropolis.[29] The Delphic oracle had foretold that the Dorian invaders would prevail only if they avoided killing the Athenian king. When Kodros heard of the prophecy, he disguised himself as a peasant and wandered out beyond the city walls, pretending to gather wood. Coming upon the enemy camp near the Ilissos River, the king intentionally provoked an argument with two guards, whereupon a fight ensued, with Kodros killing one of the soldiers and the other killing Kodros in turn. Realizing what had happened, the Athenians asked the invaders to return to them the body of their king. When the Dorians, too, figured out that they had killed the king of Athens, they retreated, certain that their siege could now only fail.

By the fifth century B.C. the days of Kodros and the Athenian mon-

archy ("rule by one") were long gone. Indeed, the great kingships of Mycenaean Greece (ca. 1600–1100 B.C.) did not survive the collapse of Bronze Age civilization, and when monarchies emerged in the period that followed, local kings (*basileis*) seem to have been considerably weaker than their Mycenaean predecessors. During the eighth and seventh centuries these kings would have ruled with the consent and support of aristocratic families, most likely buttressed by marriage alliances. The transition away from kingship seems to have been a gradual one, with local aristocracies ("rule by the best") and oligarchies ("rule of the few") eventually taking over.[30] At Athens, a few eminent old families had become enormously wealthy off the bounty of their landholdings. Known as the Eupatrids ("Good-Fathered" or "Wellborn"), these clans were fiercely competitive with one another, establishing rivalries that endured for generations. In the course of the eighth century they gained control of the powerful civic offices of polemarch (magistrate of war) and eponymous archon (chief magistrate). In 712 B.C., the aristocracy's authority was further increased when the office of archon basileus (king magistrate) was opened to them as well, giving the Eupatrids power within all branches of city administration, including the law courts. The Athenians seem to have had an innate resistance to the idea of any one individual dominating governance. Originally, the three archonships were held for a ten-year term, but in 684/683 they were reduced to one year, limiting the power of any one man. Under the reforms of Solon, who served as eponymous archon in 594 B.C., there was a brief period during which the number of archons rose to ten, but it was later reduced to nine when the office of polemarch was moved to the body of strategoi ("army leaders" or "generals"). The movement toward fuller inclusion in participatory government began under Solon and culminated at the end of the sixth century with the "democratic revolution" led by Kleisthenes in 508/507 B.C.

By the time Antiphon served as eponymous archon in 418/417, Athens had thus enjoyed ninety years of democracy, and its nine annual archons were now chosen by lot from a short list of eligible candidates. An inscribed decree published during the archonship of Antiphon lays out terms for the lease of the sacred precinct of Kodros.[31] There is debate over the exact location of this sanctuary. Some scholars place it within the city walls to the southeast of the Acropolis, and others locate it outside the walls on the banks of the Ilissos.[32] In any case, the inscription

prescribes that the lessee enclose the temenos with a wall, paid for at his own expense. He is also required to plant no fewer than two hundred young olives within the sanctuary, more if he likes. In return, the lessee will have control over "the ditch and all the rainwater that flows between the shrine of Dionysos and the gates through which the *mystai* [initiates in the Eleusinian Mysteries] make their way to the sea," that is, to the Bay of Phaleron. He shall also have control of all the water that flows "between the public house and the gates that lead to the baths of Isthmonikos."

This text underscores the great premium on water in ancient Athens and use of open spaces as water traps for capturing this precious resource. The lessee gets a fair deal: in exchange for building the enclosure wall and planting the grove, he claims the freshwater collected here. In the process, he honors the gods and forefathers by beautifying the shrine of one of the noblest and most selfless of Athenian mythic ancestors. Indeed, upon Kodros's death (by tradition, around 1068 B.C.) it was decided no one would deserve the title of king again. His son Medon (whose name means "Ruler") thus became the first archon, or "commander."[33]

THE MARKETPLACE OF ANCIENT ATHENS, known as the Agora, occupied a low, flat area to the northwest of the Acropolis (page 9). This space was filled with flowers and greenery. We are told that the general Kimon, responsible for the Academy grove, also planted plane trees in the Agora in an effort to beautify the city following its destruction by the Persians.[34] The sack of the Acropolis in 480 B.C. destroyed the temple (still under construction) that immediately preceded the Parthenon, a building known as the Older Parthenon. But the wrath of the Persians spilled down from the Acropolis cliffs as well and consumed the city. The relandscaping of the Agora went a long way toward reestablishing normalcy. A grove of laurel and olive trees surrounded the Altar of the Twelve Gods in its northwest corner; excavations have revealed pits, measuring roughly a meter in diameter, for planting these trees.[35] The grove was watered by a channel directing runoff from two fountain houses at the higher ground to the south.

Plutarch tells the story of a plane tree that stood in the very center of the Agora, just beside the bronze statue of the orator Demosthenes.[36]

When a soldier accused of wrongdoing was summoned before his chief officer, he stopped first at this statue, placing in the entwined fingers of Demosthenes the only gold he had. Leaves from the plane tree blew down and covered the gold within Demosthenes's clasped hands. When the soldier returned from his ordeal, he found his treasure intact. This was taken as proof of the incorruptibility of Demosthenes.

THE TREES, GARDENS, WOODS, and wetlands of Athens were inhabited by a robust wildlife. We can imagine rock doves, jackdaws, swifts, nightingales, swallows, cuckoos, crows, eagles, falcons, and other raptors flying overhead.[37] Of course, the little owl, or *glaux,* took pride of place as the symbol of Athens and its patron goddess. Aristophanes's *Birds,* first performed in 414 B.C., reads like an ornithological handbook for the city. A sampling of Aristophanes's fowl includes the hoopoe, nightingale, magpie, turtledove, swallow, buzzard, pigeon, falcon, ring-door, cuckoo, red-foot, red-cap, purple-cap, kestrel, diver, ouzel, osprey, wood thrush, quail, goose, pelican, spoonbill, redbreast, peacock, grouse, horned owl, teal, swan, bittern, heron, stormy petrel, figpicker, vulture, sea eagle, titmouse, redbird, finch, gull, coot, chick, and wren. If even a fraction of this list was truly resident in Attica, the avian population of the city-state could be regarded as exceptionally wide-ranging and diverse.[38]

We must not underestimate the aural presence of native wildlife to the experience of ancient Athens. In the days before the urban noise-scape of automobiles, sirens, trains, planes, and factories, it was the song, cry, and croak of the wild that accompanied life's moments through the day. For those listening, these sounds signaled the passage of time as well as making it possible to echolocate oneself within the city. Natural acoustics are easily forgotten in our era of headphones and earbuds. But the sounds of the Greek countryside—from the tune of songbirds in the morning, to the screech of cicadas in the peak heat of the day, to the croaking of frogs at dusk and the hooting of the owl in the evening— were to ancient listeners like the chiming of a clock. It is no wonder that Aristophanes seized upon the resident avian and reptilian populations for his dramatis personae in the *Birds* and the *Frogs.* Anyone who has spent long Mediterranean days with seagulls overhead, or evenings sleeping beside wetlands thick with frogs, knows that cacophony that

so resembles crowds of humans rapt in conversation. To reconstruct in our mind's ear the music and mayhem of Mother Nature is essential to appreciating the ancient ambience.

While man-made groves and gardens adorned the metropolitan environment, it was tracts of land left wild that brought something of the countryside into the city's reach. Just a short walk to the southeast of the Acropolis, outside the city walls and on the banks of the Ilissos, was a marshy, wooded area known as Agrai, literally "Wilderness" or "Hunting Ground" (page 9).[39] Damp with wetlands and uncut vegetation, this was a refuge for waterfowl, game birds, and other small animals. Just minutes from the Acropolis, Agrai was easily accessible for urbanites wishing to hunt and fish. It was also an area bristling with shrines and sacred landmarks commemorating past encounters between mortals and the divine. Local place-names reflect this landscape: Dionysos in the Marshes (Limnai), Artemis the Huntress (Agrotera), the Mother in the Wilderness (Metroon in Agrai).[40] So, too, the slopes of the Acropolis itself were (and still are) rich with natural microenvironments: caves, springs, rocks, crags, and brambles that served as the setting for the most venerable tales from the city's distant past.

THAT SO MANY of these places of memory should have to do with water should come as no surprise. In words attributed to the sixth-century philosopher Thales of Miletos, "water sustains all."[41] This certainly was the case for Athens, where the life-giving power of ancient sources bound generations of citizens to the same places: springs, lakes, pools, rivers, streams, marshes, caves, and watery crevices were places to which local inhabitants flocked for respite from the Mediterranean heat and to quench their thirst. Over time, wells and fountain houses were built atop natural springs to capture the gush of potable water. They became central meeting places for the community and one of the few destinations to which the young women of Greek households could be sent honorably and safely to collect what was needed for family use. Naturally, these locations became the settings for tales of nymphs and maidens. Spring nymphs figure centrally in local genealogies. Regularly identified as the very earliest ancestors, these nymphs supposedly married into local royal families, providing a hereditary link to the natural environment and, for future generations, an implicit claim upon the land.[42]

Myths emerged from local landscapes, helping to explain how things came to be as they are. Generations of Athenians believed in a common ancestry all blessed by local divinities that inhabited an intimately familiar topography. This common origin is the key to Athenian identity and solidarity. It makes possible a communal spirit while also potentiating a chauvinism vis-à-vis other Greeks, to say nothing of lesser peoples. Such beliefs, whether real or fanciful, dominate collective imagination and shape a worldview of past, present, and future. To stand in the same cave or at the same spring as one's great-great-grandmother did; to set the same offering of fruit, grain, meat, or honey on the same altar in a ritual performed by blood relatives centuries before; to perceive that fellow citizens share one's genetic continuity with a very ancient past—the power of these experiences attests to the oft-claimed truth that nothing defines identity and belonging like the ways in which individuals and communities remember and forget.[43] And since human beings tend to comprehend identity best as a narrative, the stories that the Athenians told themselves and the setting of these tales are the key to understanding not only who they believed they were but also their most monumental collective efforts.

THE MODERN CITYSCAPE of Athens has all but eclipsed the rich network of ancient springs and waterways, now buried beneath congested thoroughfares. Street names preserve their memory and track their courses: Kifissou Avenue runs atop the Kephisos River some 3 kilometers (2 miles) to the west of the Acropolis, while Kallirrhöe Street, at the southeast, begins near its eponymous spring and carries on to the south following the route of the Ilissos River that runs beneath it. The tributary of the Kephisos, the Eridanos River, courses underground to the northwest of the Acropolis skirting the north flank of the Agora. A stretch of its wide riverbed, some 50 meters (164 feet) across, was rediscovered during the digging of the Constitution Square metro station in the late 1990s beneath Amalias Avenue at Othonos Street.[44] The Eridanos flows on toward Mitropoleos Square, where it manifests itself in the presence of a few old plane trees now growing among the tables of the street cafés.

To the east of the Acropolis, the Ilissos River, long converted into an underground rainwater conduit, flows along its original course beneath

Mesogeion, Michalakopoulou, and Vasileos Konstantinou Avenues. From here it runs past the ancient spring of Kallirrhöe and carries on beneath Kallirois Avenue through the suburb of Kallithea, from which it has been routed, in modern times, directly into the Bay of Phaleron. But, in antiquity, the Ilissos circled around to the south of the Acropolis, coursing westward to join up with the Eridanos before emptying into the Kephisos and flowing on into Phaleron Bay.

The three rivers of Athens rise in the mountains to the north of the city: the Kephisos flows from Mount Parnes, the Ilissos from Mount Hymettos, and the Eridanos from Mount Lykabettos (pages 7 and 9). These waterways would have been the principal points of reference for the city, sustaining vibrant ecosystems, providing a focus for human activity, and serving as thoroughfares for transporting goods and people. While Plato's *Phaidros* paints an idyllic image of the pastoral along the Ilissos's grassy banks, we must acknowledge that the reality on the ground might have been quite different. An inscription, dating to the late fifth century B.C., forbids that anyone tan hides or throw litter into the Ilissos, further stipulating that no animal hides should be left to rot in the river above the temple of Herakles.[45] Similarly, the Eridanos was so filthy in antiquity that it was said no Athenian maiden could draw "pure liquid from it" and "even cattle backed off" from its waters.[46]

The Kephisos is the largest of the three rivers. It gushes south for some 27 kilometers (16.8 miles) from the foothills of Parnes, a great mountain where wild boars and bears once roamed.[47] Coursing south across the Thriasion Plain to the west of Athens, the river eventually flows into the Bay of Phaleron. Today, it can be seen channeled in conduits running alongside the Athens-Lamia National Road and, for its southernmost 15 kilometers (9 miles), languishing in canals beneath the four-lane elevated highway known as Kifissou Avenue, a place for dumping garbage and toxic waste. An environmental reclamation effort is under way.[48] For now, though, the Kephisos bears little resemblance to the noble river of antiquity, one so revered that it was worshipped at its own sanctuary.

The shrine was located close to the place where the Ilissos joined the Kephisos, about halfway between the port of Piraeus and Phaleron. Around 400 B.C., a man named Kephisodotos ("Given by the Kephisos") dedicated a marble relief stele here.[49] It is likely that he was named by grateful parents whose prayers for a child had been answered favor-

ably by the river. Greeks prayed to rivers to help them conceive children, and we can detect a certain trend toward potamonymy ("naming after rivers") in communities flanking famous streams.[50]

Moisture being essential for conception and growth, it follows that rivers and their female offspring, the nymphs, were closely associated with the begetting and nurturing of children.[51] In the sculptured stele offered by Kephisodotos (below), he perhaps stands as donor, second from left, between a female figure of uncertain identity (Artemis?) and a personification of the Kephisos, at center; three spring nymphs follow behind. The sanctuary in which Kephisodotos set up this dedication had, in fact, been founded by a woman named Xenokrateia just ten years earlier. It seems that she may have vowed to dedicate her young son to the river but, because of the Spartan invasion of Attica at this time, she was unable to move beyond the city walls. Xenokrateia found an ingenious solution to this dilemma by establishing her own new shrine to the Kephisos in a protected area where the river flowed inside the city's Long Walls. Here, Xenokrateia offered a marble relief to the Kephisos, and to the "altar-sharing gods," as "a gift for the *didaskalias*" ("instruction" or "upbringing") of her son, Xeniades.[52] The stele shows Xenokrateia standing behind her little boy (following page), who reaches up to a male

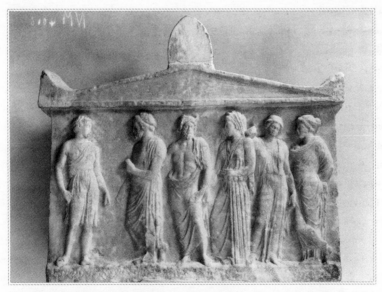

Marble relief stele dedicated by Kephisodotos, shown second from left, followed by the Kephisos River (with horns) and three nymphs.

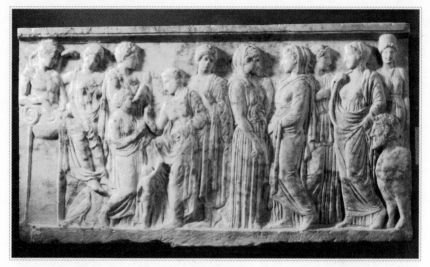

Marble relief stele dedicated by Xenokrateia, shown in foreground, at left, with young son who reaches up to the Kephisos River; the bull-bodied Acheloös at far right.

figure that must be the Kephisos River. At the far right of the scene we see Acheloös, whose cosmic, primordial identity makes him an ideal proto-type for all Greek rivers.[53] Portrayed as a man-headed bull, here he does not specifically reference the great old river of Akarnania but, instead, represents the riparian nature of the shrine, just like that encountered by Sokrates and Phaidros on the banks of the Ilissos in the passage quoted at the opening of this chapter.

The child-nurturing powers of the Kephisos are further attested by a marble statue group that Pausanias spies as he's passing along its banks in the second century A.D.[54] The sculptures showed a woman named Mnesimakhe and her little son depicted in the very act of cutting his hair as a votive offering. We know from many sources that first locks were cut from the hair of children and offered to rivers as "a token of the fact that everything comes from water."[55] Here, we see something of the very personal relationships that bound Athenians with the rivers that made life itself possible.

The relief sculpture dedicated by Kephisodotos shows the Kephisos River as a man with small horns. Euripides calls the Kephisos "bull-visaged" in his play the *Ion*.[56] Even the loud rushing of the river's cur-rents is likened to the deep, lowing sound of a bull. We have also seen

the grand old river Acheloös appearing as a horned bull with a human face on the votive relief dedicated by Xenokrateia. As the second-largest river in Greece, flowing in the west between Akarnania and Aitolia, the Acheloös was regularly depicted in vase painting as a bull- or human-headed bovine with a great beard, denoting its venerable age.[57]

Three other Greek rivers are named Kephisos: one flowing from Mount Parnassos near Delphi, another from Mount Kithairon and through the Nysian Plain near Eleusis, and another at Argos where, Aelian tells us, the people portrayed their Kephisos with "a likeness to cattle."[58]

The Kephisos of Athens, bullish as the rest, played a prominent role in the great procession of initiates who marched from Athens to Eleusis as early as the seventh century B.C. for induction into the Mysteries. In September of every year for a thousand years, worshippers walked west from Athens along the 14-kilometer (9-mile) Sacred Way to the sanctuary of Demeter and Kore. This was an occasion to which youths and scoundrels of Athens greatly looked forward. For on this day, they were allowed to stand by the Kephisos bridge and shout gross obsceni-ties at their elders marching in silent procession, unable to speak back. We learn that to enjoy such sport, men and women, or perhaps men dressed as women, wore masks and veils to hide their faces as they harassed those crossing the bridge.[59] This misbehavior was ordained by the sacred rite and is typical of role-reversing cult practices in which people of lower rank are temporarily given license to mock their superi-ors. Such suspension of social hierarchies may have enabled participants in the Mysteries to approach Demeter and Kore with a fitting sense of humility.[60] In any case, bridges and bad language went together. The Greeks even had a word for it, *gephyrismos,* or "bridginess," and in Plutarch "bridge words" correspond to our "four-letter words" today.[61]

Like all rivers, the Kephisos was understood to be the child of Okeanos, the freshwater river that encircled the earth, and his wife, Tethys, a sea goddess whose name means "Nurse."[62] By some accounts, the Kephisos had a daughter named Diogeneia, who gave birth to the naiad nymph Praxithea. (The word "naiad" comes from the verb *nao,* "to flow," and refers to river nymphs.) By other accounts, Praxithea is the daughter, rather than the granddaughter, of the Kephisos.[63] In any case, Praxithea marries King Erechtheus of Athens, a union that fol-lows a well-attested pattern by which naiads wed local kings and play

prominent roles in local genealogies. The maiden Oreithyia (she who was abducted by the North Wind along the Ilissos, as discussed by Sokrates and Phaidros) was a daughter of Praxithea and, thus, a grand-daughter (or great-granddaughter) of the Kephisos. And so we find the royal family of Athens descended directly from its greatest river and his nymph daughter. As a naiad, Praxithea nurtures her family, providing the wetness necessary for the germination of seed, ensuring fecundity, growth, and prosperity in the royal line. In this, she follows a model in which naiad nymphs, as mothers of the city, protect the community's all-important water supplies that come from local springs and streams.

According to Apollodoros, Praxithea had a nymph sister, Zeuxippe, who married King Pandion of Athens in a similar arrangement. Zeuxippe gave birth to two daughters, Prokne and Philomela, and twin sons, Boutes and Erechtheus.[64] This is the same Erechtheus who goes on to marry Praxithea, his mother's sister. Hyginus names Zeuxippe as daughter of the Eridanos River.[65] It can be difficult fitting various versions of myths, recounted for different purposes and across many centuries, into comprehensive genealogies, and there is no avoiding repetition and contradiction. Compilers of myth variants, working centuries later than the first telling of the tales, created anthologies filled with inconsistencies.[66] Mythmaking is an ever-dynamic process with no definitively "right" or "wrong" version, though a force akin to natural selection seems to exert itself on the crucial features.

The Eridanos ("Morning River" or "River of Dawn") is the shortest of the Athenian rivers, rising from the slopes of Mount Lykabettos and coursing southwestward to skirt the north side of the Agora.[67] Waste-water and torrential overflows from the ancient marketplace were, by the end of the sixth century B.C., guided into the Eridanos through a stone channel that has been designated by its excavators as the "Great Drain."[68] When the politician and general Themistokles built new fortifications for Athens following the Persian destruction of 480, the Erida-nos was enclosed in a stone-lined channel directing its flow out beyond the Dipylon, the "Double Gate," and through the Kerameikos cemetery.

Athenians had begun to bury their dead along the banks of the Erida-nos very early, by the end of the twelfth century B.C. One hundred sub-Mycenaean graves have been found on the north side of the river and a few on the south bank. During the tenth century there was a shift, and the south bank was increasingly used for burials. By the Archaic period,

that is, roughly, from the turn of the seventh to the sixth century B.C., the main necropolis was firmly established here. It became known as the Kerameikos cemetery owing to its proximity to an industrial area where potters (*keramei*) worked their kilns firing ceramics for the city (page 9).[69] The Eridanos may have been regarded as a kind of river of Hades and, like the river Styx, a stream to be crossed on one's journey to the underworld.[70]

THE THIRD RIVER of Athens, the Ilissos, flows from Mount Hymettos at the northeast of the city, circling down and around to the south of the Acropolis. As recently as the 1950s, the river could be seen at the foot of the Panathenaic Stadium, known as the Kallimarmaro, or "Beautifully Marbled." In myth, Ilissos was understood to be the son of the sea god Poseidon and the earth goddess Demeter. A child of the land and the sea, the Ilissos was a vital player in local ecosystems and home to a host of shrines. The spot sacred to Acheloös and the nymphs referenced in the *Phaidros* was on the river's east bank at the foot of the Ardettos Hill (page 9). About 500 meters (0.3 mile) downstream, on the west bank, rises the spring known as Kallirrhöe. Today, it is just a faint rivulet falling beside the little church of Agia Photini, but early on the area was so marshy that it was called Vatrachonis ("Frog Island").[71] This mere trickle of water is likely to be one and the same as the great spring Kallirrhöe that Thucydides claimed to be the main source for water for the early city.[72] With the building of a formal fountain house over it, the place became known as Enneakrounos, or "Nine-Headed," for the nine spouts built to facilitate collection, and eventually becomes the preferred spot for Athenian brides to take their nuptial baths.[73] Just opposite the spring, on the banks of the Ilissos, sits a little shrine of Pan. His image can be seen to this day, carved into the rock face of a surviving wall, a lone reminder of devotions practiced on this spot in the ancient past.[74]

Kallirrhöe was the daughter of Okeanos and Tethys, who, according to Hesiod, produced a total of forty-one nymph daughters who protected girls and maidens just as Apollo and the rivers protected boys and youths.[75] By one account, Kallirrhöe mated with Khrysaor, son of Medousa, and gave birth to a terrible three-bodied giant known as Geryon, eventually killed by Herakles. In the sixth century B.C. the poet Stesichoros wrote a *Song of Geryon* that celebrated the conflict of

the giant and the hero, a fight in which Poseidon sided with his monstrous grandson while Athena protected her favorite, Herakles.[76] This conforms to a pattern that will become familiar, one in which Athena and Poseidon battle each other through proxies. By some later accounts, Kallirrhöe mated with Poseidon and gave birth to Minyas, founder and king of Orchomenos in Boiotia.[77] The relationship between Poseidon and spring nymphs was always a delicate one. Should he become angry with them, he can withdraw his water and cause their springs to go dry.

On the southeast bank of the Ilissos, just opposite Kallirrhöe, stretches the area known as Agrai (page 9). Fittingly, we find Artemis here, worshipped in the marshy, wild, and wooded setting that she so favored.[78] In this precinct, the goddess was called by the cult name Agrotera, "the Huntress," just as she was at Marathon, where she helped the Athenians defeat the Persians in 490 B.C. The wetlands of Marathon Bay and the marshy plain to the west of it where the battle was fought represent exactly the kind of terrain in which Artemis is happiest. So, too, here on the swampy banks of the Ilissos, Artemis Agrotera finds a home.

Foundations of a small Ionic temple, probably erected around 435–430 B.C., sit on a rocky knoll positioned just above the south bank of the river, roughly opposite the spring of Kallirrhöe (page 9).[79] These belong to the temple of Artemis Agrotera, the setting for one of the most exceptional sacrifices in the Athenian festival calendar. Before the battle at Marathon the Athenians vowed that they would sacrifice to Artemis Agrotera one goat for every Persian killed. This was in accordance with a long tradition of prebattle sacrifices (*sphagia*) offered to deities in hopes of a favorable outcome.[80] When an astounding 6,400 Persians were killed at Marathon (to Athens's loss of just 192 men), the Athenians were unable to find enough goats to make good on their promise. So it was decreed that forever after six hundred goats would be sacrificed annually in fulfillment of the vow. This sacrifice was offered each year on the anniversary of the battle, the sixth day of the month Boedromion, in our early September. It was observed at least into the first century A.D.[81] Not many rituals could have impressed themselves on the consciousness of the Athenians with the same force as seeing six hundred goats led to the banks of the Ilissos for sacrifice every year.

AS WE RETURN to the city's beginnings, we reflect on how beautifully situated Athens is, set far enough inland that it could be easily defended yet close to a series of excellent harbors (some 6 kilometers, or 3.7 miles, to the south) that link it to the wider world. Of all the hills that the early settlers could have chosen for their acropolis citadel, they decided not on the highest peak but on that which had the best water source. The Acropolis, which rises to a height of 150 meters (500 feet), was the most promising among a number of candidates. Steep cliffs gird it on three sides, leaving only one point of easy access on the west and rendering it more easily defensible from enemy assault. Though Mount Lykabettos, to the north, is the highest hill in Athens at 277 meters (909 feet), it lacks the all-important combination of water, natural defenses, and a summit that could be easily leveled, elements that made the Acropolis so attractive to early city builders (below).

Many city-states across Greece were founded on acropolis citadels.

View of the Acropolis from the southwest with Mount Lykabettos in the distance. © Robert A. McCabe, 1954–1955.

But few could boast an acropolis rock as prominent as the Athenian. It rises abruptly from the surrounding lowlands and, throughout the city, is never lost to view. This bare, stark "bunker" of limestone, encompassing an area of just 7.4 acres, has persisted as the focal point of Athens from the fourth millennium B.C. to the present (previous page and insert page 1).[82]

The well-watered slopes of the Acropolis's northwest shoulder were as suited to times of peace as to those of siege. Here, twenty-two shallow wells have been discovered dating to the Late Neolithic period (ca. 3500–3000 B.C.), when they would have provided water for inhabitants who, presumably, lived nearby.[83] For reasons that remain unclear (perhaps a drought from climate change, decimating the population), these wells were abandoned during the millennium that followed. It is not until the Middle Bronze Age (ca. 2050–1600 B.C.) that new wells were dug along this same slope, as well as to the south of the Acropolis. At the same time houses were built on the south slope and, possibly, also on the summit. Graves for children have been found atop the Acropolis and more tombs and graves to the south.[84]

The water-rich veins running through the Acropolis rock result from its geological formation, in which porous limestone overlies a layer of calcium carbonate marl, the uppermost part of the so-called Athens Schist.[85] Rainwater filters down through cracks in the limestone until it meets and gathers atop the marl. Since the geological stratigraphy of the Acropolis tilts from high at the southeast to low at the northwest, water trapped atop the marl level drains down to the west end, emerging in a series of natural springs.

A Mycenaean palace was built atop the Acropolis sometime between 1400 and 1300 B.C. (facing page).[86] By 1250, the citadel was protected by massive fortification walls, stretches of which survive to this day. They stood as high as 10 meters (33 feet) and, in some places, were 5 meters (16 feet) thick. These walls are constructed in the so-called Cyclopean masonry style in which huge unworked stones were piled one atop another (page 28), so huge that it was believed only giant Cyclopes could have lifted them into place.

Down below, at the foot of the Acropolis and encircling its entire western end, a second circuit wall may have been constructed, giving additional protection to the citadel's entrance and water sources. It is believed to have run from just west of the Mycenaean Spring, on the

north, to just east of the South Spring, the site of the later Asklepieion, at the south of the Acropolis (below).[87] Ancient sources refer to this wall both as the Pelargikon, the "Place of the Storks," and as the Pelasgikon, named for the Pelasgoi, the pre-Greek inhabitants of Athens about whom we know very little.[88] Whoever built the walls atop and around the Acropolis at the end of the Bronze Age, the sheer size of these fortifications points to the severity of the perceived threat. But absence of evidence of burning or destruction on these walls suggests they worked well and may never have been breached, that is, until the Persian assault nearly eight hundred years after they were built.

The Mycenaeans made brilliant use of a natural cleft along the north face of the Acropolis, gaining access to the water-rich levels beneath.[89] A vertical fissure some 35 meters (115 feet) deep was caused when a great chunk of bedrock sheared off the Acropolis and came to rest parallel to it. Around 1200 B.C., a staircase of eight flights was built down the narrow corridor. Cuttings in the rock held wooden steps leading all the way down; the lower courses had treads of stone resting upon the wood, all slotted into notches within the rock face. At the base of the staircase, a circular well shaft descended a further 8 meters (26 feet) through the

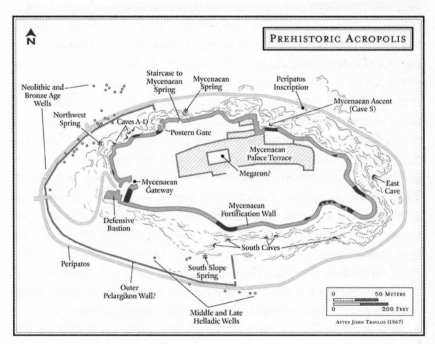

Prehistoric Acropolis.

Parthenon with Mycenaean wall in foreground, from west.

underlying marl to create a reservoir. Excavators have designated this construction the "Mycenaean Spring" (previous page). Though used for only about twenty-five years before it collapsed, it nonetheless provided a secure water source at a time when early Athenians were under threat of attack.[90]

Seven hundred years later, around 470–460 B.C., an impressive fountain house was built atop a spring some 90 meters (300 feet) to the west of the Mycenaean Spring, there on the north slope of the Acropolis (labeled Northwest Spring on previous page).[91] It is likely to have been the statesman Kimon who initiated construction of this springhouse at the same time he bolstered the fortification wall at the south side of the Acropolis. The Kimonian fountain house was set within the rocky overhang of a cave that gives access to the flowing water deep beneath; very special care was taken to maintain the original, rustic appearance of the craggy setting. First used during the Neolithic period,[92] the Northwest Spring is likely to be that associated with the nymph Empedo, whose name means "firmly set" or "in the ground"; indeed, its water source is so deep that inlets leading to its draw basin sit 6 meters (20 feet) below ground level. A boundary inscription found nearby in the Agora and

dated to the first half of the fifth century speaks of the *Numphaio hiero horos,* "the boundary of the sanctuary of the Nymph."[93] This has been taken to mean the nymph Empedo.

In time, this spring comes to be known as Klepsydra (literally, "Water Hider"), owing to its remote location, hidden within the rocky cliffs.[94] It was an important resource for the people of Athens, especially since a number of preexisting wells in the area had been filled with debris and put out of use during the late sixth and early fifth centuries. With the introduction of the Klepsydra fountain in the 460s, the north slope of the Acropolis was made more accessible to visitors, a very different state of affairs from in the Archaic period and earlier, when the precious water sources were guarded behind walls.[95] This marks an important shift in the function of the north slope, no longer just a source of secure and plentiful water but a place of shrines, worship, and visitation. In a very real sense, this evolution into a place of commemoration and devotion marks the expansion of the sacred space of the Acropolis down its slopes and the opening up of the Sacred Rock to the larger community. This development harmonizes with the new democratic spirit sweeping Athens, a process that will culminate, decades later, with the erection of its greatest temple, the Parthenon.

TODAY, AS IN ANTIQUITY, a path circles the Acropolis, roughly halfway up its slopes. This enables visitors to circumnavigate the Sacred Rock and to visit the host of caves and crags that came to be used as sacred places. During the mid-fourth century, someone carved into the bedrock along the northern stretch of this pathway an inscription giving its name and length: "The Peripatos, five stades and eighteen feet."[96] This measures some 893 meters, or just over half a mile. The inscription can be seen to this day, just east of the sanctuary of Aphrodite and Eros, more than halfway around the northern face of the Acropolis as one approaches its east end (page 27). Since 2004, the Peripatos walkway has been reopened to the public, affording the great pleasure of viewing the city from above while walking a wilderness landscape, right in the heart of Athens. Strolling the Peripatos and visiting its caves, crags, springs, and lush vegetation bring viewers as close as one can get to an ancient experience of the natural environment.

Roughly a dozen caves penetrate the rocky slopes of the Acropolis,

and over time at least half of these came to be regarded as sacred. The caves of Apollo, Pan, and the nymphs, together with the sanctuaries of Aphrodite, Aglauros, and Asklepios positioned on rocky ledges near caves, claim special places of memory here amid the cliffs.[97] All across Attica, some twenty-eight sacred caves have been identified. Athens is the only city that allowed cave sanctuaries within the limits of its urban area for easy access to the experience of a rustic, sacred landscape setting.[98] In this, we may perceive the intensity of Athenian religiosity, an urgent desire to connect with the prehistoric cave dwellers, the Neolithic ancestors who may have made their homes within these rock shelters. Let us visit these caves, starting at the northwest shoulder of the Acropolis and at an elevation of some 125 meters, or 410 feet, above sea level. Here, high above the Klepsydra fountain, we find a broad level shelf that opens onto four further caves, designated A–D (below and page 27). Cave A sits farthest to the west, shows a low rock-cut bench, and is of unknown use. Cave B was sacred to Apollo, and Cave D was sacred to Pan. Cave C has been assigned to Zeus, but not all scholars agree.

The shallow rock shelter known as Cave B, second from the west, was among the most famous settings in all of Athenian myth (facing page). Long identified as the shrine of Apollo Hypo Makrais, "Apollo

Acropolis, north slope, Caves A–D, from northwest.

Cave of Apollo Hypo Makrais (Cave B), from the north.

Under the Long Rocks" or "Apollo Below the Heights," this is the spot where the god is said to have forced Kreousa, daughter of King Kekrops, to make love to him. From this union, the child Ion was conceived. Having given birth in secret, Kreousa hides her shame by leaving the infant wrapped in swaddling clothes, here in the same cave where she had lain with the god.[99] Apollo intervenes, instructing the god Hermes to rescue his son and carry him to Delphi. At the Delphic sanctuary, Ion was educated by a priestess of Apollo and served as a temple boy within the shrine of his father.[100]

As we know from Euripides's play, named the *Ion* after the youth, Kreousa later marries Xouthos, with whom she finds herself unable to conceive a child. The pair travel to Delphi to seek the oracle's advice. After a series of misunderstandings and the subsequent revelation of hidden identities, Kreousa is reunited with Ion and recognizes him as her son. Ion grows up to marry Helike, daughter of King Selinos of Aigialeia (and thereby granddaughter of Poseidon), and establishes a city named Helike for her in Achaia on the north coast of the Peloponnese. Here, Poseidon Helikonios was worshipped well into the Roman period.[101] The children of Ion and Helike, and their descendants forever after, were called Ionians, and thus our hero establishes what comes to

be known as the Ionian race. Through this myth the Athenians were able to claim kinship with their Ionian neighbors in East Greece, strategically emphasizing this cultural connection when seeking Ionian support during time of war. Importantly, Ion himself led an expedition, with the help of the Athenians, against their longtime enemy, Eleusis. He lost his life in this battle, just outside the sanctuary of Demeter and Kore.

The cave of Apollo Hypo Makrais has been explored and studied by archaeologists from the late nineteenth century on.[102] Over a hundred niches have been cut into its rock walls and onto the spur that separates it from Cave C.[103] In fact, human activity is evidenced here from as early as the thirteenth century B.C. The myth of Kreousa and Apollo may be evocative of Neolithic times when the prehistoric populations of Attica lived in just such rock shelters and deep caves. Here, the earliest inhabitants of what would become Athens made new families that went on to become great ones, just as we have seen with Ion. Safeguarding and remembering the rock shelters of primitive days, set close to the opulence of the Parthenon and other lavishly built Acropolis structures, would keep something of the remote past near at hand. These places of memory were constant reminders to the Athenians of their rustic origins.

Cave C, a shallow rock shelter just to the east of Apollo's Long Rocks, has sometimes been identified as housing the shrine of Zeus Astrapaios. This suggestion rests on somewhat tenuous evidence put forward by Strabo, who writes of a place that was used as a lookout for determining the appropriate moment for sacrifices to be sent to Delphi.[104] The Pythaistai, organizers of the sacred procession, are said to have watched from the sanctuary of Zeus Astrapaios for a starting signal in the sky: lightning above a place called Harma on the distant slopes of Mount Parnes (page 7).

The next cave to the east, the one identified as sacred to Pan and the nymphs, is actually a complex of three adjoining caves, designated D, D_1, D_2, their rock faces covered with cuttings and niches for votive offerings. A number of marble votive reliefs showing Pan and the nymphs have been recovered here.[105] The cult of Pan was introduced to Athens relatively late, around 490 B.C., in thanks for the god's assistance in defeating the Persians at Marathon. Pan worship spread quickly throughout Attica with numerous mountainside shrines identified on

Mounts Parnes, Pentelikon, Aigaleos, and Hymettos, as well as at Marathon and the hill of Eleusis.[106]

The cave of Pan and the Nymphs on the north slope facilitated Pan's worship without a long trip to his woodland haunts. Families regularly made pilgrimages to such shrines, but the Acropolis cave site enabled more continuous devotions. We hear that shortly after Plato's birth, his parents took him up to Mount Hymettos to sacrifice to Pan, the nymphs, and Apollo Nomios. Going off to make a sacrifice, Plato's father laid the infant down for a moment, returning to find bees swarming about little Plato's lips, now smeared with honey, an omen of his future mellifluence.[107] No doubt, other Athenian parents brought their little ones up to Pan's cave on the Acropolis in similar devotions experienced closer to home.

In his *Ion,* Euripides focuses on this cave of Pan and indicates that it was close to a place where Athenian maidens danced. We hear that Pan's pipe playing accompanied their nimble steps:

> O seats of Pan and rock lying near the Long Rocks full of recesses, where the girls of Aglauros, all three, tread choral dancing places with their feet, running-courses of green-sprouting grass in front of Pallas's [Athena's] temple, to the flashing-tuned, wild cry of hymns when you pipe the syrinx, O Pan, in your caves where sunlight does not enter . . .
>
> Euripides, *Ion* 492–502[108]

This would suggest that ritual dancing took place near the caves of Pan and Apollo, a subject we will return to in chapter 7.

Farther east on the Peripatos, more than halfway along the north slope, we come to a broad terrace near the entrance of Cave S, a natural cleft in the rock from which a well shaft leads down to the water beneath and a Mycenaean ascent leads up to the summit (page 27). More than twenty niches were carved into the cliff face of the adjacent ledge and once held votive dedications in marble. Two inscriptions carved in the living rock and dating to the mid-fifth century B.C. have led to the site's identification as a shrine to Aphrodite and Eros. One text specifically mentions Aphrodite and a festival of Eros.[109] A nearby pit filled with stone *phalloi,* pottery, and terra-cotta figurines further bolsters the case

for a link with Aphrodite. This shrine has sometimes been identified as the sanctuary of Aphrodite in the Gardens, mentioned by Pausanias as the destination of the girl *arrephoroi* who carried unnamable things (*arreta*) in night rituals during the Arrephoria festival.[110] But this is by no means certain.

Meanwhile, beneath the sanctuary of Aphrodite, some 20 meters (66 feet) down from the Peripatos walkway, an artificially leveled terrace (designated the "Skyphos Sanctuary") preserves a rare look at ritual practices of the early third century B.C.[111] Here, some 221 miniature drinking cups, all of the same *skyphos* shape, have been found in the exact placement where they were carefully set by worshippers thousands of years ago.

Just above the shrine of Aphrodite and Eros, we see column drums salvaged from the Older Parthenon (destroyed by the Persians in 480 B.C.) set in commemorative display within fortifications built after the Persian siege (page 73). Metopes and architrave blocks from the ruins of the Old Athena Temple are similarly set into this wall just a little farther to the west. These architectural members bear witness to the most devastating event in Athenian history: the Persian sack. Their display rendered the memory of this destruction ever present. Keeping open the wounds of trauma, as we shall see, was a definitive feature of Athenian public art and the collective psyche.

THE EASTERN FACE of the Acropolis is the most precipitous of all (insert page 1, bottom). Its sheer cliffs are penetrated by one deep cave measuring 14 meters (46 feet) in width and 22 meters (72 feet) in depth. This cave was first excavated by Oscar Broneer in 1936; he found little in it.[112] But years later, laborers clearing for a "modern" Peripatos in front of the cave and down its slopes found (at a much lower elevation) an inscribed stele still attached to its base. The text, published by George Dontas in 1983, concerns sacrifices made to the nymph Aglauros, one of the three daughters of the legendary king Kekrops.[113] It records honors awarded by the Athenians to Timokrite, priestess of Aglauros in 247/246 or 246/245 B.C., with specific instructions that the decree be mounted "in the shrine of Aglauros."[114] The location of this sanctuary concurs with Herodotos's description of the surprise attack by the Persians in 480:

In front of the Acropolis, and behind the gates and the ascent, was a place where no one was on guard, since no one thought any man could go up that way. Here some [Persian] men climbed up, near the sacred precinct of Kekrops's daughter Aglauros, although the place was a sheer cliff.

Herodotos, *Histories* 8.52–53[115]

It is within this sanctuary that the eighteen-year-old ephebes would come to make their solemn pledge of allegiance to Athens. Invoking Aglauros (one of the daughters of Kekrops), Ares (god of war), and other divinities, the young men swore the Ephebic Oath upon their freshly acquired weapons, promising to defend their city as new soldiers.[116] Its nearness to the very spot where the Persians breached the Acropolis made the sanctuary of Aglauros a perfect place for the ephebes to pledge their defense of Athens. Herodotos goes on to say that once the Persians had breached the citadel, some Athenians leaped to their deaths from this eastern cliff, rather than leave themselves to the enemy's rage:

When the Athenians saw that they [the Persians] had ascended to the acropolis, some threw themselves off the wall and were killed, and others fled into the chamber [of the temple?].

Herodotos, *Histories* 8.53[117]

It is from these same cliffs that, according to a later source, Aglauros is said to have willingly jumped to save Athens from a siege by Eumolpos, fulfilling a prophecy given by the Delphic oracle. This story, told in a commentary on a speech by Demosthenes, says that the Athenians then established a sanctuary to Aglauros under the cliffs and that it was here the ephebes swore their oath.[118] The commentator is surely confusing Aglauros with yet another princess of Athens, the daughter of the Athenian king Erechtheus, she who was sacrificed to save the city from Eumolpos's attack. In the chapters that follow, we will see just how the myths of the maiden princesses of Athens become fused and blended over time. Nonetheless, the memory of a triad of heroic daughters survives, including the one who gave her life for the city and who thus provided special inspiration for the young soldiers of Athens. Here, on the dramatic eastern cliffs of the Acropolis, landscape, topography, myth, history, and memory come powerfully together in a single highly charged location.

PROCEEDING ALONG THE Peripatos walkway to the south slope of the Acropolis, we find cliffs similarly pocketed with caves and ledges, home to Neolithic inhabitants already in the fourth millennium.[119] At the east end, an especially deep cave (page 27) in which significant Neolithic material has been found sits above the later site of the Theater of Dionysos Eleutherios.[120] At some point after the middle of the sixth century B.C., the natural hollow in the slope beneath this cave began to be used for seating viewers who watched dramatic performances down below, where a temple of Dionysos was built around 530. By the end of the fifth century this theater comprised a wood-built structure with *theatron,* orchestra, and scene building and seating for around five thousand to six thousand viewers.[121] In the 330s, the statesman and orator Lykourgos greatly expanded this theater to accommodate an audience of around seventeen thousand, rebuilding it, along with a new temple of Dionysos, entirely of marble. Just to the east of the Theater of Dionysos stood the Odeion of Perikles, believed to be a great covered concert hall built by the leader in the 440s B.C. (page 305).[122]

In 320/319 B.C., a man named Thrasyllos who served as *choregos* (a benefactor who financed theatrical productions) set up a monument high above the Theater of Dionysos—just in front of the Neolithic cave—to commemorate his contribution. Two tall Corinthian columns, reerected at the cave mouth, represent an enhancement of Thrasyllos's dedication set up by his son years later.[123] The enduring power of this cave as a divine place of memory is manifest by its use until recently as a shrine of Panagia Spiliotissa, "Our Lady of the Cave." Painted icons and other offerings to the Virgin are hung all about its rustic interior. Tradition has it that with the coming of Christianity, the cave's former resident (possibly Artemis) was replaced by the Virgin Mary. Ritual visitation continued at this site, especially by mothers bringing their sick children to the grotto in hope of a cure.[124]

At the center of the south slope, we find more caves and a broad rock terrace lying close to yet another major spring (marked "South Slope Spring" on page 27). It is easy to understand why this location attracted inhabitants from early on (Middle Helladic material has been found within the caves) and how, in time, an Archaic springhouse came to be built here. The area later served as the setting for an important

sanctuary to the healing gods Asklepios and Hygieia.[125] Established in 420/419 B.C., in the wake of the great plague at Athens, the Asklepieion was a place where pilgrims came to seek cures, pray at the temple, purify themselves in the spring waters, and spend the night in the adjoining stoa. Indeed, one wonders if Our Lady of the Cave takes some of her curative powers from a distant memory of the healing abilities of Asklepios and Hygieia, long settled here on this same south slope.

To the west of the Asklepieion, a tumulus of Middle Helladic date (1900–1600 B.C.) and wells of the Late Helladic period (1600–1050 B.C.) have been discovered, while farther to the south Neolithic remains have been unearthed. What appears to be an ancient foundry has been recovered here, along with evidence of refuse from bronze casting.[126] And much farther down to the southwest, a fascinating sanctuary has been identified by a fifth-century stone inscription reading *horos hiero numphes,* "boundary of the sanctuary of Numphe (the Bride)." The large number of loutrophoroi (vases used by brides for their nuptial baths) found here suggests it was a place special to women at the time of approaching marriage.[127]

The south slope remains ever vibrant across the ages, with impressive additions made by the Pergamene king Eumenes II, who built a vast stoa here (page 305) in the second century B.C., as well as by the Roman philhellene Herodes Atticus, who constructed a covered theater (*odeion*) here in the second century A.D., a performance space used to this day. But there is no greater testament to the sanctity of place than the abundance of chapels and churches that have been built on the Acropolis slopes over time. In addition to Panagia Spiliotissa we have the chapels of Saint George Alexandrinos and Saint Paraskevi (at the Theater of Dionysos) and Our Lady of the Holy Spring (at the Asklepieion). On the north slope are remains of the cave chapel of Saint Athanasios, the Church of the Transfiguration of the Savior, and the Church of Saint Nikolaos (recently restored).

AT THE VERY CORE of Athenian solidarity and civic devotion was the awareness of a shared past, and part of that awareness for some was special pride in being earthborn, or *gegenes* (from the Greek Ge or Gaia, meaning "Earth," and *genes,* meaning "born"). *Gegenes* denotes a literal springing up from the earth itself. The sense is slightly differ-

ent from another designation, *autochthonos,* from *autos* ("self") and *chthon* ("earth"), which refers to the very first or oldest inhabitants of a region, a people that have always lived on the same land and that were not brought in from elsewhere.[128] But even in antiquity many authors, including Plato, use the two words interchangeably.[129] In the funeral oration of his *Menexenus,* Athenians are praised for coming out of the soil, and Athens is acclaimed for "growing human beings."[130]

According to certain accounts, the first earthborn ruler of Attica was the primeval Ogyges, whose name may reflect a connection with that of Okeanos.[131] He is said to have been the first lord of Boiotia (named for his father, Boiotos) and king of Thebes (named for his wife, Thebe).[132] By other accounts, Ogyges is the first king of Athens and father of the Attic hero Eleusis. During his rule, the earth suffered its first worldwide flood, the Ogygian deluge named after him. Next came the *autochthon* Aktaios, who is sometimes identified as the first king of Attica. Indeed, it has been suggested that there may be a connection between the names Aktaios and Attica with an alternation that allows for a further connection with the similarly non-Greek "Ath-" form, seen in Athena and Athens.[133] Aktaios's daughter, the nymph Agraulos or Aglauros I (mother to Aglauros II, she of the sanctuary near the Acropolis east cave), married the second *gegenes,* King Kekrops.[134] In the visual arts, gegenic rulers are traditionally shown with snaky legs, signaling, among other things, their close connection to the earth, and Kekrops is no exception (page 133).[135] By most traditions Kekrops and Aglauros I had three daughters, Herse, Aglauros II, and Pandrosos, as well as a son, Erysichthon. By another tradition they had a son called Kranaos, said to be an *autochthon,* who succeeded as king. Fascinatingly, Kranaos is described as a Pelasgian. Following the reign of Kranaos there was yet another flood, the deluge of King Deukalion of Attica. And finally, we come to the gegenic Erechtheus, or Erichthonios, who ruled Attica during the days when kings were human.[136] Homer is the first to speak of him as earthborn and specifically as springing from the cultivated lands of Attica: "Great-hearted Erechtheus whom once Athena tended after the grain-giving fields had born him."[137] It was an appropriately auspicious start.

Erechtheus's birth myth is singular in every respect. According to Apollodoros, conception occurred when the god Hephaistos caught sight of the maiden Athena.[138] He chased her, even as the virgin god-

dess resisted his advances. Much excited, Hephaistos "spilled his seed" upon her leg. Disgusted, Athena wiped the semen from her thigh with a piece of wool and threw it upon the ground. There, the seed of Hephaistos impregnated Mother Earth. From this improbable union, the hero known as Erechtheus was conceived. All Athenians were the progeny of this king, and while not sprung directly from the soil, they understood themselves to be descended from Mother Earth herself.[139] No birth story could give the Athenians a stronger claim upon the land.

THE EARLIEST GENEALOGIES of the Athenian people are richly inhabited by both earth and water divinities. But the origins of the goddess who would become the city's patron are in water. By most accounts, Athena is said to have been raised on the banks of Lake Tritonis or the river Triton, in Libya. Aeschylus refers to the river Triton as Athena's "natal stream" (*genethlios poros*).[140] Versions of her birth myth are conflicting and many. By some accounts, she is the daughter (or foster daughter) of the sea god Triton, son of Poseidon. By most, she is the daughter of Zeus. Hesiod tells us that Zeus gave birth to Athena on the banks of the river Triton. Apollodoros adds that Zeus then placed her under the care of Triton, who reared her alongside his own daughter, Pallas. Pausanias contradicts this version, identifying Athena as the daughter of Poseidon and a nymph named Tritonis.[141] Thus, Athena's epithet Tritogeneia, which could mean "Triton-Born," might point to her foster father, Triton, or to the lake/river beside which she was born, or to her nymph mother, who mated with Poseidon. Alternatively, the epithet could refer to the third day of the month on which Athena is said to have been born or even to "third born," which might have some connection to the recurring triad of daughters born to Athenian kings. Herodotos tells us that somewhere near Lake Tritonis Athena was drawn into a fight with her sibling Pallas. Athena killed her sister and claimed the name, thereby becoming Pallas Athena.[142] By other accounts, Pallas is a patronymic. Whatever the case, references to Lake Tritonis, the river Triton, and the epithet Tritogeneia persist across time and may point to the goddess's Libyan origins, long before she came to Athens.

The most widely known account of Athena's birth story has her spring from the head of Zeus as a fully formed warrior-goddess. Zeus

had heard a prophecy that he would be overthrown by his second child, and so, when the nymph Metis, daughter of Okeanos and Tethys, conceived a baby, Zeus had to prevent her from giving birth. And so, naturally, he swallowed her whole.[143] In time, Zeus suffered a terrible headache, and Hephaistos, god of craft, came to the rescue. Taking up his ax, Hephaistos struck Zeus's throbbing skull in an effort to bring relief. Out popped Athena in full armor, brandishing her spear. Born from a father rather than from a mother, Athena nonetheless inherited traits from her maternal side. Metis, whose very name means "Cunning" or "Wise Counsel," endowed her daughter with such astuteness that she was ever known as the goddess of wisdom. The birth story of Athena is so crucial in the Athenian awareness that it will take center stage on the east pediment of the Parthenon. Celebrating the very moment she sprang into being only befits the "mother" of all Athenians.[144]

Despite watery origins, Athena comes to be more strongly identified with the earth, with the serpents that live in it and the olive trees that grow from it. Above all, she becomes a fierce advocate for the land of Attica. She is a shrewd architect of military strategies designed to protect it and a warrior goddess prepared to defend it with all her might.[145] It is Athena's wisdom, cunning, and craft, as well as her increasingly intimate ties to the land and therefore the people, that finally enable her to win Attica for her own.

Writing in the age of the Parthenon's creation, Herodotos tells the story of Athena's victory in the contest for the patronage of Athens, a foundation myth retold in greater detail by Apollodoros four hundred years later.[146] Zeus had announced that the Athenians' primary devotions would go to whichever divinity could first provide a witnessed gift to the city. Toward that end, Poseidon, going first, struck his trident into the Acropolis to unleash a gift of a sea spring.[147] For her part, Athena planted an olive tree, an offering that promised the precious commodities of oil and wood but that required care and patience in its cultivation. The choice was one between the wild, untamed sea and olives that demand human attention and vigilance, the development of agriculture, and, indeed, civilization itself. Kekrops testified that he had witnessed Athena plant the olive tree first, and so the twelve gods whom Zeus appointed as arbiters judged Athena the winner. Infuriated at the outcome, Poseidon let loose a torrent, submerging Attica beneath the rising flood.

Poseidon's retributive flooding of the Thriasion Plain, the great flat-land between Athens and Eleusis, is not simply yet another inundation. We must view it alongside the age-old flood myths of the Sumerian, Akkadian, and Hebrew traditions.[148] Just as these floods serve to mark an ultimate "before and after," a transformed relationship between god and man, a point from which the present age can claim descent, so too the flooding of the Thriasion Plain, signaling the end of the first Bronze Age, marks the dawn of Athenian awareness. And more: Poseidon's power to summon torrential waters, earth-splitting tremors, and era-ending cataclysms suggests an age of virtual chaos. Athena, in contrast, represents the approach of a "thinking divinity": civilized, orderly, intel-ligent, nourishing, cultivated, and urbane—everything the Athenians, somewhat despite themselves, will aspire to be.

All is not necessarily for the better, though. Just as in the ancient Near East, the great flood marks a decisive break between man's proto-history, a spiritually informed age of antediluvian sages, and a later era in which spiritual information was less available and held by a jeal-ous elite.[149] So, too, in the *Works and Days* of Homer's contemporary Hesiod we find a world getting, for the most part, progressively worse.[150] Hesiod describes a Golden Age of peace and harmony during the rule of Kronos, followed by a Silver Age during the reign of Zeus. This, in turn, gives way to a Bronze Age, then a Second Bronze Age, or "Age of Heroes," before the Iron Age of Hesiod's own day, characterized as a time of toil and misery for men.[151] However much we may exalt the glories of Periklean Athens as constituting a golden age, their own view was that the best days were past.

The flood that Poseidon unleashed was by no means the first to con-sume Attica. The sources are inconsistent on just how many times Ath-ens was inundated. We have already noted the first Greek flood, which occurred during the primordial era of Ogyges and is usually associated with the flooding of the Kopaic basin in Boiotia to the northwest of Attica. Plato placed this flood around 9500 B.C., though others have dated it much later, probably sometime in the fourth millennium.[152] But there is a separate tradition for a local Ogygian deluge in Attica itself. Sextus Julius Africanus, writing in the third century A.D., observes, "After Ogyges, on account of the great destruction caused by the flood, what is now called Attica remained without a king for 189 years, until the time of Kekrops."[153] It was this Ogygian deluge that was understood

by the Greeks to have brought an end to what Hesiod called the Silver Age.

In his *Kritias*, Plato gives a vivid description of just how radically this first inundation changed the topography of Athens, especially the Acropolis, whose summit was supposedly once vast, connecting the far-flung hills of Athens into one high plateau:

> The Acropolis was different from now, since by now it has suffered from the effects of a single night of torrential rain which washed away the soil and left the Acropolis bare; and this appalling deluge—the third destruction by water before the one that took place in the time of Deukalion—was also accompanied by earthquakes. Before then, the Acropolis extended from the Eridanos to the Ilissos, included the Pnyx, and ended, on the side opposite the Pnyx, with Lykabettos; and the entire Acropolis was covered in soil and was almost all level.
>
> Plato, *Kritias* 111e–112b[154]

The Ogygian deluge occurred three floods before the deluge of King Deukalion's time.[155] Now Deukalion was the son of the Titans Promania and Prometheus, and the great flood that took place in his reign was understood to have brought an end to the first Bronze Age.[156] Foreseeing this catastrophe, Prometheus advised his son to build a chest, to take his wife, Pyrrha, with him, and to wait out the rising waters within the safety of its walls. For nine days and nights Deukalion and Pyrrha floated until the storm subsided. When the waters receded, they founded a new race of men. The debt is clearly to Mesopotamian and later myths in which a "flood hero" survives the deluge and goes on to become progenitor of a new line.[157] From Ziusudra in the *Eridu Genesis,* to Atrahasis of the *Epic of Atrahasis,* to Utnapishtim of *The Epic of Gilgamesh,* to Noah of the Bible's book of Genesis, we see the same story of a sole survivor who builds a chest/boat/ark to wait out the waters and start over.[158] Deukalion and Pyrrha start over in a big way. They give birth to three daughters.[159] And they give birth to a son, Hellen, who gives his name to a new nation called Hellas and a new people called Hellenes.

Among those Hellenes, even in antiquity, Athenians were regarded as the most deisidaimoniacal (intensely religious), a fact borne out by our brief tour through their places of memory. Writing in the first half of the

fifth century B.C., Pindar described Athens as "daimonion," that is, possessed or inhabited by *daimones* ("divine beings"). Five hundred years later, Saint Paul was struck by the same quality, observing, "Men of Athens, I found you in all things daimon-fearing."[160] Thus, in the *Phaidros*, when Sokrates and his student settle in along the banks of the Ilissos for an afternoon's conversation, it is normal that their thoughts turn straightaway to the divine. They are simply behaving as good Athenians do. Indeed, as they finish their discussion, Phaidros asks, "Shouldn't we offer up a prayer to the local gods before we leave?" Sokrates obliges, uttering these words to the rustic gods of the woodlands:

O dear Pan and all the other gods of this place, grant that I may be beautiful inside. Let all my external possessions be in friendly harmony with what is within. May I consider the wiser man rich.

As for gold, let me have as much as a moderate man could bear and carry with him. Do we need anything else, Phaidros? I believe my prayer is enough for me.

Plato, *Phaidros* 279b–c[161]

The natural landscape brimmed with divine presence. The power of place is so intense that the slightest moment, or glimpse of an object, or word, can evoke the sacred. Votive objects, most likely terra-cotta dolls dangling from the sheltering trees, trigger the memory process and inspire the two friends to pray. Stories from the past, no doubt first heard by Sokrates and Phaidros as children, come flooding back and subsume the present moment. "Isn't it from somewhere near *this* stretch of the Ilissos that people say Boreas carried Oreithyia away?" Phaidros asks. Narrative and earthly matter are incessantly directing the Athenians' attention backward in time, and this overwhelming suggestiveness of myth and place would literally be carved in stone on the ultimate place of memory and sanctity, the Acropolis and its supreme temple.

An awareness of the rich network of places of memory embedded in its rivers and springs, marshes and woodlands, caves and summits, reveals to us the enormous impact of the Attic landscape on ancient sensibilities. The comprehension of divine presence in a human world, of genealogical succession across great spans of time, and of heroic deeds that lie at the very foundation of cities—all this knowledge was insep-

arable from the local landscape, the earth and water, vegetation and wildlife, that bore witness to how things came to be as they are. But for the gods and their progeny, even the earth itself was not a large enough stage. For a full understanding of reality as Athenians perceived it, we must also turn our eyes skyward and consider the great arc of heaven under which their past unfolded.

2

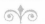

BEFORE THE PARTHENON

Gods, Monsters, and the Cosmos

ON ANY CLEAR NIGHT you can see it hanging in the far northern sky. Drako, the "Dragon" or "Serpent," is circumpolar, never rising or setting for most observers in the Northern Hemisphere. From around 3942 to 1793 B.C., Thuban (Alpha Draconis) was the north polar star. The earth's axial precession will bring it round again, and it will be the polestar once more sometime around A.D. 21000.[1]

The Greeks believed that Athena herself pitched Drako into the night sky. In the primordial battle between the gods and the Giants she heaved the monster with all her might into the heavens:

> Some also say this Drako was thrown at Athena by the Giants, when she fought them. Athena, however, snatched its twisted form and hurled it to the stars, fixing it at the very pole of heaven. And so, to this day, it appears with twisted body, as if recently transported to the stars.
>
> Pseudo-Hyginus, *Astronomica* 2.3[2]

From the northern cliffs of the Acropolis, one can see Drako even now, perpetually looming on the night horizon.

The Serpent still keeps vigil over a sanctuary that in antiquity teemed

with the imagery of snakes, sea monsters, and serpent-tailed human composite figures (insert page 2, top). This abundance of land and sea serpent iconography, though largely unstudied, is absolutely vital to our understanding of the pre-classical Acropolis. Since the second quarter of the sixth century B.C., limestone sculptures filling the pediments of the Archaic sanctuary buildings would depict coiled serpents ready to strike, a triple-viper-bodied monster pleading for mercy, and Herakles battling both the fish-tailed Triton and the snake-headed Hydra. One cannot help but wonder whether this plethora of reptilian monsters washed into the Athenian imagination with the great deluges of the primordial era. The receding waters might well have been thought to have beached all manner of fearsome monster in need of slaying.

In any case, by the time the Parthenon is built, or rebuilt, in the mid-fifth century B.C., this iconography is still de rigueur, and so its west pediment bursts with serpentine images. At the left side of the gable a snake emerges from beside Kekrops, the first Attic king (page 112), while, at center, serpent-tailed Triton supports Poseidon's chariot and a sea monster serves as foothold for Poseidon's sea nymph wife, Amphitrite (insert page 5, right). A Triton similarly holds up Athena's chariot from beneath while, at her side, a serpent once wrapped round her olive tree. And within the Parthenon's eastern chamber, a great golden snake was coiled within the shield of the Athena statue (insert page 7, bottom). Pausanias, who saw Pheidias's masterwork of gold and ivory, now long lost, tells us that this *drakon* is Erichthonios himself, the progenitor of all Athenians.[3]

We know from Herodotos that as early as the second decade of the fifth century a real snake (*ophis*) was kept on the Acropolis to guard the Sacred Rock, and no doubt also as a reminder of the earthborn origins of the earliest Athenian kings.[4] The priestess of Athena fed this snake a monthly ration of honey cakes. As the Persians advanced on the city in 480 B.C., the priestess announced that the cake had been left uneaten. Taking this as a sign that the sacred snake had abandoned the Acropolis, she advised the Athenian people to do the same. Thus, the Athenians were persuaded to evacuate their city prior to the attack that destroyed the earlier iteration of the Parthenon, along with the Old Athena Temple and most everything else on the Acropolis. Plutarch calls this act of the *drakon* an omen straight from heaven, signaling that Athena herself had fled.[5]

In the last quarter of the fifth century, when the temple known as the Erechtheion (after Erechtheus) was built near the site of the ruins of the Old Athena Temple, the sacred snake came to live there (pages 65 and 108). This snake was, apparently, given full run of the space beneath the shrine. We hear of an altar called "Thyechoos," believed to have stood on the north porch, just above where Poseidon's trident struck the Acropolis rock. Though the etymology is much debated, one interpretation of "Thyechoos" has it meaning "Cake-Eating Snake";[6] and a semicircular hole in the floor of the Erechtheion's north porch might well have served as the chute for dropping honey cakes to the resident in the crypt beneath.[7]

The catasterization of Drako, the smashing of the Serpent giant into stars, was an enduring commemoration of Athena's victory in the Gigantomachy, or fight for cosmic hegemony between the gods of Olympos and the nether forces of Chaos. As a constellation, visible for all eternity, Drako was a perpetual reminder of the battles that shaped the world as Athenians came to know it. Other monsters, too, were likewise installed within the arc of heaven. The Lernaean Hydra, an evil water serpent whose multiple heads grew back twice over once they were cut off, was catasterized following its death at the hands of Herakles. Having raised the beast deliberately to kill Herakles, the goddess Hera was so saddened at the Hydra's death that she lovingly placed it in heaven's dark blue vault, where it became known as the constellation by the same name. So, too, Hera catasterized a crab she sent to bite Herakles, creating the star group Cancer. But the firmament is not merely a rogues' gallery; heroes and heroines find permanent homes there as well. King Erechtheus becomes Auriga, the charioteer, while his three daughters are transformed into the constellation Hyades through the intervention of Athena.[8] Star groups are thus the ultimate places of memory, set up as eternal reminders of cataclysmic and epic sagas from the very distant past.

It is against this backdrop that we should understand an alternative tradition in which Athena destroys a giant named Aster, or "Star." We are told that a festival "was held during the reign of Erichthonios because of the murder of Asterios the Giant."[9] The sixth-century tyrant Peisistratos is said to have transformed this local feast into the great festival known as the Panathenaia, and Aristotle reports that the games associated with it were held "on account of the Giant Aster who was killed by Athena."[10]

In our age of electronic screens the night sky no longer commands such rapt attention. In antiquity, however, the heavens served as the night's most captivating spectacle and the only thing that huge numbers of people could see simultaneously from far-flung locations. The heavenly bodies did not merely bear the names of heroes and monsters; they were those very beings transformed. And the movements of the stars were crucial to managing agriculture and navigation, as well as for the festival calendars of Greek sanctuaries.[11] This, of course, was true throughout the ancient world as early as predynastic Egypt and fourth-millennium Sumer.

In recent years, a fresh focus on archaeoastronomy has revitalized interest in the impact of Greek cosmology on ancient ritual practice.[12] Recognition of links between star groups, their periods of visibility, and the Athenian festival calendar has been made possible through the development of new software.[13] These programs enable us to call up the night sky on any given date in Greek antiquity and to know precisely which astronomical bodies were visible from which locations. It is even possible to embed the local horizon and so re-create the astronomy in the context of specific landscape features that, depending on their height, would have changed the visibility of the night sky.[14] Especially significant are the heliacal rising, the one time in the year when a star or constellation appears above the horizon in the east just before sunrise, and the acronychal rising, the time when a celestial body is seen to rise in the east a few minutes after sunset.[15] These events served as giant megaphones to alert observers that it was time to start plowing, to begin a sea voyage, to make one's way toward the sanctuary for a festival, or to undertake some other purpose unthinkable outside its proper time.

In this chapter, we will attempt to turn out the lights and see the ancient night sky as it was. For the features of the earth tell only part of the story; we cannot fathom the consciousness that created the Parthenon without appreciating the collective memory of cosmic battles, ancient star wars, and clashes with Giants and monsters. These primordial events furnish the big picture of Athenian awareness, the key to the people's existence and origins. One therefore looked to celestial movements not only for the proper timing of rituals commemorating the past's defining events but also for guidance in any purpose, none more important than the development of sacred sites.

The sculptural decoration of the Acropolis buildings beginning in

the sixth century opens for us a world in which religious and cosmological narratives are tightly interwoven, one that feeds a larger appetite for genealogical narrative already explored in chapter 1. The Athenian urge to tell the story of how things came to be finds its roots in the heavenly and epic narratives of the ancient Near East. In Archaic Athens, just as in Sumer two millennia before, succession myths gave sanction to the present state of affairs. By projecting into an invented and very remote past, one could attempt to explain and understand the present.[16]

HESIOD TELLS in his *Theogony* (ca. 700 B.C.) that in the beginning there was Chaos, emptiness devoid of matter.[17] From this emerged Gaia (Earth), Tartaros (the stormy abyss that lies deep within the Earth), and Eros (Love), followed by Erebos (a place of darkness between the earth and the underworld) and Nyx (Night). Gaia parthenogenically produced Ouranos (Sky), the Ourea (Mountains), and Pontos (Sea). Each night, Ouranos completely covered Gaia, mating with her and producing powerful and terrifying children. These included six male and six female deities known as the Titans, as well as three horrific one-eyed Giants known as the Cyclopes and three hundred-handed monsters known as the Hekatonkheires.

Wary of his children, Ouranos locked them away in the deepest recesses of Earth, Tartaros, a place said to be "as far beneath Hades as the sky is above the earth."[18] This caused Gaia great pain, and hoping to liberate her children, she secretly planned to castrate her husband. Giving her youngest, Kronos, a sickle fashioned from flint, she persuaded him to slice off his father's genitals, a deed the lad accomplished in one swift stroke. But the awful wound only enlarged the troubled family, as the dripping blood fell upon Earth, impregnating it to produce the Gigantes (Giants), the Erinyes (Furies), and the Meliae (Ash-Tree Nymphs). Ouranos's severed testicles, meanwhile, fell into the sea off Cyprus (or, by another tradition, off Kythera), effervescing as they hit the water, from which foam emerged that loveliest and most sexually robust of goddesses, Aphrodite.

Kronos then freed his brothers and sisters from the depths of Tartaros, to become king of the Titans, before siring more children with his sister Rhea. He remained terrified, however, that his own offspring would grow up to overthrow him as he had done to his father. Ouranos

had prophesied as much. To prevent this, Kronos undertook the accustomed remedy of uneasy fathers and swallowed each infant at birth, all except for his youngest son, Zeus. In that boy's case, Rhea tricked Kronos, wrapping a stone with a blanket in place of the baby. While Kronos swallowed the stone, Zeus was spirited away to a cave on Mount Ida in Crete to be raised, according to various traditions, by a goat, a nymph, or Gaia herself. When he grew to take as his first love Metis, this Okeanid nymph contrived her own plan for tricking Kronos. She fed him a mixture of mustard and wine that caused him to regurgitate Zeus's brothers and sisters. Thus were the gods freed.

Once reunited with their youngest sibling, the Olympians launched a violent ten-year campaign against their father and his generation of Titans.[19] As the so-called Titanomachy raged on, Zeus emerged as lord of the Olympians while Atlas became leader of the other side. The Titans laid siege to Mount Olympos as only Titans could, piling one mountain atop another until they reached the summit and from there hurling huge boulders at the gods.

The Titanomachy provided a narrative structure for comprehending the cataclysmic events that shaped the universe. The earliest clashes had been those between earth and sky gods; their children, the Titans, eventually battled *their* children, the Olympians. The next cosmic conflict was that between the Olympian gods and the Giants of their own generation, the so-called Gigantomachy. These celestial and terrestrial wars set a new generation against an earlier one in universal struggles to tame the brutal forces of nature and the cosmos. And it was in terms of these "boundary catastrophes" that primordial time was comprehended and organized into eras, much as the great floods provided reference points in chapter 1.[20]

The battle of the gods and the Titans follows a classic model for succession seen in ancient Near Eastern and European genealogical myths in which one generation of divinities overthrows a dominant, older generation. Indeed, Hesiod refers to the Titans as the "former gods," the *theoi proteroi,* a term also found in the Rigveda, the sacred collection of Vedic Sanskrit hymns dated sometime between 1700 and 1100 B.C.,[21] wherein the older generation of Sadhyas residing in heaven are subdued by the storm god Indra. There are also "former gods" in Hittite texts, identified with the infernal gods of the Babylonian pantheon, the Anunnaki.[22] Just like Hesiod's Titans, the Anunnaki are locked in the depths

of the underworld by a storm god who leads a younger generation of divinities in revolt. Babylonian myth of the second millennium gives a parallel story in which the Anunnaki are defeated and cast into the depths of Earth by the young Marduk, a god who rides into battle on his storm chariot, armed with arrows, lightning, and the winds.[23]

The Olympian gods are aided in the Titanomachy by the Cyclopes, still angry with Kronos for imprisoning them in the depths of Tartaros. They arm Zeus with lightning, thunder, and the thunderbolt, weaponry forged in their foundry deep within Earth. These tools transform Zeus into a proper sky god, the equivalent of his ancient Near Eastern counterparts, all-powerful young upstarts who bring down prior pantheons.[24] The Cyclopes' offerings to Zeus give intelligible form to the fulmination through which he destroys the enemy. As Martin West has put it, "Thunder is what you hear, lightning is what you see, and the thunderbolt is what hits you."[25] Thus, the noise, crash, and din of primordial battle is manifest: a fantastic multimedia and kinetic display of sound, light, and electrostatic discharge.

This terrifying cosmic spectacle adorns the earliest stone temple on the Acropolis in sculptures summoning the shrieking acoustics, the spectacular visual effects, and the so-called *mysterium tremendum,* the overwhelming awe and dread of confronting the unimaginable power of the gods.[26] Indeed, to inspire such wonder and terror was an essential aim of architectural sculpture throughout Greece during the sixth century; we need only think of the giant stone pediment of the temple of Artemis at Kerkyra (Corfu) with its menacing Medousa, ferocious panthers, and lumbering Giants fallen dead in the corners of the gable.[27] The experience of sacred space was meant to be shocking, anxiety inducing, and disorienting, playing havoc with the emotions. Thus, Archaic sanctuaries teem with Gorgons, sphinxes, wild animals, monsters, and Giants.

The Athenian Acropolis was the same, only more so. Sometime around 575 B.C., the Athenians began work on an immense stone temple, the largest of its day for Attica. By now, several of its neighboring city-states were ruled by powerful tyrants who had enhanced their local sanctuaries with monumental temples, and this might have fueled an innate Athenian competitiveness to build one of their own.[28] By the mid-seventh century the tyrant Kypselos at Corinth had constructed for Apollo the first great stone temple with peristyle colonnade and tiled

roof on the Greek mainland, followed shortly thereafter by a comparable structure for Poseidon at Isthmia.[29] By the turn of the sixth century, many more mainland temples were surrounded with what would become the classical Greek signature: the exterior colonnade.[30] Since bigger is better when it comes to prayer and pleasing the gods, Athens was not to be outdone, and Athena would soon have an enormous stone temple of her own.

Deeply apprehensive of surrendering control to any one man, the Athenians had resisted tyranny throughout the seventh and into the sixth century. Power at Athens remained in the hands of a few noble and highly competitive families, clans that had risen to wealth off the abundance of their landholdings. And so it fell to these Eupatrids and their oligarchies to initiate the formalization of the Acropolis shrines. But all was not well at Athens; indeed, tensions between the haves and the have-nots had brought the city-state to a point of near collapse. As we have seen in chapter 1, Solon was brought in as archon and mediator in 594 and set to work completely reorganizing civic representation, allowing for limited empowerment of the citizen masses. By forgiving their debts, abolishing their sale into slavery to fellow Athenians, and giving them an increased voice in the assembly and law courts, Solon raised the people of Athens to a new level of prosperity and fuller participation in government. Interestingly, Solon's reforms also codified laws concerning prizes for athletic victors, asserting for the first time the role of the state in athletic concerns. Harmony at the intersection of athletics, the aristocracy, and the people was vital to the equilibrium of the state.[31]

The newfound stability brought by Solon's reforms enabled Athenians to reconfigure not only their Acropolis as sanctuary but also their local festival of Athena. A string of Athenian athletes had already distinguished themselves at the Olympic Games during the course of the seventh century, winning victories in 696, 692, 644, 640, and 636 B.C.[32] Now it was time for them to compete at home in games that would bring competitors to Athens from all across the Greek world. This shift may have been part of a major reorganization of the festival in 566 B.C., when the city celebrated its first Great Panathenaia, an international version of what until then had been a local feast. A series of inscriptions dated to this time show that official action was taken to make a *dromos* ("racetrack" or "road") and "for the first time" to establish the *agon* ("contest") for the "Steely-Eyed One," Athena herself.[33] Later sources

tell us that this reorganization took place during the archonship of Hippokleides, that is, in 566/565.[34] As an athletic aristocrat from the horse-racing family of Miltiades (from the clan Philaidai), Hippokleides's exact role with regard to the festival is unknown. But his leadership in this regard seems to have been encroached upon by Peisistratos, an ambitious member of a rival family from his home district of Brauron in eastern Attica. A late source credits Peisistratos with the introduction of the Great Panathenaia, and given his bold actions soon thereafter, it seems the young aristocrat seized this opportunity to advance his designs for establishing a tyranny of his own.[35]

While Solon's laws worked well in bettering the lot of the Athenian masses, fierce rivalries within the aristocracy endured, particularly those between three dominant clans. The rich and reactionary conservatives of the grain-producing plains (*pedies*), led by Lykourgos, wanted the new laws repealed. The somewhat weaker men of the coast (*paraloi*), led by Megakles, were fairly happy with Solon's reforms. The smallest and poorest group, the men of the hills (*hyperakrioi*), led by Peisistratos, were somewhat disappointed since they had hoped to receive additional lands under the new regime. But of the three noble families and their leaders, Aristotle tells us that it was Peisistratos who was most open to democracy.[36] A distant relative of Solon himself, Peisistratos would eventually win the backing of both the nobility and the people;[37] in doing so, he would become the shining personality of sixth-century Athens.

THE NEW STONE TEMPLE on the Acropolis rock might have been a result of Solon's inspired program, but it would take decades to quarry the limestone, transport it to the summit, organize teams of stonemasons and building crews, and raise the structure. A great ramp, some 80 meters (262 feet) long and over 10 meters (33 feet) wide, had to be built on the western slope of the Acropolis for the hauling of materials and equipment. Surely, the temple was finished in time for the inauguration of the Great Panathenaia of 566, when this same ramp would have served as pathway for the sacred procession, leading the marchers and a hundred head of cattle up the slopes to the altar of Athena. The new temple would not disappoint.

It rose from a platform measuring 46 by nearly 21 meters (151 by 69 feet), rivaling the great size of the temple of Artemis at Kerkyra. Its Doric

peristyle showed six columns on the façades and thirteen down the flanks (insert page 1, bottom image, temple at south or top).[38] The temple was made of limestone and adorned with metopes and gutters of Hymettian marble; the roof was crowned with marble tiles and ornaments (akroteria) that included sphinxes, palmettes, and maidens (below).[39]

Most astonishing are the robustly carved limestone figures in the gables, richly colored with red, blue, green, and black pigment. A large number of fragments recovered in the late nineteenth century allow for the reconstruction of the pedimental compositions. A lion and lioness killing a bull adorn the center of one pediment, while the other preserves a bull gored by a lioness alone. Both gables feature scenes of cosmic and terrestrial battles, showing serpent-tailed monsters and huge coiling snakes slithering into the narrow corners of the pedimental frame (below, facing page, and insert page 4, top).[40]

Modern interpreters have called this Archaic building by many names: Hekatompedon ("Hundred-Footer"), Temple H, H-Building,

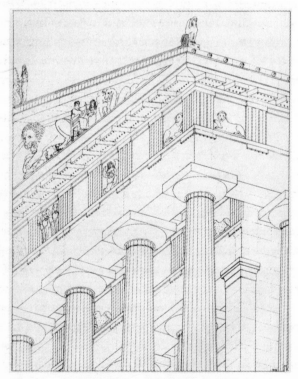

Reconstruction drawing of façade of Bluebeard Temple (Hekatompedon?) by M. Korres.

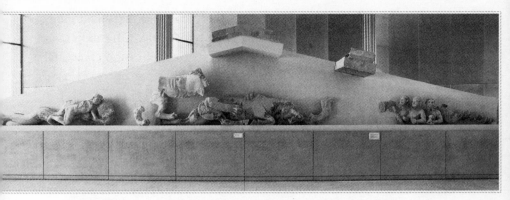

Bluebeard Temple pediment (Hekatompedon?). Athens, Acropolis
Museum.

the Ur-Parthenon, and the Bluebeard Temple,[41] this last designation
referring to a unique sculptural group usually assigned to the corner of
one of the pediments.[42] It shows a weird and wonderful human-headed,
three-bodied monster with spreading wings incised on the back wall
of the tympanum and a lower torso that terminates in three entwined
snaky coils (above and insert page 3, top). The grinning, mustachioed,
and wide-eyed faces of the beast are trimmed at the chin by pointed
beards highlighted in blackish-blue paint: hence the nickname. Scholars
have long debated the identity of this beast.[43]

As it appears so early in the history of architectural sculpture, this
fantastic creature has few iconographic parallels. The closest is found
not in monumental stone but painted on a Chalkidean water jug dated
some thirty years later (insert page 3, bottom).[44] The vase shows a very
similar composite with human head (albeit only one), giant bird wings,
and legs in the form of viper coils. This monster, too, is wide-eyed with a
pointed beard and must represent Typhoeus or Typhon, the most hideous
monster of the primordial era. By some accounts, he was the last son of
Gaia and Tartaros and known as the Father of All Monsters. But in the
Homeric Hymn to Pythian Apollo, Typhon is the child of Hera alone—a
kind of parallel to Zeus's child Athena.[45] Fascinatingly, Hephaistos is
also regarded as the son of Hera alone; both Typhon and the god of the
fiery forge can be seen as the embodiment of Hera's rage against Zeus.
The presence of Typhon on the Hekatompedon pediment might in some
way have reminded the Athenians of their problematic ancestor He-
phaistos.[46] Whatever the case, Typhon represents a Greek counterpart

to the gruesome water reptiles slain by gods/heroes in Mesopotamian, Babylonian, Hittite, Vedic, and European lore.[47] Following the model of the great dragon figure that can only be slain once, Typhon meets his match in the storm god Zeus, who kills him with extraordinary violence.

Typhon appears amiable enough on the Chalkidean water jug, though he is shown on his very best behavior, beseeching Zeus to spare his life. Zeus, whose name appears in a painted inscription just before him, fiercely brandishes his flaming thunderbolt. Head-to-head in cosmic combat, the elegant, well-coiffed, and beautifully dressed Zeus confronts the wild, hairy, and lumbering behemoth Typhon in an archetypal clash between the younger generation of civilized Olympians and the older generation of feral monsters, celestial and terrestrial.

When we turn to the Bluebeard pediment, we find a demon creature similarly confronted by Zeus, very little of whose figure survives; just a small part of the storm god's draped left arm can be made out in low relief against the tympanum wall. It is clear, however, that the arm stretches out toward the three-bodied monster, and it is likely that we have Zeus, once again, threatening with his thunderbolt.

Apollodoros tells us that Typhon was a beast like no other: taller than the mountains, his head brushing the stars. When he spread his arms, he could touch the farthest reaches of East and West.[48] Hesiod tells us that out of Typhon's shoulders came "a hundred fearsome snake-heads with black tongues flickering."[49] The Bluebeard monster's chest and shoulders are, indeed, pierced by holes with traces of lead surviving within them, where twelve small limestone snakes may once have been attached.[50] Writing centuries later, Apollodoros similarly reports that from the monster's thighs down, huge vipers emitted a long hissing sound: "Such and so great was Typhon when, hurling kindled rocks, he made for the very heaven with hissing and shouts, spouting a great jet of fire from his mouth."[51]

We should not underestimate the "acoustical effect" of monstrous creatures portrayed in Archaic Greek sanctuaries. We are at a disadvantage today, our sense of realism persuaded only by Dolby Surround sound. The ancients were far more suggestible, and the evocation of sound completes pictures and brings deeper understanding to how the images were received. Looking at the deliberately openmouthed Typhon on the Chalkidean vase or at the beseeching hand gesture of the Bluebeard monster, we must try to imagine what those versed in Hesiod's

description of the beast would have heard: "There were voices in all his fearsome heads, giving out every kind of indescribable sound. Sometimes they uttered as if for the gods' understanding, sometimes again the sound of a bellowing bull whose might is uncontainable and whose voice is proud, sometimes again of a lion who knows no restraint, sometimes again of a pack of hounds, astonishing to hear; sometimes again he hissed; and the long mountains echoed below."[52] These susurrous sounds and clamor brought the narrative to life, palpably inducing the intended emotional response of fear.

Zeus is angry and unmoved by the monster's clattering arsenal. He unleashes the full force of the elements, inciting a horrifying din of his own with fire, water, and wind. Hesiod describes it: "A conflagration held the violet-dark sea in its grip, both from the thunder and lightning and from the fire of the monster, from the tornado winds and the flaming bolt. All the land was seething, and sky, and sea; long waves raged to and fro about the headlands from the onrush of the immortals and an uncontrollable quaking arose."[53] The Bluebeard-Typhon holds out in his hands a wave, a flame, and a bird, signaling the cache of water, fire, and wind that he will surrender to Zeus if only he is spared. But Zeus stands firm and Typhon is destroyed. A full blast of celestial and terrestrial tumult is thus effectively conjured in the single image of the Acropolis pediment's Bluebeard monster.

At the left of the gable, Zeus's son Herakles is shown subduing the water serpent Triton (page 55 and insert page 4, top).[54] This can now be understood as a parallel scene in which the father-son duo tame the forces of nature and the cosmos across two generations: Zeus dispatches Typhon, while Zeus's son Herakles kills Poseidon's son Triton. And, of course, Triton has his own special genealogical connection to the myth narrative of Athens, having served as Athena's foster father following her birth near the lake or the river Triton in Libya. Indeed, the Bluebeard pediment is framed with imagery evoking the north Libyan wetlands where Triton lived and this battle with Herakles took place. Some forty fragments from the underside of the raking cornice show two forms of brightly painted, incised lotus flowers (insert page 4, bottom); twenty others show waterfowl, including storks and sea eagles.[55]

The clash of Zeus and Typhon similarly took place at the seaside, alternatively set along the coasts of Syria and Cilicia. According to one tradition, Zeus lures Typhon out of his pit with the promise of a fish feast

by the seashore. In another, Typhon hides Zeus's weapons and sinews within his cave near the sea.[56] The lotus and waterfowl on the underside of the pediment's raking cornice thus evoke the flora and fauna of Typhon's lair as well as that of Triton. And thus the architectural frame is conceived as a "window" through which flying birds and marsh vegetation can be seen to set the stage on which gods, heroes, and monsters engage in cosmic clashes.[57]

EXACTLY WHERE the building that held the Bluebeard pediment stood and by what name it was called in antiquity remain a mystery. This is because the temple seems to have occupied the same spot where the Parthenon stands today. In any event, we cannot know what filled that space before the construction of the giant twenty-five-course platform on which the Parthenon still rests.

There is, however, another theory about the placement of the Bluebeard Temple, one setting it to the north of the Parthenon where foundations are preserved from a temple built at the end of the sixth century. The so-called Old Athena Temple, as we have seen, will be destroyed by the Persians and supplanted by the Erechtheion. But meanwhile, it stood on what have been nicknamed the Dörpfeld foundations after the nineteenth-century Acropolis excavator Wilhelm Dörpfeld (page 65). He believed that the Bluebeard Temple had been set on the innermost foundations until the Old Athena Temple, built on the outermost, replaced it.[58]

A marble metope from the Bluebeard Temple was salvaged after the temple's destruction and inscribed with an important text, dated to 485/484 B.C. Known as the "Hekatompedon Inscription," it names two distinct buildings that stood on the Acropolis: the Neos (referring to the Archaios Neos, or Old Athena Temple), and the Hekatompedon, or "Hundred-Footer."[59] An excellent case has been made, contra Dörpfeld, for the identification of the Bluebeard Temple as the Hekatompedon, placing it on a site beneath the present Parthenon.[60] Indeed, the eastern room of the Parthenon was still called the *hekatompedon* in the fifth century B.C. and into the Roman era, perhaps reflecting a continuity in the naming of successive buildings on this site. And, as Rudolph Heberdey documented long ago, every piece of Archaic poros sculpture

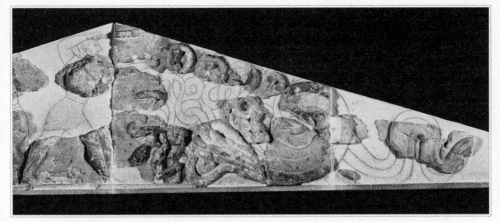

Herakles battling the Lernaean Hydra, limestone pediment. Athens,
Acropolis Museum.

found on the Acropolis was recovered from the area to the south of the
Parthenon, between the temple and the south fortification wall. [61]

The Bluebeard Temple looks eastward for inspiration, not only in its
narrative themes that focus so deliberately on genealogical succession
myths and primordial battles between weather monsters and composite
fiends, but also in its architectural forms. The incision of lotus flowers
beneath the cornice, the trumpet-shaped spouts that guided rainwater
from its gutters, and the upturned edge of the roof above the gable's
apex in a tong-shaped embellishment, all these features show influence
from the grand visual traditions of the ancient Near East.[62]

The Hekatompedon Inscription mentions additional buildings that
stood on the Archaic Acropolis for which no stone foundations survive
today. These are called the *oikemata,* or "houses," a term that suggests
they were of smaller scale than the Hekatompedon and Archaios Neos.
Fragments of small limestone sculptures can be reconstructed to fill at
least five small pediments from buildings that might be the *oikemata*
mentioned in the inscription (one is shown above).[63] It is likely that
these structures served as treasuries, perhaps housing gifts dedicated
to Athena by rival Eupatrid families of Attica, much as the treasury
buildings at contemporary Olympia and Delphi held offerings of rival
city-states. Their pedimental sculptures range in date from around 560–
550 B.C. to the early fifth century.[64]

ONE OF THESE PEDIMENTAL GROUPS shows Herakles battling the Lernaean Hydra (previous page), the aforementioned water serpent with huge body and nine heads that, when cut off, grew back again.[65] Herakles and his nephew Iolaos worked as a team in subduing this monster.[66] As Herakles bashed off each head with his club, Iolaos would quickly cauterize the wound with a flaming torch. This prevented new heads from regenerating. Thus, the slimy monster was exterminated. Importantly, Hydra was the child of Typhon. So we find, once again, two successive generations in pitched battle on the Archaic Acropolis. Zeus kills Typhon in the age of the Titans (Bluebeard pediment), while his son Herakles kills Typhon's daughter Hydra in the era that follows (the small poros pediment). As we shall soon see, by the close of the sixth century another great temple will be built (the Archaios Neos or Old Athena Temple), this on the north side of the Acropolis plateau, and its pediment will display a cosmic conflict of a later generation still, the battle of the gods and the Giants. But this will come after the momentous years of Peisistratos's illustrious tyranny.

WE CANNOT KNOW exactly what Peisistratos's involvement in the Great Panathenaia of 566 entailed, but he clearly regarded it as an opportunity to advance his ambitions for taking control of Athens. This he tried three times, establishing his first tyranny in 561/560 B.C. through a clever ruse in which he first claimed his life was under threat and then, once the people had granted him protection, employed his bodyguard to help him seize the Acropolis. Soon expelled from Athens, Peisistratos returned in the mid-550s for a short, second regime and, finally, in 546, when he succeeded in establishing a tyranny that lasted for thirty-six years. Peisistratos spent the decade between his second and his third coups in very productive exile, developing strengths that can, in a sense, be seen to exemplify what would become ideal Athenian virtues: careful planning, an entrepreneurial spirit in building wealth through hard work, dogged determination, a taste for culture, and the projection of strong personal charisma. Relocating to distant Thrace in the northeast of Greece, Peisistratos amassed a fortune in mining concessions from the gold and silver of Mount Pangaion, developed a network of interna-

tional contacts with powerful tyrants, and rallied a mercenary army in anticipation of his return to Athens for a final takeover. Once back in power, he adopted a progressive global economic view, engaging Athens in international trade, minting the city's first coins and encouraging productivity that, for example, saw Athens overtake Corinth as the leading exporter of fine painted pottery.[67] Peisistratos was, no doubt, impressed by the vast stone temple (55 meters by more than 108 meters, or 180 by 354 feet) begun by the tyrant Polykrates on Samos in mid-century and by the grandeur and excess of the East Greek sanctuaries at Ephesos, Didyma, and Miletos. We cannot know how he might have enhanced the Hekatompedon or old shrine of Athena in his day. But taking careful note of what strong rulers were accomplishing abroad, he followed their example. Like Polykrates on Samos, he introduced a major upgrade in the local water supply at Athens, building an aqueduct from Mount Lykabettos to the Agora and, apparently, constructing the Enneakrounos Fountain House above the spring of Kallirrhöe. As John Camp has explained, the laying out of the Agora, the very focal point of Athenian life and government, was largely the work of Peisistratos and his sons, who also established new drainage systems, fountains, and shrines, including the sanctuary of Dionysos Eleutherios on the south slope of the Acropolis.[68]

Peisistratos effectively exploited the power of his "cult of personality" in appealing to the sensibilities of the Athenian masses. Herodotos tells us that returning to Athens after his first exile, Peisistratos contrived a spectacular homecoming in which he was taken up the Acropolis in a chariot driven by a woman dressed as Athena.[69] Nearly 6 feet tall (1.8 meters) and strikingly beautiful, Phye wore the armor of the goddess, explicitly communicating to the crowd of spectators that Athena herself welcomed Peisistratos back. The tyrant lost no opportunity to parade before the people his particular devotion to the goddess, taking care at the same time to flaunt her special fondness for him.[70]

This highly visible display recalls another attempt at tyranny played out upon the Acropolis stage some seventy-five years earlier, that of Kylon in 632/631 B.C. Having risen to fame as a victor in the Olympic Games, encouraged by a Delphic oracle, and supported by his father-in-law (the tyrant of Megara), Kylon tried to seize the Acropolis during the annual festival of Zeus. He and his accomplices met with strong resistance and became trapped on the Sacred Rock, where they took sanctu-

ary at Athena's statue, according to Herodotos, or at her altar, according to Thucydides.[71] Kylon escaped, but his co-conspirators were held on the Acropolis without food or water in a long standoff that left them close to death. Some of the archons from the Alkmeonid family (whose leader, Miltiades, was chief magistrate at the time) promised the accomplices safe passage off the Acropolis but later reneged, killing them as they took refuge at the altars of the accursed goddesses (Semnai) down below. This act of gross impiety—murder within a sanctuary—brought a lasting curse upon the entire Alkmeonid clan.[72]

The stories of Kylon and Peisistratos illustrate the dominance of the Acropolis plateau as an ever-visible landmark and target for takeover. Seizing the Sacred Rock symbolized a conquering of all Attica for aspiring tyrants, as it would for the Persian army in 480 B.C. Even with its transformation from Bronze Age fortress to Iron Age sanctuary, the Acropolis retained its power as a bulwark, the ultimate prize for contenders in a centuries-long game of King of the Mountain.

To be sure, Peisistratos commandeered power in an unconstitutional manner, but by all accounts he governed according to the laws of Solon, taking care of the city masses as well as the rural majority. He made loans to small farmers, encouraged the cultivation of olives for export, and exacted a 5 percent tax on agricultural production. He unified disparate local cults from all across Attica into a centralized whole in which all Athenians held a stake, exercising special care to preserve their long-standing relationships with particular noble clans. Indeed, it is likely that Peisistratos instituted hereditary priesthoods that ensured the oldest families would forever keep their responsibility (and privilege) of looking after these cults.[73] The Eteoboutadai, that is, the clan of the plains led by Lykourgos, received the distinction of providing priests for the most venerable of the Acropolis cults, those of Athena Polias and Poseidon-Erechtheus. From this point forward, civic, religious, and cultural life at Athens was deeply intertwined. It was becoming clearer and clearer just what it meant to be an Athenian.

When Peisistratos died in 528/527 B.C., he was succeeded by his sons, who ruled until Hipparchos was murdered in 514 and Hippias was exiled in 510. The early years of their rule went smoothly as they devoted their energies to their father's vision, beautifying the city with buildings and monuments and greatly enhancing its cultural and religious institutions.[74] The sons of Peisistratos (known as the Peisistratids)

played a major role in promoting music, poetry, and the arts at Athens. Their most ostentatious project was the construction of an enormous temple to Olympian Zeus (the Olympieion, page 9) on the banks of the Ilissos River, replacing a shrine that their father had built on this very ancient site, occupied already in Neolithic days. The hugely ambitious plan called for a temple platform measuring 41 by 108 meters (135 by 354 feet), clearly meant to rival the gargantuan temples of Hera on Samos and Artemis at Ephesos. But the project would be abandoned and languish incomplete for centuries until the Roman emperor Hadrian finished it in A.D. 131/2.[75]

It was not until Hipparchos made a reckless advance on Harmodios, a young man already attached to an older lover, Aristogeiton, that the fortunes of the Peisistratids turned. The ensuing rejection, affront, and further retaliatory insult led to Hipparchos's assassination at the Panathenaia in 514.[76] Hippias now grew bitter and difficult while the rival Alkmeonid family, having spent much of the Peisistratid tyranny in exile, planned a comeback. They persuaded Sparta (with the encouragement of the Delphic oracle) to help them overthrow Hippias. The Spartan king, Kleomenes, obliged, setting siege to the Acropolis, where Hippias and his supporters were ensconced. In 510 B.C., after some family members were taken hostage, Hippias agreed to leave Athens for good. The ousted despot took refuge with the Persian governor at Sardis in Anatolia and, twenty years later, returned to Attica in the company of the Persian army, traitorously giving advice on how best to defeat the Athenians at Marathon.

Having successfully ousted the tyrant, the Athenian people now sought to remove the Spartan-led army that was in control of their citadel. Demonstrating an extraordinary ability to take quick and decisive collective action in the face of crisis, ordinary Athenians gathered en masse at the foot of the Acropolis and forced the surrender of the coalition of Spartans and Athenian nobility holding the summit. They called for the return of Kleisthenes, a member of the Alkmeonid family who had helped in overthrowing Hippias but was later expelled by a rival within his clan.[77] Kleisthenes returned as champion of the people in 508/507 and swiftly introduced sweeping reforms that laid the foundations for true and direct *demokratia,* in which the people (*demos*) held the power (*kratos*), the very basis for our modern democratic system today.[78] Kleisthenes reconfigured the legislature, the court system,

and the formation of the Athenian "tribes," breaking the power of the nobility and establishing the framework for a national army. Ten new tribes were geographically described so that each contained people from different parts of Athenian territory: the coastal districts, the inland regions, and the urban areas. Each tribe would henceforth consist of a mix of individuals from across these diverse areas, bringing together men of vastly different backgrounds, skill sets, and kinship networks.[79] But the experience of serving on tribal teams, both in the legislature and in the Panathenaic competitions, would soon knit these men together in a real brotherhood of common interests. Kleisthenes extended Athenian citizenship to all adult resident males and their offspring, creating a new Council of 500 to which each of the ten newly created tribes would send fifty delegates chosen, democratically, by lot. Furthermore, he instituted ostracism, establishing a process through which unpopular leaders could be expelled. In short, Kleisthenes ushered in an egalitarian revolution, bringing to the Athenian people what he called *isonomia* (equality vis-à-vis law) and what we call democracy itself.

By the end of the sixth century B.C., Athens was ready not only for a new system of government but also for a new temple on the Acropolis. Just as, sixty-five years before, the Bluebeard Temple had projected dynamic images of cosmic combat in the wake of Solon's reforms, so the temple of the young democracy would launch a powerful narrative of genealogical struggle: the battle of the gods and the Giants. This theme featured prominently in the Panathenaia, woven as it was into the figured fabric (peplos) presented to Athena at the festival and, during the second half of the sixth century, painted on so many Attic vases (especially those found on the Acropolis itself).[80] Within the realm of myth, the Gigantomachy may be seen as the next generational conflict following that in which Zeus destroyed Typhon.

Having vanquished the older generation of Titans, the Olympians turned to the cosmic war with the Giants. These are the terrible creatures that sprang from blood dripping out of Ouranos's severed testicles and mingling with Earth. The Giants, so big that their heads touched the clouds, outnumbered the Olympian gods twenty-four to twelve. And so the gods enlisted the help of mighty Herakles to improve their odds.[81] Athena and Herakles fought side by side in battle, valiant warriors who made an excellent team. Athena so distinguished herself that she became

known as Gigantoleteira or Gigantoletis ("She Who Destroyed the Giants").[82] Earlier in this chapter we saw Athena kill one giant named Drako and another named Aster. There is yet a third deadly beast she annihilates in the Gigantomachy, the fearsome Enkelados, whose name means "Sound the Charge." According to some sources, Athena lifted and hurled the island of Sicily at this monster as he fled the battlefield, crushing him beneath Mount Aitna.[83] The supreme size and strength of gods and Giants made them quite capable of throwing boulders, mountains, and even whole islands in the course of combat.

The Gigantomachy took pride of place on the great gable of the Archaios Neos or Old Athena Temple, a structure built at the north side of the Acropolis at the turn of the sixth to the fifth century.[84] The temple rose from the so-called Dörpfeld foundations, still visible today (below, and see also page 68 and insert page 2, bottom). Its pediments were filled with colossal figures carved in expensive marble imported from the island of Paros. One of the gables showed lions savaging a bull just as on the old Bluebeard Temple. The other pediment featured the Gigantomachy, dominated by a dynamic image of Athena lunging toward a fallen giant (following page). The goddess is shown in feverish

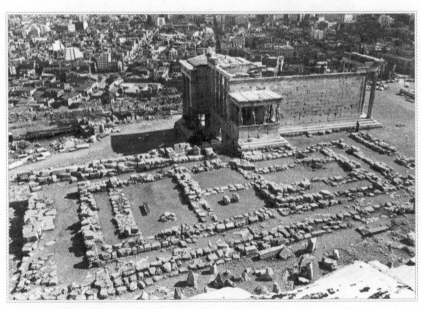

Erechtheion and foundations of Old Athena Temple, from south.

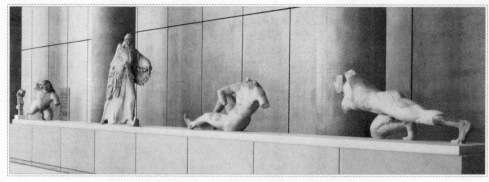

Athena slaying giant, Gigantomachy pediment, Old Athena Temple. Athens, Acropolis Museum.

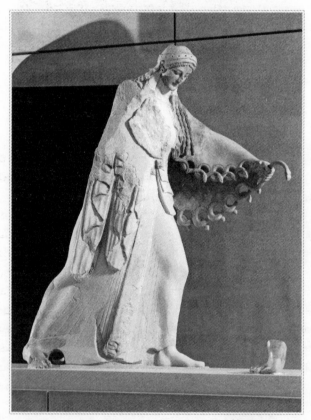

Athena from Gigantomachy pediment, Old Athena Temple. Athens, Acropolis Museum.

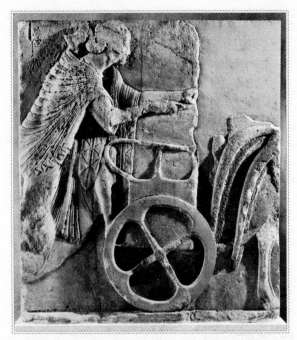

Charioteer from frieze (?), Old Athena Temple.
Athens, Acropolis Museum.

pursuit of the enemy, employing her snaky aegis not only as a shield but also as a weapon. She manipulates a hissing, biting snake head, using it to menace a fallen giant.[85]

This bold composition crowned a Doric temple that measured roughly 21 by 43 meters (69 by 141 feet) and showed six columns across the façades and twelve down its flanks (following page and insert page 2, bottom).[86] Built of poros limestone quarried in the Piraeus, the Old Athena Temple was adorned with marble roof tiles, gutters, akroteria, lion's-head waterspouts, and metopes.[87] It seems also to have been decorated with a marble frieze of which little survives: one fragment clearly shows the god Hermes and another, a charioteer (above).[88] As we shall see in chapter 5, chariots had very special meaning at Athens since being introduced into Athenian warfare by the founder, King Erechtheus/Erichthonios himself.

The plan of the Old Athena Temple was unusual as the main room at the east was completely separated from the three rooms at the back or

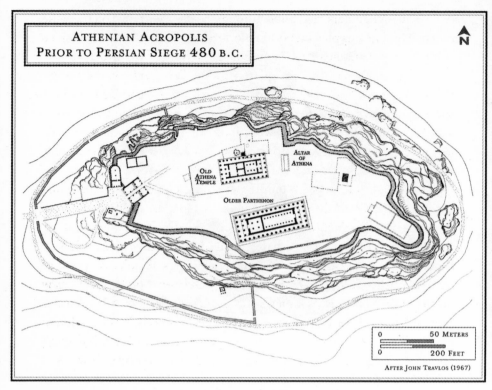

ATHENIAN ACROPOLIS
PRIOR TO PERSIAN SIEGE 480 B.C.

N

ALTAR
OF
ATHENA

OLD
ATHENA
TEMPLE

OLDER PARTHENON

0 50 METERS
0 200 FEET

AFTER JOHN TRAVLOS (1967)

Plan of Athenian Acropolis in 480 B.C.

west end of the structure (above and page 265). Its eastern cella had two rows of three columns dividing the interior into three "aisles." Here, an olive wood statue of Athena was housed, known as the "ancient image" (*to archaion agalma*). This relic, believed to have fallen from the heavens in the early days of Athens, was the most sacred object in the city. It was aniconic (an effigy without human shape), consisting of a simple olive wood tree trunk.[89] Like cult statues in all Greek sanctuaries, the image was regarded not as a representation of the deity but as the divine essence itself. Therefore, Athena's statue was dressed in ornate fabric and adorned with a golden diadem, earrings, necklaces, and bracelets. It even had its own gold libation bowl.[90] Once a year the statue would be taken down to the sea at Phaleron for bathing before returning to its "house" on the Acropolis.

The back of the Old Athena Temple was separated from the eastern room by a dividing wall and comprised an anteroom opening onto

two smaller chambers, accessible through a single entrance on the west porch. This curious plan seems to reflect the integration of three distinct cult places and anticipates the unusual subdivision of the structure that would "replace" it in the last quarter of the fifth century, the Erechtheion (pages 65, 74, 108, and 265). Indeed, the Erechtheion reserves special cult places for Athena at the east and for Poseidon, Erechtheus, and his brother Boutes at the west, indicating that this building, like its predecessor, was devoted to the joint worship of multiple gods and heroes.[91]

Two rough limestone column bases found embedded in the foundations of the Old Athena Temple (page 65) in 1885 may be remnants of an even earlier incarnation of the shrine dating to the first half of the seventh century.[92] These bases would have held wooden columns supporting a superstructure of mud brick. This temple, or perhaps an even earlier (albeit hypothetical) eighth-century predecessor, may be the shrine of which Homer speaks when he says that Erechtheus "entered the rich temple of Athena" on the Acropolis.[93] This is likely to have been the temple where Kylon took refuge in his failed coup attempt during the 630s. Interestingly, this seventh-century shrine was

Bronze Gorgon akroterion (?), from Acropolis, seventh century B.C. Athens, Acropolis Museum.

called the Old Temple (Archaios Neos), just like the building that replaced it. All these incarnations of Athena's holy precinct (hypothetical eighth-century shrine, seventh-century temple, Old Athena Temple, and Erechtheion) sat upon the site of the Bronze Age Mycenaean palace (page 27), making visible in perpetuity a bond with the heroic past. (At other sites, like Mycenae and Tiryns, Iron Age temples are built atop or near the "big room" or "megaron" of the local palace's remains.)[94] A small bronze cutout relief (previous page) may give a hint at the decoration of the seventh-century Athena temple.[95] We see the terrorizing face of Medousa, the Gorgon sister, sticking out her tongue and baring her sharp incisors. If one imagines also the horrifying screech the Gorgons were thought to make, one can re-create the effect meant to scare away any force of sinister intent.

IN ADDITION TO the construction of the Old Athena Temple, the early years of Athenian democracy might also have witnessed the inception of a second new structure on the Acropolis, set just to the south and roughly parallel to Athena's shrine. On the very spot where the Bluebeard Temple might have stood, a massive platform of nearly ten thousand limestone blocks was laid in preparation for the building of a new temple, sometimes called the Grandfather of the Parthenon, or Parthenon I, by Dörpfeld, Manolis Korres, and other scholars.[96] But a contrasting view dates the foundations much later, after the battle of Marathon in 490, when they would have been positioned to support the immediate predecessor of the Parthenon, a building simply referred to as the Older Parthenon.[97] These foundations, constructed of limestone blocks quarried 10 kilometers (6 miles) away in the Piraeus and set some twenty-one courses deep on its south side, represent an enormous undertaking in anticipation of a huge new structure.

If this platform was already laid at the end of the sixth or early fifth century, it might have been that the young democracy wished to replace the Bluebeard Temple, tainted as it might have been with links to the Peisistratid tyranny. With a new regime dawning, memories of the disastrous ending of the old administration had to be expunged. After all, the tyrant Hippias was now ensconced with the Persians, and his memory was one thing that need not be preserved in stone. Any thought of finishing his giant temple of Olympian Zeus near the Ilis-

sos was abandoned when his tyranny came to an end. So it might have been that the Bluebeard Temple was regarded as a monument in need of replacing. In any event, if there was a plan for a new temple to replace the Hekatompedon, it was not yet to be realized.

For in the East, King Darius of Persia was busy with plans of his own, ever expanding his empire westward into territories long held by the Greeks of Asia Minor (on the western coast of present-day Turkey). By 499 B.C., these Ionian states had had enough and pushed back against Persian aggression. The Athenians sent help in the form of ships and troops but paid heavily for this support. The Persians crushed the Ionian revolt and then turned their sights, and revenge, squarely upon the Athenians themselves. War was inevitable. With the Persian threat looming, the populist leader Themistokles, elected archon in 493, diverted the Athenian treasury to a more urgent need than that of building a new temple. He focused Attic resources on the creation of a fleet of warships, galvanizing the city's maritime assets in a move that would prove indispensable to Athenian survival.

In August of 490 B.C., tens of thousands of Persian troops landed on Marathon beach, the turncoat Hippias showing the way. Plutarch tells us that the hero Theseus appeared to the Athenians in the course of the ensuing battle, rushing out in front of them in full armor and leading them to victory just as in days of old.[98] In what is regarded as one of the greatest military watersheds of all time, 6,400 Persians are said to have fallen that day to Athenian losses of just 192.[99] The extraordinary bravery of the Athenian soldiers and their Plataian allies instantly catapulted them to epic heroic status. The Marathon dead were awarded the extraordinary honor of burial on the spot where they fell, placed together in one great tumulus that became a monument unto itself.[100]

In the wake of the triumph at Marathon, construction began in earnest on the immediate predecessor of the Parthenon, the so-called Older Parthenon.[101] Athena needed to be thanked and honored for the astonishing victory. The new temple would have six columns on its ends and sixteen running down its sides (page 68 and following page), and for the first time ever the Athenians would build a temple entirely of marble. This marble would come from their own Mount Pentelikon, the city's swelling pride permitting no import of materials.[102]

But Persian fury would intervene. A vast Persian army and navy advanced into Attica in 480 B.C. to avenge their defeat at Marathon.

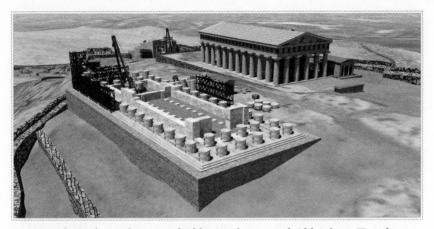

Hypothetical visualization of Older Parthenon and Old Athena Temple in 480 B.C., prior to Persian siege.

Now under the command of Darius's son Xerxes, the enemy first won a critical battle at Thermopylai, defeating the 300 valiant Spartans under the command of Leonidas, before marching on to Athens. Seeing what was coming and discouraged by reports that the sacred snake had disappeared from the Acropolis, most Athenians evacuated the city, seeking refuge on the nearby island of Salamis. Everyone knew that the Persian attack would be violent, but no one was prepared for the devastating destruction of the most holy buildings on the Acropolis itself. The Persian army surrounded the Sacred Rock, one division positioning itself on the Areopagus to better shoot flaming arrows up at the wooden ramparts. A few Persian soldiers scaled the precipitous and unguarded eastern cliff of the Acropolis, just above the sanctuary of Aglauros (insert page 1, bottom). Once on top, they opened the western gate, and the full Persian army flooded in, massacring those few suppliants and defenders who had chosen to stay, plundering the temples, and setting the whole citadel ablaze. It was an atrocity beyond comprehension for the Greeks. Hellenes had long followed a code by which the holy places of enemies were respected and spared during war. After all, their destruction was certain to incur divine wrath. But the Persians worshipped other gods and showed no respect for the Olympians.

The Old Athena Temple was hit hard in the siege, as was the Older Parthenon still under construction to the south of it. Manolis Korres, the architect-engineer-archaeologist who oversaw the Acropolis Restoration Program for some thirty years, has established that the Older

Parthenon was standing to a height of just two or three column drums, still unfluted, when the Persians attacked. But there was wooden scaffolding set up all around it, providing plenty of fuel to feed the flames (facing page).[103] Korres has identified thermal fractures on many of the temple's blocks, including the upper steps of its platform, which would be reshaped, capped, and reused more than thirty years later for the Periklean Parthenon.[104]

The Athenians did not despair but, keeping hope, retrenched and brilliantly expelled the Persians just a year later. Thanks to Themistokles's insight and careful preparation, they had developed their secret weapon: a powerful fleet of two hundred warships manned by a legion of highly trained and financially compensated oarsmen drawn from the *thetes*, the poorest of Athenian citizen classes. Themistokles himself would lead the stunning naval victory off the island of Salamis in September of 480, a victory that would soon be followed in 479 by sound defeat of the Persian land forces, deprived of their naval support, at the Battle of Plataia.[105] Thucydides tells us that immediately after the "barbarians had departed from the land," the Athenians brought their women, children, and possessions back from their places of refuge and began "rebuilding their city and its walls."[106] Any surviving blocks in

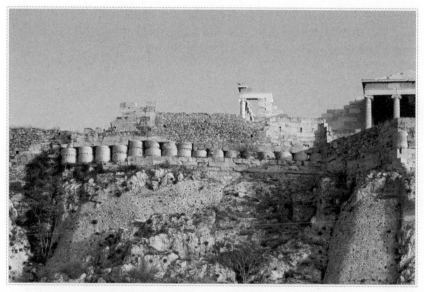

Display of reused column drums, north fortification wall, Athenian Acropolis.

a condition to be reused were gathered up for hasty construction of the great defensive walls that Themistokles ordered for the immediate securing of the city. These included blocks fallen from the Acropolis buildings. Broken and battered Archaic statues, including the famous *korai* ("maidens") that had once stood as sumptuous dedications to the goddess, were collected and buried in pits within the sanctuary, lovingly laid to rest within the sacred space.

Column drums from the Older Parthenon and surviving triglyphs, metopes, architrave, and cornice blocks from the Old Athena Temple were salvaged and built into the Acropolis's north fortification wall, no doubt under the watch of Themistokles (previous page).[107] That they are displayed in the same architectural order as they would have appeared on the temple (column drums carefully stacked to reconstruct "columns," metopes and triglyphs reconstructed in their proper sequence) shows a reverential reconstruction meant to evoke the destroyed temples and not simply an expeditious reuse of architectural elements to strengthen the fortification wall. Thus these architectural relics formed a commemorative display: proof of the Persian atrocities and the destruction of the city's most sacred shrines. They bore witness to the horrors suffered by a generation of Athenian heroes in the early decades of democracy. And so, the Athenians reconciled their desire to remember and their desire to create; their need to memorialize and their need to move forward.

The Old Athena Temple was not completely destroyed in the Persian attack; its façades and part of its westernmost room (known as the

Hypothetical visualization of surviving opisthodomos of the Old Athena Temple with Erechtheion at right.

opisthodomos) seem to have remained standing while its roof and interior collapsed (facing page).[108] This would help explain why the Erechtheion (built just to the north of it in the last quarter of the fifth century) respected its foundations and adopted such a peculiar design for its southern flank. Indeed, the long stretch of wall to the east of the Porch of the Maidens was left completely blank, something very strange within the larger scheme of Greek architecture. But if battered remains of the Old Athena Temple still occupied parts of the Dörpfeld foundations at the time when the Erechtheion was built, this southern wall might have been left necessarily unadorned as it was mostly hidden by the standing ruins (facing page and page 265). The Erechtheion's karyatid porch extends farther south to encroach upon the Dörpfeld foundations at a place where the Old Athena Temple may have completely collapsed. While it is difficult to prove this was so, it does make sense and would continue the tradition in which ruined walls of earlier periods (see the Mycenaean fortifications, page 28) were preserved and respected on the Acropolis as relics of the past. What is clear is that the Acropolis was ever a place of memory, bearing palpable witness to earlier eras, past struggles against deadly enemies, and the victories that defeated them. Again, in the absence of photography or film, it was essential to preserve tangible evidence of past history, or else future generations might forget it, or not believe it at all.

Like the cosmic battles of Zeus and Typhon projected on the Bluebeard Temple pediment and the clash of gods and Giants on the Old Athena Temple, a new generation of terrifying enemies confronted Athenians of the early fifth century. The Persian behemoth had raised its ugly head, but this monster, like Drako, Typhon, Triton, the Hydra, and Enkelados before it, would be soundly slain, this time, in the waters off Salamis and in the wheat fields of Plataia.

3

PERIKLEAN POMP

The Parthenon Moment and Its Passing

PERIKLES WAS ABOUT FIFTEEN when the smoke rose from the smoldering Acropolis in 480 B.C. We cannot know if he watched with his family from Salamis, to which most Athenians fled. It is said that when the Athenian fleet routed the Persians, months later, in waters off that island, his (future) friend Sophokles, aged sixteen, was chosen to lead the victory dance. Already renowned for his good looks and flair as an entertainer, Sophokles performed the triumphant paean, serving as top boy in the male chorus, an auspicious debut for one who would eventually rank among the greatest tragedians of all time.

We can only wonder how the trauma of the Persian attack affected the psyches of the Attic teenagers who grew up to forge what has been called the golden age of Periklean Athens. Theirs was a rarefied cohort, those young men of the highest privilege, but also united in their common experience of unimaginable shock suffered at a tender age. Did the ordeal of seeing the very existence of the young democracy threatened spur them on to special greatness as thinkers, artists, architects, playwrights, generals, and, yes, politicians, achieving things that endure superlative even today?

Perikles, for one, was certainly set on a road to success from the start; even his name (*peri* + *kleos*) promises he would be "surrounded

by glory." The boy studied music with the theorist Damon and went on to learn philosophy from Anaxagoras, whom he would befriend.[1] As an adult, and aspirant to power, Perikles would still enjoy discussing philosophy, especially with Protagoras and Zeno of Elea, and he was close to the geometer Hippodamos of Miletos, whom he would hire to lay out the harbor town of Piraeus. But among his very dearest friends was Pheidias, the master sculptor who would collaborate with him in planning the Parthenon and its sculptural program. That, however, would not be for some time, a quarter century later, when Athens was at its imperial zenith.

While he was still in his early twenties, in the spring of 472, Perikles's very first public act was to finance a production of Aeschylus's *Persians,* a play that celebrated none other than the Athenian victory at Salamis. It was a canny gesture for the future statesman, presenting a drama that spoke hopefully to his generation, still scarred by the Persian War period and the sack of the Acropolis. Standing at the very center of this cohort, Perikles the aristocrat would rise as a champion of the people, the man as naturally cool and aloof as Olympian Zeus discovering a gift for charismatic oratory with which he could stir the masses.[2] By that time it was democracy not as the Athenians had first imagined it but an even purer strain, for good and ill.

Much of what we know of Perikles comes from the golden hindsight of those who wrote after his death, Thucydides and Plutarch chief among these admirers.[3] But a few facts speak for themselves, attesting to the magnitude of Perikles's accomplishments. Every two years from 450 to 429, he was elected by popular vote (with the exception of only one term) to the council of ten generals, or strategoi. The office of strategos was far more than a military responsibility, giving the ten who held it the authority to speak before all others at meetings of the assembly. One of the few elected positions, the strategos was as close as one could come to being a civic leader in a democracy that now distributed most jobs by lot, or sortition. (This seemed to the Athenians only fair, ensuring every man had an equal chance at most public positions—those requiring no special expertise anyway—and that none was unduly advantaged by reason of wealth.) That Perikles could hold on to his elected office for some twenty years, never successfully challenged or ostracized (as his father had been and so many of his friends and enemies would be), speaks to his exceptional skills.

IN TIME, Perikles came to embody Athens of the fifth century in a way that Peisistratos had done for the Athens of the sixth. But if the masses were readily swayed, his fellow aristocrats were not as easy to dispatch. Perikles was of the Alkmeonidai, rival clan of the Peisistratids, his mother's brother being none other than Kleisthenes, architect of the Athenian democracy. And through his father, the war hero and politician Xanthippos, Perikles belonged to the Athenian tribe Akamantis and the deme (or burg) of Cholargos. In 461 B.C., when he was roughly thirty-five, he stepped into the political spotlight as a leading advocate for the ostracism of Kimon, who was related through marriage to the Philaidai. Enmity between the two families went back a generation, when Xanthippos had imposed exile and a hefty fine of fifty talents on Kimon's father, Miltiades, the general responsible for the victory at Marathon.[4] Unable to pay the fine, the heroic warrior died in jail, bequeathing the onerous penalty and the attendant resentment to his son.

Kimon would become a war hero in his own right, distinguishing himself fighting the Persians at Salamis and later in Thrace, Skyros, and at the battle on the Eurymedon River in Pamphilia (southern Turkey). As a leading statesman throughout the 470s and 460s, he had a crucial part in building the Athenian navy, which allowed the city to become an empire. Military victory was remunerative, and so, having paid off his father's debt, Kimon lavished his personal fortune on civic projects. He is said to have been the first to adorn Athens with elegant spaces for public use.[5] He planted many plane trees in the Agora. He transformed the Academy into a shady grove, well watered by an aqueduct some 3 kilometers (nearly 2 miles) long, carrying runoff from the market. Spoils from his military conquests also enabled Kimon to finance the rebuilding of the south wall of the Acropolis, the laying out of the Long Walls connecting Athens to the Piraeus, and the construction of the Klepsydra fountain and the Painted Stoa (from which the philosophical school of Stoicism takes its name). But when, in 462 B.C., Kimon led an unsuccessful mission in support of the Spartans (against the Helot uprisings), he opened himself to accusations of fraternizing with Athens's enemy. This gave Perikles the perfect opportunity: he launched a case for ostracism against Kimon. Thus did Perikles use a tool of fifth-century democracy (the ancient version of today's recall referendum) to

advance his personal political ambitions, forcing his main rival to leave Athens for ten long years.

There was another contender for leadership at Athens, Perikles's own mentor Ephialtes, the great reformer and champion of the masses. A tumultuous moment, 462 was also the year Ephialtes introduced reforms stripping the Areopagus Council (the aristocratic body composed of former archons and other elite officeholders, a kind of senate) of nearly all its functions except that of murder tribunal. Henceforth, all other criminal and civil trials would be handled by the law courts, in which all Athenian citizens could serve. This decisive truncation of aristocratic influence and its typically moderating effect marks the beginning of what has been called Athens's radical democracy. To put it mildly, not everyone was pleased. The following year, Ephialtes was assassinated. This left Perikles's path to power wide open.

By 457, Perikles was recognized for valor at the Battle of Tanagra, Plutarch reporting that among Athenian soldiers he was "the most conspicuous of all in taking no care for his safety."[6] And so, before reaching the age of forty, this consummate patriot and thoughtful man of action managed to consolidate his position as the leading statesman of Athens. Over the next thirty years he would preside over a radical democracy, a powerful empire, a savage war with Sparta, and an extravagant building program on the Acropolis. Before considering the latter, which gave us the Parthenon, chief among its wonders, let us consider the political context, which was then, as ever, bound up with the Athenian self-understanding.

Even the greatest cynic must acknowledge that the central tenets of Athenian radical democracy were inspired: individual freedom, self-government, equal protection before the law (regardless of wealth), the right of any citizen to own land and houses in Athenian territory, and an affirmation of the individual's commitment to the well-being of the community as a whole. All Athenian (male) citizens could participate in the deliberations and vote in the assembly, or ekklesia (where some measures required a quorum of six thousand), and by serving as jurors in the law courts, the heliaia, where a minimum panel of two hundred males over the age of thirty was required but up to six thousand were kept in service. With the authority to impose ostracism, this body, not the assembly, was where the real power lay. Then there was the Council of 500 (boule), comprising fifty members chosen by lot from each of

the ten Kleisthenic tribes. In all, some eleven hundred citizens now held office each year at Athens, most chosen through sortition, only about a hundred elected, including the ten strategoi. After 487 B.C., archons were no longer elected by the people but chosen by lot;[7] and by 457 even *zeugitai* (those of minimal property, enough for subsistence) could serve as archons. Civic life grew to ensure a job for every citizen, with anyone who neglected his due involvement reviled as an *idiotes*. Thus power was never more dispersed in the polis and, as a consequence, its exercise never more fractious. Soon, the need for a monumental reminder of first things would seem ever more urgent.

Democracy had taken form for the first time in human history precisely because of the profound and all-pervading sense of a common Athenian ancestry, one that originated in the mists of the Bronze Age, the sons of Erechtheus—of Athena herself—all belonging to the land. *Politeia,* that touchstone of Athenian life denoting the conditions and rights of the citizen, was a concept whose sense extended far beyond our notions of politics, positing a mythic "deep time" and a cosmic reality in which the citizen could not locate himself or understand his existence except through religious awareness and devotions. All were pledged to the good of the polis, and by extension that of one another, and by that mutual understanding popular rule could be trusted. But radical democracy was inevitably an expansive vision of rule and, just as inevitably, a costly one, dependent on the revenues of empire. However much that vision may have included ever more lavish tributes to the divine order of things, its abundant benefits to the individual citizen distracted him, weakening the very solidarity and selflessness that had made democracy trustworthy.

It was Perikles himself who introduced payment for jury service. Now men sitting on juries were compensated for their service just as soldiers and the oarsmen of the great triremes were. Priesthoods, long an inherited privilege of the elite, were now opened to a wider cut of the citizenry through use of the lot. And while sacred offices had always brought emoluments, we now hear of cash salaries and payments in skins, hides, and meat portions from the animal victims. The benefits of citizenship grew so great that in time it seemed better to limit those eligible rather than to restrain the benefits, lest too many outsiders share in the wealth of Athens. Aristocratic Athenian men had long favored rich foreign brides, as Perikles's own maternal grandfather had done, marrying well at Sikyon.

As typically happens, less eminent citizens began following suit, taking foreign wives, with every confidence of passing Athenian citizenship on to their sons. But in 451/450 B.C., Perikles introduced legislation under which citizenship could be conferred only on those whose mother and father were both from Athenian families.[8] The Periklean citizenship law, exclusionary as it was, had the effect of elevating the status of Athenian women by making them, more than ever, desirable for marriage. Apart from the ownership of property and its legal protection, women had few rights or benefits, being ineligible for military service or politics. It was required that male guardians speak for them in the law courts and handle all their financial and legal affairs, but women did enjoy the wealth of the city equally within their families, and those who held key priesthoods enjoyed not only the prestige but a salary and a share in the sacrifices.[9]

Amid the demands of a populace expecting ever greater emoluments, the key to Perikles's success, apart from his spending lavish sums, was certainly his unrivaled gift for oratory. Plato calls him, in the *Phaidros,* "the most perfect of all in rhetoric,"[10] though elsewhere the philosopher takes him to task for artifice in delivering orations that seem to have been written out in advance.[11] In his comedy *The Demes* (performed in 412 B.C.), the playwright Eupolis gives a rather breathless description of Perikles's gifts:

Speaker 1: That man was the most powerful speaker of all.
Whenever he came forward, like a great sprinter
Coming from ten feet behind, he bested his rivals.

Speaker 2: You say he was fast . . . But, in addition to his
 speed,
Persuasion somehow or other sat on his lips,
So entrancing was he. He alone of the politicians customarily
 left his sting in his hearers.
 Eupolis, *Demes,* PCG V 102[12]

That sting would need to remain in effect if Perikles was to persuade his fellow Athenians to join his vision for a newly resplendent Acropolis. To judge by his stunning success, it did.

BY THE MIDDLE of the fifth century, the Acropolis had stood in semi-ruins for thirty years. The platform on which the Older Parthenon was to have been built lay broken, its marble blocks still fractured from Persian fire. The roof of the Old Athena Temple had collapsed, but despite the utter destruction of the interior its battered façades and apparently a good bit of its westernmost room still stood (page 74).[13] Cleanup on the Acropolis had already begun under Themistokles in the 470s, when usable blocks were salvaged for hasty construction of the city's new defensive walls. But much of the Sacred Rock remained a sad, wounded, and dark memorial to Persian atrocities. There could have been no more galvanizing reminder of this sacrilege.

This is why the famous oath said to have been sworn by the Greeks just before the Battle of Plataia in 479 included this line: "I will not rebuild a single one of the shrines that the barbarians have destroyed but will allow them to remain for future generations as a memorial of the barbarians' impiety."[14] Though the authenticity of this oath has been questioned, its citation in both the literary and the epigraphic records suggests that it was real.[15] So, too, does archaeological evidence, which shows no major building initiatives on the Acropolis between 480 and 447 B.C. But, as Manolis Korres has stressed, this pledge was probably motivated as much by a need to restore Athenian solvency as by the totemic power of the ruins.[16] Rebuilding could not take place until Athens was on a stable financial footing, and this would take time.

Fighting with the Persians, in fact, continued after the Athenian victory at Plataia, as the Greek allies attempted to dislodge the enemy from lands it had taken across the Aegean Islands, Thrace, Asia Minor, Anatolia, and Cyprus. A confederation of Greek states was created in 478 for joint defense against the Persians, at first consisting largely of islanders but in time growing to include 150 to 170 member states. The island of Delos in the very center of the Aegean made the perfect base for the organization that historians have labeled the Delian League but in antiquity was simply called "the Greeks and their allies." Member states contributed ships, timber, grain, and troops to the war effort. Finally, in 449 B.C., the Athenian ambassador Kallias negotiated a peace with the Persians, ensuring freedom for the Greek cities of Asia Minor and prohibiting Persian satrapies (even Persian ships) anywhere in the Aegean.[17] This marked a watershed not only for the Greek confederation generally

but for the Athenians in particular, who were now launched on a new course toward empire.

Perikles lost no time in turning to a long-deferred goal: the rebuilding of the Acropolis (below). With peace at hand, the unspent balance in the league's treasury was no longer needed to fund the war. Perikles transferred five thousand talents into "Athena's account," which would now serve as a blank check for his vision. A monumental double gateway, the Propylaia, would replace the former entrance at the west; the shrine of Athena Nike, just beside it, would be wholly reconfigured with a new marble temple surrounded by a sculptured parapet. The unfinished Older Parthenon at the south of the plateau and what remained of the Old Athena Temple at the north would be renewed with the building of the Parthenon and the Erechtheion. Every structure would be made from bright white Pentelic marble and enhanced with a dazzling profusion of carved decoration. It would cost a fortune.

Plutarch tells us that the extravagance of Perikles's plan brought loud resistance in the citizen assembly, where critics accused him of squandering state funds.[18] Thucydides (not the historian but a man of the

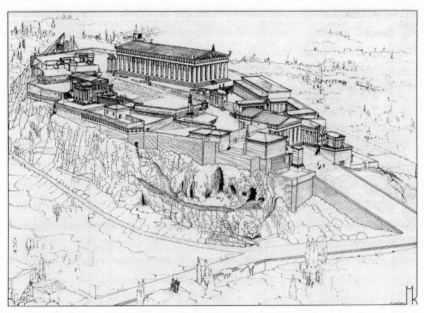

Reconstruction drawing of the Athenian Acropolis, classical through Hellenistic periods, by M. Korres.

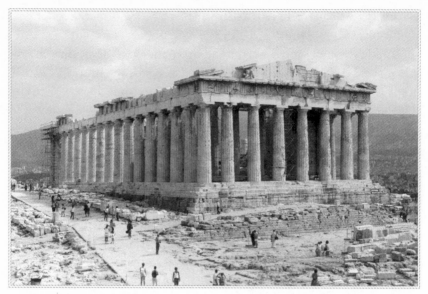

Parthenon from northwest, 1987.

same name who was the political successor to Kimon) was one of those who railed most fiercely against Perikles. But the leader deftly parried all accusations, offering to cover the expenses himself, provided he be allowed to inscribe "Perikles built it" upon the sacred structures.[19] In the end, the citizen assembly acquiesced fully to their leader and his ambitious plans, allocating vast sums year after year to move the project forward. And move forward it did, creating the biggest, most technically astonishing, ornately decorated, and aesthetically compelling temple ever known (above).

First and foremost, this supremely deisidaimoniacal people wanted to honor Athena in the most spectacular way they could, thanking her for victory over the Persians. Since more is more when it comes to prayer, the Parthenon had to be excessive in its splendor. By now, an entire generation of Athenians had grown up never having known a grand and glorious Acropolis. And so, too, perhaps, the "Persian War teenagers" wanted to leave their own children something more than a citadel in ruins, a barren ground zero that fossilized the bitter memories of defeat. It was time to forge a new narrative for the city, one of Athenian triumph and supremacy, a visual tribute to its miraculous rise from the ashes. Athens possessed all the necessary ingredients to achieve this: a strong leader, the collective will of the people, an abundance of talented

artists and artisans, access to quality marble, an exquisitely evolved aesthetic sensibility, optimism, manpower, and money, lots of it.

The Parthenon would be, among other things, a new home for the treasury of the allied Greek states, Perikles having shrewdly maneuvered the relocation of the funds from Delos to Athens in 454/453 B.C. The previous year, when the Greek fleet had suffered a serious defeat by the Persians in the waters off Egypt, Perikles used the setback as his pretext for moving the treasure to Athens, allegedly for safekeeping. With that, the confederation was suddenly transformed into what we call the Athenian League. From the 460s on, more and more states contributed money rather than ships to the common pool of resources and it now fell to the Athenians alone to administer these funds. By 454, when Perikles effected the fund transfer, the balance stood at an extraordinary sum of 8,000 talents.[20] The allies would still have to collectively donate a total of 600 talents to Athens in annual tribute (roughly 17 tons of silver, worth something like $360 million in present value, though this is terribly difficult to figure).[21] A sixtieth of this tribute was reserved for the goddess Athena herself and placed in a special account controlled, of course, by the Athenian state. We know that by 431 B.C., some 6,000 talents (170 tons of coined silver) were housed on the Acropolis, much of this within the Parthenon itself. The gold and ivory statue of Athena in fact served as a kind of vault (insert page 7, bottom). Its robes were plated with 40 to 44 talents of solid gold, weighing twenty-three hundred to twenty-five hundred pounds. Piety permitted that the city could use this raiment as a line of credit, removing sections of the gold as needed, provided the debt was eventually repaid.[22] Thus, a staggering treasure came under Athenian control. It permitted the polis to build a peerless navy for defense of the Athenian League but also to advance Athenian self-interest, expanding its international trade and beautifying the Acropolis beyond all imagining. There were also those lavish benefits to individual citizens. In this process, Athenian hegemony over the confederation's members evolved into the Athenian Empire, reducing the other Greek members to subject peoples.[23]

The Parthenon, a potent symbol of the growing wealth and power of this empire, attested to Athenian supremacy, feeding the city's eternal appetite for competition with other states and nations. It was also, more literally, the place where the profits of lording it over foreign Greeks, the riches of allied tribute, were held. Inscribed inventories confirm a bur-

geoning treasure.²⁴ Dedications wrought from gold, silver, and bronze, and fashioned from ivory, packed the Parthenon's interior: weapons, vessels, lamps, shields, furniture, boxes, baskets, jewelry, musical instruments, statues, and other gifts for the goddess.²⁵ These filled the eastern cella (called the *hekatompedon* in the inventory lists) as well as the westernmost room (referred to as the *parthenon*). Built at a moment when civic religion, self-regard, and imperial ambitions began to overtake Athenian thinking, the Parthenon, even in all its luxurious grandeur, was looked upon with sincerity and awe as the epicenter of the city's most venerable ideals and virtues.

Perikles's master plan for the Acropolis had yet another motivation: long-term employment for hundreds, if not thousands, of laborers. More than a hundred thousand tons of marble needed to be quarried for the rebuilding of the Acropolis; seventy thousand blocks had to be cut and transported to the Sacred Rock, hauled to the top, where they would be finished by stonemasons, and set in place.²⁶ Roads had to be built up the slopes of Mount Pentelikon for access to new quarries, as well as to Athens itself, some 16 kilometers (10 miles) to the southwest. Manolis Korres has reconstructed the process of quarrying, cutting, and transporting the blocks (some weighing as much as thirteen to fourteen tons) to the city center.²⁷ Riggers and teamsters loaded the freshly hewn stones at the quarry onto wheeled carts and sledges pulled by oxen and horses for the six-hour journey along a flagstone road. A new ramp, broadened to 20 meters (66 feet) in width, was built up the west slope of the Acropolis for hauling materials to the top. There, a team of as many as two hundred craftsmen worked on the marble, up to fifty sculptors carved the figured decoration, and any number of additional men labored on construction crews and support teams.²⁸

Thus, all citizens would share in the prosperity of the city. Plutarch expounds the litany of laborers employed in Perikles's scheme: carpenters, modelers, metalworkers, stonemasons, dyers, gilders, ivory softeners, painters, embroiderers, and engravers, as well as the purveyors of all the materials needed and those who transported materials, including sailors, helmsmen, wagon makers, keepers of oxen, and muleteers. In addition, rope makers, linen weavers, leather workers, road builders, and quarrymen were needed, plus a host of unskilled laborers to support all the others. "The requirements of these projects," Plutarch observes, "divided and distributed surplus money to pretty well every age-group

and type of person."[29] The citizenry of Athens would be employed not only for the sixteen-year period of the Parthenon's construction and adornment (447–432 B.C.) but also for the time it took to build the Propylaia (437–432), the Erechtheion (421–405), and the temple of Athena Nike (427–409). Indeed, full employment, thanks to Perikles's vision, lasted well past his death, into the last decade of the fifth century.

Inscribed accounts listing payments to these workers, as well as expenditures for construction materials, suggest that the total cost of the Parthenon was around 469 silver talents (something like $281 million today).[30] This was paid, in part, with revenues from the silver mines at Laureion but largely from Athena's own coffers, those fed by allied tribute. A financial committee of six Athenians and a scribe was elected annually to administer the payment of a vast array of expenses for the construction of the temple.

The accounts also tell us that construction of the Parthenon began in 447/446 B.C., that its gold and ivory statue of Athena was dedicated at the Great Panathenaia of 438, and that work was completed in 433/432, when the larger-than-life-size figures were finally set within the pediments.[31] It seems that, like so many construction projects before and since, the building wasn't quite finished in time for its scheduled dedication. Nonetheless, the superstructure was up, the roof was on, and sculptured figures could easily be placed in the pediments five years later. The exquisite quality of the carving of these figures confirms that the extra time was well spent (page 106). And it is nevertheless astonishing that the superstructure alone was fully standing in just nine years. Athenian naval technology no doubt contributed to the speed with which the building went up.[32] Knowledge of lines, winches, blocks, and pulleys for the hoisting of sails and lifting of cargo was easily transferred to hauling and lifting marble column drums and cornice blocks.[33]

A decision had been made at the outset to build the Parthenon entirely of high-quality, fine-grained white marble from the city's own Mount Pentelikon. Thus, from top to bottom, from roof tiles to all three steps (*krepidoma*) of the platform on which the temple sits, to every last carved decoration, this thoroughly Athenian monument is made entirely of Athenian material. A hundred thousand tons of Pentelic marble were carried up the Acropolis, re-creating a veritable "mountain of marble." The Parthenon would be as solid, enduring, and dazzling as Mount Pentelikon itself.

Ancient sources name Iktinos as the designer/architect of the temple, and Kallikrates as a sort of general contractor.[34] Writing some four centuries after the completion of the Parthenon, Vitruvius names Karpion as a co-author, with Iktinos, of a technical manual on its engineering, suggesting a key role for him, though he is unattested elsewhere.[35] Mnesikles is named as the architect of the Propylaia, begun in the same year as the Parthenon. But of all the names that come down to us from the cohort of geniuses who conceived and executed the Periklean building program, it is that of Pheidias, friend of Perikles, that figures most centrally as the general overseer of the Parthenon project.[36]

Pheidias seems to have started his career as a painter (like his brother Paionios) but soon focused on sculpture, winning some of the most coveted commissions of his day. A recognized talent already during Kimon's years of leadership, Pheidias had been selected to create a bronze statue group at Delphi commemorating the Athenian victory at Marathon. Funded by a tithe of the Persian spoils, this monument featured Kimon's own father, Miltiades, hero of the battle, flanked by statues of Athena and Apollo. These were joined by images of the legendary Athenian kings Erechtheus, Kekrops, Pandion, Theseus, and Theseus's son Akamas, indeed by all the heroes who gave their names to the ten tribes as reorganized by Kleisthenes.[37] Thus, the young Pheidias had early practice in carving the likeness of Erechtheus, experience that would serve him well in planning the Parthenon frieze. It was also under Kimon that Pheidias created a gold and ivory statue of Athena for her temple at Pellene in Achaia, a work that prefigured his chryselephantine statue of the Athena Parthenos. Pheidias's most conspicuous commission was, of course, the Bronze Athena that stood some 40 meters (130 feet) tall on the Athenian Acropolis, an image created in the 470s and financed from the Persian spoils at Salamis. The statue (page 227) looked straight out the Propylaia toward Salamis, while the crest of its helmet is said to have been visible all the way from Sounion.[38] But Pheidias's most famous creation of all was the colossal gold and ivory statue of Zeus he made for the temple at Olympia, an image that would become one of the Seven Wonders of the Ancient World.

By the time Pheidias unveiled the Athena Parthenos statue in 438 B.C., he stood accused in a high-profile lawsuit of embezzling gold intended for the cult image. This was part of a wave of legal actions that erupted at this time, owing to the diffusion of power within the radical democracy.

Before long, Perikles's beloved Milesian mistress, Aspasia, was charged with impiety. Athenaeus, quoting Antisthenes (a pupil of Sokrates), tells us how Perikles wept bitterly while pleading her case before the court.[39] And soon, new legislation was passed making it a crime to "teach about the heavens," directly targeting Perikles's teacher Anaxagoras. Perikles himself had been accused of bribery and embezzlement, and it was when these charges failed to bring him down that his enemies resorted to assailing his inner circle. Plutarch tells us that Pheidias eventually cleared his name by asking that the gold from the goddess's statue be removed and weighed, thus proving that none was missing. But the accusers persisted, charging him with impiety for sneaking his own likeness and that of Perikles into the composition of the Amazonomachy shown on Athena's shield, the friends allegedly resembling two Greek warriors portrayed there.[40] Convicted and exiled from Athens, the greatest sculptor of the Periklean age and chief overseer of the Parthenon project would die in jail.

IN PLANNING the new temple of Athena, Pheidias and his team of architects had looked back to the Older Parthenon, a building begun around 488 but destroyed by the Persians before it could be finished.[41] Its giant foundation, rising some 11 meters (36 feet) from the bedrock on the south side, would be used to support the new structure. Since its uppermost courses were damaged by fire, the great three-stepped platform would be entirely encased within newly hewn marble blocks. Some economies were observed, such as the use of blocks that had been cut for the Older Parthenon but were still lying in the quarries of Mount Pentelikon or atop the Acropolis itself. It has been suggested that one-quarter of the total construction cost of the Parthenon was saved by the reuse of blocks prepared for the earlier structure.[42] The height of the steps of the Parthenon's *krepidoma*, including the top step (stylobate), the steps leading into the cella, and the diameter of the peristyle columns, was kept identical to that of the Older Parthenon, making the salvage possible.[43]

Still, there were many changes in plan. The footprint of the new Parthenon was extended to the north (following page), making it much wider but somewhat shorter than its predecessor at 30.80 by 69.51 meters (101 by 228 feet). To accommodate the extra width, two columns were added to the façades, making for a peristyle of eight columns

rather than six at front and back and seventeen down the sides.[44] The new proportions allowed for a more capacious interior of the cella, no doubt in anticipation of Pheidias's monumental statue of Athena.[45] The Parthenon's peristyle thus comprises forty-six columns in all, with the spaces between the columns at front and back screened by metal grilles and gates to secure the treasure held within. A second row of six columns was added behind the peristyle on the façades, creating a prostyle arrangement reminiscent of the great sixth-century Ionic temples of East Greece, the massive dipteral shrines at Samos, Ephesos, and Didyma.[46] This innovation is contrary to Doric conventions that call for a single colonnade wrapping around the cella. Indeed, the Parthenon integrates many Ionic features into an overall Doric program: not just the double row of columns at front and back, but also the bead and reel moldings on the Doric frieze crown, the continuous Ionic frieze set high within the colonnade, and four Ionic bases (possibly supporting proto-Corinthian columns) that stood in the temple's westernmost room (page 233).[47]

Widening the platform 5 meters (16 feet) to the north had another consequence: the footprint overlapped a preexisting shrine. Out of respect for the continuity of this holy place, the spot was marked by a small temple structure (*naiskos*) built exactly above it, within the Parthenon's north colonnade (below and facing page). Manolis Korres has identified evidence for this *naiskos* set between the seventh and the

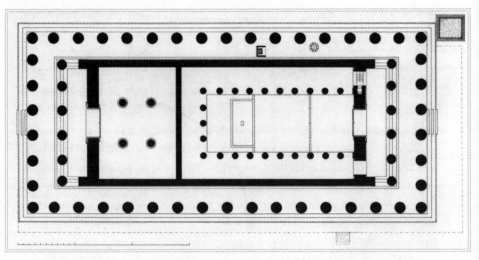

Plan of Parthenon, with Older Parthenon (dashed line) beneath; *naiskos* and altar in north peristyle, by M. Korres.

Reconstruction drawing of the
Parthenon's north peristyle with
naiskos and altar, by M. Korres.

eighth columns (from the east end) of the colonnade as well as a circular
altar that sat to the east of the structure, between the fifth and the sixth
columns (from the peristyle's east end).[48] The altar indicates that ritual
observance was continued at this new incarnation of the earlier shrine.
Fascinatingly, the *naiskos* is aligned on the same axis as the Older Par-
thenon, rather than along the slightly shifted one of the new Parthenon.
We will return to the puzzle of this *naiskos* in chapter 6, but for now let
us recognize the care the builders took to preserve the continuity of this
especially sacred spot.

Another point of reference for the new temple was the sanctuary of Zeus at Olympia. Finished in 456 B.C., the temple was now the largest in Greece.[49] Naturally, the architects at Athens viewed the Olympian shrine with an eye to surpassing it. The Parthenon's exterior columns are, in fact, exactly the same height as those of the Zeus temple: 10.43 meters (34.21 feet). But the Parthenon's extra width (eight columns across the façade to Olympia's six) and the use of marble rather than soft limestone make the building incomparably more magnificent.

The new Parthenon maintained the same basic plan as its predecessor: a great room at the front on its eastern end and a completely separate, smaller room at the west, or back of the building (page 90). Inscribed inventories dated 434/433 B.C. refer to this easternmost room as the *hekatompedon*, or "hundred-footer," just as we have seen for the temple that might have stood on this spot during the sixth century, that which held the Bluebeard pediment.[50] Two windows pierced the eastern wall of the cella on either side of the doorway, allowing extra light to flood in upon Pheidias's gold and ivory Athena. A recessed section of floor paving in front of the statue's base might have accommodated a shallow pool of water. This would have facilitated humidification of the ivory components (susceptible to cracking if too dry) and would have reflected morning light from the east windows to better illuminate Athena's image. The eastern cella featured an elegant means for supporting the roof: a two-tiered colonnade satisfied the canons of Doric proportion (which didn't allow for tall, slender columns) and, at the same time, created a transparent, screen-like arrangement that wrapped around the sides and back of Athena's statue (insert page 7, bottom). This increased the apparent size of the cult image and greatly enhanced the mystery of the space.[51]

In contrast, the western room of the Parthenon was much smaller, measuring 13.37 by 19.17 meters (43.86 by 62.89 feet), with its greater dimension being north to south. Fifth-century inventories refer to this chamber as the *parthenon*, a word meaning "of the maidens," the sense of which we shall discover in due course.[52] Its roof was supported by four slender columns. The outlines of their bases suggest not Doric but the canonical Attic Ionic profile (toros-scotia-toros). This change of order was necessary since the ceiling of this chamber was higher than that of the peristyle; the use of stouter Doric columns would have made them impossibly large and there was no need for a two-tiered colonnade

arrangement here, as we saw in the eastern cella. And so, yet another innovative solution was devised: Ionic columns (with more slender proportions) were introduced. Poul Pedersen goes even a step further and suggests that these columns featured capitals that foreshadowed the Corinthian order, a point to which we will later return (page 233).[53]

Perhaps in nothing did the Parthenon's architects and engineers outdo themselves so much as in the advanced use of optical refinements, which they raised to a high art. Builders had for some years been exploring remedies for apparent distortions experienced when viewing large temples from a distance. An allusion of sagging is seen at the centers of the long horizontal lines of the stylobate, as well as the lower two steps beneath it (stereobate), and in the cornice (architrave or entablature) up above. An extraordinary correction was found to remedy this illusion by making all horizontal surfaces bow upward at center.[54] Thus, on all four sides of the Parthenon we see upwardly curving surfaces and lines. For example, the steps on the flanks of the platform arch up 6.75 centi-

Curvature of *krepidoma*, north steps of Parthenon.

meters (2.66 inches) higher at their centers than at their ends (previous page). So, too, do the horizontal lines of the architrave bow up in the middle. A breathtaking level of technical sophistication went into the execution of these adjustments to exacting tolerances. Ingenious combinations of reverse asymmetry can be detected, along with slight diminutions in curvature, all painstakingly worked out to achieve subtle, and enormously pleasing, visual effects.

It has long been noted that there are few, if any, straight lines in the Parthenon. First, the very platform on which it sits tilts up, from a low of 3 centimeters (1.2 inches) at the east end to a high of 5 centimeters (1.9 inches) at the west.[55] This makes for an imposing visual impression as one enters the Acropolis through the Propylaia: the giant west façade of the Parthenon tilts high and looms large (page 84). In addition, the side walls of the Parthenon lean slightly inward, as do each of the forty-six columns of the peristyle. Indeed, if the axes of the flanking columns were extended into the sky, they would meet 2.5 kilometers (1.5 miles) above the platform on which they stand.[56] When we look at the entablature and its Doric frieze, we see that the metopes tilt slightly outward while the triglyphs slant in. And so, from top to bottom, the Parthenon tips, slants, recedes, inclines, and bows, all the while transmitting an overwhelming sense of harmony and balance.

The Parthenon's colonnade epitomizes the post-and-lintel system of load bearing in classical architecture. Yet here, too, subtle adjustments trick the eye to compelling effect, to create a reassuring sense of order and solidity while still appearing fascinatingly delicate. The columns taper upward, so they are wider at the base than at the top. At the same time, they swell outward at their midpoint, a phenomenon known as entasis, which gives the appearance of a flexed muscle, as if bulging as it bears the weight. The columns at the very corners of the temple are slightly thicker than the others, creating the impression of extra solidity here on the flanks. Similarly, the final two columns on either end of the façades are not as far apart as other adjacent columns. This device, known as corner contraction, allows the second-from-the-end columns to sit directly below triglyphs. Thus, the corner triglyphs are not centered above the corner columns but rest at the corners of the entablature. The logic of this was considered far more satisfying than centered corner triglyphs with impossible partial metopes at the corners.

All these calculated differences and variations are governed by a

complex system based on a ratio of 4:9, pulling the building (in both plan and elevation) into a unified whole.[57] The precision with which the ratio is observed among the individual proportions of the Parthenon is nothing short of astonishing: it governs the height of the columns and entablature to the width of the stylobate; the minimal column diameter to the axial distance between them; the width of the stylobate to its length. The result is a kind of buoyancy, a sublime integration of disparate members that is organic, almost alive as the Parthenon seems to breathe and flex supporting its Pentelic load. The American Beaux Arts architect Ernest Flagg likened the effect of these ratios to that of aural harmony: "The hearer may be entirely ignorant of the methods used, yet charmed by the results. So, too, the observer of harmonious dimensions may be ignorant of their very existence, yet captivated by them."[58]

This visual perfection could not have been achieved without a highly evolved and supremely disciplined technical competency. The fluting of the columns, the carving of the sculptures, the smoothing of surfaces to be joined, indeed every block on the Parthenon was finished on-site. Stone sanding plates enabled artisans to finish surfaces to an accuracy of one-twentieth of a millimeter, so that individual blocks might rest seamlessly against each other. But the passage of time itself has accentuated the uncanny impression of perfect wholeness. One of the most fascinating discoveries made by Korres is that after centuries of constant pressure exerted by the blocks upon one another, granules of marble have fused from one slab into the next, creating a solid mass of stone. Korres calls this *erpismos,* or "snaking," within the crystalline structure of the marble, the arrangement of individual granules deformed into an undulating path.[59] He was able to observe this phenomenon following an earthquake in 1981 when blocks in the Parthenon's *krepidoma* separated enough that he could peer into the core of the platform. What Korres saw was astonishing: discrete blocks seamlessly fused together. This makes the metaphor of the Parthenon as a reconstituted Mount Pentelikon all the more powerful.

OF ALL THE INNOVATIONS introduced by the Parthenon, however, it is the extraordinary abundance of sculptural decoration that is most overwhelming. Nothing like it had been attempted before: two giant and lavishly adorned pediments, each bursting with dozens of larger-

than-life-size figures; a Doric frieze with an unprecedented ninety-two sculptured metopes wrapping around the entire exterior of the temple; and an astounding 160 meters (525 feet) of continuous sculptured frieze, set high on the cella wall within the peristyle. Visual pomposity was entirely of a piece with the aim of proving Athens supreme. But even more important, and just as we have seen on the great temples of the Archaic Acropolis, the Parthenon's sculptural program is steeped in genealogical narratives that beckon ever backward across imagined aeons. In an age without scriptures or media, this great billboard of the polis held up a constant reminder of just who the Athenians were and where they came from. It is precisely this projection of vast strata of time through monumental sculptures that made Athenian visual art so compelling to the Athenian mind. We cannot remotely understand the temple's ultimate significance, beyond its status as an exercise in formal perfection, without understanding the stories that these sculptures tell.

The Parthenon's east pediment gives us the very beginnings of Athenian genealogical history: the birth of Athena set in Hesiod's Golden Age. Its companion pediment at the west presents the birth of Athens itself, that is, the primeval contest between Athena and Poseidon for divine patronage of the city. This event is set during the reign of King Kekrops in the first Bronze Age. Just beneath Athena's birth scene we find in the east metopes the cosmic battle of the gods and the Giants. Of course, as the primary façade, or "front," of the Parthenon, this east end appropriately shows a profusion of divinities, both in the pediment and on the metopes. On the south and west flanks we find metopes that tell stories drawn from a slightly later era, the second Bronze Age, when the greatest of Athenian heroes, Theseus, battled the Amazons (west metopes) and the monstrous Centaurs (south metopes). Finally, the most consequential "boundary event" of the late Bronze Age—the Trojan War—is narrated across the north metopes. This saga was for the Greeks the ultimate marker between mythical and truly historic times.

When Pausanias visited the Parthenon six hundred years after it was built, he admired the sculptures filling the pediments as well as Pheidias's magisterial image of Athena housed within but made no mention of the metopes, the first of the figured decoration to be completed on the temple. Never before had this element—roughly square panels, which on the Doric friezes alternate with blocks marked with three vertical bars, called triglyphs—been carved with figured reliefs all around

an entire temple. To do this on the Parthenon (the largest of all Doric temples) meant fourteen figured panels on the east and west and thirty-two on the north and south. Perhaps surprisingly on a building of such exacting standards, these sculptures show an extraordinary range in style and execution, likely reflecting numbers of artists and apprentices on the job. Older sculptors, trained in the so-called Severe style of the 470s–450s B.C., might have looked back to the example of sculptured decoration on Zeus's temple at Olympia. But younger sculptors, inclined to look forward, experimented with innovative forms and compositions to create what has been called the high classical style. And so, among the Parthenon metopes, the sublimity of certain figures contrasts markedly with the awkwardness of others. This is especially true of the south metopes, depicting the battle of the Lapiths and the Centaurs; the variation in approach and competency is conspicuous (pages 100–101).

Manolis Korres's reconstruction of the northeast corner of the Parthenon brings to life the seamless integration of sculptures within the architectural frame (following page). A winged Nike alights on the rooftop, signaling the Parthenon's role as victory monument, an identity to which we shall return. One can only imagine the effect of Nikai akroteria "hovering" above each of the four corners, bringing airborne dynamism to the pulsing earthbound frame. (Meanwhile, the peaks of the gables were surmounted by floral akroteria showing akanthos leaves. See insert page 6, bottom.) Just below the Nike figure, rainwater would have gushed from the lion's-head spouts that drained the gutters, lending further movement and energy.[60] Spilling out from the narrowed corner of the pediment's frame, four vigorously modeled horse heads, nostrils flaring and mouths agape, are shown pulling against the bit. The horses draw the chariot of the setting Moon (Selene) as she sinks into the sea. And just beneath, we see a metope showing the Sun (Helios) driving his quadriga in the opposite direction, up from the watery depths. At lower right, two small fish jump among the waves, and at left a small duck skims the water. Bright painted colors and bronze attachments would have further animated the figures populating this densely imagined universe. Metal wings would have spread from Helios's team, while a bronze harness yoked them to the chariot. Helios himself would have been crowned with a bronze sunburst, while a solar disk might have hung in the space above.[61]

The god's arrival signals the dawn of the day on which the cosmic

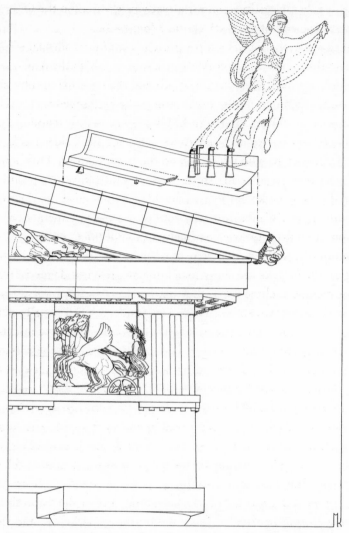

Reconstruction drawing of northeast cornice of Parthenon with Nike akroterion, horses from Selene's chariot in pediment, and Helios metope, by M. Korres.

battle of the Gigantomachy was fought. Gods and Giants can be seen raging on the thirteen other picture panels across this façade, but the condition of these east metopes is so poor that only the barest outline of figures can be made out. Nonetheless, we can distinguish Hermes, Dionysos, Ares, Athena, Eros, Zeus, Poseidon, and other Olympians taking

on the deadly Giants in a contest already celebrated on the Old Athena Temple at the end of the sixth century (page 66).

Meanwhile, the south metopes present a conflict from a later moment of the mythical past, the second Bronze Age, in which the Athenian hero Theseus helps his friend Peirithoös (king of the Lapiths) in subduing the monstrous Centaurs. A fight breaks out at the king's wedding feast when the Lapiths' neighbors, half man/half horse, get wildly drunk (inexperienced imbibers as they are) and attack the bride and bridesmaids as well as the Lapith men, who try to defend the ladies' honor. This boundary event was very popular in Greek architectural sculpture, prominently featured (two decades earlier) on the west pediment of the Zeus temple at Olympia. The Centauromachy serves as a rousing metaphor for the triumph of civilization over barbarism, of order over chaos, just as the Gigantomachy and Titanomachy of earlier ages do.[62] On the Parthenon metopes, the Greeks are shown wielding swords and daggers (accentuated by metal attachments) as they battle the savage Centaurs, who fight back with water jars and barbecue spits, indeed, with their bare hands and hooves. Vibrant paint and a full array of bronze attachments (helmets, crowns, and weapons) lent flash and definition to the carvings.

For much of this understanding, we are indebted to Charles François Olier, the Marquis de Nointel (French ambassador to the Ottoman court from 1670 to 1679), and his team of artists who drew these metopes, and the rest of the Parthenon sculptures, during their visit to the Acropolis in 1674. Just eleven years later, Venetian cannon fire would blow the temple apart, destroying much of what the marquis had seen. The careful crayon drawings that remain, sketched looking up from ground level, are regularly attributed to a single member of the team, the Flemish artist Jacques Carrey. In fact, we do not know the exact identity of this hand, and many scholars prefer to call him the Nointel Artist or "l'Anonyme de Nointel."[63]

When the seventeenth-century drawings are integrated with photographs of the surviving south metopes (all in the British Museum except one left behind by Elgin at the southwest corner of the Parthenon), a full range of forms and subject matter becomes apparent (following pages).[64] The compositions of the easternmost of the south metopes (29–32) reveal the telltale awkwardness in the rendering of figures in relation to one another. Greek warriors look staged, their stiff poses lacking har-

mony and grace: hopping on one foot, facing the viewer while harmlessly pinching a Centaur's chest, pulling at a Centaur's ear (?). The Centaurs are equally clumsy: grabbing an unwieldy Lapith woman in awkward abduction, and reduced to hair pulling and throat grabbing in fighting the Lapith men. But when we turn to the adjacent metopes (27–28), we see a whole different level of sophistication and competency in the harmonious integration of elegant figures into the compositional whole. Even the Centaurs look noble. This disparity in style and execution has led some to believe that the "old-fashioned" metopes had been carved for an earlier building altogether and simply reused here. Rhys Carpenter

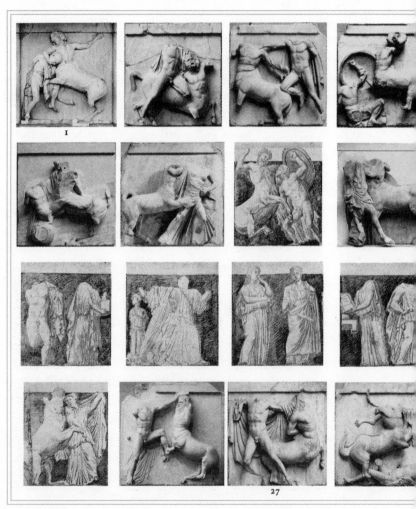

Battle of the Lapiths and Centaurs, south metopes, Parthenon.

maintained that those "behind the times" panels were carved for a Kimonian Parthenon, planned and prepared in the 460s but never realized (hence the similarity to decorations at the temple of Zeus at Olympia).[65] He and others have pointed to the fact that more than half of the south metopes have had one or both end surfaces cropped to make the slabs about 5 centimeters (2 inches) narrower. Indeed, on four metopes the borders have been shaved so much as to snip the tails of two Centaurs, as well as Lapith drapery and other relief details. All this suggests that some of the south metopes had to be reduced in size to fit here.

And then there is the baffling question of the nine metopes in the

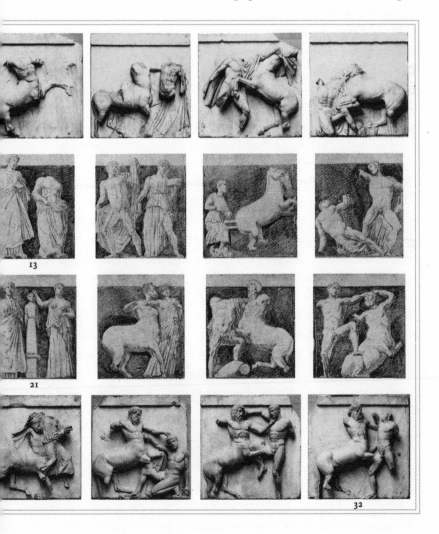

very center of the south side (13–21, known only through the Nointel drawings) that lack Centaurs altogether (previous pages). These show women taking refuge at a cult statue, Helios driving his chariot (?), women with some item of furniture (a loom or bed?), dancing figures, and other images that seem strange within the context of the Centauromachy. Scholars have offered various speculative interpretations, some assigning these panels to the Lapith wedding feast preceding the drunken brawl, others arguing for wholly unrelated subject matter, such as the myth of Daidalos.[66]

All this suggests a number of changes to the design and decoration of the Parthenon in the course of its construction. Manolis Korres has now established that the Ionic frieze within the Parthenon's colonnade originally extended all the way around the front porch. He has reiterated Dörpfeld's view that the original plan called for this inner frieze to be Doric (one of alternating triglyphs and metopes, just as we see on the exterior of the Parthenon).[67] The regulae and guttae (a band with truncated cone ornaments, which typically appear under triglyphs) visible just beneath the Parthenon frieze represent preparations already in place when, for whatever reason, a change was ordered calling for an Ionic frieze instead. This view has been challenged, but it remains clear that decisions were reversed and altered while the Parthenon was being built, perhaps reflecting democratic deliberation.[68] Certainly the Parthenon is not the vision of a single genius, and there was lively discussion and debate in the citizen assembly, if only because every expense had to be approved. But the possibility of a decision to replace a planned Doric frieze with a continuous narrative band, one that would achieve such renown as to be eventually known simply as *the* Parthenon frieze, merits close attention. For as we shall see in the next chapters, it is this frieze— whose claim to being the greatest masterpiece in all of Greek art is so strong but whose meaning has remained so obscure—that articulates the most startling of all the Parthenon narratives. It is this frieze that is at the heart of the temple's ultimate meaning.

THE WEST METOPES (so badly damaged one can barely make them out) present yet another of Theseus's exploits, the battle of the Greeks and the Amazons. This conflict was provoked by Theseus's abduction of the Amazon queen, Antiope, whom he carried off from north-central

Anatolia to Athens and married. Enraged, her tribe of warrior women stormed all the way from the southeast corner of the Black Sea to wage war with the Athenians. By some accounts, the Amazon siege of the Acropolis was launched from a camp they set up on the Areopagus Hill, just as the Persians will do in historical times. The west metopes show mounted Amazons furiously battling (and killing) Greeks.[69] But, once again, there emerges a tale of civilized Hellenes defeating exotic "others," in this case, savage fighting women from the East, a thinly veiled reference to the Athenian triumph over the Persians.

The north metopes present yet another parable of triumph over eastern exotics, in that greatest boundary event at the end of the Bronze Age: the Trojan War. Once again, we find Helios driving his chariot, here, appropriately in the easternmost panel, just around the corner from the Helios metope of the temple's east façade, where the morning light would first strike the Parthenon. The north metopes have suffered greatly, but one can make out a sequence of events from the night Troy fell: the Moon's chariot setting into the sea; men at the stern of a ship; Menelaos, who led the Spartans, drawing his sword as he approaches his unfaithful wife, Helen, who has taken refuge at the statue of Athena; Aphrodite (little Eros upon her shoulder) persuading Menelaos to spare his wife; Anchises, Aeneas, and Ascanios escaping from Troy; while Athena, Zeus, and other Olympians play their parts.

WERE IT NOT FOR Pausanias's telling us that the east pediment shows the birth of Athena, we would never have guessed it from the few surviving figures. Most of the pediment was dismantled long ago, some of it as early as the fifth century A.D., when the Parthenon was transformed into a church. This required the addition of an apse, which extended through the center of the east façade, interfering with the sculptured pediment and frieze (page 337). The Nointel drawings show the gable's condition in the seventeenth century with only its corner figures in situ (insert page 5, left). These, of course, would later be taken by Elgin, except for a draped female figure (Hera?) and a male torso (Hephaistos?), which were later discovered among the Acropolis stones.

Two powerful chariot groups frame the pediment as the rising Sun (Helios) drives his quadriga up from the waters at the south corner and the setting Moon (Selene) steers her horses into the sea at the north.

These personifications effectively demarcate Athena's birthday, setting it in the remote past of Hesiod's Golden Age. The upper torso of Helios and the heads of his horses emerge from a tempestuous sea, whose choppy waves can be seen atop the plinth from which they arise. The imagery gives palpable form to the *First Homeric Hymn to Athena,* which describes the moment of her birth: "A fearsome tremor went through Great Olympos from the power of the Steely-eyed one [Athena], the earth resounded terribly round about, and the sea heaved in a confusion of swirling waves. But suddenly the main was held in check, and Hyperion's splendid son [Helios] halted his swift-footed steeds for a long time, until the maiden, Pallas Athena, took off the godlike armor from her immortal shoulders, and wise Zeus rejoiced."[70]

The prominence of celestial bodies in the Parthenon sculptures is striking. We have already witnessed the arrival of Helios in the Gigantomachy metopes of the east façade, and we have noted both Helios and Selene in the metopes at the north, marking the day of the fall of Troy. Now, on the great east gable, we see the pair prominently featured, and we shall see them once again, on the base of Athena's statue within the Parthenon's cella (insert page 7, bottom).[71] These multiple appearances of Sun and Moon reinforce a cosmic awareness already expressed on the Archaic Acropolis: the unity of the celestial and the terrestrial, from which the city's greatest mythological narratives were conceived.

The very center of the pediment, where we should find the culminating moment of Athena's birth, is forever lost (insert page 5, left). We might imagine it showed something like what is described in the *Homeric Hymn to Athena:* "Of Pallas Athena, glorious goddess, first I sing, the steely-eyed, resourceful one with implacable heart, the reverend virgin, city-savior, doughty one, Tritogeneia, to whom wise Zeus himself gave birth out of his august head, in battle armor of shining gold: all the immortals watched in awe, as before Zeus the goat-rider she sprang quickly down from his immortal head with a brandish of her sharp javelin."[72] While the birth of Athena is represented in vase paintings of the sixth and fifth centuries, the east pediment of the Parthenon marks its first appearance in architectural sculpture. Based on images from vases, we might expect to find an enthroned Zeus beside Athena (as a full-grown adult in full armor) at the center of the composition, flanked by Hephaistos holding the ax that cracked Zeus's throbbing head and induced the birth. Poseidon, Hermes, and Hera might be standing by, and certainly one or both

of the twin goddesses of childbirth, the Eileithyiai, who are regularly shown assisting in the "labor." Many reconstructions have been hypothesized across the years, but, truth be told, we simply cannot know how the central (missing) figures were arranged.[73]

What does survive of the east pediment are four figures from the south side and three from the north, flanked at the corners by the chariots of the Sun and Moon (insert page 5, left). The reclining male (just to the right of Helios's horses) has been identified on the basis of the feline skin on which he sits as either Dionysos (if a panther) or Herakles (if a lion). Both god and hero are known in Greek art to assume the recumbent pose of a banqueter; indeed, both are often shown lifting a cup as this figure on the east pediment seems to do. Since he looks away from the central action and down in the direction of the Theater of Dionysos on the Acropolis's south slope, most interpreters identify him as the god of theater, attending the birth of Athena but distracted by his own cult place below.

Dionysos also turns his back on a pair of female goddesses, Demeter and Kore, who sit upon boxes that surely represent the *kistai,* containers holding the "sacred things" used in the Eleusinian Mysteries. Kore (figure E), at left, wraps her arm lovingly around her mother, Demeter (figure F). To their right, a goddess rushes toward the center of the action, her arms raised high (figure G). This is likely Hekate, goddess of the night, lifting her torches, which would make for a cohesive group of interrelated chthonic deities here at the southern corner.

Turning to the north side of the pediment, we find a comparable group: three female figures, the standout being a spectacularly voluptuous woman (figure M) shown collapsing into the arms of a companion (figure L) who holds her from behind (following page and insert page 5, left). The two figures are carved from a single piece of marble and rest together upon a low couch. It is no wonder that the sultry woman has been identified as that most erotic of female divinities, Aphrodite. Diaphanous drapery reveals the fullness of her body as "ribbons" of delicate fabric frame her swelling breasts and abdomen, with great swaths of cloth swirling about her legs. The goddess's chiton slips to reveal her soft right shoulder, while the transparency of the fabric at her breasts allows the areolae to show through.

Interpreters have long debated the identity of Aphrodite's two companions. Most see her mother, Dione, in the woman (figure L) who supports her from behind, though others have suggested Artemis, Peitho

(Persuasion), Themis (Justice), one of the goddesses of the seasons (Horai), or one of the Hesperides. The woman (figure K) who sits on a rock, just behind the pair, has been identified as Hestia (goddess of the hearth), Leto, Amphitrite, one of the goddesses of the seasons (Horae), or one of the Hesperides. This range of opinion makes plain that we really do not know who these women are.[74] In any case, the possible contenders include characters hardly prominent within the ranks of the Olympians who might have witnessed the birth.

It must be acknowledged that this composition is strange; never before had Aphrodite been shown in the lap of a woman, and no subsequent instance is known. The low bed on which the voluptuary collapses in so many ways evokes the birthing couches depicted in Cypriot stone sculpture and, closer to home, on Attic grave reliefs.[75] The attendant who holds her from behind assumes the standard pose of midwife. Taken as a pair, the two women with Aphrodite could be seen as the Eileithyiai, the goddesses of childbirth (who are always present at the birth of Athena). One is known as "she who delays," the other as "she who urges" the moment of birth. Indeed, they are suitably arranged to perform this function for the blooming, reclining one. And so we could propose (though purely speculatively) that "Aphrodite" is, actually, Metis, consort of Zeus and mother of Athena. Though she does not physically give birth to the goddess, she appears figuratively post

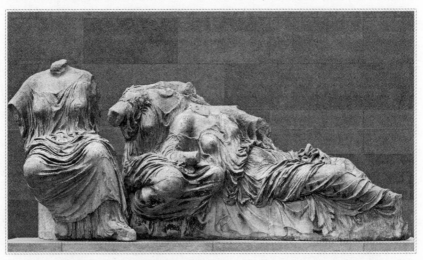

East pediment, voluptuous female figure reclines on a low couch, attended by two women (figures K, L, and M).

labor. For the genealogical sense of the scene requires that she be present. After all, this goddess of cunning intelligence must pass on these faculties to her daughter, the goddess of wisdom.[76]

The west façade of the Parthenon, and the twenty-five larger-than-life figures that fill its gable, would have been the first sight to confront worshippers emerging from the Acropolis gateway and entering the sacred space (insert page 5, right). This first impression manifests on a grand scale the common genealogy of the Athenian people, that which made their supremacy possible. We see the primeval contest of Athena and Poseidon for patronage of the city as witnessed by the ancestral royal families of the Athenian Bronze Age. The gable suffered greatly in the Venetian cannon fire of 1687, and also from the Venetian commander General Morosini, who, the following year, attempted to pull down the images of Athena and Poseidon, only to shatter them upon the ground. More than a century later, Lord Elgin would pick up some of the pieces and carry them off. But other bits were left lying on the Acropolis, and so today the magisterial figures of Athena and Poseidon remain divided between the British Museum in London and the Acropolis Museum in Athens.

One can hardly imagine a more fitting commemoration of Athena's victory over Poseidon than the thrilling composition at the very center of the gable, where god and goddess meet in the heat of the contest.[77] Thanks to the Nointel Artist, and derivative images from Greek vase paintings, we have a good idea of the original disposition of the figures in a dynamic V shape.[78] The divine contestants have arrived on the Acropolis, Athena's chariot driven by Nike (foretelling her victory) and Poseidon's by a female figure who must be his wife, the Nereid Amphitrite.[79] Athena's right arm is raised high as she hurls her spear into the Acropolis rock, whence springs her olive tree. Though no tree is preserved among the pedimental fragments, fourth-century vase painting, clearly inspired by this image, shows an olive sprouting between Athena and Poseidon.[80] The sea god, in turn, hurls his trident into the bedrock. Whether we are witnessing the sea spring bursting forth or the subsequent earthquake and deluge that the disgruntled Poseidon unleashed is difficult to know. What is clear is that this bombastic central composition could not have failed to seize the attention of anyone entering the Acropolis.

Relics from the contest of Athena and Poseidon are not only described

in literature but preserved in material remains on the Acropolis itself.[81] Apollodoros tells us that Athena planted her olive tree in the sanctuary of Pandrosos, which lay just beside the Erechtheion; Pausanias saw the tree growing near the north porch, where a modern incarnation of the olive grows today (below).[82] And he tells us that on the day following the Persian sack of the Acropolis, Athena's tree sprouted a new branch four feet long, signaling that Athens would be reborn. Over the years, invading enemies attempted to cut the olive down, but a sprig was always saved for replanting, and the tree always grew back. Shoots from the original were carried out to the Academy and planted in the protected grove that remained ever sacred to Athena. Indeed, it was oil from these trees that filled the amphorae awarded victors at the Panathenaic Games.

Poseidon's gift of a sea spring was heard by Pausanias, roaring from its cistern beneath the Erechtheion, in a din of crashing waves that

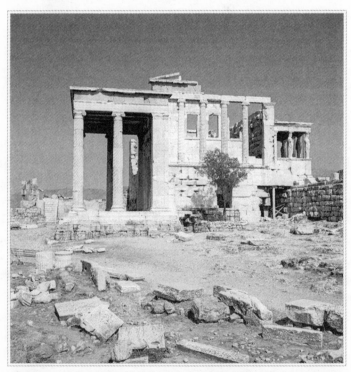

Erechtheion, from west, showing olive tree of Athena replanted by the American School of Classical Studies at Athens in 1952. © Robert A. McCabe, 1954–55.

Aperture in ceiling of north porch, Erechtheion,
Athenian Acropolis.

kicked up whenever a south wind blew. And with his own eyes the trav-
eler saw three holes piercing the Acropolis rock, where Poseidon had
hurled his mighty trident, a witness also borne by Strabo.[83] To this day,
one can see a three-pronged indentation in the bedrock beneath the
Erechtheion's north porch, visible through an opening deliberately cut
through the floor.[84] High in the ceiling, directly above, is an aperture
cut through the coffer blocks giving direct access to the sky (above).
Thus, the trajectory of Poseidon's trident was left unbroken when the
temple was built upon the very spot where the god's spear pierced the
earth, the trident marks and sea spring giving, as Pausanias tells it, "evi-
dence in support of Poseidon's claim upon the land."[85]

Returning to the west pediment (insert page 5, right), we find the
messenger gods Hermes (behind Athena) and Iris (behind Poseidon)
rushing to bring word of the outcome of the contest. Iris, the rainbow

goddess of sea and air, would have hovered slightly, her feet just off the ground, her diaphanous dress windswept to reveal the swelling form of her lovely body. She is the very essence of the ephemeral rainbow, a cosmic phenomenon that witnessed the very beginnings of Athens.

Similarly, watery depths are conjured, just as on the Archaic Acropolis, by a plethora of marine serpents and slithering snakes. In the Nointel drawing, a male torso, probably that of a Triton, can be made out rising from the pediment floor to support the outermost of Athena's horses. And beneath Poseidon's chariot, we find a similar Triton buoying up a yoked horse, his finned and snaky tail curling up from the watery depths. We see, too, a wonderful-looking *ketos*—a vicious sea beast with porcine snout and huge, deadly teeth—skimming the water's surface while supporting the left foot of Amphitrite as she drives the chariot. Together with the snake lurking by Kekrops's leg (page 112), and that which probably circled Athena's olive tree, these creatures manifest a contrast of earth and water embodied in Athena and Poseidon themselves.

The corners of the west pediment are inhabited by figures that have long been identified as the great rivers of Athens, the Kephisos, Ilissos, and Eridanos.[86] This interpretation conforms with the east pediment of Zeus's temple at Olympia, where the two local rivers, the Alpheios and the Kladeos, lie in the corners of the gable, as Pausanias confirms during his visit.[87] The river gods on the Parthenon similarly serve to establish the topographical coordinates of the contest on the Athenian Acropolis. The grand Kephisos is shown at the very north (or left) side (facing page), lying beside its younger tributary, the Eridanos, known from the Nointel drawings. At the opposite (south) end of the gable the Ilissos kneels just beside a female figure that is the spring of Kallirrhöe (insert page 5, right) in another topographically correct arrangement.

But the river gods of the west pediment serve a purpose far beyond spatial orientation; indeed, they are integral to the genealogical message of the sculptural program as a whole. The Kephisos River was the father of the naiad nymph Praxithea, who married King Erechtheus and became queen of Athens and mother to a generation of royal daughters. And so the presence of the Kephisos here further validates the Athenian claim upon the land of Attica: not only are Athenians autochthonous, descendants of the gegenic Kekrops and Erechtheus/Erichthonios, but on the maternal line they are descended from Athens's greatest river.

There is little consensus about the figures that fill out the rest of the

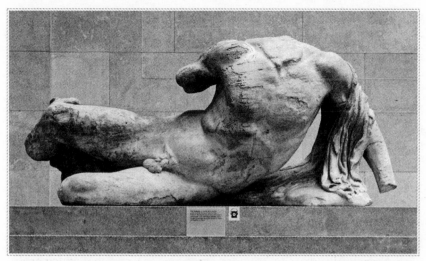

Kephisos River, west pediment, Parthenon.

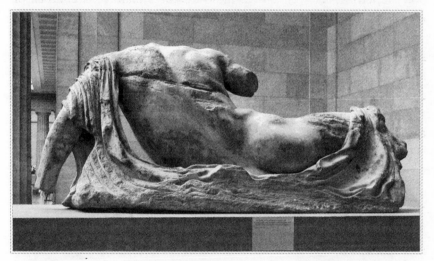

Kephisos River, west pediment, Parthenon.

gable.[88] Barbette Spaeth suggests that at left (north side) are the descendants of the Athenian royal house while at right (south side) are the dynastic family of Eleusis.[89] And so the descendants of Athena inhabit the space behind her while the offspring of Poseidon crowd the space behind him. This would be wholly in keeping with the larger genealogical project of architectural sculpture seen on the Acropolis from the Archaic period on.

Athena's victory was not the end of the contest exactly. Poseidon's

son Eumolpos carries on his father's bid for Athens, rallying an army of Thracians to take the city. In the ensuing battle, Erechtheus kills Eumolpos's son Himmarados before he himself is killed by Poseidon. Thus, the primeval clash is carried on through the generations that follow. This foundation myth may, in fact, speak to the ancient tensions between Athens and Eleusis during the historical period. It is through cult ritual that this conflict is resolved, and so the west pediment presents the origins of cult practice within the sanctuaries of Athena Polias at Athens and of Demeter and Kore at Eleusis. Eumolpos plays a pivotal role in founding the Eleusinian Mysteries, serving as one of the first priests of Demeter and Kore. A clan named the Eumolpidai held the special privilege of providing Eleusinian priests throughout the historical period.

Kekrops, father of the Athenian royal line, is, as we've said, king during the contest between Athena and Poseidon. At the north side of the pediment we find him kneeling, a snaky coil beneath his left knee signaling his earthborn origins (below). Wrapping her arm around her father from behind is one of his three daughters, probably Pandrosos. Her two sisters, Aglauros and Herse, sit farther to the right, as known only from the Nointel drawings. The crayon sketches (insert page 5, right)

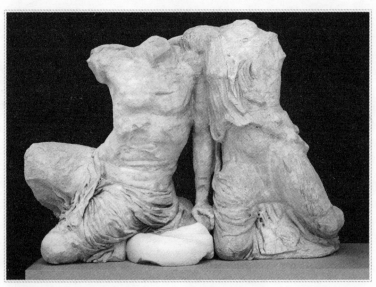

Kekrops and Pandrosos, west pediment, Parthenon.

also show a young boy leaning across their laps, no doubt Erechtheus/ Erichthonios, who came into their care following his gegenic birth.

At the opposite end of the gable we find a parallel arrangement for the royal house of Eleusis.[90] Here, we see Queen Metaneira, wife of King Keleos, with her three daughters, said to be named Diogeneia, Pammerope, and Saisara.[91] And here, too, we find a young boy stretched across the laps of the maidens, no doubt the child Triptolemos, who was looked after by the Eleusinian princesses just as Erichthonios was by the daughters of Kekrops. And so, we observe a perfect genealogical symmetry, with two sets of three royal daughters, one at Athens and the other at Eleusis, each set with a boy to nurse. And just as the daughters of Kekrops perform special rites for their local goddess, Athena, so, too, the daughters of Keleos perform sacred offices for Demeter and Kore in the Eleusinian Mysteries.[92] Religious practice of the historical period is thus explained through the charter myths of the ancestors, the founders of the cults that survive for nearly a thousand years at Athens and Eleusis.

IT BECOMES APPARENT that we cannot understand the Parthenon or the Athenians themselves outside the sphere of religion. This is true of the birth of democracy, too. Indeed, the novelty of democratic rule would not have been conceivable without the intense awareness of the common bond forged by shared genealogy as fostered by religion. The nexus between the cosmology that defined Athenian consciousness and the unique civic life that these people created for themselves is not only revealed but exalted in that epitome of Athenian self-awareness, the Parthenon. To this extent the Parthenon celebrates democracy, but not on the terms that have been suggested since the Enlightenment. And perhaps not even on the terms that obtained in Athens by the age of Perikles.

When we marvel today at the extraordinary triumph of engineering, architecture, and aesthetics that endures on the Sacred Rock, it is hard to fathom that anyone could have opposed its creation in the first place. But Plutarch tells us it was this more than any other of Perikles's endeavors that his enemies maligned and slandered. In the assembly, they shouted that Athens had lost its good name in the disgraceful transfer

of the common fund from Delos to the Acropolis. "The Greeks regard it as outrageously arrogant treatment, as blatant tyranny, when they can see that we are using the funds they were forced to contribute for the military defence of Greece," critics cried.[93] Indeed Perikles's excuse about safeguarding the treasure was only a ruse to spend it on his own extravagant enterprise. Squandering the compulsory contributions of the confederation, Perikles and his supporters were now, it was charged, "gilding and decorating the city, which like a wanton woman, adds to her wardrobe precious stones and costly statues and temples worth their millions."[94] The Athenian Empire was not only flexing its muscles but covering them in purple.

Not that the effort lacked admirers. Plutarch, for his part, could only marvel at how such magnificence and permanence of construction had been wrought so fast.

> This is what makes Perikles' works even more impressive, because they have durability despite having been completed quickly. In terms of beauty each of them was a classic straight away at the time, but in terms of vigour each is a new and recent creation even today; and so a kind of freshness forms a constant bloom on them and keeps their appearance untouched by time, as if they contained an evergreen spirit and an unaging soul mingled together.
>
> Plutarch, *Life of Perikles* 13[95]

But it is Thucydides who has the final word, looking into the future with uncommon prescience. He foresaw that the marble summit of the Acropolis would live on through the ages, giving the impression that the Athenians were even greater than they were. The lasting spectacle of its soaring marble, exquisitely hewn, would, in future, eclipse any of rival Sparta's achievements:

> For if the city of Lakedaimon [Sparta] were to become desolate and nothing of it left but temples and foundations of buildings, I think as time went by future generations would believe her fame to be greater than her power was. And yet, the Spartans occupy two-fifths of the Peloponnese and lead the alliance, not to speak of their numerous partners abroad. Still, as their city is scattered near and far and lacks magnificent temples and public buildings, spread out as it is in vil-

lages after the old fashion of Hellas, their power will seem inferior. But if the same things happen to Athens, one will think by the sight of their city, that their power was double what it is.

Thucydides, *Peloponnesian War* 1.10.2[96]

Thus, over the course of the fifth century, a new Athenian identity emerges, one carefully constructed to glorify Athens and incite fear in the hearts of its enemies. The trappings (and overreach) of empire continued to bloat Athenian self-regard.[97] Still, it must be said that the picture that Athens consistently projected of itself—in funeral orations, speeches in the law courts, dramatic performances, and the sculptures of the Parthenon—stands in contrast to the self-image expressed by other cities. We continually hear from the Athenians about their exceptionalism, how they are resilient, persistent, competitive, aggressive, quick but thoughtful in action, innovative, aesthetically aware, and open to engaging outsiders on the world stage. And many non-Athenians accepted this characterization. Perhaps no words capture it more powerfully than those Thucydides attributes to the Corinthian envoys who addressed the first Spartan congress in 432 B.C.

On the eve of the Peloponnesian War, the Spartans summoned members of the Peloponnesian League (especially those with grievances toward Athens) to testify before the Spartan assembly. The Corinthians were gravely worried by the Athenians' alliance with their former colony, now enemy, Kerkyra (Corfu), a pact signed in 432 B.C. amid the Corinth-Kerkyra War. Combining its great naval might with Kerkyra's (as well as with that of Rhegium in southern Italy and Leontini in Sicily, according to alliances forged in 433/432), Athens would soon be in a position to threaten trade routes, especially those that carried shipments of grain from the west. This was of critical concern to all Peloponnesians, especially to the landlocked Spartans, whom the Corinthians considered far too complacent for their own good. The ambassadors stressed the growing cause for alarm and pulled no punches in contrasting the natures of the Athenian and the Spartan peoples:

> You have never considered what manner of men are these Athenians
> with whom you will have to fight, and how utterly unlike yourselves.
> They are revolutionary, equally quick in the conception and in the
> execution of every new plan; while you are conservative—careful

only to keep what you have, originating nothing, and not acting even when action is most urgent. They are bold beyond their strength; they run risks which prudence would condemn; and in the midst of misfortune they are full of hope.

... They are impetuous, and you are dilatory; they are always abroad, and you are always at home. For they hope to gain something by leaving their homes; but you are afraid that any new enterprise may imperil what you have already. When conquerors, they pursue their victory to the utmost; when defeated, they fall back the least. Their bodies they devote to their country as though they belonged to other men; their true self is their mind, which is most truly their own when employed in her service.

Thucydides, *Peloponnesian War* 1.3.70–71[98]

One can only imagine the emotional effect of such a speech on the Spartans who listened.[99] As Josiah Ober has shown, Spartan culture had long aimed to instill a deep-seated code of conduct among its soldier citizens. Behavior contrary to its norms was simply unthinkable under Sparta's military oligarchy. As we have seen, Athens, too, had a code of sorts, one well summarized by the words Thucydides attributes to the Corinthians: "Their bodies they devote to their country as though they belonged to other men; their true self is their mind, which is most truly their own when employed in her service." It was this delicate balance of individualism and the polis, the citizen's utter devotion, uncompelled, to its good, that made Athens unique, even before its radical democracy, which perforce created certain possibilities and dynamisms other political systems could not sustain. Of course, Thucydides is writing as an Athenian and as one of Perikles's greatest admirers. But whether these words truly came from Corinthian lips or no, there is a truth to them.

Nowhere is this belief more powerfully expressed than in that most famous of Greek orations, the eulogy Perikles delivered in the autumn of 431 at the end of the first season of the Peloponnesian War. Just a year after the Corinthians' address to the Spartan assembly, war had indeed broken out as feared, and now Perikles stood in the public cemetery (*demosion sema,* page 9) addressing the families of the fallen and the citizenry as a whole. This is what Thucydides tells us he said, honoring the first Athenians to die:

I will speak first of our ancestors, for it is right and seemly that now, when we are lamenting the dead, a tribute should be paid to their memory. There has never been a time when they did not inhabit this land, which by their valour they have handed down from generation to generation, and we have received from them a free state.

Thucydides, *Peloponnesian War* 2.36.1[100]

Perikles goes on to praise Athens as the best city in all of Greece, attributing its preeminence to its status as a global center. Panhellenism had long been a feature of aristocratic life, but Athens (and Perikles) had awakened all citizens, rich and poor alike, to its virtues. Free trade and a vibrant network of international partners benefited all Athenians:

Because of the greatness of our city, the fruits of the whole earth flow in upon us; so that we enjoy the goods of other countries as freely as of our own.

Thucydides, *Peloponnesian War* 2.38.2[101]

Perikles takes this opportunity to respond to critics of his lavish building program, no doubt gesturing toward his gleaming Acropolis overhead. Yes, imperialism had created the wealth necessary to bring together the genius of gifted artists, architects, and artisans and to pay for the sumptuous materials. But this effort made Athens beautiful for all citizens— both the elite and the masses. Perikles makes no excuses for the desire to be surrounded by beautiful things; indeed, with a true populist's instinct, he deems it shameful *not* to strive against poverty.

For we are lovers of the beautiful, yet simple in our tastes, we cultivate the mind without loss of manliness. To avow poverty with us is no disgrace; the true disgrace is in doing nothing to avoid it.

Thucydides, *Peloponnesian War* 2.40[102]

Perikles ends his oration by extolling the superiority of Athenians, who, alone among the Greeks, created a society that others wished to imitate:

We do not copy our neighbors, but are an example to them.
. . .
I say that Athens is the school of Hellas, and that the individual Athe-

nian in his own person seems to have the power of adapting himself to the most varied forms of action with the utmost versatility and grace.

Thucydides, *Peloponnesian War* 2.37.1 and 2.41.1[103]

Of course, as has often been noted, Perikles was speaking only of free male citizens, who gained access to the privileges of democracy as their birthright. All citizens were equal, but others were not equal to them before the law: women, resident aliens, and slaves were excluded. And those living under the yoke of Athenian imperialism would have quarreled with this rosy picture. But even if the Athenian self-understanding was inflated and (somewhat) self-deceiving, its virtues were nevertheless unique. "The power of adapting himself to the most varied forms of action with the utmost versatility and grace": it was something the citizens of no other city or nation could claim. But like any good ever imagined, it would find its way to wretched excess.

Perikles would be dead within two years but not before suffering the loss of his sister and both his legitimate sons, Xanthippos and Paralos, to the epidemic that swept Athens in three deadly waves between 430 and 426 B.C. The plague arrived in the second year of the Peloponnesian War and overwhelmed the densely populated city, its masses huddled behind the defensive walls. One Athenian in three perished. The proud Perikles was reduced to going before the citizen assembly to plead for an exception to the citizenship law he himself put forth with great fanfare twenty years earlier. In what some critics saw as "punishment for his haughtiness and arrogance," Perikles begged his people to accept the lad known as Perikles the Younger, the leader's illegitimate son by his foreign mistress, Aspasia, as an Athenian citizen and his legitimate heir. This they did for him. But the younger Perikles would later know the full wrath of the democracy in a way his father never had. Along with five other strategoi, he was to be executed for his part in the failure to rescue a group of shipwrecked Athenians following the Battle of Arginusae (islands just to the east of Lesbos) in 406 B.C.

A HUNDRED YEARS ON, Athenian democracy was still alive, but the moment that produced the Parthenon was fast being eclipsed. As an indication of how things had changed, let us consider the story of the orator

Lykourgos and his condemnation of his fellow Athenian Leokrates, a drama that played out in the law courts of late classical Athens.

Lykourgos was among the most visible and upstanding of Athenians during the third quarter of the fourth century. A former pupil of Plato's, he came to power in 338 B.C. as steward of the financial administration, controlling the Athenian treasuries and wielding great power for the next twelve years. Lykourgos swiftly balanced the state budget by raising taxes on cargo passing through the port of Piraeus, increasing rents on leases of the silver mines at Laureion, and confiscating the assets of convicted criminals. He used his influence to persuade the wealthiest citizens to make large voluntary contributions (liturgies) to the state under a system known as euergetism ("good works").

And he did not neglect the legacy of Perikles, undertaking his own vast building program to refurbish fifth-century monuments that had fallen into disrepair. Under Lykourgos, Athens flourished financially, commercially, legislatively, and architecturally; traditional cults were strengthened and new gods introduced.[104] Lykourgos constructed a new temple of Apollo Patroos (the "Fatherly") in the heart of the Agora. He rebuilt, entirely of Pentelic marble, the Panathenaic stadium above the banks of the Ilissos, and the Theater of Dionysos on the south slope of the Acropolis, expanding it to seat some seventeen thousand viewers.[105] Just to the north of the Acropolis, Lykourgos refurbished the City Eleusinion and to the west, the Pnyx Hill, the meeting place of the citizen assembly. Beyond the city walls, the Lykeion was enhanced, a new arsenal was built in the Piraeus, and the sanctuaries of Demeter and Kore at Eleusis and of Amphiaraos at Oropos were refurbished.[106]

A member of the Eteoboutad clan, one of the oldest and most distinguished families of Athens, Lykourgos could claim descent from the eponymous Boutes, brother of King Erechtheus. In fact, Lykourgos probably served as priest of Poseidon-Erechtheus on the Acropolis; we know that his son Habron was allotted this hereditary priesthood, later ceding it to his brother Lykophron.[107] Wooden images of Lykourgos and his sons (carved by Timarchos and Kephisodotos, sons of the master sculptor Praxiteles) were set up within the Erechtheion itself, giving evidence of their close connection to the cult.[108] In the years following his death in 324 B.C., Lykourgos would be held up as a symbol of Athenian democracy, posthumously honored in 307/306 with the city's most

illustrious awards: his portrait set up in the Agora and his descendants entitled to eat for life at public expense in the Prytaneion (the seat of the executive officers of Athens).[109]

At the very heart of the Lykourgan agenda was a desire to educate the youth of Athens, to reinvigorate Perikles's vision of the city as the "School of Hellas."[110] The statesman placed new emphasis on the training of eighteen-year-old men who had begun their military service in the ephebic corps. Registered according to their demes (districts of the Attic countryside), the youths swore an oath of loyalty upon first receiving their new weapons within the sanctuary of Aglauros on the east slope of the Acropolis.[111] The ephebes were given a new pride of place within the religious and athletic life of Lykourgan Athens where they were now entrusted with providing equestrian escort for a host of sacred processions and featured heavily in the Panathenaic festival and competitions. They were also sent on topographical memory tours to holy places all across Attica and its borderlands so they might learn about their ancestors, local foundation myths, landscapes, and monuments. It was enhanced training for the noble life of the traditional Athenian citizen, one in which patriotism took center stage.[112] And it was the spirit of that life Lykourgos might have seen deteriorating before his eyes among his fellow citizens. In any case, when he invoked it in the court action against Leokrates in 330 B.C., his purpose was as much to provide Athenian youths with an object lesson in proper behavior as it was to do justice to a scoundrel.[113]

Leokrates had comported himself disgracefully eight years earlier, following the defeat of Athens by Philip II of Macedon at the Battle of Chaironeia. In the wake of this disaster, the Athenians passed a decree forbidding citizens or their families to leave the city. Leokrates flagrantly broke this law, fleeing to the island of Rhodes and, later, settling in the town of Megara, 43 kilometers (27 miles) northwest of Athens. Taking along his money, mistress, household goods, and business concerns, Leokrates placed self before city, violating the most sacred tenet of traditional Athenian civic life.[114]

When, after eight years, Leokrates returned to Athens, Lykourgos hit him with a sensational lawsuit. The charges were many and varied: treason, failure to protect the city's freedom, impiety vis-à-vis the sanctuaries he was sworn to defend, abandonment of his aged parents, and desertion for his refusal to serve in the armed forces. Most heinous of

all, Leokrates had broken the oath sworn as a young ephebe and binding for one's natural life. Lykourgos quotes the ephebic vow in his oration *Against Leokrates:*

> I will not bring dishonor on my sacred arms nor will I abandon my comrades wherever I shall be stationed. I will defend the rights of gods and men and will not leave my country smaller, when I die, but greater and better, so far as I am able by myself and with the help of all.
>
> Lykourgos, *Against Leokrates* 77[115]

In the courtroom Lykourgos would argue foremost that Leokrates had broken this solemn pledge, dishonoring the gods and sinning against the very homeland that had nurtured him to adulthood.

Lykourgos gave the court a rousing civics lesson: "The power that keeps our democracy together *is* the oath . . . For there are three things upon which the state is built: the archon, the juryman, and the private citizen. Each of these gives an oath as a pledge, and rightly so."[116] Lykourgos then cites the Oath of the Plataians, pledged by allied Greeks just before the Battle of Plataia in 479.[117] "It would be well for you to hear it," Lykourgos instructs, reading the oath in full:

> I will not hold life dearer than freedom, nor will I abandon my leaders whether they are alive or dead. I will bury all allies killed in the battle. If I conquer the barbarians in war, I will not destroy any of the cities which have fought for Greece but I will consecrate a tenth of all those which sided with the barbarian. I will not rebuild a single one of the shrines that the barbarians have destroyed but will allow them to remain for future generations as a memorial of the barbarians' impiety.
>
> Lykourgos, *Against Leokrates* 81[118]

Lykourgos reflects on what makes Athens so special, reiterating the Periklean vision of Athens: "The greatest virtue of your city is that she has set the Greeks an example of noble conduct. In age she surpasses every city, and in valor too our ancestors have no less surpassed their fellows."[119] Lykourgos then invokes the story of Kodros, which we considered in chapter 1, that stirring tale of how the last king of Athens gave

his life to save his city. When the Peloponnesians had suffered famine owing to crop failures, they marched north to Athens in search of fertile lands. Kodros knew from a Delphic prophecy that if the Dorians killed him, the people of Athens would be spared. And so the king, disguised as a peasant, bravely wandered out near the enemy camp and provoked a skirmish with its guards, who killed him. "Remember the reign of Kodros," Lykourgos implores. "Such was the nobility of the kings of old that they preferred to die for the safety of their subjects rather than to purchase life by the adoption of another country."[120]

Finally, Lykourgos turns to yet another exemplary tale of the ancestors, a story set in the late Bronze Age, when Eumolpos, son of Poseidon, led an army of Thracians to claim Attica for his own. The son, as we have seen, was attempting to avenge his father's loss in the contest with Athena for divine patronage of the city. In the late 420s the story was the subject of a play by Euripides, and though it has since been largely lost, it would have still been familiar to Lykourgos's audience. Erechtheus, king of Athens, seeks advice from the oracle at Delphi on how he might save Athens from this prodigious assault. The oracle's answer? Nothing less than the sacrifice of his own daughter will suffice. The king shares this shocking news with his wife, Praxithea, who answers with one of the most stirring and civic-minded speeches in all of Greek drama. "Listen carefully to the iambic lines, gentlemen, which in the play are spoken by the mother of the girl," Lykourgos instructs the jury. "You will find in them a greatness of spirit and a nobility worthy of Athens and a daughter of the Kephisos."[121]

The fifty-five lines from Euripides's *Erechtheus* that Lykourgos then speaks represent the longest quotation of any Greek play by an ancient orator. Queen Praxithea's horrific proposition manifests the most basic principles of Athenian patriotism: a conviction that Athens is better than all other cities; pride in the autochthonous origins of its people; devotion to the forefathers and their ancestral religion; the primacy over individual self-interest of the common good, toward which the citizen properly feels an overwhelming sense of love, duty, and honor; boldness and resilience; the ability to take quick action; and above all a readiness to die for one's country. Praxithea answers her husband without hesitation:

(1) Favors, when granted in a noble way, please people even more. When one acts, but acts slowly, this is less noble. I, then, will give

my daughter to be killed. I take many things into account. First, I could not find a better city than this one [Athens]. We are a people born from this land, not brought in from elsewhere. Other cities are founded as if by throws of the dice; (10) people are imported to them, different ones from different places. A person who moves from one city to another is like a peg badly fitted into a piece of wood: a citizen in name, but not in action.

Secondly, our very reason for bearing children is to protect the altars of the gods and our fatherland. The city as a whole has one name but many dwell in it. Is it right for me to destroy all these when it is possible for me to give one child to die on behalf of all? I can count and distinguish between things larger and smaller. (20) The ruin of one person's house is of less consequence and brings less grief than that of the whole city.

If our household had a harvest of sons in it, rather than daughters, and the flame of war were engulfing the city, would I not send my sons into battle with spears, fearing for their deaths? No, let me have daughters who can fight and stand out among men and not be mere figures raised in the city for no purpose. When mothers' tears send their children off to battle, many men become soft. (30) I hate women who choose life for their children rather than the common good, or urge cowardice. Sons, if they die in battle, share a common tomb with many others and equal glory. But my daughter will be awarded one crown all to herself when she dies on behalf of this city, and in doing so she will also save her mother, and you [Erechtheus], and her two sisters . . . are these things not rewards in themselves?

And so, I shall give this girl, who is not mine except through birth, to be sacrificed in defense of our land. (40) If this city is destroyed, what share in my children's lives will I then have? Is it not better that the whole be saved by one of us doing our part? . . . And as for the matter which most concerns the people at large, there is no-one, while I live and breathe, who will cast out the ancient holy laws of our forefathers. Nor will Eumolpos and his Thracian army ever—in place of the olive tree and golden Gorgon head—plant the trident on this city's foundations and crown it with garlands, thus dishonoring the worship of Pallas [Athena].

(50) Citizens, make use of the offspring of my labor pains, save yourselves, be victorious! Not for one life will I refuse to save our city.

O fatherland, I wish that all who dwell in you would love you as much
as I do! Then we would live in you untroubled and you would never
suffer any harm.

Lykourgos, *Against Leokrates* 100 =
Euripides, *Erechtheus* F 360 Kannicht[122]

What Praxithea does not know is that her daughters have already
sworn an oath of their own: if any one of them should die, so shall the
others.[123] The oath of Erechtheus's daughters is thus invoked by Lykour-
gos alongside the oath of the ephebes and that of the Greeks at Plataia.
It is all to remind the jurors that at the very core of the citizen's sacred
relationship to the state was the solemn act of oath taking, the very tie
that binds. In this, Lykourgos echoes the words of his teacher, Isokrates:
"First, venerate what relates to the gods, not only by performing sacri-
fices but also by fulfilling your oaths. Sacrifices are a sign of material
affluence, but abiding by oaths is evidence of a noble character."[124]

Finishing his long quotation from the *Erechtheus,* Lykourgos closes
his case: "On these verses, gentlemen, your fathers were brought up,"
emphasizing the centrality of Euripides's text in the traditional edu-
cation of Athenian youth.[125] He then asks the jurors to consider how
Queen Praxithea, against a mother's instinct, loved her country more
than her own children and was willing to give them in ultimate sacrifice
to save the city. Importantly, Praxithea acts quickly and, thus, nobly in
ensuring salvation for Athens.[126] If women can bring themselves to act
like this, Lykourgos declaims, then men (like Leokrates) "should show
toward their country a devotion which cannot be surpassed."[127] If all
citizens loved Athens as Praxithea did, it would flourish and remain
ever safe from harm. Leokrates doesn't love Athens, and so he must be
punished.

Lykourgos asserts that Athenians owe a debt to Euripides for pass-
ing this story down to them, thus providing a *paradeigma* ("fine exam-
ple") that citizens can keep before them to "implant in their hearts a
love of their city."[128] By no coincidence, this same word appears in the
Periklean funeral oration: Athens does not copy (*mimeitai*) other cities
but is a *paradeigma* to them. Lykourgos is doubtless recalling that great
moment of oratory.[129] But all these Lykourgan flourishes would not
achieve their intent: in the end, despite abundant evidence and exhor-
tation, the jury would acquit Leokrates by a single vote. The verdict

must have surely confirmed Lykourgos's worst fears about the hearts of his fellow citizens. For all he had done in his political life to uphold and reanimate the values that had made Athens great, here was painful evidence that at least for half of the citizenry the days when those values were truly inviolable were past. The good of Athens above all was sacred no more to the Athenians, the prospect of Macedonian domination after Chaironeia perhaps having finished a job that the radical democracy, with all its bountiful blandishments, had begun.

NEVERTHELESS, LYKOURGOS'S SPEECH *Against Leokrates* was not entirely in vain. Without it, we would know very little of Euripides's lost play or of the story of Erechtheus and the sacrifice of his daughters, a centrally important one for our purposes. As the great progenitor in whom the primordial past culminates and through whom the Athenians enter history, Erechtheus represents a kind of missing link, his place in the Parthenon's sweep of the ages unsuspected until recently. In fact, the family of Erechtheus can now be understood to stand at the very heart of the Parthenon sculptural program. This recognition will furnish the key to understanding the temple's most enigmatic and prominent imagery, and in so doing lead us to revise our most basic understanding of the building itself. It is the story of the magnanimity of the royal house of Erechtheus that brings so vividly to life that most essential conviction expressed by Perikles in his funeral oration: Athens is worth dying for. And it turns out that even as the once indelible principle was fading, someone saw fit to illustrate it for all time in the holiest of places.

4

THE ULTIMATE SACRIFICE

Founding Father, Mother, Daughters

THE YEAR WAS 1901. The site was Medinet Ghoran. Pierre Jouguet and his team of excavators set off across the Egyptian sands to the southwest of the Fayum oasis. Here, they would dig through the winter months, from January through March, efforts that were mightily repaid. The French team unearthed hundreds of mummies from a broad network of rock-cut tombs comprising a vast Hellenistic cemetery.[1] While the burials themselves were not particularly rich, the mummy casings would prove, some sixty years later, to be a treasure trove.

Those casings were not of gold or gilded wood, like Tutankhamen's coffin and those of other well-known Egyptian royalty. Rather, they were of papier-mâché. For more cost-conscious customers, morticians of Hellenistic Egypt used discarded scraps of papyrus, pasting them together over the linen wrappings of the dead. When it had dried and hardened, the resulting cartonnage could be plastered, painted, or even gilded to give the impression of a much finer material. This treatment is typical of burials of commoners during the last three centuries B.C., when Alexander the Great's Macedonian general Ptolemy I and his descendants ruled Egypt.

The ink on those paper scraps did not dissolve, and so together with

Pierre Jouguet contemplating a mummy casing. *La Revue du Caire* 13, no. 130 (1950).

the earthly remains, the texts that had originally been copied onto those papyri by scribes at Alexandria and elsewhere survived. More copies than ever intended: if a scribe made an error in his transcription, the whole sheet was discarded, only perfect copies being good enough for the libraries of the Hellenistic world. But as paper was precious, the abortive imperfect copies would be sent off to morticians for making coffins. And so Hellenistic Egyptian tombs and their mummy casings have become crucial sources for the recovery of lost and unknown texts.

Jouguet brought dozens of mummies back from the trenches of Medinet Ghoran for study at the Institutes of Papyrology in Paris and Lille (above). From these, he managed to extract a number of Greek and demotic Egyptian texts, though it proved difficult to separate the fragile papyrus layers without damaging them to the point of losing what had been written. This would remain the case until the early 1960s, when Professor André Bataille and Mlle Nicole Parichon of the Sorbonne's Institut de Papyrologie developed a new technique, first soaking the cartonnages in a 13 percent solution of hydrochloric acid, heated to 70 degrees Fahrenheit, and then placing them in a steam bath of 10 percent glycerin solution. This dissolved the glue and allowed individual sheets to be peeled apart, revealing lines of Greek not seen since the

third century B.C. The innovation caused something of a popular sensation, *Life* magazine (below) proclaiming in November 1963, "Secrets Cooked from a Mummy."[2]

In 1965, however, what might be viewed as the "curse of the mummy" struck.[3] Crossing a street in central Paris, Bataille was hit by a car and killed. But the papyrus fragments he had extracted back on September 19, 1962, had already created a buzz. Mummy casings 24 and 25 had yielded texts from a Greek comedy, the *Sikyonios* ("the man from Sikyon," a city in the Peloponnese not far from Corinth), together with the name of its author, Menander. Written in the late fourth or early third century B.C., the play was already known from 150 lines extracted from the mummies by Jouguet just a few years after their discovery.

Professor André Bataille and Mlle Nicole Parichon extracting the *Erechtheus* fragments from the mummy cartonnage. *Life,* November 15, 1963, 65.

Remarkably, the new additions belonged to the very same manuscript Jouguet had identified sixty years before, suggesting that a single papyrus scroll had been recycled across three different mummies!

Scholars of Greek comedy were energized. Among them was the young Colin Austin, a doctoral student at Christ Church, Oxford, just finishing his dissertation on the comic playwright Aristophanes. In the autumn of 1966, Austin traveled to Paris. He was welcomed by Jean Scherer, Bataille's successor at the Institut de Papyrologie at the Sorbonne. Scherer presented Austin with fragments of the *Sikyonios* for study, making clear that he had reserved for himself the rights of publication. He also produced additional fragments recovered from mummy casing 24, and considering these mere "scraps" compared with Menander's text, he generously offered them to the young scholar to publish.

Colin Austin's heart skipped a beat. In that instant, he had already recognized that these "scraps" contained lines from the long-lost play titled the *Erechtheus,* by one of the greatest of all Greek dramatists, Euripides.[4]

The existence of the *Erechtheus* had long been known from later authors who quote from it freely.[5] Far and away the longest quotation is the chunk of fifty-five lines we have seen Lykourgos use in his oration *Against Leokrates* delivered in 330 B.C., nearly a century after the *Erechtheus* was first performed, probably around 422 B.C.[6] Making his case against the traitor, Lykourgos hails the example of the eponymous king's daughters, who gave their lives to save Athens, and he quotes the patriotic speech of their mother, Queen Praxithea, who willingly acceded to sacrificing her progeny. But how does a Hellenistic papyrus text, literally buried until the early twentieth century and still unrecognized for another sixty years, transform our understanding of the world's most familiar building today? As much as anything, the answer reveals the improbably circuitous workings of the field of classics.

Colin Austin's knowledge of Greek was so expert that he instantly recognized in the Sorbonne papyrus the same play of Euripides that Lykourgos had quoted in his oration. To recover a more substantial portion of a major text was a coup that classicists dream of. But Austin kept a poker face. Thanking the professor, he went straight home, over the moon at his good fortune.

Austin dispatched his duties in record time, transcribing the Greek

and publishing it, with commentary, a year later. It was not easy work. To begin with, huge chunks of text were lost where the paper had been cut into the shape of wings, the wings of the Egyptian Horus falcon, a decorative element on the mummy case to which the cartonnage naturally had to conform (below).[7] Austin's first publication of the fragments appeared in *Recherches de Papyrologie* for 1967, with translation in French, under the title "De nouveaux fragments de l'*Érechthée* d'Euripide."[8] The following year, he published the Sorbonne papyrus together with all known fragments of the *Erechtheus* from other sources in his *Nova fragmenta Euripidea in papyris reperta*.[9] Austin's accompanying commentary was in Latin with no translation, in accordance with the convention of the German series (Kleine Texte) in which it appeared.

Fragment preserving Euripides's *Erechtheus*. Sorbonne Papyrus 2328a.

Fragments preserving Euripides's *Erechtheus*. Sorbonne Papyrus 2328b–d.

While the monumental discovery of Euripides's lost *Erechtheus* was big news in philological circles, it remained largely unnoticed by archaeologists. Such discoveries take quite a while to reach the mainstream of classical studies, let alone the general public. A Spanish translation of the play would appear in 1976 and an Italian one in 1977.[10] But the text would not come out in English until 1995, more than thirty years after the recovery of the fragments.[11] And nearly twenty-five years would pass between Austin's first publication of the *Erechtheus* fragments and my demonstration of their relevance to the Parthenon frieze.[12] One might well imagine classical studies as a focused and insular field in which everyone knows the doings of everyone else. But those who study Greek sculpture rarely keep up with papyrological discoveries, just as papyrologists seldom follow what's new in Greek architectural sculpture.

The fragments peeled from Jouguet's mummy casing 24 are known as Sorbonne Papyrus 2328 and contain approximately 120 lines of the *Erechtheus*, not including the 55 quoted by Lykourgos. Prior to this discovery, only 125 lines of the play had been known: Lykourgos's quotation plus 34 additional lines given by Stobaeus and various individual lines quoted in a number of other sources.[13] With the new discovery the extent of the play recovered rose to just under 250 lines, which, to judge by other Euripidean dramas, should account for one-fifth or one-sixth of the entire play.[14]

But how do new fragments of this ancient play lead us to reexamine the Parthenon? Before we answer that question in the next chapter, it is worth delving a bit into the story of the primordial Athenian king, who looms larger in the classical Athenian consciousness than has been understood for millennia.

AS WE HAVE SAID, it was through Lykourgos's lengthy quotation in *Against Leokrates* that the *Erechtheus* had been known to modern readers. But the play's significance, and that of its namesake, Erechtheus, had not been fully appreciated until Austin's publication of the new fragments in 1967. Indeed, Erechtheus had been best known from the temple on the Acropolis that bears his name, the Erechtheion. Its construction is generally placed in 421 B.C., after the Peace of Nikias brought a break in the fighting between Athens and Sparta, ending the first phase of the Peloponnesian War. The Erechtheion is thought to have been com-

pleted sometime after 409/408 B.C., when inscribed building accounts detail work completed as well as work left to be done.[15] Largely based on circumstantial evidence, the date for the start of construction on the Erechtheion remains contested, with some scholars putting it as early as 435 B.C. and others as late as 412.[16] The temple's famous Porch of the Maidens, the arrangement of six karyatids holding up the lintel at the southwest corner, is known to every schoolchild who studies Western art (page 271). But what do we know of the hero for whom the building is named?

The Oxford classicist Martin West has aptly called Erechtheus "the big spider at the heart of Attic myth."[17] The hero is already present in the *Iliad*, wherein Homer says that "Athens, the well built citadel," is the land of "great-hearted Erechtheus." Born of the earth, "giver of grain," Erechtheus was nursed by Zeus's daughter Athena, who settled him "in her own rich temple" on the Acropolis.[18] In the *Odyssey* this imagery was reversed.[19] It is Athena who enters "the strong house of Erechtheus" atop the Acropolis, presumably a reference to the Mycenaean palace erected here during the Late Bronze Age (page 27). Herodotos tells us that Erechtheus and Athena were worshipped jointly at Athens.[20] The people of Epidauros made an annual sacrifice to the divine pair, according to an old agreement by which the Epidaurians gained, in return, permission to cut Athenian olive trees for the carving of sacred statues. Herodotos refers to Erechtheus both as "earth-born" and as "king of the Athenians," telling us the people first acquired this name during his reign. The temple of Erechtheus, Herodotos also reveals, housed the venerable olive tree and sea spring, tokens of the ancient foundational contest between Athena and Poseidon.[21]

Erechtheus is not always easy to distinguish from a figure known as Erichthonios, or from a variant named Erichtheus.[22] These personae share the same extraordinary birth myth, arising directly out of the earth.[23] Each has a wife named Praxithea.[24] The yoking of horses and the introduction of the chariot are ascribed to both heroes. And both are associated with the Panathenaic festival.[25]

That the two share a very unusual birth myth concerning Hephaistos signals that they are, in fact, one and the same. As we have seen, the smithing god was smitten by the beauty of the maiden goddess Athena. Ignoring her protests, he pursues her but manages only to ejaculate upon her thigh.[26] The unwelcome effluent is wiped away by the chaste god-

dess with a piece of wool she discards on the ground. This gesture of disgust results in the impregnation of Mother Earth who, in time, gives birth to Erechtheus/Erichthonios. It has been argued that the hero's very name derives from *erion* or *erithechna* (meaning "wool" or "woollen"). Alternatively, it has been seen as deriving from *chthonios* (meaning "belonging to the earth"). Some combine the two and translate "Erechtheus" as "Woolly-Earthy," though this is unlikely. [27]

In Athenian eyes there was only one hero, Erechtheus.[28] He was the primordial king of the polis, born from the earth and nurtured by Athena. But at some point during the fifth century B.C. Erechtheus "splits" into two.[29] The construct of "Erichthonios" appears and, by the fourth century, has entirely taken over the early mythologies of the birth and childhood of the hero. Erechtheus then develops into a persona exclusively associated with the mature king of Athens who sacrificed his daughter and fought the war against Eumolpos.[30]

Erechtheus and Erichthonios thus come to be perceived as two distinct personalities or, possibly, a younger and older version of the same individual. Erichthonios is always depicted in Greek art as a child or baby, sometimes shown accompanied by guardian snakes.[31] Erechtheus, on the other hand, is always portrayed as an adult, the mature king of

Ge rises from the earth to hand the baby Erichthonios to Athena while Kekrops, with the tail of a snake, watches at left; Hephaistos and Herse (?) stand at right. Cup by Kodros Painter, 440–430 B.C. From Tarquinia.

Aglauros and King Erechtheus (with scepter) at left; Pandrosos at center; Aigeus and Pallas (?) at right. Cup by Kodros Painter, 440–430 B.C. From Tarquinia.

Athens.[32] A red-figured vase in Berlin, dating to the third quarter of the fifth century B.C., shows the two heroes together, each labeled by name: Erichthonios as a baby and Erechtheus as an adult (previous page and above).[33] Some have argued on this basis that the two are completely separate individuals.[34] We must, however, take care not to read visual culture too literally. The image-generating process, like the mythopoetic, is complex and nonlinear.[35] It is fully possible to have two aspects of one hero portrayed on a single vase, just as it is feasible for Erechtheus to "split" into two personae. The dynamic character of myth and the processes through which images are created and used allows for far more flexibility than some modern interpreters might like.

Greek myth is an ever-changing phenomenon that "morphs," as George Lucas would have it, into new and sometimes contradictory versions with each retelling. There is no correct or better version of any myth, just as there is no "wrong" recounting of these tales. Their transformative nature forces upon the modern audience a frustrating, even unsettling level of ambiguity, a theme to which we shall return. Suffice it to say, our heroes Erechtheus and Erichthonios are hopelessly intertwined, their stories woven together by each other's myriad adaptations spanning hundreds of years. What remains indisputable, however, is

that Erechtheus is the only name given to the defining king of Athens. He is known as such from his very first appearance in the *Iliad*. Erechtheus alone is the recipient of a cult in a temple called the Erechtheion, not the Erichthoneion. Athens is called the land of Erechtheus, never the land of Erichthonios. Likewise, the Athenians were always the "Erechtheidai" and at no time the "Erichthoniadai."[36]

To be sure, our appreciation of Erechtheus has been muted over the years, not by his lack of importance, but by the vicissitudes of surviving material evidence. It doesn't help matters that he has sometimes been outshone by another legendary king, Kekrops, who Herodotos tells us reigned a generation earlier.[37] This too is a pair that presents distracting similarities. Both Kekrops and Erechtheus/Erichthonios are associated with autochthony and the establishment of Athenian cult. In art, Kekrops is depicted with serpent legs (page 133) and Erechtheus/Erichthonios is often shown with snakes.[38] Most tellingly, each has three daughters, two of whom come to a terrible end, by some accounts leaping to their deaths from the cliffs of the Acropolis. Christiane Sourvinou-Inwood has argued persuasively that Kekrops is in fact a transformation of Erechtheus. She sees the former's persona as governed by "an intensification and emphasis on the element of autochthony," hence his depiction with a snaky tail.[39] We do well to reconcile ourselves to the dynamic complexity of Athenian foundation myths over the *longue durée,* in all their richness of projection, transference, and contamination.

Still, it remains that Erechtheus is the first Athenian king to be mentioned in Greek literature, present already in Homer at the turn of the eighth to the seventh century B.C. His rise to prominence in mid-fifth-century Athens, a reawakening of the sleeping hero, so to speak, seems intricately bound up with the vision of Perikles and his efforts to renew the Acropolis temples. In the wake of the Persian Wars and the collective trauma suffered by the Athenians, what better than to go back to the very beginning, to the oldest founding father and the founding principles upon which the city had been built. Erechtheus was the man for the moment, a hero whose family tragedy embodied the very spirit of self-sacrifice so emphatically projected by the Periklean democracy.

Of irreducible significance is that, without Athena, Hephaistos's seed would never have been spilled upon the earth and Erechtheus would never have been born. Indeed, while Athena remains a virgin goddess, she is, in a very real sense, the genitor of Erechtheus and, therefore, of

all Athenians. In this sense, Erechtheus can and must be understood as later championing the cause of his "mother," Athena, just as Eumolpos avenges the defeat of his father, Poseidon.

After Athena wins the primordial contest for patronage of Athens, tensions with Poseidon persist. The gods' mortal issues, Erechtheus and Eumolpos, continue the rivalries of their respective parents, Eumolpos reigniting hostilities when he bands an army of Thracians from northeastern Greece to settle the score for his father.[40] Thucydides tells us that in days of old when towns were independent of the Athenian king, they sometimes made war upon him "as did Eumolpos and the Eleusinians against Erechtheus."[41]

Hearing of the impending siege, King Erechtheus consults the oracle at Delphi to learn how he can stop Eumolpos. The answer is devastating: the king must sacrifice his daughter to save the city. Erechtheus shares the bad news with his wife, Praxithea, asking her leave to let their daughter die. The queen answers with that rousing, patriotic speech we examined in chapter 3. Lykourgos is clearly confident of the power of those lines to stir the Athenian heart even a hundred years after they were first performed, advising the gentlemen of the jury: "You will find in them a greatness of spirit and a nobility worthy of Athens and a daughter of the Kephisos."

Emboldened by his wife's ardor, Erechtheus sacrifices their youngest daughter, a nameless girl simply called "Parthenos," or "Maiden," throughout the play. The names of the daughters of Erechtheus and Praxithea are greatly confused in the ancient sources, with conflicting lists given by various authors over several hundred years.[42] Later authors speak of four and even six daughters of Erechtheus, as well as several sons. Phanodemos names Protogeneia and Pandora as the sisters who died (to save Athens from Boiotian, not Thracian, attack) while giving the names Prokris, Kreousa, Oreithyia, and Chthonia for the surviving daughters.[43] Apollodoros names Prokris, Kreousa, Oreithyia, and Chthonia and, interestingly, lists a son named Pandoros as well as two others named Kekrops and Metion II. He has Chthonia as a survivor who goes on to marry Boutes.[44] But Hyginus says that Chthonia is the girl who was sacrificed (to Poseidon) and that the other girls killed themselves.[45] Yet he also names Aglauros as a *son* of Erechtheus by another of his daughters, Prokris—never mind that Aglauros is regularly identified as the *daughter* of Kekrops.[46] In the great tangled web that is Attic myth,

the most potent configurations replicate themselves: in the three daughters of Erechtheus we see the same pattern evident in chapter 1 with the three daughters of Deukalion and the three daughters of Kekrops.[47] And there are of course connections: both Deukalion and Erechtheus have a daughter named Pandora, while Kekrops has a daughter named Pandrosos. More than likely we are seeing a Pandora/Pandrosos substitution in the same manner as Erechtheus/Erichthonios.[48]

The battle ensues, and as promised by the oracle, the Athenians are victorious. But, in a turn of events that Praxithea did not anticipate, Erechtheus is killed, swallowed up in an earthquake caused by Poseidon. As for the two older daughters, we learn that they kept their oath that if one of them should die, the others would die as well. The surviving fragments of the *Erechtheus* do not explicity tell us how the sisters die, but there may be some suggestion that they leaped off the Acropolis in a suicide pact. Though the text is very uncertain here, lines apparently spoken by Praxithea seem to address the two daughters whose bodies may lie before her.[49] This would concur with the account given in Apollodoros which says that following the sacrifice of the youngest daughter, the two remaining sisters killed themselves.[50]

It should be remembered that later writers, including Apollodoros, ascribe death by suicidal leap to another pair of royal daughters, those of King Kekrops, who ruled a generation before Erechtheus.[51] Having looked into a forbidden box containing the baby Erichthonios and a snake, the sisters Aglauros and Herse were driven mad and jumped from the Acropolis or, in an alternative account, into the sea.[52]

Aspects of Athenian myth are thus transferred between different sets of royal sisters so that even within the corpus of a single author the same triad might be disposed of in different ways. In his play the *Ion,* first performed in 414–412 B.C., some years following the *Erechtheus,* Euripides clearly states that *three* daughters of Erechtheus were sacrificed.[53] The boy Ion asks his mother, Kreousa (understood to be the youngest sister of three girls, apparently just a baby and too young to be killed when the others were sacrificed), "Is it true, or merely a tale, that your father killed your sisters in sacrifice?" Kreousa replies, "He dared to kill his maiden daughters as sacrifices [*sphagia*] for this land."

What is important here is that the two older daughters of Erechtheus kept their pledge and died, either by the hand of their father or by their own devices. While Queen Praxithea thought that she was giving just

one child to die on behalf of all, she in fact loses all three daughters and her husband, a far greater sacrifice than she could have imagined.

The discovery of the new fragments of the *Erechtheus,* peeled from the mummy brought to Paris by Pierre Jouguet, is nothing short of momentous for the clarity of understanding it brings to the temples standing on the Acropolis today. For the first time ever, we can read the words Euripides gives to Athena, as spoken to Queen Praxithea toward the very end of the play, when she stands alone on the Acropolis, having lost her entire family. The goddess delivers what can be described as a divine charter for the construction of the two great temples on the Sacred Rock: the Parthenon and the Erechtheion. Athena first instructs Praxithea to bury her daughters in the same tomb, over which she is to build a sanctuary, establishing sacred rites in their memory. She then directs the queen to bury her husband in the middle of the Acropolis and to erect a sacred precinct for him. Finally, Athena names Praxithea as her priestess and entrusts her with the care of these holy places. Only Praxithea will have the right to make burnt sacrifice on the altar of Athena that serves both tomb-shrines (page 231). Fascinatingly, Athena's speech employs language well known from sacred laws (*leges sacrae*), texts inscribed in stone to decree cult practice, including the construction of temples within Greek sanctuaries.[54]

It now becomes clear just how aptly this naiad nymph, daughter of the Kephisos, is named. "Praxithea" is a compound of the roots *prasso* ("to perform") and *thea* ("goddess"), and so the name means, quite literally, one who does things for the goddess. She is Athena's ideal priestess: noble, selfless, and strong. It is relevant here that the historical priestess of Athena Polias who served on the Acropolis at exactly the time the *Erechtheus* was first performed was a woman of exceptional power and character. Her name was Lysimache, and she was daughter of Drakontides of Battae, sister of Lysikles, the treasurer of the Athenians. Lysimache held the priesthood of Athena Polias for an impressive sixty-four years (spanning the last decades of the fifth century as well as those of the early fourth). It is very possible that Euripides had this well-known city official in mind when he constructed the potent and patriotic character Praxithea for his *Erechtheus.*[55] Aristophanes certainly had Lysimache in mind when he wrote the leading role for the heroine Lysistrata in his famous comedy of that same name, first performed in 411 B.C.[56]

The newly recovered fragments of the *Erechtheus* preserve for us the

pivotal closing speech of Athena, in which she commands her old rival Poseidon to leave Athens in peace:[57]

(55) I bid you to turn your trident away from this soil, sea-god Poseidon, and not to uproot this land and destroy my delightful city . . . Has not one victim given you your fill? Have you not torn my heart apart, (60) hiding away Erechtheus deep beneath the earth?

Athena then turns and speaks directly to Queen Praxithea:

Daughter of Kephisos, savior of this land. Now hear the words of motherless Athena. (65) First, I shall tell you about the girl whom your husband sacrificed for this land. Bury her where she breathed out her lamented life, and these sisters of hers in the same earth-tomb, because of their nobility (70) for they did not presume to abandon their oath to their dear sister. Their souls have not gone to Hades but I myself have brought their spirit [*pneuma*] to the uppermost reaches of heaven [*aither*] and I shall give them the name that mortals will call them all throughout Greece, "the Hyacinthian goddesses" (75) . . . brightness of the hyacinth, and saved the land. To my fellow citizens I say not to forget them over time but to honor them with annual sacrifices and bull-slaying slaughters, (80) celebrating them with holy maiden dancing choruses . . . enemy . . . to battle . . . spear army . . . make to these, first, a preliminary sacrifice before taking up the spear of war, not touching the wine-making grape nor pouring on the pyre anything other than the fruit of the hardworking bee [honey] together with river water. It is necessary that these daughters have a precinct that must not be entered [*abaton*], and no one of the enemies should be allowed to make secret sacrifice there, for their victory and the suffering of this land.

(90) And I order you to construct a precinct for your husband in mid-city with stone enclosure. On account of his killer, he will be called, eponymously, Holy Poseidon-Erechtheus, by the citizens worshipping in cattle sacrifices.

(95) And for you, [Praxithea], who re-erected the foundations of this city, I grant, being called priestess, the right to make burnt sacrifice on my altar on behalf of the whole city. You have heard what [must be] brought to pass in this land. Now I shall pronounce the

judgment of Zeus, my father in heaven. Eumolpos, born from the
Eumolpos who has died.

<div style="text-align: right">Euripides, Erechtheus F 370.55–101 Kannicht[58]</div>

In the chapters that follow, we shall see how the goddess's words have
reverberated in the Athenian psyche, expressing the very essence of the
people's self-understanding, thereby forming a basis for our understand-
ing of Acropolis temples, cults, and rituals. We have already noted that
Athena's speech reads like the text of so many sacred laws establishing
cult places. Euripides's play and, as we shall soon see, Pheidias's Parthe-
non sculptures, vividly express Athenian core values while at the same
time they instruct the citizenry on how things came to be as they are. For
now, let us acknowledge how explicitly Euripides's Athena explains the
origins of the two temples that stand on the Acropolis: the Erechtheion
and the Parthenon. Euripides etymologizes the names of these two cult
places, one meaning "of Erechtheus" and the other "of the Maidens."
The special character of Acropolis cult practice, in which the Erech-
theion and the Parthenon shared a single priestess and a single altar, can
now be understood in relation to the myth in which Praxithea is charged
with looking after the shrine of her husband (the Erechtheion) and that
of her daughters (the Parthenon), both set within temples of Athena.

Lykourgos's lengthy quotation from the *Erechtheus* takes on height-
ened meaning when we consider that he himself was regarded as a direct
descendant of the noble family of Erechtheus and Praxithea. His fam-
ily clan, the Eteoboutadai, controlled the hereditary priesthoods of
Poseidon-Erechtheus and Athena Polias, passing the sacred offices down
through its generations for an astounding seven hundred years. Likely
to have served as priest of Poseidon-Erechtheus himself, Lykourgos was
highly knowledgeable about Acropolis cult and hierarchies. When he
stands before the jury and recounts patriotic tales from the legendary
past, he does so with the authority of his own birthright and experience.[59]

As the consummate Athenian, Lykourgos closes his case with an
invocation of the Attic landscape, the shrines, and the monuments that
bound the citizenry together in a common identity:

> If you acquit Leokrates, you will vote for the betrayal of the city, of
> its temples, and its fleet. But if you kill him, you will be encourag-
> ing others to preserve your country and its prosperity. Imagine then,

Athenians, that the country and its trees are appealing to you, that the harbors, dockyards, and walls of the city are begging you for protection, yes, and the temples and sanctuaries, too.

Lykourgos, *Against Leokrates* 150[60]

For all this effort and eloquence, the jury returned a split verdict: 250 voting to convict Leokrates, 250 to acquit. The man whose crime was presented as an affront to the very soul of the city walked free.

The example of Erechtheus and his family continued nonetheless to loom large within Athenian consciousness, serving as a model for civic selflessness, even when the days of such fervor and of the democracy it enabled were numbered. The idea of sacrificing one's life for the common good (*to kalon*) remained central to Athenian democratic ideology over the century separating Perikles and Lykourgos, as weariness over paying the ultimate price grew. Wars to maintain Athenian supremacy took their toll even before the city-state's forces were crushed by Macedonian legions in 338 B.C. during Philip's effort to unite Greece. After Chaironeia, Athenians no longer controlled even their own food supplies and, increasingly threatened by the whims of foreign generals and kings, found themselves gripped by anxiety and unease. Meanwhile, the story of Erechtheus and his daughters endured as a recurring theme in Attic funeral orations, which is no wonder, given how effectively Euripides's play employed traditional Athenian language of the *logos epitaphios*.[61] The myth is invoked in the Platonic dialogue called the *Menexenus*, as well as in Isokrates's *Panegyrikos* and in his *Panathenaikos*.[62] And when it comes time to eulogize the fallen from the Battle of Chaironeia in 338 B.C., Demosthenes praises the example of Erechtheus's daughters as inspiration for the young men of the tribe Erechtheidai, who resisted the Macedonians.[63] Later, the orator Demades will have to save his still-refractory fellow Athenians from the wrath of their conqueror Philip, but this same Demades will also hail the daughters of Erechtheus for their noble virtue and devotion to the land that reared them.[64]

The esteem of the Athenians for the story of the sacrifice of Erechtheus's daughter is as striking as it is long-lived. To realize its centrality to Athenian consciousness is to appreciate that the Parthenon's most prominent puzzle has a solution hidden in plain sight. But before we come to that appreciation, let us reflect a bit upon the meaning and implications of this most definitive myth of Athenian belonging.

WHAT ARE WE to make of such admiration for what is, essentially, an act of violence against a blameless maiden? In presenting virgin sacrifice as an inspiring example of selflessness, were the Athenians not simply whitewashing a tale of cruelty and misogyny? In answering this question, we must first make it clear that the examples of virgin sacrifice encountered in Greek literature are all set in the mythical past. Not one source attests to the actual killing of a maiden during historical times. Furthermore, archaeological evidence for human sacrifice, even in prehistoric Greece, is problematic, inconclusive, and slight.[65]

Herodotos only once describes an instance of human sacrifice, and this drawn, again, from the realm of myth. He tells us that King Menelaos, bringing his wayward wife, Helen, back from Troy, was becalmed at a port in Egypt. Here, he was compelled to sacrifice two Egyptian boys to ensure that favorable winds would fill his sails and allow his ship to continue.[66] Calling this measure an "unholy act," Herodotos clearly finds human sacrifice repellent.

Plutarch recounts the story of three captive Persian princes, the nephews of Xerxes, who were killed by Themistokles as a preliminary sacrifice (sphagia), just before the Battle of Salamis.[67] If true, this would constitute a rare historical instance of human sacrifice in Greece. But this act could equally be understood as the execution of enemy captives during time of war. It is far from clear whether Plutarch is recounting an actual event or is just invoking an old paradigm.[68] The historicity of Plutarch's account has been thrown into question by the fact that the sacrifice of the Persian boys is said to have been made to Dionysos Omestes, a god worshipped on Lesbos, home to Plutarch's source for the story, Phainias.[69] And, in a sense, Plutarch's account presents a parallel to the deaths of the daughters of Erechtheus, three Attic princesses sacrificed as sphagia prior to the battle, just as are the three Persian princes.[70] This symmetry may suggest a fictive rather than a historical occurrence.

There is hardly a culture on earth that does not have some shadowy prehistory of human sacrifice practiced by certain groups under certain circumstances. While there is no evidence that fifth-century B.C. Athenians sacrificed maidens, they surely believed that virgin sacrifice occurred in the days of the heroic past. And, as we shall see, they might

even have believed that the tomb of the daughters of Erechtheus rested beneath the western room of the Parthenon, a chamber they themselves called Παρθενών ("of the Maidens"). I shall argue in chapter 6 that the maidens in question are none other than the daughters of Erechtheus and Praxithea.

How did such dark stories of sacrifice and death function within the larger worldview of the Greeks? What role do they play in the construction of models for heroism? Let us, for a moment, consider the great hero Achilles, the "best of the Achaeans," who fought at Troy. Achilles was faced with an impossible dilemma: to die young and thereby enjoy a "big story" unto immortality, or to survive the war and return home to a long if impermanent life. "If I stay here and fight, I shall lose my safe homecoming [*nostos*] but I will have a glory [*kleos*] that is unwilting," he reflects in the *Iliad*. "Whereas if I go home my glory will die, but it will be a long time before the outcome of death shall take me."[71] Here lies the essence of Greek heroism. To be a hero, one must experience death. It is death itself that gives the hero power. As Gregory Nagy has explained, the Greek hero is first and foremost a figure of religious worship, a dead person who receives cult honors and who is expected, in return, to bring prosperity to the populace.[72]

The surest route to heroism is an honorable death in battle. Courage displayed in giving his life to defeat the enemy brings lasting glory to Achilles, as well as to Patroklos, Hektor, and so many of the greatest names that come down to us from Greek epic. The hero Odysseus is unusual in achieving both *kleos* and *nostos*. He survives the perils of the Trojan battlefield yet attains a big story through the adventures of his ten-year journey home, as recounted in the *Odyssey*. Upon reaching Ithaka, Odysseus receives the additional glory of warm welcome from Penelope, the loyal, loving wife still awaiting him.[73]

A man's path to heroic status is clear beginning with the earliest epic poetry. But what of a woman's? No Greek woman is given Achilles's choice, to fight and die in battle or to journey home to a waiting family. These options are unthinkable within the framework of experiences open to female members of the community. But women of Greek myth do achieve heroic status and lasting honors. Like men, they do so by dying. Their deaths, however, are not on the field of battle but on the altar of sacrifice.

Virgin sacrifice presents a paradox in which something as dark and

sinister as the killing of a maiden can be viewed as a female's means of ascent to heroism. By making the ultimate sacrifice, Greek maidens attain the *kleos* that comes of having a big story. In return, they achieve immortality and cult adoration. (In a world of such intense pieties, the worshipper can have no higher aspiration than to become herself worthy of worship.) Critics inclined to see cruelty and misogyny will not view this as a square deal. After all, a girl has no real say in whether she lives or dies. The martial hero has at least the opportunity to fight for his life. The fate of the sacrificial virgin is sealed by those who impose it upon her. But this is to miss the point. Within the cultural norms of ancient Greek society, it is impossible to think of a young woman going into battle. How, then, is she able to set herself apart, to offer the ultimate gift and save her community? Without virgin sacrifice, women could have never enjoyed authentic heroic status, the culture's highest honor.[74]

Greek myth is full of stories in which girls of noble birth are sacrificed to avert catastrophe in times of social crisis.[75] When Herakles and the Thebans were about to attack Orchomenos, an oracle declared that the city could be saved only if a highborn citizen would die by his or her own hand. The daughters of Antipoinos, Androkleia and Aleis, volunteered. Following their deaths, they were buried within the local sanctuary of Artemis Eukleia, where they received cult honors.[76] When the same city, Orchomenos, was struck by a terrible epidemic, an oracle proclaimed that only a maiden death could stop the spread of disease. The daughters of Orion, who had been taught weaving by Athena, stepped forward and stabbed themselves in the throats and shoulders with their bodkins and shuttles, thus ridding the city of plague.[77] When Athens was threatened by epidemic, or by some accounts famine, the daughters of Leos were given in sacrifice, receiving in return their own shrine and cult honors in the Athenian Agora.[78]

The most famous virgin sacrifice in Greek myth is of course Agamemnon's killing of his daughter, Iphigeneia.[79] This enabled the Greek fleet to set sail for the Trojan War. A thousand ships were becalmed for months in the harbor at Aulis, waiting for favorable winds, when the commander, King Agamemnon, consulted the seer Kalchas. Nothing short of the sacrifice of the king's own daughter would reinspire the wind. When Aeschylus tells this story in his *Agamemnon* of 458 B.C., he focuses on the rage of the girl's mother, Klytaimnestra. But when Euripides tells the tale in his *Iphigeneia at Aulis* in 405, we see a tre-

mendous shift in emphasis. Euripides's Iphigeneia first begs for her life but later goes willingly to sacrifice, reminding her distraught mother that in doing so, she will save Hellas. "You bore me for all the Greeks not yourself alone," Iphigeneia remonstrates, expressing much the same sentiment as Praxithea: just as boys go to war, girls go to sacrifice, both for the good of the city.[80]

Why such a shift in sentiment between the telling of this tale by Aeschylus and its retelling by Euripides? In the wake of the Persian Wars, themes of heroism and self-sacrifice gained popularity on the Athenian stage. Sophokles took up the subject of virgin sacrifice in his *Andromeda, Iphigeneia, Polyxena,* and, possibly, in his lost *Kreousa.* But it is during the Peloponnesian War (431–404 B.C.) and the plague at Athens (430, 429, 427/426 B.C.) that we see a great eruption of interest in these stories. Perhaps their retelling helped to acknowledge the burden of loss and sacrifice shared by the women of Athens during these troubled times. Euripides brings human sacrifice to the stage in his *Hekuba, Ion, Iphigeneia at Aulis, Children of Herakles,* and, of course, *Erechtheus.*[81] And, notably, the *Children of Herakles* and *Erechtheus* share a common framework for projecting a strong, cohesive Athenian ideology.[82]

In *Children of Herakles,* Euripides gives us the rare opportunity to hear words from the lips of a sacrificial victim, Makaria, the "Blessed One," daughter of Herakles and Deianeira. Together with her brothers, she takes refuge at Athens, having been expelled from Trachis. When the children's uncle Eurystheus declares war on Athens, an oracle advises the Athenian king, Demophon, that only the voluntary death of one of Herakles's children can save the city.[83] Makaria valiantly volunteers. Following her sacrifice, a spring is named for her at Marathon.[84] As Makaria marches stalwartly toward the altar of her death, she delivers a compelling treatise on virgin sacrifice, exalting it as an opportunity for female heroism. Makaria views herself as an active agent in the saving of the city, one glad to trade her life for *kleos:*

> Then fear no more the Argive enemy's spear! I am ready, old man, of my own accord and unbidden, to appear for sacrifice and be killed. For what shall we say if this city is willing to run great risks on our behalf, and yet we, who lay toil and struggle on others, run away from death when it lies in our power to rescue *them*? It must not be so, indeed; for it deserves nothing but mockery if we sit and groan now

as suppliants of the gods and yet, though we are descended from that
great man who is our father [Herakles], show ourselves to be cow-
ards. How can this be fitting in the eyes of men of nobility?
. . .

 Lead me to the place where it seems good that my body should be
killed and garlanded and consecrated to the goddess [Athena]! Defeat
the enemy! For my life is at your disposal, full willingly, and I offer to
be put to death on my brothers' behalf and on my *own*. For, mark it
well, by not clinging to my life I have made a most splendid discovery,
how to die with glory.

<div align="right">Euripides, Children of Herakles 500–10, 528–34[85]</div>

Dying with honor had incomparable resonance in a society as rav-
aged by war and plague as Athens was during the last third of the fifth
century. Scarcely a family was spared the loss of someone in these terri-
ble times. Describing the bravery of those who stayed in Athens to nurse
the sick during the plague, Thucydides hailed the *Athenian* instinct to
feel shame for thinking of one's own safety in the face of communal
crisis.[86] Against the backdrop of these events, we can understand how
the retelling of tales of virgin sacrifice was far more than theatrical
entertainment. It was a means of expressing the core values of Athenian
democracy at a time when solidarity among citizens was paramount.

 As we have said, Euripides's *Erechtheus* was probably first per-
formed round about 422 B.C.[87] Presented in the Theater of Dionysos on
the south slope of the Acropolis, the play was viewed by thousands.[88]
Each year the festival of the City Dionysia brought together the great-
est assembly of all Athenians in one spot.[89] Viewers were not merely
entertained but took in a harsh message, one presented within the ritual
framework of a religious feast. The message was simple: democracy
requires pain and loss.

 "Of all the rituals relevant to democracy, sacrifice is preeminent,"
writes the classicist and political theorist Danielle Allen. She demon-
strates how democracy must prove to its citizens who have suffered loss,
in one instance, that they should continue to keep faith with their gov-
ernment and fellow citizens in the future."[90] Responding to this need
takes the shape of public rituals, repeated acts that create and sustain
trust and order within the community—necessities that simply don't

exist to such a degree, if any, in authoritarian regimes. The story of the daughters of Erechtheus manifests precisely the nexus of sacrifice, loss, trust, and ritual that makes democracy work. This is why it was so central to Athenian foundational myth and why, as we shall see, it was such an obvious subject matter for commemoration on the Parthenon.

The *Erechtheus* continued to have profound resonance for Athenians a century after its first performance, when Lykourgos quoted so extensively from it in making his case against Leokrates. In her book *Why Plato Wrote*, Allen demonstrates how Lykourgos adopted Platonic vocabulary, deliberately using one of Plato's favorite superlatives, *to kalliston* ("the most beautiful and noble"), a total of six times in the speech. At eight different points, he exhorts the jurors to learn from the paradigms he holds up for them. First among these is the importance of educating the people toward virtue (*arete*) and that which is noblest (*to kalliston*).[91] And in turning toward virtue, Athenian youths will inevitably find their way to patriotism.[92] Behind Lykourgos's words is a practical policy agenda. He insists on the importance of training the ephebes as part of his larger mission of paideia.[93] Thus, Perikles's vision of Athens as the "School of Hellas" lives on in the courtroom of Lykourgos, even if the words are not as stirring as they were in Perikles's day.

In what are likely to be the most authentic words surviving from Perikles, those of the funeral oration that he delivered for the soldiers who died in the Samian War of 439 B.C., he reflects, "We cannot see the gods . . . but we believe them to be immortal from the honors we pay them and the blessings we receive from them, and so it is with those who have given their lives for the city."[94] Here we are at the intersection of the civic religion into which Athens grew and the cosmological awareness it had possessed since time immemorial. Those who will give themselves for the common good are as worthy of collective worship as the gods themselves. Democracy is no mere political arrangement but ultimately a spiritual one.

The daughters of Erechtheus were not only worshipped as divinities at Athens; they were set up into the heavens by Athena herself, transformed into stars for all eternity.[95] Catasterism is the greatest honor of all: to become one with the eternal cosmos as a star shining ever after down upon Athens. "I have caused their spirit to dwell in the uppermost reaches of heaven," Athena proclaims in the *Erechtheus,* "and I will give

them a name men will call them all throughout Greece, the Hyakinthian goddesses."[96] Joined together in an everlasting choral dance among the stars as the constellation Hyades, the noble daughters of "great-hearted" Erechtheus and "great-spirited" Praxithea take their place as founding daughters in a charter myth worthy of Athens itself. Athena places the maidens lovingly into that same sky wherein she once hurled the giant Drako in a primordial cosmic battle, endless eras earlier.

5

THE PARTHENON FRIEZE

The Key to the Temple

HE WAS HACKED to death in Isfahan. Francis Vernon died the way he lived: adventurously.

Pirates had kidnapped him as a young man just out of Christ Church, Oxford, selling him into slavery. Traveling along the northern coast of the Gulf of Corinth in October 1675, he watched his companion Sir Giles Eastcourt succumb to disease at Vitrinitza between Amphissa and Naupaktos.[1] Later that year, Vernon set sail from Greece to Turkey, losing all his field notes and letters when his boat was plundered along the way. Still his "insatiable desire of seeing" impelled him on, eventually to Persia, where, in September 1676,[2] at age forty, he met his end at the hands of some locals who liked his penknife.

Before his untimely murder, Vernon had earned the respect of some of the greatest thinkers of his day. In 1669 he was sent to Paris as secretary to Ralph Montagu, ambassador extraordinary to Louis XIV, and became over the next three years an important intermediary in scholarly exchanges between French and English scientists. He came to know many members of the newly founded Royal Society and kept its secretary, Henry Oldenburg, informed of scientific developments on the Continent.[3] Vernon regularly corresponded with the orientalist Edward Pococke, whom he may have known from his Christ Church days, and

with the astronomer Edward Barnard and the mathematician James Gregory, who expressed admiration for Vernon's "great knowledge in many sciences and languages."[4] Vernon would be among the first to see the young Isaac Newton's influential treatise on calculus, "De analysi per æquationes numero terminorum infinitas," sent to him by the mathematician John Collins.[5] Upon his return to England in 1672, Vernon himself was elected to the Royal Society, his nomination made by none other than its secretary, Henry Oldenburg.

Vernon didn't linger long in London. By June 1675, he was on the move to Venice and then to Greece, disembarking on Zakynthos with Eastcourt. The pair had decided to break off from their traveling party bound for Constantinople and to journey instead around the Greek Peloponnese and on to Athens where they stayed a few months.[6] In September, they crossed to the north side of the Gulf of Corinth, where Eastcourt fell ill and died. Vernon returned to Athens, where he stayed until late that year, copying inscriptions and examining architectural monuments. In all, he visited the Acropolis three times with the express purpose of measuring the Parthenon.[7] Vernon's calculations have proven to be remarkably accurate. Especially significant is his measurement of the width of the interior room, or cella, at the east end of the temple, where others would reckon only the size of the exterior colonnade. Just twelve years later, Venetian cannons would blow the interior of the Parthenon to bits, and the original dimensions of the room Vernon had taken such care to measure would be lost but for him. Fortunately, he had recorded his findings in his personal diary as well as in a letter to Oldenburg posted from Smyrna on January 10, 1676, before setting off for his fateful rendezvous in Isfahan.[8]

Vernon was the first to see in the Parthenon frieze animals brought to sacrifice followed by a triumphant procession. Somehow, he found time to look up from his calculations to describe the "very curious sculptures" (facing page) in the letter he posted from Smyrna.[9] And in writing of the south frieze in his diary entry for August 26, 1675, Vernon notes, "Men to west end on horseback people in triumphant/Chariotts." His entry for November 8 describes a procession showing "Severall Bullockes with people conducting them to Sacrifice."[10] Vernon's field notes having been lost at sea, his personal diary and the letter to Oldenburg preserve his only surviving observations on what he calls the "Temple of Minerva." The building "will always bear witness that the ancient

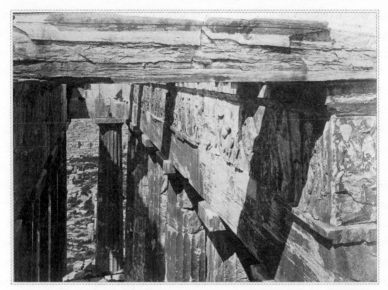

West portico of Parthenon. William J. Stillman, from albumen silver print, 1882.

Athenians were a magnificent and ingenious people," he writes. Vernon didn't leave Athens without making his own mark. To this day, one can see "Francis Vernon" carved on a block on the south wall of the Theseion, a temple that has been since ascribed to Hephaistos, in the Athenian Agora.[11] This inscription includes the date, 1675, as well as the names of his companions, Eastcourt and Bernard Randolph.[12]

Precious few commentaries on the Parthenon sculptures between antiquity and the seventeenth century survive, making Vernon's observations all the more significant. That he takes a careful look at the long "ribbon"[13] of figured relief that wrapped around the interior of the Parthenon's colonnade is not surprising: the exquisiteness of its carving, the classic lines and features of its human figures, the sensitive modeling of the drapery over flesh—all these aspects have led to the recognition of "Parthenonian style" as the highest standard for Western perceptions of beauty. But that he should have beheld in those lovely figures something that succeeding centuries of commentaries have failed (or been reluctant) to perceive, that it shows a *triumphant* sacrificial procession, may be the ultimate tribute to this remarkable man's powers of seeing.[14]

THE EARLIEST SURVIVING EXPLANATION of the Parthenon sculptures dates a full six hundred years after the temple was built. In his *Description of Greece,* the traveler Pausanias, who visited the Acropolis in the second century A.D., identifies the subject matter of the east pediment as the birth of Athena, and Athena's contest with Poseidon as that on the west.[15] He also describes in detail the monumental gold and ivory statue, the so-called Athena Parthenos, housed within the east room of the temple. Dazzled by the radiance of the colossal image, Pausanias heads straight for the east door to peer inside at the statue, apparently never looking up to notice the frieze set high among the shadows within the porch (below).

Had he looked up, Pausanias might have caught a glimpse of the lively spectacle, a band of sculptured relief showing 378 human and 245 animal figures and running some 160 meters (525 feet) around the top of the cella wall within the colonnade. Set at a height of 14 meters, or about 46 feet, and deeply shaded under the ceiling of the peristyle for most of the day, the frieze measures just over 1 meter from top to bottom, or roughly 3 feet 4 inches in height.

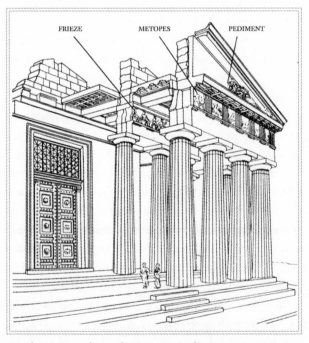

Parthenon's sculptural program: pediments, metopes, and frieze.

Much has been written in recent years about the viewing of the Parthenon frieze, the framing of its images between the columns, and the optimal lines of sight for the spectators down below.[16] Truth be told, the frieze would have been difficult to see from ground level. The earthbound Athenian would, of course, have made out the profiles of figures set against the frieze's deep blue painted background. Skin pigments of reddish brown for men and white for women would have made the sexes distinguishable at a distance. Light green and red pigment preserved on costumes worn by some of the horsemen, and traces of green paint on a few of the rocks shown on the west frieze, give a hint of how vibrantly colored the frieze originally appeared. Gilding is preserved on the heads of certain figures, enlivening their hair. Horses were painted in white, black, and brown. There are drill holes for the attachment of bronze bridles and reins, gilded sandal straps, and other details that would have fairly glistened.[17] Smaller details in the carving would have been obscure, like the composition as a whole.[18] But viewers would have already known the subject matter, thus easily recognizing the figures glimpsed between the columns. Still, to peer straight up at the frieze from thirty to forty feet below would have required an inordinate amount of squinting and neck craning.[19]

In fact, the primary intended viewers of the Parthenon frieze were not mortal visitors to the Acropolis but the gods eternally gazing down upon it. As Brunilde Ridgway's aptly titled book expresses it, sculptured images on Greek temples were meant as "prayers in stone."[20] Conditioned as we are to focus on our own experience as viewers, it is hard to fathom a world in which the pleasure of the gods came first. But it did. The perfection of the Parthenon frieze is all the more astonishing when we consider that, apart from the sculptors who carved it in situ, very few people had the opportunity to see this masterwork up close.[21]

While the principal purpose of architectural sculpture was to delight the gods, humans were certainly enthralled and edified by the sculptured decoration of Greek temples. Euripides's sketch of a chorus of Athenian serving maids admiring the sculptures of the sanctuary of Apollo at Delphi provides a rare glimpse into the viewing experience of pilgrims at a Panhellenic shrine. The young Ion, servant of Apollo's temple, guides the Athenian women through the iconography, pointing out the hero Herakles (assisted by Iolaos) battling the Lernaean Hydra in one sculptured panel. "Friend, look over here! . . . I see him," cry the chorus of

serving maids, adding, "I cast my eye everywhere." Ion draws the women's attention to an image of the goddess Athena shaking her Gorgon shield at Enkelados in the battle of the gods and the Giants. "I see my goddess, Pallas!" chimes the chorus, in an ecstatic moment of recognition when the cosmic war of aeons past is suddenly rendered present.[22] Visual culture was intended not merely as an aesthetic experience but also to inform and educate, particularly in matters of the common faith. Above all, images rendered the gods and heroes present within the sanctuary. The power of the image was much nearer the power of reality in such a time and place where there were no mere likenesses.

The word for "sculpture" or "statue" in Greek was *agalma*, which literally means "pleasing gift" or "delight."[23] Works of art needed to be perfect in order to please and honor divinities in a fitting way. It is often noted, sometimes with surprise, that the backsides of the Parthenon's pedimental figures are carved, even though they would never have been seen once put in place (page 111, second figure). Set close against the tympanum wall of the gable, the posteriors of these figures would be known only to the gods, who might well be offended by imperfections humans would not notice.

Contrary to this understanding, it is the human response to the Parthenon sculptures that has preoccupied commentators over the centuries. The first post-antique description of the temple we have is that of Niccolò da Martoni, who wrote about it in his *Pilgrimage Book* after a visit to Athens in February 1395.[24] By this time the Parthenon had been transformed, first into a Christian church, becoming Orthodox with the great schism of Christianity around 1000 and then, after the Frankish conquest of 1204, into a Latin cathedral known as Notre-Dame d'Athènes.[25] Martoni praises the precious icons that he sees within the church as well as the relics of saints and a copy of the gospels said to have been transcribed by the emperor Constantine's mother, Helen. Martoni then describes the Parthenon itself: its size, the number of its columns (he counts sixty), its construction, and its sculptural decoration. He is particularly impressed by a story he was told regarding the temple's marble doors: these were the gates of Troy, brought to Athens by victorious Greeks after the Trojan War. Martoni's account demonstrates the staying power of local narrative and its role in shaping, and reshaping, the myth-history of the Parthenon.

Without an ancient source to confirm what ancient viewers saw in the

Parthenon frieze, post-antique interpreters have been free to reconstruct meanings on their own. The first to comment directly on the frieze was Cyriaco de' Pizzicolli, known as Cyriacos of Ancona. This Italian merchant, humanist, and antiquarian served as envoy for Pope Eugenius IV. He visited Athens in 1436 and in 1444, writing detailed letters, keeping diaries, and making careful drawings on each trip.[26] A fire at the library of Pesaro in 1514 destroyed Cyriacos's original drawings of the Parthenon. But copies had been made, some more reliable than others, to give us a good sense of what he saw and how he saw it. One reproduction, made in silverpoint as a presentation sample of his work for Pietro Donato, bishop of Padua, reproduces a drawing (following page) from a letter Cyriacos wrote to Andreolo Giustiniani-Banca from the island of Chios on March 29, 1444.[27] In a Latin text above the drawing, Cyriacos writes, "My special preference was to revisit . . . [the] greatly celebrated temple of the divine Pallas and to examine it more carefully from every angle. Built of solid, finished marble, it was the admirable work of Phidias, as we know from the testimony of Aristotle's instructions to king Alexander as well as from our own Pliny." Cyriacos goes on to give a detailed description of the Parthenon: "It is raised up on 58 columns: 12 at each of its two fronts, two rows of six in the middle and, outside the walls, seventeen along each side."[28]

Importantly, Cyriacos gives the first documented identification of the Parthenon frieze as a depiction of a contemporaneous historical event, set in the fifth century B.C. He writes, "On the topmost friezes of the walls . . . the noted artist fashioned with outstanding skill [representations of] Athenian victories during Perikles's time."[29] In this letter, Cyriacos invokes the issues that have dominated discussions of the Parthenon ever since: its status as a masterpiece; its authorship and the master sculptor Pheidias; a preoccupation with counting; and, of course, the reading of the frieze as a historical event, set in the days of Perikles. We must ask ourselves whether ancient Athenian viewers would have been preoccupied with these same matters, or whether they merely reflect the tastes and interests of the Italian Renaissance, during which Cyriacos lived.

Cyriacos's drawings suggest that the eye of the beholder very much shaped his vision of the Parthenon. They show distorted proportions and inaccurate placement of the sculptures in relation to the architecture. Fanciful additions, including winged cherubs crowding the west

Cyriacos of Ancona, copy of drawing of Parthenon's west façade in silverpoint and ink.

pediment, betray the influence of popular Renaissance types (above). The tall narrowness of his Parthenon, apparently set on a high podium, is more suited to a Roman temple than to a building of the classical Greek period. Cyriacos's stylish Athena, shown struggling with frisking horses on his version of the west pediment, looks more like a wellborn lady of the quattrocento than a Greek goddess.[30] Her rival Poseidon has been wholly omitted from the composition.

Cyriacos gets his numbers hopelessly wrong, too, from his calculations of the column diameters (5 feet), to the width of the peristyle corridors (8 feet), to the dimensions of the entablature beams (9.5 by 4 feet).[31] We must ask: Why have modern interpreters been happy to accept Cyriacos's view of the Parthenon frieze as a representation of a

historical event even knowing that so many of his other observations are completely off the mark?

The Ottoman Turkish writer Evliya Çelebi visited the Acropolis sometime between 1667 and 1669. Like Cyriacos, he saw the Parthenon very much through his own lens. This colorful courtier, musician, and litterateur recounted his expedition to Greece in the eighth of the ten volumes of his *Book of Travels (Seyahatname)*. This work has been described as "possibly the longest and most ambitious travel account by any writer in any language."[32] By the time Çelebi visited Athens, the Parthenon had been transformed into a mosque, a consequence of the Ottoman conquest of 1458. "We have seen all the mosques of the world," Çelebi writes, "but we have never seen the likes of this!" Çelebi is amazed by the "sixty tall and well-proportioned columns of white marble, laid out in two rows one above the other."[33] He is equally impressed with four great columns of red porphyry set between the prayer niche and the pulpit, beside which stand four additional columns of emerald-green marble. These colored columns were, no doubt, remnants of an earlier phase in the Parthenon's reconfiguration, surviving from its days as a Christian basilica.

Çelebi's enthusiasm for the Parthenon sculptures is palpable. "The human mind cannot indeed comprehend these images—they are white magic, beyond human capacity," he writes. Extoling the "hundreds of thousands of works of art carved in white virgin marble," he observes that "whoever looks upon them falls into ecstasy and his body grows weak and his eyes water for delight."[34] Çelebi further reflects that in these sculptures the "human forms seem to be endowed with souls." His imagination gets the better of him, however, when he attempts a catalog of the figures he sees. "Whatever living creatures the Lord Creator has created, from Adam to the Resurrection, are depicted in these marble statues around the courtyard of the mosque," he writes. "Fearful and ugly demons, jinns, Satan the Whisperer, the Sneak, the Farter; fairies, angels, dragons, earth-beasts; . . . sea-beasts, elephants, rhinoceri, giraffes, horned vipers, snakes, centipedes, scorpions, tortoises, crocodiles, sea-sprites; thousands of mice, cats, lions, leopards, tigers, cheetahs, lynxes; ghouls, cherubs."[35] The mind reels attempting to reconcile Çelebi's report of this fantastical menagerie with what we know of the Parthenon sculptures today.

It is, however, the expedition of the artist James Stuart and the ama-

teur architect Nicholas Revett, organized on behalf of the Society of Dilettanti from 1751 to 1753, that has had the most lasting impact on our understanding of the Parthenon sculptures. The English travelers surveyed, calculated, and drew the Parthenon, presenting their work in a sumptuous multivolume publication, *The Antiquities of Athens: Measured and Delineated*.[36] In volume 2, published in 1787, the authors present drawings of the Parthenon frieze, offering as well an interpretation of what it depicts: the Panathenaic procession.[37] Stuart and Revett identified the cavalcade and chariots moving from west to east along the flanks of the Parthenon as the Athenian army following behind bearers of offerings, musicians, maidens, elders, and those who lead animals to sacrifice (below and pages 160–61 and front of book). In the eyes of Stuart and Revett, the marchers collectively represent the Athenian citizenry celebrating the great city feast of the Panathenaia.[38]

The procession marches toward gods seated either side of a group of five mortals at the very center of the east frieze, positioned just above the door of the temple. We see a woman with two girls, at left, and a man and a child holding a piece of cloth, at right (pages 162 and 165 and front of book). The identification of this scene rests firmly on the assumption that the cloth displayed is the sacred dress, or peplos, of Athena, a gift presented to the goddess as the culminating event of the Panathenaic ritual. But Stuart and Revett first advanced this idea only tentatively and as a query: "May we not suppose this folded cloth to represent the peplos?"[39] Over time, their gentle question has hardened into established dogma.

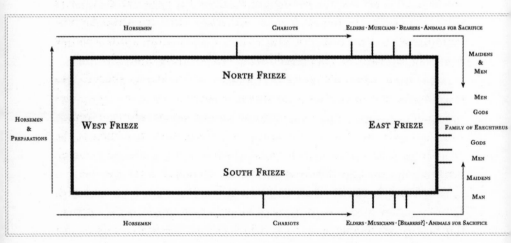

Parthenon frieze, sequence and direction of procession.

Seldom has this view been challenged over the past 220 years, though it has presented enormous difficulties for a coherent reading of the frieze. This central panel of the east frieze has long been called the "peplos scene" or sometimes even the "enigmatic peplos incident," a highly unsatisfactory name for what plainly seems to be the climax of the entire composition,[40] prominently set above the main door of the temple, where anyone entering might look up and see it. Interpreters have struggled to understand whether the image shows the presentation of the new peplos to Athena or the folding up and putting away of the old peplos.[41] This second view would certainly be something of an anticlimax, obliging us to ask why there might be such a postlude in what should be a place of culmination and central meaning.

Scholars have assembled lists of all the elements we should expect to find in a Panathenaic procession, gathered from sources of late classical through Byzantine date. But their lists do not match what we see on the Parthenon.[42] We know that a wellborn maiden, called a *kanephoros* after the basket, or *kanoun,* that she carried, was chosen to lead the Panathenaic procession.[43] But we see no basket bearer on the frieze.[44] Athenian allies are known to have served as tribute bearers in the procession and resident foreign women as water bearers. These, too, however, are absent. At least from the fourth century B.C. but probably even earlier, a wheeled ship-cart transported the peplos, hoisted like a sail up its mast, as it made its way in procession through the Agora and up the Sacred Way to the Acropolis. But this spectacle is nowhere to be seen on the frieze.[45] Above all, we miss the hoplites, the famous foot soldiers who were the heart and soul of the Athenian army from the Archaic period on.[46] If the Parthenon frieze does indeed show a fifth-century Athenian army, the hoplites could not conceivably be omitted.

Equally strange is the presence of figures we would not expect to find in a Panathenaic procession. We see men bringing heavy water jars (pages 192 and 193 and front of book), when we know that it was foreign women who carried water for the Panathenaia.[47] Even more troubling is the anachronistic appearance of chariots, which had not been used in Greek warfare since the Late Bronze Age, some seven hundred years earlier.[48]

The reading of the frieze as a contemporary event set in the fifth century B.C. would also propose a singular exception to all conventions for Greek temple decoration, which consistently derived its subject matter from myth.[49] Indeed, recent work on the function of images in

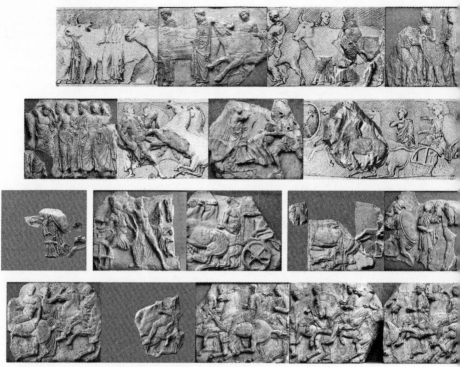

North frieze, Parthenon, showing animals led to sacrifice, offering
bearers, musicians, elders, chariots, and horsemen.

ancient Greece has stressed their primary role as vehicles to help us see
what could no longer be seen, that is, the legendary days of the mythical
past.[50] Visual representations served as markers of memory (*hypomne-
mata* or *mnemeia*) for what once was, and so it seems strange to memo-
rialize the same spectacle that could be observed in the flesh each year
at the Small Panathenaia or every fourth year (on a grander scale) at
the Great Panathenaia. It would not square even with the rest of the
Parthenon's sculptural program. The pediments indisputably show the
birth of Athena and the contest of Poseidon and Athena for patronage
of the city. Its metopes show gods battling Giants and Greeks fighting
Amazons, Centaurs, and Trojans. Why should the frieze depart from
this otherwise mythological program?

This was a question asked repeatedly by the architectural historian
A. W. Lawrence, who followed his famous older brother, T. E. Law-
rence, in the study of archaeology at Oxford. Arnold went on to hold

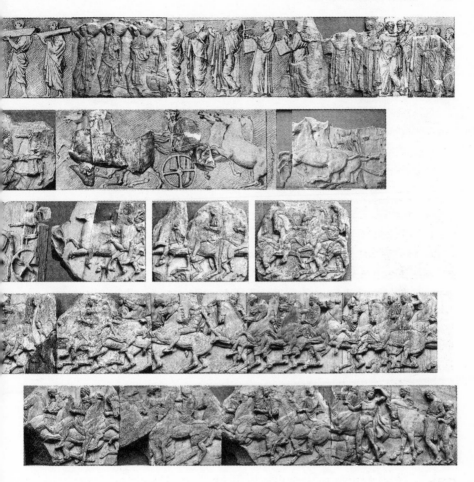

the Laurence Chair in Classical Archaeology at Cambridge from 1944 to 1951. Many of Arnold Lawrence's perspicacious insights have stood the test of time, above all his concern for the anomaly posed by the traditional reading of the Parthenon frieze. "This must have verged on profanation," he writes in his 1951 article "The Acropolis and Persepolis." "At every other Greek temple the sculpture illustrates mythological scenes."[51] Twenty years later, Lawrence reiterated this concern: "Never before had a contemporary subject been treated on a religious building and no subsequent Greek instance is known . . . The flagrant breach with tradition requires explanation."[52]

To be fair, some scholars have argued for a mythological interpre-

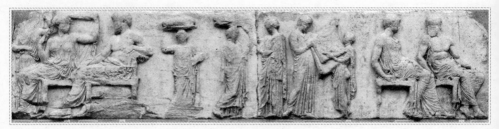

Erechtheus and family flanked by Hera and Zeus (at left), Athena and
Hephaistos (at right), east frieze, Parthenon.

tation, but no known myth could be adduced that adequately fit the
images. Already fifty years ago, Chrysoula Kardara read the central
panel of the east frieze as a representation of the inauguration or first
Panathenaic festival, an overall approach that makes very good sense,
though she did not have the benefit of the surviving text of Euripides's
Erechtheus.[53] Kardara identified the figures in the central panel (above
and page 165) as King Kekrops and the child Erechtheus/Erichthonios
handing over the new peplos to Athena. She saw the female figures at
left of the scene as Mother Earth (Ge) with two of Kekrops's daughters.
Kristian Jeppesen, who likewise wrote before the *Erechtheus* fragments
were found, identified the adult male figure at the center of the scene
as Boutes, brother of Erechtheus, standing with the child Erichthonios.
He saw the female figures at the left as the three daughters of Kekrops:
Herse, Aglauros, and Pandrosos.[54] Some interpreters reject any and all
notions of a unified narrative subject for the frieze, seeing it as a series of
images with multiple meanings. Still others, unwilling to see the frieze
as a snapshot of reality but unable to find a myth to fit, view it as a vague
reference to a timeless, generic Panathenaia.[55]

Burkhard Fehr sees no link whatsoever between the Parthenon frieze
and the Panathenaia.[56] Instead, he reads the frieze as a comprehensive
discourse on Athenian democracy, illustrating the correct behavior of
members of the community within this democratic system. For Fehr,
the central panel of the east frieze presents an exemplum of the ideal
family unit. We are looking at the Greek *oikos* (household) in which a
mother trains her daughters in textile production while the father pre-
sents his young son with a *himation* (mantle), the ultimate symbol of
citizen status.

I HAD NEVER HEARD of the mummies of Pierre Jouguet, let alone the momentous discovery of the papyrus fragments wrapped around them, until a bone-chillingly cold afternoon in a guest room at Lincoln College, Oxford. It was early January 1991, and I was deep into research for my book on Greek priestesses, fast on the trail of Queen Praxithea. Huddled beside an electric fire, I opened Jan Bremmer's *Interpretations of Greek Mythology,* keen to read Robert Parker's article "Myths of Early Athens." Within seconds I forgot the frosty chill of the guest room, enthralled by the tale of the Athenian king Erechtheus and how he sacrificed his daughter to save the city. Why had I never heard of this riveting story in my years of study? And how soon could I get my hands on a copy of Euripides's text?

Lincoln College's resident papyrologist, Nigel Wilson, lived steps away in the front quad. He obligingly lent me his copy of *Nova fragmenta Euripidea,* which I carried across the Turl to the newsstand for photocopying. Holding the Kleine Texte edition down on the flashing glass of a first-generation Xerox machine, I watched as, page by page, Euripides's *Erechtheus* spilled out in one long roll of slippery paper, strangely reminiscent of papyrus scrolls of the ancient past.

I carried the Xerox around with me for the better part of the next six months, working on the fragmentary Greek whenever I could steal a free moment, all the while waiting for a time when I could turn my full attention to the text. World events conspired to bring three full months of unexpected research time the following summer. As director of excavations on the island of Yeronisos off western Cyprus, I usually head for the trenches in May to begin the summer field season. But the dig had to be canceled in 1991, because of Saddam Hussein's invasion of Kuwait and the ensuing first Gulf War. Operation Desert Storm's ground campaign had begun at the end of February, and by spring uncertainty still hung in the air. It was this unforeseen chain of events that grounded me Stateside for a full summer of unscheduled and uninterrupted research. Euripides's *Erechtheus* was the first order of business.

Staring out the leaded windows of Bryn Mawr College's classical seminar room in the Thomas Library, I fixed my eyes on the weeping cherry tree below. It was late afternoon, August 15, and I had finally

finished reading through the fragmentary Greek text. I was stunned by the power of Praxithea's patriotic speech and intrigued by Athena's appointment of Praxithea as first priestess of Athena Polias, and my mind's eye turned to the central panel of the Parthenon's east frieze. I had been poring over it all morning, trying to come to grips with the woman at its very center, the so-called priestess of Athena. Why didn't she hold a temple key, the single attribute that would absolutely confirm her priestly status? Confirm, that is, if she were a historical priestess. But what if she were the first, mythical priestess of Athena, Queen Praxithea herself? Thus two independent lines of inquiry, both in pursuit of the priestess of Athena, collided in a single image shown on the east frieze. Could I be looking at what Euripides is talking about: a family group, with father, mother, and three daughters? And do I see Queen Praxithea, mother and priestess, at the very center of it all?

By November the following year, I stood face-to-face with Colin Austin himself, there in the Cambridge University lecture hall where Anthony Snodgrass had invited me to present my reinterpretation of the Parthenon frieze. I had set aside the priestess book and had worked on nothing else throughout the intervening fifteen months, devouring all I could find on foundation myths, landscape, memory, ritual, sacrifice, drama, democracy, and architectural sculpture. And now I met the man who had first recognized in Sorbonne Papyrus 2328 the words of Euripides himself. Colin held in his hand the Kleine Texte volume containing the *Erechtheus* fragments. As we left with a band of students and faculty making our way to the post-lecture reception, he asked: "Would you like to read it together?" And when we had finished, seated there at the far end of the table of merrymakers, he turned and asked if I would care to read it again. So we went back to the beginning and read the play through for a second time. This was the first of many such encounters and the beginning of an enduring conversation. Colin never stopped learning from the *Erechtheus* fragments and encouraged me to do the same. His untimely death in 2010 sadly brought an end to our wide-ranging discussions, but following his advice, I have continued to learn from all that this remarkably rich text has to teach.

AND SO I OFFER a wholly new paradigm for understanding the Parthenon frieze, one that sees it as a representation of the great founda-

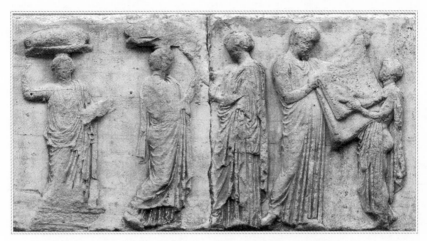

Erechtheus (second from right), Praxithea (center), and daughters
preparing for sacrifice, east frieze, Parthenon.

tion myth from Athens's legendary past.[57] Viewing the frieze against
the backdrop of the story set out in Euripides's *Erechtheus,* we can
understand, for the first time, the momentous family portrait shown in
the central panel of its east side. Mother, father, and three daughters
have embarked on a supreme act of selfless love for their city, an act of
ultimate sacrifice that exemplifies the core values upon which Athenian
democracy was built. The unthinkable will be demanded of this family,
and yet its members will not be found wanting. They shall give their
utmost for the community, laying aside self-interest to serve a greater,
common good.

Understanding these figures as members of a family group enables
us to perceive subtle adjustments in their heights, communicating that
the three girls are sisters of three separate ages (above). The maiden at
far left stands slightly shorter than the girl beside her, while the child at
far right is shorter still.[58] Indeed, the "enigma" of this scene falls away
as we recognize the Athenian royal family: Erechtheus, Praxithea, and
their three daughters.[59]

This portrait group would have been immediately recognizable to
Athenians because of the distinctive presence of three girls. Most royal
families in Greek myth had at least one treasured son. The Athenian
dynasty was unusual for its abundance of daughters and scarcity of
male heirs. As we have seen, by most accounts, Erechtheus had three
daughters, as did Kekrops before him and Deukalion even earlier still.

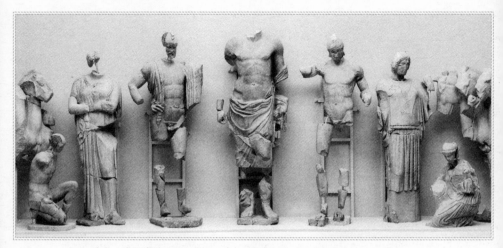

Royal family of Elis preparing for chariot race with Zeus at center,
Queen Sterope and King Oinomaos at left, Pelops and Hippodameia
at right. Olympia, east pediment.

From its first days, then, the Acropolis was inhabited by a profusion of
royal maidens. This is not surprising given that the patron of the city
was a female divinity. There is a synergy and cohesion between the vir-
gin goddess of the city and the virgin daughters of its earliest kings.

If we look to the greatest temple that immediately preceded the Par-
thenon, that of Zeus at Olympia completed in 456 B.C., we similarly find
on its east end the local royal family in a solemn lineup (above).[60] King
Oinomaos of Elis, his wife, Sterope, his daughter Hippodameia, and her
suitor, Pelops, are shown in the pediment rather than on a frieze, but
the parallel is nonetheless strong. The east façade of a temple is always
its most significant: this is the location of the main entrance that faces
the open-air altar upon which sacrifice was offered. Unlike in Christian
churches, Greek altars were located outside and to the east of temple
buildings. This allowed the cult statue to look out through the front
door, to watch and savor the animal sacrifices offered to it. Importantly,
having the front door at the east end of the temple allowed the rising sun
to pour its radiance upon the icon of the divinity each morning. One
must remember, the cult statue was no mere representation of the god
but the divine presence itself. Cult statues therefore needed to be awak-
ened with first light, bathed, dressed, fed, and delighted with animal
sacrifice, offerings, and gifts.[61]

In keeping with the primacy of the east façade, we shall begin our

look at the Parthenon frieze here and work our way westward to the back of the temple. This, of course, is the reverse of the direction that pilgrims would have taken as they entered the Acropolis at the west and walked along the flanks of the Parthenon toward its east end. But this only serves to remind us that the intended primary viewer of the Parthenon sculptures was Athena, not the human visitors. To make sense of the sculptures, then, we must read from the goddess's point of view, beginning at the east, where our narrative starts.[62]

The woman shown at the very center of the east frieze has long been identified as a fifth-century priestess of Athena Polias, a cult title meaning "Athena of the City."[63] Strikingly, though, she lacks the chief iconographic indicator of her sacred office: the temple key. From the Archaic period on, large, rodlike keys served to identify priestesses. These women appear in terra-cotta and stone statuary, on grave markers, and in vase painting,

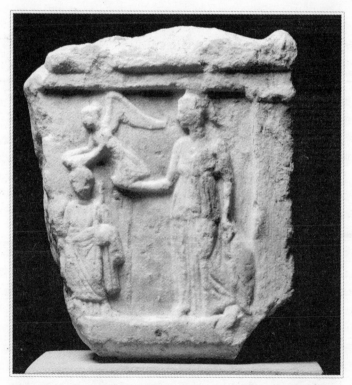

Honorary relief, Athena with Victory crowning priestess at lower left, found on the Athenian Acropolis. Second half of fourth century B.C.

their rank at the top of the temple hierarchy always recognizable by the keys they hold.[64] We need only look to the image of Athena's priestess on a fourth-century B.C. honorary relief found on the Acropolis to see the prominence of the temple key cradled in her left arm (previous page).[65] Raising her right hand in a gesture of prayer, the priestess stands beside the statue of Athena Parthenos. Nike (Victory), perched on Athena's hand, leans over to crown the priestess with honors. We would expect a historical priestess on the Parthenon frieze to look much like this woman on the honorary relief set up on the Acropolis in the late classical period.

The absence of a key in the hand of the woman at the center of the east frieze is, in fact, the catalyst for this entire revisionary study of the Parthenon. For it was in writing *Portrait of a Priestess: Women and Ritual in Ancient Greece* that I first had to account for this so-called keyless "priestess." Ultimately, I had to reject the conventional reading of this scene and open myself to a wider range of possibilities as to whom this female figure represents. *The Parthenon Enigma* is a direct result of this conundrum.

And so, on that August afternoon at Bryn Mawr, the full kaleidoscope of possibilities converged to focus upon a singular realization. The woman shown at the center of the east frieze has as yet no need of a key, for she is none other than the first mythical priestess of Athena, Praxithea herself. In fact, the queen is shown here just before the sacrifice of her daughter, before the goddess proclaimed her a priestess. She lacks the temple key because there was not yet a temple on the Acropolis to be locked or unlocked. Praxithea is, indeed, the Ur-priestess of Athena Polias, and her vibrant story provides the founding myth upon which the historical priesthood would be based.

The bearded man shown behind her has traditionally been identified as the priest of Poseidon-Erechtheus or, alternatively, as the chief magistrate of Athens, the archon basileus.[66] But there is no evidence for the participation of either man in the culminating rite of the Panathenaia, a feast that was ministered by female cult officials.[67] What is distinctive about this man is his costume. He wears the long, unbelted, short-sleeved tunic typically worn by priests, indeed by men who offer sacrifice. Attic funeral reliefs that commemorate priests show them dressed in this same costume.[68] A priest named Simos (facing page) wears it on a marble gravestone of fourth-century B.C. date. Like the

Late classical Attic funerary relief
of priest named Simos. Late fifth/
early fourth century, Athens.

man in the center of the Parthenon's east frieze, Simos strikes a *contrapposto* pose, with weight shifted onto his right leg. In his right hand, he holds the knife of sacrifice, the standard attribute for male priesthood and counterpart to the temple key of female sacred office. The knife identifies Simos as the one who slits the throat of the sacrificial animal.[69]

That the male figure in the center of the east frieze carries no knife argues against his identification as a historical priest of the fifth century B.C. But what man would be standing with Queen Praxithea and her daughters? The mythical king Erechtheus is dressed as a sacrificer as he solemnly prepares to offer his youngest daughter, in accordance with the Delphic oracle. The priesthood of Poseidon-Erechtheus will be established in his memory, just as the priesthood of Athena Polias will remember his wife, Praxithea.

The identity and sex of the child shown at the far right of the scene (following page) are vigorously debated. Is this a girl or is it a boy? The eighteenth-century commentators Stuart and Revett saw the figure as a girl.[70] During the nineteenth century and most of the twentieth, inter-

preters tended to see a boy. In 1975, Martin Robertson, Lincoln Professor of Classical Archaeology and Art at Oxford, reinvigorated the debate, arguing afresh that we have a little girl here. He pointed to the horizontal creases encircling the child's neck as distinctively feminine, indeed as the signs of female beauty sometimes referred to as "Venus rings."[71] John Boardman, Robertson's successor to the Lincoln Professorship, followed in identifying the child as a girl. Employing comparative anatomy of masculine and feminine posteriors, he contrasted the configuration of a boy's bare bottom (page 208), shown on the north frieze, with that of the child shown at the center of the east frieze, concluding that the two children must be of different sexes.[72] Today, the field stands evenly divided between those who see a boy and those who see a girl in this figure.[73]

I would argue that it matters little whether this figure *looks* to the modern eye like a girl or a boy. Archaic and classical Greek artists were so unused to depicting the female nude that when confronted with this challenge, they relied on what they knew best: the male nude. A fine example can be seen on a red-figure vase in Bari, Italy, showing nude girls exercising (facing page).[74] They are endowed with well-developed

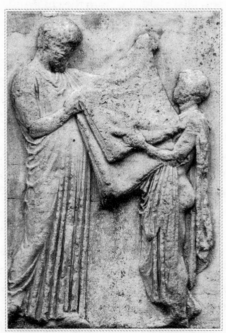

Erechtheus and daughter displaying her funerary dress, east frieze, Parthenon.

Women exercising in palaistra. Krater, from Rutigliano. Bari, Museo Civico, Italy.

masculine physiques, heavy musculature approaching that of body-builders. The girls' breasts emerge implausibly from their armpits, as if afterthoughts.

Anatomical analysis will not provide the answer as to the child's sex. For this we must depend on context. Those who see a boy must construct an unattested scenario in which a temple boy participated in the culminating ritual of the Panathenaia.[75] Within the context of Greek religion, which regularly required that female attendants serve the cults of female divinities, especially in the case of virgin goddesses, it would be very surprising to find a boy involved so prominently in the sacred rite of Athena.[76]

What of the cloth? Athena's peplos was, from the very start, women's work. Wool from which to weave it was washed and carded by virgin hands. The little fingers of prepubescent girls, known as *arrephoroi*, set its warp under the supervision of Athena's priestess. A team of noble-women known as *ergastinai*, or "worker-weavers," labored at their looms to produce the dress over a nine-month period that corresponded to the gestation term of a baby.[77] It is unlikely that such care would be taken with the sacred garment only for it then to be "manhandled" by a priest and a boy. Indeed, within the context of Greek ritual, male hands might even have been perceived as contaminating, entirely unsuited to

touching the goddess's dress. Surely it was the priestess who presented the peplos to Athena, just as in the *Iliad* the Trojan priestess Theano offers Athena a beautifully woven fabric in supplication.[78]

Those who view the child as a girl usually identify her as one of the historical *arrephoroi*, a pair of seven- to eleven-year-old girls selected from prominent citizen families to serve on the Acropolis for a festival cycle.[79] Their cult title signals that they carry "unnamed" or "secret" things, the *arreta*. The girls participated in a special nighttime ceremony, the Arrephoria, in which they transported the "unnamable things" down the slopes of the Acropolis.[80] Later, they carried something else back up again. The girls also served at the festival of the Chalkeia, during which they helped with the warping and weaving of the peplos. But, as we've said, the *arrephoroi* are always mentioned as acting in pairs, sometimes two pairs together, probably representing the outgoing and the incoming teams of two. That the child shown at the far right of the central panel has no partner makes it unlikely that she represents an *arrephoros*.[81]

When viewed with reference to the foundation myth, however, this child may be identified as the youngest daughter of King Erechtheus and Queen Praxithea. She is about to be sacrificed at the hand of her father, who is dressed as a priest for the event. Apollodoros tells us that Erechtheus sacrificed his youngest daughter first.[82] The girl's dress is, very conspicuously, opened at the side, revealing her nude buttocks. It would be unthinkable for a historical girl, an *arrephoros* from an elite family, to be portrayed with backside casually exposed during the most sacred moment of the Panathenaic ritual.[83]

I would argue that the girl's nudity is not accidental. Her garment is open to communicate that she is in the process of changing clothes. Removing her everyday attire, our heroine is about to put on her funerary dress, a great winding sheet that she and her father hold up for all to see. Through a pictorial device known as "simultaneous narrative," the artist compresses present and future events into a single image.[84] We see the dressing ritual of the present and anticipate the virgin sacrifice that is to follow moments later, its imminence betokened by the shroud.

In the Greek world, young women who died before marriage were buried in their wedding dresses.[85] Therefore, in Greek tragedy, we find maidens headed for death changing, in advance, into their bridal/ funerary robes. In the *Trojan Women*, Euripides presents the princess-

Polyxena sacrificed by Neoptolemos at tomb of Achilles near Troy.
Tyrrhenian amphora by the Timiades Painter, ca. 570–560 B.C.

prophetess Kassandra as she is taken from Troy, dressed as a bride for
Agamemnon.[86] In fact, Kassandra is dressing for her murder at the hands
of Klytaimnestra. So, too, in *Iphigeneia at Aulis,* Euripides presents his
heroine all decked out in her wedding finery (*kosmos*), complete with
a bridal crown (*stephane*), as she prepares for what she thinks will be
her marriage to Achilles.[87] Actually, of course, Iphigeneia is going to her
death.

Some skeptics view the folded fabric in the so-called peplos scene
as being too large for the funerary dress of a sacrificial maiden. But
throughout Greek tragedy special emphasis is placed on the voluminous-
ness of the garments worn by virgins as they go to sacrifice. Viewed as
an expansive winding sheet, the cloth displayed on the Parthenon frieze
is entirely appropriate for dressing the little Erechtheid. In Aeschylus's
Agamemnon, Iphigeneia is described as being "wrapped round in her
robes" as her father leads her to the altar.[88] The word used here is *pep-
loisi,* the plural of *peplos,* suggesting several fabrics wrapped entirely
around Iphigeneia. Before the maiden Makaria is killed in Euripides's
Children of Herakles, she asks her father's companion Iolaos to veil her
with *peploi,*[89] likewise indicating a plurality of veils. Little remains of a
lost play by Sophokles called *Polyxena* that dramatized the sacrifice of
King Priam's youngest daughter at the tomb of Achilles. Nonetheless,
a surviving fragment refers to Polyxena's "endless" or "all enveloping"

tunic (*chiton apeiros*), further attesting that the draping of the maiden as she is led to be killed is no small matter.[90]

The violence of Polyxena's death is explicitly portrayed on a sixth-century B.C. amphora in London (previous page).[91] The princess of Troy is held horizontally high above the altar just the way an animal is raised as it is sacrificed.[92] Achilles's son, Neoptolemos, slits Polyxena's throat. Great streams of blood burst forth. Most distinctive here is Polyxena's costume. Her arms are wrapped inside what is truly an "all enveloping" garment, a vast winding sheet woven with elaborate patterned decorations. Polyxena is already fully enfolded in her shroud as her neck is cut.

On the central panel of the Parthenon's east frieze, the young daughter of Erechtheus, just like Polyxena, Iphigeneia, and Makaria, must be veiled in voluminous fabric as she goes to her death. Just as one decorated a sacrificial animal, wrapping ribbons around its horns, so, too, one dresses up a virgin for sacrifice, draping her in beautifully woven garments evocative of bridal costume.

I maintain that the central image of the east frieze should be read as a dressing scene, a *kosmos,* or adornment of the maiden, just prior to sacrifice. The fact that we are shown a moment prior to the bloody climax is in keeping with the conventions of Greek art of the high classical period. We should not expect to see the altar of sacrifice, the knife that will slit the throat, or any of the blood and gore so obvious as in Archaic depictions of virgin sacrifice.[93] Images like that on the Polyxena vase are out of fashion by the 430s B.C. So, too, is the scene depicted on a white-ground lekythos in Palermo showing Agamemnon leading Iphigeneia to the sacrificial altar.[94] To be sure, the knife is shown in Agamemnon's hand. But this vase predates the Parthenon frieze by sixty years, reflecting an Archaic taste for the gruesome detail of the culminating act. By the time the Parthenon frieze is carved in the 430s, the approach is more sophisticated, favoring anticipatory tension over graphic violence.

Still, it must be said that there are few surviving representations of human sacrifice in Greek art before the fourth century B.C. It is an extraordinary subject, confined to extraordinary contexts. One can hardly speak of established conventions for it in Greek art. One of the reasons that the "peplos scene" has remained such a puzzle is that it shows an uncommon event for which no standard iconography exists.[95]

Both in visual and in dramatic arts, the high classical period saw

tastes move away from earlier preference for the explicit, favoring the subtler pleasure of expectation over the high drama of execution. The vogue for understatement can be seen in the famous statue of a discus thrower, the *Diskobolos,* attributed to the sculptor Myron and dated to the middle of the fifth century B.C.[96] In the many copies of this work, we see the nude athlete crouching, rotating, and lifting the discus high behind him. Tightly wound like a spring about to be released, the athlete is captured in a split second of maximum potential prior to the kinetic burst of hurling the discus. Myron became so associated with this "pregnant" instant before the climax that we speak today of the "Myronic moment" when describing statuary of the period. Similarly, in classical Greek drama, climactic death scenes are never shown onstage but, instead, are recounted to the audience by messengers.

This same principle can be seen in the east pediment of the temple of Zeus at Olympia (page 166). Without Pausanias's description of the central scene as the preparation for the chariot race of Pelops and Oinomaos, we might never guess who was who among the dignified and somber figures. Would we catch the subtle reference to the impending action, hinted at in the crouching figure of the untrustworthy groom tampering with the chariot wheel?[97] A tragedy is about to occur: Pelops will cheat in the chariot race, and King Oinomaos will be killed. The Parthenon's east frieze, like the east pediment at Olympia, shows the local founding family in its own "pregnant" moment solemnly preparing for the awful outcome.

These iconic images of the founding families of Athens and Olympia were created exclusively for their respective contexts: the primary temples of each sanctuary. Neither the family group on the Parthenon's east frieze nor the family group on the Olympia east pediment has iconographic parallels in vase painting or sculpture. Nor would any clues to their subjects have been needed at the time. Greeks at Olympia would have not only recognized but expected to see a reference to the local foundation myth in the place of prominence on Zeus's temple. So, too, would the Athenians have instantly recognized the royal house of Erechtheus. Indeed, Greeks on the whole were accustomed to the depiction of prominent families, both heroic and divine, in their visual culture.[98] But the impulse to connect the general population to the first family was nowhere more spiritually urgent or politically motivated than at Athens. To see the Erechtheids at the center of this central sculpture of

Serving boy bringing clean clothes to Kastor and Polydeukes; at right, their father, King Tydareos. Amphora, by Exekias, ca. 540 B.C.

the preeminent temple itself represents a kind of culmination, that of the larger program of genealogical narrative we have seen at work on the Acropolis since the Archaic period. It is also a culmination of that narrative's societal function.

The two older girls at the far left of the panel have never fit comfortably into the historical reading of the scene (page 165). While many scholars have identified them as the two *arrephoroi* who figured so importantly in the rituals of Athena,[99] the pair are clearly too old to fill a post reserved for seven- to eleven-year-old girls. Their costumes, a tunic (*chiton*) beneath a mantle (*himation*), are the standard dress for adult women, not prepubescent girls, who regularly wore the peplos. Costume is an important indicator of age and here precludes the possibility that these young women could be *arrephoroi*.[100]

Upon their heads, the maidens carry what appear to be cushioned stools. It is imagined that these are for the two adult figures, the "priestess of Athena" and the "priest of Poseidon-Erechtheus," to sit on.[101] Some believe that these "sacred officials" are destined to join the assembly of divinities shown to either side of the central panel. Already in 1893, Adolf Furtwängler expressed the opinion that the priest and the priestess are about to sit down to share a sacred meal with the gods, the so-called Theoxenia (page 162).[102] But this reading poses problems. Can

historical individuals join a group of invisible immortals?[103] And why should the priest and priestess have cushioned stools when all but two of the gods (Dionysos and Artemis) do not?

Sometimes a stool is not just a stool. In the Greek world, it was used not only for sitting but also for transporting clean clothes, especially precious garments not to be sullied by unnecessary handling, elaborately woven fabrics that were enormously expensive, representing countless hours of labor at the loom. Images from vase painting regularly show such finery carried on stools. A black-figured amphora by Exekias presents a serving boy bearing clean clothes on a stool carried upon his head (facing page).[104] These are intended for the twins Kastor and Polydeukes, young princes of Sparta (brothers of Helen), who arrive at the left of the scene. The little servant also carries a jar of oil, suspended from his wrist, a further signal that the twins are about to wash, perfume themselves, and change. The fabric on the stool appears rounded from the front, where it is folded over, and squared off from behind, where we see its opened ends. Were we to view the boy head-on, the bundle would appear rounded and cushion-like, just like that carried by the girls on the Parthenon frieze.

A red-figured jug in the Metropolitan Museum of Art presents two women perfuming richly woven fabrics on a swinging stool suspended

Women perfuming fabric on swinging stool. Oinochoe, Meidias Painter, ca. 420–410 B.C.

above a fire (previous page).[105] One bends down to pour fragrant oil on the embers while the other tends the clothing. Here, as on the Exekias vase, we see bundles of fabric representing not seat cushions but folded garments. In its original state, the Parthenon frieze would have been painted, and lively details of the fabric, its woven decoration, creases, and folds, would have made its identity clear.

In the Greek world, there were three great necessities for such elaborately woven fabrics: the baby's swaddling clothes, the bride's wedding dress, and the corpse's shroud. The word "peplos" applies to all three; indeed, it simply means an "uncut length of heavy woolen cloth." Depending on the context, we find the word "peplos" translated as "robe," "dress," "tapestry," "awning," "swaddling clothes," and "shroud."[106] The weaving of fabrics with figural designs took many months, even years, and would have been one of the chief occupations of women within the Greek household. Penelope is the archetypal woman at the loom, painstakingly weaving (and unweaving) a shroud for her father-in-law, Laertes, across the years of her husband's absence, as recounted in the *Odyssey*. Shrouds were prepared well in advance, anticipating the deaths of family members. Even to this day in certain Greek families, luxury sheets or embroidered cloths are set aside for the wrapping of bodies at the time of burial.

From antiquity through the Middle Ages, the shroud was a highly charged signifier, proof that a death had occurred. One need only think of the rich symbolism invested in the so-called Shroud of Turin, which, forgery or not, has so potently symbolized the death and resurrection of Christ.[107] The presence of three shrouds in the central panel of the Parthenon frieze clearly communicates that three deaths are imminent. The stark white flesh of the youngest daughter, caught in the process of changing into her funerary dress, signals the impending tragedy is already in train, the time of sacrifice ineluctably near.

By this new reading we have three girls preparing for death (page 165). The youngest goes first, so her peplos is being unfolded and displayed. The oldest daughter, second from left, is handing her stool to her mother. The daughter at far left stands frontally, her garment still folded and carried upon her head. According to the myth, the oracle at Delphi had demanded the death of one daughter. Apollodoros tells us this was to be the youngest of the three.[108] Praxithea and Erechtheus agree to that girl's sacrifice, unaware that the sisters have pledged the

famous oath, that if one of them should die, so will the others. That the other two are shown carrying their own funeral dresses with unannounced plans of leaping from the Acropolis ironically foreshadows an even greater sacrifice than the parents expected to make.

What is the object cradled in the arm of the girl at far left? Though damaged and difficult to read, the shape of a lion's paw has been deciphered at its lower right corner.[109] This has led to its identification as a footstool, presumably for use with one of the stools carried by the girls.[110] Lion's paws, however, are used to adorn not only footstools but the legs of small metal chests, including jewelry boxes. Images from vase painting regularly show such boxes cradled in the arms of serving maids. Reading the frieze panel as a dressing scene prior to virgin sacrifice, we can understand this object to hold the precious ornaments with which the maiden offering will be adorned.[111] The second-century A.D. orator Aelius Aristides described the preparations for the sacrifice of Erechtheus and Praxithea's daughter as follows: "And her mother, dressing her up, led her just as if she were sending her to a spectacle."[112]

A red-figured pyxis in Paris provides an excellent parallel for this dressing scene. It shows preparations for the costuming of a maiden about to be married (below).[113] The bride is seated at the left and looks up at the wedding dress dramatically held out to her by a serving maid.

Bridal *kosmos* with dress and jewelry displayed before bride. Pyxis, Painter of the Louvre Centauromachy, ca. 430 B.C.

Andromeda dressed for sacrifice to sea dragon, Ethiopian servants bring clothing and jewelry. Pelike, workshop of the Niobid Painter, ca. 460 B.C. © 2014, Museum of Fine Arts, Boston.

At far right, a second servant carries a small metal box containing the bride's jewelry, the finishing touches to her wedding *kosmos*. The same can be seen on the Parthenon's east frieze. Father and sacrificial daughter display the funerary dress she is about to put on. At left, one of her sisters carries the box of jewelry with which she will be adorned just prior to her sacrifice.

The princess Andromeda, lashed to stakes and left for an insatiable sea dragon, is depicted in Greek vase painting with very similar iconography.[114] When a sea monster terrorized the Ethiopian coastline, the Delphic oracle proclaimed that the beast could be placated only through the sacrifice of the king's daughter. And so Andromeda was led to a cliff overlooking the sea and chained to great rocks to prevent her from fleeing, should she not agree with her father's act of selflessness. A red-figured vase in Boston shows the princess in her finest raiment and jewelry, ready to meet death (above).[115] An Ethiopian servant approaches from the left, upon his head a folding stool with a small chest resting atop what appears to be a cushion but what surely represents the clean and carefully folded fabric of Andromeda's funerary dress.

On the reverse of the vase (facing page), a second black attendant

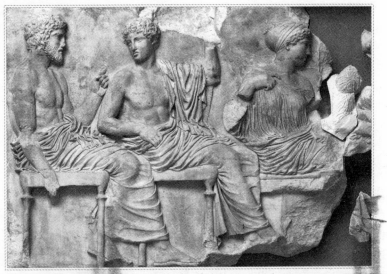

Poseidon, Apollo, and Artemis, east frieze, slab 6, Parthenon.

Erechtheus and daughter display fabric, Athena and Hephaistos turn away, east frieze, Parthenon. Stuart and Revett, *Antiquities of Athens* 2: Pl. 23.

Athena's body language would then suggest a callous rejection of her people's gift (above), an event without sense or precedent.[119]

But radically reimagining the central image of the Parthenon's east frieze allows the puzzle pieces to fall into place. Assuming a scene of preparations for virgin sacrifice makes the averted gazes of the flanking figures perfectly comprehensible: not only is it improper for gods

King Kepheus oversees sacrifice of his daughter
Andromeda; Ethiopian servant approaches. Pelike,
ca. 460 B.C. © 2014, Museum of Fine Arts, Boston.

carries in even more trimmings for Andromeda's *kosmos:* another jewelry box and a small jar of fragrant oil. Indeed, more is more when it comes to dressing up a virgin victim for sacrifice. Andromeda's forlorn father, King Kepheus, gravely supervises the preparations, rather as King Erechtheus does on the Parthenon frieze, creating the same excruciating anticipation. In both images, we have the tragic ambiguity of a dressing ritual equally befitting a wedding and a virgin sacrifice.

Two groups of six seated Olympians turn their backs on the central panel of the east frieze (pages 162, 182, and 185). To the south we see Hermes, Dionysos, Demeter, Ares, Hera, and Zeus. Just beside Hera stands a winged figure who is variously identified as Nike, Iris, or Hebe (goddess of youth).[116] At the north side we find Athena, Hephaistos, Poseidon, Apollo, Artemis (following page), Aphrodite, and a standing Eros.[117] Strangely, the gods turn their backs on the goings-on of the central panel, looking out toward the groups of men and maidens filling the rest of the east frieze. Were this a historical Panathenaic procession, the gods would certainly be taking notice of the culminating moment of the ritual.[118] If it were the presentation of the peplos to Athena, the goddess would hardly be so indifferent to her own birthday offering.

to watch mortals die, but it would defile their divinity. In Euripides's *Alkestis,* Apollo must leave before Alkestis dies, "lest pollution taint me in this house." So, too, in Euripides's *Hippolytos,* Artemis makes it clear that she must not watch the death of Theseus's son: "Farewell: it is not lawful for me to gaze upon the dead, nor to trouble my eye with the dying gasps of mortals, and now I see that you are near the end."[120] Aelian, writing in the second or third century A.D., gives an account of a comic poet's dream. In it, the nine Muses must leave the poet's house just before his demise.[121]

On what occasions do gods assemble in the manner of the Parthenon's east frieze? In the *Iliad* we find them convening atop Mount Ida to watch mortals in the Trojan War combat below. The gods cheer their favorites. In Greek architectural sculpture such "councils of the gods" always appear on the *east* end of temples and regularly for the purpose of watching battles. The Siphnian Treasury at Delphi, a building dated sometime before 525 B.C., shows the first continuous sculptured Ionic frieze in Greek architecture. On its east side, we find the gods seated on stools, one after another, just as on the Parthenon frieze, suggesting a clear influence (below).[122] On the Siphnian Treasury, it is the Trojan War that commands the collective Olympian attention, a particular clash between Achilles and Memnon over the body of Antilochos.[123] Gods supporting the Trojan Memnon—Ares, Aphrodite (or Eos?), Artemis, and Apollo—sit at the left; those in Achilles's corner at right:

Ares, Aphrodite (or Eos?), Artemis, Apollo, and Zeus, east frieze, Siphnian Treasury, Delphi.

a missing figure (probably Poseidon), followed by Athena, Hera, and Thetis. Between these two groups, we find Zeus enthroned.

A council of the gods also appears on the east frieze of the temple called Theseion (and/or Hephaisteion) in the Athenian Agora. Construction of this temple was begun sometime between 460 and 449 B.C., though it was not finished or dedicated until much later, around 416.[124] The sculptured friezes on its east and west porches were probably carved in the 430s or 420s, after the completion of the Parthenon. At the center of the east frieze, just above the porch, we see a battle that has been variously identified as Greeks versus Trojans, Theseus battling Pallas and his sons, and gods versus Giants.[125] Judith Barringer has offered an attractive suggestion, identifying the scene as representing the war between early Athenians and the people of Atlantis, a clash from the antediluvian past, famously referenced in Plato's *Timaeus*.[126] Six divinities sit in attendance, three to either side of the central combat. The identities of those at right are uncertain: Poseidon or Hephaistos (?), Amphitrite (?), and one illegible figure. To the left we see Athena, Hera, and Zeus, seated on rocky outcrops.

Barringer laments the fact that there are no iconographic parallels for an Atlantis-versus-Athens showdown, but this would seem perfectly in keeping with the site specificity of such a temple sculpture. The iconography of the Parthenon's east frieze, like the east pediment of Zeus's temple at Olympia, is also unexampled in contemporary sculpture or vase painting. And this is precisely what has led to the great enigma concerning its subject. Our best guide in such temple mysteries is the ultimately genealogical function of architectural sculpture; it demands the telling of local versions of myths, grounding the formula in specific landscapes, cult places, family lines, and divine patronage. And so iconography, far from hewing to a general repertoire throughout the Greek world, can be as maddeningly variable and contradictory as myth itself.

A third frieze featuring an assembly of gods stands just meters away from the Parthenon. The little temple of Athena Nike was built at the very western edge of the Acropolis in the 420s B.C. and finished during the teens of the century (page 225).[127] Its east frieze shows a lineup of divinities whose identities are debated. Nonetheless, some of them have been named, from left to right: Peitho, Eros, Aphrodite, and, farther along, Leto, Apollo, Artemis, Dionysos, Amphitrite, and Poseidon, with a fully armed Athena, standing at the center of the composition. The god shown

just to her right is probably Hephaistos. Next, we see Zeus, enthroned, and then Hera, Herakles, Hermes, Kore, Demeter, the Graces, and Hygieia.[128]

The gods are gathered here to watch the battles that rage around the other three sides of the Nike temple. Greeks fighting Greeks appear on the north and west, and Greeks fighting horsemen in eastern costume are seen at the south. This south frieze has been the focus of particular debate concerning just who this eastern enemy might be. One understanding sees them as Trojans. Another, advanced by Chrysoula Kardara, holds that all three sides of the temple show Erechtheus's war with Eumolpos, the soldiers in eastern costume being the Thracian mercenaries who fought on the side of Poseidon's son.[129] Still other scholars have argued that the frieze shows scenes from the Persian Wars, with Greeks fighting the troops of Darius at Marathon or the army of Xerxes at Plataia.[130] This interpretation obviously suggests images of historical

East frieze, Parthenon, showing groups of maidens, men, gods, and the family of Erechtheus.

battles rather than mythological ones. If true, it would place the south frieze of the Nike temple well outside the conventions for Greek temple decoration with its traditionally mythological subject matter. Some would counter this objection, however, saying that by the end of the fifth century the Battle of Marathon had taken on mythical proportions of its own as a "modern legend" and was thus fair game for memorializing in architectural sculpture.

These patterns give one good reason to conclude that the gods on the east frieze of the Parthenon have gathered to watch a mythical battle, that of Erechtheus and Eumolpos, which has finished. They now sit as a group ready to receive the thanksgiving sacrifice through which tensions will be ritually resolved (previous page and front of book). The gods have properly turned their backs on the scene of preparation for the virgin's death (the *sphagion*, or preliminary sacrifice), looking out toward the procession that approaches from the other three sides of the temple. This procession brings animal offerings for the post-battle, thanksgiving sacrifice that follows the Athenian victory. The Parthenon frieze can thus be understood to show not just some historical Panathenaia but the very first Panathenaia, the foundational sacrifice upon which Acropolis ritual was based ever after. The offerings of cattle and sheep, of honey and water, as shown on the north and south friezes, are all made in honor of the king and his daughters as described in Euripides's *Erechtheus*.[131] The cavalcade of horsemen is the king's returning army, back from the war just in time to join the procession celebrating their victory.[132]

The mythical human sacrifice offered before battle is, thus, separated by the divine assembly from the thanksgiving sacrifice offered after the battle, the immortals filling the interval between that which is just before and that which is just after. The plenitude of early Athenian society is represented by the groups of elders, maidens, horsemen, and youths marching east toward the central spectacle. On account of its selflessness, the royal family is shown deified, taking their rightful places at center among the gods. Indeed Cicero tells us that Erechtheus and his daughters were worshipped as divinities at Athens.[133] The placing of the royal family within the midst of the Olympian gods is wholly in keeping with the temporal conceit of the frieze, which "reconciles" the time just before and just after the battle.

To either side of the divine company, we find two groups of cloaked men: six at the south and four at the north (previous page and facing page).

Group of men, east frieze, Parthenon.

Group of maidens, east frieze, Parthenon.

Some are bearded, some clean shaven, several are shown leaning upon sticks. Like much else, the identity of these men is debated, along with their numbers and what their numbers signify.[134] Four additional men can be seen at the north, and one man at the very south corner of the east frieze.[135] These are traditionally identified as parade marshals, those

charged with keeping order in the procession. Two of these "marshals" have been further classified as *teletarches,* that is, officials in charge of the ceremony.[136]

When these cloaked men to either side of the gods are counted as ten, they are identified as the Eponymous Heroes, brave individuals from the mythical past whose names were assigned to the ten tribes of Athens when the Kleisthenic democracy reorganized them in 508 B.C.[137] When counted as nine, they are seen as the archons of Athens, the tenth conscripted to the center of the "peplos scene."[138] For this to work, one of the men on the east frieze must be subtracted and identified as a parade marshal. One scholar who counts the men as nine sees them, instead, as the *athlothetai,* a group of officials who administered religious and athletic matters for the Panathenaia. This reading gives nine *athlothetai* standing to either side of the gods with a tenth official seen in the mature male figure at the center of the east frieze.[139] The men have also been identified as lesser Athenian deities and, more simply, as generic citizens.[140] The counting and naming of the men on the east frieze is a dizzying and highly subjective enterprise. From the so-called marshals, heads can be added or subtracted to achieve a particularly significant number of heroes or officials.

But whoever these men are, they are clearly related to the groups of maidens marching just beside them. Whether mythical kings, heroes, or generic Athenians from the legendary past, these men are likely to represent the fathers, uncles, brothers, or other male kin of the young women shown next to them at the far ends of the frieze (page 185, previous page, and front of book). Juxtaposition of fathers and daughters would echo the special relationship of Erechtheus and his daughters featured in the central panel. It would also be a profound statement of the necessity for participation by citizens of all stations, both male and female, in securing the common good, the ultimate democratic virtue being to give oneself for the sake of the polis.

As we have seen in chapter 3, in 451/450 B.C. Perikles introduced radical new legislation by which Athenian citizenship would pass only to those with both a mother and a father from citizen families. Previously, the honor passed through the father's line alone. Men had been free to marry foreigners or non-Athenian Greeks and still have children who were citizens. But the Periklean citizenship law, by limiting the pool of marriageable prospects, gave a powerful new status to Athenian

women, now much sought after as brides.[141] The grouping of men and maidens on the east frieze of the Parthenon may express the newly mandated purity in the Athenian bloodline. By assuring that all citizens had two inherited ties to the land, being descended on both sides from the legendary ancestors, the new regime for legitimate marriage reinforced group solidarity and civic identity as never before.

Maidens dominate the east frieze, thirteen at the north and sixteen at the south.[142] They march in pairs and carry libation bowls, jugs, and what may be incense burners. I maintain that they represent the sacred maiden choruses that Athena instructs Praxithea to establish in memory of her deceased daughters. In the *Erechtheus*, Athena proclaims, "To my fellow citizens I say not to forget them over time but to honor them with annual sacrifices and bull-slaying slaughters, celebrating them with holy maiden dancing choruses."[143] What we see are the mythical predecessors of the girls who would keep the all-night vigil for the Panathenaia, the *pannychis*, during historical times.[144] The fact that there are so many female figures, thirty-three in all, on the most important side of the temple speaks to the extraordinary significance of women in the foundational myth of Athenian identity.

LEAVING THE EAST FAÇADE and turning the corners to the north and south sides of the Parthenon, we find animals being led to sacrifice. On the south frieze there are ten cows and on the north frieze four cows and four rams (pages 160, 190, 191, and 197). Already in the *Iliad* bulls and rams are specified as offerings made to Erechtheus: "To him Athenian youth make sacrificial offerings, with bulls and rams as each year comes around."[145] We will remember that at the end of the *Erechtheus*, Athena instructs that the deceased king be honored: "On account of his killer, he will be called, eponymously, Holy Poseidon-Erechtheus, by the citizens worshipping in cattle sacrifices."[146] Two inscriptions found in Athens further attest to sacrifices made to Erechtheus. One mentions "a ram for Erechtheus," and another, very fragmentary text mentions a "bull," and just possibly, an "ox" or bull, and "a ram."[147]

Behind the animal offerings, on the north frieze, march three male offering bearers with trays (*skaphai*) and four youths carrying water jars (*hydriai*)[148] for the sacrifice (pages 161, 192, top, 193, and front of book). The south frieze (pages 196–97), which has suffered so much damage,

Youths leading cattle to sacrifice, north frieze, Parthenon.

preserves just a fragment of one male tray bearer. This is enough, how-
ever, to suggest that there was a second group carrying trays here as
well. The ninth-century lexicographer Photios tells us that the tray bear-
ers were foreigners, resident aliens (*metoikoi*) at Athens, and that they
wore purple chitons in the procession. Importantly, he tells us that the
bronze and silver *skaphai* they carried were filled with honeycombs and
cakes.[149] And indeed, in the tray of one *skaphephoros* from the north
frieze we can make out textured cross-hatching very much like that of a
honeycomb, best viewed in a plaster cast of the sculpture in Basel (page
192, bottom, and page 193, far left).[150]

Honey is an offering associated with underground, chthonic deities,
not Olympians like Athena.[151] But in the *Erechtheus*, Athena unambigu-
ously instructs that libations for the dead princesses should include only
honey and water and *not* wine. The goddess ordains that prior to all
battles the daughters of Erechtheus be propitiated: "Make to these, first,
a preliminary sacrifice before taking up the spear of war, not touching
the wine-making grape nor pouring on the pyre anything other than
the fruit of the hardworking bee [honey] together with river water."[152]
The explicit combination of these two offerings carried by men bearing
trays and men carrying heavy bronze water jugs on the Parthenon frieze

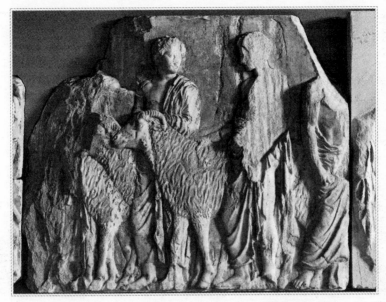

Youths leading ewes to sacrifice, north frieze, Parthenon.

surely refers to this special libation ordained by Athena for the daughters of Erechtheus.

The goddess goes on to give instructions for the building of a shrine for the dead princesses, one with forbidden access: "It is necessary that these daughters have a precinct that must not be entered [*abaton*], and no one of the enemies should be allowed to make secret sacrifice there."[153] We can now understand just why the chthonic gift of honeycomb is so appropriate for the daughters of Erechtheus, buried as they are together in their common "earth-tomb." The sisters have returned to Gaia (Ge), from which their own father was born and to which he will unexpectedly return when swallowed by a chasm created by Poseidon. Thus, Erechtheus leaves this world as he came into it, directly through Mother Earth.

A neat parallel for honey offerings in metal *hydriai* has been discovered at an underground sanctuary at Poseidonia (Paestum) in southern Italy: nine bronze water jugs filled with a molasses-like substance that appears to be honey, apparently deposited in the late sixth century B.C. The shrine was dedicated to a chthonic deity, most likely Persephone—or, possibly, a group of nymphs, to judge by a vase found nearby with the inscription "I am sacred to the nymphs."[154] We should not forget

North frieze, Parthenon, surviving slabs and lost figures known from the
Nointel Artist, showing tray and water jug bearers, pipe and lyre players,
by George Marshall Peters.

that the daughters of Erechtheus are also children of the naiad nymph
Praxithea, and thereby granddaughters of the river Kephisos. Libations
of river water entirely befit their genealogy. Furthermore, the daughters
of Erechtheus might have had their own special connection with Per-
sephone. Like the Erechtheids, Persephone was just a maiden (Kore)
when she was snatched into the underworld by Hades. According to
Demaratus, it was Persephone who received the sacrifice of Erechtheus's
daughter. And at the very end of the *Erechtheus*, one line starts with the
name "Demeter," Persephone's mother.[155]

Returning to the frieze, we see musicians marching (above and page
161) just behind the offering bearers. On the north side, these include
four playing the *aulos* (a double reed, similar to the oboe) and four the
kithara (a seven-stringed lyre). This stretch of the frieze was largely

Plaster cast of tray bearer carrying honeycombs, figure N15,
north frieze, Parthenon.

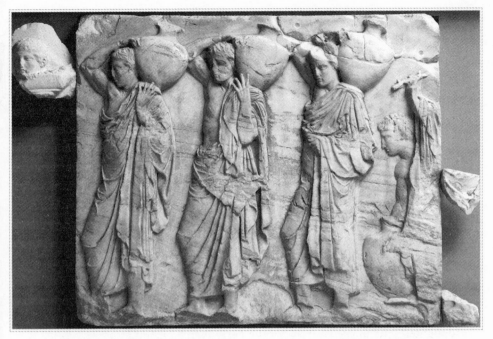

Tray bearer (N15) and men carrying water jugs, north frieze, Parthenon.

destroyed by the Venetian cannon fire of 1687, but it can be recon-
structed, thanks to drawings the Nointel Artist made thirteen years
earlier. And a few fragments of one kithara player survive in Athens to
give us a sense of what the figures looked like. The comparable stretch
on the south frieze is entirely missing. Some of this, too, was lost to the
Venetian explosion and some of it deliberately cut out to make windows
when the Parthenon became a cathedral in the thirteenth century. The
drawings of the Nointel Artist are, once again, invaluable; they con-
firm a matching group of musicians here on the south side (page 197,
second row from bottom). Now Euripides explicitly refers to the aulos
and kithara in a choral song from his *Erechtheus,* perhaps inspired by
the musicians shown on the Parthenon frieze. The old men of the chorus
ask, "Shall I ever shout through the city the glorious victory song, crying
'*Ie paian*' [an exclamation of triumph], taking up the task of my aged
hand, the Libyan pipe sounding to the kithara's cries?"[156]

Behind the musicians march groups of older men, sixteen on the
north frieze and seventeen or eighteen on the south (pages 160–61, fol-
lowing page, and 196–97). The positions of some of their hands, held

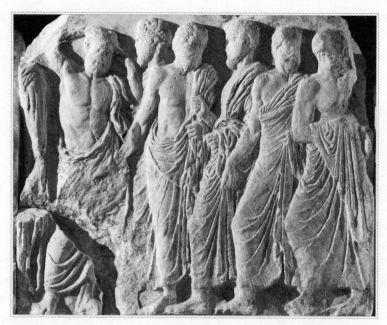

Group of elders, with one crowning himself, north frieze, Parthenon.

up with fingers pressed together, have led some scholars to imagine olive branches, once painted here against the background of the frieze. This would link them to the *thallophoroi,* the elders of the city who carried branches in the Panathenaic procession.[157] Xenophon tells us that "they choose the beautiful old men as *thallophoroi* for Athens."[158] On the north frieze, one of the men is seen to stop and turns to face the viewer straight on (above). In an arresting gesture he raises both arms to adjust the wreath upon his head. Drill holes preserved in the marble show where a metal crown had been attached.[159] These groups of men represent the most senior marchers on the frieze, epitomizing the finest and most handsome of the Athenian elders.

Finally, we come to the parade of chariots and horsemen that takes up roughly half of the north and south friezes and most of the west frieze (pages 158, 160–61, and 196–97). Here we must ask: If this represents the fifth-century Athenian army, why are there chariots, which had not been used in Greek warfare since the end of the Bronze Age, some seven hundred years earlier? And where are the hoplites? We know from Thucydides that hoplites did participate in the historical Panathenaic procession, at least by 514/513 B.C. He tells us that when the tyrant

Hipparchos was assassinated while serving as procession marshal that year, his brother, Hippias, rushed to the hoplites who were marching and confiscated their weapons.[160] The complete absence of the hoplite foot soldiers makes it most unlikely that we are looking at a fifth-century army. These problems go away if we understand the soldiers and chariots to represent the forces of Erechtheus during the early days of Athens.

We will remember that Erichthonios is said to have appeared at the first Panathenaia as a charioteer with an armed companion at his side.[161] And we have already seen an image of a charioteer carved on the marble frieze of the Old Athena Temple at the end of the sixth century (page 67). This figure may well represent the hero Erechtheus/Erichthonios. We learn from Nonnos, writing in the fifth century A.D., that Erechtheus was intimately associated with the yoking of horses to chariots and that he brought his stallion Xanthos ("Light Bay" or "Auburn") under the harness, teaming him together with the mare Podarkes ("Swift-Footed").[162] Both horses were sired by Boreas, the North Wind, and born to the Sithonian Harpy, Aellopos ("Storm-Footed"), after he raped her. Boreas gives the horses to his father-in-law, Erechtheus, as a "love price" in payment for Oreithyia, Erechtheus's daughter whom Boreas abducts from the banks of the Ilissos River. Thus, the chariot groups seen on the Parthenon frieze are closely associated with Erechtheus and evoke the strategic advantage they provided the Athenians in their war against Eumolpos.

We find ten four-horse chariots on the south frieze and eleven on the north. Each has a driver and armed rider with helmet and shield (pages 160–61, 196, 197, 198, top, and front and back of book) looking very much like the *apobatai,* the armed chariot riders who competed in a special class of Panathenaic event. This contest required the soldiers to mount and dismount a chariot moving at full speed.[163] The oldest and most distinctive event of the Panathenaia, the *apobates* race was open only to members of the Athenian tribes. Plutarch suggests this was an especially demanding event in the Panathenaic Games, duplicating the harsh conditions of combat, which required robust athleticism while carrying a full load of armor and weapons.[164] Those performing this remarkable feat on the Parthenon frieze are not Athenians taking part in the historical games but their legendary forebears who actually made war this way.

Inscriptions from the second century B.C. locate the *apobates* race

South frieze, Parthenon, showing cattle led to sacrifice (lower right),
followed by musicians, elders, chariots, and horsemen.

in the vicinity of the City Eleusinion, the temple to Demeter and Kore
perched on the southwest slope of the Acropolis (just above the Agora).[165]
Sometime in the fourth century B.C., a victor in the *apobates* race set up a
monument here in the City Eleusinion to celebrate his triumph (page 198,
bottom).[166] It features a sculptured relief showing the athlete driving a
four-horse chariot, its composition and iconography matching that of
the charioteers on the Parthenon frieze.

There is good reason to believe that the *apobates* race commemorated
the first Athenian victory, the one enabled by Erechtheus's introduction
of the chariot. This would explain why the event was open only to the
scions of old citizen families, the perceived descendants of the earliest
Athenians. It would also explain why the race seems to have been run to
the City Eleusinion as its final destination.[167] Conducting the *apobatai*
toward the Eleusinion connects it with the defeated Eumolpos, who came
to be so closely associated with Eleusinian cult. And there is, as well, the

matter of what would otherwise be a strange detour taken by the Pan-
athenaic procession on its way up the Acropolis; beginning at the Dipylon
Gate at the northwest of the city, the sacred train went deliberately out
of its way to circle the Eleusinion (insert page 7, top).[168] To do so would
make sense if the sanctuary was believed to occupy the site of Eumolpos's
encampment at the foot of the Acropolis, and thus an important place of
memory around which the Athenians could take a victory lap.[169]

Horses and riders dominate the composition in terms of sheer
numbers of figures, occupying all of the west and more than a third
of the north and south sides of the frieze (pages 158, 160–61, facing
page, above, pages 199 and 200, and front and back of book). Inter-
preters have undertaken the counting of horsemen, looking for all man-
ner of encoded historical and political meanings. John Boardman, for

Charioteer and armed rider, south frieze, slab 31, Parthenon.

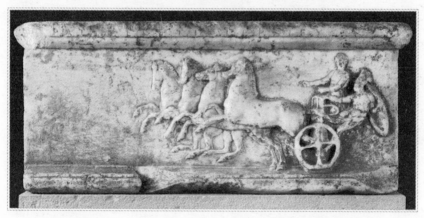

Victory monument, *apobates* race, found near the City Eleusinion, Athenian Agora.

instance, has counted 192 horsemen in all and sees in this the number of the fallen at Marathon.[170] Several scholars distinguish four groups of fifteen horse riders on the north frieze and see in this a reference to the four pre-Kleisthenic tribes of Athens.[171] They then count ten ranks of six riders on the south frieze, as a reference to the ten tribes created by Kleisthenes in 508.[172] These various ranks of riders are differentiated through their costumes and equipment. Some wear Thracian caps, others double-belted woolen chitons, and others still the himation, or cloak.

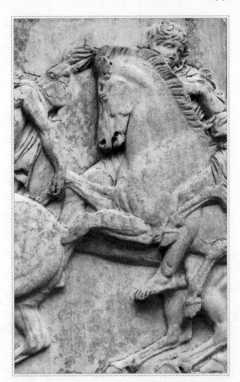

Horse rider, north frieze, slab 41.
Parthenon.

We see some riders in metal or leather body armor, some with helmets, others with flat broad-brimmed traveler's hats, and still others wearing hats of so-called Thracian style, with three flaps. In fact, to see in the imagery a fifth-century Athenian army taking part in the Panathenaic procession may inevitably oblige one to ascribe to these mounted figures multiple levels of meaning at once.[173]

According to Aristotle, however, it was only in days of old that the cavalry dominated the army.[174] In addition, there is no evidence for the participation of the cavalry in the Panathenaic procession. Throughout the historical period, mastery of horses was viewed as noble, harking back to the glorious past, but by the time of Perikles it was a decidedly antiquarian pursuit, much as polo is today. Indeed, Xenophon points to the heroic associations of the equestrian tradition, one that maintained its aristocratic cachet across the centuries.[175] It is far more plausible, then, to see the horse riders on the Parthenon frieze as members of the heroic cavalry of Erechtheus, noble forebears of the venerable tradition of the Athenian knights, rather than as some anachronistic presence in a fifth-century spectacle.[176]

The west frieze is generally viewed as representing preparations for the Panathenaic procession (below). Frisking horses are held, mounted, and put through their paces by younger and older men. Iconographic parallels have been drawn between these figures and those shown on a series of Athenian red-figured cups.[177] The vases show young horsemen in a variety of costumes, including the wide-brimmed traveler's hats, "coonskin" caps, and Thracian hats with flaps, the very same variety evident on the Parthenon frieze. The event depicted on the Attic cups has been identified as the *dokimasia,* an annual tryout of men and horses held by the Athenian cavalry, as described by Aristotle.[178]

A central element of the *dokimasia* was the testing of Athenian youths in their eighteenth year for acceptance into the military as ephebes. This is the age at which young men would enter their names upon deme registers as members of their tribes.[179] They swore their Ephebic Oath upon

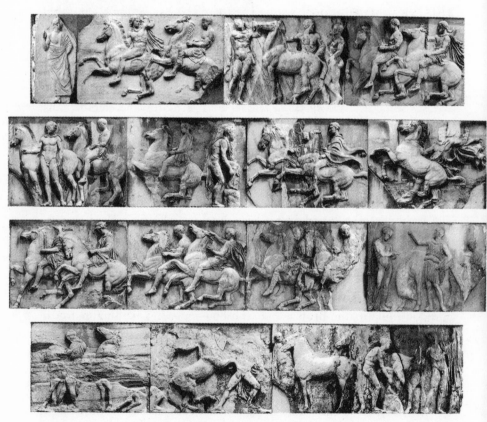

West frieze, Parthenon, showing horse riders and preparation for the procession.

the arms they'd just received in the sanctuary of Aglauros on the east slope of the Acropolis (insert page 1, bottom).[180] This oath, as discussed in chapter 3, was regarded as a relic of the heroic age, a rite of passage reaching back to the earliest days of Athens. In the images of the young riders on the Parthenon frieze, Athenians would likely have recognized the origins of their contemporary *ephebate*.[181] Indeed, the lofty status of the Athenian knights finds its roots in the cavalry of King Erechtheus, the young noblemen who won the city's first decisive victory in the battle against Eumolpos. We must remember that in the early sixth century, when Solon reconfigured the citizenry in a first blueprint for what would become Athenian democracy, the *hippeis* class, made up of those who had enough money to maintain a horse and thus join the cavalry, ranked second only to the wealthiest of Athenian landowners.

THIS NEW MYTHOLOGICAL READING of the Parthenon's sculptural program allows it to be understood as a coherent whole and as comprehending the vast sweep of time embedded in Athenian consciousness. The east pediment celebrates the origins of Athena, while the east metopes show the boundary event in which she first distinguished herself so valiantly: the Gigantomachy. The west pediment celebrates the origins of Athens in the contest of Athena and Poseidon, manifesting for all to see the genealogies of the royal houses of Athens and Eleusis. It emphasizes the descent of the Athenian tribes from Athena through Kekrops and Erechtheus and that of the Eleusinian clans from Poseidon through Eumolpos and Keleos. The "boundary catastrophe" of the deluge is intimated by Poseidon's striking the earth with his trident, furious at his defeat. The west metopes, in turn, show the later, heroic age in which Theseus battles the Amazons, while the south metopes memorialize his decisive role in the Centauromachy. The north metopes manifest that greatest boundary event of all, the Trojan War, which brought a decisive end to the Bronze Age, the final moment dividing mythical from historical time. The articulation and perpetuation of genealogical narrative can thus be seen as a primary function of sacred architectural sculpture in general and of the Parthenon in particular.[182]

Our mythological understanding of the frieze fits comfortably into this genealogical program, with the great carved band narrating the last Athenian hurrah of the heroic age: the war between Erechtheus and

Eumolpos. By portraying the struggles of successive generations against the forces of chaos and barbarism, the Parthenon's sculptural program repeats a pattern already witnessed on the Archaic Acropolis and discussed in chapter 2. The limestone pediments of the Hekatompedon and the small poros buildings (*oikemata*) present, respectively, Zeus killing Typhon and Zeus's son, Herakles, killing Typhon's daughter, the Lernaean Hydra. In the very same way, the conflict between Athena and Poseidon on the Parthenon's west pediment is carried on by their children, Erechtheus and Eumolpos, as depicted on the Parthenon frieze. And so have the Athenians, generation by generation, ensured a future for their city. As it was, so shall it ever be: the Parthenon's full sculptural program is also, of course, a not-so-subtle metaphor for the Athenian triumph over the Persians in 479 B.C.[183]

It is the duty of all Athenians to save the city from exotic, barbaric outsiders, to preserve an Athens by and for the autochthonous Athenians: this is the central message of this supernal temple, where metaphysical understanding and civic solidarity are wedded for all to see. That the frieze shows the royal family itself personally paying the ultimate price to save Athens is of the highest significance, and not merely for offering a heroic contrast to the ways of the Persian royals, who survived the great defeat at Salamis. That the very founding family of Athens, from whom all are descended, could not put itself above the common good speaks to a radical egalitarianism, not in circumstances, but in responsibility, the very antithesis of the barbarian sentiment that society exists for the exaltation of its most exalted members. All may not be equal in Athens, but all are equal in relation to this sacred trust, which comes of being bound to the same earth and to one another by birth. And this trust in one another is what permitted the delicate plant of democracy to take root.

ANGELOS CHANIOTIS, professor of ancient history and classics at the Institute for Advanced Study in Princeton, has observed that "from Plato to Aelius Aristides, the praise of Athens was always based on a standard constellation of Athenian victories over the barbarians: the victory of Theseus over the Amazons, of Erechtheus over Eumolpos, and the Persian Wars." He asks, "Can the victory over Eumolpos, so prominent in Athenian collective memory, be the only one absent from the iconogra-

Poseidon and Eumolpos ride into battle. Lucanian pelike
from Herakleia, near Policoro, Italy.

phy of the Parthenon?"¹⁸⁴ Indeed, the Athenian victory over Eumolpos
is not only present on the Parthenon; it is spectacularly celebrated in the
largest, most lavish, and most aesthetically compelling length of sculp-
ture ever carved by human hands.

When Pausanias visited the Acropolis, he saw a big bronze statue
group of Erechtheus fighting Eumolpos set up right in front of the Par-
thenon. He tells us that this was the most important work ever created
by the master sculptor Myron of Eleutherai, that acclaimed portrayer
of the so-called Myronic moment of tension before the high action, as
exemplified in his statue of the *Diskobolos*.¹⁸⁵ Since Myron was active
in the middle of the fifth century, we can imagine his bronze Erechtheus
in battle set just below the sculptured frieze on which his great victory
was glorified.

By the fourth century B.C., the war of Erechtheus and Eumolpos
was so well known that it was painted on a vase produced in the West-
ern Greek colony of Lucania in southern Italy. Vibrant images on this
wine jar from Herakleia, near Policoro, portray the antagonists charg-
ing into battle.¹⁸⁶ On one side of the vase we see Poseidon, riding with
trident held high and accompanied by an armed warrior who is, surely,
his son Eumolpos (above). The father-son duo charge into battle astride

horses, creatures with which Poseidon always had a very special connection, having been known since the *Iliad* as the "tamer" of horses and, thanks to his creative coupling with mares, even as the "father" of some equines. In time, Poseidon acquires the epithet Poseidon Hippios.[187]

On the other side of the vase we see Athena, spear in one hand and shield in the other, as she is driven into battle on a chariot (below). Just as the horse is special to Poseidon, so the chariot is special to Athena as the vehicle introduced to Athens by her own "son," Erechtheus/Erichthonios. The charioteer, however—and most astonishingly—is a maiden. The girl leans forward, holding her reins high and brandishing a whip, as she urges the yoked horses toward the battlefield. This maiden is likely to be none other than Erechtheus's brave daughter, shown here as Athena's comrade in the war against Eumolpos. Portraying Athena as a kind of *apobates* rider to the girl's charioteer, the artist makes explicit the goddess's intimate connection to the maiden called Parthenos, the girl who gave her life to save Athens.

The fact that the battle of Erechtheus and Eumolpos is not attested in surviving literature prior to Euripides's *Erechtheus* has led some scholars to question whether it can be represented on the Parthenon frieze. Since Euripides wrote "a decade after the frieze was finished," one skeptic argues, "the play cannot be the source of the sculpture."[188]

Athena and daughter of Erechtheus ride into battle.
Lucanian pelike from Herakleia, near Policoro, Italy.

Of course it can't, and no one has claimed that it is. As we have seen, the popularity of a particular myth, like that of its variants, can ebb and flow over time. It is even possible that the arrow of inspiration was shot the other way, with Euripides getting his idea from what he saw on the Parthenon frieze. What if those wordlessly eloquent images moved him to bring to the stage the very story most prominently narrated on his city's newest and most wondrous temple? And what if the Erechtheus myth, reenergized in the wake of the Persian Wars, was expanded to include a major victory over an exotic enemy, evoking that most recent, and greatest, of all Athenian triumphs? One can understand how the story of Erechtheus, elevated to a new prominence within Athenian consciousness, reached a peak in popularity at this time, celebrated in architectural sculpture, ritual practice, and, yes, drama. As Perikles and the Athenians renewed their Acropolis, they embraced a reinvigorated hero, a fresh face for a fresh start.

A false assumption that text precedes image has long bedeviled our understanding of visual culture. It is motivated, in part, by the mostly documentary and illustrative role that images play in our contemporary world, capturing moments in time as supplement to the main work of literary accounts. The field of classical archaeology has been particularly beset by this bias, going back to the days of Heinrich Schliemann and earlier, when written texts were the primary guides and the archaeologist's job was to search for material evidence to support what the texts say, just as Schliemann used the *Iliad* to discover the Troy and Mycenae of Homer. In a field shaped for centuries by philological inquiry, visual culture has invariably suffered, its distinctive grammar and stories neglected.

In fact, a "language of images" and a "language of texts" exist quite independent of each other.[189] Sometimes they overlap, but more often they take parallel tracks that never intersect. Art can inspire words just as words can inspire art. And a myth or story that is "in the air" at a particular moment can find expression equally in either. In the course of history, myths can be retold and codified through visual as well as through textual and oral expression, not to mention through ritual itself. Just like the chorus of serving maids in Euripides's *Ion,* who view the sculptures decorating the temple of Apollo at Delphi, the poet might have walked around the Parthenon and been inspired by the stories that its sculptured figures tell.[190] We have no difficulty accepting that

the Parthenon sculptures inspired Keats's poem "On Seeing the Elgin Marbles for the First Time." Or that, two years later, in 1819, in "Ode on a Grecian Urn," the poet would transmute his experience of the Parthenon frieze into that of viewing a more compact artifact, a fictional Greek vase:

> What men or gods are these? What maidens loth?
> . . .
> What pipes and timbrels? . . .
> . . .
> Who are these coming to the sacrifice?
> To what green altar, O mysterious priest,
> Lead'st thou that heifer lowing at the skies,
> And all her silken flanks with garlands drest?

From these lines we can hardly divorce the figures of the Parthenon frieze seen by Keats in the British Museum: maidens, pipe players, offering bearers, sacrificial victims, priest, and lowing heifers.

The technique used by Euripides has been called cinematic, employing "zoom" and "wide-shot" narration to modulate the audience's intimacy with powerful visual icons.[191] In the *Erechtheus*, he gives us a close-up of Pheidias's statue of Athena Parthenos wrought in gold and ivory: "Raise a cry [*ululate*], women, so the goddess may come to the city's aid, wearing her golden Gorgon."[192] The chryselephantine statue of Athena did, indeed, wear a Gorgon-headed aegis upon her chest (insert page 7, bottom) and Euripides effectively "zooms" in on this detail, focusing his audience's attention on the famous cult image. I would argue that Euripides also accesses the sculptures of the Parthenon's west pediment when he places on the lips of Praxithea these words: "Nor will Eumolpos and his Thracian army ever—in place of the olive tree and golden Gorgon head—plant the trident on this city's foundations and crown it with garlands."[193] So, too, he evokes the aulos and kithara players that we see on the north frieze (pages 161, 192, and front of book) when he has his chorus of old men sing: "taking up the task of my aged hand, the Libyan (lotus) pipe sounding to the kithara's cries."[194] The next slab over from the musicians on the north frieze, in fact, shows a group of old men, one fixing a wreath upon his head (page 194). It can be no coincidence that Euripides's chorus intones:

"and may I dwell peacefully with grey old age, singing my songs, my grey head crowned with garlands."[195]

Thus Euripides seems to draw poetic inspiration from the Parthenon itself. He is even more imaginative when he focuses on the groups of men and maidens depicted on the east frieze (pages 185, 187, and front of book). In his mind's eye, the marble maidens come to life as the chorus of old men asks: "shall the young girl share with aged man in the dance?"[196] It may have been a bit of fantasizing on the part of the poet by now approaching sixty. For these are the *parthenoi* of the first Athenian maiden chorus, and their dance partners will be the young ephebes, *not* the old men of the city.

THE PARTHENON HAS long been recognized as the most lavishly decorated of all Greek temples. The profusion of sculptures adorning its pediments, metopes, and frieze, its chryselephantine statue of Athena Parthenos, no less than the sophistication of its architecture, set it apart from other temple buildings. Indeed, its abundance of adornment has aptly been described as "hyper-decoration."[197] This distinctly Athenian predilection for opulence has, in turn, been read as a wasteful effort to flaunt and enhance Athenian ethnic prestige and political power.[198]

But one can imagine a further motivation for the hyper-decoration of the Parthenon, one beyond pretension. The vivid and abundant sculptural adornment might have served much the same purpose as the astonishing cultivation of the literary and rhetorical arts at Athens during this same period. In her study of Plato's view of the uses of philosophy, Danielle Allen articulates Plato's theory of the role of language in politics. The philosopher calls for the vivid (*enarges*) and abundant use of language to educate the citizenry toward the formation of values.[199] We might make the same claim for architectural sculpture.

Sculptured images permanently visible on major monuments went a long way in teaching and sustaining these values for the citizens that beheld them every day. And they spoke with equal eloquence not just to the elites, who could read, but to those of the populace who were illiterate. The primary function of the hyper-decoration of the Parthenon, in some sense of the Parthenon *tout court,* was paideia, the education of the young by means of a visual extravaganza.

As Allen has shown, Plato and Lykourgos recognized the central

Nude male, horse rider, adolescent, and boy, north frieze, slab 47. Parthenon.

role of myth, poetry, and aitiology in teaching the young. Architectural sculpture provided a giant screen onto which the myths could be projected. Turning the next generation toward virtue by reminding them of the sacrifices made and the oaths taken by the youths and maidens of early Athens inspired generation after generation of young Athenians to do the same. The forefronting of Athenian youths in the Panathenaic competitions, especially in the tribal contests, the choral dances of the night vigil, the procession, and on the Parthenon frieze itself makes explicit the necessity of engaging the next generation in just what it means to be an Athenian.

The carved figures render the gods and the ancestors eternally present. They teach the genealogy of a venerable people, the origins of their enduring rituals, and the values that defined Athenian identity. Now, at last, we can see a powerful myth narrative animating the lifelike features of the Parthenon frieze to help us recognize a more profound meaning in its imagery. By engaging with a new paradigm and adjusting our perspective by a few degrees, we can see things that have not been evident for centuries.

At the very northwest corner of the Parthenon frieze is an arresting figure, among the first that visitors might see as they emerge from the Propylaia and make their way toward the front of the temple. Should

they stop here and make the effort to look up into the shadows of the colonnade, they would behold a beautiful male nude who steadies a rearing horse while gesturing with his left hand to three young men who follow behind him (facing page). It is as if he were urging them forward. The first is a young mounted rider shown in profile, the next is an adolescent on foot, wearing a short tunic, and the third is a boy much younger by far, partially nude with mantle thrown loosely across his shoulders. We seem to be looking at the ages of man: boy, youth, and young adult are hailed and welcomed into the march of life as Athenians.

Farther down this north frieze, we see the group of old men marching. There is the one who stops in his tracks and deliberately turns toward the viewer, lifting his arms to crown himself (page 194), his strong, mature body caught in an arresting pose. He represents the best, the noblest, and the most handsome of Athenian elders, the very pinnacle of what a man can become when nurtured by and devoted to his city. The frieze thus provides a mirror in marble, reflecting back the ideal citizen from childhood to maturity, his glory, not his individuality, not the poetry or philosophy he makes, but in the fact of his being one of the many. It is the responsibility of Athens to educate him in the history, identity, values, and interests into which he has been born. In doing so, the polis provides the answer to that most compelling of all human questions: Where do I come from?

6

WHY THE PARTHENON

War, Death, and Remembrance in
the Shaping of Sacred Space

THE GERMAN ARCHAEOLOGIST PITCHED OUT a challenge. Eugene
Plumb Andrews was intrigued. Freshly graduated from Cornell,
Andrews had come to Greece on a fellowship from the American School
of Classical Studies with hopes of running in the first modern Olympic
Games the following summer. On this blustery afternoon in December 1895, atop the Acropolis summit, he was one among many students
who had gathered to hear what Dr. Wilhelm Dörpfeld had to say. Young
Andrews would come away seized by a new and overpowering purpose,
one that would cause him to set aside his Olympic dreams altogether.

Directing attention to the architrave, the great hundred-foot lintel
resting atop the eight columns of the Parthenon's east façade, Dörpfeld
had pointed out deep holes just below the metopes. He then drew the
students' attention to the outlines of great circles, each 1.2 meters (4 feet)
in diameter and barely visible as a discoloration in the marble. These
were the "ghosts" of metal shields that once hung here, booty seized
from a defeated enemy and displayed as trophies. But whose victory?

Dörpfeld then pointed to hundreds of small holes drilled just beneath
the triglyphs. These comprised twelve groups of cuttings, each of three
lines, except for the last two groups of two lines each. The professor

explained that these were dowel holes for the attachment of large gilded bronze letters that once spelled out a dedication. By studying the relative positions of the holes, one could, in theory, make out the letters of the alphabet that had been attached and in this way work out the inscription. "Such things have been done, and it is time that this were done," Dörpfeld mused on the puzzle he was presenting.[1] Eugene Andrews decided on the spot that *he* was the man to solve it.

Within a month, Andrews was riding up the Parthenon's east façade each morning in the rigging of a boatswain's chair (below), grateful no doubt for his experience as a yachtsman. He took strips of wet paper,

Eugene Andrews taking squeezes of the dowel holes on the Parthenon's east architrave, 1895.

crossed at right angles, and pushed them deep into the drillings; thus Andrews took squeezes of each cluster of holes in the inscription. The work was arduous. He could complete just one squeeze a day, leaving the paper to dry overnight and praying that winds would not blow it off before morning.[2]

By late February 1896, Andrews stood in the library of the American School of Classical Studies on the slopes of Mount Lykabettos, presenting the results of his labors to the assembled scholars. Draping his squeezes all about the library shelves, he moved from sheet to sheet, explaining his reconstruction of the lost letters, some 251 in all. Andrews had managed to decipher the entire inscription. But not everyone was pleased with the result, least of all Andrews himself.[3]

It had long been assumed that the so-called Parthenon Inscription was somehow connected with Alexander the Great's dedication of three hundred Persian shields on the Acropolis following his decisive victory at Granikos near Troy in 334 B.C.[4] This was the first of three major battles he had won against the formidable Persian army. At Granikos, Alexander routed the forces of Arsames, the satrap of Cilicia, whose forces he'd stripped of their armor, sending it as booty to Athens for dedication at the Parthenon.[5] Alexander intended a bold and explicit reminder that the battle of Granikos had been won in revenge for the Persian destruction of the Acropolis in 480. It might have been more than 150 years in the making, but this was a dish as delicious as it was cold.

But Andrews's decoding of the holes in the Parthenon's architrave revealed a very different commemoration: praise not for mighty Alexander but, instead, for the most vile of Roman emperors, Nero.

> The Areopagus Council and Council of the Six Hundred and the People of Athens [honor] Emperor Greatest Nero Caesar Claudius Augustus Germanicus, son of a God, In the year of the General of the Hoplites for the eighth time and also Superintendent [of Athens] and Lawgiver [was] Ti[berius] Claudius Novius Son of Philinos, in the year the Priestess [of Athena was] Paulleina, Kapito's Daughter.[6]

We know little of Nero's interaction with the Athenians, but the Parthenon Inscription attests that in A.D. 61/62 they granted him a series of unprecedented honors. First, the city's highest award, a crown, was bestowed upon him by decree. Even more unusual, indeed

unique, was the distinction of immortalizing Nero's honors with an inscription on the east façade of the Parthenon. The gilded letters followed no Athenian custom but rather the standard practice for texts on Roman triumphal arches and other monuments.[7] It was all the more remarkable recognition considering that the emperor, having spent more than a year in Greece, never even bothered to set foot in Athens itself. The accolades were, furthermore, premature. There had been no great victory that year, just the promise of peace on the eastern front. Such self-inflicted indignities were the wages of foreign domination, suffered first under the Macedonians and then under the Romans.

In the mid-first century A.D., the Parthians were the empire's great eastern enemy. Rome had battled them for decades over control of Armenia, a land of strategic importance to both sides. By A.D. 58, a crisis erupted when the Armenian king installed his brother on the throne. The Romans invaded, removing the brother and crowning a Cappadocian prince who was their trusted ally. Parthia was quick to retaliate in a series of military campaigns that threatened to escalate into a great war. In A.D. 61/62, however, a compromise was brokered under which the Romans agreed to let the brother rule Armenia provided he acknowledged that he owed his kingship to Nero himself. Resolution of the Armenian problem did usher in a welcome period of peace. It was this relatively inglorious diplomatic victory of Nero's that was celebrated in the Parthenon Inscription.

It is not known whether the shields that hung between the gilded bronze letters on the Parthenon were those dedicated by Alexander or ones taken later from fallen Parthians by Nero's Roman army. The egomaniac Nero would certainly have enjoyed comparison with Alexander. In any event, the inscription revealed by Eugene Andrews's careful work shows that nearly five hundred years after the construction of the Parthenon, the temple remained an ultimately prestigious victory monument. The Parthenon would ever be a symbol of triumph over eastern enemies: Greeks over Persians, Romans over Parthians, and, as we shall see in chapter 8, the Attalids of Pergamon over the Gauls. But the tribute to Nero for his eastern victories would not last long on the Parthenon; the bronze letters of the inscription were swiftly removed from the architrave following Nero's suicide in A.D. 68. It was only the dowel holes left behind that would bear witness to what Andrews himself called "the

story of how a proud people, grown servile, did a shameful thing, and were sorry afterward."[8]

It is worth remembering that nearly ninety years before Alexander hung Persian shields on the Parthenon, Euripides placed these words on the lips of his chorus of old men in the *Erechtheus:*

> Let my spear lie idle for spiders to entangle in their webs; and may I dwell peacefully with grey old age, singing my songs, my grey head crowned with garlands, after hanging a Thracian shield upon Athena's columned halls.

<div align="right">

Euripides, *Erechtheus* F 369.2–5 Kannicht[9]

</div>

The Thracian shield of which Euripides's writes, seized from Eumolpos's defeated army and hung on Athena's "columned halls," points to a tradition for displaying war booty on the Parthenon long before the time of Alexander the Great. The poet seems also to allude directly to the Parthenon's north frieze, at the place where we see one man among the elders stopping to crown his "grey head with garlands" (page 194). Euripides's powerful imagery, envisioning spears left to gather cobwebs, references a time of peace following Erechtheus's victory.

A century later, Plutarch quotes these same lines from the *Erechtheus* when looking back on the Peloponnesian War. He writes of the so-called Peace of Nikias, which brought a welcome, if fleeting, break in the fighting in 423/22 B.C. During this one-year truce between Athens and Sparta, Plutarch tells us, one could hear choruses at Athens singing "Let my spear lie idle for spiders to entangle in their webs."[10] Indeed, it is on the strength of Plutarch's remarks that the first performance of the *Erechtheus* has been dated to the City Dionysia of 422.

In fact, the practice of dedicating arms and armor taken from the battlefield is attested in sanctuaries all across the Greek world. Sacred space was everywhere endowed with a distinctly martial aura. After all, much of the asking and thanking that went on within holy precincts had to do with the desire for a positive outcome in combat. And this is because of the centrality of war in Greek life. Whether with foreigners or fellow Greeks, it was an experience that touched every family; no household escaped the relentless, brutal, and ubiquitous culture of conflict and killing.[11] Prayer and sacrifice offered in petition or gratitude for

victory were very personal as well as communal experiences, and within a fairly all-consuming cycle of death, loss, and remembrance, war and worship were tightly interwoven.

In this respect, as in so many others, Athens was determined to show itself supreme. All male citizens between the ages of eighteen and sixty were eligible to fight, making for lifelong engagement with the spectrum of emotions that includes dread, terror, agony, and grief. Sons, brothers, fathers, grandfathers, cousins, and friends all fought side by side and fell together. The solidarity of genealogical awareness so central to democracy was also a centripetal counterforce to the centrifugal energies of carnage. For much of the Archaic and classical periods, men went to war each "season," that is, during the summer months between the time for planting and the harvest. In Plato's *Laws,* the Cretan lawgiver Kleinias remarks that for Greeks peace "is merely a name; yet, in truth, an undeclared war always exists by nature between every Greek city state."[12] If the Athenians are relatively unrecognized for the obsessively religious folk they were, their martial character is likewise underremarked in the familiar litany of attributes. But the two in fact go not only hand in hand but also a long way in illuminating the people who made the Parthenon, as well as what it represented to them.

MOSTLY, GREEKS FOUGHT over border disputes. In the Peloponnesian War, of course, they fought over much more.[13] Athens's stunning rise to power and empire in the fifty years following the Persian sack filled the Spartans with dread. The defensive alliance forged between Athens and the naval power Kerkyra in 433 B.C., and agreements signed with Rhegium in southern Italy and Leontini in Sicily shortly thereafter, created an Athenian monopoly of seaborne trade that threatened the transport of food supplies from Sicily to the Peloponnese. And so by 431 B.C., just a year after the stunning sculptures were set up within the pediments of the Parthenon, Athens and its allies entered into a war with Sparta, one that would last some twenty-seven years. This conflict would pit a peerless naval power against an invincible ground force in a historical iteration of the cosmic struggle between sea and land. Across the decades of slaughter, a terrible plague would strike Athens, bringing even more death and dying to the city's households. For all the sublimity

of the Acropolis temples, the grand festivals, and the sacred rites still performed, gloom now filled the Athenian heart. The next battle, with the next death of a family member, was never far away.

Hoplite warfare only magnified the horrors. It required great phalanxes of foot soldiers, wielding spears and carrying heavy shields, charging headlong at one another, and the result was piles and piles of corpses, some half a dozen deep. The goriest description is the one Xenophon gives of the battle at Koroneia in 394 B.C.: "the earth stained with blood, friend and foe lying dead side by side, shields smashed to pieces, spears broken asunder, daggers drawn from their sheaths, some on the ground, some in bodies, others still gripped by hand."[14] Herodotos puts in the mouth of the Persian commander Mardonios blood-chilling words about the Greek way of war: "When they have declared war on each other, they fight on the best and most level ground they can find, so that the winners go away with great losses; I will not say anything about the losers, for they are utterly destroyed."[15]

The grisly job of collecting, sorting, and identifying the dead is one that does not easily fade from memory.[16] This physically and emotionally draining task befell the army too, the separating of enemy corpses from those of comrades, friends, and relatives, many beyond recognition. We hear that the Spartans, anticipating great carnage, scratched their names on little bits of wood (skytalis), wrapping them around their left wrists as they left for battle against the Messenians.[17] The need for these proto–dog tags speaks to how disfiguring hoplite warfare was.

At the end of each combat season, Athenians set up inscribed casualty lists giving the name, patronymic, and tribe of each of the war dead. Pausanias tells us that these lists included not just citizens but also allies, slaves, and foreign mercenaries who fought for Athens.[18] Cremated remains of the dead were publicly displayed for three days before burial in the public cemetery (demosion sema), said by Thucydides to be located in "the most beautiful suburb of the city."[19] Excavations show that it started about 200 meters (656 feet) outside the Dipylon Gate and lined the broad avenue running from the Kerameikos to the Academy (page 9).[20] Along this route casualty lists, mass burials, and tomb monuments have been unearthed; indeed, in 1979 the family plot of Lykourgos himself was discovered near the Academy's entrance, confirming what we know from literary sources, that the patriot received

the highest honor of public burial.[21] And it was here in the *demosion sema* that Lykourgos's idol Perikles would have stood as he delivered his famous eulogy for the first to die in the Peloponnesian War. Such rituals of remembrance—funeral orations, grave monuments, epitaphs, casualty lists, and burial rites—all reflect an intense desire to demonstrate that the dead would never be forgotten. Importantly, these public commemorations reassured surviving warriors that should the worst come to pass, their corpses too would be retrieved, their ashes buried, their memory kept alive, and their families made proud.[22]

The Athenian battlefield was perhaps the most truly democratic space in the democratic society, as men of all ages, equals in representing their tribes, came together in quick, decisive, and bloody resolution of disputes. The brief and brutal anguish of infantry combat has been said to have defined a man's entire relationship with his family, community, and country.[23] So, too, the extreme experience of rowing the great triremes of the Athenian navy (some 170 oarsmen to a ship) brought rich and poor Athenians together on an utterly equal footing, in cramped and miserable galleys where they were acculturated firsthand to democratic values in their rawest state.[24] Sharing long weeks of boredom and anticipation, interrupted by bursts of sheer terror in swift and gory battle, the men of Athens bonded fast with one another in their respective tribal brotherhoods. Fear and loss were as galvanizing as shared lineage. Thucydides speaks of this effect at Athens following the catastrophic defeat of the Sicilian expedition in 413 B.C.: "They were overwhelmed by their calamity, and were in fear and consternation unutterable. The citizens and the city were alike distressed; they had lost a host of cavalry and hoplites and the flower of their youth, and there were none to replace them . . . Still they determined, so far as their situation allowed, not to give way. They would procure timber and money by whatever means they might, and build a navy. As befits a democracy, they were very amenable to discipline while their fright lasted."[25]

When defeated, the Athenians picked themselves up and remembered. In victory, they remembered too. The precious panoplies of armor and weapons were stripped from the fallen enemy and collected in Greek sanctuaries, giving tangible proof of triumph. The dedication of war booty served several purposes, chiefly that of giving thanks as well as pleasure to the gods who made victory possible. But it also

inspired and indoctrinated future generations of warriors who visited the shrines, educating the young and reminding the broader citizenry of a shared military history.

In this chapter, we shall look at how the imperative of memorializing the heroic dead shaped sacred space, furnishing another mystic cord of memory whereby the Athenians were bound to their remote past.

Map of Greece.

As with genealogy, this bond connected the present-day populace not only to one another but also to their legendary forebears and to divinities. It also amplified the emotional and psychic charge of such places, beyond even the effect of their sanctification to particular gods, creating a unique nexus of death, memory, and holiness, of which the Parthenon is the most sublime example.

The pattern is attested throughout Greece. Mythic heroes from the Bronze Age whose "tombs" were still visible in historical times and heroes from the present who died defending their communities: both groups were commemorated within the great sanctuaries. War, death, and remembrance overhung each city, informing the placement of local shrines and the development of local rituals. We will consider as particular examples the great Panhellenic sanctuaries of Olympia, Delphi, Isthmia, and Nemea (facing page), where the tombs of mythical heroes are located close to the temples of Olympian gods. Ultimately, of course, our purpose is to understand how the meaning of the Acropolis's most sacred spaces developed from the perceived presence of the tombs of Erechtheus and his daughters within temples of Athena: the Erechtheion and the Parthenon. In this way we can understand how the Parthenon inevitably also became the Athenians' (and, eventually, all Greeks') supreme place of memory.

STUDENTS OF ANCIENT GREECE have long been taught to study space hallowed to gods (and votive offerings left there) as distinct from funerary space (and grave goods), but the two are more interconnected than such thinking allows. Not so surprisingly perhaps: triumph in battle required a combination of human and divine will; the favor and intervention of the gods were absolutely essential but so too was the shedding of human blood. Gods and goddesses must do their part, handing out good fortune and distributing defeat; heroes must give their lives, in return for which their remains are, fittingly, sanctified. Tombs and temples are thus intricately linked, much like the asking and thanking that characterized Greek piety as a whole. It is no wonder, then, that trophies of war took pride of place within the great sacred precincts. They are the perfect totems of the city's rightness with the gods.

The great Panhellenic sanctuaries, those that drew Greeks from everywhere across state borders, were dynamic arenas for the display

and commemoration of military victories. Indeed, the development and growth of these sanctuaries were in large part financed by the spoils of war, linking death and worship together from their earliest foundations. At the end of the eighth and the beginning of the seventh centuries, there is a surge in the dedication of arms and armor at sanctuaries and, at the same time, a decline in martial grave goods deposited in private burials.[26] This has been seen to reflect a shift in emphasis, from honoring an individual's role as a warrior (marked privately by his family) to commemorating the soldier as national hero, recognized publicly in rituals financed by the state. This institutionalization of commemoration rites in public sanctuaries has been seen to play an important role in state formation itself.[27]

By the early fifth century there were four principal Panhellenic shrines on the official festival circuit of the Greek mainland, known as the *periodos*. Olympia and Delphi were the most prestigious, with festivals held in the first and third years of the sequence. Celebrations at Isthmia and Nemea, both held every second and fourth year of the cycle, were carefully timed so as not to interfere with the more senior festivals.[28] Pilgrims came from all over the Greek world to participate in these feasts; city-states sent their finest athletes to represent them in the associated games. These states contributed to and invested in the Panhellenic shrines, constructing lavish treasury buildings, dedicating expensive offerings, setting up statues of renowned members of their communities, erecting victory monuments, and, very important, offering tithes from the spoils of war, arms and armor from fallen enemies. The local administrations overseeing these Panhellenic sanctuaries not only consented to the setting up of offerings by independent states but absolutely welcomed them as critical investments in their financial, cultural, and religious well-being.

Anthony Snodgrass has shown how sacred pilgrimage to the *periodos* sites made for a world of competitive emulation and cultural exchange in sanctuary centers where information and ideas could be shared by travelers from across the Greek world. In early days, this was very much the rarefied milieu of prominent aristocratic families competing with one another; over time, it evolved into a conspicuous showcase for interstate rivalries, even enmities.[29] This is brilliantly communicated in the dedication of vast amounts of armor and weapons that gave these sanctuaries their overwhelmingly martial character. It has been esti-

mated that more than a hundred thousand helmets had been dedicated at Olympia by the seventh and sixth centuries B.C.[30] The sanctuary of Poseidon at Isthmia was not far behind, with quantities of arms and armor offered throughout the eighth and seventh centuries, soldiers' booty awarded after successful campaigns. More than two hundred fragmentary helmets and countless shields have been excavated from within Poseidon's precinct, where dedications from wars peaked during the mid-sixth and early fifth centuries.[31] The road leading out from the sanctuary to Corinth was lined with helmets, shields, and cuirasses conspicuously set up as a display of Corinthian superiority.[32]

Delphi was a most prestigious setting for the dedication of war booty. It housed the world's most famous oracle and, as the so-called navel of the earth, was visited by throngs of pilgrims from across the ancient world who came to consult the Pythia about their future. Visibility was supreme at Delphi, and if a state wanted to show off, this was the place to do it. In the mid-sixth century, the rich king Kroisos of Lydia dedicated a gold shield at the temple of Athena Pronaia just down the road from the Apollo sanctuary.[33] Herodotos tells that some two thousand shields were sent to Delphi following the Phokians' defeat of the Thessalian cavalry in a conflict a few years before the Battle of Thermopylai.[34] In 339 B.C., the Athenians sent golden shields to be hung on the new temple of Apollo (the old one having burned down in 373). These were inscribed: "The Athenians from the Medes [Persians] and Thebans when they fought against the Greeks."[35] This, of course, was terribly insulting to the Thebans, who had collaborated with the Persians some 140 years earlier. The Athenians made absolutely sure that no one would forget this, broadcasting it here in perpetuity, at the very "navel of the earth." In 279 B.C., following their victory over the Gauls at Thermopylai, the Athenians and Aetolians once again hung gold shields upon the architrave of Apollo's temple.[36]

In fact, no city-state dedicated more monuments at Delphi than Athens did, heaping the sanctuary with lavish offerings to keep Athenian supremacy ever on full display.[37] The Athenians built a treasury entirely of Parian marble, decorated with sculptured metopes showing the exploits of their great heroes Herakles and Theseus. Pausanias says the building was financed from the spoils of their victory at Marathon in 490 B.C.[38] We have already noted in chapter 3 that a victory monument celebrating Miltiades's success at Marathon was set up by the Athenians

at Delphi. Kimon's father, the hero of the battle, was shown in a bronze portrait statue, flanked by Athena, Apollo, and the legendary kings and heroes of Athens, images created by no less a master than Pheidias himself. The Athenians also built a marble stoa at Delphi, commemorating their victory over the Persians at the Battle of Mykale in 479. Here they displayed the actual cables used by Xerxes to bind his famous pontoon bridge across the Hellespont, a triumph of engineering that enabled the Persian army to stream into Greece from Asia. As tangible "objects of memory," the captured cords bore witness to the courage with which Athenians reversed their losses of a decade earlier to defeat the Persian foe.

Panhellenic sanctuaries thus served as international stages on which the Greek city-states broadcast their commitment to winning, putting their resolve on display through the dedication of victory monuments and the establishment of rituals honoring those who served.[39] Let us consider how this system worked.[40] Olympia served as the regional cult place for all of Elis (a district in the northwest Peloponnese), as well as a center for interstate activity. As administrators of the sanctuary, the people of Elis financed the building of the temple of Zeus with spoils from their victory over Pisa in 470 B.C. But when the Spartans wished to hang a golden shield on the front gable of the temple (prime real estate for showing off their victory over the Athenians at Tanagra in 458/457), the Elian administration was happy to consent. And so the Spartans installed a great gold shield with a Gorgon's head (a symbol of Athena and thereby Athens) along with a hurtful inscription: "From the Argives, Athenians, and Ionians."[41] This was particularly stinging to their Athenian adversaries, who would ever after suffer in seeing their humiliating defeat memorialized at Zeus's Panhellenic shrine.

Years later, the Messenians and Naupaktians set up their own victory monument somewhat deflating this Spartan trophy. Supported on a tall column to reach the height of the golden shield fixed on the gable, the beautiful marble statue of Nike (page 224) was offered by the people of Messene and Naupaktos following the Athenian victory over the Spartans at Sphakteria in 425. Thus, we see a monumental tit-for-tat. The master sculpture Paionios's winged Nike flew right in the face of the Spartan victory dedication from thirty years earlier. Gold and marble may endure, but triumphant advantage is fleeting.

As early as the Archaic period, we find a tradition for setting winged sphinxes atop tall columns within Greek sanctuaries. The Naxians erected such a sphinx column just beneath the temple of Apollo at Delphi around 570–560 B.C. (page 242). Fragments of similar sphinx columns have been found in the sanctuaries of Apollo on Delos, Apollo at Cyrene, and Aphaia on Aegina, as well as on the Athenian Acropolis (where the column probably stood just north of the Old Athena Temple, insert page 2, bottom).[42] These dedications served as apotropaic devices, the airborne creatures intended to ward off evil forces that might threaten the temple's beauty. The flying Victory of Paionios can be seen as a fourth-century iteration of this long tradition of winged creatures set high in the air above sanctuaries, propelled into flight, as it were. With Panhellenic precincts functioning as great arenas for competitive displays of booty and power, the need for protective charms, as well as boastful emblems of victory, was great.

The Spartan surrender at Sphakteria was a huge triumph for the Athenians and their allies. It is no wonder the Athenian general Kleon brought 120 shields from the battlefield to Athens for public display.[43] Some were hung in the Painted Stoa within the Agora; one among these, unearthed during excavations in 1936, bears an inscription confirming its provenance: "over the Spartans at Pylos."[44] Ninety-nine other shields, also from this victory, were apparently carried up the Acropolis for display on the high podium that supports the Athena Nike temple (page 225).[45]

As worshippers approached the Acropolis, the first thing they would see was the small, elegant shrine of Athena Nike, perched atop the old Mycenaean defensive bastion, a constant reminder of its glorious past as an unbreached citadel. Construction began on the Nike temple in the mid-420s B.C. and was completed around 410.[46] It replaced an earlier cult building from the first decade of the century, a structure that replaced an even earlier, Archaic shrine. The graceful Ionic temple of the late fifth century, the last of the Periklean vision for the Acropolis, served as an important harbinger of what was to come once the visitors passed through the Propylaia and into the sacred space. Indeed, this beacon of Victory heralded the astonishing excess of military booty, trophies, and treasures that would dazzle worshippers once inside, culminating in a treasure trove of dedications within the Parthenon itself.

Statue of Nike carved by Paionios and dedicated by
the Messenians and Naupaktians at the sanctuary
of Zeus, Olympia, following their victory over the
Spartans in 425 B.C.

All around the podium of the Nike temple, pairs of cuttings can be seen
in the marble for the attachment of hooks of some kind, no doubt to
affix shields upon the marble wall.[47] A strong case has been made that
the shields once held here were those taken by Kleon at Sphakteria.
Just a year following this battle, in Aristophanes's play the *Knights*, the
"Sausage-Seller" comments that Kleon hung his shields in an unusual
manner, that is, with their handles still attached.[48] Trophy shields usu-
ally had their handles removed before they were hung for display and
Kleon apparently chose not to do this. The strange double cuttings on
the podium have been interpreted as dowel holes necessary to hang the
shields with their handles intact, perhaps so they could be taken down
and used.[49]

The Nike temple bastion is sheathed in Pentelic marble blocks that wrap around the Mycenaean fortifications that still stand beneath it. Indeed, the Athena Nike precinct is built on the very spot where the Mycenaean defensive bastion stood, at some distance out from the gateway in a highly strategic spot (page 27). This construction was vital to the security of the Acropolis, giving a direct line of fire down onto the right-hand side of an advancing enemy. This was the vulnerable side, since most fighters held their sword in their right hand and their shield in their left. The ability to get off a good shot from high on the upper right was crucial to protecting ancient fortresses generally: similar Mycenaean defenses are found near the gateways of Mycenae, Tiryns, and Thebes.[50]

At Athens, local memory would have held this particular spot especially sacred. It was from these high walls that the heroic ancestors kept

Athena Nike temple and bastion, Athenian Acropolis, from northwest.

the enemy at bay. In fact, the architects of the fifth-century Nike temple were so keen to keep the epic past visible that they cut windows into the bastion, through which one could see and touch the Mycenaean walls, those of the so-called Cyclopean masonry.[51]

Such immediate proximity to a preserved stretch of Mycenaean fortifications made the placement of Kleon's Spartan shields all the more potent. Decades following their dedication, the Nike bastion would be crowned with a stunning sculptured parapet. On it were carved a series of winged Victories shown leading cattle to a thanksgiving sacrifice for Athena, the goddess who made Athenian triumph possible.[52] Among the winged figures we see the famous "Sandalbinder," a Nike who gracefully bends over to tie her shoe. We also see a Nike who holds a helmet, while another adorns a trophy, and on the south side of the parapet, armor is shown, further spoils of triumph. At the very west end of this south flank, we see the goddess Athena herself (below). Her job is done, and she takes her rest, seated on a large block of stone. Her shield, no longer needed, is propped upright against the back of her seat. A Victory approaches the goddess, bringing yet another trophy from the battlefield, the base of which can be made out in front of Athena's right foot. Kleon's Spartan shields would thus have been beau-

Seated Athena from south side of Nike temple parapet. Acropolis Museum.

Reconstruction drawing of Bronze Athena with other dedications on the
Acropolis. By G. P. Stevens.

tifully echoed in the relief sculptures above them, sculptures depicting
a panoply of helmets, shields, and armor, carved years after Kleon's
booty was first displayed.

ACROSS SOME EIGHT HUNDRED YEARS, the first image to greet wor-
shippers as they walked through the gateway and into the Acropolis
precinct was Pheidias's colossal bronze statue of Athena (above), itself
a victory monument, said to have been financed by a tithe of the Per-
sian spoils taken at Marathon in 490 B.C.[53] The image stood just in
front of what remained of the Old Athena Temple, 40 meters (131 feet)
beyond the Propylaia. Part of its base survives in situ and shows that
it measured 5.5 meters (18 feet) square.[54] Traditionally dated to the
460s–450s B.C., the statue is now believed by some to have been more
or less contemporary with the Parthenon.[55] An inscribed marble slab
listing expenses for the materials and labor that went into the making
of the statue indicates that it took nine years for the Bronze Athena
to be completed.[56] Like the Athenians themselves, the Bronze Athena
looked forward, gazing out from the Acropolis directly at the island of

Salamis, where the Athenians had won their freedom and defeated the Persian foe.[57]

There had never been anything quite like it at Athens; indeed, the colossal goddess is estimated to have stood somewhere between 9 and 16 meters (30 and 50 feet) in height.[58] Pausanias tells us that one could see the tip of Athena's spear and the crest of her helmet all the way from Cape Sounion, some 70 kilometers (43 miles) east of Athens.[59] We have some idea of what the statue looked like, thanks to firsthand accounts and images replicating it on coins, vases, and sculpture.[60] Athena is believed to have stood with shield at her left side and her right hand outstretched, holding a winged Nike or, possibly, an owl. Her spear would have rested at her side. Pausanias tells us that her shield was decorated with carved figures showing the battle of the Lapiths and the Centaurs. Coins dating to A.D. 120–150 show the Bronze Athena standing before a gabled temple that must be the Parthenon, with a staircase and gateway leading up the Sacred Rock.[61]

Walking past the Bronze Athena, pilgrims would have been faced with a brilliant abundance of rich dedications from across centuries of worship and victory. A stretch of Xerxes's cables, another piece of those we have seen dedicated at Delphi, was displayed here on the Acropolis as well. But what could be seen standing on the Sacred Rock could not compare with the precious treasures locked inside the Parthenon, the Erechtheion, and the opisthodomos of the Old Athena Temple. In fact, some of the most illustrious trophies of Athenian victories were housed in this surviving back chamber of the ruined Archaic temple of Athena (page 74).[62] Here was the sword of the hated Persian general Mardonios, who sacked Athens in 480, only to die the following year at Plataia.[63] And here was the golden breastplate and bridle of Masistios, commander of the Persian cavalry who died in a skirmish leading up to the Battle of Plataia. So deeply mourned was this talented horseman that the inconsolable Persians shaved the manes of all their horses and pack animals, as well as their own hair, to express their collective grief.[64]

Inscribed treasury accounts document a vast catalog of bounty that filled the Parthenon itself: its eastern cella, westernmost room, and porches were packed with arms and armor, precious metal vessels, jewelry, coins, furniture, musical instruments, and more.[65] We hear of Persian daggers (*akinakes*), some overlaid with gold, others with sheaths of ivory; dozens and dozens of bronze helmets, including an Illyrian one

from Lesbos and another from Achaia; hundreds of bronze shields, dozens made of gilded wood; sabers and swords, greaves, a panoply dedicated by Alexander, son of Polyperchon; over a hundred spear points, used arrows, and a small ivory javelin.

There were also baskets and boxes by the dozens, some of gilt wood, others of silver and bronze; gold coins and unmarked gold and silver; gilt statues of maidens, golden Nikai, Gorgons, monsters, and griffins; and a silver gilt mask. Hundreds of gold and silver libation bowls and other precious vessels filled the temple, along with lyres made of ivory, gold, and wood and a gilt ivory case for double-pipes. There were hundreds of pairs of earrings, and rings of gold and onyx; five wide-collar necklaces with stones; a golden belt; a necklace with stones and rosettes and a ram's head. But the most famous jewelry of all was that dedicated by Roxane, Baktrian wife of Alexander the Great, who offered a gold necklace to Athena Polias along with a golden rhyton. Her gifts appear in the inventories for the year 305/304 B.C.[66]

A writing tablet, a gilt bridle, a lustral basin, an incense burner, a sacrificial knife with ivory sheath, a linen chiton, some fine muslin cloth, boots: these are varied and very personal offerings that filled the shelves and floors and porches of the temple. Its westernmost room, that which the inventory accounts refer to as the *parthenon,* had giant doors, even bigger than those opening onto the eastern cella, and a great treasure trove locked within: seven gilt Persian swords and a gold-plated helmet, three bronze helmets, and many shields, as well as quantities of furniture, including seven couches from Chios and ten from Miletos, stools, and tables (one with inlaid ivory).[67] And then there were those hundreds of pairs of gold earrings, silver and gold bowls, and so many lyres, all dedicated here in the room called the *parthenon.*

THIRTY YEARS AGO, in a pair of identically titled back-to-back articles, the Assyriologist Georges Roux and the Greek epigraphist Jacques Tréheux vigorously debated the big question: "Pourquoi le Parthénon?"[68] Indeed, why is the Parthenon called by this name? Its translation is simple enough: "Place of the Maidens." But which maidens and why? Roux rejected this meaning out of hand, advancing the opinion that the word refers not to a group of girls but to the virginity of the goddess Athena and that the room called *parthenon* was, in fact, the eastern

cella of the temple, home to Athena's monumental cult statue. Tréheux vehemently disagreed, arguing that the word *parthenon* demands a plurality of maidens and that the room in question is the westernmost or back chamber of the building (page 90).

In amplifying this debate, the French duo seized on an enigma that had puzzled experts since the early days of classical archaeology. Already in 1893, Adolf Furtwängler insisted that *parthenon* be understood in a plural sense, indeed as a cult place for a group of Athenian maidens. He even named the daughters of Erechtheus (or, possibly, the daughters of Kekrops) as the maidens in question.[69] Wilhelm Dörpfeld saw these maidens not as mythical princesses but as historical *ergastinai*, the "worker women" who wove the peplos for the Panathenaic festival. He suggested that the actual weaving took place within the rear chamber of the Parthenon.[70] But there were also, in these early days, those who looked to Athena's virginity as the source of the name of the building and who, like Roux in later years, believed the *parthenon* to be one and the same with the eastern cella of the temple.[71]

At the root of this debate are a series of inscribed inventories that record sacred property housed within the Parthenon (facing page). Beginning in 434/433 B.C. and running until circa 408/407 B.C., the inventories of the treasurers of Athens describe offerings held in the *proneos* (the east porch), in the *hekatompedon* (believed to be the eastern cella), and in a place called *parthenon* (most likely the western room of the building).[72] The accounts also speak of the contents of the *opisthodomos*, which has now been identified as the surviving back room of the Old Athena Temple where treasures, and possibly the olive wood statue of Athena, were kept, at least until the Erechtheion was built (page 74).[73]

The building we call Parthenon today was known by several names in antiquity. In the fifth century it was simply referred to as "the temple," *ho neos*.[74] According to a late source, the architects who actually worked on the project and wrote a treatise on its construction—Mnesikles and Kallikrates—called the building the "Hekatompedos," or "Hundred-Footer."[75] This name could have been used in remembrance of what came before it on this same spot. (As discussed in chapter 2, something called the Hekatompedon is attested on the Archaic Acropolis and may have occupied the space where the Parthenon stands today.)[76] But by the fourth century, the word *parthenon* had come to be used for the entire temple.[77] It is Demosthenes who, in 345/344 B.C., gives us our first

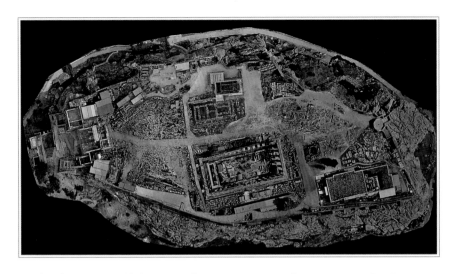

Orthophotomosaic of the Acropolis, 2009. © Acropolis Restoration Service

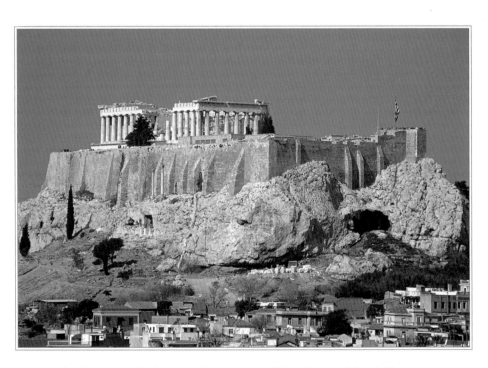

Athenian Acropolis from southeast, view of East Cave and South Slope.

Limestone snake from Bluebeard Temple pediment (Hekatompedon?),
Athenian Acropolis. © Acropolis Museum

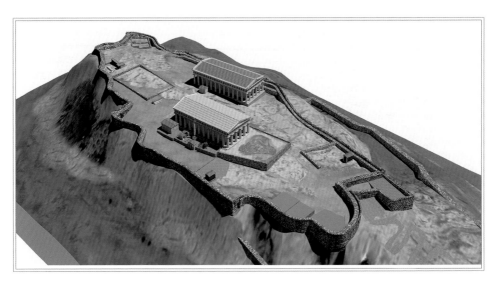

Hypothetical visualization of Archaic Acropolis with Hekatompedon at south
(above) and Old Athena Temple at north (below). D. Tsalkanis

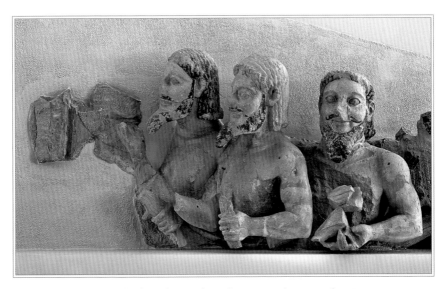

Bluebeard monster, Bluebeard Temple pediment (Hekatompedon?),
Athenian Acropolis. © Acropolis Museum

Zeus battling Typhon, Chalkidean hydria. Munich, Staatliche
Antikensammlung 596

Herakles wrestling Triton, Bluebeard Temple pediment (Hekatompedon?),
Athenian Acropolis. © Acropolis Museum

Raking cornice with lotus flowers, Bluebeard Temple pediment
(Hekatompedon?), Athenian Acropolis. © Acropolis Museum

Birth of Athena, east pediment,
Parthenon.

Contest of Athena and Poseidon, west
pediment, Parthenon.

Maiden basket bearer leads sacrificial procession toward Athena's altar at far left, behind which Athena and her priestess stand, as male worshipper approaches. Attic black-figure cup, ca. 550 B.C. Private collection

Akanthos finial akroterion, Parthenon. © Acropolis Museum

Processional route along the Panathenaic Way from the Kerameikos to the Acropolis.

Life-size replica of Pheidias's statue of Athena Parthenos by A. LeQuire, Centennial Park Parthenon, Nashville, Tennessee.

Owl perched upon altar as male worshipper approaches; sheep and bull
await sacrifice, black-figure hydria. Uppsala University Antikensammlung 352

Pheidias Showing the Frieze of the Parthenon to His Friends, Sir Lawrence
Alma-Tadema, 1868. Birmingham Museum and Art Gallery © Birmingham
Museums Trust

attested use of this word to describe the Parthenon as a whole.[78] Interestingly, Plutarch combines the two names, referring to the building as the "Hekatompedon Parthenon."[79] And by the time Pausanias writes in the second century A.D., he refers to the temple simply as "the building they call Parthenon."[80]

As Roux and Tréheux point out, there are other sanctuaries besides

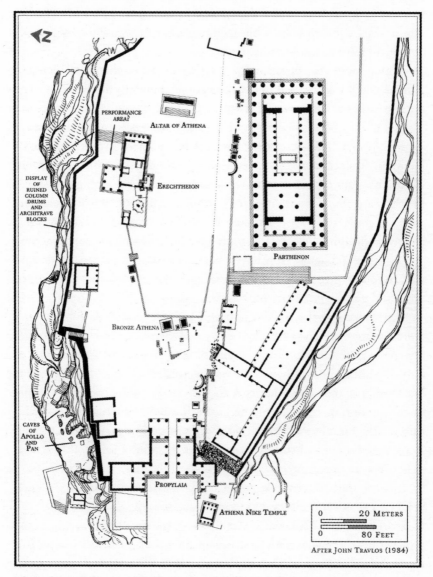

Plan of Acropolis showing classical and Hellenistic monuments.

that of Athena at Athens that have places called *parthenon* within them. These include the shrines of Artemis at Brauron, Artemis at Magnesia on the Maeander, and Meter Plakiane at Kyzikos on the Black Sea.[81] The presence of maidens, and a room for them, at the shrines of the virgin goddess Artemis are easy to understand. Less clear would be why the mother goddess Meter Plakiane would be associated with a *parthenon*.[82] Seizing on the case at Magnesia, Roux points out that Artemis was worshipped here under the epithet Loukophryne and not Parthenos, and uses this to bolster his argument that Athena Polias at Athens could still have a temple called Parthenon.[83]

Which invites the question: Is "Parthenos" an epithet at all? Indeed, Athena is not worshipped under the name Athena Parthenos at any site outside Athens.[84] But even if it were, it would be highly unusual for a place-name to be formed from an epithet. Normally, place-names are formed from a divinity's proper name. A place sacred to Hera is called a Heraion. A place sacred to Artemis is an Artemision. A precinct sacred to Athena should be called an Athenaion. A room belonging to a single maiden is a *parthenion* (in Greek script, παρθένιον, with the ending -ιον). A *parthenon* (written παρθενών, with the ending -ων), however, is clearly a place that belongs to a plurality of maidens. Most nouns whose ending is spelled -ων or -εων have a collective sense.[85] *Elaion* is therefore a place full of olive trees, *hippon* a place for horses, *andron* is a place for men, and *gynaikon* a place for women.

Our "place of the maidens" could well be explained by Athena's words at the very end of Euripides's *Erechtheus* in which she instructs Praxithea to bury her dead daughters in a single earth-tomb and to establish a temenos to them. Athena then orders the queen to build, for her dead husband, a precinct (*sekos*) with stone enclosure in the middle of the Acropolis. Euripides is here offering by etymology an explanation for the foundation of the two great cult buildings on the Periklean Acropolis: if the Erechtheion incorporates the tomb of Erechtheus, then the Parthenon must incorporate the tomb of the virgins.

Indeed, the westernmost room of the Parthenon could have been perceived to cover the very spot where the tomb of the virgin daughters of Erechtheus lay. This would accord with the Erechtheion, where the tomb of Erechtheus was understood to rest beneath the western part of the building. If this is so, then the heroic father and daughters were more intimately connected to the worship, and cult buildings, of Athena than

Western room of Parthenon as reconstructed with proto-Corinthian columns. By P. Pedersen.

we have previously imagined. Not only was their sacrifice celebrated on the frieze; together with the goddess herself, they received the most holy and most glorious temple honors, sacrifices, and ritual devotions.

While heroes of other Panhellenic sites may have died tragic deaths and received burial within sanctuaries, cult honors, and funerary games, it is at Athens alone that the heroic deaths served a higher purpose. Indeed, only at Athens did the city's founder-hero and his heroic daughters give their lives to save their entire community and its future. The transcendent selflessness of the Athenian heroines speaks directly to the core values that the citizens of Athens professed as uniquely their own.

The identification of the west room of the Parthenon with the tomb of the Erechtheids is bolstered by evidence for burials of other heroic maidens in proximity to the temples of the goddesses with whom they were closely connected. Iphigeneia's tomb was located in the sanctuary of Artemis at Brauron, while the tomb of the daughters of Antipoinos was set within the sanctuary of Artemis of Glory in Thebes. Of course, Iphigeneia was sacrificed to resolve a crisis for the collective good of the Greeks; she helped the Greek fleet set sail for the Trojan War. And

the daughters of Antipoinos gave their lives in order to save their city of Thebes from attack, just as the Erechtheids did for Athens. All these maidens received heroic burials and sacred rites within the holy precincts of the goddesses they were close to.[86]

The westernmost room of the Parthenon, in fact, gives us an important hint of its ambient funerary character (previous page). Poul Pedersen has persuasively argued that the four interior columns supporting its roof were crowned by a proto-version of Corinthian capitals.[87] He further relates the layout of this unusual "center-space room" to the cult building of the Eleusinian Mysteries, the Telesterion at Eleusis, a structure designed by none other than the architect of the Parthenon itself: Iktinos.[88]

Vitruvius tells us that the Corinthian order originated with a basket (*kalathos*) left at the tomb of an aristocratic maiden at Corinth. An akanthos plant grew up and around the openwork of the basket, giving it a beautiful, leafy appearance that caught the eye of the architect Kallimachos as he passed by. Inspired by this pleasing form, Kallimachos reportedly designed a column capital imitating the shape of the tender leaves entwining the basket: thus, the Corinthian order was born. And as Joseph Rykwert has demonstrated, Vitruvius's account contains five telltale elements: a virgin, a death, an offering basket, akanthos, and the notion of rebirth.[89] As we shall see at the end of this chapter, the daughters of Erechtheus are intimately associated with each of these elements. And it would seem that the deliberate innovation of proto-Corinthian capitals on the columns in the room called *parthenon* signals the funerary function of this deeply sacred space.

Akanthos leaves take center stage, once again, at the very peak of the Parthenon's gables, which were crowned by an astonishing pair of giant floral akroteria, one at either end of the temple (insert page 6, bottom). Carved in Pentelic marble, these show a highly innovative and ambitious openwork design and soar to an astounding height of nearly 4 meters (13 feet). Some twenty-seven fragments of these rooftop anthemia survive, showing fully developed akanthos scrolls and spreading leaves. It is a wonder that this delicate masterpiece of openwork, carved from heavy marble, could have survived production and hoisting into place.[90] Indeed, Pedersen emphasizes the groundbreaking free-plastic manner in which the openwork floral finials have been rendered. He makes a connection between these pioneering akanthos akroteria and

the akanthos leaves of the equally innovative proto-Corinthian capitals he restores in the Parthenon's westernmost room. Tracing the metamorphosis of traditional lotus-palmette and scroll anthemia seen on Archaic and classical funerary monuments, Pedersen sees a development toward akanthos leaf finials for gravestones of the late fifth and early fourth centuries.[91] Of essential importance to our argument is the relation between the akanthos elements on grave stelai and those atop and within the Parthenon. With four Nikai hovering above the corners of its roof (page 98) and two akanthos akroteria at the very peak of its gables (insert page 6, bottom), the Parthenon signals loud and clear that it is at once a monument to Athenian victory and at the same time a final resting place for the maidens who gave their lives to win Athenian triumph.

This reading may also help explain just why the Erechtheion and the Parthenon shared a single priestess and a single altar (page 231). Normally, each temple had its own altar and its own presiding priest or priestess. The peculiarity of Acropolis cult practice can now be understood in light of the founding myth that has Praxithea looking after the tomb shrine of her husband as well as that of her daughters, both housed within temples of Athena: the Erechtheion and the Parthenon. As the sole surviving member of the royal family, Praxithea is appointed first priestess of Athena on the Acropolis. She alone has the right to initiate burnt sacrifice on Athena's altar, an altar that serves both temples.

One can only wonder if the small *naiskos* and altar identified by Manolis Korres in the north peristyle of the Parthenon (page 91) has something to do with an ancient understanding of a very early shrine beneath the platform of the Periklean temple. We recall Athena's words to Praxithea in the *Erechtheus:* "It is necessary that these daughters have a precinct that must not be entered [*abaton*] and no one of the enemies should be allowed to make secret sacrifice there."[92] Could this *naiskos* mark the spot of the inaccessible holy place of the maiden daughters of Erechtheus perceived to be down below?

NEARLY THIRTY YEARS AGO, Donald G. Kyle argued that the Panathenaia developed from funeral games initiated by prominent old Athenian families.[93] This would explain why games and competitions (in memory of the heroic dead) were such an integral and essential part

of the Panathenaic festival. It would also signal that the grand procession from the Kerameikos to the Acropolis (insert page 7, top) had as its ultimate destination not only the altar of Athena but also the tombs of Erechtheus and his daughters. Thus, from cemetery to cemetery the citizenry marched, ever mindful of lives lost across the ages to ensure the very survival of Athens itself.

We have noted earlier that "Parthenos" is not a proper epithet for Athena. Instead, I maintain that the name comes to the goddess by attraction, referring not to Athena herself but to the youngest daughter of Erechtheus, the girl who is called "Parthenos" throughout Euripides's play. So intimately was this maiden associated with Athena that in time their identities merged. And so the foundation myth gave rise to a double-barreled cult title incorporating the name of the divinity with that of the local heroine: Athena-Parthenos. This follows the same pattern through which the cult title Poseidon-Erechtheus was formed. At the end of the *Erechtheus,* Athena proclaims that on account of his killer, Erechtheus will henceforth be called Holy Poseidon-Erechtheus. The double-barreled cult names, Poseidon-Erechtheus and Athena-Parthenos, thus represent the incorporation of local hero cult into the worship of local Olympians.

This same model of double-barreled worship, combining an Olympian deity with a local hero, is found at other Greek sanctuaries. Zeus-Agamemnon was worshipped at Sparta, Apollo-Hyakinthos at Amyklai, and Artemis-Iphigeneia at Brauron. Each of these sites features the tomb of the local hero/heroine situated close to the temple of the locally worshipped Olympian.[94] The pattern at Athens is the same, only more so, for the daughters of Erechtheus are part of a larger program of paideia. They are vitally central to the teaching of a unique set of values and the establishment of a common knowledge that made Athens different from every other city-state in Greece.

THE SPECIAL RELATIONSHIP between tombs and temples brings us to the larger question of the role of hero cult in shaping sacred space.[95] Greeks of the historical period regularly stumbled upon remains from the prehistoric era. The great stretches of Cyclopean masonry surviving from the Late Bronze Age were fairly indestructible, becoming a permanent feature of ancient sites. Mycenaean walls are visible to this day on

the Athenian Acropolis, juxtaposed with constructions postdating them by eight hundred years and more (page 28). Classical Athenians would have understood these remains to be relics from the time of their earliest ancestors. They clearly constructed stories, and rituals, around them.

Iron Age Greeks of the Peloponnese discovered Bronze Age ruins and believed them to be the tombs of epic heroes. A Mycenaean bridge is still in use to this day at Arkadiko near the modern road leading from Tiryns to Epidauros. One of a handful of bridges that survive from the Late Bronze Age, it is made of Cyclopean masonry and runs some 22 meters (72 feet) in length, supported by a corbeled arch.[96] Recognizing the great antiquity of this structure, historical Greeks of the classical period erected a shrine near it, following a larger pattern by which hero cult was established in proximity to Bronze Age remains.

The relationship of tombs, temples, and foundation myths can in fact be observed at far-flung Panhellenic sites, battening down our argument for Athens. If the perceived tombs of local heroes influenced the development of sacred space at these other sites, it becomes more reasonable to infer that the "tombs" of Erechtheus and his daughters played significant roles in the planning of the Erechtheion and the Parthenon, and thus shaped what the Parthenon meant to the Athenian people as a whole.

Athens was the earliest state to ardently emulate Olympia in developing its own festival of Panhellenic proportions. Indeed, the Great Panathenaia's close association with the Olympic model both established and reinforced its high status.[97] Of the four *periodos* sites, Olympia maintained the strongest ties to the elite, aristocratic origins from which it sprang. The Athenians, never to be outdone, enlarged, expanded, and highlighted this aspect of exclusivity, forging for themselves a hugely comprehensive display of elite tribal excellence that harkened back to the aristocratic glory days of the city. All the while, of course, the noble origins of the festival and athletic contests were veiled beneath the mantle of democratic values shared with those lucky enough to be numbered among the citizenry. Athenians had competed and won with great success at the Olympic Games throughout the seventh century, beginning with Pantakles's victory in the stade race of 696 B.C.[98] No wonder they wanted a Panhellenic festival all their own.

And looking to the model at Olympia, we find the tomb of Pelops, local founder of the games, right in the heart of the sanctuary. He was a

hero of such proportion that, to this day, the whole of southern Greece is called the Peloponnese, Island of Pelops. An immigrant from Lydia, Pelops won the hand of the daughter of the king of Pisa by beating him in a chariot race, thereby becoming a member of the royal family of Elis. His open-air precinct, the Pelopion, stood within the sacred grove (*altis*) at Olympia and just beside the great ash altar, close to the foundations of early apsidal buildings that harken back to the distant past. The *heroön* of Pelops was flanked by the Archaic temple of Hera and the great classical temple of Olympian Zeus.[99]

In the sanctuary of Zeus at Nemea, also in the Peloponnese (page 218), a hero shrine to the baby Opheltes, mythical prince of the city, has been unearthed close to the temple.[100] Here, as at Athens, a child of the local king dies, is buried near the local temple, and is honored in funeral games. The son of King Lykourgos, Opheltes was born under a dark prophecy. Death would come to the child if any part of his body touched ground before he learned to walk. One day, when in a leafy grove with his nurse, Hypsipyle, Opheltes met his fate when seven Argive warriors passed by and asked for a drink of water. Hypsipyle laid the baby down in a bed of celery, whereupon a snake sprang out and fatally bit the child. The warriors killed the snake and instituted funeral games in the boy's honor, changing his name from Opheltes to Archemoros.[101]

Pausanias saw the *heroön* of Opheltes and the tomb of his father, King Lykourgos, during his visit to Nemea in the second century A.D.[102] Excavations have revealed a pentagonal, open-air precinct, identified as the enclosure for the tomb and altar of Opheltes-Archemoros.[103] It represents the Hellenistic phase of a shrine already established in the Archaic period, when the Nemean Games were inaugurated (573 B.C.) and the first temple of Zeus was built.[104] Not far from Opheltes's shrine, twenty-three planting pits for fir or cypress trees have been unearthed, constituting a sacred grove that memorialized the spot where Opheltes died among the celery plants.[105]

Tomb, temple, and games: they can be found, as well, at the Panhellenic sanctuary of Poseidon at Isthmia. Here, a princely child dies and is honored with athletic competitions. Melikertes was the son of Athamas and Ino, king and queen of Orchomenos in Boiotia. Hera was angry at Ino for having raised the child Dionysos, illegitimate son of her own husband, Zeus. In retaliation, she caused Athamas to go mad and

murder his eldest son. Fearful for the life of her remaining boy, Ino took Melikertes and leaped with him into the Saronic Gulf. Mother and son were transformed into sea deities and acquired new names: Ino became Leukothea ("White Goddess") and Melikertes became Palaimon. Just as with Opheltes-Archemoros, the prince gains a double-barreled name: Melikertes-Palaimon. Dolphins carried his corpse to the shores of nearby Isthmia, where the Corinthian king Sisyphos discovered the body. Before meeting his tormented end of forever pushing a stone uphill, Sisyphos buried the boy in a pine grove near the sea and instituted the Isthmian Games in his memory.[106]

Excavations at Isthmia have revealed an open-air sanctuary identified as the *heroön* of Melikertes-Palaimon.[107] Though Roman in date, it is built upon a classical manhole cover for the water reservoir of the early stadium. By the mid-first century A.D., this opening was perceived to be the tomb of Melikertes-Palaimon, becoming the focal point of the hero's cult worship. So vital was the foundation myth and the physical remains that "proved" its existence that both could be invented in later periods and proudly projected back into a newly remembered past.

Athens might have started by copying Olympia, but it was not long before other cities and sanctuaries began to emulate the Athenian model of matchless pomp in festival ritual. Nowhere is this more strongly felt than at the sanctuary of Apollo-Hyakinthos at Amyklai, 5 kilometers (3.1 miles) south of Sparta. Here, a handsome local prince, Hyakinthos, suffered death before his time, was buried within the temple of Apollo, and was commemorated in a festival called the Hyakinthia. This feast included a grand procession, the ritual weaving of a dress (chiton) for the god, as well as an all-night vigil, or *pannychis*—in which maidens and youths sang and danced—sacrifices, and a feast.[108] In time, athletic competitions were added to these festivities. Each of these elements can be seen to draw inspiration from the Panathenaia. Even more, the Amyklaion developed into a major shrine for the display of arms and armor and played a critical role in local paideia, preparing the young men of Sparta for their future role as warriors. It is clear that young women participated in the cult as well, singing and dancing at the Hyakinthia festival.

Hyakinthos was the son of the eponymous founder of Amyklai, King Amyklas. As a beautiful boy, he was deeply loved by both Apollo and Zephyr, the West Wind. One day, when Apollo and Hyakinthos were

out throwing the discus, jealous Zephyr interfered, causing the discus to blow off course. It hit and killed Hyakinthos on the spot. Apollo was inconsolable. In memory of his beloved, the god inaugurated the Hyakinthia festival. King Amyklas buried his son directly beneath Apollo's cult statue, the base of which took the shape of an altar.[109] Upon entering through the bronze doors of the temple, worshippers first made offerings upon this altar/base to the dead hero Hyakinthos before sacrificing to Apollo himself.

According to Pausanias, the venerable cult statue of Apollo was aniconic (not unlike Athena's old olive wood image at Athens). It consisted of a great cylinder standing 13 meters (43 feet) tall, crowned with a helmet and given vestigial arms, in which it held a spear and a shield.[110] Apollo's conspicuous martial aspect at Amyklai served to inspire the young men of Sparta toward a future in the great fighting force of the city-state. The bronze armor of Timomachos of Thebes (said to have aided the Spartans in their war against the Amyklaioi) was displayed in the sanctuary along with other spoils and booty. Pausanias especially remarks on the large number of dedications made by soldiers and athletes he saw during his visit to the shrine.[111] Exposure to objects of memory from military exploits of the past fortified the effect of the Hyakinthia as a kind of initiation for young men about to become warriors.[112]

The name Hyakinthos is a very ancient one with pre-Greek origins, signaling the great antiquity of cult worship here.[113] But the Hyakinthia festival was probably not introduced until sometime in the eighth century B.C. when the sanctuary was formalized.[114] So important was the observation of these sacred rites to Spartans, and especially to the Amyklaioi, that they interrupted warfare each summer so that all could return home to participate in the three-day festival.[115] From what we can tell, it began with a solemn day of mourning and sacrifice, commemorating Apollo's grief in losing his beloved. In contrast, the second day was one of joy, expressed in a colorful procession along the Sacred Way from Sparta to Amyklai. There was singing and dancing by maidens, performances by choruses of boys and adult males, the singing of a paean, and the presentation of a woven chiton to Apollo, all culminating in a celebratory communal banquet.[116]

There is obvious overlap between the daughters of Erechtheus and the young hero Hyakinthos; indeed, at the end of the *Erechtheus,* Athena proclaims that the girls will henceforth be called the "Hyakinthian god-

desses."[117] Like Hyakinthos, the maidens die young, are buried beneath the temple of the goddess with whom they are so closely associated, and come to be remembered in cult worship, festival, and contests. But comparison stops here. Unlike Hyakinthos, a victim of Zephyr's petty jealousy, the daughters of Erechtheus died for the noblest of causes, saving their city, an act that speaks to the core values that made Athenians different from everyone else.

The best-known story of the dying Hyakinthos is how his blood dripped upon the earth and was transformed into the violet flower we still call hyacinth today.[118] According to one tradition, all three of the daughters of Erechtheus were sacrificed at a place called Hyakinthos Pagos, "the Purple Rock."[119] Assimilation of the Spartan myth with the Athenian tale of the Erechtheids may also account for a late tradition in which Hyakinthos was an adult Spartan living at Athens. When a plague threatened the city, an oracle demanded virgin sacrifice to make it stop, and so Hyakinthos offered his daughters to be killed.[120] Thus the mythical and ritual orbits of Athens and Sparta become very much entwined.

Let us conclude our pilgrimage through the Panhellenic *periodos* sites at the very center of Earth. In primordial times at Delphi, the earth-serpent Python presided over the cult center of his mother, Ge. Apollo wanted to take Delphi for his own and so slew the mighty Python, burying him deep within a cleft on the slopes of Mount Parnassos. This is the spot from which oracular vapors rose, sometimes called the *omphalos,* or "navel," the very center of the earth. It is atop this fissure and the burial place of Python that Apollo's temple came to be built. Thus we find, once again, a "tomb" beneath a temple. Python gives his name to the Pythia, the priestess who sat above the cleft on a tripod within Apollo's temple, pronouncing oracles. Python also gives his name to the Panhellenic festival the Pythaia and athletic competitions known as the Pythian Games. Thus, the serpent is forever commemorated within Apollo's sacred precinct.[121]

A second monumental death occurred within the sanctuary at Delphi, one that was commemorated with a tomb, shrine, festival, and sacrifices. Neoptolemos, son of Achilles, was killed by a priest in the doorway of Apollo's temple.[122] We are told that his body was first buried on the spot where he was killed, that is, beneath the temple's threshold. King Menelaos later moved it a short distance away.[123] Strabo speaks of

Location of Shrine of Neoptolemos and the Akanthos Column set just
beside it, sanctuary of Apollo, Delphi.

Neoptolemos's grave, and Pausanias claims to have seen it, just to the
left, or north, as one exits the temple of Apollo.[124] Foundations for a
small building unearthed on this spot have been identified as belonging
to the hero shrine of Neoptolemos, though this is not certain (above).[125]

Still, the importance of Neoptolemos at Delphi is of paramount inter-
est. In Homeric epic, the young warrior takes center stage in a number of
grisly episodes. On the night of the fall of Troy, Neoptolemos savagely
beats King Priam to death, using the body of Astyanax, the king's own
little grandson, as a club. The fact that this murder takes place upon the

Altar of Zeus makes it a grave sacrilege. Indeed, it is believed that the priest at Delphi killed Neoptolemos in retaliation for the blasphemy. Neoptolemos also kills Polyxena, daughter of King Priam and consort of his own father, Achilles (page 173). And Neoptolemos himself suffers a violent death, murdered just before the altar of Apollo, which is, of course, the fire altar for all of Greece.

Heliodoros's novel, the *Aethiopika,* describes in detail a festival honoring Neoptolemos and celebrated during the Pythian festival.[126] Throngs of youths and maidens marched all the way from Thessaly to participate in the holy rites, offering a sacrifice of a hundred animal victims (*hekatomb*) in front of Neoptolemos's tomb. The feast seems to

Daughters of Erechtheus as dancing Hyakinthides/ Hyades. Akanthos Column, sanctuary of Apollo, Delphi.

have held special meaning for the young people who experienced a kind of initiation rite through procession, dance, and sacrifices.

Sometime during the 330s B.C., when Lykourgos was holding up the example of the Erechtheids as inspiration for the young of Athens, a unique monument showing three beautifully sculptured maidens was set up at Delphi—right in front of Neoptolemos's hero shrine (previous page). The girls were literally held aloft, supported by a high pillar standing some 14 meters (46 feet) tall, reaching the height of the Apollo temple itself. Facing outward, their backs joined to the column from behind, the maidens seem to hang in the air, their diaphanous, knee-length dresses fluttering in the breeze. The tips of their toes are pointed downward, hovering just above a ring of large, unfurling akanthos leaves, exquisitely carved in lush, teeming foliage. But the apparent fecundity of the akanthos plant belies a darker meaning; we know by now that the akanthos signals death.

The Akanthos Column is one of the most enigmatic monuments to survive from the sanctuary of Apollo. Gloria Ferrari has identified its three maidens as the daughters of Erechtheus shown catasterized as the dancing star cluster Hyades, set in the heavens by Athena herself, as we have seen at the end of Euripides's *Erechtheus*.[127] The column propels the girls into the sky where they belong, joined in an eternal circle dance among the stars as the Hyakinthian goddesses. Their heads are crowned with basketlike diadems resembling those worn by *kalathiskos,* or "basket" dancers. We can picture the maidens of Heliodoros's *Aethiopika,* those who danced their way to Delphi with trays and baskets upon their heads, reaching their destination at the shrine of Neoptolemos, beneath the image of the dancing Erechtheids. Here, they may have joined hands in a circle dance, imitating their heroic role models, who floated high above them.

The Akanthos Column ultimately derives from the long tradition of setting images up on tall pillars within Greek sanctuaries, winged figures that appear to fly. Just as the great Archaic sphinx, dedicated by the people of Naxos at Delphi, hovered high beside Apollo's temple (see its location on page 242), so, too, the dancing Erechtheids hung in the air atop the Akanthos Column. And like the flying Nike of Paionios set in front of Zeus's temple at Olympia (page 224), the Akanthos Column reminded all who passed, friend and foe alike, of the supremacy of Athens and the enormous sacrifices made to achieve this. Each girl raises

her right arm to support a great bronze tripod, lost long ago. It has now been shown that this tripod was further surmounted by a stone *omphalos*, the very symbol of Delphi as center of the Earth.[128]

Over time, Neoptolemos develops into a model hero for young men, just as the daughters of Erechtheus do for young women. In fact, the very name Neoptolemos means "young warrior" or "recruit." And like other heroes encountered in this chapter, he acquires a second name: Pyrrhos.[129] This means "fire" and further links Neoptolemos to the fire of Apollo's altar, just meters from his tomb. Importantly, the name also connects him with Pyrrha, wife of the Athenian king Deukalion. The chest in which Pyrrha and Deukalion took refuge during the great flood, in fact, came to rest atop Mount Parnassos, just above Delphi. The name Pyrrhos thus associates Neoptolemos with the Athenian royal family and may help to explain why the Akanthos Column and its dancing Erechtheids were placed so close to the hero's shrine (page 242).

Two key memorials were thus intentionally juxtaposed at Delphi. One commemorated the archetypal young warrior: bold, ruthless, and "fiery." The other celebrated the archetypal maidens: graceful, elegant, yet no less brave and tenacious in giving their lives to save their city. Indeed, both male and female role models were required in the education of young citizens, in shaping a common knowledge for appropriate gendered behavior, both steeped in valor and patriotism. In the shadow of Apollo's temple and in the light of its eternal altar fire, youths and maidens sang, danced, and sacrificed. The shrine of Neoptolemos-Pyrrhos and the column of the dancing Erechtheids above it served as a key destination for young pilgrims at Delphi, especially those from Athens, a place where they performed special rites of initiation and reinforced their identities as Athenians in full view of all.

YOUTHS AND MAIDENS PERFORMED THESE rites in preparation for their future lives in which war, death, and remembrance would figure so centrally. These forces were as powerful in the shaping of the youthful psyche as in the formation of Greek sacred spaces and the monuments that filled them. As festive and joyful as the atmosphere of holy shrines might have been, energized with processions, singing, dancing, and other spectacles, we must remember the darkness that otherwise

overhung daily life: the darkness of incessant warfare and of primordial self-sacrifice, both of which made that life possible. The aching memory of lives lost by every single family who entered the holy precinct was carried with them up the Sacred Way.

What Athenian paideia was ultimately trying to teach was courage. For courage was essential to survival in the brutal world that was Greek antiquity. Athenians spent two out of every three years at war during most of the fifth century. It has been argued that in this war making, Athenians understood more clearly what they were doing than others of their time.[130] For democracy fostered free speech, deliberation, and forethought, all of which clarified the reasons for one's actions. From this, the revolutionary ideal of self-sacrifice for a greater good was born. Piety, paideia, and ritual tradition fueled the bravery needed to sustain this ideal. And it is this courage that enabled Athenians, old and young alike, to face the enormous challenges that winning and defending democracy so urgently required.

7

THE PANATHENAIA
The Performance of Belonging and the Death of the Maiden

ONLY TEN WOULD BE CHOSEN. Night after night, nervous boys filed into the ruins of the Theater of Dionysos at the foot of the Acropolis, taking a place center stage. There, each sang his heart out while the odd foreign woman sat among the marble thrones, where eminent Athenians had assembled in ancient times. She fixed her gaze upon each of them, one by one, until she had seen two hundred "ragged urchins." Isadora Duncan knew exactly what she was looking for. She would leave Athens with a chorus of ten Athenian boys.[1]

Duncan and her family had come to Athens in the autumn of 1903, setting up residence at a place called Kopanos on the slopes of Mount Hymettos, a location that afforded them an unobstructed view of the Acropolis. Construction of the family compound, which they called their "temple," was begun with great ambition but never finished. With typical impetuousness, the family had purchased land lacking an accessible water source. By the end of the year Isadora would have left. But the months spent in Athens were transformative and full. Engaging with poets, singers, dancers, monks, villagers, and royalty, they created their own community, in which they experimented with dance, theater,

music, and weaving. The Duncans recited and danced each morning in the Theater of Dionysos. In the afternoons they scoured the city's museums and libraries, trying to understand ancient Greek form and movement through a study of poetry, drama, sculpture, and vase painting.

Especially eager to understand the sound of ancient music, Isadora and her brother Raymond, who had met and quickly married Penelope Sikelianos, sister of the great poet, sought out manuscripts of Byzantine liturgical music. They had a theory that songs of the early Christian Church derived from the strophes of ancient Greek hymns. The Duncans also listened carefully to local men and boys singing traditional folk tunes, ever alert for vestiges of classical Greek music.

Isadora was determined to re-create an ancient boys' chorus to tour with her across Europe in Aeschylus's *Suppliants*. Indeed, she collected the best young male voices of Athens, enlisting an Orthodox novice priest with a specialty in Byzantine music to train the ten lucky lads for the ensemble known as the Greek Choir. Clan Duncan and the singing boys left Athens for Vienna, Munich, and Berlin before the year's end.

In Munich they performed for students of the great archaeologist Adolf Furtwängler, who introduced the event with a lecture on the Greek hymns that had been set to music by the novice. The boys, costumed in robes and sandals like an ancient chorus, sang this canon. Isadora herself danced all fifty of the Danaids. The audience was enthralled.

With each new venue, however, enthusiasm for the choir waned. By the time they got to Berlin, six months into the tour, the boys' voices had started to change, the once mellifluous tones growing ever more shrill and off-key. They had lost that heavenly boyish expression that had so captured Duncan in the Theater of Dionysos. They had also grown in height, some sprouting up by as much as a foot, and in rambunctiousness. By the spring of 1904, they would be sent home to Athens via second-class coach train from Berlin, in their bags the knickerbockers that had been bought for them at Wertheim's department store, mementos of Duncan's great experiment re-creating the ancient Greek chorus.[2]

Though breathless and flamboyant, Isadora's pursuit of what she perceived to be ancient sounds and movements remains instructive today. During her time in Athens, Duncan climbed the Acropolis often, summoning the power of the architecture to stir something within herself. Her descriptions of awaiting inspiration are affecting and natural:

For many days no movement came to me. And then one day came the thought: these columns which seem so straight and still are not really straight, each one is curving gently from the base to the height, each one is in flowing movement, never resting, and the movement of each is in harmony with the others. And as I thought this my arms rose slowly toward the Temple and I leaned forward—and then I knew I had found my dance, and it was a Prayer.[3]

Duncan had understood, in an instant, the quintessence of movement as prayer. Her epiphany, within the peristyle of the Parthenon,

Isadora Duncan in the porch of the Parthenon, photographed by Edward Steichen, 1920.

elicited a gesture that sprang from her diaphragm, forcing her arms upward in a pose of supplication. Edward Steichen's celebrated photographs of Duncan's striking stances within the Parthenon's colonnade (previous page) were shot in 1920, seventeen years after she wrote the lines quoted above.[4] Like so many others before and after her, Duncan would feel compelled to revisit the Parthenon throughout her life.

Generations of ancient Greeks did the same. In fact, every August for more than 800 years they streamed en masse toward the Acropolis, in a colorful procession that was the climax of the Panathenaic, or "All-Athenian," festival. Officially founded in the year 566/565 B.C., according to tradition, the Panathenaia was celebrated until the fourth century A.D., when a series of edicts issued by the Christian emperor Theodosios put an end to all "pagan" rites and festivals, closed Greek temples, and eradicated traditional worship. The final festival was probably held in A.D. 391 or, at the very latest, in 395.[5]

Across the uninterrupted centuries of observance, every fourth year saw an especially grand weeklong version of expanded contests and rites. Known as the Great (or Greater) Panathenaia, this version was international, open to participants and competitors from across the Greek world, whereas the Small (or Lesser) Panathenaia, observed during each of the intervening years, was local, its competitions open to Athenian citizens alone.[6] One naturally thinks of the Olympics by comparison, the quadrennial games open to the whole Greek world (with Panhellenic contests held in the intervening years at Delphi, Nemea, and Isthmia). There are indeed meaningful similarities, not least of which is that the Panathenaia, like the Olympics, was at bottom a religious observance. But while it must be allowed that the Olympic, the Pythian, and other Panhellenic festivals were more important occasions in the Greek world generally (even than the greater version of the Panathenaia), there was no more important occasion in Athens. The Panathenaia comprised the days when the Athenians were most intensely, ecstatically themselves—a crescendo of being and consciousness. At its heart, more important than any of the other rituals or competitions, was the procession itself. And the destination of that sacred, definitive procession was none other than the sacred altar of Athena just to the northeast of the Parthenon (insert page 7, top).

In what can be described as the ultimate multimedia spectacle, the procession of worshippers was the culmination of both the Great and

the Small Panathenaic festivals. This visual and acoustic marvel began at dawn in the Kerameikos, just outside the city gates at a structure called the Pompeion, or "Procession Building." Here, processionists lined up in groups according to their social status, gender, and age cohort. Passing through the Double Gate (Dipylon), they followed the Sacred Way, crossing the Agora and climbing up the Acropolis, where they entered through the monumental gateway (Propylaia) before marching on toward Athena's sacred altar (page 9).[7] In train were a hundred head of cattle for sacrifice to the goddess, an act of collective devotion. Following the sacrifice, the meat was cooked and distributed, a feast shared by all participants, citizens and noncitizens alike.

The Small Panathenaia was, as we have said, a local festival, its competitions open only to citizens from the ten tribes. The Great Panathenaia, including contests open to all Greeks, nevertheless restricted certain competitions to Athenian citizens alone. These so-called tribal events included some of the horse races, the boat race, the torch relay race, and a men's beauty contest. Also among these was the *pyrrichos,* a competition for armed dancers, and the *apobates* race, which involved contestants jumping on and off a moving chariot wearing full armor. The vigil called the *pannychis,* or "all-nighter," generally thought to have been held on the eve of the procession, was open only to youths and maidens from citizen families. The following day, as the procession reached the gateway of the Acropolis, only members of these families were allowed to enter Athena's sacred precinct.

The rites and competitions of the Panathenaia, in substance and exclusivity, enabled Athenian citizens to articulate the very essence of who they were. In no other setting, perhaps not even warfare, would they have so keenly felt the awareness of being bound together as families and tribes descended from a common point in the epic past. As in Linnaean taxonomy, one could find himself based on membership in a household (*oikos*), a kinship group (*genos*)—known across four generations and associated with the elite—a larger "brotherhood" group (*phratry*), and one of the ten tribes (*phylai*) established by Kleisthenes in 508/507 B.C. in the early days of the democracy. This intricate system made the blood bond of Athenian citizenship essential while exerting enormous pressure against any notion of including outsiders.[8]

The prominence of the tribal events at the Panathenaia sets it apart from festival practice at other Panhellenic game sites, those at Olym-

pia, Delphi, Isthmia, and Nemea. Little if any emphasis was placed on the superiority of the local hosts at these sanctuaries. Indeed, at Athens, administration of the festival was itself very much a tribal affair. Each tribe appointed one representative, drawn by lot, to a board of ten magistrates known as *athlothetai* who oversaw the organization and preparations for the festivities, including the awarding of prizes.[9] They were also responsible for the financing of the games, a hugely expensive undertaking. The office had a four-year term, providing time enough for officeholders to announce and organize the contests, as well as for them to oversee the weaving of the sacred peplos for Athena, a job performed by a group of women called *ergastinai* (workers) over nine months.[10] As we understand it from the fragmentary sources, a giant tapestry-peplos was presented to the goddess (from the sixth century on) every four years at the Great Panathenaia, while a small peplos was woven for the Small Panathenaic festivals held during the intervening years.[11] These peplos offerings are understood to have been deposited near the olive wood statue in the Old Athena Temple (or what remained of it) and possibly later in the Erechtheion, following its construction in the last quarter of the fifth century B.C., though this is by no means certain.

Time was crucial in all matters related to administering the festival. The timing of the events themselves was synchronized with celestial configurations of star groups and moon phases so that the Panathenaia would be as one with the cosmos.[12] Athenian piety also required that the festival be in harmony with the natural surroundings, the landscape, flora, and fauna of Athens, all the places of memory that pulsed with the mythic past and kept it alive. But like the rivers and the wind, the observances of the festival were sometimes wildly kinetic, and this is perhaps the hardest element for us to recover.

Maps, plans, and models of ancient Athens, still and inert as they are necessarily, give little sense of the robust fields of movement that enlivened the city in antiquity. We are conditioned to experience "ruins" as static and unchanging, and so it is hard to grasp the vibrancy of ritual in action, the motion that once invigorated the placid scenes that we see today. We instinctively focus on the buildings when, in fact, the action took place in the spaces left between them. Temples were usually locked tight, serving as safe houses for valuable votive offerings and treasure. Life throughout the ancient Mediterranean, meanwhile, was lived mostly outdoors. Working, worshipping, dining, dancing,

even sleeping for much of the year, happened on verandas, under covered porticoes and grape arbors, in courtyards, on balconies, in streets, roadways, marketplaces, fields, and, yes, sanctuaries. It is therefore ultimately necessary to focus on the voids between structures, the open spaces that served as gathering places for spectacle and performance. We will consider how these spaces were transformed by the actors and by the processions, dances, footraces, and rituals that brought life to them. Engaging with the ephemeral and performative aspects of Panathenaic ritual allows us to better understand the full dynamics of the process through which Athena was honored.[13]

Such engagement suggests that in Greek antiquity the expenditure of energy through physical exertion constituted a prayer or votive act unto itself. Just as recent scholarship has encouraged us to view the act of writing, not just the inscription, as a votive, so, too, ritual movement can be understood as an offering that brought pleasure to the gods.[14] Looking cross-culturally at the Classic Maya, we find examples of the practiced, rapid movement of the feet—dance, in other words—constituting an attitude of prayer. Ritual foot shuffling summoned the essence of the divine.[15] The physicality of the human body was thus employed as an instrument of ritual communication. It is important to view the Panathenaia within this context. At Athens, we see the full citizenry of the body politic coming together with outsiders from across the Greek world in a grand kinetic offering to the goddess through marching, singing, reciting, running, jumping, throwing, wrestling, riding, sacrificing, and feasting.

BEFORE FOCUSING ON the Panathenaia itself, we would do well to consider the festival within the broader context of Greek religion. We must remember that the Greeks had no "sacred book" to set down a universal system of beliefs and laws. They had no unified "church" with central authority, no "clergy" to instruct in beliefs. The Greeks did not even have a separate word for religion, since there was no area of life that it did not permeate.[16] Religion was embedded in everything. And it was wholly a local enterprise, dependent on the traditions of tightly knit family groups across many generations. Thus, every detail concerning religious practice was locally ordained. Each sanctuary had its own rules and regulations, guidelines for access, dress, comportment, festi-

val calendars, dedications, sacrificial practice, and hierarchy of sacred officials to oversee administration of sacred rites.[17]

The Athenians, as we have said, were the most religious in a world steeped in religion. At Athens, it has been estimated that there were around 130 to 170 festival days per year, meaning more than a third of the calendar was devoted to observing religious feasts.[18] These offered the opportunity for eating flesh, a happy by-product of the animal sacrifices offered to the gods (this is the "meat sacrificed to idols" against which Paul will later warn the Church at Corinth). By a convenient twist of mythological precedent, it was determined that gods preferred the inedible parts of sacrificial victims, the fat and bones, leaving the juicy cuts of meat to be shared by the human worshippers.[19] The absence of refrigeration meant that sacrificial meat from a large animal like a cow, bull, or ox had to be cooked and eaten on the spot. Meat was rarely eaten outside religious contexts, making for a "chicken every Sunday" way of life in which large family groups feasted together as part of sacred rites. At both the Great and the Small Panathenaic festivals, where a hundred head of cattle were sacrificed, there was plenty to go around.

The musical and athletic contests of the Panathenaia were also part of the larger, overarching religious program. Athletic games were not the secular enterprises we know today, centered on the glory of the individual winner. The goal of the festival was to give honor to the goddess, to please Athena, and to remember the ancestors. So sacred was the athletic endeavor that a truce was called for the period before and during the Olympic Games, known as *ekecheiria*, or "the laying down of arms."[20] This allowed festival participants to travel safely to and from Olympia over a three-month period. The same principle would have applied during the Great Panathenaia. In the months leading up to the feast, special ambassadors called *spondophoroi* were sent out to announce the competitions to Greek communities across the Mediterranean and as far east as the Arabian Gulf.[21]

The Panathenaic Games stood out from the other Panhellenic contests for their lucrative cash prizes.[22] Those high-minded people had an appetite not merely for competition but for rewards of material value. The Athenian state paid out vast amounts to sponsor the games. So, too, did the oldest and most affluent families of the city, upon whom the expectation of benefaction rested very heavily. By the fifth century, however, Athenian allies and colonists were obliged to send a cow and

a panoply of weapons for the Great Panathenaia.[23] Thus, the financial burden came to be more broadly shared.

From the mid-sixth century on, prizes for the Panathenaia took the form of precious Athenian olive oil held in vessels specially commissioned by the state. Known as Panathenaic prize amphorae, these vases conform to particular specifications of size, volume, shape, and decoration.[24] On one side, they show Athena helmeted in her full martial guise, brandishing her spear and shield and striding aggressively forward. In painted letters beside the picture panel appear the words "From the Games at Athens," TON ATHENETHEN ATHLON. Some idea of the value placed on winning in the Panathenaic Games can be understood from the size of the prizes. Panathenaic amphorae held exactly thirty-six kilos of olive oil. We hear of one winner who received 140 amphorae, five tons of oil in all. The value of that quantity has been estimated at 1,680 drachmas, roughly five and a half years' salary for the average worker.[25] The exorbitant compensation of star athletes is one of our lesser-known Athenian legacies.

An amphora from the so-called Burgon group, dating to around 560 B.C., represents the earliest in the sequence of prize amphorae (previous page).[26] Athena is shown striding forward on the belly of the vase,

Panathenaic prize amphora with Athena brandishing spear and shield; siren on neck, owl on reverse of neck. Burgon type, ca. 566 B.C.

with a bird-bodied siren on one side of its neck and an owl on the other. It is of great interest that the two winged creatures, both associated with mourning and lament, are paired together on this very early Panathenaic prize amphora. By the 540s, a canonical image is established for Panathenaic amphorae, one that shows Athena striding forward and flanked by two columns surmounted by cocks; a vase by the Princeton Painter follows this Panathenaic model (below).[27] By now, the goddess's iconic mascot, the little owl, has come to perch upon her shield. We shall soon have more to say about the persistence of winged creatures within the orbit of Athena, where they have very special significance.

The reverse side of Panathenaic vases regularly shows images drawn from the musical and athletic competitions. The Burgon, for example, shows a two-horse chariot race known as the *synoris*. Straight through the Hellenistic period, Panathenaic amphorae will continue to be decorated in the black-figured technique of the sixth century. Thus, they maintain an Archaic look, deliberately evoking the earliest days of the festival.

While the precise event schedule of the Great Panathenaia is not

Amphora of Panathenaic shape and iconography, showing Athena brandishing a spear and a shield (on which an owl alights). Princeton Painter, ca. 540s B.C.

known for certain, it is believed that the feast was celebrated across eight days, from roughly the twenty-third to the thirtieth day of the month Hekatombaion.[28] Athens, like many Greek cities, had its own names for months. Hekatombaion means an offering of "one hundred" animal victims, referring to the number of cattle sacrificed at the Panathenaia. Athenian Hekatombaion falls roughly from the middle of July to the middle of August in our calendar. The Panathenaic festival would thus have taken place during the final eight days of the month, culminating in procession and sacrifice on the twenty-eighth of Hekatombaion, or, around the fifteenth of August. In time, this day came to be recognized as the birthday of Athena.[29] The legacy remains with us: our month of August falls under the zodiac sign of Virgo, the Virgin. And in both the Catholic and the Orthodox traditions, the fifteenth of August is celebrated as the greatest feast of the Virgin Mary, the day on which she was taken up bodily into heaven.

The schedule of athletic events for the Great Panathenaia can be reconstructed, up to a point, thanks to the survival of lists of prizes for winners given in order of their victories. These are preserved on a key inscription dated around 380 B.C.[30] Of course the inscription attests to practices of the early fourth century and may not reflect those in other periods of the festival's more than eight-hundred-year history; however steeped in tradition, the Panathenaic festival was by no means static or unchanging. Events and venues were added and eliminated across the centuries. Nonetheless, we can confirm that by the fourth century the festival program ran across eight days.

The first day was devoted to musical contests and the recitation of poetry, the second day to athletic competitions for boys and youths, the third day to men's athletic contests, and the fourth to equestrian events. The fifth day began the tribal contests open to Athenian citizens alone, and carried over into the sixth on which the torch races and the all-night vigil on the Acropolis, the *pannychis*, took place. (It should be said that this all-night revel may have taken place later in the week, following the sacrifices and feasting.)[31] The seventh day saw the great procession and sacrifices on the Sacred Rock, followed by more tribal competitions, the *apobates* and boat races, on day eight. While it is not known precisely when the prizes were awarded, it is assumed that this took place on the final day.

Let us imagine the experience of participants over this week of festiv-

ities. Around the twenty-third of Hekatombaion, worshippers gathered for musical competitions and recitations of epic and lyric poetry that signaled the start of the Panathenaia. Indeed, music may have served to summon the essence of the divine, inviting the goddess's presence for the week of events offered in her honor. We must not mistake the primary function of music in sacred ritual: it is a means of communicating with the divine, bringing the community together in a shared experience that transcends the quotidian, an altered state of being.

The musical events were first performed in the Agora, where temporary stands were erected in an area known as the orchestra. Some believe that the contests were transferred in the 430s to a music hall built by Perikles at the southeast foot of the Acropolis, just beside the Theater of Dionysos (page 305).[32] Still, epigraphic evidence attests to the continued use of the Agora for some musical performances, even after the death of Perikles.[33]

By the last quarter of the fourth century, Demetrios of Phaleron is believed to have moved the musical and rhapsodic competitions to the Theater of Dionysos.[34] The theater had been entirely rebuilt by Lykourgos in the 330s, increasing its seating capacity to around seventeen thousand. Lykourgos also built a new Panathenaic stadium entirely of marble, set just beside the Ilissos River (page 9). The footraces along with most of the gymnastic events were no doubt moved at this time to the lavish new stadium. Venue changes allowed contemporary Athenian leaders to put their own stamps on the competitions, eclipsing the memory, not always pleasant, of former regimes. Setting the Panathenaic competitions became, in this sense, a power play, whereby vast numbers of worshippers could be made aware of the contributions of political leaders to refreshing traditions, even as the universal past was invoked and glorified.[35]

The recitation of epic song narratives on the first day of the festival reconnected worshippers with the sentiments and ideals of their ancestors. If there was anything that approached the status of a sacred foundation text for all Greeks, it was Homer's account of the Trojan War and its aftermath as told in the *Iliad* and the *Odyssey*. In *Against Leokrates*, Lykourgos emphasizes that the ancestors legislated changes to the Great Panathenaia in order to ensure that Homer's, and *only* Homer's, work would be recited at the festival. "Poets," Lykourgos observes, "depicting life itself, select the noblest actions and so through argument and

demonstration convert men's hearts."[36] Lykourgos is referring to what has been called the "Panathenaic Regulation," by which the Homeric poems were established as those to be performed, or "reperformed," at the Panathenaia. This measure has been traced, by some, all the way back to Solon's day.[37] Listening to the *Iliad* and the *Odyssey* enabled all participants in the festival, Athenians and non-Athenians alike, to start the week off "on the same page," reflecting in the proper spirit on their common origins as Hellenes. There would be plenty of time later in the week for the Athenians to show off their superior lineage while the outsiders watched.

A roster of rhapsodes recited the Homeric poems in a relay sequence, one picking up where the other left off, each declaiming five hundred to eight hundred lines. In a sense, this resembled the footraces of the tribal competitions that followed, the sharing of the performed text as a "team event." Indeed, both the athletic and rhapsodic competitions were referred to as *agones* (contests). And like all Panathenaic contests the rhapsodic, at its core, was a ritual, one in which participants both collaborated and competed, as Gregory Nagy has emphasized. It is generally believed that the versions of the Homeric poems recited at the Panathenaia were organized, or reorganized, by Hipparchos, son of Peisistratos.[38] By the Hellenistic period, theatrical contests were added to the schedule of events, and by Roman times we hear that tragedies were also performed.[39]

In the middle of the fifth century, Perikles, by now one of the *athlothetai* overseeing the festival, seems to have put his own stamp on the first day of the festival. Apparently, he had a decree passed introducing a musical contest, personally prescribing every detail of how contestants should blow on the aulos, sing, or pluck the kithara.[40]

That musical competitions became so integral to the Panathenaic Games signals the centrality of music making (which included rhapsodic recitation) in ancient Athens. It equates this art with athletic contests, placing it under the same umbrella of competition and expenditure of energy for the delight of the goddess, a species of prayer. There is indeed a certain physicality to playing instruments, singing, and reciting poetry that renders the effort akin to athletic exertion. Music, no less than athletics, demands raw talent, rigorous training, and performance skills. For this reason, with memorization of words, athletics, and dance, music was central to the education of the young. That the Panathenaic

competitions tested all the abilities cultivated in Athenian paideia is no accident: this training of the next generation in the values and ideals of the polis was essential to good citizenship. To be Athenian was to belong, by reason of birth above all but by formation as well.

Music was ubiquitous at the Panathenaia. The sounds of pipes and lyres accompanied athletic contests as well as animal sacrifices and other rites. Indeed, the shrill tones of the aulos masked the cries of animal victims as their throats were cut upon the altar of sacrifice. Music punctuated and articulated the progressive stages of sacrifice. Some sense of the ancient experience may survive in the Spanish bullfight in which a band of musicians accompanies each phase of the spectacle: arrival of the bull, arrival of the torero and banderilleros, entry of the picador on horseback, killing of the bull, awarding of prizes, and exit from the arena. In Athens, musical punctuation also marked stages within athletic competitions, the sound of pipes signaling the start of events and the awarding of prizes.

The musical competitions (*musikes agones*), held on the first day of the festival, were divided into two classes, one for boys and one for men, separating voices that had not yet changed from those that had.[41] They were further subdivided into contests for playing and singing with aulos accompaniment and ones for accompaniment by the kithara.[42]

The English word "guitar" derives from the word kithara denoting the large seven-stringed lyre.[43] The global renown of ancient *kitharodes* who traveled on tour from town to town finds certain parallels in the fame of contemporary rock musicians who sing and play the guitar. In some sense, kithara players were the rock stars of Greek antiquity, and they were comparably compensated, enjoying the patronage of wealthy tyrants and political leaders. At the Panathenaia, the value of their prizes hugely exceeds the awards given in all other contests. First-place *kitharodes* received not an amphora of olive oil but a gold crown worth a thousand drachmas, plus five hundred drachmas in silver. By comparison, *kitharistai,* those who played the kithara but did not sing, received a crown worth just five hundred drachmas, plus three hundred drachmas in cash. And the *kitharode* competition had second-, third-, fourth-, and even fifth-place finishers, where no other Panathenaic contests did. All musical competition was lucrative but nothing matched the kithara contest. First place in competitions for a combination of singing and playing the pipes (*aulodia*) brought prizes of a wreath and three

hundred drachmas in cash. Musicians who played the pipes alone without singing (*auletai*) received only a wreath.[44]

Athletic competition, meanwhile, was organized into three leagues: one for boys, one for beardless youths (*ageneioi*), and one for men.[45] These contests started on the second day, with boys competing in six events and youths in five. On the third day, the men's competitions comprised nine events.[46] Track-and-field contests included running the *stadion* (at Athens, a distance of 185 meters, or 607 feet), the *diaulos* (2 stadia, or 370 meters), the *hippios* (4 stadia), and the *dolichos* (24 stadia). Men also competed in a special two-stadia race that required them to run fully armed, testing the strength and endurance needed on the battlefield.

The pentathlon events were hugely exciting for viewers, who watched naked athletes compete in a comprehensive and grueling test of their physical strength, stamina, speed, and flexibility. Indeed, competitors had to show real versatility and all-around robustness in running the *stadion,* competing in the long jump, throwing the discus and the javelin, and wrestling.[47] Boxing and the punishing *pankration*, a combination of boxing and wrestling with no holds barred (only eye gouging,

Burly athletes competing in the *pankration*. Panathenaic prize amphora, the Kleophrades Painter, ca. 525–500 B.C.

kicking, and biting were forbidden), rounded out the *gymnikoi agones,* literally contests undertaken in the nude. A Panathenaic amphora by the Kleophrades Painter, dating to the last quarter of the sixth century, captures something of the brutal drama of the *pankration:* a burly nude combatant is twisted into an unwieldy position by his able adversary as a judge watches (previous page).[48] These contests provided thrilling and extreme spectacles for the throngs of Panathenaic viewers. We hear of one acclaimed *pankratiast* from Sikyon, Sostratos, who in the fashion of modern-day World Wrestling Federation stars, won a nickname for his special prowess: Akrochersites, "the Fingerer" or "Mr. Fingertips." This was owing to his signature move, in which he entered the ring and immediately broke the fingers of his opponents, putting them at serious disadvantage for the rest of the match. It proved an effective strategy; indeed, "the Fingerer" won three consecutive victories at the Olympics (364, 360, and 356 B.C.), twelve combined victories at the Nemean and Isthmian Games, and two at the Pythian Games at Delphi. Though there is no surviving evidence that he competed at Athens, we know he was honored with portrait statues set up at both Olympia and Delphi.[49]

The fourth day of the Panathenaia was devoted to equestrian events. These were first held in the Agora but, by the fourth century, had been transferred to a hippodrome built at New Phaleron.[50] The equestrian competitions naturally had a certain military aura about them, testing the speed of the horses as well as the agility of riders and drivers, skills critical on the battlefield. There were bareback races, two-horse chariot races (*synoris*) that ran eight laps around the hippodrome, and four-horse chariot races (*tethrippon*) that ran for twelve laps. There were races for Athenians and those for non-Athenians; races run by yearlings and those run by mature horses. As is the practice today, awards went to the owners rather than to the jockeys or charioteers. Indeed, fielding a team of horses was enormously expensive, impossible for all but the wealthiest of the elite.

The fifth day of the games was wholly reserved for contests open to Athenian citizens alone. There was the *pyrrichos* (a dance in full armor), the *apobates* race, an equestrian event called the *anthippasia,* a boat race, the *euandria* (a beauty contest for mature men), and a torch relay race. These tribal contests evoked sacred memories of the earliest ancestors, emphasizing their physical and aesthetic excellence, their strength and agility in battle, and their grace in dance and comportment. Above

all, tribal events stressed military readiness and power; foreign teams and visitors were compelled to watch a celebration of Athenian supremacy designed, at least in part, for their discomfort.

The pyrrhic dance competitions required contestants to dance nude, hold a shield, and imitate movements from combat: dodging, jumping, crouching, striking, hitting, and lunging.[51] There were separate heats for boys, beardless youths, and men. The dance was attributed to Athena herself, who, according to her birth story, sprang from the head of Zeus in full armor and dancing the *pyrrhike*. It was understood to be a dance of joy anticipating her victory in the Gigantomachy.[52]

The *anthippasia* involved a mock cavalry battle.[53] Riders from five tribes competed against those of the other five, arranging themselves in rows on horseback and riding through each other's lines. This grand spectacle was evocative of the great battles of the epic past. So, too, were horseback javelin throws, which required contestants to hit a target while galloping at full speed.[54]

Perhaps the most surprising of the tribal events, at least for the modern reader, is the male beauty contest.[55] Prizes for the *euandria* included an ox and, according to Aristotle, shields.[56] The ox suggests the entire tribe feasted together following the victory, which might mean that the *euandria* was a team event in which the beauty, size, and strength of one group of men were tested against those of groups from other tribes. Xenophon tells us that the *euandria* at Athens was, as such things went, utterly "unmatched in quality."[57] This competition celebrated the Athenian ideal of personal conduct known as *kalokagathia,* a compound of two adjectives, *kalos* ("beautiful") and *agathos* ("good" or "virtuous"). We hear of one Athenian who won three separate events at the Panathenaia: the torch race, the *tragedoeia* (tragic acting competition), and the *euandria*. This man, it would seem, had it all: looks, strength, athleticism, acting talent, and, no doubt, a certain charisma.[58] One only wonders how well he played the kithara.

Just after sunset on the fifth day, the tribal torch races, or *lampadephoria,* were run. These seem to have been run by young ephebes, starting from out beyond the city walls in the Academy and speeding through the Dipylon Gate and the Agora, making their way up to the Acropolis.[59] This would have brought a thrilling visual display of firelight in the darkness, to say nothing of agility, speed, teamwork, and athleticism. Forty runners representing each of the ten tribes raced for

sixty meters in the relay, handing off the flaming torches until a distance of twenty-five hundred meters had been covered.

The torch race served the greater purpose of transferring fire from the altar of Prometheus in the Academy to the altar of Athena on the Acropolis. Thus, the event reenacted the stealing of fire and the lighting of the first sacrificial altar by Prometheus, father of King Deukalion and ancestor of all Athenians. The first runner to reach the Acropolis won the honor of lighting Athena's altar for the sacrifices that would be offered there the next day. His tribe would share in the feast of an ox, as well as a hundred drachmas in cash. Each of the forty runners on the winning team received an additional thirty drachmas and a water jar.[60]

LATER THAT EVENING, citizen youths and maidens climbed the summit of the Acropolis for an all-night vigil, the *pannychis,* a most intense group experience.[61] For the girls, just past puberty, this was perhaps the first time they had ventured out from the confinement of their households at night to be in the company of young men. On the Acropolis rock they sang and danced the whole night through, no doubt taking turns in circle dances organized according to their tribes, dances that were a mainstay of their paideia from an early age.

It was through the repetitive movements of dance, set to music and the memorized words of hymns, that young people learned the myth-histories of their community, perhaps why Plato says that choral dancing represented "the entirety of education."[62] Indeed, song-dance lay at the very heart of Greek paideia. As arms and legs moved to the beat of practiced notes and words, incorporated within the heightened intensity of ritual performance, the body found, as it were, its cosmic coordination point, locating the self within the incomprehensibly vast scheme of Athenian time and space. Who am I? Where do I come from?

Where exactly on the Acropolis did the dances of the *pannychis* take place? While no surviving texts offer a conclusive answer, there is a basis for reasonable speculation. Between the north fortification wall and the Erechtheion stretches a rectangular "plaza," bounded at the west by the temple's north porch and at the east by a flight of a dozen steps. This self-contained space would have been ideal for performance (facing page).[63] The steps and staircases looking down into the plaza would have served perfectly as "bleachers" for spectators. Fascinatingly, this

Plan of Erechtheion showing location of Poseidon's trident strike, Athena's olive tree, and performance space.

square was paved over as early as the Bronze Age, indicating its use as a setting for spectacle might have been very long-lived.[64] It might well have been preserved across the ages as a special "theatral zone."

Shielded from wind and noise on four sides, this square offered ideal acoustics for choral singing and dancing. There was also its proximity to the mythically charged landscape of the Acropolis's north slope, the very spot where the high drama of legendary princesses had played out. Here, above the cave of the Long Rocks, where Apollo made love to Kreousa and where the infant Ion was abandoned, girls might join hands in a circle dance on the eve of the Panathenaic procession. One might hear the piping of Pan drifting up from his cave in accompaniment, just as it had for the dances of the daughters of King Kekrops in the passage from Euripides's *Ion* quoted in chapter 1.[65] And then there was the memory that the daughters of Kekrops and possibly the oldest daughters of Erechtheus leaped from the Acropolis cliffs to their deaths.[66] Last, it is here within the ramparts of the north fortification wall that salvaged col-

umn drums, metopes, and architrave blocks from the destroyed Archaic temples were displayed (page 73). Landscape, myth, history, and ritual spectacularly collide in this uniquely charged place of memory.

Can we know what songs the girls sang as they joined hands in their choral dance? The beautiful choral ode of Euripides's *Children of Herakles* may give us a hint. To be sure, it is sung by a chorus of old men, a rarity in Greek tragedy, but one that we also find in Euripides's *Erechtheus*. Nonetheless, the ode may hold for us some vestige of the kinds of hymns that might have been sung at the Panathenaia, including at the *pannychis*. The chorus invokes the full heavenly cosmos to join it:

> O earth, O moon that stays aloft the whole night long. O gleaming rays of the god that brings light to mortals, be my messengers, I pray, and raise your shout to heaven, to the throne of Zeus and in the house of gray-eyed Athena! For we are about to cut a path through danger with the sword of gray iron on behalf of our fatherland, on behalf of our homes, since we have taken the suppliants in.
>
> . . .
>
> But, lady Athena, since yours is the soil of the land and yours is the city, and you are its mother, its mistress, and its guardian, divert to some other land this man who is unjustly bringing the spear-hurling army here from Argos! By our goodness we do not deserve to be cast from our homes.
>
> For the honor of rich sacrifice is offered to you, nor do the waning day of the month, or the songs of the young men or the tunes to accompany their dancing ever slip from our minds . . . On the windswept hill [of the Acropolis], loud shouts [*ololugmata*] resound to the beat of maiden dance steps the whole night long.
>
> Euripides, *Children of Herakles* 748–758, 770–783[67]

There is much to gather here about the Panathenaic *pannychis*. At the very start of the hymn, the chorus invokes the celestial bodies of Earth, Moon, and Sun as messengers to Zeus. Later, it specifies the timing of the festival, that it begins "the day on which the moon wanes." Indeed, the lunar calendar shows a waning crescent moon for the twenty-eighth of Hekatombaion. This would have made for very faint illumination of the Acropolis during the all-night vigil. The stars above would have been seen to shine all the more vibrantly.

The crescent moon is featured prominently on Athenian silver coinage, appearing on the earliest of the owl coins, minted in around 510–505 B.C.[68] During the 470s, the crescent is introduced in the upper left field of Athenian tetradrachms, just beside Athena's owl (page 290). While this crescent has sometimes been interpreted as a reference to Athenian victories at Marathon or Salamis, this is unlikely.[69] We know the Battle of Marathon took place under a full moon and, furthermore, that the crescent appeared on Athenian coins already in the last decade of the sixth century, well before the Persians landed on Greek shores.

The crescent moon may instead signal the Panathenaic festival and, in particular, the twenty-seventh through the twenty-eighth of Hekatombaion, the night of the waning moon, when Athenian maidens and youths gathered on the Acropolis for their vigil. Euripides gives us a hint in the *Erechtheus*. A fragmentary line preserves a question the king puts to Praxithea, who appears to be handling some crescent-shaped wheat cakes: "Explain to me these 'moons' made from young wheat as you bring/take a lot of cakes from your house."[70] Could such cakes have been offered as part of the rites of the Panathenaia? Were they fashioned into little "moons" to reflect the lunar aspect under which the festival culminated?

Importantly, Praxithea summons the women of Athens to sound the shrill cry of the *ololugmata*, beckoning Athena to be present: "Ululate, women, so that the goddess may come with her golden Gorgon to defend the city."[71] We are reminded of another priestess of Athena, Theano of Troy, who, as she placed a peplos on the knees of Athena's statue, was joined by the women of the city raising the ritual cry, "Ololu!"[72] And there is also a specific reference to *ololugmata* in the choral ode of *Children of Herakles* quoted on the previous page. Here, the "shrill cries" of the maidens resound to the beat of their dance steps.

The word *ololugmata* derives from the Greek verb *ololuzein*, meaning "to cry aloud," and is related to the Sanskrit *ululih*, "a howling." The English word "ululation" and the Gaelic *uileliugh* ("a wail of lamentation") come to us through the onomatopoeic Latin *ululare*, meaning "to howl or wail."[73] Indeed, the Latin word *ulula* means a kind of owl,[74] as does the Old English word *ule*.

Today, ululation is still customary among women in Africa, the eastern Mediterranean, the Arabian Peninsula, and India. The cry is most often used in weddings and funeral rituals. In the Muslim world, it is

specifically used at funerals of martyrs. Produced by the rapid movement of the tongue and the uvula while simultaneously emitting a shrill vocal scream, the sound is both alarming and haunting.

In the ancient Greek world, women vocalized the *ololugmata* at moments of ritual climax.[75] In sacrifice, it was unleashed at the very instant when the animal victim's throat was slit. Like the sound of the aulos, the women's cries might have been a means of muffling the shriek of the dying animal. It is somewhat surprising to find the word used in the choral ode of *Children of Herakles*. Yes, *ololugmata* can be cries of joy, but they are certainly closely associated with death and sacrifice.[76] The deliberate use of this word could suggest here a dark message; the remembrances of this night, it seems, are not of unalloyed joy and light. Could the maidens have shouted the *ololugmata* to evoke the sacrifice of Erechtheus's daughter, the girl whose throat was cut by her father upon Athena's altar? It is hard to imagine that, here, on the Acropolis rock, from which there is a tradition that the daughters of Kekrops and the older daughters of Erechtheus leaped to their deaths, Athenian maidens would not have been mindful of the sacrifice of the mythical princesses, commemorating them with song and dance.

As they performed behind the northern ramparts of the Acropolis, the girls would have looked up at an astounding celestial display. The upper culmination of the star group Drako, the Serpent, coincided precisely with the period during which the Panathenaia was held. It is, as Efrosyni Boutsikas has pointed out, no coincidence that the final days of the Panathenaic festival overlapped precisely with this most significant astronomical phase of Drako, the serpent killed by Athena in the cosmic battle of the gods and the Giants, a boundary event vibrantly commemorated in this sacred feast.[77] By the time the *pannychis* commenced, Boutsikas observes, the constellation would have been visible in an upright position, having just crossed the meridian.

During this annual culmination of Drako, its two brightest stars, those located in the Serpent's head, would have been best viewed from the north porch of the Erechtheion.[78] And so, if we locate our "theatral space" just beside this porch, the singing and dancing of Athenian maidens would be situated directly beneath this astral spectacle. (A fascinating parallel, the constellation Hyades, the same as the star group Hyakinthides into which the daughters of Erechtheus are catasterized, is best viewed from the area east of the Parthenon and altar of Athena.)[79]

Of course, the suggestion that the choral dances of the *pannychis* took place in a theatral square at the north of the Erechtheion is purely speculative. It is impossible to prove that a space was used for dancing in the absence of live performers. Nonetheless, consideration of open spaces where spectacles might have occurred repays the effort and teaches us much about ritual circulation and movement. Indeed, ritual kinesis shaped sacred spaces that today sit silent and elusive, void of the action that defined their original function. The archaeological imagination can come alive through the integration of the visual, the acoustic, the mythopoetic, the architectural, and the topographic to bring deeper understanding of the experience of place and time within the ancient landscape.[80]

AS DAWN BROKE the following day, marchers would assemble just outside the city walls in the Kerameikos to begin their Panathenaic procession. There the crescent moon hanging in the eastern sky would fade away as the heavens lightened. The parade route stretched roughly one kilometer, starting at the Dipylon Gate, crossing the Agora, and climbing the Acropolis (insert page 7, top). The Sacred Way measured ten to twenty meters in width to accommodate the great number of processionists.[81] The honor of leading the marchers was reserved for a young woman of *parthenos* status, that is, a girl just past puberty but not yet married. She was handpicked by the chief magistrate himself from among the daughters of the oldest families in Athens.[82] It was a great distinction to be singled out in this way as one of the fairest daughters of the city's elite. It was the responsibility of this young woman to carry upon her head a basket containing the implements of sacrifice: knife, oils, ribbons, barley. One wonders if the visual spectacle of a young parthenos, leading the procession and carrying the sacrificial paraphernalia on her head, might not have somehow evoked the memory of one very special parthenos who, in deep antiquity, marched (with all eyes upon her) to the altar of Athena for sacrifice at her father's hand.

An Attic black-figured cup, dating to the mid-fifth century, shows just such a basket bearer approaching a flaming altar within Athena's sanctuary. The goddess and her priestess stand behind the altar while a man leans over it to shake the priestess's hand (insert page 6, top).[83] What are we looking at? Raising her arms to steady her burden, the little

basket bearer is clearly the leader of the procession of sacrificial victims (bull, sow, and ram), musicians, and soldiers that follow behind her. Here, the deep past and the contemporary rituals that commemorated it merge in an iconography that accesses both mythical times and the historical present.

One cannot help but notice a certain correspondence between maiden basket bearers and the sculptured karyatids that first appear in Greek sanctuaries in the sixth century, when sacred spaces were formalized on a monumental scale.[84] The richly dressed karyatids of the Siphnian Treasury at Delphi, for example, show high basketlike elements upon their heads.[85] These so-called *kalathos* (basket) karyatids may reflect the appearance of actual young women who circulated past them on festival days, leading processions up the Sacred Way.[86]

The same can be said for the karyatids of the south porch of the Erechtheion (facing page). Atop their heads are pads that cushion the weight of the lintel. Shown dressed in their festival finery, the Erechtheion karyatids served as mirrors in marble for the maiden basket bearers who led processions up the Acropolis.[87] The aim of the procession was, after all, to invite the deity to the festival. By making the pageant continually present through the permanent fixtures of karyatids, Athenians would have rendered the invitation to Athena perpetual, and with it the goddess's benevolent presence.[88]

Sacred images carried high in processional display would have met the karyatids at eye level and, perhaps, have been seen to interact with them. It is helpful here to consider the great temple processions of southern India that, to this day, transport statues of divinities along sacred parade routes, stopping at station points along the way.[89] In the Chittirai festival at Madurai, statues of the goddess Meenakshi and her consort Shiva perambulate across a cultic landscape before they are installed at the inner sanctum of the temple. At the Meenakshi-Sundaresvara temple, stone images of King Tirumalai Nayak and his wives emerge from the architecture to become one with the processions that pass before them.[90] This model can help us understand how the Erechtheion karyatids functioned within their ritual space. Each year at the Plynteria, or "Washing," festival, the olive wood statue of Athena was taken from the Acropolis and transported to Phaleron for bathing in the sea. Held high in sacred procession, it would have been carried right past the Erech-

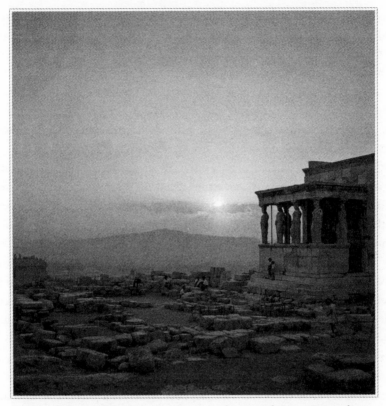

Karyatid porch of Erechtheion, from southeast, Athenian Acropolis.
© Robert A. McCabe, 1954–55.

theion karyatids, at their eye level, allowing for a kind of sacred dialogue between the stone maidens and the goddess's image.

THE DAY FOLLOWING the Panathenaic procession, that is, the seventh day of the festival, saw two great tribal contests: the *apobates* race and the boat races. Considered the "noblest and grandest of all competitions," the *apobates* race required a charioteer to drive four horses at full speed while an armed hoplite jumped in and out of the chariot.[91] In principle, this mimicked the actions of a warrior in battle, but as we have noted, the days of chariot warfare were long past. Like other tribal events, the *apobates* race evoked the days of early Athens and the exploits of the ancestors.

As observed, the founder himself, Erechtheus/Erichthonios, introduced the chariot to Athens and competed in a chariot race at the very first Panathenaia. The fact that the *apobates* race concluded at the City Eleusinion highlights a special connection between this event and the defeat of Eumolpos. We have already noted that the Panathenaic procession takes a special detour around the City Eleusinion on its way up the Acropolis (insert page 7, top). This was perhaps done as a nod to Eumolpos, who went on to play a central role in Eleusinian cult.

The tribal regatta held the same day at Munychia Harbor in the Piraeus was, in essence, a mock naval battle. We are told that the tomb of Themistokles was positioned with full view of these rowing races, which surely commemorated Athenian victory at the Battle of Salamis, a monumental triumph won under his leadership.[92] As with other tribal contests, the prize for the boat races went to the entire team rather than to an individual winner. First prize consisted of three oxen, a three-hundred-drachma cash award, plus another two hundred drachmas set aside "for banqueting."[93] From this we can infer that the winning tribe enjoyed a great feast of ox meat following their victory.

MUCH AS WE MAY try to reconstruct the days of the Panathenaia, a central mystery remains: Just how did the ancient Athenians themselves understand their most important festival? What, in their view, were its origins, and how did they comprehend the meaning behind the rituals they practiced so faithfully for nearly a thousand years? This was, after all, a culture intensely pious and obsessively aware of its past; its understanding might have shifted over centuries, but in such a world there is no place for mere traditions, custom for its own sake. Yet recovering the contemporary understanding is frustrated by a problem inherent in ancient religions: those bound by a shared system of beliefs rarely have cause to describe them. It is mostly from outsiders looking in that we learn about a community's religious practice.[94] But there were no outsiders then writing about Athenian cult ritual.

Late-nineteenth-century scholars, eager to explain the Panathenaia, seized upon the birthday of Athena as the occasion for the festival.[95] Despite immediate protests from August Mommsen, the brother of the great Theodor Mommsen, the only classical scholar ever to win the

Nobel Prize in Literature, this idea was generally accepted.[96] Over the course of the twentieth century it became "established fact," with some scholars still holding to the notion even today. In fact, though, despite knowing so much about it, we are at a loss to definitively explain the reason for the Panathenaia, a cause for chagrin. Some have interpreted it as a kind of New Year's festival; others as a celebration of the new fire.[97] Noel Robertson has neatly summed it up this way: "Although so many details are so well illuminated, the center is dark. There is no understanding of the origin and significance of the festival, of its social or seasonal purpose, and there has been almost no inquiry."[98]

One alternative to the birthday-party hypothesis has gained strength in recent decades. This view holds that the festival commemorated Athena's victory in the Gigantomachy.[99] To be sure, the battle of the gods and the Giants looms large in Acropolis ritual and iconography. It was spectacularly displayed on the Old Athena Temple at the end of the sixth century (page 66). That this episode from cosmic prehistory was woven into the peplos offered to Athena is significant, as is its appearance in Athenian vase painting from the mid-sixth century on, including many fragments found on the Acropolis itself. There is enough evidence, however, that the Gigantomachy, though central, is but one of several boundary events celebrated at the Panathenaia, one among a group of core narratives by which the Athenians defined themselves. In this sense, what can be said of the Parthenon can also be said of the festival, and this is no accident: it presents several pieces of the genealogical story at once.

The foundation myth of Erechtheus's victory over Eumolpos, and the virgin sacrifice that ensured this Athenian triumph, is also one of these central events celebrated in the Panathenaic festival. Capping off the Late Bronze Age, this victory joins the Titanomachy, the Gigantomachy, the exploits of Theseus, the Trojan War, and other genealogical myths celebrated on the Acropolis from the Archaic period on. Just as ancient Near Eastern epic and visual culture simultaneously celebrated succession myths across a vast stretch of time, so, too, Athenian ritual commemorated a "layering" of successive local victories pushing Athenian identity further and further back into the distant past. Indeed, it would be strange if a ritual as deeply social as that of the Panathenaia could have developed without a strong mythological narrative at its core. And

so the deep history that informed Athenian consciousness was every year enacted kinetically, just as throughout the year it was attested in the immobile marble of the Parthenon.

But what of the games? From the *Iliad* on, athletic competitions are associated with funeral games established in memory of dead heroes.[100] The death of Achilles's beloved friend Patroklos and the funeral competitions held in his honor become the archetype for athletic contests of the historical period. Games are appropriate memorials for heroes since physical labor and the expenditure of energy embody the struggles of humans on earth. It is fitting, then, that games honor human heroes rather than divinities, although the honors for mortals and immortals are never far apart. As we saw in the last chapter, the tombs of local heroes are set close to temples of Olympian gods: Pelops at Olympia, Opheltes-Archemoros at Nemea, and Melikertes-Palaimon at Isthmia.[101] It is their deaths that the Panhellenic athletic competitions commemorate. But this raises another question: Which Athenian heroes exactly were commemorated in the Panathenaic Games?

A half century ago, Homer Thompson was one of the few who looked for local heroes behind the contests at Athens, focusing on the hero shrines of the Athenian Agora.[102] But if one is to look there, why not on the Acropolis itself? Surely Erechtheus, whose tomb was understood to lie beneath the Erechtheion, presents an ideal candidate. Certainly, he follows the model we have seen at Olympia, Nemea, and Isthmia, where the deaths of local royal heroes are commemorated through athletic games.

And if we are to look for the most obvious heroes, why not heroines? After all, unlike the other Panhellenic game sites, the Athenian Acropolis is sacred to a female divinity. It seems plausible that with the general elevation of women brought about by the Periklean citizenship law of 451/450, the daughters of Erechtheus would have been incorporated into the joint worship of Athena and Erechtheus. In fact, we know that by Cicero's time Erechtheus and his daughters were worshipped as divinities at Athens.[103] It is likely, then, that the heroines, together with their father, were commemorated in the Panathenaic Games.

THE PRESENTATION OF THE SACRED peplos to Athena represents a culminating moment within the Panathenaic festival. And we have seen

how the same prominence has been ascribed to a garment on the central slab of the Parthenon's east frieze. This prominence has supported the faulty view of the frieze narrative as depicting a historical Panathenaia, but while the frieze cloth is not Athena's peplos, as some have thought, the salience of such a garment in the festival and on the frieze is no coincidence.[104] But before we investigate the connection, it is natural to ask, why would a peplos be woven for Athena in the first place? After all, ritual does not exist without reason; there must be a precedent in myth.

The offering of clothing to divinities was widespread in Greek religious practice. But evidence for the ritual weaving of garments for cult statues, such as the months of laborious work preceding the Great Panathenaia, is less abundant. Ongoing excavations are constantly adding to what we know.[105] The ritual weaving of garments is attested in the sources for Athena Polias at Athens, Hera at Argos, Hera at Olympia, and, as we have seen, Apollo at Amyklai.[106] Fabrics woven for Hera are understood to represent her wedding dress, an appropriate symbol for Zeus's wife, the archetypal bride. At Amyklai, a mantle (chiton) was woven as the funeral shroud of Hyakinthos, who, we have noted, was buried beneath Apollo's statue base.

Fabrics were woven with elaborate figured designs for three great occasions in Greek life: birth (swaddling clothes), marriage (the wedding dress), and death (the funeral shroud). The peplos woven for Athena cannot represent her swaddling clothes (given her birth fully grown) or her wedding dress (given her perpetual virginity). But if we remember that Athena-Parthenos was worshipped jointly on the Acropolis just as Apollo-Hyakinthos was at Amyklai, by comparison with the chiton woven for Apollo (as Hyakinthos's shroud), the peplos of Athena could represent the funerary cloth of the daughter of King Erechtheus. The pattern is the same. Local deity and local hero are so intimately associated that the death shroud of the hero becomes the dress-offering for the divinity.

As noted earlier, ancient sources refer to two distinct peploi: a small one offered to Athena's olive wood statue at the annual Panathenaia and a large one presented at the Great Panathenaia, a huge tapestry with woven figured scenes. At least by the end of the fourth century, the tapestry/peplos was transported to the Acropolis in procession aboard ship. Like a sail it was hoisted up the mast of a vessel, which some believe was one of the triremes from the Battle of Salamis, that was lifted from the

water and set on a wooden carriage. The Panathenaic ship became an important "object of memory" for the Athenians, a relic from their victory over the Persians.[107] It was pulled in procession atop a wheeled cart that carried it along the Panathenaic Way from the Kerameikos as far as the City Eleusinon.[108]

The peplos-sail attached to the boat's yardarm was woven with images showing the battle of the gods and the Giants and, very likely, with scenes of other cosmic clashes and boundary events from primordial and epic days. When, in 302/301 B.C., Demetrios the Besieger, the prince of Macedon, audaciously had his own image woven into the peplos, it was regarded as a colossal act of hubris (a graver sin than the mere cockiness the word connotes today). Clearly, the gods were displeased: a giant squall blew in during the procession, ripping the peplos-sail in two, a terrible omen.[109]

What exactly did this peplos—dress, tapestry, and sail—represent? Citing Elizabeth Barber's work on the role of ornately woven figure cloths in funerary rituals, Brunilde Ridgway has suggested that the peplos tapestry was used as a shroud to veil the ancient olive wood statue of Athena during the festival of the Plynteria.[110] This ritual, which called for the stripping, washing, and wrapping in cloth of Athena's image, mimics the preparation of a corpse for burial in funerary rites. It may allude to a period of mourning for Aglauros, the first of the sacred *plyntrides,* in honor of whom the festival was founded. These interpretations illustrate the ambiguity and flexibility of the various ancient Greek terms used to describe cloth.

Heliodoros's novel, the *Aethiopika,* may hold relevance for our understanding of the origins and function of the Panathenaic peplos, a fabric apparently connected with death. Here, we find Theagenes, a descendant of Achilles himself, traveling from Thessaly to Delphi to participate in celebrations at the shrine of Neoptolemos-Pyrrhos, as discussed in chapter 6. In the course of the festivities, he catches sight of the beautiful virgin priestess Chariklea and falls madly in love. Chariklea returns his affections, but the lovers are thwarted by her guardian, who hopes to marry her off to his nephew. And so the pair plan to elope in the dead of night, making their way to a Phoenician ship in nearby harbor, bound for Carthage.

Arriving at the boat, Chariklea is dressed in a sacred garment that is described as her "mantle of victory" (*niketerion*) or her "funeral

shroud" (*entaphion*).[111] It is a curious choice of very divergent meanings for the garment. Heliodoros's description must be based on some historical precedent understood by the ancient audience but lost on us. I would suggest that the peplos of Athena fulfilled both of the functions described by Heliodoros, a writer much influenced by the tradition of Athenian cult practice. He readily draws upon Panathenaic ritual in his fictional description of the festival at Delphi, transferring key elements: a procession, a *hekatomb*, ritual dancing, and a priestess. For historical Athenians the peplos was very much a mantle of victory, just as the entire Panathenaia was a celebration of Athenian supremacy. The mythological basis for the peplos, however, is the funeral shroud of the *parthenos* who gave her life to ensure Athenian victory over Eumolpos. It is thus symbolically, though not actually, the shroud so proudly displayed on the Parthenon's east frieze. Just as the chiton woven for Apollo at Amyklai was a replica of the shroud of his beloved Hyakinthos, so the peplos woven for Athena commemorates the winding cloth of her beloved *parthenos*. Thus the merging of meanings (victory mantle and funerary shroud) in the fictional account of Chariklea's dress, a powerful image conjured by Heliodoros just a hundred years before the last of the Panathenaic peploi was presented to the goddess.

ONE FUNCTION, among many, of Greek temples was to house the image of the divinity.[112] The colossal statue of Athena that towered within the eastern cella of the Parthenon at nearly 12 meters, or 39 feet, in height, was a spectacle beyond belief.[113] Pheidias created the likeness from the most precious materials known to man, gold and ivory. Athena's face, arms, and feet were carved from ivory, while a ton of pure gold was hammered into the draping of her dress, helmet, spear, and shield. The lifesize replica of the Athena Parthenos statue made for the Centennial Park Parthenon in Nashville, Tennessee, gives us some idea of its original grandeur (insert page 7, bottom).[114] Athena's outstretched right hand held a golden statue of Nike standing some 6 feet tall. Between Athena's shield and her feet coiled a golden snake, the sacred serpent of the Acropolis and very embodiment of the founder Erechtheus/Erichthonios. The cost of the statue is estimated to have been as much as, or even more than, the building of the Parthenon itself.

We know quite a lot about the appearance of the so-called Athena

Parthenos, thanks to an eyewitness description by Pausanias, comments by Pliny and Plutarch, and some marble copies carved on smaller scales.[115] Athena's helmet was decorated with a sphinx and two Pegasus figures while griffins and deer adorned the visor and cheek pieces. Such guardian figures accentuated the protective power of the goddess. An ivory Gorgon's head adorned Athena's chest, and low at her side rested the golden shield, nearly 5 meters (16 feet) across. Its surface was decorated with reliefs repeating the great martial themes of the Parthenon's east and west metopes: Gigantomachy on the interior of the shield and Amazonomachy on the exterior. The soles of Athena's sandals were adorned with images from the battle of the Lapiths and the Centaurs, echoing the theme of the Parthenon's south metopes. The statue's iconography summed the past just as the Parthenon did.

Pliny and Pausanias, writing more than five hundred years after the dedication of the statue, tell us that its base showed the birth of Pandora.[116] Pausanias immediately thinks of Pandora in Hesiod's *Theogony* and *Works and Days*. She was the first woman, and her curiosity compelled her to open a secret jar better kept closed; she thus released all manner of great evils into the world.[117] But why should this colossal troublemaker be featured on the statue base of the Athena Parthenos? Indeed, she has nothing to do with Athens.

It happens there is a second, independent tradition at Athens, for another Pandora, this one beneficent and with earth goddess associations.[118] Her very name, "Giver of All," reflects a generous nature belied by her doppelgänger. A confusion seems to have arisen by Roman times between the local Athenian Pandora and the evil one of Hesiod's creation story. Hesiod himself mentions this other persona in his *Catalogue of Women* as the "lovely Pandora," the daughter of King Deukalion and Pyrrha.[119] This Pandora is said to be the sister of Thyia and Protogeneia, names also given for the daughters of Erechtheus.[120] It is this Attic Pandora, the youngest daughter of Erechtheus who "gave all" to save her city, who I assert is the maiden shown on the base of the Athena Parthenos statue.

It should be remembered that Erechtheus had a trio of daughters with the same names as Deukalion's three girls: Pandora, Protogeneia, and Oreithyia (or Thyia). This clearly suggests contamination, or fusion, between the stories of two mythical family lines. We have already noted in chapter 4 the complexity attending the names of Erech-

theus's daughters, with sources giving conflicting lists over several hundred years. In the great tangled web of Attic myth, the pattern of three daughters repeats itself. Just as Deukalion and Erechtheus have daughters named Pandora, so, too, Kekrops has a daughter named Pandrosos. There may well be fusion here between the names Pandora and Pandrosos, just as we have already seen for Erechtheus and Erichthonios.[121] But let us proceed with the understanding that the "birth of Pandora" attested by Pausanias on the base of the Athena Parthenos statue was the birth, or rather the crowning, of Pandora, daughter of Erechtheus. Just as the Amazonomachy, Gigantomachy, and Centauromachy from the Parthenon metopes are quoted on Athena's shield and sandals, so, too, the story told on the frieze—that of the sacrifice of Erechtheus's daughter—is quoted on the base of the Athena Parthenos statue.[122] The statue base has been estimated to have stood roughly 90 centimeters (35 inches) tall, and since the Parthenon frieze itself also measures roughly a meter in height, we may have yet another visual link between the sculptured relief of the base and that of the frieze.[123]

The composition of the statue base has been reconstructed on the evidence of surviving copies and according to the testimony of Pliny, who tells us that some twenty divinities were shown in the scene (insert page 7, bottom, and following page, top).[124] From what we can understand, "Pandora" was shown at the center of the group as a small girl wearing a peplos, standing frontally with her arms hanging at her sides. Athena stands at the right with a stephane in her hand, ready to crown the maiden.[125]

Two Athenian vases that predate the Parthenon show very similar imagery. On a red-figured krater in London we see a girl being crowned by Athena, while Zeus and Poseidon (to the left) and (to the right) Ares, Hermes, and a female goddess (Aphrodite or Hera?) attend the ceremony (following page, bottom).[126] Athena holds out a leafy wreath for the girl, who is dressed in a peplos and faces frontally, frozen and statue-like, clutching an olive (or laurel) branch in each hand. The maiden's transfixed frontal gaze suggests the intensity of her altered state. She is isolated within the composition, separated by more than space in the very center of the scene, which has traditionally been interpreted as the creation of the first woman, Pandora. That reading, however, is frustrated by the absence of Hephaistos, a key figure in the creation story, and the prominence of the war god Ares, who rushes in at the right in full battle dress. He is a companion figure here to the warrior god-

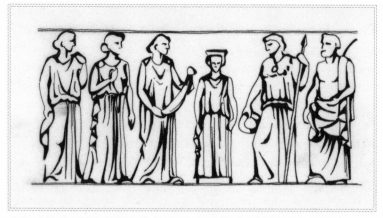

Reconstruction drawing of the base of Athena Parthenos statue showing girl about to be crowned. By George Marshall Peters after N. Leipen, *Athena Parthenos*, Pl. 6.

dess Athena, who stands at the left of the girl. The atmosphere is not one of creation but one of martial victory. We are reminded of Praxithea's proclamation in the *Erechtheus:* "My child, by dying for this city, will attain a crown destined solely for herself."[127] Here, then, is Athena awarding the promised crown to the daughter of Erechtheus following her sacrificial death. Running in from the battlefield, Ares bears news of the Athenian victory that this death has ensured.

A similar female figure—shown in a frontal pose, arms hanging at her sides, and dressed in a peplos—can be observed on a white-ground cup (facing page) from Nola, near Naples. It too has been interpreted

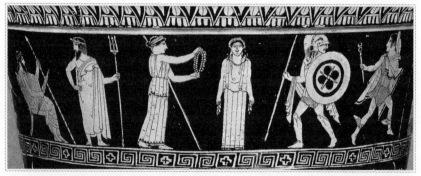

Enthroned Zeus and Poseidon at left; Athena crowning daughter of Erechtheus at center; Ares and Hermes at right. Calyx krater, the Niobid Painter, ca. 460–450 B.C.

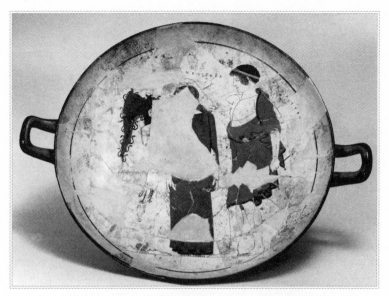

Anesidora, at center, crowned by Athena and Hephaistos. White-ground cup from Nola, the Tarquinia Painter, ca. 460 B.C.

as showing the creation of Pandora, as told by Hesiod. We see Athena and Hephaistos reaching out to crown the girl from either side.[128] The maiden's name is inscribed above her: "Anesidora," meaning "She Who Sends Up Gifts," a name very similar to Pandora, "Giver of All."[129] But the name Anesidora carries a distinctly chthonic connotation, since her gifts are sent up from below. Indeed, the name suggests a dead girl buried within the earth.[130] It is very possible that a maiden named Anesidora, in some fifth-century tradition, comes to be known as Pandora by the time Pausanias writes in the Roman period. I submit that the base of the Athena Parthenos statue shows a crowning of Erechtheus's daughter, a girl variously named Anesidora/Pandora/Pandrosos. She is appropriately joined by Athena and Hephaistos, in a sense her "grandparents," who caused the birth of Erechtheus/Erichthonios. The deceased girl is shown welcomed into her new status as heroine, crowned, in the words of Praxithea, with a wreath "destined solely for herself."

If we take account of this special relationship between Athena and Pandora, understood to be the *parthenos* daughter of Erechtheus, certain persistent problems in Acropolis ritual practice are resolved. For instance, the principle that "whoever sacrifices a cow to Athena is obliged

to sacrifice a ewe to Pandora [or Pandrosos]." This comes to us from Philochoros, who, having served as seer and inspector of sacred victims (*mantis* and *hieroskopos*) at Athens at the end of the fourth century B.C., knew whereof he spoke. Surviving manuscripts give both variants of the name Pandora/Pandrosos.[131] Also this: the Parthenon's south frieze shows cows alone being taken to sacrifice, reflecting Athena's command that Erechtheus be honored with cattle sacrifices. The north frieze, by contrast, shows a combination of cows and sheep in procession. It is likely that the sheep sacrifice was destined for Erechtheus's daughter, a girl alternately called Pandora, Pandrosos, or Anesidora. The connection between Philochoros's text and the Parthenon frieze has been noted before, but there has never been a plausible explanation for why a sacrifice should be made to Pandora within the context of Acropolis ritual.

This reading also helps shed light on a long-baffling passage in Aristophanes's *Birds*. The soothsayer Bakis pronounces an oracle that demands, "First sacrifice to Pandora a white-fleeced ram."[132] The meaning of this oracle has never been understood. But if this Pandora is the benevolent Erechtheid of the Attic tradition, and not the problematic Pandora of Hesiod, things fall into place.

IF THERE IS one more piece of the puzzle of the Panathenaia, of how the Athenians understood their great festival, it is a figure whose ubiquity renders it hidden in plain sight.

From the Panathenaic amphorae, to the famous silver tetradrachms that dominated Athenian coinage, to a host of images from Attic vase painting and sculpture, there is one symbol that is utterly synonymous with Athena. This is, of course, the owl. The inseparability of Athena and her winged companion has long been studied but never fully explained. Why is the owl so intimately associated with her? What is it about this particular creature that makes it the quintessential symbol of the goddess and, by extension, the city of Athens?

As a natural predator, the owl has a distinctly martial aspect that jibes with Athena's role as warrior goddess.[133] Again and again, we find the owl appearing on the battlefield to urge Athenian soldiers on to victory. In Aristophanes's *Wasps,* we are told that Athena sent her sacred owl to fly over Athenian troops at Marathon, bringing them good

luck.[134] Plutarch writes of the difficulties Themistokles suffered in convincing the Greek allies to fight at Salamis—until, that is, an owl landed on the rigging of his trireme.[135] On Attic coins of the Roman imperial period Themistokles stands in full armor aboard his ship, a little owl alighting on its prow.[136]

In Greek art, owls are regularly shown with their heads facing front, their bodies turned in profile. On a purely naturalist level, this manifests the exceptional range of rotation of an owl's head and emphasizes the effect of its outsized eyes with their intense, unwavering gaze. Gloria Ferrari has explained that this straight-on stare was perceived as a masculine trait in ancient Greece (as it still is in some parts). Men looked at those whom they would confront straight in the eyes: bold, brash, and unafraid. Women, on the other hand, were expected to be "cow-eyed" (*boopis*) as Hera, queen of the gods, is so often described.[137] The female glance should be lowered, to express *aidos*, that is, "shame," "modesty," or "humility."

Athena is called *glaukopis*, "owl-eyed," as early as the seventh century in Homer's *Iliad* and Hesiod's *Theogony*.[138] This epithet could refer to the silvery, gleaming gray-green (*glaukos*) colors of her eyes or to her steely, unblinking gaze, as unusual for a female as Athena's warrior aspect. Indeed, Athena Glaukopis is the most masculine of female divinities, and as goddess of war, wisdom, and craft she evinces no shame in her wide-eyed stare.

It must be acknowledged that frontal faces are quite rare in Archaic and classical Greek art.[139] The effect of this unusual perspective is purposefully arresting, to say that something out of the ordinary is happening. This invariably involves a physical or psychological transition between two states of being. Individuals caught between wakefulness and sleep, sobriety and drunkenness, silence and musical rapture, calm and sexual ecstasy, life and death, all look directly at the viewer, seizing upon a single moment suspended in time. We have noted in the images of Anesidora/Pandora that her full face is to the viewer as she experiences a kind of "apotheosis" through her crowning. At this moment the daughter of Erechtheus is caught between life and death, humanity and divinity. That Athena's owl presents the same unsettling aspect is no coincidence. Death, indeed, hangs in the air.

Owls were understood to portend death as early as the Babylonian period in Mesopotamia, circa 1800–1750 B.C. Consider the terra-cotta

"Queen of the Night," winged she-demon
with talon feet; flanked by lions and large owls.
Terra-cotta relief, Old Babylonian period,
ca. 1800–1750 B.C.

plaque known as the Queen of the Night, or the Burney relief (above),
believed to be from southern Iraq. It shows a nude female figure with
wings springing from her shoulders and bird talons on her feet. She
perches atop two lions and is flanked by a pair of huge, menacing owls.
The she-demon's identity is much debated; suggestions include Lilîtu/
Lilith, female demon of an evil wind and/or the night; Innana/Ishtar,
goddess of sexual love, fertility, and warfare; and Ereshkigal, goddess of
the underworld, Ishtar's sister.[140] In her hands she holds the ring and rod
symbols that signify the measurement of time by use of a string and stick.

In the Greek world, owls carried a similar connotation of death,
lament, and mourning. In the visual arts, winged figures often repre-
sent the human soul leaving the body. Female "death spirits," some-
times called Keres, were understood to transport souls to Hades. We

find winged sirens, harpies, griffins, and sphinxes employed as guardian figures on Greek funerary monuments.

The winged soul of the dying Prokris can be seen flying out of her body and up to the heavens on a red-figured krater in London, dating to around 440 B.C. (below).[141] Her husband, Kephalos, out hunting, accidentally killed her with his spear, mistaking her for a wild animal hiding in the bushes. We see him with his hunting hound, at left, while Prokris's father, King Erechtheus, stands at right, pointing with great agitation to her winged spirit as it slips away. Prokris's soul, shown as a woman's head on a bird's body, faces the viewer head-on, just like the lifeless face of the woman left behind, the two together telling of the ineffably altered state that is death.

The owl's role as harbinger of death holds the key to its close association with Athena. We have seen that the word *ololugmata,* the shrill wailing of women at times of sacrifice and death, provides the root for the word "owl," *ulula* in Latin and *ule* in Old English. Alkman's *First Partheneion,* or "Maidens' Song," a remarkable text dated to the seventh century B.C., preserves lines sung by the girls' chorus under his supervision at Sparta:

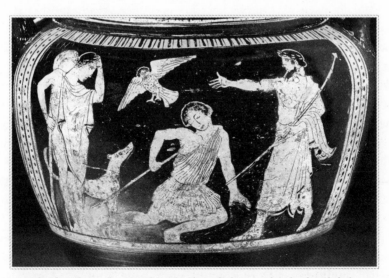

Death of Prokris, showing her "bird-soul" leaving her body while her husband Kephalos and father Erechtheus watch. Column krater, by Hephaistos Painter, ca. 440 B.C.

> I would say I myself,
> a maiden, wail [*lelaka*] in vain from the sky,
> an owl [*glaux*].
>
> Alkman, *First Partheneion* 85–87[142]

Gloria Ferrari points to an important connection between the girls' chorus that sings this song and the Hyades, the inconsolable nymph sisters who mourn the death of their brother, Hyas, killed in a hunting accident. Known for their weepy raininess, the Hyades become the archetypal singers of dirges, engaged in eternally funereal lament. In the "somber, relentless quality of the night owl's hooting," Ferrari hears the "mourning voice" of the Hyades.[143] Their grief culminates in their transformation into the star cluster Hyades, a constellation that is further associated with the dead daughters of Erechtheus, catasterized as the Hyakinthides. Some of the final lines preserved in the fragments of Euripides's *Erechtheus* give the words "to/for the Hyakinthides," and "stars."[144]

In Athenian vase painting, we find a number of intriguing images that show Athena in the company of three owls. A white-ground lekythos in Kansas bears the image of a helmeted Athena seated within her sanctuary (facing page).[145] One owl alights upon her shield, another stands beneath it, and a third perches atop her altar. When the image is read as the souls of the three daughters of Erechtheus, the owl on the altar can be seen as the maiden who was sacrificed (on Athena's altar) while her sisters, who kept their oath and died as well, are paired together at the left of the scene (as we see them on the Parthenon frieze, set apart from their little sister). The dead heroines are shown on the vase as winged souls, their bodies lost but their spirits living on within the sanctuary of Athena. In this, I build on Ferrari's interpretation, whereby she associated these owls with the daughters of Kekrops.[146] I argue instead that they represent the daughters of Erechtheus, who are, after all, related to and (in the ancient record) often confused with the Kekropids.

A hydria in Uppsala, Sweden, makes the connection even more emphatically. Here, a single owl perches atop an altar within Athena's shrine, signified by a Doric column (insert page 8, top).[147] A man leads a ram to sacrifice while a bull stands in readiness at the far right. These represent the same animal victims (sheep and cattle) that are depicted on the north frieze of the Parthenon. Remember Philochoros: "Whoever

Athena seated in her sanctuary with two owls by her shield, at left, and one sitting upon her altar, at right. White-ground lekythos, the Athena Painter, ca. 490–480 B.C.

sacrifices a cow to Athena is obliged to sacrifice a ewe to Pandora."[148] If the owl perched upon the altar represents the sacrificed daughter of Erechtheus, whose name may, in fact, be Pandora, then the ram is an offering for her, while the bull is destined for her father, Erechtheus.

An intriguing image of an anthropomorphized owl, appearing on a mug in the Louvre, once again embodies the intimacy of Athena and the girl who gave her life for Athens (following page).[149] The wide-eyed bird staring back at us is armed and helmeted as it charges into battle, human arms emerging from its feathered body to brandish a spear and a shield (an olive frond spreads across the back of the vase). Here is a warrior owl, a predator, a bird dressed like a hoplite. In this single image, Athena and her favorite symbol merge into one. And in their combined presence, we sense as well the soul of the little princess who saved Athens. Praxithea likened the sacrifice of her daughter to sending a son into battle: heroism such as few girls could accede to but one to equal any heroic death for the salvation of the city. On this cup the sacrifice and the transformation have already occurred: the "warrior girl" is dead, and transformed; her spirit lives on as a winged owl. Flying over the battlefield, she inspires Athenian victory, just as hovering above the Acropolis, she summons Athenians to ritual observances.

Anthropomorphized warrior owl
brandishing spear and shield.
Mug, ca. 475–450 B.C.

The Louvre cup dates to the second quarter of the fifth century and is related to a series of Athenian vases known as owl skyphoi, produced from about 490 B.C. into the 420s, after which production relocated to the workshops of Apulia in southern Italy. Thousands of these distinctive vessels survive, uniform in shape and decoration. On front and back they show an owl flanked by two olive twigs.[150]

Many of these cups have one horizontal and one vertical handle, an unusual configuration that may have to do with a dual function. A horizontal handle might be used to bring the skyphos to a drinker's lips, while the vertical handle might be used to pour libations upon the ground or an altar. In chapter 1, we visited the so-called Skyphos Sanctuary on the north slope of the Acropolis. Here, over two hundred cups of skyphos shape were found deliberately arranged in rows, perhaps reflecting how worshippers performing such a ritual set down their cups after offering a libation. Indeed, it is likely that the owl skyphoi were used on very specific ritual occasions.

We find yet another anthropomorphized owl on a tiny terra-cotta loom weight from Tarentum in southern Italy (facing page), now in the Art and Artifact collections at Bryn Mawr College.[151] As on the owl mug in the Louvre, human arms are seen to emerge from the bird's body. The owl is busy spinning, lifting a distaff as it draws wool from a basket down below. Form, function, and decoration meld seamlessly in this object: when suspended in air from the loom, dangling on threads, these

Girl owl with human hands spins thread on distaff. Terra-cotta loom weight from Tarentum.

little owls would appear to fly. Imagine the tiny fingers of a girl weaving the weft through the warp, tickling the threads and causing the owls to dance in the air.

No class of objects, however, made for a wider dissemination of Athena's companion than the large silver tetradrachms, known simply as "owls." Minted without interruption from the last decade of the sixth century until the first century B.C., these coins and their contemporary imitations circulated as far away as Yemen and Afghanistan.[152] They present Athena on the obverse and, on the reverse, her owl, an olive sprig, and the letters ATHE (an abbreviation for the words "of the Athenians"). Some specimens show the crescent moon in the field just to the left of the owl's head (following page), a device that, we have argued earlier, may well signal the Panathenaic festival itself, a feast that culminated on the day the moon waned. As the quintessential Athenian celebration, the Panathenaia was so synonymous with Athens that the crescent moon communicated what the city was best known for. In Aristophanes's *Birds,* the owl coins are famously referenced when Euelpides asks, "And who is it brings an owl to Athens?"[153] This can be understood as a kind of "coals to Newcastle" joke, hilarity at the thought of bringing to the city the one thing it was awash in.

AS NOTED at the opening of this chapter, the Panathenaia was not the most important event in Greece, but it could not have been more impor-

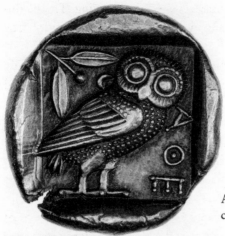

Athenian silver tetradrachm,
ca. 450 B.C.

tant at Athens, as the ultimate rite of belonging. We have focused on the singular role of the tribal events, competitions, and rituals that set the Panathenaia apart from all other Panhellenic festivals. These represent a manifestation of a larger Athenian obsession with genealogy that we have tracked throughout this book. Legitimacy of descent was the sine qua non of membership in the citizenry.

For those who made the cut, the benefits of belonging were enormous. Citizens alone could own land and household properties and assume the considerable rights and duties of the propertied class.[154] They could purchase leases for the silver mines at Laureion, receive windfall distributions of cash and corn, participate in tribal and public festivals, and hold public offices and priesthoods. Only citizens could vote, speak, and plead in the law courts and in the assembly. Thus the citizenry utterly monopolized economic, legal, political, and social privileges at Athens. It is no wonder that Athenians jealously guarded this identity, keeping the system stable throughout the fifth and fourth centuries and for much of the Hellenistic period.

The legend of autochthony played beautifully into the perpetuation of this system. It has been shown that the concept of indigenousness was introduced during the first half of the fifth century in tandem with the advancement of a democratic ideology that asserted political equality for all citizens. Under a common autochthonous origin, even the lowliest citizen was of noble birth and, therefore, superior to any noncitizen. This was especially important in a cosmopolitan city like

Athens where the population of outsiders was ever growing. These non-citizens included many with greater wealth than the majority of true Athenians.[155]

Thus, we can understand why the story of Erechtheus and his family reemerged at precisely this time, in the age of the Parthenon. It provided an important model not only for autochthony but for the new inclusion of Athenian women in the requirements of citizenship. As we have seen, under the Periklean citizenship law one had to be born not only of a citizen father but also of a woman whose father was a citizen. The mother, furthermore, had to have been accepted as a legitimate member of her father's brotherhood group (phratry) and township (deme).[156]

Certainly, there is no greater spokesperson for the exclusivity of Athenian citizenship than Praxithea herself. Her formidable speech in the *Erechtheus* is as xenophobic as it is patriotic:

> First, I could not find a better city than this one. We are a people born from this land, not brought in from elsewhere. Other cities are founded as if by throws of the dice; people are imported to them, different ones from different places. A person who moves from one city to another is like a peg badly fitted into a piece of wood: a citizen in name, but not in action.
>
> Euripides, *Erechtheus* F 360.5–13 Kannicht[157]

By this time, Praxithea has already made clear her harsh views on adoption: "Where is the advantage in adopted children? We should consider those truly born better than mere pretences."[158] Later in the play, we find a fragmentary line that further disparages "otherness." The speaker, who seems to be Erechtheus himself, remarks: "The region beyond is inhabited, I believe, by barbarians who eat no fish."[159] Nothing could have been stranger to an Athenian than people who prefer a fish-free diet.

Athenians believed themselves superior to everyone else, in the Greek world and beyond, and looked upon outsiders—fish eaters and abstainers alike—with a measure of contempt. The irony, perhaps, from our perspective at least, is that such chauvinism was the lifeblood of their notion of democracy. Only with pure Athenian blood could the delicate balance of sacrifice and privilege be assured to function. The ethnically variegated, those random assemblies of strangers constantly streaming

in, with no genetic loyalty to the polis, might as easily favor tyranny and oligarchy, if it seemed convenient.[160] Citizenship according to authentic Athenian descent was the only way to safeguard the system that had been so hard-won, wrestled from the tyrants of the sixth century. It also ensured that privileges were guaranteed even to those true Athenians who had few possessions or skills.[161] Thus was Athenian democracy in essence a system for distributing privileges and responsibilities according to pedigree. Autochthony transcended wealth, power, and any other status.

Athens stood out among all cities of its day for the level of personal engagement that it allowed citizens in the management of their polis.[162] For this system to work required not only genetic affiliation but proper formation, too. The city instructed its young in the responsibilities, no less than the privileges, of *politeia* from a very early age. Paideia and the socialization of citizen offspring took precedence over everything else, performance in choral song-dance, athletic competitions, and public ritual being entirely mandatory. The institution of the Panathenaia was in this sense the great showcase of the formation efforts: not merely *the* ritual extravaganza of the year, but a way of ensuring that the mold would stay more or less intact across the generations. The procession at the heart of the festival was all the reminder an impressionable soul needed about his or her place in the world. Making their way from the Kerameikos cemetery and the graves of the ancestors, through the Athenian Agora, the great scene of commerce, and up the slopes of the Acropolis to the sacred precinct of Athena, the living felt themselves linked in a great chain to the dead and to the gods.[163]

Perhaps, then, it is not so surprising that one of the most revolutionary concepts to emerge from democratic Athens is the notion that a citizen should be *in love* with his city. Indeed, Euripides puts on Praxithea's lips some of the most startling words ever uttered by a mother: "I love my children but I love my country more." The queen goes on to lament that others do not share the depth of her fervor: "O fatherland, I wish that all who dwell in you would love you as much as I do! Then we would live in you untroubled and you would never suffer any harm."[164]

Perikles himself is credited with having introduced the concept of this emotional bond to the polis. Nowhere is this more eloquently expressed than in his funeral oration for the first to fall in the Peloponnesian War. Looking out at the mourners and up at the Acropolis, Perikles instructs:

You must yourselves realize the power of Athens, and feed your eyes upon her from day to day, till love of her fills your hearts; and then, when all her greatness shall break upon you, you must reflect that it was by courage, sense of duty, and a keen feeling of honor in action that men were enabled to win all this.

Thucydides, *Peloponnesian War* 2.43[165]

LOVE, COURAGE, DUTY, HONOR, and action: these are the virtues that upheld Athenian democracy. And if the burdens were compensated by substantial rewards, no Athenian would have traded this birthright for five times the gold of the richest man in the polis. The values of *politeia* were deeply ingrained and subscribed to by even the most ironically minded. To be an Athenian was in the end to profess a religion, and civic performance was the expression of one's identity as well as devotion. Performance was the means by which the young were educated and thereby the values of the community perpetuated. Procession, recitation, musical and athletic competitions, singing, dancing, sacrificing, and feasting—all these actions constituted a greater "prayer" to Athena. They delighted the goddess and commemorated the ancestors while uniting the citizenry under the banner of collective celebration. No less than a hundred head of cattle or the lavishly embroidered peplos, the communal expenditure of energy through motion, exertion, and competition was a votive offering. Naturally, it took forms that expressed the Athenians' special love of excellence and beauty, as well as their healthy appetite for rivalry and contest, fed by an extravagant self-regard.

THE WELL-SCRUBBED LEGACY

The Sincerest of Flattery and the Limits
of Acquired Identity

HE GOT AS FAR AS the inside of a cigar box. Opening the lid of Argüelles, the Havanas that Lopez & Brothers sold out of Tampa, Florida, one could find a portrait of the artist in a prospect of laurel leaves and scenes from his painting *Sappho* of 1881. By then, he had amassed a fortune and every honor available to a Victorian gentleman. But his success did not sit well with every set in London. "The case of Sir Lawrence Alma-Tadema is only an extreme instance of the commercial materialism of our civilization," sniffed the eminent critic Roger Fry, a member of the Bloomsbury Group. "Doubtless most real artists covet honestly enough a tithe of Sir Lawrence's money. That does not smell. But his honors! Surely by now, that is another thing. How long will it take to disinfect the Order of Merit of Tadema's scented soap?"[1]

It took around sixty years. A shrewd businessman and jolly good company, Alma-Tadema was among the most financially successful painters of his day. Offering colorful images of toga-clad Greeks, Romans, and Egyptians luxuriating in romantic architectural settings, he delighted a Victorian public yearning to make a little piece of this fantasy their own. By the time of his death in 1912, the weight of critical opinion dismissing his work as sentimental kitsch had become over-

whelming, and with the ultimate ascendancy of less naturalistic styles, his work, meticulously researched and wrought, fell into obscurity.

Opinion began to change in the early 1970s, as retrospectives and new publications brought renewed attention. By 1990, a catalogue raisonné had appeared.[2] Alma-Tadema's rehabilitation is now more or less complete, taking account of his interaction with the Pre-Raphaelites, his influence on European Symbolist painters like Klimt and Khnopff, and his broader role within nineteenth-century English painting.[3] As usual, the sales history tells the larger story: His major painting, *The Finding of Moses*, had sold for £5,250 in 1904, though by 1960 the Newman Gallery couldn't find a buyer for it. Failing to meet its reserve, it was bought in later that year for £252.[4] By November 2010, however, *Moses* sold at Sotheby's in New York for a record-smashing $35,922,500.

One of the reasons for the rediscovery of Lawrence Alma-Tadema is the obsessive exactitude with which he tried to make the antique work visible. Archaeological exertion and archival digging were part of his art. And so it is that this Dutch-born artist, dismissed by Ruskin as the worst painter of the nineteenth century, enters into the story of latter-day efforts to understand the Athenians' great architectural enigma, the Parthenon. In particular, it is his answer to a fiery question of classical scholarship—was the Parthenon painted or pure white as popularly imagined?—that matters most for our story. Sir Lawrence made his view clear with a painting from 1868 called *Pheidias Showing the Frieze of the Parthenon to His Friends* (insert page 8, bottom).[5] It is a fantastic re-creation of the moment when the sculptor unveils his newly carved frieze to Perikles and his mistress, Aspasia. The young Alkibiades is present too, leaning against his teacher, Sokrates, the entire viewing party aloft on a wooden scaffold erected high above the Acropolis, affording them a rare "frieze-eye" view. Inspiration for this painting came, no doubt, from Alma-Tadema's visit to the British Museum in 1862, when he first set eyes on the Elgin Marbles.

Pheidias Showing the Frieze could only have diminished Sir Lawrence's standing among the Victorian elite. For he did not depict the frieze as it appeared piecemeal in the museum's galleries, its white marble honey-hued with oxidation and grime. Instead, he showed the sculptures in living color: men with reddish-brown skin, draped in white mantles, standing beside horses black, white, or gray, all set against a deep blue background. When displayed in public for the first time in

1877, the painting's "fairground colours" were cause for much dismay. Exhibited in London once again in 1882, the painting reignited debate in what might be called the polychromy wars of classical scholarship.[6] We can only speculate on the inspiration for Alma-Tadema's artistic license in coloring the Parthenon frieze as he did. Was it his honeymoon trip through Florence, Rome, Naples, and Pompeii in 1863–1864? Had the experience of the grand Mediterranean tour with his bride, Marie-Pauline Gressin, brought heightened color and emotion to his imagined view of the Parthenon?

More likely, Alma-Tadema, a devoted student of archaeology and architectural history, had read Charles Newton's *History of Discoveries at Halicarnassus, Cnidus, and Branchidae,* published in 1862. In this groundbreaking volume, the archaeologist documented the vivid colors preserved on the relief sculptures of the newly discovered tomb of King Mausolos at Halikarnassos (modern Bodrum), one of the seven wonders of the ancient world.[7] Newton reported of the mausoleum that the "whole frieze was coloured . . . the ground of the relief was ultramarine, the flesh a dun red, and the drapery and armour picked out with colours."[8] And he drew inevitable comparisons with the Parthenon frieze, a monument that fell under his care as keeper of Greek and Roman antiquities at the British Museum. "The bridles of the horses, as on the frieze of the Parthenon, were of metal, as may be seen by an examination of the horses' heads, several of which are pierced for the attachment of metal." Newton adds, "This variety of colour must have greatly contributed to the distinctness and animation of the composition."

Recognition of ancient polychromy understandably came as a shock to those who had been introduced to Greek art through plaster casts. Since the fifteenth century, the making, trading, collecting, and display of white plaster casts had played an enormous role in the shaping of European taste for the antique.[9] The highly respected eighteenth-century German art historian Johann Winckelmann, despite never having set foot in Greece, became chief promulgator of the belief that ancient Greek sculpture was bright white. In Winckelmann's aesthetic view, one deeply informed by his own homoerotic sensibilities, purity was the very essence of beauty. In his *Geschichte der Kunst des Alterthums* of 1764, he wrote, "A beautiful body will, accordingly, be the more beautiful the whiter it is."[10] The neoclassical aesthetic defined

and promoted by Winckelmann made the pure whiteness of marble an enduring fetish.

Those who had traveled to the Aegean experienced a different reality. As we have seen, encountering the Parthenon frieze up close in the 1750s, James Stuart observed bits of metal preserved in the many holes drilled into the marble, and he suggested these were for the attachment of bronze fittings: spears and swords for the horsemen, bridles and reins for the horses, wreaths, and other accessories for those who march in procession. Such metal ornaments would have glistened in the raking sunlight pouring into the exterior colonnade. Stuart and his colleague Nicholas Revett also observed traces of color preserved on the Parthenon and the Theseion. In volumes 2 and 3 of *The Antiquities of Athens,* they published engravings showing in clear outline where paint had once enhanced the decorative moldings of these temples.[11]

The French architectural theorist Quatremère de Quincy announced the existence of ancient polychromy in his book *Le Jupiter olympien,* in 1814, a work that should have informed those who saw the Elgin Marbles in 1817, when they were first installed in a temporary gallery at the British Museum. Nonetheless, there was a persistent reluctance to accept that the Parthenon frieze had once been painted. Purity and simplicity were the aesthetic ideals of the day in Britain.[12] The Parthenon, as pinnacle of Western art and taste, was seen to conform to Winckelmann's old axiom: white is to sculpture what color is to painting.

By 1830, the French architect Jacques-Ignace Hittorff established, beyond a doubt, that Greek temples had been extensively painted with bright colors. Firsthand examination of ancient monuments during travels through Italy and Sicily yielded irrefutable evidence of pigments preserved on architectural moldings. He outlined his discoveries in a seminal paper titled "Architecture polychrome chez les Grecs." (Hittorff would go on to present a groundbreaking study of color on the poros architecture of Selinunte, Sicily, in a book called *Restitution du temple d'Empédocle à Sélinonte,* published in 1851.)[13]

A German treatise on the topic was to follow: Franz Kugler's *Ueber die Polychromie der griechischen Architektur und Skulptur und ihre Grenzen* in 1835. Lord Elgin's former secretary, W. R. Hamilton, was asked to translate the book for the Royal Society of Literature. The translator was intrigued. He wrote straightaway to the trustees of

the British Museum, urging them to form a committee to investigate whether traces of pigment might survive on the Parthenon marbles. By this time, several sets of moldings had been taken from the sculptures for the purpose of producing plaster casts, the first for Elgin himself in 1802.[14] Additional moldings were taken in 1817 under the supervision of Richard Westmacott Sr., and with the new debate over ancient polychromy raging, even more casts were made in 1836–1837.[15]

The mold maker Pietro Angelo Sarti was called from Rome to a meeting in the Elgin Room at the British Museum in December 1836. The topic for discussion was polychromy on the Parthenon sculptures.[16] Sarti was asked to describe the process that had been used in preparing the marbles for casting in 1817 and in 1836. Among those gathered was the scientist Michael Faraday, who, earlier that year, had discovered electromagnetic induction. Faraday was aghast to hear how the Parthenon marbles had been prepared for molding, with a prewash of soap lyes and/or strong acid. Used repeatedly, each time a set of molds was taken, these corrosives, explained Faraday, would have "removed every vestige of colour that might have existed originally on the surface of the marble."[17] But the castings continued, at least for the moment. And Faraday's further concerns, regarding the grime and dirt collecting on the surface of the sculptures (resulting from "the London atmosphere" of "dust, smoke, and fumes"), went largely unheeded. He advocated for dry brushing and very careful washing with a little carbonated alkali (like washing soda) rather than soap or acid.[18]

The grand reopening of the Crystal Palace at Sydenham nearly twenty years later would renew interest in the coloring of ancient stone. For the exhibition of 1854, the architect and design theorist Owen Jones created a multicolored Greek Court exhibiting brightly painted casts of the Elgin Marbles. Jones's vision for the court was influenced by his firsthand experience of ancient monuments during his travels through Italy and Greece in 1842. On the Greek leg, he met the young French architect Jules Goury, who had assisted the German architectural historian Gottfried Semper in his radical studies of polychromy in ancient architecture. Jones and Goury traveled together to Cairo, Constantinople, and Granada, where they undertook a landmark study of Islamic polychrome decoration at the Alhambra palace.[19]

Owen Jones's exhibit prompted a debate on polychromy at the Royal Institute of British Architects, and he followed up with a paper, "An

Apology for the Colouring of the Greek Court," published in the institute's *Transactions* for 1854. It was no apology for the truth: he presented substantial evidence for his use of color, including Hellenistic terra-cotta figurines in the Louvre, as well as stone fragments from Selinunte shown to him by Jacques-Ignace Hittorff himself. He also pointed to excavations on the Athenian Acropolis in the winter of 1835–1836, when a trench 25 feet (roughly 7.5 meters) deep at the southeast corner of the Parthenon had yielded fragments of marble female torsos preserving "the brightest red, blue, yellow, or rather, vermillion, ultramarine, and straw color." Jones declared with unwavering confidence, "To what extent were white marble temples painted and ornamented? . . . I would maintain that they were entirely so."[20]

Popular taste for the whiteness of ancient sculpture was now fully under siege. Publishing in the same volume of the institute's *Transactions,* the philosopher and critic G. H. Lewes nicely summarized the prevailing opinion of the day: "The idea of the Greeks having painted their statues is so repugnant to all our modern prejudgments . . . that to accuse them of having *painted statues,* is to accuse them of committing what in our day is regarded as pure 'barbarism.'" Yet, as Lewes conceded, "However startling, the fact remains: the Greeks *did* paint their statues. Living eyes have seen the paint."[21]

The fact of paint was too much for most Victorians to bear. They had never liked even the tawny tint that clung to the surface of the sculptures. While aversion to the swarthiness of the stone has never been explicitly ascribed to racism, one does get the sense that such a bias, so prominent in the age of empire, might account for a measure of the vehemence of the insistence upon a pure-white past. Some individuals displayed an almost obsessive compulsion to have the marbles scrubbed "clean." Debate over whether the honey tones were natural or man-made preoccupied British commentators for decades, some proposing that Pentelic marble contained a higher concentration of iron than other varieties and thus suffered a greater degree of oxidation over time. An apostle of this view, Charles Cockerell, called the surface patina "nature's polychromy." F. C. Penrose, on the other hand, argued that the Parthenon's starkness was intentionally toned down with a thin, transparent wash of ocher, or some other substance, applied in antiquity.[22]

In 1858, Richard Westmacott Jr., principal restorer of the museum's sculptures, won approval from the British Museum trustees to thor-

oughly clean the Elgin Marbles using fuller's earth, a gritty clay abrasive widely employed for the removal of oil and grime. Public outcry ensued in a series of angry letters published in *The Times*.[23] Despite Westmacott's vigorous scrubbing, the marbles seem to have become dirty again within ten years. The keeper Charles Newton drew attention to dark stains on the walls and ceilings of the British Museum galleries and then pointed to the "black, greasy substance" deposited on the Parthenon sculptures themselves. He bitterly complained about the "foulness of the atmosphere" in the exhibition space, something he attributed to the "pouring of streams of hot air into imperfectly ventilated rooms," as well as to the miserable air quality in Victorian London. Newton urged that the Parthenon marbles be washed with water every five years or, better yet, put under glass.[24] By October 1873, his concerns had been heard, and the Parthenon frieze was protected behind a glass casing that remained in place until the 1930s, when a glorious new gallery was built for the marbles.[25]

In the first three decades of the twentieth century, the Parthenon sculptures were regularly cleaned with hard brushes and water. But in the early 1930s the museum's chief scientist, Dr. H. J. Plenderleith, prescribed a new method for cleaning, one that used a "neutral solution of medicinal soft soap and ammonia," together with distilled water.[26] This procedure was followed for four years, after which everything changed.

In 1931, an enormous donation was promised to the museum for the construction of a grand new gallery to house the Elgin Marbles. The benefactor was the hugely well-connected and ever-scheming art dealer Joseph Duveen, who had made a fortune turning his father's import business into a house of art and antiques. Duveen had a particular talent for matching works of art owned by declining European aristocrats with the wallets of socially rising American millionaires. He formed a mutually rewarding partnership with the renowned art historian Bernard Berenson, in which the connoisseur and the showman provided clients with attributions and advisory services. This collaboration allowed the two friends, both men of humble beginnings, to enjoy a posh lifestyle to which they could formerly only aspire.

Duveen took a very personal interest in the preparation of the galleries that bear his name to this day (page 348, bottom). When choosing fabrics for the wall coverings of his new exhibition space, Duveen expressed a keen interest in "the actual colours of the marbles."[27]

When announcing his gift to the British Museum trustees, he emphasized the necessity of removing every trace of dirt and grime from the sculptures. The board member Lord Crawford noted in his diary that the trustees "listened patiently" as the dealer "lectured and harangued us, and talked the most hopeless nonsense about cleaning old works of art." Duveen had expressed in no uncertain terms that "all old marbles should be thoroughly cleaned—so thoroughly that he would dip them into acid," Crawford writes.[28] As an arriviste, Duveen might have harbored a natural impulse to prettify the past. Indeed, as an art dealer, he was known to have stripped, repainted, and varnished canvases to make them more attractive for the market. Lord Crawford asserted that Duveen had "destroyed more old masters by over-cleaning than anybody else in the world."

So it was that Duveen's money bought him a front-row seat at the super-cleaning of the Elgin Marbles from June 1937 through September 1938. Lord Duveen, as he was known by now, enjoyed very special access to the sculptures and the team of unskilled masons charged with scrubbing them; indeed, he gave orders directly to the crew.[29] They had wire brushes, an ample supply of the harsh abrasive Carborundum (silicon carbide), and, for particularly stubborn stains, copper chisels.[30]

On September 26, 1938, the scientist H. J. Plenderleith reported that the scraping of the sculptures had exposed the light crystalline subsurface of the marble to a raw state. In some places, the stone's original surface had been stripped of one-tenth of an inch. Consequently, certain figures appeared to have been "skinned."[31] Sculptures particularly affected included, from the east pediment, the figure of Helios, the back of the two horse heads from his chariot group, and the head of the horse pulling Selene's chariot. From the west pediment, it was the figure of Iris that suffered.[32]

The trustees decided not to make a public statement about what had happened; nonetheless, news of the cleaning was leaked to the press, and on March 25, 1939, the *Daily Mail* broke a sensational story: "Elgin Marbles Damaged in Cleaning . . . Traces of patina have been removed leaving an unnatural whiteness."[33] As tantalizing as the story was, it was soon wiped off the front pages with the onset of World War II; indeed, the Elgin Marbles would be kept under wraps for the duration of the war and the frieze transferred to an unused section of the London Underground for safekeeping. This was a wise move, for the

Duveen Gallery was badly damaged in the bombings of 1940 and had to be entirely rebuilt. It did not open again until 1949, by which time the wire brush scandal had been largely forgotten and remained so until the publication of the third edition of William St. Clair's *Lord Elgin and the Marbles* in 1998. Controversy was reignited. In response, the British Museum produced an unprecedented and wonderfully comprehensive publication of all internal documents relating to the case. In addition, it sponsored an international conference on the matter in December 1999.[34] Thus, much of what we know about the long debate over polychromy, as well as the British Museum's stewardship of the marbles, has come to light only recently.

We have also learned much from the ongoing autopsy of the Parthenon itself. Indeed, exciting new evidence for the vivid painting of the temple has been revealed by the Acropolis Restoration Service's work on the Parthenon's west colonnade. It was a matter of removing other architectural accretions. During the Frankish period, a bell tower with staircase was built within the porch at the very southwest corner of the Parthenon, then serving as the cathedral Notre-Dame d'Athènes. One of the tower's brick walls had long concealed a section of an anta capital, just beneath the architrave. With the Ottoman capture of Athens in 1458, the cathedral was transformed into a mosque and the bell tower into a minaret.

In the early 1990s, the brick wall of this medieval staircase was removed. For the first time in 750 years, the anta capital of the Parthenon's rear porch was exposed. Extensive traces of green and red paint were found preserved on its Ionic and Lesbian moldings, as well as on the profile moldings above the frieze within the north and west colonnades.[35] Separately, Egyptian blue and red hematite paint have been found on the horizontal cornice as well as on the triglyph-metope frieze.[36] Laser surface cleaning, undertaken in 2006–2009,[37] has further revealed traces of light green paint on the costumes of two of the horsemen on the west frieze, the only stretch of the relief panels that Elgin left in place.[38] And, on the west pediment, significant traces of blue (amid an orange-brown layer of the original ancient patina) have been revealed on the drapery stretching across the back of King Kekrops (page 111).[39]

The polychromy wars entered a twenty-first-century phase with the opening of the new Acropolis Museum on June 19, 2009. Timed to co-

incide with the festive inauguration of the galleries in Athens, there came from the British Museum a press release announcing new research that revealed polychrome paint on the Elgin Marbles. Using the latest technology to detect infrared light emitted by pigment particles of Egyptian blue, a British team had been able to recover barely visible traces of color on the belt of Iris from the west pediment. "I always believed the frieze must have been painted," offered one senior curator. "This new method leaves no room for doubt." He further observed that originally the marbles would have been painted red, white, and blue. "Yes," he added, "the colours of the Union Jack," shooting a little cannonball of British nationalism toward the happy party gathered at the foot of the Acropolis.[40]

THE POLYCHROMY CONTROVERSIES ARE but a short chapter in the long, vexed history of efforts to see the Parthenon and the people who made it as they were. It is a chapter, nonetheless, typical of the perils of self-projection in attempting to apprehend the distant past. Athens having served as an ideal for so many later cultures, it is perhaps unavoidable that of all antique realities it would have suffered the most distortions in the course of successive attempts at appropriating its legacy. Only recently have some advanced methods of investigation liberated our own understanding from preconceptions that have stood since the Renaissance and the Enlightenment. And yet there remains who knows how much more to unearth.

At the same time, popular understanding, particularly as reflected in our civic discourse and architecture, continues to uphold certain assumptions of supposedly Athenian derivation—assumptions, for instance, about the primacy of empirical reason over belief, the centrality of the individual, and the basis of democracy—just as surely as it clings to an aesthetic of pure-white marble. As a practical matter, we are bound to stick to our self-serving construction of the Athenian reality for the foreseeable future. It may, therefore, come as some comfort to discover that peoples more historically proximate to classical Athens, with the sincerest of intentions and the most studious of efforts, were not altogether unerring in their effort to capture the Athenian ideal, to develop from it an identity of their own. To set things in perspec-

tive, then, perhaps even to gather a thing or two we latter-day imitators might have missed, let us in closing consider the case of the very first would-be Athenians.

AS EARLY AS the late fourth century B.C., the political and economic hegemony of Periklean Athens was mostly a memory. At the beginning of the second year of the Peloponnesian War, in 429, Perikles himself had perished, struck down by the deadly plague that would claim a full third of the Athenian population. Things went from bad to worse, the war ending in defeat for Athens and its allies in 404. The Greeks would continue their infighting until Philip of Macedon finally conquered them in 338, bringing a decisive end to the Athenian democracy.

The Athenian legacy of course lived on in the new regime, not least because of Aristotle's conscription as tutor to Alexander, Philip's son. Still, as the age of the Parthenon receded, the geopolitical center of the Greek world shifted east. Successive powers would rise, claiming, to one degree or another, identification with bygone Athenian greatness. The first and most zealous of these would be Pergamon. During the

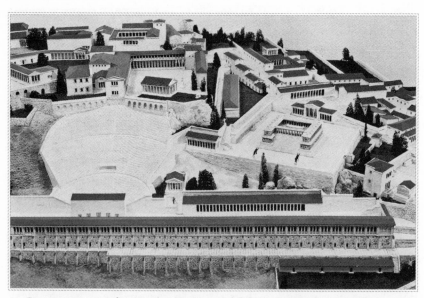

Pergamon acropolis, reconstruction model with theater, temple of Dionysos, and stoa; on summit above, temple of Athena Polias and the Great Altar.

latter third and entire second centuries B.C., for about 150 years, this kingdom in western Anatolia set about modeling itself in the image of classical Athens. So passionate was the Pergamenes' love of Athenian art, architecture, philosophy, religion, and culture that they lavished their own "city on a hill" with gleaming white marble buildings in conscious imitation of the Periklean Acropolis.[41] And though aware that their ancestry sprang from Tios on the Black Sea, the Pergamene kings acquired through pure invention, abetted by the Athenians themselves, an identity that can be called neo-Athenian. This they did even to the point of carving a frieze of their own, in direct imitation of the Parthenon frieze, linking themselves to the very genealogy that the Athenians had guarded so jealously and celebrated annually in the Panathenaia, by this time, for more than four hundred years.

By the middle of the second century, Pergamene kings could boast of their own acropolis of white marble buildings, including a temple to Athena Polias Nikephoros ("Athena of the City, Bringer of Victory"), a copy of Pheidias's statue of the Athena Parthenos, and, perhaps also, a copy of Pheidias's Bronze Athena,[42] as well as a cavernous theater nestled into the citadel's precipitous western slope, anchored at its base by the temple of Dionysos and a long, sprawling stoa (facing page).

It was no coincidence, of course, that each of these elements could also be found on the Athenian Acropolis (below). The Pergamene kings were likewise quick to introduce local cults of Athena Polias, Dio-

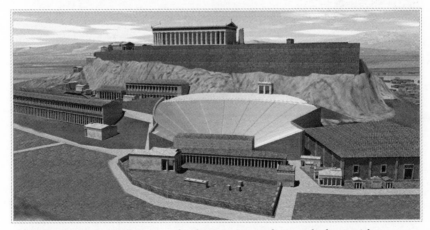

Hypothetical visualization of Athenian Acropolis, south slope with Theater of Dionysos, temple of Dionysos, Odeion of Perikles, Stoa of Eumenes II; on summit above, the Parthenon.

nysos, Zeus, Asklepios, and Demeter and Kore, replicating the long-established religious institutions as well as the more tangible fixtures at Athens. What motivated these newcomers to emulate so completely and so suddenly the Athenian model?

SET ON A PRECIPITOUS SUMMIT in northwestern Asia Minor, roughly opposite the Aegean island of Lesbos, Pergamon is an easy 26-kilometer (16-mile) sail up the Kaikos River from the Mediterranean Sea. The city's commanding cliffs attracted King Lysimachos (360–281 B.C.) of Thrace and Mysia, who inherited all of western Asia Minor following the death of Alexander the Great in 323 B.C. With its natural defenses and proximity to the fertile fields of the Kaikos River valley to feed a large garrison, this was the perfect place to build the royal treasury. To safeguard his wealth, Lysimachos appointed his trusted comrade Philetairos (ca. 343–263 B.C.), but following a series of bloody clashes between Lysimachos, King Seleukos (another of Alexander's heirs), and Seleukos's rivals, Philetairos found himself the last man standing.[43] He kept the treasure and used it to establish his own royal line, one that became known as the Attalids, presumably after his father, who was likely named Attalos.

Philetairos died in 263 B.C., succeeded by his adoptive nephew, Eumenes I. This Eumenes declared sovereignty for Pergamon, defeating the Seleucid king, Antiochos, in 262. He also became a great patron of Athenian philosophers, befriending Arkesilaos, arguably the most influential head of the Academy after the death of Plato.[44] Thus, the Attalid kings began a long relationship with the philosophical schools of Athens, a fruitful partnership that would bolster their claim to being special caretakers of Athenian learning and culture. Another nephew of Phileteiros's, Attalos I, succeeded Eumenes upon his death in 241. Like his cousin, Attalos I was well acquainted with philosophical circles in Athens, becoming a close associate of Lakydes, faithful follower of and successor to Arkesilaos at the Academy. In fact, so great was Attalos's esteem for his learned teacher that he established a special garden on the Academy grounds, which became known as the Lakydeion.

In his forty-four-year reign (241–197 B.C.), Attalos I accomplished much, but he would be best remembered for two things. First, his

refusal to pay the onerous tribute demanded by marauding Gauls from the north, a burden on the Pergamene people for years. In fact, within ten years of becoming king, he would soundly defeat the Gallic enemy.[45] Attalos's second great accomplishment was to raise four sons, two of whom, as Eumenes II and Attalos II, would follow him in peaceful succession, each serving very ably on the Attalid throne. It was under the rule of these three immensely capable individuals across two long generations, spanning 241 to 138 B.C., that Pergamon made itself a "New World" Athens, an icon in fact of the old one. Lavishing money on the city's building program in a measure to rival Perikles himself, they established a vibrant center for science, art, and culture, including a superb library of more than 200,000 scrolls, calculated to attract the most distinguished teachers and philosophers of the day.

IN 200 B.C., while harbored on the island of Aegina with his fleet, Attalos I found himself summoned to Athens. He was welcomed at the Dipylon Gate by an ecstatic throng of magistrates, priests and priestesses, and the citizen body as a whole. The people of Athens had a truly astounding honor to offer him: the assembly had voted that Attalos should henceforth be regarded as one of Athens's founding heroes. A new tribe would be named the Attalis, and his image would be added to the bronze statue group of the Eponymous Heroes that had stood in the Agora since the 430s B.C.[46] This was the monument to the city's ten founding heroes, who had given their names to the Athenian tribes established during the early days of the Kleisthenic democracy, in the last decade of the sixth century.

Thus was an eastern king, with family roots on the Black Sea, made not merely a citizen of Athens but a founding father. That such an honor could be awarded retroactively, as it were, demonstrates the flexibility and practicality of genealogical succession myths. It makes the Parthenon Inscription honoring Nero in A.D. 61/62 seem rather a small token. But in both cases, the Athenians, having seen better days, were bartering for survival with the most precious thing remaining to them: their singular identity (what we might call the most prestigious "brand" in the ancient world). For assimilating Attalos, they wanted something quite substantial in return: that he join with Rome in defending Athens

against Philip V in the Second Macedonian War (200–197 B.C.). Attalos duly complied, bringing soldiers to fight alongside the armies of Rhodes and Rome to defeat the Macedonian foe.

With his new Athenian identity in hand, Attalos I had only to make a few further changes to the Pergamene acropolis to establish an august mythic past for his relatively short-lived kingdom. This he (and his sons) would do via the legend of the hero Telephos, son of Herakles.

Meanwhile, before leaving town, the Pergamene king seems to have dedicated on the Athenian Acropolis a series of bronze sculptures celebrating his triumphs over the Gauls in 233 and 228 B.C.[47] Since the fragmentary inscription preserves only the name Attalos, there is a possibility that this offering was made by his son, Attalos II, but the agency of the father is perfectly conceivable. In any case, the installation followed the long-standing tradition discussed in chapter 6, by which conquests over eastern enemies were conspicuously commemorated with shields, swords, and other booty dedicated on, in, or near the Parthenon. Attalos's victory monuments were set atop the southern ramparts of the Acropolis practically in the shadow of the Parthenon.

Pausanias saw the dedications of Attalos when he visited the Athenian Acropolis in the second century A.D.[48] He describes a series of bronze statues showing gods battling Giants, Theseus fighting the Amazons, Athenians clashing with Persians, and Pergamene warriors defeating Gauls. Thus, Attalos integrated his own victories over barbarian tribes into the hallowed succession of military boundary events celebrated on the Acropolis from the Archaic period on. Manolis Korres has even identified the cuttings for the attachment of these statue groups atop the southern wall of the Acropolis.[49] We can envision, then, a series of bronze images set up just beneath the Parthenon and just above the Theater of Dionysos.

Attalos's sons, Eumenes II and Attalos II, were quick to understand the value of cultivating this painlessly acquired heritage, and they carried on strengthening ties with Athens and bestowing sumptuous benefactions upon the city. When we look to the south slope of the Acropolis today, we see the Theater of Dionysos, which, by the Hellenistic period, seated around seventeen thousand spectators (page 305). But where did these crowds take shelter from the intense sun and occasional rain? Enter Eumenes II, bearing an efficient solution that had already worked at Pergamon. At his home citadel, Eumenes had erected two tremen-

dous stoas just beneath the theater, one of the colonnades an astonishing 246.5 meters (809 feet) long (page 304). So the king donated funds for the construction of a smaller version at Athens, just 163 meters (535 feet) long, to the west of the Theater of Dionysos. The "Stoa of Eumenes," as it came to be called, shows the same system of arcaded buttresses that support the theater at Pergamon, a neat answer for the problem of building up against a steep cliff. Eumenes may have also provided Pergamene engineers to work on the south slope of the Acropolis.[50] The interior colonnade of the upper story was adorned with palm-leafed capitals, a signature of Pergamene style and of Attalid benefaction.

Eumenes's younger brother Attalos II (220–138 B.C.) studied in Athens as a young man, possibly under the philosopher Karneades, head of the Athenian Academy. This would explain the inscription of Attalos's name on the base of a bronze statue of Karneades found in the Agora.[51] A second dedicator is also named, Ariarathes, king of Cappadocia, who just happened to be Attalos's brother-in-law. This joint offering suggests that the two princes might have spent their salad days together in Athens, studying under Karneades. Son of an Eponymous Hero of Athens, Attalos II was awarded the great honor of Athenian citizenship in recognition of his benefactions to the city. He famously financed the construction of a great two-storied stoa, its colonnade built entirely of Pentelic marble.[52] Measuring 115 meters (377 feet) long, the so-called stoa of Attalos featured the same telltale Pergamene capitals used in the stoa of Eumenes. In 1952–1956, the American School of Classical Studies at Athens fully reconstructed the stoa of Attalos on its original foundations, making it one of the only ancient Greek buildings ever to be completely restored and used; to this day it houses the Agora Museum and the Agora Excavations offices and storerooms.[53]

The special relationship between Athens and Pergamon is further attested in a series of impressive commemorative monuments on the Acropolis. All four sons of Attalos I competed in the equestrian events at the Great Panathenaia of 178 B.C., each winning his respective competition. The princes continued to contend for prizes in subsequent Panathenaic festivals.[54] To celebrate their victories, they set up two very conspicuous monuments. Eumenes II built a pillar monument, surmounted by a four-horse chariot group cast in bronze,[55] on the terrace just below the northwest wing of the entrance to the Acropolis, in a spot roughly parallel to the placement of the Athena Nike temple at the

south. It should be remembered that the princes' ancestor Philetairos had introduced the worship of Athena Polias Nikephoros at Pergamon back in the second quarter of the third century B.C. The pairing of the Attalid victory monument with the Athenians' own temple to Victory emphatically manifested the special link between the two cities. The chariot group would come and go, but the pillar base proved durable: it later held bronze statues of Antony and Cleopatra, and following their defeat at Actium in 31 B.C. it was rededicated to the great hero of the battle, the Roman consul Marcus Agrippa. The monument can be seen to this day just to the left, in front of the northwest wing of the Propylaia as one enters the Sacred Rock.

A second monument was erected, probably to commemorate Attalos II's victory in equestrian competitions that he seems to have won at

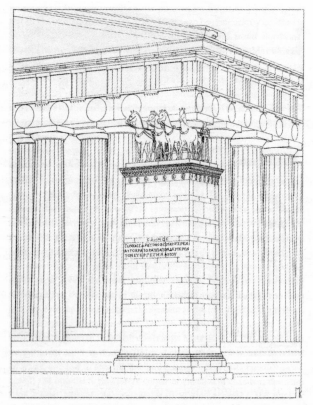

Reconstruction drawing of victory monument of Attalos II, with bronze quadriga on tall pillar at northeast corner of Parthenon, by M. Korres.

three separate Panathenaias: 178/7, 170/69, and 154/3 B.C.[56] Its towering marble podium supported a bronze four-horse chariot group (facing page).[57] Erected at the northeast corner of the Parthenon, the monument reached the height of the temple's architrave, bringing it face-to-face with the shields dedicated by Alexander after his victory at Granikos. It also directly faced the northernmost metope of the Parthenon's east façade (no. 14), which shows Helios driving his chariot up from the watery, and fishy, depths (page 98). One can only wonder how close the Pergamene dedication stood to the famous statue group of Erechtheus battling Eumolpos, a leading work by the master sculptor Myron in the mid-fifth century B.C. Pausanias describes these sculptures as set up "right by the temple of Athena."[58] Thus, by the Hellenistic period, the Parthenon precinct was filled with victory monuments from across the ages, juxtaposing images of venerable local heroes with those of newly minted Attalid kings.

BACK AT PERGAMON, the Attalids imported cults that had long existed at Athens.[59] They combined the worship of Athena Polias with that of Athena Nike to produce the cult name Athena Polias Nikephoros. Beneath the Pergamene theater stood a small temple of Dionysos, mirroring exactly the plan at Athens, where the temple of Dionysos sits just below his theater on the Acropolis's south slope.[60] High above the theater at Pergamon, we find the sanctuary of Athena Polias, again a direct quotation of the plan at Athens, where the sanctuary of Athena sits atop the theater, crowning the Acropolis citadel (pages 304 and 305). So important was visual correspondence with the Athenian model that Pergamene builders turned their Athena temple off the standard east-west axis so that it faced north, its long flank appearing above the theater just as the Parthenon does above the Theater of Dionysos on the Acropolis's south slope.

The precinct of Athena Polias Nikephoros, established at Pergamon by Philetairos, was enhanced with double-storied stoas added by Eumenes II.[61] The upper balustrades of these stoas were ornamented with sculptured reliefs depicting trophies of Pergamene victories: great panoplies of weapons, shields, armor, standards, and *aphlasta* (apulstres, tall ornaments that decorate the sterns of ships and symbolize maritime power). In this, the Pergamene shrine of Athena Polias Nike-

phoros borrows from the temple of Athena Nike at Athens. We will remember the ninety-nine shields seized by Kleon from the Spartans at Sphakteria and hung as trophies around the podium of the Nike temple. The symmetry between the booty displayed at Athens and the seized weapons depicted on the Pergamene balustrade makes the association of the two sanctuaries all the more emphatic.

The so-called Altar of Zeus, set high on a terrace near the summit of the Pergamon acropolis, was a monument like no other (below).[62] It measured roughly 35 square meters, or 100 Ionian feet, making it a true *hekatompedon,* or "hundred-footer." The date of its construction and its identification as an altar are much debated.[63] While it has traditionally been placed during the reign of Eumenes II, new study of context pottery has pushed the date down to the very end of his reign and extending into that of Attalos II and, even possibly, that of Attalos III.[64] Work appears to have begun after 165 B.C., or even later, in commemoration of Eumenes II's victories over the Gauls in 167–166 B.C. In any case, the monument was never completed.

The Great Altar's sumptuous sculptural program is a tour de force carved in marble. The exterior frieze wraps around the base of the monument, in defiance of all architectural conventions that normally require

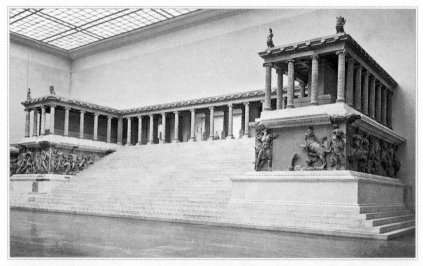

Great Altar of Zeus from Pergamon, with broad western staircase
leading up to a raised court; Gigantomachy frieze wraps around exterior
beneath colonnade.

such a frieze to be set high above the Ionic colonnade. Through the radical innovation of bringing the sculptured figures down to ground level, the altar seems intended to engage human viewers in the energy of its composition. So much for the gods as the only intended viewers; perhaps an acquired legacy was thought to require more on-the-ground selling.

The frieze presents a very ancient narrative, one borrowed straight from Athens: the Gigantomachy, the cosmic conflict presented through a multitude of images capturing the very heat of combat. It is estimated that there were between eighty and a hundred figures in the original composition spread across a field 113 meters (371 feet) long and 2.3 meters (7.5 feet) high. In what survives, we can recognize the full pantheon of divinities listed in Hesiod's *Theogony*.[65] Gods of the cosmos and the oceans join with the younger generation of Olympians to battle

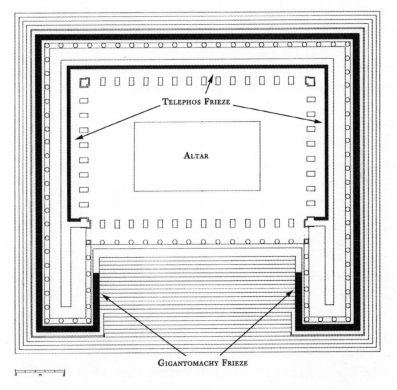

Plan of the Pergamon Altar showing placement of the Gigantomachy frieze (beneath colonnade wrapping around the exterior) and the Telephos frieze (inside the raised court, wrapping around the interior colonnade).

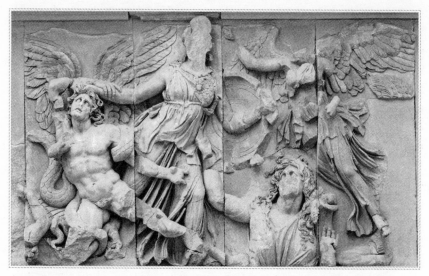

Athena fights winged giant (at left) while Nike crowns her (from right);
Ge emerges from the earth, pleading for her son. East frieze, Pergamon
Altar.

the Titans and the Giants, fantastic creatures depicted with wings, ser-
pent legs, the heads of beasts, and other marks of monstrosity.

The Giants of the Pergamon Altar can be seen as Hellenistic incarna-
tions of the terrifying creatures that appeared in our discussion of the
Archaic Acropolis at Athens (chapter 2). Some recall aspects of the hid-
eous Typhon with broad wings and serpent legs. Still others are reminis-
cent of the fish-tailed Triton that we saw wrestling with Herakles on the
poros pediments. The triumph of order over chaos, as represented by
the Olympian gods' overcoming the Giants, works also as a metaphor
for Pergamene victory over the barbaric Gauls.

At the west side of the altar, a flight of two dozen steps 20 meters
(66 feet) wide leads up to an interior court. Here, a second, smaller
frieze wraps around its interior colonnade (previous page). Forty-seven
of its original seventy-four relief panels survive. They tell the story of the
foundation of Pergamon through the exploits of the hero Telephos, son
of Herakles and the princess Auge of Tegea on the Greek mainland.[66]

In contrast to the flamboyant style of the Gigantomachy frieze, this
interior frieze presents a quiet, dignified narrative, one that takes us
rather literally through the life story of Telephos. The juxtaposition of
two very different sculptural styles mirrors what we find on the Parthe-

non, where the vibrant poses of Athena and Poseidon on the Parthenon's west pediment contrast with the calm, collected mood of the foundation story told on the frieze. Indeed, the Pergamon Altar is a very studied imitation of the Parthenon in its style, its content, and the programmatic organization of its sculptured decoration. The figures of Athena and Zeus on the east frieze of the Great Altar are directly modeled on the dynamic central composition of Athena and Poseidon on the Parthenon's west pediment. We see Athena in the same energetic stance, lunging to the right, with her left leg bent at the knee and pushing through the great sweep of her dress (facing page). She grabs a fallen, winged giant (Enkelados?) by the hair while Ge (his mother?) emerges from the earth, imploring Athena to spare him. Meanwhile, Zeus's explosive pose, with thick, exaggerated musculature, derives directly from the figure of Poseidon on the Parthenon's west gable (below). He raises his arm to hurl a thunderbolt (in place of Poseidon's trident) as three Giants are brought to their knees (and snake-legs) before him.

Again and again on the Pergamon Altar, we find references to Athens, its cosmic struggles, and its defining boundary events. At the north side of the Gigantomachy frieze, we see a dynamic female figure poised to hurl a globe encircled with a coiling snake (following page). The maiden pulls her right arm back, fully cocked for the pitch, and thrusts

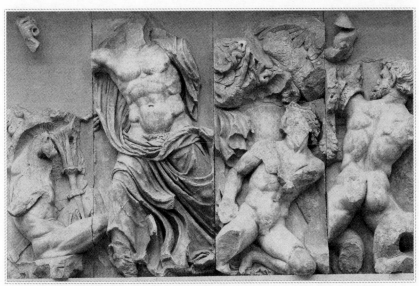

Zeus hurls thunderbolt at Giants. East frieze, Pergamon Altar.

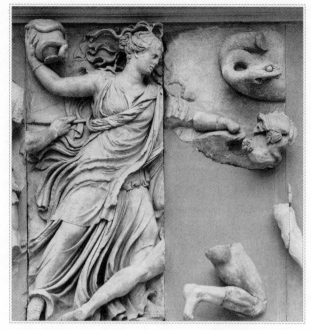

"Nyx" hurls serpent into the heavens. North frieze,
Pergamon Altar.

her left arm straight out, to steady her aim. This figure has tradition-
ally been identified as a personification of Nyx, goddess of the night,
or, alternatively, as Persephone or Demeter.[67] One cannot help but be
reminded, however, of the young Athena, the only deity in Greek myth
who is famous for pitching a serpent into the sky. Hurled to the very pole
of heaven, Drako's constellation dominates the northern sky ever after.
Can it be a coincidence that this image of a serpent thrown skyward is
placed on the north side of the Gigantomachy frieze? Even though this
figure is not meant to represent Athena, it is deeply evocative of her
vibrant catasterization of that most deadly of Giants.

Further along the north frieze we find another quotation from Ath-
ens, indeed, from the Parthenon sculptures. A monstrous fish, replete
with scales, gills, fins, and a bulging eye, emerges spectacularly from the
waters beneath Helios's chariot (inset, facing page). We think immedi-
ately of the Parthenon's abundance of serpents and fish-tailed creatures,
especially the fish that similarly swim beneath Helios's chariot on east
metope 14 (page 98), just behind the victory monument of Attalos II
(page 310). The Pergamon Altar thus takes familiar land and marine

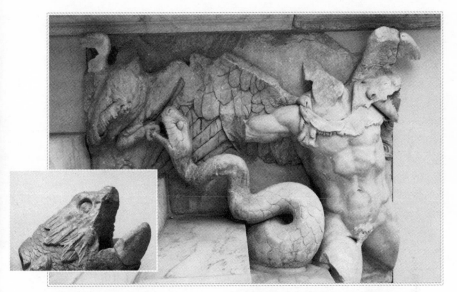

Serpent slithers up western staircase, locked in combat with eagle of
Zeus, while fallen winged giant looks on. Inset: Monstrous fish emerging
from the sea beneath Helios's chariot, north side. Gigantomachy frieze,
Pergamon Altar.

creatures seen on the Athenian Acropolis and inflates them to an all-
new level of amplification in the bombastic sculptures of the Gigan-
tomachy frieze. And one only need look to the snake bursting from its
relief background and slithering up the altar's staircase (above) to be
reminded of the serpents of the Archaic Acropolis (insert page 2, top,
and page 4, top). Makes one wonder just how much fishy iconography
we have lost from the Acropolis.[68]

EVEN THE ROOF of the Pergamon Altar was decorated with marble
akroteria figures familiar from the Athenian Acropolis: Athena, Posei-
don, Centaurs, and Tritons. Once again, the figures of Athena and Po-
seidon seem to quote their likenesses on the Parthenon's west pediment:
Athena wears a Gorgon's head aegis draped across her chest, as she
rushes forward (following page, left); Poseidon turns his full, rippling
torso to the viewer as he lifts what is, no doubt, a trident with his out-
stretched right arm (following page, center). As for the altar's rooftop
statues of rearing Centaurs, can they have been inspired by anything
other than the south metopes of the Parthenon? Likewise with the burly

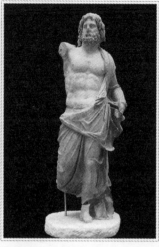

Rushing Athena, with
Gorgon's head on her chest.
Akroterion figure, Pergamon
Altar.

Poseidon emerges from
the sea. Akroterion figure,
Pergamon Altar.

Burly Triton with "skirt" of
seaweed. Akroterion figure,
Pergamon Altar.

Triton akroteria, hulking mermen with seaweed around their waists
and fish tails emerging from their loins (above, right).[69] These are the
sons of Triton, the same sea monster shown wrestling Herakles on the
Bluebeard Temple of the Archaic Acropolis and repeated in the Triton
figures of the Parthenon's west pediment (insert page 5, right).

WITH SO MANY direct quotations from the Parthenon manifest, it
should come as no surprise that the altar's Telephos frieze takes direct
inspiration from the Erechtheus frieze of the Parthenon. Indeed, there
may be no greater proof that the Parthenon frieze shows the myth of
Erechtheus than this later frieze that strives so explicitly to emulate
it. Both friezes channel the myth of the city founders, the oracles that
determined their fates, their roles in defending their cities from hostile
invaders, and their contribution in establishing local cult. Both do so in
a long, continuously sculptured "ribbon" of marble relief. But as with
the altar's Gigantomachy panels, there is a key difference. While the
Parthenon frieze rings the upper recesses of the peristyle, the Telephos
frieze encircles the interior colonnade of the altar's raised court, seen
directly at eye level (page 313).[70] One wonders if, once again, in their
conscientious imitation of the Parthenon, the sculptors at Pergamon set

out to compensate for a weaker claim to divine descent. No one in Athens was in any doubt of Athenian genealogy. But the Telephos frieze had to make a somewhat harder sell, establishing the legitimacy of the Attalid dynasty for all, Pergamene and visitor alike, to see. There were no centuries of certainty that this descent issued from prehistory.

It is perhaps not surprising that the Pergamene kings, in their sedulous cultivation of neo-Athenian identity, chose for their founder a hero who had been celebrated in an eponymous play of Euripides's. After all, if the Athenians could point to the master's *Erechtheus,* the Attalids could claim his *Telephos.*[71] Greek tragedy, just like Greek architectural sculpture, was an important vehicle for retelling charter myths.[72] Again and again in Greek drama we find the foundation of local cult occasioned by the death of a local royal hero: Pentheus at Thebes, Hippolytos at Troezen, Opheltes at Nemea, Iphigeneia at Aulis, Erechtheus and his daughters at Athens, and, yes, Telephos in Mysia. No one was keener to tell these tales than Euripides, whose corpus included not only the *Erechtheus* and the *Ion,* but the *Children of Herakles* and *Iphigeneia at Aulis,* as we have seen, also the *Bacchai, Hypsipyle,* and *Telephos.* In fact, the theatrical propagation of myth might have, if anything, seemed more urgent to the Pergamenes. Andreas Scholl has stressed the architectural similarity between the Great Altar and the *skene* (scene building) of the Greek theater.[73] It is possible that the very form of the altar itself refers to the Greek stage and to the mythic dramas played out upon it.

Presenting a continuous narrative in which leading characters appear repeatedly as they make their way through sequential episodes of the foundation story, the Telephos frieze is nothing if not far easier to read than the one on the Parthenon. We take it in like a cartoon strip with successive events in sequence side by side, beginning with the birth of Telephos and ending with his death. Thus, we learn the full story of how Pergamon came to be. It begins with the lovely Auge, princess of Tegea in the Greek Peloponnese, who served as virgin priestess for the local cult of Athena. Her father, King Aleos, had good reason to place his daughter in this sacred office: an oracle had prophesied that if Auge ever gave birth to a son, he would grow up to kill his grandfather's male heirs.

Auge had a special role among the *plyntrides* at Tegea, that is, the sacred washers of the goddess's robes. In this, she mirrors Aglauros, princess daughter of King Kekrops at Athens, who served among the

plyntrides of Athena. One day, when Auge was on the banks of a stream washing the robes of the goddess, Herakles came by. He seduced the princess, and as always happens when gods or demigods make love to mortals, Auge immediately conceived. Ashamed of losing her virtue, the princess exposed her infant son on the slopes of Mount Parthenion, meaning "of the virgin." In this, we see a parallel to King Erechtheus's daughter Kreousa, who left her baby son, Ion, to die in a cave on the north slope of the Acropolis, the very cave in which Apollo had made love to her. Telephos is saved from exposure by a deer or lioness. Ion is rescued by Hermes, sent by Apollo to carry him to Delphi. And so did Ion go on to found the Ionian race. Telephos naturally has the chance to father a people, too. As the frieze would have it, these are the Attalids of Pergamon. Of all the heroes the Pergamenes might have appropriated as their founder, and there are many, they chose thoughtfully and well. Telephos ("the Wanderer") embodied both their Asiatic roots and their Athenian ambitions.

The north side of the Telephos frieze depicts the earliest chapters in the hero's life: the story of his parents, their impromptu romance, and its aftermath. Having left baby Telephos on the mountainside, Auge is

Herakles pauses to admire his infant son Telephos, suckled by a lioness. Telephos frieze, Pergamon Altar.

sent off to sea in a little boat by her father, to hide her shame from the people of Tegea. The boat washes up at Mysia on the western shores of Anatolia, not far from where the city of Pergamon will be founded. The kindly king Teuthras rushes down to the beach and rescues Auge, whom he adopts and comes to love as his own daughter. She establishes a cult of Athena, brought directly from Tegea, where she had formerly been priestess of the goddess. The new cult, however, is named for Athena Polias, the same title under which Athena was worshipped at Athens. And as first priestess of Athena Polias at Pergamon, Auge assumes a role parallel to that of the Athenian queen Praxithea.

Meanwhile, back on Mount Parthenion, the infant Telephos has survived, nursed by a lioness. On the north wall of the colonnade, we see a panel showing Herakles as he discovers Telephos (facing page).[74] The beefy hero, leaning on his signature club, dissolves into tenderness at the sight of his infant son. The trophy of his violent slaying of the Nemean lion, the fearsome skin he wears, looks more like a benign blanket draped atop his club. With one leg crossed over the other as he watches his boy suckling on the teats of the lioness, the hero seems quite undone. (Earliest traditions had it that Telephos was suckled by a deer rather than by a lioness. But since the deer was sacred to the Gauls, hated enemies of the Attalids, the lioness variant was preferred. Of course, the lion also has the advantage of close association with Herakles's first labor.)

Along the eastern wall of the colonnade, we see the wanderings of Telephos as a young man. Having consulted the Delphic oracle about finding his mother, Telephos is told to travel east to the shores of Anatolia. This brings him to Mysia, where he is welcomed by the sympathetic king Teuthras, still on his throne. The king begs the obviously heroic lad to help him defeat Idas, an enemy who threatens to usurp him. Success, Teuthras promises, will win Telephos the hand of Princess Auge in marriage. Since Auge's priesthood of Athena Polias was no doubt like the sacred office at Athens (on which it is modeled), open to married women, it posed no impediment for her proposed nuptials.[75]

In the panel showing Telephos and his men welcomed at Teuthras's court, we see figures in Phrygian caps, setting the scene in Anatolia. Next come Telephos's comrades, one of whom wears an Athenian helmet, signaling that he hails from the Greek mainland. At the far right, we see Telephos himself, in a full-muscle cuirass (following page). The hero turns to the right to receive a helmet and weapons from Auge, again

Telephos as a young warrior wearing breastplate
(far right) welcomed in Mysia; his comrades (at left)
wear Phrygian cap and Attic helmet. Telephos frieze,
Pergamon Altar.

connecting her with Aglauros, for, as we have seen, it is within the sanctuary of Aglauros on the Acropolis's east slope that Athenian ephebes received their weapons. At Athens, it was the priestess of Aglauros who oversaw the ritual in which young soldiers also swore their oath of loyalty. And here, we find Auge enacting this same priestly role.

The remainder of the east frieze is devoted to Telephos in battle with Idas's troops and the aftermath. Returning as a victor, Telephos is met by King Teuthras, ready to make good on his promise of marriage. Fortunately, mother and son recognize each other just in the nick of time, averting an incestuous side story. But Telephos does not remain lonely, going on to marry the local Amazon queen, Hiera. When Argive Greeks arrive in Mysia, having lost their way to the Trojan War, they engage in battle with Hiera's Amazons. The frieze shows Telephos fighting for the Amazons against the Greeks. Thus are the Attalids ingeniously able to

write their founding hero into the scripts of two great boundary events we have already seen in the Parthenon metopes: the Trojan War and the Amazonomachy. In the Pergamene version of the battle with the Amazons, Hiera is killed, and Telephos is badly wounded by Achilles.

Not without justification, it happens. Dionysos had been deeply offended when Telephos failed to make sacrifice to him. The god retaliated during the battle with the Greeks, causing Telephos's leg to become entangled in the roots of a grapevine, making Telephos a sitting duck for Achilles's lance. The son of Peleus wields the special spear the Centaur Chiron had given his father as a wedding gift. The wound Achilles inflicts will not heal, and Telephos is lamed.

In great pain, Telephos consults an oracle: only the weapon that inflicted the wound, he learns, can heal it. The south frieze shows his journey back to the Greek mainland in search of the spear that pierced him. He is received at Agamemnon's palace in Argos as a visiting dignitary. Nonetheless, when the king refuses to help find the spear, Telephos explodes with rage and grabs his infant son, Orestes. The frieze shows Telephos holding the boy upside down, about to kill him upon Agamemnon's household altar, until, finally, Chiron's spear is found. Filings from its tip are rubbed into the wounded foot and it heals.

We next see Telephos returning to Pergamon to become king and establish a cult of Dionysos. Thus is the angry god appeased, his vendetta against the royal house ended. It is a version of what we have observed at Athens, where Poseidon was in constant conflict with Athena. Angered by the rejection of his gift of a sea spring, the god unleashed earthquakes and floods. Erechtheus, however, does not make timely amends. In the play named for him, Euripides has Poseidon create a great chasm that swallows the king into its depths. It is only when Queen Praxithea establishes a new cult of Poseidon-Erechtheus on the Acropolis that bygones are bygones.

The worship of Athena Polias remains the primary cult for both Athens and Pergamon. But secondary cults are welcomed in both cities to assuage divine hurt feelings. Queen Praxithea and Queen Auge serve analogous roles as priestesses of the primary cults of Athena Polias. King Erechtheus and King Telephos hold special roles as founders of new, secondary cults: that of Poseidon-Erechtheus and that of Dionysos Kathegemon, the "God Who Leads."

The southern wing of the Telephos frieze shows the final chapter in

Telephos's story. Reclining on a couch, he is now consecrated the founding hero of Pergamon, his recumbent pose straight from established formulas for showing Herakles after the completion of his labors. Like father, like son, is the unmistakable message. The founder at last takes his ease, having traveled so far and accomplished so much, having won for his people the world to which they are now heirs.

His final resting place also speaks to following received models carefully. Deep within the foundations of the Pergamon Altar are the remains of an apsidal building made of andesite blocks dating to the time of Attalos I.[76] The builders of the altar took evident care to respect this subterranean construction. It appears to describe a tomb-shrine on the model of those we have seen for Pelops at Olympia, Opheltes at Nemea, Melikertes-Palaimon at Isthmia, Hyakinthos at Amyklai, and Erechtheus and his daughters at Athens. These founders all received cult worship at the places where they were believed to have been buried. And so the apsidal structure beneath the Pergamon Altar is likely to have been just such a hero shrine, for none other than the city's forefather, Telephos.[77] The claim proved persuasive: Pausanias speaks of those who make sacrifices to Telephos at Pergamon and remarks that all hymns sung within the local Asklepieion began with mention of Telephos's name.[78] He further states that the tomb of Auge could still be seen at Pergamon, a mound of earth surrounded by a basement of stone.[79] If the example of Athens applied, mother and son must have received joint worship on the Pergamene citadel.

The Telephos story not only enabled the Attalid kings to integrate themselves into Athenian genealogy and the great boundary events of the Amazonomachy and Trojan War. It allowed them to acknowledge the fact (or contradiction, at least in relation to their being Athenian) of their Asiatic roots as well. The name Telephos is, actually, Hittite in origin, from Telepinu, which means "Disappearing God."[80] It certainly befits one who wanders from the mountains of Arkadia to the shores of Mysia, to Agamemnon's palace in Argos, and back to Mysia. Telephos's marriage to the Amazon queen Hiera and his fighting beside her against the Greeks has a similar effect, squaring the circle of being at once Athenian and Asiatic, admitting the Attalid dynasty to the mythic narratives common to all mainland Greeks while at the same time locating their origins in Anatolia. The exploits of Telephos furthermore establish military prowess and piety as two of the greatest hallmarks of Attalid rule.

With no great "mother city" or past to call their own, the Attalid kings could have done much worse in a century and a half.

In their studied self-fashioning, the Attalids went beyond myth and mortar to raise the "Athens of the East." At the very summit of their citadel lies a building that has been identified as a library, to which they brought all the learning of the ancient world home.[81] In the center of the reading room stood a copy of Pheidias's statue of Athena Parthenos, carved in marble imported all the way from Mount Pentelikon.[82] Standing just over 3 meters (nearly 10 feet) tall, roughly a fourth of the size of the original, this local copy served to remind the city of its aspirations, calling all Pergamenes to the Athenian ideal, the virtue that Plato describes as *to kalliston,* all that is most noble.

The Attalids went so far as to organize their own Panathenaic festival. The feast is mentioned in a letter sent by Eumenes I to the people of Pergamon, dated around 260–245 B.C.[83] The king recommends that at the next Panathenaia the people should award gold crowns to five generals (strategoi) who have performed their duties in an exemplary manner. A series of bronze festival coins minted by the Pergamene sanctuary of Athena Nikephoros in the second century B.C. commemorated the occasion.[84] These show the head of Athena on the obverse and, on the reverse, an inscription: ATHENA NIKEPHOROU, "of Athena Who Brings Victory." Beside the inscription, we find, of course, the little owl.

The emulation of Athens may have been nowhere as pervasive or intense as at Pergamon, but the practice continued well beyond the twilight of that kingdom, into the Roman imperial period. At the very center of the Athenian Agora, one sees today three great stone figures rising up from their pilasters. These are the Tritones, mythical descendants of the sea serpent Triton, slain by Herakles: human from the waist up, seaweed sprouting from just below their hips, coiling fish-tailed bodies from the waist down. Their torsos show the flamboyant musculature observed in the akroteria Tritones from the Pergamon Altar and, indeed, in male figures all across its Gigantomachy frieze. But the Agora Tritones take their immediate inspiration from a model much closer to home: the figure of Poseidon from the Parthenon's west pediment (insert page 5, right).

Shown subjugated as captives, bound and in pain, the three figures are, in fact, all that is left of a series of Tritones and Giants that once decorated a stoa attached to the façade of a music hall. But this sculpture is not the handiwork of Athenians or even admiring Pergamene

craftsmen. The covered auditorium (*odeion*) was built by the Roman general Agrippa in the first century B.C. After its collapse during the reign of the emperor Antoninus Pius in the mid-second century it was rebuilt as a lecture hall.[85] The Tritones date to this later phase.

The pilasters supporting the Tritones are decorated with sculptured relief panels showing quintessential symbols of Athena: the olive tree and sacred snake.[86] And these same symbols can be seen in the Provincial Forum at Emerita Augusta, modern Mérida, in Spain. The marketplace, set up in about A.D. 50, was decorated with sculptured images of the Erechtheion karyatids and Medousa heads, drawn from the classical Athenian repertoire. One marble relief shows an olive tree, the sacred snake, and three birds.[87] The Roman legions that accompanied Augustus and Agrippa to Athens were clearly impressed with the city's monuments and aspired to re-create them back in their home cities, as far afield as Spain, if not quite with an ardor to rival Pergamon. Of course, Athenian models were regularly copied at Rome itself. Mark the Erechtheion karyatids reproduced in the Forum of Augustus and at Hadrian's villa in Tivoli.[88]

Likewise, Roman provincial coinage placed the image of the Athenian Acropolis in the hands of individuals far from Athens. Issued around A.D. 120–150, the bronze coins show the cave of Pan on the north slope of the Acropolis, the staircase leading up to the Propylaia, a gabled temple that represents the Erechtheion, and, towering above all, the colossal statue of the Bronze Athena.[89] If only by scale of production, the Roman Empire propagated images of Athens farther and wider than any force before or since. Still, there is more to appropriating a culture than copying its iconography or even insinuating oneself in its mythic foundations.

THE ATTALID KINGS did much more than re-create the city of their "college days." In a Platonic sense, they did not imitate mere appearance, as Plato said that artists did, but rather they looked to the reality of the object they copied, as carpenters contemplated the *idea* of a couch or table when building a new one. In his rejection of mimesis in book 10 of the *Republic,* Plato derides poets, who, as captives to their own inspiration, merely imitate that which appeals to the senses, never arriving at truth, the province of philosophers.[90] The Attalid princes, having

studied at Athens, were not about to make such a mistake. Far from creating a copy that was the sum of its copied parts, they seem to have visualized an *idea* that was Athens and modeled their city accordingly. Beyond amassing more than 200,000 scrolls for their great library, or importing Pentelic marble for their replica of Athena Parthenos, the Pergamenes wanted to re-create the very spirit of the ideal society they found in the Athenian model. Toward this end they adopted certain codes of behavior, including impeccable military discipline and a desire for harmonious transfer of power at times of leadership transition. The Attalid succession, the process by which Attalos I assured that his sons would follow him in turn without strife, is in its orderliness a model of Athenian *politeia* and an exception in the world of Hellenistic monarchies, riddled as they were with intrigue and murder.

And so the princes of Pergamon fulfilled the imitation of Athens that Perikles had envisioned in his famous funeral oration nearly three hundred years earlier: "We do not copy our neighbors, but are an example to them."[91]

Of course, there is an element of Athenian experience of which Pergamon, a monarchy, like Rome, an empire, could not avail itself. What the Athenians' greatest temple, especially the frieze encircling it, most passionately attests is the secret to Athenian democracy: the idea that no life was above any other or the common good. Recognition of the sacrifice of Erechtheus's daughter as the subject matter of the frieze unveils a rich system of references manifesting the paramount importance of group solidarity at Athens, especially in times of crisis. It was this particular sense of community, of belonging and its privileges, that made Athenian citizenship so enviable. More than anything else, this was the essence of the enduring Athenian identity, which bound generation after generation to it. And while this solidarity did not lead inevitably to democracy, that utterly new social arrangement could not have worked in Athens without it.

We must not lose sight of the fact that the Parthenon celebrates *demokratia* in ancient Athenian terms, not those of our time. Where democracies today pride themselves on the separation of religion from the state, no such distinction could have existed in ancient Athens, where myth, religion, and *politeia* interwove seamlessly. And while modern democracy claims its superiority to other systems on the basis of being a guarantor of individual rights and freedoms, in the classical version

emphasis fell solidly on the common good and the sacrifice of individual interests for its sake.

Not that the individual, apart from the truly heroic, counted for much elsewhere in the Greek world, certainly not in militarist Sparta, where it was the good of the polis itself, rather than the collective well-being of the people, that mattered. The idea of a sacred responsibility to one's fellows, of willing self-sacrifice for the common good, was, like democracy, an utterly revolutionary notion in the fifth century B.C. The Athenians had in effect revised the concept of heroism: the Homeric hero fought and died to assert his own individual prowess and so that his name might gloriously outlive those of all others. The Athenian hero, in contrast, fought and died to save his fellow citizens. And they would have done likewise for him. The common good took precedence over self-interest during civil crises as well, during, for instance, the plague of 430 B.C., when, rather than fleeing the city, many Athenians stayed behind to nurse the sick, risking their own lives.[92]

In Euripides's *Erechtheus,* Queen Praxithea gives utterance, as we have seen, to these noble but strange ideas—so strange Lykourgos fears they are in danger of being forgotten by the time he quotes them in *Against Leokrates:*

The city as a whole has one name but many dwell in it. Is it right for me to destroy all these when it is possible for me to give one child to die on behalf of all?

The ruin of one person's house is of less consequence and brings less grief than that of the whole city.

I hate women who choose life for their children rather than the common good, or urge cowardice.

Is it not better that the whole be saved by one of us doing our part?

Not for one life will I refuse to save our city.

Euripides, *Erechtheus* F 360.10–50 Kannicht
= Lykourgos, *Against Leokrates* 100 [93]

At the very heart of Athenian democracy, then, lies the conviction that no single life, even a royal one, should be set above the lives of the

many. In the first century, John's Gospel will define the zenith of love this way: "Greater love has no one than this, that he lay down his life for his friends" (15:13). That this notion of self-sacrifice as love, which sounds to us so familiar, should have been subscribed to at Athens 450 years before Christ is hugely significant, revealing how a trust in one's fellow citizens allowed rule by the people to endure, even through crises such as only the most authoritarian state could have otherwise survived.

Democracy in its various forms has ever since remained, at bottom, a balance between the individual's obligations to the community and the community's responsibilities toward the individual. The latter, though less celebrated, was not ignored at Athens. For two hundred years, the radical Athenian experiment was sustained in no small part by voluntary contributions made by well-off citizens to support those who had nothing.[94] At the same time, an ethos of self-restraint and respect for the law, and, above all, genuine concern for other Athenians—high or low, they were descended from the same exalted stock—ensured the balance. In this way, the fabric of society was as well considered as the peplos of the goddess. Ironically, it is the management of this balance, the quintessential Athenian value, that has most severely challenged contemporary democracies, the would-be heirs of Athens, in our time.

EPILOGUE

And now, with gleams of half-extinguished thought,
With many recognitions dim and faint,
And somewhat of a sad perplexity,
The picture of the mind revives again.
> —WORDSWORTH, "Lines Composed a Few Miles
> Above Tintern Abbey, on Revisiting the Banks
> of the Wye During a Tour," July 13, 1798

TO REVISIT MONUMENTS in our memories, experiencing them across occasions within the times of our lives, is to revive the "picture of the mind," as Wordsworth put it. It is difficult enough, conjuring up what we have once seen with our own eyes and how we saw it. How much more difficult it is to look back at antiquity, through the veils and filters that separate us from it. Whether our understanding of the ancient past bears any resemblance to the experience of those who lived in it remains an open question.

In these pages we have had occasion to consider some individual encounters with our subject from across the ages: Sokrates, whom Plato's dialogue places on the banks of the Ilissos; Pausanias's tour of the Sacred Rock; Cyriacos's highly original drawings of the Parthenon's façade; Evliya Çelebi's fantastical account of its menagerie of sculptured figures; Francis Vernon's meticulous measuring of the temple; Law-

rence Alma-Tadema's innovative rendering of the frieze in color; Eugene Andrews's acrobatic and painstaking efforts to obtain squeezes of the Parthenon Inscription; Isadora Duncan's ecstatic dance within its colonnade. To these, let us add one more: Virginia Woolf, who had two encounters, the first on her 1906 tour, the second in 1932. On the latter trip, she wrote:

> What can I say about the Parthenon—that my own ghost met me, the girl of 23, with all her life to come: that; & then, this is more compact & splendid & robust than I remembered. The yellow pillars—how shall I say? gathered, grouped, radiating there on the rock, against the most violent sky . . . The Temple like a ship, so vibrant, taut, sailing, though still all these ages. It is larger than I remembered, & better held together . . . Now I'm 50 . . . now I'm grey haired & well through with life I suppose I like the vital, the flourish in the face of death.
>
> *The Diary of Virginia Woolf*, April 21, 1932[1]

It may seem strange that the Parthenon should have appeared larger the second time, where most things, particularly those seen in youth, tend to appear shrunken on revisiting. The Parthenon was, in fact, physically larger when Woolf viewed it for the second time, thanks to reconstruction work undertaken by a civil engineer named Nikolaos Balanos from 1922 to 1933.[2] Balanos's restoration of the temple's north and south peristyles, its southeast cornice and west façade, complete with a new lintel of reinforced concrete, radically altered the monument's visual impact. The raising of the north and south colonnades reunited the east and west ends of the Parthenon for the first time since its devastation by Venetian cannon fire in 1687. This, surely, accounts for Woolf's impression that the temple had got larger. Still, she was acutely aware that her age and the approach of mortality had also altered her perception of the building. Time so alters our experience of the visual that no two viewings are ever quite the same.

And so, as each generation visits, and revisits, the Parthenon, the monument is apprehended differently, based on the contexts in which viewers have lived and the cultures that have informed the ways they see and think.[3] Many of us today share something of Woolf's experience, having seen one Parthenon in our youth and another one "better held together" in our adult years. The past thirty years of conservation work

on the Athenian Acropolis have given us a stronger and more accurately restored Parthenon. The lion's share of this effort has been devoted to reversing the "improvements" of Balanos, those very interventions that made Woolf's "second" Parthenon appear sturdier. Balanos's extensive use of mild steel clamps and ties to connect the crumbling blocks unwittingly caused further damage to a building that had already suffered fire, explosion, weathering, and wear. He neglected to cover his steel reinforcements in lead, as the ancient Greeks had been careful to do with the original wrought-iron clamps that fastened the blocks together. This oversight made the marble all the more vulnerable to the elements. Unprotected steel inevitably rusts and, with this, it expands, leading catastrophically to further splitting and deterioration of the stone.

In 1971, the Greek Ministry of Culture called for the creation of a task force to address these issues, establishing the Working Group for the Preservation of the Acropolis Monuments. Five years later, this evolved into the Committee for the Conservation of the Acropolis Monuments, a group still in place to this day.[4] Among the many interventions undertaken by the Acropolis Restoration Service since 1986 is the removal of Balanos's steel clamps, now replaced with corrosion-proof titanium rods and ties. Each block of the Parthenon has undergone meticulous autopsy, having been cleaned, scanned, and photographed from every angle and, where necessary, restored with infilling of freshly cut Pentelic marble and white portland cement. Errors in earlier reconstructions have been corrected, blocks have been put back in their original positions, and newly hewn stones have been introduced where structurally necessary (facing page).[5] For the first time in centuries, we now see a more robust and authentic Parthenon, truer to its original construction and, yes, "larger . . . & better held together."

This process of taking down the Parthenon and putting it back up, block by block, has revealed a wealth of new information about the materials, tools, techniques, and engineering that went into its original construction. Manolis Korres (page 334), head of the Parthenon Restoration Project for three decades and a member of the Committee for the Conservation of the Acropolis Monuments, has opened for us a whole new understanding of just how the Parthenon was built. He has explained the methods for quarrying and conveying marble blocks down the slopes of Mount Pentelikon to Athens, the process known as the *lithagogia*, or "stone transporting."[6] He has identified changes in

Parthenon during reconstruction work, from east, 1987.

plan and decoration made during the building's construction as well as the fact that the Parthenon's Ionic frieze originally wrapped all the way around its eastern porch. He has reconstructed the original appearance of the building's roof and walls, including the two windows that flanked its entrance on the east. He has identified the fire damage from Roman times and the traces of the Parthenon's transformations into church, cathedral, and mosque during the Byzantine, Frankish, and Ottoman periods. Korres has even been able to map the trajectory of the cannon fire of 1687 that blew apart the insides of the Parthenon, documenting the effects of this blast on individual blocks of marble.[7]

What emerges is a whole new way of seeing and understanding the Parthenon across the centuries. The new Acropolis Museum, opened in June 2009, displays for the first time a wealth of contextual material excavated from atop the Acropolis as well as from the wells, tombs, shrines, houses, and foundries sited down its slopes. The museum presents the materiality of the Acropolis from the Neolithic period through late antiquity, giving in-depth, up-close access to objects and images, grand and everyday, sacred and utilitarian, familiar and foreign to us.[8] In so many ways, we stand at a new beginning in Acropolis studies, one in which we can take a fresh look at expertly conserved objects,

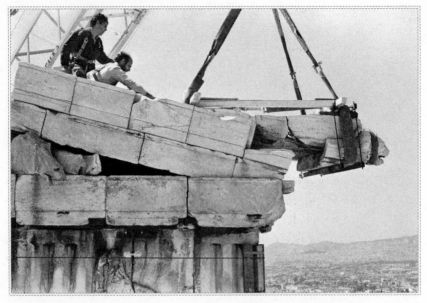

Manolis Korres atop the northeast cornice of the Parthenon, 1986.

displayed in spacious, light-drenched galleries that enable us to see with new eyes. It is a moment for looking forward as well as for reassessing that which we believed in the past.

This new context and the fuller picture it gives us of the ancient reality also make it possible as never before to challenge even the most fundamental orthodoxies of interpretation. The accidents of survival in the evidence that comes down to us, the ways in which the "winners" shape the lasting story we receive (regardless of whether it was ever true), the biases of time and culture that heighten and obscure what we regard as vital, the power of personal and cultural memory in shading our comprehension of the "facts"—all these elements conspire to render our constructions of the past at best spectral and approximate. When the object of scrutiny is as beautiful and iconic as the Parthenon, a monument onto which meanings have been projected across two millennia, it is all the more difficult to see it with "ancient eyes."

THE TENACITY OF the received wisdom has been especially true respecting the Parthenon frieze, entrenching an interpretation first

offered nearly 230 years ago. But thanks to more than three decades of work by the Acropolis Restoration Service, the time is ripe for the reassessment of old views that have evolved into dogma.

Why has the meaning of the Parthenon frieze been obscured for so long? First and foremost we can cite the shortcomings of the available source material that represents just a fraction of what originally existed.[9] To this, we can add the influence of cultural sensibilities that have rendered the theme of virgin sacrifice unbearable to imagine on a building regarded as the "icon of Western art," the embodiment of democracy itself. Post-antique societies have been repelled by the idea of human sacrifice. Indeed, all major contemporary world religions place prohibitions on its practice. Relegated to the realm of the barbaric, uncivilized, and "primitive," it is a practice long regarded as something others do, particularly others who are the enemy. Yet vestigial evidence for human sacrifice can be found in the prehistory of every land on earth. Myth, folklore, and archaeological evidence attest to the practice of human sacrifice in prehistoric Europe, Africa, Asia, the Americas, and the Pacific Islands.[10] Indeed, we find reference to it in our oldest surviving religious texts, including the Indian Vedas.[11]

To recoil at the thought of an act as "barbaric" as human sacrifice displayed above the door of the Parthenon may also be a result of viewing it, mistakenly, in the secularized terms of Western civic life, rather than as a religious building primarily. We might ask, what Christian church does not show a scene of human sacrifice above its door? The crucifixion of Christ, moreover, follows a very familiar pattern: kingly father gives beloved child to save populace.

The ultimate sacrifice, in which a precious child is given for the common good, is in fact central in many world religions, just as it is in global myth and folklore. In the Hebrew Bible's book of Judges we learn that Jephthah must sacrifice his daughter in fulfillment of a vow he made to God.[12] In the book of Genesis we find God testing Abraham's faith, asking him to sacrifice his beloved son, Isaac. Abraham obediently leads the boy to the top of Mount Moriah, wholly prepared to kill him. But the willingness is sacrifice enough: stopping the deed just in the nick of time, the Lord says to Abraham, "Now I know that you fear God."[13] A ram is substituted for Isaac and the burned offering proceeds, following a pattern that is also found in Greek myth. We see, for example, a

deer substituted for Iphigeneia as she is led to sacrifice upon the altar at Aulis.[14]

That classical Athens should have a story of sacrifice, death, and salvation at the heart of its founding myth makes perfect sense in the context of a long myth tradition of maiden sacrifice in times of crisis. There are other cross-cultural continuities as well. The two eldest daughters of King Erechtheus, shown on the Parthenon's east frieze, carry their funerary shrouds on stools upon their heads (page 165). The youngest, with the help of her father, displays the funeral dress that she is about to put on. The central panel thus also follows the formula of sacrificial victims shown carrying the implements of their own sacrifice. Isaac is regularly portrayed transporting upon his back the wooden sticks with which the altar fire will be lit. In the Gospels, Jesus Christ carries the cross to which he will be nailed. This imagery makes implicit that the victim submits, wittingly or not, to be killed. The daughters of Erechtheus on the Parthenon frieze need not be dragged to the sacrifice required to save their city. Their willingness, in turn, sets the civic example, just as Jesus's willing death on the cross sets the moral example: "No one has greater love than this." In this way, the Athenians made self-sacrifice as essential a part of *to kalliston* and the democratic ideal as the Christian Church made it requisite for entry into the kingdom of heaven. "For whoever would save his life will lose it, and whoever loses his life for my sake will find it" (Matthew 16:25).

It should not be forgotten that the Parthenon served as a Christian church for slightly longer than it was a temple of Athena, at least from the mid-sixth century A.D. until the conquest by the Ottoman Turks in 1458.[15] The long practice of Christianity within its walls may have erased any memory of the sacrificial scene carved above the Parthenon's eastern door. In fact, the sculptured panel showing the family of Erechtheus was taken down to accommodate the apse at the time of the conversion (facing page). The central slab of the east frieze would remain hidden until Elgin's day, built into an Acropolis fortification wall. Christianity might have pushed back against any remnant of the "pagan" myth of the sacrifice of Erechtheus's daughters, a distraction from the salvific sacrifice of Christ. We know that the Christians defaced other Parthenon sculptures in an attempt to mitigate their heathen message. On the other hand, they left one metope, at the very northwest corner

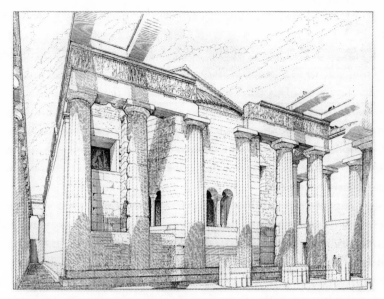

Reconstruction drawing of the Parthenon as church in the twelfth century, showing east end with apse, by M. Korres.

of the temple, completely untouched, because it resembled, to their eyes, the angel Gabriel appearing to the Virgin Mary at the Annunciation.[16]

IN CONCLUDING OUR LOOK AT the Parthenon, let us consider the question of how, generally, conventional wisdom comes to be established as fact. Indeed, how does "knowledge" get made? Helpful in this regard is Joel Mokyr's important work on the "knowledge economy," in which he lays out ways of thinking about resistance to new ideas. Mokyr demonstrates how knowledge is a self-organizing system that can be explained in Darwinian terms. Like genes, ideas are subject to a kind of natural selection. Unless innovations are advantageous, knowledge systems resist change and favor self-replication, rejecting novelty and deviations from accepted norms. Thus, contradictory knowledge has few "reproductive opportunities."[17]

"In the evolution of useful knowledge," Mokyr writes, "resistance to novelty comes from the preconceptions of existing practitioners who have been trained to believe in certain conceptions they regard . . . as

axiomatic."[18] Mokyr cites a number of famous examples: Tycho Brahe's denial of the Copernican system, Einstein's resistance to quantum theory, Priestley's refusal to give up belief in phlogiston, von Liebig's denial of Pasteur's proof that fermentation was a biological and not a chemical process. Despite Edward Jenner's discovery, in 1796, of the vaccination reaction, it took another century and the triumph of germ theory for his work to be accepted. Indeed, when he applied to the Royal Society to announce his findings, Jenner was told not to risk his reputation by presenting anything that appeared so much at variance with established knowledge.[19]

In the case of the Parthenon frieze, I believe that two developments in the first half of the nineteenth century might, in their own ways, have contributed to the narrowing of debate over how we view its sculptures and the building they were set on. Together these two forces account for much of the tenacity of the conventional wisdom.

A mere two months following the official announcement of the invention of the daguerreotype photographic process, in October 1839, an Excursion Daguerrienne set out for the Athenian Acropolis. On this

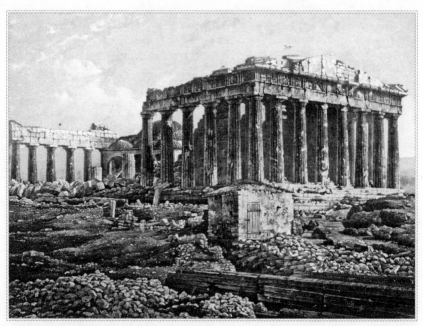

Daguerreotype, P. G. G. Joly de Lotbinière, 1839, in *Excursions daguerriennes* (1841–42).

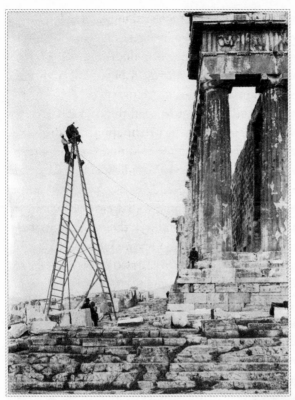

Frédéric Boissonnas photographing the
Parthenon, at northwest corner, 1907.

Socratis Mavrommatis photographing the
Parthenon, 1988.

expedition, Pierre G. G. Joly de Lotbinière shot the first daguerreotype of the Parthenon (page 338).[20] One cannot imagine how many millions of photographs of the temple have been taken since. Indeed, for most people, the first and only introduction to the monument will be through photographs, film, or digital images.

Over the next century and a half, photographers flocked to the Acropolis, striving ever harder to capture the Parthenon's vaunted magnificence. There were no lengths to which they would not go, however precarious, to get the perfect shot. From Frédéric Boissonnas's extraordinary series of images taken in the first decade of the twentieth century (previous page, top) to Socratis Mavrommatis's expert documentation of the Acropolis restoration over the past thirty years (previous page, bottom), the reproduction of the Parthenon through photography has made the image impenetrably iconic.[21] It became, as it would remain, whatever these countless images seemed to suggest. That it might not correspond to an understanding reinforced by that endless reproduction would be akin to suggesting that the *Mona Lisa* is not actually smiling.

One can hardly escape our modern notions of what visual images are for: documenting the present or *what is*. But revisionist work on the function of images in Greek antiquity has stressed a rather different role: to enable viewers to see what was *no longer* visible, that is, the mythical days of the legendary past.[22] There was no need for images of what could be seen by the human eye. Their primary role was, instead, to restore a time and a world that were lost, and thereby to make the past present. Once we engage with this ancient way of thinking, we can appreciate its internal logic. Looking at ancient images not as snapshots of contemporary reality but as windows onto the remote past, we come closer to the experience of how the ancients themselves looked at them. And we see how certain interpretations, however long-standing, become implausible.

The second development of the past two centuries has been the stress placed on the civic and political content of the frieze at the expense of its mytho-religious aspect. The reinforced association of Parthenonian style with our notion of democratic government has been relentless. But the fact that our banks and post offices (and the U.S. Custom House on Wall Street in New York, seen on facing page) may look like Greek temples is no reason to conclude that Greek temples themselves were decorated with secular iconography drawn from the historical present. Nevertheless, the identification of the Parthenon with modern Western

ideals was so intense by the nineteenth century it was impossible for some to resist the impulse to carry away and take possession of the icon, or at least parts of it, which is precisely what happened.

By the time the little mosque was removed from the Parthenon in the 1840s, Thomas Bruce, seventh Earl of Elgin, in his role as British ambassador to the Ottoman court at Constantinople, had long perpetrated his own, far more notorious removal, managing to cut most of the sculptures from the temple, pack them up, and ship them to England.[23] Whether Elgin secured permission from Sultan Selim III is contested to this day.[24] What is clear is that Elgin took the sculptures at a time when the Greeks were under Turkish occupation and not in control of their country. Whatever favors the sultan may have granted Elgin were given largely because England was the enemy of the Ottomans' enemy, France.

By August 1800, Elgin had assembled a team of artists to draw, mold, and measure the Acropolis monuments. He himself would remain in Constantinople for the next year and a half, leaving supervision of the work to a twenty-nine-year-old chaplain at the British embassy, the Reverend Philip Hunt, and the Italian landscape painter Giovanni Battista Lusieri. The team had difficulties gaining entry to the Acropolis, which served as a military installation at the time. For six months they

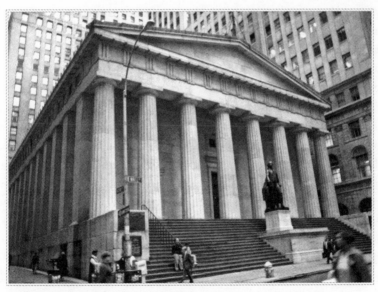

U.S. Custom House, New York, 1833–1842. Ithiel Town and Alexander Jackson Davis, architects.

occupied themselves drawing monuments in and around Athens. To get on with their mission, they would need an official letter from the Ottoman court. A document of authorization, or firman, is said to have been issued in May 1801. Its terms were, apparently, too vague, and so Hunt asked for a second, more specific firman, said to have been issued on July 6 of that year. This document does not survive; indeed, it was not to be found even in 1816 when the British Museum's Select Committee held an inquiry into the possible purchase of the Parthenon sculptures from Elgin. All that we have today is an Italian translation of an "official letter" outlining the permissions granted to Elgin, the same document that was shown to the Select Committee by Hunt in 1816. It is signed not by the sultan but by Sejid Abdullah Kaimmecam, the kaimakam pasha (acting grand vizier), and is addressed to the qadi (chief justice) and the voivode (civil governor) of Athens.

Formerly in the possession of William St. Clair, this letter has now been purchased by the British Museum. It states that Elgin's team may freely enter and leave the Acropolis, "to view, contemplate, and also draw the images." They are given further permission for "setting up scaffolding round the ancient temple of the Idols, and with moulding in lime paste (that is plaster) the same ornaments, and visible figures, in measuring the remains of other ruined buildings, and in undertaking to dig, according to need, the foundations to find the inscribed blocks, which may have been preserved in the rubble." The firman further ensures that no one should meddle with their scaffolding or implements and that "when they wish to take away some pieces of stone with old inscriptions, and figures," no opposition should be made.[25]

There is no explicit mention of permission to cut sculptures off the Parthenon. Interestingly, a letter from Mary Nisbet, the Countess of Elgin, to her mother on July 9, 1801, similarly fails to mention any such authorization. Lady Elgin expresses delight with the second firman and its permissions, which include "to copy and model everything" on the Acropolis, "to erect scaffolds all around the Temple, to dig and discover all the ancient foundations, and to bring away any marbles that may be deemed curious by their having inscriptions on them."[26]

Elgin, his wife, and his agents seem to have taken an expansive view of their permit. Much of the removal and packing of the sculptures for transport to England occurred in the spring of 1802, when Elgin himself was away from Athens. Lady Elgin stayed behind and oversaw the

operations. She did so with particular zeal. After all, it was her family fortune that was financing the ambitious program. Her letters to Elgin lend color to the final days of packing up the marbles:

24th of May, 1802,
11 o'clock at night.
Now for some news that will please you. I have got another large case packed up this day—a long piece of the Basso Relievo from the Temple of Minerva—I forget the proper term. So I have by my management, got on board four immense long heavy packages, and tomorrow the Horse's Head, etc. etc. is to be carefully packed up and sent on board; this is all that is ready for going. If there were twenty ships here, nothing more could be sent for some time—the last two cases is entirely my doing and I feel proud, Elgin!

One senses the insecurity and eagerness to please in this twenty-four-year-old wife, already pregnant with her third child. It cannot have been easy for her; indeed, we are told that Elgin's many absences caused her so much stress that she suffered asthma attacks, for which she took opium pills.[27] Still, her desperation for approval makes painful reading.

Tuesday 25th of May
Know that besides the five cases I have already told you of, I have prevailed on Captain Hoste to take three more; two are already on board, and the third will be taken when he returns from Corinth. How I have fag[g]ed to get all this done, do you love me better for it, Elgin?
 I am now satisfied of what I always thought—which is how much more Women can do if they set about it, than Men. I will lay any bet that had you been here you would not have got half so much on board as I have.

His Lordship seems to have done too little to comfort his wife or to make her feel appreciated.

Give me credit for my exertion dearest Elgin for I have been very anxious to do as much as possible . . . I love you with all my heart. Oh, never let us part again.[28]

It was not meant to be: five years later, Lord Elgin would begin divorce proceedings against Mary for adultery, winning sole custody of their five children.

From the moment the sculptures were taken down from the Parthenon, there was public outcry. The British naturalist, mineralogist, and historian Edward Daniel Clarke gives an eyewitness account of the lowering of a metope in August 1801. He observes that "removed from their original setting the Parthenon marbles have lost all their excellence!"[29] As the metope was hoisted down, the rigging dislodged an adjoining block that fell to the ground, smashing with a thunderous noise. Clarke tells us that upon seeing this, the *disdar* (local military governor) could no longer restrain his emotions. He took his pipe from his mouth, let a tear fall, and uttered, with an emphatic tone, "*Te-los* (The end! Enough!)." The artist Edward Dodwell, also on hand, wrote of the experience: "During my first tour to Greece, I had the inexorable mortification of being present when the Parthenon was despoiled of its finest sculptures; and when some of its architectural members were thrown to the ground." Even Chateaubriand piled on, charging Elgin with sacrilege.[30]

Lord Byron expressed his famous outrage initially in the poem *The Curse of Minerva* (1811), immortalizing the sin of Elgin thus: "England owns him not: Athena, no! thy plunderer was a Scot." The following year, the poet published his full-blown attack in *Childe Harold's Pilgrimage,* devoting much of the second canto to the atrocities of the pillage.[31] Within three days, the book sold out, going to press another four times before the end of that year—a nineteenth-century blockbuster. All of England now knew what Elgin had done to the Parthenon: "Dull is the eye that will not weep to see / Thy walls defac'd, thy mouldering shrines remov'd / By British hands."

Since Byron's day, there has never been a time when the removal of the Parthenon sculptures has *not* been considered controversial.

ONE CAN ONLY WONDER what the experience of visiting the Parthenon will hold in future years. Will one ever see the Parthenon sculptures returned to Athens, reunited with what Elgin left behind? Indeed, more than 60 percent of them are scattered across Europe, mostly in London, but also in Paris, Copenhagen, Vienna, Würzburg, Palermo, the Vatican, and Munich.

I hope that by now I have demonstrated that the Parthenon sculptural program is an integral part of a complex network of meanings in which geology, landscape, topography, memory, myth, art, literature, history, religion, and *politeia* are intricately interwoven. The sculptures, then, cannot properly be separated out from this system and made to stand alone, fetishized as masterpiece objets d'art. Indeed, they were never meant to be independent movable objects but part of a building, one that still stands in the center of Athens.

They are architectural elements of a religious structure, the temple of Athena, which itself fits into a religious system, a program of belief and ritual that formed the very fabric of life in the ancient city. Pediments, metopes, and frieze are in intimate dialogue with one another. Queen Praxithea, shown on the east frieze, is the nymph daughter of the river Kephisos shown on the west pediment. The succession myths of Athens play out on the pediments and frieze, while cosmic and epic boundary events are manifest in the metopes. The sculptures thus derive their original and essential meaning from their immediate context of one another, the sanctuary they share, and the city for which they were created. Apart from one another they are merely relics, however finely wrought.

The very stone the makers used emerged from Mount Pentelikon itself. Purposefully quarried from there and cut into blocks, the marble was transported to Athens and carried up to the Acropolis. Thus, the Parthenon's parts may be said to spring from the very geology of Attica.

The wholeness of the Parthenon demands our respect and warrants our every effort to reunify it, such as we can. Let us, for a moment, consider the state of the central figures of the west pediment. Poseidon's shoulders are held in London while his pectoral and abdominal muscles remain in Athens. Athena's battered head, neck, and right arm are displayed in the new Acropolis Museum while her right breast remains in the British Museum. This deliberate and sustained dismemberment of what are some of the most sublime images ever carved by humankind brings shame on those who work to uphold this state of affairs.

Angelos Chaniotis has recently likened the separation of the Parthenon sculptures to the breaking up of an exquisite symphony, never to be performed as a complete whole.[32] He invites us to imagine that a lost symphony by Tchaikovsky has been discovered. Suppose the score's manuscript was then torn apart and sold to various collectors. And sup-

pose, further, that one of the collectors refused to let "his" sheets of music be performed with the others, preventing the experience of the composition as a whole.

Chaniotis asserts that this would seem an absurdity beyond imagination were not the British Museum taking just such a stand with respect to the Parthenon sculptures. The museum is adamant that "its" fragments of the marbles should not be displayed with the rest of the pieces in Athens; to do so, they say, would prevent visitors in London from comparing the marbles with other specimens of world art. Chaniotis calls into question this privileging of an institution's mission as a "universal museum" over the integrity of the ancient work of art itself.

Our intellectual and humanistic objective should be to reassemble as much of the original Parthenon as possible and as near as is feasible to its original physical context, that is, the Athenian Acropolis. The new Acropolis Museum at the south slope of the Sacred Rock is situated to do precisely this, or could do, if it were allowed.

It was long argued that the sculptures could not go back to Athens because the Greeks lacked a proper place to house them. (Never mind what we know about how the fragments were cared for in London, thanks to Duveen and others.) This stumbling block has been spectacularly overcome by the completion of Bernard Tschumi's new Acropolis Museum, opened in June 2009.[33] Tschumi gives us a bold minimalist design in which poured concrete, steel, and glass create a vast open space, allowing the material culture of the ancient Acropolis to breathe and shine. The installation is fresh and original, filled with startling innovations in its use of materials and techniques. Among my personal favorites is the novel use of stainless steel as a base for supporting a marble column capital from the Erechtheion, the steel cast in vertical ribs that evoke the fluting of an Ionic column. Stainless steel mesh makes a surprisingly effective backdrop for smaller finds, including terra-cotta plaques, limestone relief sculptures, and a pair of bronze eyelashes from a lost statue.[34] It is a welcome alternative to the velvety fabrics long used to display antiquities in the airless neoclassical museums of Western Europe and the United States, with their "encyclopedic" and "universal" claims. In the light that floods into the giant hypostyle halls of the new Acropolis Museum, sculptures too are shown off to superb advantage.

The entire museum stands above an archaeological site (dating from the fifth century B.C. through the Frankish period), and as one makes

one's way up, floor by floor, one can peer through the dotted glass underfoot at a rich stratigraphy of context. As one looks down through four floors upon entering the uppermost gallery (where, it is hoped, the Elgin Marbles will one day be displayed along with the rest of the Parthenon sculptures), one's stomach may make a vertiginous flip. It is almost as if the architect intentionally manipulated the experience, causing a subversive jolt to be felt just before one enters the great hall in which the Elgin Marbles are *not*. Inside, one can look up through the wall of glass directly at the Acropolis. The exhibition space is exactly the same size and oriented along the same axis as the Parthenon, enabling the viewer to experience some sense of its scale and placement within Athena's sanctuary.

The ingenious design and location of the museum allow one to "walk around" the Parthenon and to take in the sculptures as they were placed in antiquity, on the exterior of the temple (following page, top). What a contrast to the Duveen Gallery at the British Museum, where the frieze is displayed outside in, as if intended for the courtyard of some latter-day Kroisos (following page, bottom). What's more, the frieze in London is cut up into sections interrupted by doorways and voids. This arbitrary segmentation has, over the past two hundred years, profoundly affected the ways in which the frieze has been read and misread, obscuring its character as a continuous narrative. In Athens, one can stand at the east end of the hall and view the Parthenon's east pediment, metopes, and frieze all together in one glance. The same can be done for the west end and the flanks of the temple, as one circumnavigates the gallery.

IN THE PAST DECADE or so we have seen a deliberate shift away from the nationalist rhetoric of earlier years, at least on the part of the Greeks, who have now offered reasonable and creative suggestions for overcoming the impasse with the British Museum. In 2002, the then minister of culture, Evangelos Venizelos, visited England with fresh ideas, declaring that "ownership" of the marbles was no longer a key issue. Proposing that the Parthenon sculptures travel back to Athens via a long-term loan agreement, Venizelos offered in exchange a never-ending rotation of the very finest antiquities that Greek museums can offer. Accommodating the British insistence on ownership, he even suggested that the gallery in which the Parthenon sculptures would be displayed be called an

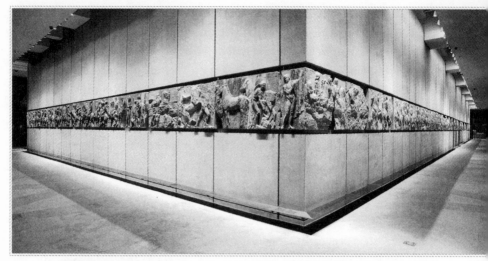

Parthenon frieze and casts of missing slabs as displayed in the new Acropolis Museum.

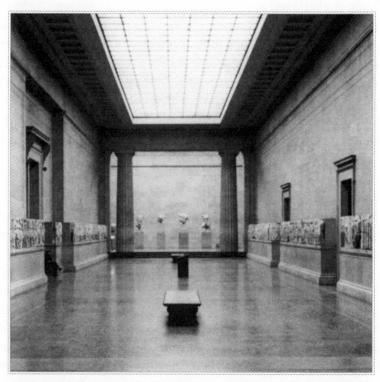

Parthenon frieze as displayed in the Duveen Gallery, British Museum.

"Annex of the British Museum." His innovative and conciliatory offer was rejected out of hand.[35]

Nonetheless, the Greeks continue to employ a light touch. Language has been adjusted to call for the "reunification" rather than the "restitution" of the marbles. The International Association for the Reunification of the Parthenon Sculptures now has branches in eighteen countries. A recently adopted slogan from one organization supporting return of the marbles asks with populist simplicity, "Why not?" In May 2009, forty-five secondary school students from Kephalonia in Greece traveled to London to demonstrate in front of the British Museum. They employed a most ancient and peaceful method of protest: a circle dance.[36]

There is not a world leader who fails to stop on the Acropolis for the requisite photo op when visiting Athens. Invariably including a call for the return of the Parthenon sculptures, these appearances have been taking place for years. Jackie Kennedy, wearing pearls and a dress in the brilliant blue of the Greek flag, climbed the Acropolis summit way back in June 1961 and made the appeal. The Clintons did it in 2002, as did Vladimir Putin shortly thereafter. Even Iran's supreme leader, Ayatollah Ali Khamenei, lifted his hands to the sky as he stood before the Parthenon and called for the marbles to be returned. In October 2010, the Chinese premier, Wen Jiabao, pledged his support for the reunification of the Parthenon sculptures. Standing on the summit, he cited the historical parallel of the Summer Palace in Beijing, which was looted in 1860 under orders from Elgin's own son, then the high commissioner to China![37]

In the meantime, we have seen in opposition to such sentiment the ideology of "cosmopolitanism" being marshaled to defend the interests of the "universal museum."[38] The debate over the stewardship of cultural material has been reduced, by some, to a tug-of-war between the universalist cosmopolitans and the retentionist nationalists. But as Craig Calhoun thoughtfully argues in his book *Nations Matter,* and elsewhere, to regard cosmopolitanism as merely the opposite of nationalism does the former no service and, at the same time, undermines democracy and transnational institutions.[39] Cosmopolitanism's acceptance of economistic, modernizing imaginaries ignores the value of social solidarity and collective choices in determining the nature of society. In transcending issues of identity, it advocates for "thin identities," which come up short as underpinnings for democracy. The cosmopolitan global elite's

insistence on a placeless universality for cultural objects further ignores the complexities of financial interests attending ownership, imbalances of power among nations, and class inequality that result in the cultural heritage of the poor remaining ever under the control of the rich.

Nevertheless, sentiments are shifting, even in England. A poll of 130,000 voters sponsored by *The Guardian* newspaper in July 2009 found that 94 percent favor return of the Elgin Marbles.[40] This might be seen as part of a larger trend that in 2004 moved Parliament to pass the Hunting Act, banning that most quintessential of elite British pastimes: foxhunting. To many, the Elgin Marbles, like foxhunting, represent an overbearing past, one not worth hanging on to in a changing world. When even the monarchy must actively court public approval to survive, no vestige of traditional Britain is sacred.

Indeed, it has been estimated that less than 9 percent of the British public has ever entered the British Museum to look at the Elgin Marbles. And even cosmopolitan foot traffic seems not to have held up. Visitorship at the new Acropolis Museum, in only its first year, far surpassed that at the Duveen Gallery: 2 million, as against just 1.3 million who entered the British exhibition.[41] Some of this may be ascribed to the newness of the new Acropolis Museum, but if it can attract such numbers with only 40 percent of the Parthenon sculptures on display, one can just imagine the drawing power of the sculptural program made whole again.

Traditionally, official British opposition to returning the marbles has been particularly strong in the House of Lords, where the nature of peerage has made for more fantastical and unfiltered pronouncements than one might hear in the House of Commons. Urging his fellow peers to block any such surrender, Lord Wyatt of Weeford pleaded in 1997, "My Lords, it would be dangerous to return the marbles to Athens because they were under attack by Turkish and Greek fire in the Parthenon when they were rescued and the volatile Greeks might easily start hurling bombs around again."[42]

But even the House of Lords is now changing, as hereditary peers are phased out and new life peers are made. The Wyatts of the world are being replaced by a new generation, including the archaeologist Lord Renfrew of Kaimsthorn, a major proponent of the protection of cultural heritage.[43] Meanwhile, a new generation of politicians is also coming up. Deputy Prime Minister Nick Clegg hosted the Marbles in Exile con-

ference as a resident member of the European Parliament in 2002. The Liberal Democrat MP Andrew George now serves as chairman of the Marbles Reunited campaign.

As the national sentiment has changed, so, too, have the terms of debate, moving away from old legal arguments and toward new ones based on ethics. The actor Stephen Fry has urged Britain to keep it classy and make a preemptive move to return the Parthenon sculptures, simply because it is the right thing to do.[44] The recent return of a fragment of the Parthenon frieze by the University of Heidelberg is an example of an initiative that bypassed legal frameworks to put ethics first.

Maxwell Anderson, director of the Dallas Museum of Art and former head of the Association of Art Museum Directors, has offered a compelling vision for the future in general. Facing issues of ethics, cost, and scarcity, museums should move beyond traditional roles as collectors and owners and toward ones as partners engaged in exchange.[45] Recent loans to U.S. museums from Italy, exchanges resulting from the return of antiquities illegally acquired by the J. Paul Getty Museum, the Metropolitan Museum of Art, Boston's Museum of Fine Arts, and others, are already having an enormously positive impact. The American public is being treated to a vibrant rotation of meaningful objects that are enlivening permanent collections across the country.

Returned to the city for which they were carved, the Parthenon sculptures could take their place in what could become the world's leading "universal museum." For such a designation must surely be measured by how much international cooperation and interdependence an institution can foster through loans, exchanges, and other agreements. That, after all, is what globalization is meant to be good for.

Such a universalism is only fitting where the Parthenon is concerned. We are all outsiders looking in, trying to understand, striving to keep ourselves from getting in the way of what we see. A photograph taken in 1954 shows a couple in Monastiraki Square, just north of the Athenian Acropolis (following page).[46] The woman tugs at the man's jacket. What are we looking at? Is she pulling him back from the path of the truck speeding toward them? Or is the woman beckoning him to stop and look, to gaze up at the temple that has graced the summit of the Acropolis for nearly twenty-five hundred years? There it is, still standing, after all this time: the Parthenon. Do those who pass it every day of their lives still "see" it? Does the Parthenon stop them in their tracks

and fill them with awe? How much did the ancient Greeks themselves continue to pause and wonder, generations after the temple was built?

What we see and how we see it requires excavation through the muddy layers of memory. Even within a single lifetime it is difficult to recall what we once saw, how we felt, and what we thought when we saw it. "I cannot paint / what then I was," mused Wordsworth. And so we continue, with or against the current, aiming to glimpse, if only for a moment, the experience of the ancient past. Like the Athenians them-selves, we are ever torn between past and present, myth and history, memory and imagination, tradition and innovation.

The Acropolis from Monastiraki Square, at the north.
© Robert A. McCabe, 1954.

Acknowledgments

If a picture is worth a thousand words, then the photographs of Socratis Mavrommatis and the drawings of Manolis Korres represent a treasure trove that could fill all the largest libraries of the world. I am deeply indebted to them for allowing their work to be shown here and thank them for generously sharing their knowledge and kindness with me during the writing of *The Parthenon Enigma*.

Robert A. McCabe's evocative photographs of Athens in the 1950s capture the magic and power of place that embrace this extraordinary city. I thank him for his generosity in sharing them and for thirty years of treasured friendship.

And to George Marshall Peters, whose new drawings of the Parthenon frieze are presented here, I give thanks, for his exquisite work and for the pleasure of having excavated together across two decades on Yeronisos off Cyprus.

Andreas Constantinou's powerful cover image of the Parthenon within the greater cosmos makes us wonder just how many catasterized heroes and heroines still inhabit the night sky. Kevin Glowacki's photographs of the Acropolis slopes and caves give access to the natural landscape circumscribing the Sacred Rock. I am grateful to them both.

The Acropolis Museum has been for me a shining beacon of scholarly exchange and I thank its director, Prof. Dimitrios Pandermalis, and his colleagues who have generously shared its light with me during the writing of this book. Kathy Paraschis, Cornelia Hadziaslani, Christina Vlassapoulou, Nikki Dolis, Fani Mallouchou-Toufano, Angeliki Koureli, Eleni Korinou, and Eirene Manoli have read parts of the manu-

script, answered questions, facilitated photographic orders, and helped in other ways for which I am ever grateful.

A stimulating year as a member of the Institute for Advanced Study in Princeton has made all the difference to this book. Words cannot adequately express my thanks to Angelos Chaniotis, Professor of Ancient History and Classics, for supporting *The Parthenon Enigma* every step of the way and for sharing with me his knowledge and kindness. Interaction with the institute's larger community of scholars has shaped this book in important ways, for which I am especially grateful to Danielle Allen, Yves Alain Bois, Caroline Bynum, Nicola di Cosmo, Freeman Dyson, Didier Fassin, and Richard Taylor.

I thank the John D. and Catherine T. MacArthur Foundation for its support during a critical period of research and thinking at the start of this work. I am grateful for visiting fellowships at All Souls College, Magdalen College, New College, and Corpus Christi College, Oxford University, and at the Radcliffe Institute for Advanced Study, Harvard University, all of which gave access to great libraries and great scholarly communities at the beginning of my research.

Anton Bierle kindly invited me to serve as visiting professor in the Departement Altertumswissenschaften, University of Basel, which offered the perfect setting for the final period of work on *The Parthenon Enigma*. I am much indebted to the students of my graduate seminar, Performance, Myth, Archaeology, Text, for helping me strengthen the arguments presented here. Dr. Tomas Lochman, curator of the Skulpturhalle Basel des Antikenmuseums, facilitated my study of the rich collection of plaster casts of the Parthenon sculptures, for which I am very grateful.

Andreas Scholl, director, Antikensammlung Berlin, generously shared his time and hospitality with me during my study of the Pergamon Altar and offered a host of valuable insights for which I thank him.

I am grateful to my students at New York University for the lively class discussions upon which this book was forged, especially members of my undergraduate lecture course The Parthenon and Its Reception from Antiquity to the Present and three graduate seminars: The Athenian Acropolis, Archaeologies of Performance, and Archaeologies of Ritual.

A talented team of students from Bryn Mawr College, Columbia Uni-

versity, New York University, and Princeton University gave invaluable help in the preparation of the manuscript, bibliography, and illustrations. I thank Angel An, Molly E. Allen, Michael Anthony Fowler, Megan Gannon, Philip J. Katz, Rooni Lee, Andreina Mazzei, Eric Miller, Catherine Person, Calloway B. Scott, Laura Surtees, Christina Tsui, Talia Varonos-Pavlopoulos, Catherine Wayland, and Donna Zuckerberg for their excellent work and for bringing much joy to this labor.

Marina Thomatos's computer formatting, Matt Kania's brilliant new maps, Angela Schuster's inspired touch in the preparation of images, and Gene McGarry's expert copyediting have contributed mightily to this effort. Natalia Vogeikoff-Brogan, archivist of the American School of Classical Studies at Athens, was wonderfully generous with her time in assisting me in the school's archives. I thank them all.

Cassandra Pappas's exquisite design skills have blessed every page of this book. Working with her, and the extraordinary team at Knopf, especially Maria Massey (production editor), Kathryn Zuckerman (publicity), and Juhea Kim (editorial), has been an author's dream.

I am deeply indebted to generous colleagues and friends who have read all or part of the manuscript, offered valuable suggestions, answered a host of questions, and given important help in other ways. I thank Mehmet Ali-Ataç, Richard C. Anderson, Norbert S. Baer, Margaret Bent, Alan Boegehold, Efrosyni Boutsikas, Jan Bremmer, John McK. Camp, Miriam Caskey, Angelos Chaniotis, Alexandra Christopoulou, Tracey Cullen, James Diggle, Freeman Dyson, Nathan Elkins, Gloria Ferrari, Jean Gascou, Kevin Glowacki, Yannis Hamilakis, Nancy Klein, Elena Korka, Manolis Korres, Mary Lefkowitz, David S. Levene, Dionysia Mavromati, Socratis Mavrommatis, Robert A. McCabe, Gregory Nagy, Phillis Pantilidou, Domniki Papadimitriou, Nickolas Pappas, Kathy Paraschis, Michael Peachin, Brunilde S. Ridgway, Niki Sakka, Charles Scribner III, Guy Smoot, Anthony Snodgrass, Marion Boulton Stroud, Noel Swerdlow, D. Tsalkanis, Peter Van Alfen, Christina Vlassoupoulou, Anastasia P. Vournas, and M. L. West. I am especially grateful to James Ottaway Jr. for cheering this work on at every stage and for offering invaluable comments on the text.

The encouragement of Colin Austin, Isaiah Berlin, Joan and Patrick Leigh Fermor, Homer and Dorothy Thompson, Martin Robertson, and George Lucas, at critical times in this work, have contributed more than they will ever know.

Tina Bennett has nurtured this book with the thoughtful care of the most beneficent of naiad nymphs. George Andreou, an Olympian among editors, has given me the supreme delight of being challenged by the finest, and most generous, of minds. To both, I am ever grateful.

Notes

ABBREVIATIONS

AA *Archäologischer Anzeiger*
AbhMainz *Abhandlungen der Geistes- und Sozialwissenschaftlichen Klasse, Akademie der Wissenschaften und der Literatur in Mainz*
ABV J. D. Beazley, *Attic Black-figure Vase-painters*, Oxford: Clarendon Press, 1956
Addenda² T. H. Carpenter with T. Mannack and M. Mendonca, *Beazley Addenda: Additional References to ABV, ARV², and Paralipomena*, second edition, Oxford: Oxford University Press, 1989
AJA *American Journal of Archaeology*
AJP *American Journal of Philology*
AM *Mitteilungen des Deutschen Archäologischen Instituts, Athenische Abteilung*
AncWorld *The Ancient World*
Antiquity *Antiquity: A Quarterly Review of Archaeology*
AntK *Antike Kunst*
ArchDelt *Archaiologikon Deltion*
ArchEph *Archaiologike Ephemeris*
ARV² J. D. Beazley, *Attic Red-figure Vase-painters*, second edition, Oxford: Clarendon Press, 1963
BCH *Bulletin de Correspondance Hellénique*
BMMA *Bulletin of the Metropolitan Museum of Art*
Boreas *Boreas: Münstersche Beiträge zur Archäologie*
BSA *Annual of the British School at Athens*
CEG P. A. Hansen, *Carmina Epigraphica Graeca* I–II, Berlin: DeGruyter, 1983–1989
Chiron *Chiron: Mitteilungen der Kommission für alte Geschichte und Epigraphik des Deutschen Archäologischen Instituts*
CIA *Corpus Inscriptionum Atticarum*
CIG *Corpus Inscriptionum Graecarum*, Berlin, 1825–1877
CJ *Classical Journal*
ClAnt *Classical Antiquity*
ClMed *Classica et Mediaevalia*
CP *Classical Philology*

CQ Classical Quarterly
CR Classical Review
CRAI Comptes Rendus des Séances de l'Académie des Inscriptions et Belles-Lettres
CW Classical World
FdD Fouilles de Delphes
FGE D. L. Page, Further Greek Epigrams: Epigrams before A.D. 50 from the Greek Anthology and Other Sources Not Included in "Hellenistic Epigrams" or "The Garland of Philip," Cambridge, U.K.: Cambridge University Press, 1981
FGrH F. Jacoby, Die Fragmente der griechischen Historiker, Berlin, 1923–1930, Leiden, 1940–1958
FHG K. Müller, Fragmenta Historicorum Graecorum I–IV, Paris, 1841–1870
GRBS Greek, Roman, and Byzantine Studies
Historia Historia: Zeitschrift für alte Geschichte
HSCP Harvard Studies in Classical Philology
HTR Harvard Theological Review
IG Inscriptiones Graecae
JCS Journal of Cuneiform Studies
JdI Jahrbuch des Deutschen Archäologischen Instituts
JHS Journal of Hellenic Studies
JOAI Jahresheft des Österreichischen Archäologischen Instituts
Kannicht R. Kannicht, ed., Tragicorum Graecorum Fragmenta TrGF, vol. 5, Euripides, pts. 1 and 2, Göttingen: Vandenhoeck & Ruprecht, 2004
LCS A. D. Trendall, The Red-figured Vases of Lucania, Campania, and Sicily, Oxford: Clarendon Press, 1967
Lenz and Behr F. W. Lenz and C. A. Behr, eds. P. Aelii Aristides, Opera quae exstant omnia, Leiden: Brill, 1976
LIMC Lexicon iconographicum mythologiae classicae, Zurich: Artemis, 1981–1997
MMAJ Metropolitan Museum of Art Journal
OGIS W. Dittenberger, Orentis graeci inscriptiones selectae, Leipizig: Hirzel, 1903–1905
OpAth Opuscula atheniensia
Para. J. D. Beazley, Paralipomena, Oxford: Clarendon Press, 1971
PCG R. Kassel and C. Austin, eds., Poetae Comici Graeci, Berlin, 1983–
Phoenix Phoenix. The Classical Association of Canada
PMG D. L. Page, Poetae melici graeci, Oxford: Clarendon Press, 1962
P.Oxy The Oxyrhynchus Papyri I–, London: Egypt Exploration Society, 1898–present
PTRS Philosophical Transactions of the Royal Society
RA Revue Archéologique
RC C. B. Welles, Royal Correspondence in the Hellenistic Period, New Haven, Conn.: Yale University Press, 1934
RE Pauly-Wissowa, Real-Encyclopädie der klassischen Altertumswissenschaft (1893–1980)
RÉA Revue des Études Anciennes
RÉG Revue des Études Grecques
RendLinc Rendiconti Lincei, Atti dell'Accademia Nazionale dei Lincei
RhM Rheinisches Museum für Philologie
SEG Supplementum Epigraphicum Graecum
ThesCRA Thesaurus cultus et rituum antiquorum, Basel: Fondation pour le lexicon iconographicum mythologiae classicae, Los Angeles: Getty Publications, 2004–

TrGF *Tragicorum Graecorum Fragmenta*
YCS *Yale Classical Studies*
ZPE *Zeitschrift für Papyrologie und Epigraphik*

PROLOGUE

1. See R. K. Sutton, *Americans Interpret the Parthenon: The Progression of Greek Revival Architecture from the East Coast to Oregon, 1800–1860* (Niwot: University Press of Colorado, 1992). William Strickland consciously modeled the Second Bank of the United States (1818–1824) in Philadelphia on the Parthenon, directly copying architectural details from Stuart and Revett's *Antiquities of Athens*, 2: plates 1–9. Strickland painted palmettes on the underside of the entablature, rather than having them carved, because that is how they appear in Stuart and Revett's plates; *Antiquities of Athens*, 2: plate 6. The Philadelphia Museum of Art is commonly called "the Parthenon on the Parkway" and its location "the Acropolis of Philadelphia"; indeed, it faithfully follows optical refinements used on the Parthenon itself. See L. Haselberger, "Nineteenth- and Twentieth-Century Curvatures in Europe and North America: A Preliminary List," in *Appearance and Essence: Refinements of Classical Architecture: Curvature*, ed. L. Haselberger (Philadelphia: University Museum, University of Pennsylvania, 1999), 310–11. For an excellent overview, see P. Tournikiotis, "The Place of the Parthenon in the History and Theory of Modern Architecture," in Tournikiotis, *Parthenon*, 202–29.

2. Winckelmann, *Geschichte der Kunst des Alterthums*, 26, 316. The book became an instant classic, directly influencing the views of Lessing, Herder, Goethe, Hölderlin, Heine, Nietzsche, and others. See E. Décultot, *Johann Joachim Winckelmann: Enquête sur la genèse de l'histoire de l'art* (Paris: Presses Universitaires de France, 2000); J. Morrison, *Winckelmann and the Notion of Aesthetic Education* (Oxford: Clarendon Press, 1996); R. Herzog, *Von Winckelmann zu Schliemann: Eine Anthologie mit Beiträgen zur Geschichte der Archäologie* (Mainz: Philipp von Zabern, 1994); A. Potts, *Flesh and the Ideal: Winckelmann and the Origins of Art History* (New Haven, Conn.: Yale University Press, 1994).

3. Johann Hermann von Riedesel, *Remarques d'un voyageur moderne au Levant* (Amsterdam, 1773), 123 (reprint Charleston, S.C.: Nabu Press, 2012).

4. Bastea, *Creation of Modern Athens*, 102.

5. Ibid.; Beard, *Parthenon*, 99–100; Hamilakis, *Nation and Its Ruins*, 58–63; D. W. J. Gill and C. Gill, "HMS *Belvidera* and the Temple of Minerva," *Notes and Queries* 57 (2010): 209.

6. Bastea, *Creation of Modern Athens*, 102–3, with reference to A. Meliarakes, "Ceremony on the Acropolis of Athens," *Hestia* 18, no. 447 (1884).

7. Leo von Klenze, *Ideale Ansicht der Akropolis und des Areopag in Athen* (1846), purchased by Ludwig I (who had already resigned as king) in 1852; now in the Neue Pinakothek in Munich.

8. Bastea, *Creation of Modern Athens*, 103; Yalouri, *Acropolis*, 34–38, 77–100; J. Tanner, *The Invention of Art History in Ancient Greece* (Cambridge, U.K.: Cambridge University Press, 2006), 31–96; Squire, *Art of the Body*, 1–68; Mallouchou-Toufano, "From Cyriacos to Boissonas," 178–96.

9. Society of Antiquaries of Scotland, *Proceedings of the Society of Antiquaries of Scotland XXII* (Edinburgh: Neill, 1888), 64. See also M. Lynch, ed., *The Oxford Companion to Scottish History* (Oxford: Oxford University Press, 2001); National Register of Archives (Scotland), *National Monument of Scotland* (Edinburgh: National Register of Archives [Scotland], 1997); W. Mitchell, *The National Monument to Be Completed for the Scottish National Gallery on the Model of the Parthenon at Athens: An Appeal to the Scottish People* (London: Adam and Charles Black, 1907).

10. For Walhalla, see H. Stellner and D. Hiley, trans., *Walhalla: Official Guide* (Regensburg: Bernhard Bosse, 2002); H. Hanske and J. Traeger, *Walhalla: Ruhmestempel an der Donau* (Regensburg: Bernhard Bosse, 1998); A. Müller, *Donaustauf und Walhalla* (Ratisbon: G. J. Manz, 1846). For Nashville, see C. Kreyling, W. Paine, C. W. Warterfield Jr., and S. F. Wiltshire, *Classical Nashville: Athens of the South* (Nashville: Vanderbilt University Press, 1996); C. K. Coleman, "From Monument to Museum: The Role of the Parthenon in the Culture of the New South," *Tennessee Historical Quarterly* 49 (1990): 139–51; Tsakirgis and Wiltshire, *Nashville Athena;* B. F. Wilson, *The Parthenon of Pericles and Its Reproduction in America* (Nashville: Parthenon Press, 1937).

11. E. Gombrich, *The Story of Art* (London: Phaidon Press, 1950), 52. See Spivey, *Understanding Greek Sculpture,* 19–29; Squire, *Art of the Body,* 33–53.

12. D. Buitron-Oliver, *The Greek Miracle* (Washington, D.C.: National Gallery of Art, 1992). The phrase "the Greek miracle" was first used by the Swiss archaeologist Wildemar Deonna, *L'archéologie: Sa valeur, ses méthodes* (Paris: H. Laurens, 1912), 81. See also A. de Ridder and W. Deonna, *Art in Greece* (New York: Knopf, 1927), 350–54; W. Deonna, "Du 'miracle grec' au 'miracle chrétien': Classiques et primitifs dans l'art antique," *L'Antiquité Classique* 6 (1937): 181–230; W. Deonna, *Du miracle grec au miracle chrétien: Classiques et primitivistes dans l'art,* 3 vols. (Basel: Les Éditions Birkhæuser, 1945–1948).

13. H. Baker, *Cecil Rhodes, by His Architect* (Oxford: Oxford University Press, 1934), 10.

14. K. Marx, *Grundrisse,* trans. M. Nicolaus (Harmondsworth: Penguin, 1973), 110–11; Kondaratos, "Parthenon as Cultural Ideal," 45–49.

15. A. Scobie, *Hitler's State Architecture: The Impact of Classical Antiquity,* Monographs on the Fine Arts 45 (University Park: Pennsylvania State University Press, 1990); C. C. Graham, *A Historical and Aesthetic Analysis of Leni Riefenstahl's Olympia* (Ann Arbor, Mich.: University Microfilms, 1985); M. Mazower, *Inside Hitler's Greece: The Experience of Occupation, 1941–44;* S. Marchand, *Down from Olympus: Archaeology and Philhellenism in Germany, 1750–1970.*

16. S. Freud, "A Disturbance of Memory on the Acropolis" (1936), published in an open letter to Romain Rolland on the occasion of Rolland's seventieth birthday, 1936, especially line 247: "Our father had been in business, he had had no secondary education, and Athens could not have meant much to him."

17. B. Johnson, "Curator Afraid of Losing His Marbles," *Daily Telegraph,* July 1, 1998, 34.

18. Dodwell, *Classical and Topographical Tour Through Greece,* 1:321. For E. Dodwell, see J. McK. Camp, et al., *In Search of Greece: Catalogue of an Exhibit of Drawings at the British Museum by Edward Dodwell and Simone Pomardi from the Collection of the Packard Humanities Institute* (Los Altos, Calif.: The Packard Humanities Institute, 2013).

19. A. de Lamartine, *Voyage en Orient,* 2 vols. (Paris: Nizet, 1855; offset reprint, 1978), 1:95.

20. E. E. Viollet-le-Duc, *Dictionnaire raisonné de l'architecture française* (Paris: Bance, 1854–1868); S. Kondaratos, "The Parthenon as Cultural Icon," in Μαθήματα ιστορία της αρχιτεκτονικής [Lessons on the history of architecture] (Athens, 1975), 2:209.

21. Le Corbusier, *Journey to the East,* ed. I. Žaknić (Cambridge, Mass.: MIT Press, 1987), 166, 179, 216–17. For Le Corbusier, the Parthenon "marked the apogee of this pure creation of the mind"; see C. E. Jeanneret, *Vers une architecture* (Paris: G. Crès, 1923), especially 105–11, 166, 179–181.

22. Kaldellis, *Christian Parthenon,* 26–27; Korres, "Parthenon from Antiquity to the 19th Century," 140–43.

23. Korres, "Parthenon from Antiquity to the 19th Century," 143–44. By this

time, Pheidias's statue of Athena Parthenos was long gone. In 295 B.C., the tyrant of Athens, Lachares, cut off parts of the statue's gold robe to pay his army (when threatened by Demetrios of Macedon's assault on Athens). See Plutarch, *Moralia* 379c–d; Athenaios, *Deipnosophists* 9.405; Pausanias, *Description of Greece* 1.25.7, 1.29.16; Habicht, *Athens from Alexander to Antony,* 81–87; W. B. Dinsmoor, "The Repair of the Athena Parthenos," *AJA* 38 (1934): 93; Leipen, *Athena Parthenos,* 10.

24. Korres, "Parthenon from Antiquity to the 19th Century," 146–48; Kaldellis, *Christian Parthenon,* 27–29.

25. T. E. Mommsen, "The Venetians in Athens and the Destruction of the Parthenon in 1687," *AJA* 45 (1941): 544–56; C. Hadziaslani, *Morosini, the Venetians, and the Acropolis* (Athens: American School of Classical Studies at Athens, 1987); C. Hadziaslani, "Morosini in Athens," in *Archaeology of the City of Athens,* http://www.eie.gr/archaeologia/En/chapter_more_8.aspx.

26. And all that the word "ruin" entails. Efforts to connect with the fragmentary structure, to transform it, and to even make it whole again, began immediately and continue to this day. See Hamilakis, *Nation and Its Ruins,* 243–301. I thank Yannis Hamilakis for helpful discussions of these issues.

27. R. Ousterhout, "Bestride the Very Peak of Heaven: The Parthenon After Antiquity," in Neils, *Parthenon,* 322–24, explains how the little mosque must have been built after 1699, when the French ambassador Comte de Ferriol visited the Acropolis. He suggests it might have been part of repairs made in 1708. The mosque appears for the first time in drawings made in 1755 by J. D. Le Roy. See also Korres, "Parthenon from Antiquity to the 19th Century," 155–56; M. Korres, "The Pronaos," in *Study for the Restoration of the Parthenon* (Athens: Ministry of Culture, Committee for the Preservation of the Acropolis Monuments, 1989), 2a:55–56.

28. Aristotle, *Politics* 3.1279b.

29. For a history of the Acropolis Restoration Service (CCAM), see Toganidis, "Parthenon Restoration Project"; Mallouchou-Tufano, "Thirty Years of Anastelosis Works on the Athenian Acropolis"; Mallouchou-Tufano, Η Αναστύλωση των Αρχαίων Μνημείων; Mallouchou-Tufano, "History of Interventions on the Acropolis"; Mallouchou-Tufano, "Restoration Work on the Acropolis"; Korres, *Study for the Restoration of the Parthenon.*

30. Korres, "Der Pronaos und die Fenster des Parthenon"; M. Korres, "Acropole," *Chronique des Fouilles en 1985, BCH* 110 (1986): 673–76; Korres, "Recent Discoveries on the Acropolis"; Korres, "Architecture of the Parthenon"; Korres, "History of the Acropolis Monuments"; Korres, "Parthenon from Antiquity to the 19th Century"; Korres, Panetsos, and Seki, *Parthenon,* 68–73; Korres, "Die klassische Architektur und der Parthenon"; Koutsadelis, *Dialogues on the Acropolis;* Korres, *From Pentelicon to the Parthenon;* Korres, *Stones of the Parthenon;* Ridgway, "Images of Athena on the Akropolis," 125.

31. See, among many others, I. Hodder, *Entangled: An Archaeology of the Relationships Between Humans and Things* (Malden, Mass.: Wiley-Blackwell, 2012); J. Assman, *Cultural Memory and Early Civilization: Writing, Remembrance, and Political Imagination* (Cambridge, U.K.: Cambridge University Press, 2011); R. Hannah, *Time in Antiquity* (London: Routledge, 2009); L. Meskell and R. W. Preucel, *A Companion to Social Archaeology* (Malden, Mass.: Wiley-Blackwell, 2006); Brown and Hamilakis, *The Usable Past;* A. Wylie, *Thinking from Things: Essays in the Philosophy of Archaeology* (Berkeley: University of California Press, 2002); Van Dyke and S. Alcock, *Archaeologies of Memory;* A. Gell, *Art and Agency: An Anthropological Theory* (Oxford: Oxford University Press, 1998); A. Schnapp, *The Discovery of the Past,* 2nd ed. (London: British Museum Press, 1996); C. Renfrew and E. B. W. Zubrow, *The Ancient Mind: Elements of Cognitive Archaeology* (Cambridge, U.K.: Cambridge University Press, 1994); Tilley, *Phenomenology of Landscape;* J. Gero and M. Conkey, *Engendering Archaeology: Women and Prehistory* (Oxford: Basil Black-

well, 1991); Connerton, *How Societies Remember*; C. Renfrew, *The Archaeology of Cult: The Sanctuary at Phylakopi* (London: British School of Archaeology at Athens, 1985); P. Vidal Naquet, *The Black Hunter: Forms of Thought and Forms of Society in the Greek World* (Baltimore: Johns Hopkins University Press, 1986); L. Gernet, *The Anthropology of Ancient Greece*, trans. J. Hamilton and B. Nagy (Baltimore: Johns Hopkins University Press, 1981); Vernant, *Myth and Thought*; Vernant, *Myth and Society;* M. M. Austin and P. Vidal-Naquet, *A Social and Economic History of Greece* (Berkeley: University of California Press, 1980).

32. The bibliography on Greek religion is vast and ever growing. Essential reading includes A. Chaniotis, "Greek Religion," in *Oxford Bibliographies Online: Classics*, http://www.oxfordbibliographies.com/view/document/obo-9780195389661/obo -9780195389661-0058.xml; R. Parker, *On Greek Religion* (Ithaca, N.Y.: Cornell University Press, 2011); Sourvinou-Inwood, *Athenian Myths and Festivals;* H. Bowden, *Mystery Cults of the Ancient World* (Princeton, N.J.: Princeton University Press, 2010); J. N. Bremmer and A. Erskine, eds., *The Gods of Ancient Greece: Identities and Transformations* (Edinburgh: Edinburgh University Press, 2010); Kearns, *Ancient Greek Religion;* V. M. Warrior, *Greek Religion: A Sourcebook* (Newburyport, Mass.: Focus, 2009); S. I. Johnston, *Ancient Greek Divination* (Malden, Mass.: Wiley-Blackwell, 2008); J. N. Bremmer, *Greek Religion and Culture, the Bible, and the Ancient Near East* (Leiden: Brill, 2008); Ogden, *Companion to Greek Religion;* Connelly, *Portrait of a Priestess;* R. Parker, *Polytheism and Society at Athens* (Oxford: Oxford University Press, 2005); H. Bowden, *Classical Athens and the Delphic Oracles: Divination and Democracy* (Cambridge, U.K.: Cambridge University Press, 2005); J. D. Mikalson, *Ancient Greek Religion* (Malden, Mass.: Blackwell, 2005); Sourvinou-Inwood, *Tragedy and Athenian Religion;* Buxton, *Oxford Readings in Greek Religion;* C. Sourvinou-Inwood, "What Is Polis Religion?," in Buxton, *Oxford Readings in Greek Religion,* 13–37, originally published in *The Greek City: From Homer to Alexander,* ed. O. Murray and S. R. F. Price (Oxford: Oxford University Press, 1990), 295–322; S. R. F. Price, *Religions of the Ancient Greeks* (Cambridge, U.K.: Cambridge University Press, 1999); Calame, *Choruses of Young Women;* Parker, *Athenian Religion;* Kearns, "Order, Interaction, Authority"; F. T. van Straten, *Hiera Kala: Images of Animal Sacrifice in Archaic and Classical Greece* (Leiden: Brill, 1995); Bremmer, *Greek Religion;* M. Detienne and J.-P. Vernant, *The Cuisine of Sacrifice* (Chicago: University of Chicago Press, 1989); L. B. Zaidman and P. S. Pantel, *Religion in the Ancient Greek City,* trans. P. Cartledge (Cambridge, U.K.: Cambridge University Press, 1992); H. S. Versnel, *Inconsistencies in Greek and Roman Religion* (Leiden: Brill, 1990); P. E. Easterling and J. V. Muir, eds., *Greek Religion and Society* (Cambridge, U.K.: Cambridge University Press, 1985); W. Burkert, *Greek Religion,* trans. J. Raffan (Cambridge, Mass.: Harvard University Press, 1985); P. Veyne, *Did the Greeks Believe in Their Myths?,* trans. P. Wissing (Chicago: University of Chicago Press, 1988); Simon, *Festivals of Attica;* Vernant, *Myth and Thought;* Vernant, *Myth and Society;* D. G. Rice and J. E. Stambaugh, *Sources for the Study of Greek Religion* (Missoula, Mont.: Society of Biblical Literature, 1979).

33. Chaniotis, *Unveiling Emotions;* Y. Hamilakis, "Archaeologies of the Senses," in *The Oxford Handbook of the Archaeology of Ritual and Religion,* ed. T. Insoll (Oxford: Oxford University Press, 2011), 208–25; Chaniotis, "Rituals Between Norms and Emotions"; Chaniotis, "From Woman to Woman"; Chaniotis, "Dynamic of Emotions and Dynamic of Rituals"; D. Cairns, ed., *Body Language in the Greek and Roman Worlds* (Swansea: Classical Press of Wales, 2005); D. Konstan, *The Emotions of the Ancient Greeks* (Toronto: University of Toronto Press, 2006); Sojc, *Trauer auf attischen Grabreliefs;* K. Herding and B. Stumpfhaus, eds., *Pathos, Affekt, Gefühl: Die Emotionen in den Künsten* (Berlin: De Gruyter, 2004); J. H. Oakley, *Picturing Death in Classical Athens* (Cambridge, U.K.: Cambridge University Press, 2004); D. Konstan and K. Rutter, eds., *Envy, Spite, and Jealousy: The Rivalrous Emotions in Ancient Greece*

(Edinburgh: Edinburgh University Press, 2003); W. Harris, *Restraining Rage: The Ideology of Anger Control in Classical Antiquity* (Cambridge, Mass.: Harvard University Press, 2001); S. Tarlow, *Bereavement and Commemoration: An Archaeology of Mortality* (Oxford: Wiley-Blackwell, 1999); H. A. Shapiro, "The Iconography of Mourning in Athenian Art," *AJA* 95 (1991): 629–56; Winkler, *Constraints of Desire;* P. Zanker, *Die trunkene Alte: Das Lachen der Verhöhnten* (Frankfurt: Fischer, 1989); P. Walcot, *Envy and the Greeks: A Study of Human Behaviour* (Warminster: Aris & Phillips, 1978).

34. D. Damaskos and D. Plantzos, eds., *A Singular Antiquity: Archaeology and Hellenic Identity in Twentieth-Century Greece* (Athens: Benaki Museum, 2008); Hamilakis, "Decolonizing Greek Archaeology"; Hamilakis, *Nation and Its Ruins;* Brown and Hamilakis, *Usable Past;* Hamilakis, "Monumental Visions"; Hamilakis, "Cyberpast/Cyberspace/Cybernation"; Hamilakis, "Sacralising the Past"; Bastea, *Creation of Modern Athens;* Hamilakis and Yalouri, "Antiquities as Symbolic Capital"; Yalouri, *Acropolis.*

35. Hamilakis, "Museums of Oblivion"; Yalouri, "Between the Local and the Global"; Hamilakis, "Monumentalising Place"; Yalouri, *Acropolis;* Y. Hamilakis, "'The Other Parthenon': Antiquity and National Memory at Makronisos," *Journal of Modern Greek Studies* 20 (2002): 307–38.

36. Cyriacos of Ancona, writing in 1444, is the first to identify the frieze as showing a victory from the days of Perikles (see Bodnar, *Cyriacos of Ancona,* letter 3.9, pages 18–19), while Stuart and Revett (*Antiquities of Athens,* 2:12) are the first to identify the frieze as a representation of the Panathenaic procession.

37. Connelly, "Parthenon Frieze and the Sacrifice of the Erechtheids"; Connelly, "Parthenon and *Parthenoi.*"

38. M. Lefkowitz, *Greek Gods, Human Lives: What We Can Learn from Myths* (New Haven, Conn.: Yale University Press, 2003), 237–39.

39. Boutsikas, "Greek Temples and Rituals"; Boutsikas and Hannah, "Aitia, Astronomy, and the Timing of the Arrhēphoria"; Boutsikas and Hannah, "Ritual and the Cosmos"; Boutsikas, "Astronomical Evidence for the Timing of the Panathenaia"; Salt and Boutsikas, "When to Consult the Oracle at Delphi"; Boutsikas, "Placing Greek Temples."

40. Pindar, frag. 76; Acts of the Apostles 17.22.

41. Theophrastos, "The Superstitious Man"; see D. B. Martin, *Inventing Superstition: From the Hippocratics to the Christians* (Cambridge, Mass.: Harvard University Press, 2004), 23–24.

42. J. N. Bremmer, and J. Veenstra, eds., *The Metamorphosis of Magic from Antiquity to the Middle Ages* (Leuven, Belgium: Peeters, 2003); C. Faraone, *Ancient Greek Love Magic* (Cambridge, Mass.: Harvard University Press, 1999); F. Graf, *Magic in the Ancient World* (Cambridge, Mass.: Harvard University Press, 1997); P. Mirecki and M. Meyer, eds., *Magic and Ritual in the Ancient World* (Leiden: Brill, 2002); D. Ogden, *Magic, Witchcraft, and Ghosts in the Greek and Roman Worlds: A Sourcebook* (Oxford: Oxford University Press, 2002); D. Collins, *Magic in the Ancient Greek World* (Hoboken, N.J.: John Wiley & Sons, 2008).

43. Plutarch, *Life of Perikles* 38.2.

44. C. Wickham, *The Mountains and the City: The Tuscan Apennines in the Early Middle Ages* (Oxford: Oxford University Press, 1988), 6.

I THE SACRED ROCK

1. Plato, *Phaidros* 229a. Translation: Nehamas and Woodruff, *Phaedrus,* 4.

2. Translation: Nehamas and Woodruff, *Phaedrus,* 6.

3. Plato, *Phaidros* 238d. Translation: Nehamas and Woodruff, *Phaedrus,* 18, and earlier discussion of Boreas and Oreithyia, 229b–c, 4.

4. The bibliography on landscape and memory in ancient Greece is ever growing. Essentials include L. Thommen, *Environmental History of Ancient Greece and Rome* (Cambridge, U.K.: Cambridge University Press, 2012); I. Mylonopoulos, "Natur als Heiligtum—Natur im Heiligtum," *Archiv für Religionsgeschichte* 10 (2008): 51–83; A. Cohen, "Mythic Landscapes of Greece," in *Greek Mythology*, ed. R. D. Woodland (Cambridge, U.K.: Cambridge University Press, 2007), 305–30; J. L. Davis, "Memory Groups and the State: Erasing the Past and Inscribing the Present in the Landscapes of the Mediterranean and the Near East," in *Negotiating the Past in the Past*, ed. N. Yoffee (Tucson: University of Arizona Press, 2007), 227–56; H. A. Forbes, *Meaning and Identity in a Greek Landscape: An Archaeological Ethnography* (Cambridge, U.K.: Cambridge University Press, 2007); J. Larson, "A Land Full of Gods: Nature Deities in Greek Religion," in Ogden, *Companion to Greek Religion*, 56–70; S. G. Cole, *Landscapes, Gender, and Ritual Space: The Ancient Greek Experience* (Berkeley: University of California Press, 2004); Van Dyke and Alcock, *Archaeologies of Memory*; S. Alcock, "Archaeologies of Memory"; N. Loraux, *The Divided City: On Memory and Forgetting in Ancient Athens* (New York: Zone Books, 2002); R. Bradley, *An Archaeology of Natural Places* (London: Routledge, 2000); W. Ashmore and A. Bernard Knapp, eds., *Archaeologies of Landscape: Contemporary Perspectives* (Oxford: Blackwell, 1999); H. A. Forbes, "The Uses of the Uncultivated Landscape in Modern Greece: A Pointer to the Value of the Wilderness in Antiquity?," in Shipley and Salmon, *Human Landscapes in Classical Antiquity*, 68–97; J. D. Hughes, *Pan's Travail: Environmental Problems of the Ancient Greeks and Romans* (Baltimore: Johns Hopkins University Press, 1994); Tilley, *Phenomenology of Landscape*; Isager and Skydsgaard, *Ancient Greek Agriculture*; R. Osborne, *Classical Landscape with Figures: The Ancient Greek City and Its Countryside* (London: George Philip, 1987); A. Motte, *Prairies et jardins de la Grèce antique, de la religion à la philosophie* (Brussels: Palais des Académies, 1971).

5. See W. R. Connor, "Seized by the Nymphs: Nympholepsy and Symbolic Expression in Classical Greece," *ClAnt* 7 (1988): 155–89; Larson, *Greek Nymphs*, 10–20, for discussion of nympholepsy and divination; C. Ondine-Pache, *A Moment's Ornament: The Poetics of Nympholepsy in Ancient Greece* (New York: Oxford University Press, 2011), 37–44.

6. For Plato's positive conception of traditional Greek religion, see M. McPherran, *The Religion of Socrates* (State College: Penn State University Press, 1999), 291–302.

7. Definitions proposed by I. Morris and B. Powell, *The Greeks: History, Culture, and Society*, 2nd ed. (Upper Saddle River, N.J.: Pearson, 2009), 119–21, 179. Greek historians differentiated myth and history in various ways. Writing about the flooding of the Nile in his *Histories* 2.21–23, Herodotos contrasts his own efforts in laying out history with what is "mythic." The association of the inundation of the Nile with Okeanos is, for Herodotos, the most *mythikon* and the most *anepistemonikon* ("not worth knowing") way of looking at the event. Thucydides, in turn, comments that his history will be perceived as less easy to read because of the absence of *mythodes* within it; see *Peloponnesian War* 1.22. I thank Nickolas Pappas for very helpful discussions of this material.

8. Scodel, "Achaean Wall," 36.

9. López-Ruiz, *When the Gods Were Born*, esp. 1–47.

10. See, among others, Vlizos, *E Athena kata te Romaike Epokhe*; Smith, *Athens*; Goette, *Athens, Attica, and the Megarid*; Camp, *Archaeology of Athens*; Travlos, *Pictorial Dictionary*; Harrison, *Primitive Athens as Described by Thucydides*.

11. Plato, *Kritias* 111a–e.

12. Thompson, *Garden Lore*.

13. Isager and Skydsgaard, *Ancient Greek Agriculture*, 19–43; L. Foxhall, *Olive Cultivation in Ancient Greece: Seeking the Ancient Economy* (Oxford: Oxford Uni-

versity Press, 2007); L. Foxhall, "Farming and Fighting in Ancient Greece," in Rich and Shipley, *War and Society in the Greek World,* 134–45.

14. K. Mitchell, "Land Allocation and Self-Sufficiency in the Ancient Athenian Village," *Agricultural History* 74 (2000): 1–18; R. Sallares, *The Ecology of the Ancient Greek World* (London: Duckworth, 1991), esp. 208–12 (Solon's reforms).

15. D. Braund, "Black Sea Grain for Athens? From Herodotus to Demosthenes," in *The Black Sea in Antiquity: Regional and Interregional Economic Exchanges,* ed. V. Gabrielsen and J. Lund (Aarhus: Aarhus University Press, 2007), 39–68.

16. Aristotle, *Politics* 1326a40–b24.

17. These reforms included the standardization of weights and measures, coinage, the prohibition on exports (except for olive oil), and the institution of the Council of 400 comprising a hundred representatives chosen from each of the four Ionian tribes.

18. Lykourgos, *Against Leokrates* 77. Translation: Burtt, *Minor Attic Orators,* 69–71. The oath is inscribed on a fourth-century stele found in 1932 in the sanctuary of Ares and Athena Areia at Acharnai: L. Robert, *Études épigraphiques et philologiques* (Paris: Champion, 1938), 296–307; M. N. Tod, *Greek Historical Inscriptions* (Oxford: Clarendon Press, 1948), 2:303, no. 204. The oath is also cited by Pollux 8.105ff. and Stobaeus 4.1.8. Though surviving evidence dates only from the fourth century, Siewert, in his "Ephebic Oath," cites allusions to the pledge already in the fifth-century works of Sophokles and Thucydides and suggests its roots may go back to the Archaic period.

19. Thompson, *Garden Lore.*

20. For the Academy, see Travlos, *Pictorial Dictionary,* 42–51, figs. 213, 417; Camp, *Archaeology of Athens,* 64.

21. Thucydides, *Peloponnesian War* 2.34; Plutarch, *Life of Kimon* 13.7; scholion on Sophokles, *Oidipous at Kolonos* 698, 701.

22. See Travlos, *Pictorial Dictionary,* 345–47. According to Guy Smoot, the word could, alternatively, be connected to the root "leuk," "light," or "to shine," and thus to Apollo's role as the god of dawn and the rising sun. Pausanias, *Description of Greece* 1.19.3, says that the Lykeion was named after Lykos, son of Pandion, and that Apollo Lykaios was first named so here. Since Pandion means "All-Shining," it might follow that the name of his son, Lykos, continued in this sense.

23. D. Birge, "Sacred Groves in the Ancient World" (Ph.D. diss., University of California, Berkeley, 1982); R. Barnett, "Sacred Groves: Sacrifice and the Order of Nature in Ancient Greek Landscapes," *Landscape Journal* 26 (2007): 252–69.

24. Plutarch, *Lives of the Ten Orators* 8.41–42; Thompson, *Garden Lore,* 6.

25. J. P. Lynch, *Aristotle's School: A Study of a Greek Educational Institution* (Berkeley: University of California Press, 1972), 68–105; for Theophrastos, see Diogenes Laertius, *De causis plantarum* 5.46. For the gardens of the Lykeion, see E. Vanderpool, "The Museum and Gardens of the Peripatetics," *ArchEph* (1953/1954B): 126–28. The trees of the Lykeion were cut down, like those of the Academy, by the Roman general Sulla when he sacked Athens in 86 B.C. Desperate for wood to build his deadly siege engines, Sulla deforested much of Athens and its surrounding countryside; see Plutarch, *Life of Sulla* 12.3. Remains of the ancient Lykeion were unearthed, by chance, in 1996 during construction of the Goulandris Museum of Contemporary Art, between Rigillis Street and Vassilissis Sofias Avenue. Subsequent excavation of the site has produced material dated from the sixth century B.C. to the early Byzantine period. A well of the fourth century B.C. is lined with curved ceramic tiles and pierced with hand and foot holes for climbing in and out. The foundations of a large palaistra (50 by 48–50 meters, or 164 by 157–64 feet), complete with central courtyard surrounded by stoas, date mostly to the first century A.D. Baths at the northeast and northwest corners of the complex preserve hypocausts, a furnace, frigidarium, and calderium (NE) as well as a tepidarium, caldarium, and footbath (NW). See E. Lygouri-Tolia, "Οδός

Ρηγίλλης (η παλαίστρα του γυμνασίου του Λυκείον," *ArchDelt* 51 (1996): 46–48; E. Lygouri-Tolia, "Excavating an Ancient Palaestra in Athens," in *Excavating Classical Culture in Greece: Recent Archaeological Discoveries in Greece*, ed. M. Stamatopoulou and M. Geroulanou (Oxford: Beazley Archive and Archaeopress, 2002). I thank Dr. Niki Sakka of the Greek Archaeological Service and Emorphylli Panteliadis of the Directorate for the Restoration of Ancient Monuments for their kindness in showing me the site.

26. For Kodros, see Kearns, *Heroes of Attica*, 56–57, 178; *LIMC* 6, s.v. "Codrus"; Kron, *Die zehn attischen Phylenheroen*, 138, 195–96, 215, 221–27, 246; N. Robertson, "Melanthus, Codrus, Neleus, Caucon: Ritual Myth as Ancient History," *GRBS* 29 (1988): 225–26. Kodros appears with the Eponymous and Marathonian heroes in Pheidias's Marathon monument at Delphi, probably dating from the 450s; Pausanias, *Description of Greece* 10.10.1. Basile is of uncertain identity, though the name seems to be associated with Basileia, "Queen." H. A. Shapiro, "The Attic Deity Basile," *ZPE* 63 (1986): 134–36.

27. Traditional dates for Kodros: 1089–1068 B.C. Aristotle gives an alternative account in the *Athenian Constitution* 3.3, where he states that Medon was king of Athens rather than the first archon.

28. *IG* II²4258, funerary epigram of Kodros, dating to Augustan period.

29. The earliest attestation of this story is by Lykourgos, *Against Leokrates* 84–87, who says Kodros was killed near the gate, outside the city. Pausanias, *Description of Greece* 1.19.5, adds that Kodros was killed near the banks of the Ilissos River.

30. G. Anderson, "Before Tyrannoi Were Tyrants: Rethinking a Chapter of Early Greek History," *ClAnt* 24 (2005): 173–222.

31. *IG* I³ 84, decree for sanctuary of Kodros, Neleus, and Basile; see Athens, Epigraphical Museum 10616 (418/417 B.C.). J. R. Wheeler, "An Attic Decree, the Sanctuary of Kodros," *AJA* 3 (1887): 38–49; C. L. Lawton, *Attic Document Reliefs: Art and Politics in Ancient Athens* (Oxford: Clarendon Press, 1995), 83–84, plate 2, no. 4.

32. Travlos, *Pictorial Dictionary*, 332–33, places the sanctuary within the city walls in an area today bordered by Makrigianni Street, Syngrou Avenue, and Chatzichristos Street. G. T. W. Hooker, on the other hand, places it outside the city walls on the banks of the Ilissos, "The Topography of the *Frogs*," *JHS* 80 (1960): 112–17, in keeping with the testimonia of Lykourgos and Pausanias (note 29, above), who state that Kodros was killed outside the walls of Athens.

33. Smoot, "Poetics of Ethnicity in the Homeric *Iliad*," notes that in the *Iliad*, Medon is the bastard brother of Lokrian Ajax and substitute leader of Philoktetes's contingent at Troy. According to Smoot, Lokrian Medon and Athenian Medon are based on the same prototype.

34. Plutarch, *Life of Kimon* 13.8.

35. Thompson and Wycherley, *Agora of Athens*, 135.

36. Plutarch, *Life of Demosthenes* 31.

37. R. Lamberton and S. Rotroff, *Birds of the Athenian Agora*, Agora Picture Book 22 (Princeton, N.J.: American School of Classical Studies at Athens, 1985).

38. H. K. L. Mühle, *Beitraege zur Ornithologie Griechenlands* (Leipzig: E. Fleischer, 1844); N. Dunbar, *Aristophanes, "Birds"* (Oxford: Clarendon Press, 1995).

39. R. Simms, "Agra and Agrai," *GRBS* 43 (2002/2003): 219–29.

40. Travlos, *Pictorial Dictionary*, 112–20; E. Greco, *Topografia di Atene: Sviluppo urbano e monumenti dalle origini al III secolo d.C.*, vol. 2, *Colline sud-occidentali, Valle dell'Ilisso* (Paestum, Italy: Pandemos, 2010).

41. Aristotle, *On the Heavens* 294a28. For the impact of water sources on memory and place, see Ö. Harmanşah, ed., *Of Rocks and Water: Towards an Archaeology of Place* (Providence, R.I.; Joukowsky Institute Publications/Oxbow Books, 2014).

42. Larson, *Greek Nymphs*, 10.

43. Connerton, *How Societies Remember*; J. Fentress and C. Wickham, *Social

Memory (Oxford: Blackwell, 1992), 26; N. Lovell, *Locality and Belonging* (New York: Routledge, 1998), 1–2; N. Loraux, *The Divided City: On Memory and Forgetting in Ancient Athens*, trans. C. Pache and J. Fort (New York: Zone Books, 2002).

44. Zachariadou, "Syntagma Station," 154.

45. *IG* I³ 257; *Encyclopedia of Ancient History* (2013), s.v. "Ilissos"; I. Arnaoutoglo, *Ancient Greek Laws: A Sourcebook* (London: Routledge, 1998), 77.

46. Kallimachos, *Collection of Rivers*, quoted by Strabo, *Geography* 9.1.19.

47. Pausanias, *Description of Greece* 1.32.1; *Encyclopedia of Ancient History* (2013), s.v. "Kephissos."

48. In 2007, the *Kathimerini* newspaper and Skai 100.3 FM radio launched a campaign for the environmental improvement of the Kephisos River. The architect and town planner Vassilis Zotos and the British Graduates Society assembled a team of architects to create a program of environmentally sustainable interventions and guidelines for the regeneration of the river. See D. Koutsoyiannis, "On the Covering of Kephisos River" (in Greek), *Daemon of Ecology*, October 6, 2002.

49. Athens National Archaeological Museum 1783, ca. 410 B.C.; *IG* I³ 986 (*CEG* II 743), *LIMC* 6, s.v. "Kephisos," no. 1. The relief was discovered in 1903 at the sanctuary of the Kephisos in Echelidai halfway between the Piraeus and Phaleron. O. Walter, "Die Reliefs aus dem Heiligtum der Echeliden in Neu-Phaleron," *ArchEph* (1937): 97–119; G. Güntner, *Göttervereine und Götterversammlungen auf attischen Weihreliefs* (Würzburg: K. Triltsch, 1994), 21–23, 78–80. See also Parker, *Polytheism and Society*, 430–32; Sourvinou-Inwood, *Athenian Myths and Festivals*, 92.

50. In the *Iliad*, Hektor names his son Skamandrios after the Skamander River. On potamonymy, see R. Parker, "Theophoric Names and the History of Greek Religion," in *Greek Personal Names*, eds. S. Hornblower and E. Matthews (Oxford: Oxford University Press, 2000), 59–60; P. Thonemann, "Neilomandros: A Contribution to the History of Greek Personal Names," *Chiron* 36 (2006): 11–43; P. Thonemann, *The Maeander Valley: A Historical Geography from Antiquity to Byzantium* (Cambridge, U.K.: Cambridge University Press, 2011), 26–31.

51. Parker, *Polytheism and Society*, 430–31.

52. Athens National Archaeological Museum 2756; *IG* I³ 987 (*CEG* II 744); *IG* II² 4547–8; *LIMC* 6, s.v. "Kephisos," no. 2. See E. Voutyras, "Φροντίσματα: Το ανάγλυφο της Ξενοκράτειας και το ιερό του Κηφισού στο Νέο Φάληρο," in *Έπαινος Luigi Beschi*, ed. A. Delivorrias, G. Despinis, and A. Zarkadas (Athens: Benaki Museum, 2011), 49–58, for Xenokrateia establishing her own shrine within the city walls; and discussion in I. Mylonopoulos, "Buildings, Images, and Rituals in the Greek World," in *The Oxford Handbook of Greek and Roman Art and Architecture*, forthcoming. See also A. L. Purvis, *Singular Dedications: Founders and Innovators of Private Cults in Classical Greece*, ed. C. Marconi (New York: Routledge, 2003), 15–32; Guarducci, "L'offerta di Xenokrateia nel santuario di Cefiso al Falero"; E. Mitropoulou, *Corpus I: Attic Votive Reliefs of the 6th and 5th Centuries* B.C. (Athens: Pyli, 1977), no. 65; A. Linfert, "Die Deutung des Xenokrateiareliefs," *AM* 82 (1967): 149–57.

53. See D'Alessio, "Textual Fluctuations and Cosmic Streams."

54. Pausanias, *Description of Greece* 1.37.3.

55. Parker, *Polytheism and Society*, 431; Pindar, *Pythian Ode* 4.145 (cf. Homer, *Iliad* 23.142); Aeschylus, *The Mourners* 6; "Simonides" 32b in *FGE*; Pausanias, *Description of Greece* 1.37.3.

56. Euripides, *Ion* 1261.

57. *LIMC* 1, s.v. "Acheloös," nos. 1–5.

58. The largest of the four, the Kephisos of Mount Parnassos, rose from a spring named for a naiad nymph, Lilaia, a daughter of the Kephisos. See Aelian, *Historical Miscellany* 2.33.

59. Aristophanes, *Wasps* 1362; Strabo, *Geography* 9.1.24; H. Foley, ed., *Homeric Hymn to Demeter: Translation, Commentary, and Interpretative Essays* (Princeton,

N.J.: Princeton University Press, 1994), 67; J. S. Rusten, "*Wasps* 1360–69: Philocleon's τωθασμός," *HSCP* 81 (1977): 157–61; Mylonas, *Eleusinian Mysteries*, 256, no. 150; J. Henderson, *The Maculate Muse: Obscene Language in Attic Comedy* (New Haven, Conn.: Yale University Press, 1975), 16.

60. See Graf, "Pompai in Greece," 60, 63; S. des Bouvrie, "Continuity and Change Without Individual Agency: The Attic Ritual Theatre and the 'Socially Unquestionable' in the Tragic Genre," in Chaniotis, *Ritual Dynamics in the Ancient Mediterranean*, 139–78.

61. Strabo, *Geography* 9.1.24 (γεφυρισμοί), 6.12 (γεφυρίζοντες), 13.1 (γεφυρίζων); Plutarch, *Life of Sulla* 2.2 (γεφυριστῶν); Hesychios, s.v. γεφυρίς and γεφυρισταί; *Suda*, s.v. Γεφυρίζων. D. Clay, "Unspeakable Words in Greek Tragedy," *AJP* 103 (1982): 298. For apotropaic interpretation, see Mylonas, *Eleusinian Mysteries*, 256–57; Connelly, "Towards an Archaeology of Performance," 320.

62. D'Alessio, "Textual Fluctuations and Cosmic Streams," and Smoot, "Poetics of Ethnicity in the Homeric *Iliad*," point to evidence that the Acheloös was considered to be one and the same as the cosmic river Okeanos in certain parts of Greece during the classical period.

63. For Praxithea as daughter of the Kephisos, see Euripides, *Erechtheus* F 370.63 Kannicht; Lykourgos, *Against Leokrates* 99. For Praxithea as daughter of Diogeneia (another daughter of the Kephisos), see Apollodoros, *Library* 3.15.1.

64. Apollodoros, *Library* 3.14.8.

65. Hyginus, *Fabulae* 14.9.

66. Blok, "Gentrifying Genealogy," 258; D. Henige, *The Chronology of Oral Traditions: Quest for a Chimera* (Oxford: Clarendon Press, 1974), 37.

67. A. J. Ammerman, "The Eridanos Valley and the Athenian Agora," *AJA* 100 (1996): 699–715; *Eridanos: The River of Ancient Athens* (Athens: Archaeological Receipts Fund, 2004); Zachariadou, "Syntagma Station," 149–61; E. Baziotopoulou-Valavani and I. Tsirigoti-Drakotou, "Kerameikos," in Parlama and Stampolidis, *City Beneath the City*, 264–75. Recent excavations at the Monastiraki metro station have revealed the brick-vaulted chambers of a Roman tunnel that guided wastewater from the Agora into the Eridanos. This now forms part of an open-air museum where the river can be heard flowing deep underground.

68. Thompson and Wycherley, *Agora of Athens*, 194–96; Lang, *Waterworks in the Athenian Agora*. By the second century A.D., the Eridanos served as a drain channel for the wastewaters of the densely populated city.

69. Travlos, *Pictorial Dictionary*, 299; W. Dörpfeld, "Der Eridanos," *AM* 13 (1888): 211–20; U. Knigge, Ο Κεραμεικός της Αθήνας: Ιστορία-Μνημεία-Ανασκαφές (Athens: Krini, 1990); Lang, *Waterworks in the Athenian Agora*.

70. The river Styx and the Acheron are both located in northern Greece, and there is a sense that north is the direction for the Land of the Dead. Perhaps the location of the Kerameikos cemetery at the northwest of the city and on the banks of the Eridanos evoked this larger scheme. I thank Guy Smoot for making this point.

71. Travlos, *Pictorial Dictionary*, 204; R. E. Wycherley, *Literary and Epigraphical Testimonia* (Princeton, N.J.: American School of Classical Studies at Athens, 1957), 137–42.

72. Thucydides, *Peloponnesian War* 2.15.5.

73. Travlos, *Pictorial Dictionary*, 205.

74. Ibid., 289, 296, fig. 387.

75. Hesiod, *Theogony* 351, 981, 346.

76. Ibid., 287–94, 979–83; Apollodoros, *Library* 2.5; Stesichoros, *Geryoneis* frags. S11, S87; M. Davies, *Poetarum melicorum Graecorum fragmenta* (Oxford: Oxford University Press, 1991); M. M. Davies, "Stesichoros' *Geryoneis* and Its Folk-Tale Origins," *CQ*, n.s., 38 (1988): 277–90.

77. Servius, *On the Aeneid* 4.250; Tzetzes, *On Lykophron's Alexandra* 875.

78. Plato, *Phaidros* 229c; Kleidemos, *Atthis* 1; Pausanias, *Description of Greece* 1.19.6.

79. Discovered by the archaeologist A. Skias in 1897 and identified later that year by Wilhelm Dörpfeld. See Travlos, *Pictorial Dictionary*, 112–20; M. Miles, "The Date of the Temple on the Ilissos River," *Hesperia* 49 (1980): 309–25; C. A. Picon, "The Ilissos Temple Reconsidered," *AJA* 32 (1978): 375–424; J.-D. Le Roy, *The Ruins of the Most Beautiful Monuments of Greece*, trans. D. Britt (1770; Los Angeles: Getty Research Institute, 2004); Stuart and Revett, *Antiquities of Athens*, 1: chap. 2.

80. R. C. T. Parker, "Sacrifice and Battle," in *War and Violence in Ancient Greece*, ed. H. van Wees (London: Duckworth, 2000), 299, 308–9; M. Jameson, "Sacrifice Before Battle," in Hanson, *Hoplites*, 209–10.

81. Herodotos, *Histories* 6.117. Xenophon, *Anabasis* 3.2.11–12; Aristotle, *Athenian Constitution* 58.1; and Plutarch, *Moralia* 862, put the number of goats sacrificed at five hundred, while Aristophanes, *Knights* 660, places it at a thousand, and Aelian, *Historical Miscellany* 2.25, records the number as three hundred. See *IG* II² 1006.8–9. See Parker, *Polytheism and Society*, 400; Parker, *Athenian Religion*, 153–54. Plutarch, *Moralia* 862, mentioning "the solemn procession that the Athenians even at this day send to Agrai, celebrating a feast of thanksgiving to Hekate for their victory."

82. J. Papadopoulos, "Always Present, Ever Changing, Never Lost from Human View: The Athenian Acropolis in the 21st Century," *AJA* 17 (2013): 135–40; G. Marginesu, *Gli epistati dell'Acropoli: Edilizia sacra nella città di Pericle, 447/6–433/2 a.C.* (Paestum, Italy: Pandemos, 2010); R. Krumeich and C. Witschel, eds., *Die Akropolis von Athen im Hellenismus und in der römischen Kaiserzeit* (Wiesbaden: Reichert, 2010); E. Greco, *Topografia di Atene: Sviluppo urbano e monumenti dalle origini al III secolo d.C.*, vol. 1, *Acropoli, Areopago, Tra Acropoli e Pnice* (Paestum, Italy: Pandemos, 2010).

83. For the Neolithic Acropolis, see Pantelidou, Ἀι Προϊστορικἁι Ἀθῆναι, 242–43; Hurwit, *Athenian Acropolis*, 67–70; Immerwahr, *Neolithic and Bronze Ages*, 16–17, 48, no. 219; S. A. Immerwahr, "The Earliest Athenian Grave," in *Studies in Athenian Architecture and Topography Presented to Homer A. Thompson*, Hesperia Supplement 20 (Princeton, N.J.: American School of Classical Studies at Athens, 1982), 54–62. Hurwit, *Athenian Acropolis*, 67–68, identifies the earliest material found in the area of the Acropolis as a stray find of a Neolithic marble statuette of a corpulent woman (14 centimeters, or 5.5 inches, long and dated 5000–4000 B.C.) and Middle Neolithic potsherds found in a debris pit on the Acropolis south slope, behind the Stoa of Eumenes II.

84. For the Bronze Age Acropolis, see Hurwit, *Athenian Acropolis*, 70–84; Pantelidou, Ἀι Προϊστορικἁι Ἀθῆναι, 247–48. At least five Middle Helladic graves (ca. 2050/2000–1550 B.C.) for children have been found on the Acropolis, and one house dating to the Late Helladic I period.

85. M. Higgins and R. Higgins, *A Geological Companion to Greece and the Aegean* (Ithaca, N.Y.: Cornell University Press, 1996), 27–29; Parsons, "Klepsydra," 205; R. Lepsius, *Geologie von Attika* (Berlin: D. Reimer, 1893), 6, 53, plate 1, profile 1; W. Judeich, *Topographie von Athen* (Munich: C. H. Beck, 1931), 43ff., figs. 6–7; Mountjoy, *Mycenaean Athens,* fig. 14; Hurwit, *Athenian Acropolis,* 6–8.

86. The palace is usually dated to the Late Helladic IIIB period but could be as early as Late Helladic IIIA. See Mountjoy, *Mycenaean Athens,* 22–24, 41–43; Iakovidis, *Late Helladic Citadels on Mainland Greece,* 75, 77–79; Travlos, *Pictorial Dictionary,* 57; Camp, *Athenian Agora,* 101–2; Iakovidis, *Mycenaean Acropolis,* 113–114.

87. See Travlos, *Pictorial Dictionary,* 52–55, 91, figs. 67, 71; Camp, "Water and the Pelargikon"; Mountjoy, *Mycenaean Athens,* 40–41; Iakovidis, *Mycenaean Acropolis,* 197–221.

88. Thucydides, *Peloponnesian War* 2.17.1; Aristophanes, *Birds* 832; and an inscription from Eleusis of fifth-century date (*CIA* IV.2, 27.6; *BCH* 4 [1903]: 225, pl.

15) refer to the "Pelargikon walls." See Harrison, *Primitive Athens as Described by Thucydides*, 25–36; Harrison, *Mythology and Monuments of Ancient Athens*, 2:537. Herodotos, *Histories* 6.137.1 (quoting Hekataios); the Parian Chronicle, line 60; and Pausanias, *Description of Greece* 1.28.3, speak of the "Pelasgian Wall." (The Parian Chronicle says that the Athenians expelled the sons of Peisistratos from the "Pelasgikon teichos.") For the Pelasgians, see R. L. Fowler, "Pelasgians," in *Poetry, Theory, Praxis*, ed. E. Csapo and M. Miller (Oxford: Oxbow, 2003), 2–18; Kretschmer, "Pelasger und Etrusker"; J. L. Myers, "A History of the Pelasgian Theory," *JHS* 27 (1907): 170–225; W. Miller, "A History of the Archaeology of Athens," *AJA* (1893): 485–504; and G. Smoot, "Poetics of Ethnicity in the Homeric *Iliad*," who argues on the basis of Herodotos and linguistic evidence that the Pelasgians, a population of non-Greek-speaking (or perhaps bilingual) people, may have survived at Athens and elsewhere into the eighth century and even later.

89. First explored by Kavvadias, then by O. Broneer, "A Mycenaean Fountain House on the Athenian Acropolis," *Hesperia* 8 (1939): 317–433; Travlos, *Pictorial Dictionary*, 72–75; Mountjoy, *Mycenaean Athens*, 43–44; Iakovidis, *Mycenaean Acropolis*, 140–44, 239–43; for overview, see Hurwit, *Athenian Acropolis*, 78–79.

90. Travlos, *Pictorial Dictionary*, 72–78.

91. Ibid., 323–31; Kavvadias and Giannikapani, *North, East, and West Slopes*, 13–18; Parsons, "Klepsydra," 203; Larson, *Greek Nymphs*, 129.

92. E. Smithson, "The Prehistoric Klepsydra: Some Notes," in *Studies in Athenian Architecture and Topography Presented to Homer A. Thompson*, 143–54.

93. *IG* I³ 1063; 475–450 B.C. (*SEG* 10.357); Parsons, "Klepsydra," 205; Larson, *Greek Nymphs*, 126; B. D. Meritt, "Greek Inscriptions," *Hesperia* 10 (1941): 38, no. 3.

94. The seventeenth-century antiquarians James Stuart and Nicholas Revett identified the spring with the Klepsydra fountain. They cited the observation of the fifth-century A.D. grammarian Hesychios that the Klepsydra was once sacred to the nymph Empedo. See Stuart and Revett, *Antiquities of Athens*, vol. 1, pp. 15–16; Hesychios, app., Test. VI A; cf. VI B and IV.

95. Camp, "Water and the Pelargikon," describes how preexisting wells in the area were filled up and put out of use during the late sixth and early fifth centuries. See also Glowacki, "North Slope," 75.

96. *IG* II² 2639.

97. Kavvadias and Giannikapani, *North, East, and West Slopes*; Glowacki, "North Slope"; Pierce, "Sacred Caves," 54; Goette, *Athens, Attica, and the Megarid*, 54–55.

98. Pierce, "Sacred Caves," 44; Wickens, "Archaeology and History of Cave Use."

99. Euripides, *Ion* 10–45, 492–95.

100. Ibid., 52–55.

101. Pausanias, *Description of Greece* 7.24.5; Strabo, *Geography* 8.7.2.

102. First excavated by George Kavvadias in 1896–1897. G. Kavvadias, "Topographika Athinon kata tas peri tin Akroplin anaskaphas," *ArchEph* 2 (1897): 1–32; Travlos, *Pictorial Dictionary*, 91–95; Glowacki, "North Slope," 79–90; Wickens, "Archaeology and History of Cave Use," 2:366–67; C. Tsakos, "Sanctuaries and Cults on the Hill of the Acropolis," in Koutsadelis, *Dialogues on the Acropolis*, 166–81.

103. Forty stone plaques, once fixed in these niches, have been recovered and date from the mid-first to the third century A.D. They are inscribed to Apollo Hypo Makrais by Athenian magistrates (archons) and secretaries (*grammateis*). See P. E. Nulton, *The Sanctuary of Apollo Hypoakraios and Imperial Athens* (Providence, R.I.: Center for Old World Archaeology and Art, Brown University, 2003).

104. Strabo, *Geography* 9.2.11. Put forward by A. D. Keramopoulos in "Ὑπό τα Προπύλαια τῆς Ἀκροπόλεως," *ArchDelt* 12 (1929): 98–101, but refuted by R. E. Wycherley, "Two Athenian Shrines," *AJA* 63 (1959): 68–72; R. E. Wycherley, "The Pythion at Athens: Thucydides II,15,4; Philostratos, Lives of the Sophists II,1,7," *AJA* 67 (1963):

75–79; J. Tobin, "Some New Thoughts on Herodes Atticus's Tomb, His Stadium of 143/4, and Philostratus VS 2.550," *AJA* 97 (1993): 87–88; Glowacki, "North Slope."

105. Travlos, *Pictorial Dictionary,* 417–21; Borgeaud, *Cult of Pan;* C. M. Edwards, "Greek Votive Reliefs to Pan and the Nymphs" (Ph.D. diss., New York University, 1985).

106. Wickens, "Archaeology and History of Cave Use"; Pierce, "Sacred Caves"; Borgeaud, *Cult of Pan.*

107. Olympiadoros, *Life of Plato* 1, and the author of the *Anonymous Prolegomena* tell how Plato's parents laid their infant down near the cave of Pan on Mount Hymettos. Cicero, *Concerning Divination* 1.36, and Aelian, *Historical Miscellany* 12.45, tell how a swarm of bees gathered on the baby Plato's lips. Of course, Plato's given name and the name by which he was called as a child was Aristokles.

108. I thank Anton Bierl for his translation given here.

109. *IG* I³ 1382 (*SEG* 10.27/324) dating to the mid-fifth century says the festival of Eros took place on fourth day of Mounichion. The site was excavated by Kavvadias in the late nineteenth century and by Oscar Broneer from 1931 to 1934 and from 1937 to 1939. Among the finds were a krater by Exekias and many ostraka naming Themistokles, dating to 472/1 B.C. See Broneer, "Eros and Aphrodite on the North Slope," 31–55; Travlos, *Pictorial Dictionary,* 228–32; Glowacki, "North Slope," 46–64; R. Rosenzweig, *Worshipping Aphrodite,* 35–40.

110. Pausanias, *Description of Greece* 1.27.3, as identified by Broneer, "Eros and Aphrodite on the North Slope," 43. But others place the sanctuary of Aphrodite in the Gardens on the banks of the Ilissos River; see Rosenzweig, *Worshipping Aphrodite.*

111. See K. Glowacki and S. Rotroff, "The 'Skyphos Sanctuary' from the North Slope of the Acropolis," Archaeological Institute of America 106th Annual Meeting Abstract, Boston 2005, *AJA* (2005): session 3G (abstract), http://aia.archaeological .org/webinfo.php?page=10248&searchtype=abstract&ytable=2005&sessionid=3G &paperid=146; Glowacki, "North Slope," 65–78.

112. O. Broneer and M. Z. Pease, "The Cave on the East Slope of the Acropolis," *Hesperia* 5 (1936): 247, 250. Broneer says the cave was mostly empty (250); M. Z. Pease was able to match some sherds found within it to fragments from atop the Acropolis.

113. Dontas, "True Aglaurion." Ancient sources for Aglauros's sanctuary include Herodotos, *Histories* 8.53.2; Pausanias, *Description of Greece* 1.18.2; Polyainos, *Strategies* 1.21.2. See Hurwit, *Athenian Acropolis,* 101, 136, 204, fig. 8; G. C. R. Schmalz, "The Athenian Prytaneion Discovered?," *Hesperia* 75 (2006): 33–81; N. Oikonomides, "The Athenian Cults of the Three Aglauroi and Their Sanctuaries Below the Acropolis at Athens," *AncWorld* 21 (1990): 11–17.

114. A. Chaniotis, H. W. Pleket, R. S. Stroud, and J. H. M. Strubbe, "Athens: Decree in Honor of Timokrite, Priestess of Aglauros, 247/6 or 246/5 B.C.," *SEG* 46. 137 (1996).

115. Translation: Godley, *Herodotus: Histories,* 49, with minor changes.

116. Siewert, "Ephebic Oath."

117. Translation: Godley, *Herodotus: Histories,* 49, with minor changes.

118. Scholion on Demosthenes, *On False Embassy* 303, 328; *FGrH* 105.

119. Kavvadias and Giannikapani, *South Slope,* 1–2; Hurwit, *Athenian Acropolis,* 67–68; Goette, *Athens, Attica, and the Megarid,* 47–54.

120. T. Papathanasopoulos, *The Sanctuary and Theater of Dionysos: Monuments on the South Slope of the Acropolis* (Athens: Kardamitsa, 1995); L. Polacco, *Il teatro di Dioniso Eleutereo ad Atene* (Rome: L'Erma di Bretschneider, 1990); Kavvadias and Giannikapani, *South Slope,* 20–24.

121. Meineck, "Embodied Space," 3.

122. T. Papathanasopoulos, "Το Ωδείο του Περικλή" (Ph.D. diss., University of Rethymnon, 1999); Kavvadias and Giannikapani, *South Slope,* 24; Hurwit, *Athenian Acropolis,* 216–17.

123. Kavvadias and Giannikapani, *South Slope*, 23; R. E. Townsend, "A Recently Discovered Capital from the Thrasyllos Monument," *AJA* 89 (1985): 676–80; G. Welter, "Das choregische Denkmal des Thrasyllos," *AA* (1938): 33–68.

124. J. Freely, *Strolling Through Athens, Fourteen Unforgettable Walks* (London: Tauris Parke, 2004), 41–42. For a photograph of the shrine with icons and offerings, see K. Glowacki, http://www.stoa.org/athens/sites/southslope/index5.html, photo: P17088.JPG.

125. Kavvadias and Giannikapani, *South Slope*, 30–32; S. Aleshire, *The Athenian Asklepieion: The People, Their Dedications, and the Inventories* (Amsterdam: J. C. Gieben, 1989); J. Jensen, *Drømmenes rige: Votivreliefferne fra Asklepieion på syd-skrænten af Athens Akropolis* (Aarhus: Aarhus Universitet, 2000); Hurwit, *Athenian Acropolis*, 219–21.

126. Immerwahr, *Neolithic and Bronze Ages*, 3, 51–54; G. Zimmer, *Griechische Bronzegusswerkstätten: Zur Technologieentwicklung eines antiken Kunsthandwerkes* (Mainz: Philipp von Zabern, 1990), 62ff.; O. Pelon, *Tholoi, tumuli et cercles funéraires* (Paris: École Française d'Athènes, 1976), 79–80; N. Platon, "Ἐργασίες διαμορφώσεως καὶ τακτοποιήσεως τοῦ ἀρχαιολογικου χώρου Ἀκροπόλεως," *ArchDelt* 19 (1966): 32.

127. *IG* I³ 1064 (*SEG* 17.10); Kavvadias and Giannikapani, *South Slope*, 29–30.

128. Rosivach, "Autochthony"; Blok, "Gentrifying Genealogy." See Herodotos, *Histories* 7.161.

129. Rosivach, "Autochthony."

130. Plato, *Menexenus* 237b–c and 237d; see Pappas, "Autochthony in Plato's *Menexenus*," 66–80.

131. Guy Smoot points out that the "g/k" alternation suggests non-Greek origins; scholia to Lykophron and Aeschylus have Ogyges as an Egyptian. Blok, "Gentrifying Genealogies," 258, gives sources for Ogyges: Hellanikos of Lesbos, *FGrH* 323a F 10; Philochoros, *FGrH* 328 F 92; Apollodoros, *Library* 3.14.

132. Pausanias, *Description of Greece* 9.5.1.

133. Kretschmer, "Pelasger und Etrusker," lays out the "kt," "tt," "tth" alternation in Attica/Aktaios and the attested "Ath-" form, which, like the others, is non-Greek.

134. Hellanikos, F 10, *FHG* 62 and 156.

135. *LIMC* 4, s.v. "Erechtheus"; *LIMC* 6, s.v. "Kekrops."

136. Blok, "Gentrifying Genealogies," 258.

137. Homer, *Iliad* 2.546–48.

138. Apollodoros, *Library* 3.14.6.

139. N. Loraux, *Born of the Earth: Myth and Politics in Athens* (Ithaca, N.Y.: Cornell University Press, 2000); Parker, "Myths of Early Athens"; M. Miller, "The Athenian Autochthonous Heroes from the Classical to the Hellenistic Period" (Ph.D. diss., Harvard University, 1983).

140. Aeschylus, *Eumenides* 243.

141. Hesiod, *Theogony* 929a; Apollodoros, *Library* 3.144; Pausanias, *Description of Greece* 1.14.6.

142. Herodotos, *Histories* 1.180.

143. Apollodoros, *Library* 1.20. See Deacy, *Athena*, 1–32; K. Sydinou, "The Relationship Between Zeus and Athena in the *Iliad*," 15 (1986): 155–64.

144. For the east pediment, see Pausanias, *Description of Greece* 1.24.5; Palagia, *Pediments*, 18–39; Brommer, *Die Skulpturen der Parthenon-Giebel*; E. Berger, *Die Geburt der Athena im Ostgiebel des Parthenon* (Basel: Archäologischer Verlag, 1974), 18; Palagia, "First Among Equals."

145. Deacy, *Athena*, 41–43; S. Deacy, "Athena and Ares: War, Violence, and Warlike Deities," in *War and Violence in Ancient Greece*, ed. H. van Wees (London: Duckworth, 2000), 185–98; A. Villing, "Athena as Ergane and Promachos: The Iconography of Athena in Archaic East Greece," in Fisher and van Wees, *Archaic Greece*, 147–68.

146. Herodotos, *Histories* 8.55; Isokrates, *Panathenaikos* 193; scholia on Aelius Aristides, *Panathenaic Oration* 40–44 (Lenz and Behr) = Dindorf 3.58–59 = Jebb, 106; Apollodoros, *Library* 3.14.1. See Parker, "Myths of Early Athens," 198n49.

147. That this so-called sea spring must have offered sweet, potable water seems logical and likely; see R. Waterfield, *Athens: A History from Ancient Ideal to Modern City* (New York: Basic Books, 2004), 36.

148. Flood myths also existed among the Indo-Europeans (in ancient India, for example), and the influence could have come from this direction as well. See G. Nagy, "The Epic Hero," in *A Companion to Ancient Epic,* ed. J. M. Foley (Washington, D.C.: Center for Hellenic Studies, 2006), §60–62; also §44, §58, §59, §63–64.

149. Ataç, *Mythology of Kingship,* 151.

150. Hesiod, *Works and Days* 109–201.

151. Hesiod's configuration of five ages is unusual in that most traditions, including that of India, have only four. Hesiod adds a Second Bronze Age, the Age of Heroes, which comprises a generation that is actually better than the one that preceded it, setting it apart from the model we find in the East. See J. G. Griffiths, "Archaeology and Hesiod's Five Ages," *Journal of the History of Ideas* 17 (1956): 109–19; Nagy, *Pindar's Homer.*

152. Greek tradition differs from that of the ancient Near East in that we hear of many floods instead of one great deluge. Theresa Howard Carter's review of the geological, geomorphological, and stratigraphic evidence for a great flood in Sumer (Eridu, Ur, and Warka) and throughout the Arabian Gulf points to a date of around 3500 B.C.; see T. H. Carter, "The Tangible Evidence for the Earliest Dilmun," *JCS* 33 (1981): 210–23. I am greatly indebted to Dr. Carter for many helpful discussions of this material.

153. Julius Africanus, *Chronography,* quoted in Eusebios, *Praeparatio evangelica* 10.10.

154. Translation: Waterfield, *Timaeus and Critias,* 109–10. Plato also references this flood in *Timaeus* 25d: "Appalling earthquakes and floods appeared and in the course of a single, terrible day and night the whole fighting force of your city sank all at once beneath the earth." Translation: Waterfield, *Timaeus and Critias,* 13–14.

155. According to Plato, *Kritias* 112a, the Egyptian priests at Saïs told Solon that the destruction of Atlantis was three floods earlier.

156. According to Syncellus's king list, Herodotos's *Euterpe,* Ovid's *Metamorphoses,* Apollodoros, *Library* 1.47, and Proklos, *On Hesiod's "Works and Days"* 157–58. As M. L. West points out, Deukalion's flood is something of a latecomer, not mentioned in Hesiod and not attested until the first half of the fifth century B.C. Epicharmos, *P.Oxy* 2427 frag. 1; Pindar, *Olympian Ode* 9.49. See West, *Hesiodic Catalogue of Women,* 55; West, *East Face of Helicon,* 489. Could the deluge of Deukalion, then, be an invention of the Athenians, a way to incorporate their own legendary royal succession into the larger flood myth?

157. West, *Hesiodic Catalogue of Women,* 50–52; West, *East Face of Helicon,* 65–67, 166–67, 174–76, 377–81, and 490–93; López-Ruiz, *When the Gods Were Born,* 59; C. Penglase, *Greek Myths and Mesopotamia: Parallels and Influence in the Homeric Hymn* (New York: Routledge, 1994), 191.

158. See West, *Indo-European Poetry and Myth;* West, *East Face of Helicon,* 166–67, 490–93, who points to Ziusudra of the *Eridu Genesis* (third millennium), Atrahasis of the *Epic of Atrahasis* (tablet 3, ca. 1647–1626 B.C.), Utnapishtim of *The Epic of Gilgamesh* (ca. 1100 B.C.), and Noah of the Bible's book of Genesis (sixth–fifth century B.C.). See also W. G. Lambert and A. R. Millard, *Atrahasis: The Babylonian Story of the Flood* (Winona Lake, Ind.: Eisenbrauns, 1999); Q. Laessoe, "The Atrahasis Epic: A Babylonian History of Mankind," *Biblioteca Orientalis* 13 (1956): 90–102; J. H. Tigay, *The Evolution of the "Gilgamesh Epic"* (Philadelphia: University of Pennsylvania Press, 1982). The theme also appears in the Quran (sura 71), where an ark floats for seven days and nights.

159. For the three daughters of Deukalion, see West, *Hesiodic Catalogue of Women*, 51–53, 173, table 1.

160. Pindar, frag. 76; Acts of the Apostles 17.22.

161. Translation: Nehamas and Woodruff, *Phaedrus*, 86.

2 BEFORE THE PARTHENON

1. I. Ridpath and W. Tirion, *Stars and Planets Guide* (Princeton, N.J.: Princeton University Press, 2007), 142–43; R. H. Allen, *Star Names: Their Lore and Meaning* (New York: Dover, 1963), 202; F. Boll and H. Gundel, "Sternbilder," in *Ausführliches Lexikon der griechischen und römischen Mythologie*, ed. W. H. Roscher (Leipzig: B. G. Teubner, 1884), 6:821–24.

2. Translation: M. Grant, *Myths of Hyginus* (Lawrence: University of Kansas Press, 1960).

3. Pausanias, *Description of Greece* 1.24.7.

4. Herodotos, *Histories* 8.41.2–3; Philostratos, *Imagines* 2.17.6.

5. Plutarch, *Life of Themistokles* 10.1.

6. Herodotos, *Histories* 8.41. See H. B. Hawes, "The Riddle of the Erechtheum," unpublished manuscript in the Smith College Archive (Amherst, Mass., 1935); H. B. Hawes, "The Ancient Temple of the Goddess on the Acropolis," *AJA* 40 (1936): 120–21; and full discussion in Lesk, "Erechtheion and Its Reception," 40n5, 161–62, no. 487, 162n490, 329. N. Robertson, "Athena's Shrines and Festivals," in Neils, *Worshipping Athena*, 32–33, translates Thyechoos as "the watcher of the burnt offering."

7. Lesk, "Erechtheion and Its Reception," 161–62.

8. In Euripides's *Erechtheus* F 370.71–74 Kannicht, the daughters of Erechtheus are catasterized as the Hyades/Hyakinthides. For full discussion of the catasterism of Erechtheus as Auriga and his daughters as the Hyades/Hyakinthides, see Boutsikas and Hannah, "Aitia, Astronomy, and the Timing of the Arrephoria," especially 1–7.

9. Scholia on Aelius Aristides, *Panathenaic Oration* 362 (Lenz and Behr) = Dindorf 3.323 = Jebb 189, 4.

10. Aristotle, frag. 637 Rose; scholia to Aelius Aristides, *Panathenaic Oration* 189.

11. Ruggles, *Handbook of Archaeoastronomy and Ethnoastronomy*; Ruggles, *Archaeoastronomy and Ethnoastronomy;* J. Davidson, "Time and Greek Religion," in Ogden, *Companion to Greek Religion*, 204–18; R. Hannah, *Greek and Roman Calendars: Constructions of Time in the Classical World* (London: Duckworth, 2005); Pasztor, *Archaeoastronomy*.

12. Boutsikas, "Greek Temples and Rituals"; Boutsikas and Hannah, "Aitia, Astronomy, and the Timing of the Arrēphoria"; Boutsikas and Hannah, "Ritual and the Cosmos"; Boutsikas, "Astronomical Evidence for the Timing of the Panathenaia"; E. Boutsikas and C. Ruggles, "Temples, Stars, and Ritual Landscapes: The Potential for Archaeoastronomy in Ancient Greece," *AJA* 115 (2011): 55–68; E. Boutsikas, "Placing Greek Temples: An Archaeoastronomical Study of the Orientation of Ancient Greek Religious Structures," *Archaeoastronomy: The Journal of Astronomy in Culture* 21 (2009): 4–16; E. Boutsikas, "The Cult of Artemis Orthia in Greece: A Case of Astronomical Observations?," in *Lights and Shadows in Cultural Astronomy*, ed. M. P. Zedda and J. A. Belmonte (Isili: Associazione Archeofila Sarda, 2008); E. Boutsikas, "Orientation of Greek Temples: A Statistical Analysis," in Pasztor, *Archaeoastronomy*, 19–23; Salt and Boutsikas, "When to Consult the Oracle at Delphi"; L. Vrettos, Λεξικό τελετών, εορτών και αγώνων των αρχαίων Ελλήνων (Athens: Ekdoseis Konidari, 1999).

13. Such as Starry Night Pro and Stellarium.

14. Boutsikas, "Greek Temples and Rituals," examines the use of astronomical

observations as universal mechanisms of advance warning for Panhellenic religious events and how, in determining the proper time for the start for the celebrations at Delphi, the same event could look quite different when observed from the Attic horizon and when observed from elsewhere.

15. See Boutsikas, "Astronomical Evidence for the Timing of the Panathenaia."

16. P. Michalowski, "Maybe Epic: Sumerian Heroic Poetry," in *Epic and History,* ed. D. Konstan and K. Raaflaub (Chichester: Wiley-Blackwell, 2010), 21.

17. Hesiod, *Theogony* 108–16, 123–32.

18. Homer, *Iliad* 8.13. Translation: A. T. Murray (Cambridge, Mass.: Harvard University Press, 1924).

19. Sources for the Titanomachy include Hesiod's *Theogony* and a lost *Titanomachia* attributed to Eumelos, a semi-legendary bard of Corinth. See M. L. West, "'Eumelos': A Corinthian Epic Cycle?," *JHS* 122 (2002): 109–33; M. L. West, *Hellenica* (Oxford: Oxford University Press, 2011), 355. See also Dörig and Gigon, *Götter und Titanen.*

20. The term "boundary catastrophe" is used by Scodel, "Achaean Wall," 36, 48, 50, where she describes the Trojan War as a catastrophe that serves as a boundary between the heroes and later, weaker generations, that is, between mythical and truly historical time. I extend the term here to include floods and cosmic wars as well.

21. Hesiod, *Theogony* 424, 486, as discussed by West, *Indo-European Poetry and Myth,* 162–64. For an overview of Near Eastern influence on Archaic Greece, see W. Burkert, *The Orientalizing Revolution: Near Eastern Influence on Greek Culture in the Early Archaic Age* (Cambridge, Mass.: Harvard University Press, 1992), 94–95.

22. West, *Indo-European Poetry and Myth,* 162–63.

23. Ibid., 162–65; Ataç, *Mythology of Kingship,* 172.

24. West, *Indo-European Poetry and Myth,* 166.

25. Ibid., 248.

26. Clemente Marconi employs this term to describe the experience of Archaic Greek sanctuaries; see Marconi, "Kosmos," 222; the phrase is first used by R. Otto, *The Idea of the Holy* (London: Oxford University Press, 1928), 12–25, and by A. Huxley, *The Doors of Perception* (London: Chatto & Windus, 1954), 43.

27. G. Rodenwaldt, *Korkyra: Die Bildwerke des Artemistempels von Korkyra II* (Berlin: Mann, 1939), 15–105; J. L. Benson, "The Central Group of the Corfu Pediment," in *Gestalt und Geschichte: Festschrift Karl Schefold zu seinem Sechzigsten Geburstag am 26. Januar 1965,* ed. M. Rohde-Liegle and K. Schefold (Bern: Francke, 1967), 48–60.

28. Kypselos took control of Corinth in 657 B.C., and in around 620 Theagenes became tyrant at Megara and Kleisthenes at Sikyon, where remains of a seventh-century shrine have been found beneath the sixth-century temple. Though these tyrants seized power unconstitutionally, they were regarded by the masses as preferable to rule by aristocracy or oligarchy. See P. H. Young, "Building Projects Under the Greek Tyrants" (Ph.D. diss., University of Pennsylvania, 1980).

29. For the temple of Apollo at Corinth: R. Rhodes, "Early Corinthian Architecture and the Origins of the Doric Order," *AJA* 91 (1987): 477–80. For the temple of Poseidon at Isthmia: O. Broneer, *Isthmia: Excavations by the University of Chicago, Under the Auspices of the American School of Classical Studies at Athens* (Princeton, N.J.: American School of Classical Studies at Athens, 1971); Broneer, *Isthmia: Topography and Architecture*; E. Gebhard, "The Archaic Temple at Isthmia: Techniques of Construction," in *Archaische griechische Tempel und Altägypten,* ed. M. Bietak (Vienna: Österreichische Akademie der Wissenschaften, 2001). For broader context see A. Mazarakis-Ainian, *From Rulers' Dwellings to Temples: Architecture, Religion, and Society in Early Iron Age Greece (1100–700 B.C.)* (Jonsered: Paul Åström, 1997), 125–35.

30. By 630 B.C. at Thermon in Aetolia, the first mainland Greek temple measuring

a hundred feet long (*hekatompedon*) with wooden columns wrapping around all four sides was constructed (in both respects it followed the second-phase temple of Hera at Samos, ca. 675–625 B.C.). For the temple of Apollo at Thermon: J. A. Bundgaard, "À propos de la date de la péristasis du Mégaron B à Thermos," *BCH* 70 (1946): 51–57. For the temple of Hera on Samos: O. Reuther, *Der Heratempel von Samos: Der Bau seit der Zeit des Polykrates* (Berlin: Mann, 1957); N. Hellner, "Recent Studies on the Polycratian Temple of Hera on Samos," *Architectura: Zeitschrift für Geschichte der Baukunst* 25 (1995): 121–27. The temple of Hera and Zeus at Olympia (ca. 600 B.C.) had a colonnade of wooden columns set on stone socles, while the temple of Artemis at Kerkyra (580 B.C.) had a colonnade of limestone columns.

31. Kyle, *Athletics in Ancient Athens*, 30. For Solon, see J. Blok and A. P. M. H. Lardinois, *Solon of Athens: New Historical and Philological Approaches* (Leiden: Brill, 2006).

32. Kyle, *Athletics in Ancient Athens*, 20, 104.

33. *IG* I³ 507, ca. 565 B.C. See A. Raubitschek, *Dedications from the Athenian Akropolis: A Catalogue of the Inscriptions of the Sixth and Fifth Centuries B.C.* (Cambridge, Mass.: Archaeological Institute of America, 1949), 305–53 (no. 326) and 353–58 (nos. 327 and 328); Kyle, *Athletics in Ancient Athens*, 26–27.

34. Marcellinus, *Life of Thucydides* 3: "Hippokleides in whose archonship the Panathenaia were instituted" was archon in 566/565 B.C.; and Eusebios, *Chronica on Olympic* 53.3–4: "Agon gymnicus, quem Panathenaeon vocant, actus." For the date of 566 B.C. as the inauguration of the Great Panathenaia see Kyle, *Athletics in Ancient Athens*, 25–31; V. Ehrenberg, *From Solon to Socrates* (London: Methuen, 1968), 82–83.

35. Scholiast on Aelius Aristides's *Panathenaic Oration* 13.189.4–5 = Dindorf 3:323 credits the introduction of the festival to Peisistratos.

36. Aristotle, *Athenian Constitution* 13. For discussion of these families and their roles in shaping the conditions from which Athenian democracy emerged, see Camp, "Before Democracy," 7–12.

37. Aristotle, *Athenian Constitution* 16.9.

38. The hypothetical visualization shown on insert page 2 (bottom) is not a scientific reconstruction but is meant only to help the reader understand the placement of the early temples on the Akropolis. For scientific treatment, see Korres, "Die Athena-Tempel auf der Akropolis"; Korres, "Athenian Classical Architecture," 7; Korres, "History of the Acropolis Monuments," 38; Korres, "Recent Discoveries on the Acropolis," 178.

39. Head and belt of Gorgon figure are Acropolis no. 701 in Acropolis Museum, Athens. Some have identified this figure as an akroterion, but Korres has shown that it cannot be.

40. Snakes in corners of the gables are Acropolis Museum no. 37 and no. 40.

41. For overview see Bancroft, "Problems Concerning the Archaic Acropolis," 26–45; Ridgway, *Archaic Style*, 284–85; Hurwit, *Athenian Acropolis,* 107–12; Knell, *Mythos und Polis,* 1–6; Dinsmoor, "The Hekatompedon on the Athenian Acropolis," and for more recent study of these questions, N. L. Klein, "The Origin of the Doric Order on the Mainland of Greece: Form and Function of the Geison in the Archaic Period" (Ph.D. diss., Bryn Mawr College, 1991), 7–16.

42. Dinsmoor, "Hekatompedon on the Athenian Acropolis," 145–47, assigned this group to the east pediment of the temple, though this cannot be known. Reconstructions of the temple's pedimental compositions were offered early on by T. Wiegand, *Die archaische Poros-Architektur der Akropolis zu Athen* (Cassel: Fisher, 1904), and R. Heberdey, *Altattische Porosskulptur, ein Beitrag zur Geschichte der archaischen griechischen Kunst* (Vienna: Hölder, 1919). See also W. H. Schuchhardt, "Die Sima des alten Athena-Tempels der Akropolis," *AM* (1935–1936): 60–61; Korres, "History of the Acropolis Monuments," 38.

43. The "Bluebeard Monster" was first identified as Typhon by Harrison, *Primitive Athens as Described by Thucydides,* 27. Boardman, "Herakles, Peisistratos, and Sons," 71–72, suggests the beast represents the "body politic" of Athens in which the people of the plains, the people of the coast, and the people of the mountains are signaled by what is held in the monster's hands: water, cornstalks, and a bird. The Bluebeard Monster has also been identified as the triple-bodied Geryon; as a composite of Okeanos, Pontos, and Aither; as wind divinities known as the Tritopatores; as Zeus Herkeios; as Nereus; as Proteus; and even as Erechtheus. For an overview of these various interpretations, see F. Brommer, "Der Dreileibige," *Marburger Winckelmann-Programm* (1947): 1–4; Ridgway, *Archaic Style,* 283–88; Hurwit, *Athenian Acropolis,* 106–14.

44. Munich, Staatliche Antikensammlungen Inv. 596, by the Inscription Painter. M. Beard, *The Invention of Jane Harrison* (Cambridge, Mass.: Harvard University Press, 2000), 103–5, is quick to dismiss Harrison's association of this image with the Bluebeard Monster, though it has held up well over time; see U. Höckmann, "Zeus besiegt Typhon," *AA* (1991): 11–23. While there are, of course, methodological difficulties in relating images from monumental stone sculpture to those from vase painting, when dealing with such early periods for which the surviving corpus of images is slight and iconographies are not yet "codified," one must look as broadly as possible across surviving material culture.

45. *Hymn to Pythian Apollo,* 305–10.

46. Ibid., 305–15. I am indebted to Nickolas Pappas for making this point.

47. As West has shown, *Indo-European Poetry and Myth,* 253, 255–57, Zeus kills Typhon, just as Baal fights Yam and Mot in the Ugaritic Baal Cycle, just as Kumarbi fights Ullikummi in the Hurrian-Hittite *Song of Ullikummi,* and just as Marduk fights Tiamat in Babylonian myth. For dragon myths and serpent cult in the Greek and Roman worlds, see Ogden, *Drakon.*

48. Apollodoros, *Library* 1.6.3. For full discussion of Typhon, see Ogden, *Drakon,* 69–80.

49. Hesiod, *Theogony* 820.

50. Ridgway, *Archaic Style,* 286, points to holes drilled in the upper body of the centermost demon of the Bluebeard Monster (for the attachment of snakes?) and to a scar on his chest indicating he has been wounded. Shield bands from Olympia show Typhon with multiple snakes coming out of his head and shoulders, *LIMC* 8, s.v. "Typhon," nos. 16–19.

51. Apollodoros, *Library* 1.6.3.

52. Translation: West, *Hesiod: Theogony,* 27.

53. Translation: ibid., 28.

54. Acropolis no. 36. Ridgway, *Archaic Style,* 286; Boardman, "Herakles, Peisistratos, and Sons," 71–72.

55. Geison, Acropolis no. 4572; painted gutter, Acropolis no. 3934; painted images of water birds, Heberdey, *Altattische Porosskulptur.*

56. Oppian, *Halieutica* 3.7–8 and 3.208–9; Nonnus, *Dionysiaca* 1.137–2.712.

57. I thank Nancy Klein for helpful discussion of this point.

58. Dörpfeld, "Parthenon I, II und III." Claw chisel marks, identified on the foundations of the temple but not on the sculptures, have led to the conclusion that in fact the two cannot be associated, see Plommer, "Archaic Acropolis"; Beyer, "Die Reliefgiebel des alten Athena-Tempels der Akropolis"; Preisshofen, *Untersuchungen zur Darstellung des Greisenalters.* Summarized in Hurwit, *Athenian Acropolis,* 111–12; Bancroft, *Problems Concerning the Archaic Acropolis,* 50.

59. For a complete analysis of the Hekatompedon Inscription and restoration of the text, see P. A. Butz, *The Art of the Hekatompedon Inscription and the Birth of the Stoikhedon Style* (Leiden: Brill, 2010). R. S. Stroud provides additional commentary and bibliography in "Adolph Wilhelm and the Date of the Hekatompedon Decrees,"

in *Attikai epigraphai: Praktika symposiou eis mnemen A. Wilhelm (1864–1950)*, ed. A. P. Matthaiou (Athens: Hellenike Epigraphike, 2004), 85–97. A. Stewart examines the larger context of the Hekatompedon Inscription in his study of Acropolis stratigraphy, "The Persian and Carthaginian Invasions of 480 B.C.E., Part 1." See also G. Németh, *Hekatompedon: Studies in Greek Epigraphy*, vol. 1 (Debrecen: Kossuth Lajos University, Department of Ancient History, 1997).

60. Korres, "Die Athena-Tempel auf der Akropolis"; Korres, "History of the Acropolis Monuments," 38; Dinsmoor, "Hekatompedon on the Athenian Acropolis"; W. B. Dinsmoor Jr., *The Propylaia to the Athenian Akropolis* (Princeton, N.J.: American School of Classical Studies at Athens, 1980), 1:28–30; Ridgway, *Archaic Style,* 283; Childs, "Date of the Old Temple of Athena on the Athenian Acropolis," 1, 5n14.

61. Harpokration, s.v. Ἑκατόμπεδον, says Mnesikles and Kallikrates called the Parthenon *hekatompedon,* as did Plutarch, *Life of Perikles* 13.4; *Life of Cato* 5.3. See Roux, "Pourquoi le Parthénon?," 304–5; Harris, *Treasures of the Parthenon and Erechtheion,* 2–5; C. J. Herrington, *Athena Parthenos and Athena Polias* (Manchester: Manchester University Press, 1955), 13; Hurwit, *Athenian Acropolis,* 161–63. For find spots of poros sculpture, see Heberdey, *Altattische Porosskulptur.* I thank Professor Manolis Korres for discussing this point with me. See A. Stewart, "The Persian and Carthaginian Invasions of 480 B.C.E.," 395–402.

62. As pointed out by Ridgway, *Archaic Style,* 287, who also notes that stone fragments of what looks to be a winged monster with snaky body have been found on Samos, perhaps providing an iconographic parallel to the Hekatompedon's Bluebeard Monster/Typhon. See B. Freyer-Schauenburg, *Bildwerke der archaischen Zeit und des strengen Stils,* Samos 11 (Bonn: Rudolf Habelt, 1974), nos. 111–12, 191n84. Ridgway also suggests that the marble relief felines were attached as antae decorations in the Eastern tradition of guardian figures at the doors. M. Korres has suggested that these relief felines may have been placed along the face of the architrave, at the corners of the building, in an arrangement similar to that seen on the Archaic temple at Didyma (personal communication with M. Korres).

63. Hurwit, *Athenian Acropolis,* 115–16.

64. See the forthcoming article by N. L. Klein, "Topography of the Athenian Acropolis Before Pericles: The Evidence of the Small Limestone Buildings," in which she proposes modifications to the traditional dating. Klein places Building A around 560–550 B.C.; Buildings B and C in the second half of the sixth century; and Buildings D and E in the early fifth century. See also Ridgway, *Archaic Style,* 287–91; Bancroft, "Problems Concerning the Archaic Acropolis," 46–76; N. Bookidis, "A Study of the Use and Geographical Distribution of Architectural Sculpture in the Archaic Period (Greece, East Greece, and Magna Graecia)" (Ph.D. diss., Bryn Mawr College, 1967), 22–33.

65. Acropolis no. 1. For Hydra, see Ogden, *Drakon,* 26–28. For poros pediment, see N. L. Klein, "A Reconstruction of the Small Poros Buildings on the Athenian Acropolis," *AJA* 95 (1991): 335 (abstract); Ridgway, *Archaic Style,* 287–88; W. H. Schuchhardt, "Archaische Bauten auf der Akropolis von Athen," *AA* 78 (1963): 812, figs. 13–44. There is a second small pediment, Acropolis Museum no. 2, painted in deep red (and therefore nicknamed the "Red Triton Pediment") that similarly shows Herakles fighting the Triton; see Ridgway, *Archaic Style,* 291. For Triton, see Ogden, *Drakon,* 119, 131, 134–35.

66. In Euripides, *Children of Herakles* 87, 125, Iolaos is presented not as the nephew of Herakles but as a very close friend. According to Aristotle, at the tomb of Iolaos at Thebes, homosexual lovers pledged their fidelity to one another, while Iolaos guaranteed their oaths and punished unfaithful lovers. See J. Davidson, *The Greeks and Greek Love: A Radical Reappraisal of Homosexuality in Ancient Greece* (London: Weidenfeld & Nicolson, 2007), 354–56; Plutarch, *Life of Pelopidas* 18.5.

67. J. P. A. van der Vin, "Coins in Athens During the Time of Peisistratos," in *Pei-*

sistratos and the Tyranny: A Reappraisal of the Evidence, ed. H. Sancisi-Weerdenburg (Amsterdam: J. C. Gieben, 2000), 147–53, argues that *Wappenmünzen,* or heraldic coinage, date from the period of Peisistratos and a little later (ca. 550–515 B.C.). See J. H. Kroll, "From Wappenmünzen to Gorgoneia to Owls," *American Numismatic Society Museum Notes* 26 (1981): 10–15, and his 1993 monograph, *The Greek Coins,* where Kroll states, "Athenian numismatics begins with the anepigraphic Wappenmün-zen (heraldic coins), a uniface coinage with changing obverse types" (5). See also Kroll and Waggoner, "Dating the Earliest Coins of Athens, Corinth, and Aegina," 331–33; Lavelle, *Fame, Money, and Power,* 188.

68. Peisistratos is also said to have set up the Altar of the Twelve Gods within the Agora, a monument regarded as the physical center of Athens from which all distances were measured. See Herodotos, *Histories* 2.7; Thucydides, *Peloponnesian War* 6.54; *IG* II² 2640. For discussion see Camp, *Athenian Agora,* 41–42; Camp, "Before Democracy," 10–11; Camp, *Archaeology of Athens,* 32–35; Boersma, *Athenian Building Policy,* 15–16, 20–21; L. M. Gadberry, "The Sanctuary of the Twelve Gods in the Athenian Agora: A Revised View," *Hesperia* 61 (1992): 447–89.

69. Herodotos, *Histories* 1.60.2–5; W. R. Connor, "Tribes, Festivals, and Processions," *JHS* 107 (1987): 40–50.

70. Boardman, "Herakles, Peisistratos, and Sons," 62; J. Boardman, "Herakles, Peisistratos, and the Unconvinced," *JHS* 109 (1989): 158–59; G. Ferrari, "Heracles, Pisistratus, and the Panathenaea," *Métis* 9–10 (1994–1995): 219–26.

71. Herodotos, *Histories* 5.71; Thucydides, *Peloponnesian War* 1.126. See D. Harris-Cline, "Archaic Athens and the Topography of the Kylon Affair," *BSA* 94 (1999): 309–20; D. Nakassis, "Athens, Kylon, and the Dipolieia," in *GRBS* 51 (2011): 527–36.

72. Plutarch, *Life of Solon* 12, embellishes the story with a wonderful twist which has Kylon and his men tying a yellow string around the cult statue to keep themselves attached to Athena's protective powers as they make their way down the Acropolis. The thread snaps just as they pass the altars of the "Accursed Goddesses," and so the archons feel free to kill the escaped hostages on the spot.

73. Shapiro, *Art and Cult Under the Tyrants,* 14–15.

74. Thucydides, *Peloponnesian War* 6.54, says that "they greatly improved the appearance of their city." See Lavelle, *Fame, Money, and Power.*

75. Korres has recently shown that work might have recommenced on the temple at the time of the orator Lykourgos. M. Korres and C. Bouras, eds., *Athens: From the Classical Period to the Present Day* (New Castle, Del.: Oak Knoll Press, 2003), 153. In 174 B.C., King Antiochos IV Epiphanes commissioned the Roman architect Cossutius to complete the giant dipteral temple in the Corinthian order, but the project was later abandoned. During his siege of Athens in 86 B.C., Sulla looted some of the Olympieon's columns. Work did not resume on the temple until the reign of Hadrian when it was completed and a gold and ivory statue of Zeus was installed within. See Pausanias, *Description of Greece* 1.18.6. R. Tölle-Kastenbein, *Das Olympieion in Athen* (Cologne: Böhlau, 1994); Camp, *Archaeology of Athens,* 173–76, 199–201; R. E. Wycherley, *Stones of Athens* (Princeton, N.J.: Princeton University Press, 1978).

76. Thucydides, *Peloponnesian War* 2.20.2; Aristotle, *Politics* 1311a; Pausanias, *Description of Greece* 1.23.1–2. When Harmodios's sister was invited, then rejected, as basket-bearer at the festival, the lovers decided to kill the Peisistratids, succeeding only in the murder of Harmodios.

77. Ober, *Democracy and Knowledge,* 138–39.

78. Ibid., 12, defines *demokratia* as "the capacity [of the people, or demos] to act in order to effect change."

79. See J. Ober, *Athenian Legacies: Essays on the Politics of Going on Together* (Princeton, N.J.: Princeton University Press, 2005), 36–42, for a helpful summary.

80. Scholia on Aristophanes, *Knights* 566a (II), repeated by *Suda,* s.v. πέπλος. For

Gigantomachy in Attic vase painting, see Shapiro, *Art and Cult Under the Tyrants,* 28, 38–40, 42; Shear, "Polis and Panathenaia," 35–38; T. H. Carpenter, *Art and Myth in Ancient Greece* (London: Thames and Hudson, 1991), 74; Vian, *La guerre des géants,* 246; M. B. Moore, "Lydos and the Gigantomachy," *AJA* 83 (1979): 79–99.

81. Pausanias, *Description of Greece* 8.47.1.

82. *Suda,* s.v. Γιγαντιαί.

83. Apollodoros, *Library* 1.35; Euripides, *Ion* 209–11; Euripides, *Herakles* 908; Euripides, *Cyklops* 5–8; Kallimachos, *Fragmenta* 382 (from Choerobus, ca. third century B.C.).

84. Scholars had long dated the temple to around 520 B.C. under the regime of the Peisistratids, but the building has now been persuasively down dated to the early years of Kleisthenes's leadership, certainly after 508 B.C. See Childs, "Date of the Old Temple of Athena on the Athenian Acropolis"; Korres, "History of the Acropolis Monuments," 38–39; K. Stähler, "Zur Rekonstruktion und Datierung des Gigantomachiegiebels von der Akropolis," in *Antike und Universalgeschichte: Festschrift Hans Erich Stier* (Münster, 1972), 88–91; Stewart, "Persian and Carthaginian Invasions of 480 B.C.E.," 377–412 and 581–615; Kissas, *Archaische Architektur der Athener Akropolis.* Against this view, see Croissant, "Observations sur la date et le style du fronton de la gigantomachie"; Ridgway, *Archaic Style,* 291–95; Santi, *I frontoni arcaici dell'Acropoli di Atene,* reviewed by Stewart, *AJA* 116 (2012), www.ajaonline.org/sites/default/files/1162_Stewart.pdf.

85. Acropolis nos. 631 A–C (Giants and Athena) and Acropolis nos. 6454 and 15244 (horses). This pediment has been reconstructed by M. Moore, "The Central Group in the Gigantomachy of the Old Athena Temple on the Acropolis," *AJA* 99 (1995): 633–69, with a full chariot at its center, transporting Zeus and, possibly, Herakles into battle while Athena and other gods fight Giants at either side, a reconstruction rejected by Santi, *I frontoni arcaici dell'Acropoli di Atene,* and Croissant, "Observations sur la date et le style du fronton de la gigantomachie." See Stewart, *AJA* 116 (2012), www.ajaonline.org/sites/default/files/1162_Stewart.pdf. For reconstructions of pedimental compositions see Beyer, "Die Reliefgiebel des alten Athena-Tempels der Akropolis"; H. Schrader, *Die archaischen Marmorbildwerke der Akropolis* (Frankfurt: V. Klostermann, 1939), 345–86. For Athena in the Gigantomachy in Greek iconography, see *LIMC* 2, s.v. "Athena," nos. 381–404.

86. See Dörpfeld, "Parthenon I, II und III"; Childs, "Date of the Old Temple of Athena on the Athenian Acropolis," 1; G. Gruben, "Die Tempel der Akropolis," *Boreas* 1 (1978): 28–31.

87. Lion's-head waterspout, Acropolis nos. 69 and 70; Nike akroterion, Acropolis no. 694. See Ridgway, *Archaic Style,* 151–52, for discussion of akroterion; M. Brouskari, *The Acropolis Museum* (Athens: Commercial Bank of Greece, 1974), 58.

88. Charioteer, Acropolis no. 1342; Hermes, Acropolis no. 1343. See Ridgway, *Prayers in Stone,* 199; Ridgway, *Archaic Style,* 395–97.

89. Pausanias, *Description of Greece* 1.26.6; Athenagoras, *Embassy for the Christians* 17.

90. Mansfield, "Robe of Athena," 138–39, 185–88.

91. Pausanias, *Description of Greece* 1.26.5; Hurwit, *Athenian Acropolis,* 122–23.

92. They were first identified as belonging to the megaron of the Mycenaean palace by S. Iakovidis, *He Mykenaïke akropolis ton Athenon* (Athens: Panepistemion Philosophike Schole, 1962), 63–65, but later down dated by C. Nylander to the seventh century B.C.; see Nylander, "Die sog. mykenischen Siulenbasen auf der Akropolis in Athens," *OpAth* 4 (1962): 31–77. See also Korres, "Athenian Classical Architecture," who points out that one of these column bases had been moved out of *situ* already in the late nineteenth century. See also Glowacki, "Acropolis of Athens Before 566 B.C.," 82.

93. Homer, *Iliad* 2.546–51.

94. Mycenae: N. L. Klein, "Excavation of the Greek Temples at Mycenae by the British School at Athens," *BSA* 92 (1997): 247–322; N. L. Klein, "A New Study of the Archaic and Hellenistic Temples at Mycenae," *AJA* 97 (1993): 336–37 (abstract); B. E. French, *Mycenae: Agamemnon's Capital* (Gloucestershire: Tempus, 2002), 135–38. Tiryns: E.-L. Schwandner, "Archaische Spolien aus Tiryns 1982/83," *AA* 103 (1987): 268–84; Antonaccio, *Archaeology of Ancestors,* 147–97. Athens: Glowacki, "Acropolis of Athens Before 566 B.C.," 80.

95. National Archaeological Museum 13050, now in the Acropolis Museum. See Hurwit, *Athenian Acropolis,* 97–98; E. Touloupa, "Une Gorgone en bronze de l'Acropole," *BCH* 93 (1969): 862–64; Ridgway, *Archaic Style,* 305. For a discussion of a painted metope fragment that might also belong to this shrine, as well as associated terra-cotta members, see Glowacki, "Acropolis of Athens Before 566 B.C.," 80.

96. Korres, "Athenian Classical Architecture," 9; Korres, "Die Athena-Tempel auf der Akropolis,"; Dörpfeld, "Parthenon I, II und III"; Dinsmoor, "Older Parthenon, Additional Notes."

97. Dinsmoor, "Date of the Older Parthenon"; Miles, "Lapis Primus and the Older Parthenon," 663; for an overview, see Hurwit, *Athenian Acropolis,* 105–35; Kissas, *Archaische Architektur der Athener Akropolis,* 99–110.

98. Plutarch, *Life of Theseus* 35.

99. Herodotos, *Histories* 6.117; Pausanias, *Description of Greece* 1.32.3. The Plataian allies lost just eleven soldiers; see S. Marinatos, "From the Silent Earth," *Archaiologika Analekta ex Athenon* 3 (1970): 61–68.

100. Pausanias, *Description of Greece* 1.32.3; E. Vanderpool, "A Monument to the Battle of Marathon," *Hesperia* 35 (1966): 93–105; P. Valavanis, "Σκέψεις ως προς τις ταφικές πρακτικές για τους νεκρούς της μάχης του Μαραθώνος," in Μαραθών η μάχη και ο αρχαίος Δήμος (*Marathon: The Battle and the Ancient Deme*), ed. K. Buraselis and K. Meidani (Athens: Institut du livre–A. Kardamitsa, 2010), 73–98; N. G. L. Hammond, "The Campaign and the Battle of Marathon," *JHS* 88 (1968): 14–17.

101. Korres, "Architecture of the Parthenon," 56; Korres, "History of the Acropolis Monuments," 41; Dinsmoor, "Date of the Older Parthenon"; W. Kolbe, "Die Neugestaltung der Akropolis nach den Perserkriegen," *JdI* (1936): 1–64. Hurwit, *Athenian Acropolis,* 133.

102. Korres, *Stones of the Parthenon;* Korres, *From Pentelicon to the Parthenon.* The foundation pedestal measures 31.4 by 76 meters (103 by 249 feet).

103. The hypothetical visualization shown on page 72 is not a scientific reconstruction. Korres, "History of the Acropolis Monuments," 42, notes that only the lowest blocks of the inner walls were in place at that time.

104. Ibid.; Korres, *From Pentelicon to the Parthenon,* 107–8.

105. In 483, Themistokles had argued that the revenue from the Laureion silver mines should be used for the building of a fleet. For the building of the Athenian navy, and Themistokles's victory at Salamis, see Hale, *Lords of the Sea,* and B. S. Strauss, *The Battle of Salamis: The Naval Encounter That Saved Greece—and Western Civilization* (New York: Simon & Schuster, 2004).

106. Thucydides, *Peloponnesian War* 1.93.1–3.

107. See M. Korres, "On the North Acropolis Wall," and "Topographic Issues of the Acropolis: The Pre-Parthenon, Parthenon I, Parthenon II," in *Archaeology of the City of Athens,* http://www.eie.gr/archaeologia/En/chapter_more_3.aspx, for full discussion of history of scholarship on the display of these blocks in the Acropolis north fortification wall. Korres explains that the display was first studied in 1807 by W. M. Leake, who identified it as what Hesychios had in mind when he wrote (s.v. ἑκατόμπεδος) ". . . νεὼς ἐν τῇ Ἀκροπόλει τῇ Παρθένᾳ κατασκευασθεὶς ὑπὸ Ἀθηναίων, μείζων τοῦ ἐμπρησθέντος ὑπὸ τῶν Περσῶν ποσὶ πεντήκοντα." Thereafter, several scholars attributed both the column drums and the triglyph-metope entablature (set in the wall just to the south of the repositioned column drums) as coming from the Older Parthenon. This was corrected

by W. Dörpfeld, "Der alte Athena-Tempel auf der Akropolis zu Athen," *AM* 10 (1885): 275–77, who understood that the triglyph-metope and architrave blocks came not from the Older Parthenon, but from the Old Athena Temple.

108. Ferrari, "Ancient Temple on the Acropolis at Athens," 14–16, 25–28, argues that Dörpfeld was correct in his hypothesis that the Old Athena Temple remained standing, albeit without a peristyle, until the end of antiquity. See W. Dörpfeld, "Der alte Athenatempel auf der Akropolis II," *AM* 12 (1887): 25–61; W. Dörpfeld, "Der alte Athenatempel auf der Akropolis III," *AM* 12 (1887): 190–211; W. Dörpfeld, "Der alte Athenatempel auf der Akropolis IV," *AM* 15 (1890): 420–39; W. Dörpfeld, "Der alte Athenatempel auf der Akropolis V," *AM* 22 (1897): 159–78; W. Dörpfeld, "Das Hekatompedonin Athens," *JdI* 34 (1919): 39. Contra Ferrari, see Kissas, *Archaische Architektur der Athener Akropolis* and J. Pakkanen, "The Erechtheion Construction Work Inventory (*IG* I³ 474) and the Dörpfeld Temple," *AJA* 110 (2006): 275–81. Korres, "History of the Acropolis Monuments," 42, 46–47, allows for the survival of the cella of the Old Athena Temple. See Paton et al., *Erechtheum,* 473–74, and Hurwit, *Athenian Acropolis,* 142–44, 159, for the opisthodomos of the temple as being repaired and serving as a treasury long after the Persian destruction. T. Linders, "The Location of the Opisthodomos: Evidence from the Temple of Athena Parthenos Inventories," *AJA* 111 (2007): 777–82, argues that the opisthodomos of the Old Athena Temple was destroyed by fire in 406/405 B.C. and thereafter was no longer used as a treasury. This function was then transferred to the Erechtheion.

3 PERIKLEAN POMP

1. Plutarch, *Life of Perikles* 4–6.

2. Aristophanes, *Archarnians* 528–29, speaks of Perikles "on his Olympian height," letting loose thunderbolts.

3. Ancient sources on Perikles are collected in S. V. Tracy, *Pericles: A Sourcebook and Reader* (Berkeley: University of California Press, 2009); for shorter overviews, see V. Azoulay, *Périclès: La démocratie athénienne à l'épreuve du grand homme* (Paris: Armand Colin, 2010), 12–19; Will, *Perikles,* 12–22. The bibliography on Perikles is immense. See, among others: C. Schubert, *Perikles: Tyrann oder Demokrat?* (Stuttgart: Reclam, 2012); G. A. Lehmann, *Perikles: Staatsmann und Stratege im klassischen Athen: Eine Biographie* (Munich: C. H. Beck, 2008); C. Mossé, *Périclès: L'inventeur de la démocratie* (Paris: Payot, 2005); Podlecki, *Perikles and His Circle;* Will, *Perikles;* C. Schubert, *Perikles* (Darmstadt: Wissenschaftliche Buchgesellschaft, 1994); Kagan, *Pericles of Athens.*

4. This came after Miltiades's failed clandestine expedition against Paros in 488 B.C. For the rivalry of Perikles and Kimon, see Podlecki, *Perikles and His Circle,* 5–45; Carpenter, *Architects of the Parthenon,* 69–81.

5. Plutarch, *Life of Kimon* 13.7–8. See Martin-McAuliffe and Papadopoulos, "Framing Victory"; Camp, *Archaeology of Athens,* 63–72; C. Delvoye, "Art et politique à Athènes à l'époque de Cimon," in *Le monde grec: Pensée, littérature, histoire, documents: Hommages à Claire Préaux,* ed. J. Bingen, G. Cambier, and G. Nachtergael (Brussels: Université de Bruxelles, 1975), 801–7; Carpenter, *Architects of the Parthenon,* 69–81; Boersma, *Athenian Building Policy,* 42–64.

6. Plutarch, *Life of Perikles* 10.2. Translation: Kagan, *Pericles of Athens,* 83.

7. Aristotle, *Athenian Constitution* 22.5.

8. Plutarch, *Life of Perikles* 37.2–5; Aristotle, *Athenian Constitution* 26.3. For various interpretations of the law, see J. Blok, "Perikles' Citizenship Law: A New Perspective," *Historia* 58 (2009): 141–70; I. A. Vartsos, "Fifth Century Athens: Citizens and Citizenship," *Parnassos* 50 (2008): 65–74; Podlecki, *Perikles and His Circle,* 159–61; C. Leduc, "Citoyenneté et parenté dans la cité des Athéniens: De Solon à Périclès,"

Métis 9–10 (1994–1995): 51–68; A. French, "Pericles' Citizenship Law," *Ancient History Bulletin* 8 (1994): 71–75; A. Boegehold, "Perikles' Citizenship Law of 451/0 B.C.";
K. R. Walters, "Perikles' Citizenship Law," *ClAnt* 2 (1983): 314–36; C. Patterson, *Pericles' Citizenship Law of 451–50 B.C.* (Salem, N.H.: Ayer, 1981); Davies, "Athenian Citizenship"; S. C. Humphreys, "The Nothoi of Kynosarges," *JHS* 94 (1974): 88–95;
A. W. Gomme, "Two Problems of Athenian Citizenship Law," *CP* 29 (1934): 123–40.

 9. Connelly, *Portrait of a Priestess*, 198–202.

 10. Plato, *Phaidros* 269e; Thucydides, *Peloponnesian War* 2.35.

 11. Plato, *Protagoras* 319e–320a; Plato, *Gorgias* 515d–516d; *Suda*, s.v. Περικλῆς.

 12. Translation: Tracy, *Pericles*, 28. See Mario Telò, *Eupolidis Demi*, Biblioteca nazionale, Serie dei classici greci e latini, n.s., 14 (Florence: Felice Le Monnier 2007), frag. 1.

 13. Ferrari, "Ancient Temple on the Acropolis at Athens," 24.

 14. Lykourgos, *Against Leokrates* 81. Translation: Burtt, *Minor Attic Orators, II*, 73.

 15. For inscribed stele dating to third quarter of fourth century B.C. found at Acharnai: D. L. Kellogg, "Οὐκ ἐλάττω παραδώσω τὴν πατρίδα: The Ephebic Oath and the Oath of Plataia in Fourth-Century Athens," *Mouseion* 8 (2008): 355–76; P. Siewert, *Der Eid von Plataia* (Munich: Beck, 1972); G. Daux, "Deux stèles d'Acharne," in Χαριστήριον εἰς Ἀναστάσιον Κ. Ὀρλάνδον (Athens: Archaeological Society, 1965), 1:78–90; A. Blamire, *Plutarch: Life of Kimon* (London: Institute of Classical Studies, 1989), 151–52; J. V. A. Fine, *The Ancient Greeks: A Critical History* (Cambridge, Mass.: Harvard University Press, 1983), 323–28; R. Meiggs, *The Athenian Empire* (Oxford: Clarendon Press, 1972), 504–7. But see also P. M. Krentz, "The Oath of Marathon, Not Plataia?," *Hesperia* 76 (2007): 731–42.

 16. M. Korres, "The Golden Age of Pericles and the Parthenon," in Koutsadelis, *Dialogues on the Acropolis*, 55.

 17. Scholars date the negotiation of the Peace of Kallias from as early as 465 B.C. to circa 449. See E. Badian, *From Plataea to Potidaea* (Baltimore: Johns Hopkins University Press, 1993), 1–72, esp. 19–20, and E. Badian, "The Peace of Callias," *JHS* 107 (1987): 13–14, where it is argued there was a peace negotiated by Kallias after the Battle of Eurymedon that was not kept and that was renewed after Kimon's death. See also L. J. Samons II, "Kimon, Kallias, and Peace with Persia," *Historia* 47 (1998): 129–40; G. L. Cawkwell, "The Peace Between Athens and Persia," *Phoenix* 51 (1997): 115–30; H. B. Mattingly, *The Athenian Empire Restored: Epigraphic and Historical Studies* (Ann Arbor: University of Michigan Press, 1996), 107–16, which reprints a corrected version of H. B. Mattingly, "The Peace of Kallias," *Historia* 14 (1965): 273–81; D. M. Lewis, "The Thirty Years' Peace," in *The Cambridge Ancient History*, 2nd ed., ed. D. M. Lewis, J. Boardman, J. K. Davies, and M. Ostwald (Cambridge, U.K.: Cambridge University Press, 1992), 5:121–27; R. A. Moysey, "Thucydides, Kimon, and the Peace of Kallias," *Ancient History Bulletin* 5 (1991): 30–35; J. Walsh, "The Authenticity and the Dates of the Peace of Callias and the Congress Decree," *Chiron* 11 (1981): 31–63; A. R. Hands, "In Favour of a Peace of Kallias," *Mnemosyne* 28 (1975): 193–95; S. K. Eddy, "On the Peace of Callias," *CP* 65 (1970): 8–14.

 18. Plutarch, *Life of Perikles* 14.1.

 19. Ibid.

 20. According to Plutarch, it was Kimon who first allowed members of the confederation to pay money instead of contributing ships: "Before they knew it, they were tributary subjects rather than allies." *Life of Kimon* 11.1–3. Thucydides, *Peloponnesian War* 1.99, gives the same story but does not mention Kimon. See Carpenter, *Architects of the Parthenon*, 75–76.

 21. I thank Peter Van Alfen of the American Numismatic Association for these calculations, which he bases on wage equivalencies rather than silver commodity prices. If we calculated on the basis of present-day silver commodity prices (ca. $20/

ounce), we'd only get about $10 million for the 600 talents. But silver commodity prices are historically low today. Evidence from the fourth century B.C. shows that the daily wage for a skilled worker at Athens was 1 drachm. This can be estimated, somewhat conservatively, at $100 today. So, 1 drachm = $100; 6000 drachms/talent = $600,000 x 600 = $360,000,000.

22. Thucydides, *Peloponnesian War* 2.13.5; Diodoros Siculus, *Library* 12.40.3.

23. For the term "empire" (ἀρχή), see Thucydides, *Peloponnesian War* 1.67.4, 1.75, 1.76.2, and 1.77.2–3.

24. Lists of the allies and how much they contributed were carved on stone "tribute lists" (*symmachikos phoros*) during the years 454–409 B.C.; B. D. Meritt, H. T. Wade-Gery, and M. F. McGregor, *The Athenian Tribute Lists*, 4 vols. (Cambridge, Mass.: Harvard University Press, 1939–1953). Every year at the great festival of Dionysos Eleutherios (when the dramatic competitions brought tens of thousands of viewers to the theater on the south slope of the Acropolis), ambassadors from the allied states would present their annual tributes for all to see, depositing their offerings in the orchestra of the theater itself. Thus, Athens was glorified in a highly visible spectacle and, importantly, in the presence of foreign Greeks from all across the empire. See S. Goldhill, "The Great Dionysia and Civic Ideology," *JHS* 107 (1987): 58–76; reprinted in *Nothing to Do with Dionysos? Athenian Drama in Its Social Context*, ed. J. J. Winkler and F. I. Zeitlin (Princeton, N.J.: Princeton University Press, 1990), 97–129.

25. Harris, *Treasures of the Parthenon and Erechtheion*, 81–200.

26. Korres, *From Pentelicon to the Parthenon*, 100 with fig. 25 (for the Λ1 quarry); Korres, "Architecture of the Parthenon," 59–65; Burford, "Builders of the Parthenon."

27. Korres, *From Pentelicon to the Parthenon*; Korres, *Stones of the Parthenon*.

28. Korres, "Parthenon," 12; Burford, "Builders of the Parthenon," 32–34.

29. Plutarch, *Life of Perikles* 12; translation of 12.7: Waterfield, *Plutarch: Greek Lives*, 156.

30. Again, I thank Peter Van Alfen for calculating this rough estimate of present-day value.

31. Parthenon construction accounts: *IG* I³ 436–51; cult statue: *IG* I³ 453–60; dedication: Philochoros, *FGrH* 328 F 121. See W. B. Dinsmoor, "Attic Building Accounts I: The Parthenon," *AJA* 17 (1913): 53–80.

32. Korres, *Stones of the Parthenon*, 58, notes that due to the suspension of temple construction following the Persian invasion, there was little work for stonemasons; instead, these craftsmen would have been employed in brick making, shipbuilding, and military campaigns.

33. See J. J. Coulton, "Lifting in Early Greek Architecture," *JHS* 94 (1974): 1–19, esp. 12 and 17, where he dates the first use of the pulley hoist to the late sixth century B.C. Herodotos, *Histories* 7.36, gives us our earliest reference to the winch in Greek literature, reporting that winches were used to tighten the cables that held together the Persians' pontoon bridge, built across the Hellespont in 480 B.C. Of course, winches are known in Egypt from at least the Middle Kingdom: S. Clarke, *Ancient Egyptian Construction and Architecture* (New York: Dover, 1990), and in Assyria from the seventh century: J. Laessøe, "Reflexions on Modern and Ancient Oriental Water Works," *Journal of Cuneiform Studies* 7 (1953): 15–17. By the first century B.C., the block and tackle device was widely used for handling cargo. See Vitruvius, *Ten Books of Architecture* 10.2.2.

34. For Iktinos as architect, see Plutarch, *Life of Perikles* 13.4; Pausanias, *Description of Greece* 8.41.9; Strabo, *Geography* 9.1.12, 16; and Vitruvius, *Ten Books of Architecture* 7 praef. 12. For Kallikrates, see Plutarch, *Life of Perikles* 13.4; M. Korres, s.v. "Iktinos" and "Kallikrates," in *Künstlerlexikon der Antike*, ed. R. Vollkommer (Munich: Saur, 2001), 1:338–45, 387–93; Barletta, "Architecture and Architects of the Classical Parthenon," 88–95; J. R. McCredie, "The Architects of the Parthenon,"

in *Studies in Classical Art and Archaeology: A Tribute to Peter Heinrich von Blanck-enhagen*, ed. G. Kopcke and M. B. Moore (Locust Valley, N.Y.: J. J. Augustin, 1979), 69–73; Carpenter, *Architects of the Parthenon*, 83–158.

35. Vitruvius, *Ten Books of Architecture* 7 praef. 12. See M. Korres, s.v. "Kar-pion," in Vollkommer, *Künstlerlexikon der Antike*, 1:404–5; Barletta, "Architecture and Architects of the Classical Parthenon," 88–95.

36. Plutarch, *Life of Perikles* 13.9 uses the verb *epestatei*—indicating that Phei-dias was a kind of surveyor general.

37. Pausanius, *Description of Greece* 10.10.1–2, sees the statues of Leos, Antio-chos, Aegeus, Akamas, Theseus, and Phileas and then remarks that the images of Anti-gonos, Demetrios, and Ptolemy were later additions to the monument. The other three heroes, Ajax, Oeneus, and Hippothoon, are, however, unmentioned. Perhaps by then their images were removed to make way for those of the Hellenistic kings.

38. Ibid., 1.28.2; Martin-McAuliffe and Papadopoulos, "Framing Victory," 345–46; Hurwit, *Athenian Acropolis*, 152.

39. Athenaeus, *Deipnosophists* 13.589, says that, when speaking on her behalf in court, Perikles shed more tears than he did when his own property and life were in danger.

40. Plutarch, *Life of Perikles* 31.4.

41. Miles, "Lapis Primus and the Older Parthenon," 663–66; B. H. Hill, "The Older Parthenon," *AJA* 16 (1912): 535–58; Carpenter advocates for a Kimonian Par-thenon in *Architects of the Parthenon*, 44–68.

42. S. A. Pope, "Financing and Design: The Development of the Parthenon Pro-gram and the Parthenon Building Accounts," in *Miscellanea Mediterranea*, ed. R. R. Holloway, Archaeologia Transatlantica 18 (Providence: Center for Old World Archae-ology and Art, Brown University, 2000), 65–66.

43. Korres, "Athenian Classical Architecture," 9–13.

44. Korres, "Der Plan des Parthenon" and "The Architecture of the Parthenon."

45. Korres, "The Architecture of the Parthenon," 84–93; Korres, "Der Plan des Parthenon."

46. Prostyle porches are also regarded as Cycladic features; see Barletta, "Archi-tecture and Architects of the Classical Parthenon," 78–79.

47. Ibid., 81–82, 84, 86–88; Korres, "Architecture of the Parthenon," 84–88; Kor-res, "Parthenon," 22, 46, 52, 54; Korres, "Sculptural Adornment of the Parthenon," 33.

48. Korres, "Die Athena-Tempel auf der Akropolis," 227–29; Korres, "History of the Acropolis Monuments," 45–46; H. Catling, "Archaeology in Greece, 1988–1989," *Archaeological Reports JHS* 35 (1989): 8–9; Ridgway, "Images of Athena," 125.

49. J. M. Hurwit, "The Parthenon and the Temple of Zeus at Olympia," in Bar-ringer and Hurwit, *Periklean Athens*, 135–45; Barringer, "Temple of Zeus at Olym-pia," 8–20.

50. For discussion and full list of inscriptions, see Harris, *Treasures of the Par-thenon and Erechtheion*, 2–8, 103–200. Hurwit, *Athenian Acropolis*, 161–62. Accord-ing to Harpokration, s.v. Ἑκατόμπεδον, Mnesikles and Kallikrates used this term for the entire building; Plutarch, *Life of Perikles* 13.4, refers to the Parthenon as the "Hekatompedon Parthenon."

51. A two-tier interior colonnade can be seen even earlier at the temple of Aphaia on Aegina, built around 500 B.C. Here, it forms a perforated screen that partially hides the walls of the cella, while enclosing the cult image at the sides and back. This makes the space seem less comprehensible, bigger, and more interesting, with ever-changing light and shadows adding to the mystery of the space. I am grateful to Richard C. Anderson for helpful discussions here. See Korres, "Architecture of the Parthenon," 65, 93; Korres, "Parthenon," 48; Korres, "Sculptural Adornment of the Parthenon," 176.

52. For mention of the *parthenon* chamber in the inventories, see *IG* I³ 343.4

(434/433 B.C.); *IG* I³ 344.19 (433/432 B.C.); *IG* I³ 346.55 (431/430 B.C.); *IG* I³ 350.65 (427/426 B.C.); *IG* I³ 351.5 (422/421 B.C.); *IG* I³ 352.29 (421/420 B.C.); *IG* I³ 353.52 (420/419 B.C.); *IG* I³ 354.73–74 (419/418 B.C.); *IG* I³ 355.5 (414/413 B.C.); *IG* I³ 356.31–32 (413/412 B.C.); *IG* I³ 357.57–58 (412/411 B.C.). See Harris, *Treasures of the Parthenon and Erechtheion*, 1–8, 81–103, 253, and Hurwit, *Athenian Acropolis*, 161–63.

53. Pedersen, *Parthenon and the Origin of the Corinthian Capital*, 11–31, fig. 16; Korres and Bouras, *Studies for the Restoration of the Parthenon*, 1:20; Korres, "Parthenon," 22. On the origin of the Corinthian order, see T. Homolle, "L'origine du chapiteau Corinthien," *RA*, 5th ser., 4 (1916): 17–60; Rykwert, *Dancing Column*, 316–49.

54. Vitruvius, *Ten Books of Architecture* 3.4.5, for optical refinements and horizontal lines, especially those of the stylobate.

55. Korres, "Der Plan des Parthenon," 87.

56. Hurwit, *Athenian Acropolis*, 167 with illustration. The façade columns would meet nearly 5 kilometers (3.1 miles) above the platform. See also Dinsmoor, *Architecture of Ancient Greece*, 165, who claims that the columns project "more than 1½ miles above the pavement."

57. L. Haselberger, "Bending the Truth: Curvature and Other Refinements of the Parthenon," in Neils, *Parthenon*, 101–57; Barletta, "Architecture and Architects of the Classical Parthenon," 72–74.

58. E. Flagg, *The Parthenon Naos* (New York: Charles Scribner's Sons, 1928), 5–9. Flagg maintained that Greek art had measure obtained by rules analogous to those used by the poet and the musician: "Harmony depends on measure as in music, poetry and dance, but the measure should be exact and the proportions of a kind which the eye grasps unconsciously, as it does those of any simple geometric figure." Flagg, known for his design of the Corcoran Gallery of Art (1897) and the U.S. Naval Academy (1901–1908), was sent to study at the École des Beaux-Arts (1889–1891) by Cornelius Vanderbilt, his cousin through marriage to Alice Claypoole Gwynne. Ernest Flagg was the brother of Louisa Flagg Scribner, wife of Charles Scribner II, who commissioned him to design the two Scribner Buildings on Fifth Avenue in New York City, the book warehouse and printing plant on West Forty-Third Street, their town house at 9 East Sixty-Sixth Street, and the Princeton University Press building. I thank Charles Scribner III for sharing with me a copy of Flagg's remarkable book, *The Parthenon Naos*.

59. Korres and Bouras, *Studies for the Restoration of the Parthenon*, Chapter 3, "The Formation of the Building: Its Particular Stones," 1:249, and specific treatment of this question in Chapter 4, "Elastic and Plastic Deformations?," 1:279–85. See also the English summary by D. Hardy and P. Ramp, 685–86. See also Korres, "Der Plan des Parthenon," 55–59; W. S. Williams, B. Trautman, S. Findley, and H. Sobel, "Materials Analysis of Marble from the Parthenon," *Materials Characterization* 29 (1992): 185–94. I thank Professor Korres for discussing this phenomenon with me and for providing many helpful bibliographical references.

60. Korres, "Architecture of the Parthenon," 62.

61. Schwab, "New Evidence," 81–84, argues for changes in Korres's reconstruction of south metope 14. She removes the golden crown from Helios's head and argues that the drill hole above it may have been for the attachment of a bronze sun.

62. J. N. Bremmer, "Greek Demons of the Wilderness: The Case of the Centaurs," in *Wilderness in Mythology and Religion*, ed. L. Feldt (Berlin: De Gruyter, 2012), 25–53.

63. See F. Queyrel, *Le Parthénon*, 136–43. W. B. Dinsmoor wrote of the Nointel Artist; see "The Nointel Artist's 'Vente' and Vernon's Windows," box 21, folder 4, subsection IIe, the Parthenon frieze, and box 21, folder 1, "The Panathenaic Frieze of the Parthenon: Its Content and Arrangement," I. General introduction (November 25, 1948), Dinsmoor Papers in the Archives of the American School of Classical Studies at Athens. On page 4, Dinsmoor says he will use the name Carrey but later

changes his mind. Dinsmoor explains (page 4) that the drawings were first attributed to Jacques Carrey by Grosley (in L. Moréri, *Grand dictionnaire historique* [Paris: J. Vincent, 1732]). Cornelio Magni states that the drawings were by an anonymous Flemish painter (*Quanto di più curioso*, 1679), *Relazione della città d'Athène* (Parma: Rosati, 1688), 65–66. See T. R. Bowie and D. Thimme, *Carrey Drawings of the Parthenon* (Bloomington: Indiana University Press, 1971), 3–4. See Palagia, *Pediments*, 40–45, 61; Castriota, *Myth, Ethos, and Actuality*, 145–50; Brommer, *Die Skulpturen der Parthenon-Giebel*, 6.

64. I am indebted to Cornelia Hadjiaslani and S. Mavrommatis for kindly allowing me to reproduce images from their book *Promenades at the Parthenon*, pages 100–101, insert page 5 (left), and pages 105, 184, 190 (top), 194–95, and 199.

65. Carpenter, *Architects of the Parthenon*, 62–68.

66. M. Robertson, "The South Metopes: Theseus and Daedalus," in Berger, *Parthenon-Kongreß Basel*, 206–8; A. Mantis, "Parthenon Central South Metopes: New Evidence," in Buitron-Oliver, *Interpretation of Architectural Sculpture*, 67–81.

67. Korres, "Der Plan des Parthenon."

68. Barletta, "Architecture and Architects of the Classical Parthenon," 88–95.

69. See the discussion of the Parthenon west metopes, with emphasis on the significance of victorious Amazons and dead Greeks, in N. Arrington's forthcoming book *Ashes, Images, and Memories: The Presence of the War Dead in Fifth-Century Athens*.

70. *Homeric Hymn to Athena*, 9–16. Translation: West, *Homeric Hymns*, 211.

71. For Helios and Selene as shown on the Parthenon, on the base of the Athena Parthenos statue, and on the base of the cult statue of Zeus at Olympia (Pausanias, *Description of Greece* 5.11.8), see Ehrhardt, "Zu Darstellung und Deutung des Gestirngötterpaares am Parthenon." See also Marcadé, "Hélios au Parthenon"; Hurwit, *Athenian Acropolis*, 177–79; Palagia, *Pediments*, 18; Leipen, *Athena Parthenos*, 23–24. W. Dörpfeld, "Der Tempel von Sounion," *AM* 9:336.

72. *Homeric Hymn to Athena*, 1–8. Translation: West, *Homeric Hymns*, 211.

73. See Hurwit, *Athenian Acropolis*, 177–79; Palagia, *Pediments*, 18–39. A Roman marble *puteal* (water wellhead) in the Madrid Archaeological Museum (2691) is decorated with a sculptured relief showing similar iconography, reproduced in Palagia, *Pediments*, 18, fig. 8. For iconography of the Birth of Athena, see *LIMC* 2, s.v. "Athena," nos. 343–373.

74. For a comprehensive summary of interpretations of these figures, see Palagia, *Pediments*, app., 60, 18–39.

75. For sculptures showing women in the birthing position with midwives assisting from behind, see, among many Cypriot examples, a limestone sculpture (said to be from Golgoi) in the Metropolitan Museum of Art 74.51.2698; V. Karageorghis, *Ancient Art from Cyprus: The Cesnola Collection* (New York: Metropolitan Museum of Art, 2000), 262n424. Similar figures carved on Attic grave stelai include: Paris, Louvre Museum MA 7991; Cambridge, Mass., Harvard Art Museums, Sackler Art Museum 1905.8; Athens, Kerameikos Museum P 290; Athens, National Archaeological Museum 749; Athens, Piraeus Museum 21. Similar figures on marble funerary lekythoi include: Paris, Louvre Museum MA 3115; Athens, National Archaeological Museum 1055; Copenhagen, Ny Carlsberg Glyptotek 2564. I am indebted to Viktoria Räuchle for these references and look forward to her forthcoming doctoral dissertation on motherhood: "Zwischen Norm und Natur: Bildliche und schriftliche Konzepte von Mutterschaft im Athen des 5. und 4. Jahrhunderts v. Chr."

76. For Eileithyai, see *LIMC* 3, s.v. "Eileithyia," nos. 1–49, in Birth of Athena scenes. For Metis see L. Raphals, *Knowing Words: Wisdom and Cunning in the Classical Traditions of China and Greece* (Ithaca, N.Y.: Cornell University Press, 1993); M. Detienne and J.-P. Vernant, *Cunning Intelligence in Greek Culture and Society*, trans. J. Lloyd (Atlantic Highlands, N.J.: Humanities Press, 1978).

77. Pausanias, *Description of Greece* 1.24.5; Fuchs, "Zur Rekonstruktion des

Poseidon im Parthenon-Westgiebel"; Spaeth, "Athenians and Eleusinians," 333–36, 341–43; Palagia, *Pediments,* 40–59; Palagia, "Fire from Heaven," 244–50; Hurwit, *Athenian Acropolis,* 174–77.

78. E. Simon, "Die Mittelgruppe im Westgiebel des Parthenon," in *Tainia: Festschrift für Roland Hampe,* ed. H. Cahn and E. Simon (Mainz: Philipp von Zabern, 1980), 239–55. A vase from Pella (Pella Archaeological Museum 80.514) shows a similar scene: the thunderbolt of Zeus is shown between Athena and Poseidon, signaling his intervention/arbitrations. See also an Attic hydria in St. Petersburg, State Hermitage Museum, P 1872.130, from Kerch, ca. 360–350 B.C., which shows Athena and Poseidon on either side of an olive tree; B. Cohen, *The Colors of Clay: Special Techniques in Athenian Vases* (Los Angeles: J. Paul Getty Museum, 2008), 339–41.

79. Pausanias, *Description of Greece* 1.24.5; Hurwit, *Athenian Acropolis,* 174–77; Palagia, *Pediments,* 40–59; Palagia, "Fire from Heaven," 244, 250; Spaeth, "Athenians and Eleusinians," 333–34; Fuchs, "Zur Rekonstruktion des Poseidon im Parthenon-Westgiebel."

80. St. Petersburg, The State Hermitage Museum, P 1872.130, see note 78, above.

81. Herodotos, *Histories* 8.55, tells of Athena's victory in the contest, a story retold in greater detail by Apollodoros, *Library* 3.14.1. See Parker, "Myths of Early Athens," 198n49; Isokrates, *Panathenaikos* 193; scholia on Aelius Aristides, *Panathenaic Oration* 140 (Lenz and Behr) = Dindorf, 3.58–59 = Jebb 106.

82. Apollodoros, *Library* 3.14.1; Pausanias, *Description of Greece* 1.27.2.

83. Pausanias, *Description of Greece* 1.26.6; Strabo, writing in the first century A.D., quotes the words of Hegesias: "I see the Acropolis and the mark of the huge trident there." *Geography* 9.1.16. Translation: H. L. Jones, *The Geography of Strabo* (Cambridge, Mass.: Harvard University Press, 1924), 261.

84. Lesk, "Erechtheion and Its Reception," 161.

85. Pausanias, *Description of Greece* 1.26.5. Translation: W. H. S. Jones, Pausanias, *Description of Greece* (Cambridge, Mass.: Harvard University Press, 1918), 137.

86. A. Murray, *The Sculptures of the Parthenon* (London: John Murray, 1903), 26–27.

87. Pausanias, *Description of Greece* 5.10.7.

88. Palagia gives a wonderfully helpful chart of all the various interpretations and a comprehensive overview of the scholarship in her *Pediments,* app., 61 and 40–59.

89. Advanced by Barbette Spaeth, "Athenians and Eleusinians," 338–60. See also L. Weidauer, "Eumolpos und Athen," *AA* 100 (1985): 209–10; L. Weidauer and I. Krauskopf, "Urkönige in Athen und Eleusis: Neues zur 'Kekrops'—Gruppe des Parthenonwestgiebels," *JdI* 107 (1992): 1–16.

90. Spaeth, "Athenians and Eleusinians," 339–41, 351–54.

91. Pausanias, *Description of Greece* 1.38.3.

92. These identifications are all laid out by Spaeth, "Athenians and Eleusinians," 339ff.

93. Plutarch, *Life of Perikles* 12. Translation: R. Waterfield, *Plutarch: Greek Lives* (Oxford: Oxford University Press, 1998), 155.

94. Plutarch, *Life of Perikles* 12.2. Translation: B. Perrin, *Plutarch's Lives* (Cambridge, Mass.: Harvard University Press, 1916), 3:37.

95. Translation: Waterfield, *Life of Perikles,* 156.

96. Translation: Jowett, *Thucydides,* 6.

97. On the self-assuredness of classical Athenian citizens, see M. R. Christ, *The Bad Citizen in Classical Athens* (Cambridge, U.K.: Cambridge University Press, 2006); M. R. Christ, *The Limits of Altruism in Democratic Athens* (Cambridge, U.K.: Cambridge University Press, 2012), with overview, 1–9; R. Balot, *Greed and Injustice in Classical Athens* (Princeton, N.J.: Princeton University Press, 2001); J. Hesk, *Deception and Democracy in Classical Athens* (New York: Cambridge University Press, 2000).

98. Translation: Jowett, *Thucydides,* 47–48.

99. Sanders, "Beyond the Usual Suspects," 152–53.

100. Translation: Jowett, *Thucydides,* 127.

101. Ibid., 128.

102. Ibid., 129.

103. Ibid., 127, 130.

104. M. Faraguna, G. Oliver, and S. D. Lambert in *Clisthène et Lycurgue d'Athènes,* ed. V. Azoulay and P. Ismar (Paris: Publications de la Sorbonne, 2012), 67–86, 119–31, and 175–90; Habicht, *Athens from Alexander to Antony,* 22–27; Hurwit, *Athenian Acropolis,* 253–60; F. W. Mitchel, *Lycourgan Athens, 338–322 B.C.* (Cincinnati: University of Cincinnati, 1970); F. W. Mitchel, "Athens in the Age of Alexander," *Greece and Rome* 12 (1965): 189–204.

105. Meineck, "Embodied Space."

106. Hintzen-Bohlen, *Die Kulturpolitik des Euboulos und des Lykurg.*

107. See Humphreys, *Strangeness of Gods,* 77.

108. Pseudo-Plutarch, *Lives of the Ten Orators, Lykourgos* 843e–f.

109. Ibid., 843c; Pausanias, *Description of Greece* 1.8.2. Hintzen-Bohlen, *Die Kulturpolitik des Euboulos und des Lykurg.*

110. For Perikles's vision, see Thucydides, *Peloponnesian War* 2.34–46; Humphreys, *Strangeness of Gods,* 120; N. Loraux, *The Invention of Athens: The Funeral Oration in the Classical City* (Cambridge, Mass.: Harvard University Press, 1986), 144–45; S. Yoshitake, "Aretē and the Achievements of the War Dead: The Logic of Praise in the Athenian Funeral Oration," in Pritchard, *War, Democracy, and Culture,* 359–77.

111. Siewert, "Ephebic Oath," 102–11.

112. Humphreys, *Strangeness of Gods,* 103, 104; Steinbock, "A Lesson in Patriotism," 294–99.

113. Lykourgos, *Against Leokrates* 9–10. For compelling discussion of the case and its meaning, see Steinbock, "A Lesson in Patriotism"; Allen, *Why Plato Wrote,* 93; Ober, *Democracy and Knowledge,* 186.

114. Habicht, *Athens from Alexander to Antony,* 27; Ober, *Democracy and Knowledge,* 186–90.

115. Lykourgos, *Against Leokrates* 77. Translation: Burtt, *Minor Attic Orators, II,* 69, 71.

116. Lykourgos, *Against Leokrates* 79. Translation: Burtt, *Minor Attic Orators, II,* 71, 73. For the importance of oaths in Greek antiquity, see A. Sommerstein and A. J. Bayliss, eds., *Oath and State in Ancient Greece* (Berlin: De Gruyter, 2013); D. Lateiner, "Oaths: Theory and Practice in the Histories of Herodotus and Thucydides," in *Thucydides and Herodotus,* ed. E. Foster and D. Lateiner (Oxford: Oxford University Press, 2012), 154–84; A. Sommerstein and J. Fletcher, eds., *Horkos: The Oath in Greek Society* (Exeter: Bristol Phoenix Press, 2007); S. G. Cole, "Oath Ritual and the Male Community at Athens," in *Demokratia: A Conversation on Democracies, Ancient and Modern,* ed. J. Ober and C. Hedrick (Princeton, N.J.: Princeton University Press, 1996), 233–65; J. Plescia, *The Oath and Perjury in Ancient Greece* (Tallahassee: University of Florida Press, 1970).

117. P. Siewert, "Der Eid von Plataiai," *CR,* n.s., 25 (1975): 263–65. The authenticity of the oath has been questioned. See discussion in chapter 5.

118. Lykourgos, *Against Leokrates* 81. Translation: Burtt, *Minor Attic Orators, II,* 73.

119. Lykourgos, *Against Leokrates* 83. Translation: Burtt, *Minor Attic Orators, II,* 75.

120. Lykourgos, *Against Leokrates* 84, 86. Translation: Burtt, *Minor Attic Orators, II,* 75, 77. See Steinbock, "A Lesson in Patriotism," 282–90.

121. Lykourgos, *Against Leokrates* 98–101. Translation of section 100: Burtt, *Minor Attic Orators, II*, 87.

122. Translation is my own, based on passages quoted in Lykourgos, *Against Leocrates*, and the fragments of Euripides's *Erechtheus*, as given in the editon by R. Kannicht, 2004, which will be used throughout this book unless otherwise noted. The "F" appearing before line citations stands for "fragment" throughout.

123. The oath of the daughters of Erechtheus manifests the quintessential "one for all and all for one" principle at work, known to modern audiences as the motto of the Three Musketeers: Athos, Porthos, and Aramis of Alexandre Dumas's classic. A. Dumas, *Les trois mousquetaires*, was first serialized in March–July 1844. Following inundations across the Alps in the autumn of 1868, the slogan was used to marshal solidarity among the Swiss cantons. The German ("einer für alle, alle für einen"), the French ("un pour tous, tous pour un"), and the Italian ("uno per tutti, tutti per uno") versions of the oath came to be associated with the foundational myths of Switzerland, emphasizing unity in the face of adversity. In 1902, the motto was inscribed in Latin, "unus pro omnibus, omnes pro uno," upon the cupola of the Federal Palace of Switzerland in Bern. See S. Summermatter, "'Ein Zoll der Sympathie'—die Bewältigung der Überschwemmungen von 1868 mit Hilfe der eidgenössischen Spendensammlung," *Blätter aus der Walliser Geschichte* 37 (2005): 1–46, at 29, fig. 8.

124. Isokrates, *Demonikos* 13. Translation: D. C. Mirhady and Y. L. Too, *Isocrates I* (Austin: University of Texas Press, 2000).

125. Lykourgos, *Against Leokrates* 101. Translation: Burtt, *Minor Attic Orators, II*, 91.

126. Lykourgos, *Against Leokrates* 100 and Euripides, *Erechtheus* F 360.1 Kannicht. On the importance of not acting slowly, of responding without delay, see discussion by A. Chaniotis, "A Few Things Hellenistic Audiences Appreciated in Musical Performances," in *La musa dimenticata. Aspetti dell'esperienza musicale greca in età ellenistica*, ed. M. C. Martinelli (Pisa: Scuola Normale Superiore 2009), 75–97 and especially 89–92 (on spontaneity).

127. Lykourgos, *Against Leokrates* 101. Translation: Burtt, *Minor Attic Orators, II*, 90–91.

128. Lykourgos, *Against Leokrates* 100. Translation: Burtt, *Minor Attic Orators, II*, 85, 87.

129. Thucydides, *Peloponnesian War* 2.37.2, where the verb used is *mimoumetha*, "we copy." I am indebted to Nickolas Pappas for this observation and to James Diggle for help with the passage.

4 THE ULTIMATE SACRIFICE

1. P. Jouguet, "Rapport sur les fouilles de Médinet-Madi et Médinet Ghoran," *BCH* 25 (1901): 379–411.

2. "Secrets Cooked from a Mummy," *Life* (international ed.), November 15, 1963, 65–82.

3. See C. Austin, "Back from the Dead with Posidippus," in *The New Posidippus: A Hellenistic Poetry Book*, ed. K. Gutzwiller (Oxford: Oxford University Press, 2005), 67–69, and C. Austin, *Menander, Eleven Plays, Proceedings of the Cambridge Philological Society* Supplementary Volume 37 (2013), remarks in preface.

4. Personal communication with Colin Austin.

5. M. A. Schwartz, *Erechtheus et Theseus apud Euripidem et Atthidographos* (Leiden: S. C. van Doesburgh, 1917).

6. The dating of the play is problematic. Kannicht (394) gives the time frame set by Cropp and Fick, that is, sometime after Euripides's *Elektra* (422–417 B.C.) and before his *Helen* (412 B.C.). See M. Cropp and G. Fick, *Resolutions and Chronol-*

ogy in Euripides (London: University of London, 1985), 79–80, who go on to suggest 416 B.C. as the statistically "most likely" date for the first performance of the play. Jouan and Van Looy, *Fragments: Euripides,* 98–99, and Sonnino, *Euripidis Erechthei,* 27–34, give helpful overviews of the various chronologies that have been proposed. Most argue that the *Erechtheus* was first performed around 423/422 B.C., during the one-year armistice between Athens and Sparta, the so-called Peace of Nikias. This is because Plutarch, *Life of Nikias* 9.5, quotes lines from the *Erechtheus* (F 369.2–3 Kannicht), and says these lines could be heard sung by choruses at Athens during this year of the truce. For a date in 423 B.C., see Austin, *Nova fragmenta Euripidea,* 22; M. Treu, "Der Euripideische Erechtheus als Zeugnis seiner Zeit," *Chiron* 1 (1971): 115–31; Carrara, *Euripide: Eretteo,* 13–17; R. Simms, "Eumolpos and the Wars of Athens," *GRBS* 24 (1983): 197–203. For a date in 422 B.C., see Calder, "Date of Euripides' *Erechtheus*"; Clairmont, "Euripides' *Erechtheus* and the Erechtheum"; Calder, "Prof. Calder's Reply." C. Austin, "De nouveaux fragments de l'*Érechthée,*" 17, proposes a date of 421 B.C. or before. Collard, Cropp, and Lee, *Euripides: Selected Fragmentary Plays,* 155, place the play near 420 or shortly thereafter. For dating of the play to ca. 412 B.C., see M. Vickers, "Persepolis, Vitruvius, and the Erechtheum Caryatids: The Iconography of Medism and Servitude," *RA* 1 (1985): 18. It should be noted that Aristophanes quotes from the *Erechtheus* in his *Lysistrata* 1135 (performed in 411 B.C.) and in his *Thesmophoriazusae* 120 (performed in 410 B.C.).

7. Austin, "De nouveaux fragments de l'*Érechthée,*" 12–13n3.

8. Austin, "De nouveaux fragments de l'*Érechthée.*"

9. Austin, *Nova fragmenta Euripidea,* 22–40.

10. Martínez Díez, *Euripides, Erecteo;* Carrara, *Euripide: Eretteo.*

11. M. J. Cropp, "Euripides, Erechtheus," in Collard, Cropp, and Lee, *Euripides: Selected Fragmentary Plays,* 148–94; Collard and Cropp, *Euripides VII: Fragments,* 362–401.

12. Connelly, "Parthenon Frieze and the Sacrifice"; Connelly, "Parthenon and Parthenoi."

13. Stobaeus was a late antique compiler of Greek extracts who lived in Stobi, a city within the Roman province of Macedonia. For citations of the *Erechtheus* in other sources, see Kannicht 390–94. Kannicht's edition of the *Erechtheus* text, 2004, will be used throughout *The Parthenon Enigma* unless otherwise noted.

14. Personal communication with Colin Austin.

15. For Erechtheion building accounts see Paton et al., *Erechtheum,* 277–422, 648–50; *IG* I³ 474–79; Dinsmoor, "The Burning of the Opisthodomos," among others.

16. For an overview of the dating of the Erechtheion, see M. Vickers, "The Caryatids on the Erechtheum at Athens: Questions of chronolopy and symbolism" (in press), 6–16; W. Dörpfeld, "Der ursprünglichen Plan des Erechtheion," *AM* 29 (1904): 101–7, put the start of construction at 435 B.C.; Lesk, "Erechtheion and Its Reception," 68, puts it at 427/426. Those who date the start of work on the Erechtheion to 422/421 include A. M. Michaelis, "Die Zeit des Neubas des Poliastempels in Athen," *AM* 14 (1889): 349, and P. Spagnesi, "L'Eretteo, snodo di trasformazioni sull'Acropoli di Atene," *Quaderni dell'Istituto di Storia dell'Architettura* 9 (2002): 109–14. The discovery of the *Erechtheus* fragments in the 1960s led to the association of the building of the temple with the first performance of the play, perhaps at the City Dionysia of 422/421, see Calder, "Date of Euripides' *Erechtheus.*" See also Clairmont, "Euripides' *Erechtheus* and the Erechtheum"; and Calder, "Prof. Calder's Reply." In *Erechtheus* F 90–91 Kannicht, Athena does seem to allude to the construction of the Erechtheion.

17. West, *Hesiodic Catalogue of Women,* 106.

18. Homer, *Iliad* 2.546–51. Xenophon, *Memorabilia* 3.5.10, says that Erechtheus was nursed by Athena.

19. Homer, *Odyssey* 7.80–81.

20. Herodotos, *Histories* 5.82. For important discussion of Erechtheus and

Athena Polias, see D. Frame, *Hippota Nestor* (Washington, D.C.: Center for Hellenic Studies, 2009), 348–49, 408–13. For joint worship of Erechtheus and Athena, see Mikalson, "Erechtheus and the Panathenaia"; Kearns, *Heroes of Attica,* 210–11; Kron, *Die zehn attischen Phylenheroen; M.* Christopoulos, "Poseidon Erechtheus and ΕΡΕΧΘΗΣ ΘΑΛΑΣΣΑ," in *Ancient Greek Cult Practice from the Archaeological Evidence,* ed. R. Hägg (Stockholm: Svenska Institutet i Athen, 1998), 123–30; Parker, *Athenian Religion,* 19–20; Sourvinou-Inwood, *Athenian Myths and Festivals,* 52.

21. Herodotos, *Histories* 8.44, 8.51, 8.55.

22. Sourvinou-Inwood, *Athenian Myths and Festivals,* 51–89; Kearns, *Heroes of Attica,* 110–15, 160–61; Mikalson, "Erechtheus and the Panathenaia," 141n1; Parker, "Myths of Early Athens," 200–1; Shear, "Polis and Panathenaia," 55–60.

23. Homer, *Iliad* 2.546–51, and Herodotos, *Histories* 8.55, have Erechtheus as born of Earth, as does Sophokles, *Ajax* 201–2. Those who identify Erichthonios as the son of Earth include Pindar, frag. 253; Euripides, *Ion* 20–24, 999–1000; Isokrates, *Panathenaikos* 126; Eratosthenes, *Constellations* 13; Apollodoros, *Library* 3.14.6; and Pausanias, *Description of Greece* 1.2.6, 1.14.6.

24. According to Euripides's *Erechtheus* (F 370.63 Kannicht), Erechtheus is married to Praxithea, daughter of the Kephisos. Lykourgos, *Against Leokrates* 98, and Apollodoros, *Library* 3.15.1, also have Praxithea as the wife of Erechtheus but in Apollodoros, *Library* 3.14.6–7, we hear that Erichthonios is married to Praxithea.

25. The scholia on Aelius Aristides's *Panathenaic Oration* 43 (Lenz and Behr) = Dindorf 3:62 = Jebb 107, 5–6; 1.3.50 (Lenz and Behr) = Dindorf 3.317 = Jebb 187, 2, describe Erechtheus as the inventor of the chariot. The Parian Marble A 10 (*IG* XII, 5 444 = *FGrH* 239, A, lines 1–3; inscribed 264/263 B.C.) tells us that Erichthonios was the first to yoke horses and to institute the Panathenaic Games. See also Eratosthenes, *Constellations* 13; Apollodoros, *Library* 3.14.6. For Erichthonios as the first to celebrate the Panathenaic festival, see Harpokration Π 14 Keaney, s.v. Παναθήναια, which cites Hellanikos, *FGrH* 323a F 2; and Androtion, *FGrH* 324 F 2. See also the scholia on Plato, *Parmenides* 127a. Photios, *Lexicon,* s.v. Παναθήναια; and *Suda,* s.v. Παναθήναια.

26. Apollodoros, *Library* 3.14.6. For Hephaistos, see J. N. Bremmer, "Hephaistos Sweats; or, How to Construct an Ambivalent God," in *The Gods of Ancient Greece,* ed. J. N. Bremmer and A. Erskine (Edinburgh: Edinburgh University Press, 2010), 193–208. I am indebted to Jan Bremmer for sharing bibliographical references and for helpful discussions of this material.

27. See Hyginus, *Fabulae* 166; scholiast on *Iliad* B 5475; *Etymologicum magnum,* s.v. Ἐρεχθεύς. See also Deacy, *Athena,* 53; Powell, *Athenian Mythology,* 1–3. Guy Smoot offers an alternative etymology for the name Erechtheus, "Very Earthly" (*Eri* = "very" as an intensive prefix + *chthonios*).

28. Sourvinou-Inwood, *Athenian Myths and Festivals,* 88, is among those who see Erechtheus and Erichthonios as one and the same individual. See also Vian, *La guerre des géants,* 254–55; Kearns, *Heroes of Attica,* 110–15; Mikalson, "Erechtheus and the Panathenaia"; Kron, *Die zehn attischen Phylenheroen,* 37–39; Parker, "Myths of Early Athens," 200–1; P. Brulé, "La cité en ses composantes: Remarques sur les sacrifices et la procession des Panathénées," *Kernos* 9 (1996): 44–46.

29. Sourvinou-Inwood, *Athenian Myths and Festivals,* 51–89.

30. *RE* (1907), s.v. "Erechtheus"; Mikalson, "Erechtheus and the Panathenaia," 141–42; Kearns, *Heroes of Attica,* 133; Parker, *Athenian Religion,* 19–20; Sourvinou-Inwood, *Athenian Myths and Festivals,* 51–89, 96.

31. British Museum, 1864, 1007.125, pelike. H. B. Walters, E. J. Forsdyke, and C. H. Smith, *Catalogue of Vases in the British Museum,* 4 vols. (London: British Museum Publications, 1893).

32. *LIMC* 4, s.v. "Erechtheus."

33. Staatliche Museen, Berlin F 2537, cup by the Kodros Painter from Tarquinia,

ca. 440–430 B.C. *ARV²* 1268.2; *Para.* 471; *Addenda²* 177; *LIMC* 4, s.v. "Erechtheus," no. 7; Kron, *Die zehn attischen Phylenheroen,* 250, no. E 5, plates 4.2, 5.2; A. Avrimidou, *The Codrus Painter: Iconography and Reception of Athenian Vases in the Age of Pericles* (Madison: University of Wisconsin Press, 2011), 33–35.

34. Shear, "Polis and Panathenaia," 55–60.

35. Sourvinou-Inwood, *Athenian Myths and Festivals;* J. P. Small, *The Parallel Worlds of Classical Art and Text* (Cambridge, U.K.: Cambridge University Press, 2008).

36. Herodotos, *Histories* 8.44.2, says the people of Athens were first called Athenians during the reign of Erechtheus. Pindar, *Isthmian Ode* 2.19, and Sophokles, *Ajax* 202, both use the term "Erechtheidai" to mean all Athenians. See Sourvinou-Inwood, *Athenian Myths and Festivals,* 96; Kearns, *Heroes of Attica,* 133; Parker, *Athenian Religion,* 19–20.

37. Herodotos, *Histories* 8.48.

38. For Kekrops: *LIMC* 6, s.v. "Kekrops," nos. 1–11; for Erechtheus, see *LIMC* 4, s.v. "Erechtheus," nos. 1–31.

39. Sourvinou-Inwood, *Athenian Myths and Festivals,* 95: Powell, *Athenian Mythology,* 17.

40. Isokrates, *Panathenaikos* 193; Hyginus, *Fabulae* 46.

41. Thucydides, *Peloponnesian War* 2.15.1.

42. For collected sources, see Austin, "De nouveaux fragments de l'*Érechthée,*" 54–55, and Kearns, *Heroes of Attica,* 201–2.

43. Phanodemos, *FGrH* 325 F 4 = Photios; *Suda,* s.v. Παρθένοι. At the end of his entry, Photios cites Phanodemos, though it is not clear whether Phanodemos is responsible for all of the information given or just the final bit. Phanodemos may be regarded as a fairly reliable source and is thought to have been a collaborator of Lykourgos.

44. Apollodoros, *Library* 3.15.

45. Hyginus, *Fabulae* 46, 238. Demaratus, *FGrH* 42 F 4, says that the eldest daughter was sacrificed to Persephone.

46. Hyginus, *Fabulae* 253. Philochoros, *FGrH* 328 F 105.

47. See Kearns, *Heroes of Attica,* 201.

48. A scholiast to Aristides, *Panathenaic Oration* 85–87 (Lenz and Behr) = Dindorf 3:110, line 9, and 3:112, lines 10–15, identifies Aglauros, Herse, and Pandrosos as the daughters of Erechtheus, rather than as the daughters of Kekrops.

49. The text of fragment 370.36–42 is very problematic and editors treat it differently. See Collard and Cropp, *Euripides VII: Fragments,* 393, for discussion and translation. We get a sense that Praxithea is looking upon the corpses of her two older daughters, who have, perhaps, leaped from the Acropolis. While it is by no means certain, we may have references to a "funeral rite" (line 38) and "limbs" (line 39).

50. Apollodoros, *Library* 3.15.4.

51. Ibid., 3.14.6.

52. According to Pausanias, *Description of Greece* 1.18.2; Hyginus, *Poetic Astronomy* 2.13; Hyginus, *Fabulae* 166.

53. Euripides, *Ion* 277–78.

54. I thank Angelos Chaniotis for drawing this to my attention. For *leges sacrae,* see E. Lupu, *Greek Sacred Law: A Collection of New Documents (NGSL)* (Leiden: Brill, 2005); R. Parker, "What Are Sacred Laws?," in *The Law and the Courts in Ancient Greece,* ed. E. M. Harris and L. Rubinstein (London: Duckworth, 2004), 57–70.

55. I thank Angelos Chaniotis for this suggestion.

56. As first argued by D. M. Lewis, "Who Was Lysistrata? Notes on Attic Inscriptions (II)," *BSA* 50 (1955): 1–36. See also Connelly, *Portrait of a Priestess,* 11–12, 60, 62–64, 66, 128, 130–31, 278; S. Georgoudi, "Lisimaca, la sacerdotessa," in *Grecia al femminile,* ed. N. Loraux (Rome: Laterza, 1993), 157–96.

57. On the reconciliation, see Parker, "Myths of Early Athens," 201–4.
58. Translation is my own. I am deeply grateful to James Diggle and Anton Bierle for their kindness in helpful discussions of the text.
59. Plutarch, *Lives of the Ten Orators: Lykourgos* 843a–c; N. C. Conomis, "Lycurgus Against Leocrates 81," *Praktika tes Akademias Athenon* 33 (1958): 111–27; Connelly, *Portrait of a Priestess,* 12, 59–64, 117, 129–33, 143, 217.
60. Translation: Burtt, *Minor Attic Orators, II,* 151, 153.
61. See Sonnino, *Euripidis Erechthei,* 36–42, 113–19; M. Lacore, "Euripide et le culte de Poseidon-Erechthée," *RÉA* 85 (1983): 215–34; J. François, "Dieux et héros d'Athènes dans l'*Érechthée* d'Euripide," in *IXᵉ congrès international de Delphes sur le drame grec ancien (Delphes, 14–19 juillet 1998)* (Athens, 2004), 57–69.
62. Plato, *Menexenus* 239b; see Pappas, "Autochthony in Plato's *Menexenus*"; Isokrates, *Panegyrikos* 68–70; Isokrates, *Panathenaikos* 193.
63. Demosthenes, *Funeral Speech* 27–29, also says that the daughters of Pandion inspired the Pandionidai and the daughters of Leos (sacrificed during time of plague) inspired the Leontidai. The Athenian statesman and general Phokion invokes the Hyakinthidai (daughters of Erechtheus) and the daughters of Leos in a speech to the assembly after the destruction of Thebes in 335 B.C.; see Diodoros Siculus, *Library* 17.15.2.
64. Demades, frag. 110.
65. Bremmer, *Strange World of Human Sacrifice;* J. N. Bremmer, "Myth and Ritual in Greek Human Sacrifice: Lykaon, Polyxena, and the Case of the Rhodian Criminal," in Bremmer, *Strange World of Human Sacrifice,* 55–79; T. Fontaine, "Blutrituale und Apollinische Schönheit: Grausame vorgeschichtliche Opferpraktiken in der Mythenwelt der Griechen und Etrusker," in *Morituri: Menschenopfer, Todgeweihte, Strafgerichte,* ed. H.-P. Kuhnen (Trier: Rheinisches Landesmuseum, 2000), 49–70; *Enzyklopädie des Märchens* (1999), s.v. "Menschenopfer"; S. Georgoudi, "À propos du sacrifice humain en Grèce ancienne," *Archiv für Religionsgeschichte* 1 (1999): 61–82; *Der Neue Pauly* (1999), s.v. "Menschenopfer III"; P. Bonnechère, "La notion 'd'acte collectif' dans le sacrifice humain grec," *Phoenix* 52 (1998): 191–215; P. Bonnechère, *Le sacrifice humain en Grèce ancienne* (Athens: Centre International d'Étude de la Religion Grecque Antique, 1994); Hughes, *Human Sacrifice in Ancient Greece;* Wilkins, "The State and the Individual," 178–80; O'Connor-Visser, *Aspects of Human Sacrifice,* 211–32; Henrichs, "Human Sacrifice in Greek Religion"; H. S. Versnel, "Self-Sacrifice: Conception and the Anonymous Gods," in *Le sacrifice dans l'antiquité,* ed. J. Rudhardt and O. Reverdin (Geneva: Entretiens Hardt, 1981), 135–94; R. Girard, *Violence and the Sacred,* trans. P. Gregory (Baltimore: Johns Hopkins University Press, 1977); F. Schwenn, *Die Menschenopfer bei den Griechen und Römern* (Giessen: A. Töpelmann, 1915); J. Beckers, "De hostiis humanis apud Graecos" (Ph.D. diss., University of Münster, 1867); R. Suchier, "De victimis humanis apud Graecos" (Ph.D. diss., University of Marburg, 1848).
66. Herodotos, *Histories* 2.119.2–3.
67. Plutarch, *Life of Themistokles* 13.2–5 = Phainias, frag. 25 Wehrli.
68. Henrichs, "Human Sacrifice in Greek Religion," 213–17.
69. Hughes, *Human Sacrifice in Ancient Greece,* 112.
70. For the sacrifice as *sphagion,* see Euripides, *Ion* 277–78.
71. Homer, *Iliad* 9.410–16. Translation: Nagy in http://athome.harvard.edu/programs/nagy/threads/concept_of_hero.html. On the contrast in genre of *kleos* and *nostos,* see G. Nagy, *Comparative Studies in Greek and Indic Meter* (Cambridge, Mass.: Harvard University Press, 1974), 11–13. For the meaning of *kleos,* see Nagy, *Greek Hero,* 26–31 and 50–54.
72. Nagy, *Best of the Achaeans,* esp. 9–10, 102, 114–16, 184–85.
73. Ibid., 35–41.
74. When it comes to animal sacrifice, the purity of the victim is paramount in pleasing the gods. The younger and more unsullied, the better; therefore, lambs are

preferable to ewes and calves to cows. So, too, an untainted virgin is the most pleasing victim, and we do not hear of married, nonvirgin women being sacrificed. We do, however, hear of boys, like Menoikeus, son of King Kreon, who threw himself from the walls of Thebes to save the city from the seven warriors, in fulfillment of a prophecy made by Teiresias; see Euripides, *Phoenician Women* 997–1014. Untainted boys, like their female counterparts, were desirable in that they were still pure. See Larson, *Greek Heroine Cults,* 107–8.

75. Kearns, "Saving the City."

76. Pausanias, *Description of Greece* 9.17.1.

77. Ovid, *Metamorphoses* 13.681–84; Antoninus Liberalis, *Metamorphoses* 25.

78. Demosthenes, *Funeral Speech* 1398; Diodoros Siculus, *Library* 15.17; Plutarch, *Life of Theseus* 13; Pausanias, *Description of Greece* 1.5.2; Aelian, *Historical Miscellany* 12.28; scholiast on Thucydides, *Peloponnesian War* 6.57.

79. J. N. Bremmer, "Human Sacrifice in Euripides' *Iphigeneia in Tauris:* Greek and Barbarian," in *Sacrifices humains/Human Sacrifices,* ed. P. Bonnechère and R. Gagné (Liège: Centre International d'Étude de la Religion Grecque Antique, 2013), 87–100; J. N. Bremmer, "Sacrificing a Child in Ancient Greece: The Case of Iphigeneia," in *The Sacrifice of Isaac,* ed. E. Noort and E. J. C. Tigchelaar (Leiden: Brill, 2001), 21–43; H. Lloyd-Jones, "Artemis and Iphigeneia," *JHS* 103 (1983): 87–102 = *Academic Papers: Greek Comedy, Hellenistic Literature, Greek Religion and Miscellanea* 11 (Oxford: Oxford University Press, 1990), 306–30. I thank Jan Bremmer for helpful discussions of this material.

80. Euripides, *Iphigeneia at Aulis* 1368–401. As Wilkins, "The State and the Individual," 180, so effectively puts it: "The contribution of each sex is clear: sacrifice is required of all children of suitable age (and a corresponding sacrifice from parents): eligible boys must stand in the battle-line; eligible girls may be called upon for human sacrifice to promote victory."

81. O'Connor-Visser, *Aspects of Human Sacrifice in the Tragedies of Euripides;* N. Loraux, *Tragic Ways of Killing a Woman* (Cambridge, Mass.: Harvard University Press, 1987).

82. Wilkins has pointed out how both plays focus on city goddess, festival, and virgin sacrifice; see Wilkins, "The State and the Individual"; Wilkins, "Young of Athens," 333; Wilkins, *Euripides: Heraclidae,* 151–52.

83. Zenobios 2.61.

84. Pausanias, *Description of Greece* 1.32.6.

85. Translation: D. Kovacs, Euripides, *Children of Heracles,* Loeb Classical Library (Cambridge, Mass.: Harvard University Press, 1995), 57, 59.

86. Thucydides, *Peloponnesian War* 2.51.5.

87. For dating of Euripides's *Erechtheus,* see note 6 above, pages 390–91.

88. Estimated to have had a seating capacity of five thousand to six thousand during the fifth-century phase of the theater; see Meineck, "Embodied Space," 4. Also, H. R. Goette, "Archaeological Appendix," in *The Greek Theatre and Festivals: Documentary Studies,* ed. P. Wilson (Oxford: Oxford University Press, 2007), 116–21.

89. Sourvinou-Inwood, *Tragedy and Athenian Religion,* 71–72.

90. D. Allen, *Talking to Strangers: Anxieties of Citizenship Since Brown v. Board of Education* (Chicago: University of Chicago Press, 2004), 47.

91. Allen, *Why Plato Wrote,* 93.

92. Humphreys, *Strangeness of Gods,* 104–5; C. G. Starr, "Religion and Patriotism in Fifth-Century Athens," in *Panathenaia: Studies in Athenian Life and Thought in the Classical Age,* ed. T. E. Gregory and A. J. Podlecki (Lawrence, Kans.: Coronado Press, 1979), 11–25.

93. Allen, *Why Plato Wrote,* 137. See Steinbock, "A Lesson in Patriotism," for a full discussion of Lycourgos and the ephebeia.

94. Plutarch, *Life of Perikles* 8.6. See A. Chaniotis, "Emotional Community

Through Ritual in the Greek World," in Chaniotis, *Ritual Dynamics in the Ancient Mediterranean,* 269, 275, 280, for discussion of the personal experience of the worshipper in communicating with the gods as the foundation for belief, expressed and strengthened through ritual. When beliefs are made public through ritual, they are given permanence and monumentality, enabling humans to permanently experience divine presence.

95. Philochoros, *FGrH* 328 F 12; Kearns, *Heroes of Attica,* 57–63; Kearns, "Saving the City"; U. Kron, "Patriotic Heroes," in Hägg, *Ancient Greek Hero Cult,* 78–79; Larson, *Greek Heroine Cults,* 20. As heroines, see *Oxford Classical Dictionary* (1996), s.v. "Hyacinthides or Parthenoi"; as goddess, see *Der Neue Pauly* (1998), s.v. "Hyakinthides."

96. Euripides, *Erechtheus* F 370.71–74 Kannicht. The Hyakinthides are the same as the Hyades, line 107, scholiast on Aratus, *Phaenomena* 172.

5 THE PARTHENON FRIEZE

1. B. Randolph, *Present State of the Morea,* 3rd ed. (London: EEBO, 1789), 14. Vernon gives a matter-of-fact account of Eastcourt's death in his diary entry for September 23, 1675: "Afternoone 2 Cl. Sr Giles in sound fetcht againe with cold water sleep 2 houres wake take Jelly dye 4 Cl. buried by 9 Cl." In a postscript to a letter written from Athens, addressed to a "Reverend gentleman" and dated October 1675, Vernon recounts, "In the way betweene Lepanto and Salona, a daye's journey from Delphos, my companion died; one Sir Giles Eastcourt, a Wiltshire gentleman, who had been formerly of Oxford, I think of Edmund Hall. I have written to his friends to give them notice of what hath happened." For background on Vernon, see Wood, *Athenae Oxonienses,* 1:509.

2. The day had started well, as Vernon writes in his diary: "just at break of day arrive at Isphahan, blessed be god. Take Chamber at 7 Cl finde Armenian speaks Italian, placed bed and bages, Change fresh Linens and Finish notes" (fol. 68, in the archives of the Royal Society). The trouble started later in the day when he went to a local *kafenion* for something to eat. See D. Constantine, *Early Greek Travellers and the Hellenic Ideal* (New York: Cambridge University Press, 1984), 19, 21–24, 28–29; J. Ray, *A Collection of Curious Travels and Voyages, in Two Tomes: The First Containing Dr. Leonhart Rauwolff's Itinerary into the Eastern Countries . . . , the Second Taking in Many Parts of Greece, Asia Minor, Egypt, Arabia Felix and Petraea, Ethiopia, the Red-Sea, & from the Observations of Mons. Belon, Mr. Vernon, Dr. Spon, Dr. Smith, Dr. Huntingdon, Mr. Greaves, Alpinus, Veslingius, Thevenot's Collections, and Others* (London: S. Smith and B. Walford, 1693), 172; J. Murray (firm), *Handbook for Travellers in Greece: Including the Ionian Islands, Continental Greece, the Peloponnese, the Islands of the Ægean, Crete, Albania, Thessaly, and Macedonia and a Detailed Description of Athens,* 7th ed. (London: J. Murray, 1900), 2:250; Wood, *Athenae Oxonienses,* 3:1113–14.

3. A. R. Hall and M. B. Hall, eds. and trans., *The Correspondence of Henry Oldenburg,* 13 vols. (Madison: University of Wisconsin Press, 1965–1986), vols. 5–9.

4. S. P. Rigaud and S. J. Rigaud, eds., *Correspondence of Scientific Men of the Seventeenth Century,* 2 vols. (Oxford: Oxford University Press, 1841), 2:243; L. Twells, *The Theological Works of Dr. Pocock* (London: Printed for the editor and sold by R. Gosling, 1740), 66–68.

5. R. S. Westfall, *Never at Rest: A Biography of Isaac Newton* (Cambridge, U.K.: Cambridge University Press, 1983), 234.

6. They parted ways with the French doctor Jacob Spon and English clergyman and botanist George Wheler, who had been traveling with them since Venice.

7. On August 27, November 8, and November 10, 1675. He completed his tabulation of dimensions of the Parthenon on November 11, 1675.

8. Vernon's letter to Oldenburg (Royal Society, MS 73) was published under the title "Mr. Francis Vernon's Letter, Giving a Short Account of Some of His Observations in His Travels from Venice Through Istria, Dalmatia, Greece, and the Archipelago, to Smyrna," in *Proceedings of the Royal Society* 11 (1676): 575–82. The letter was translated into French by Jacob Spon (who had traveled with him as far as Zakynthos in 1675) in his *Réponse à la critique publiée par M. Guillet* (Lyon: Amaulri, 1679). In the letter, Vernon gives his measurements for the Parthenon in a cursory fashion only: "I was three times in it, and took all the dimensions with what exactness I could but they are too long for a letter." However, in his personal diaries, kept in the library of the Royal Society (manuscript 73) and rediscovered by Benjamin Meritt in 1946 (Meritt and Vernon, "Epigraphic Notes of Francis Vernon"), Vernon gives a whole series of exact measurements he took on November 10, 1675 (32 recto and in the transcript made for Meritt, a copy of which is among the W. B. Dinsmoor Papers in the Archives of the American School of Classical Studies at Athens, 29–31). Among the many measurements Vernon took (in English feet), he lists: "the Length of Cella, the breadth, the circumference of pillar, hence diameter, the intercolumnia, the Breadth of portico on sides, at end over east end, same but wings, the Inner to cella with cut out wing East," and so forth. In an unpublished manuscript W. B. Dinsmoor writes: "From the very beginning of the Journal it is obvious that Vernon, first among modern travellers, was concerned to a great extent with the measurements and architectural details of Greek buildings. In addition, Vernon had a decidedly mathematical interest in the proportions of buildings, as well as in topographical and astronomical matters. To this he added an indefatigable curiosity regarding inscriptions, botany, and modern manners and customs." I thank Tessa Dinsmoor for her permission to publish quotations from the Dinsmoor Papers here and am very grateful to the American School of Classical Studies archivist Natalia Vogeikoff-Brogan for her kindness in facilitating my study of the documents.

9. In which Vernon describes the frieze showing "men on horseback, others in Chariots, and a whole procession of people going to a sacrifice."

10. Diary entry for August 26, 1675 (7 recto), page 9, read from a copy of the typed transcript of Vernon's diaries, made by the Royal Society and now in the American School of Classical Studies archives: "wthin sid fregio/men to west end on horsebacke/ people in triumphant/ Chariotts." And entry for November 8, 1675 (32 recto), page 29: "Round the Fregio of the cella, the whole a procession in the/ front severall rid/ing on horses/On south side Chariotts Severall wth two wheeles 4 spokes only/at upper end/ Severall Bullockes wth people conducting them to Sacrifice a great/number/ of women in long vests goeing before . . . On north side Chariotts and horsemen just as the South Side & oven/ & a procession." Above the word "oven" (as typed in the transcript from the Royal Society), someone, no doubt Meritt or Dinsmoor, has added a handwritten correction: "ewes?" This would refer, then, to the sheeps led to sacrifice on the Parthenon's north frieze.

11. For the Theseion, see R. C. Anderson, "Moving the Skeleton from the Closet Back into the Temple: Thoughts about Righting a Historical Wrong and Putting Theseus Back into the Theseion," in *Aspects of Ancient Greek Cult II: Architecture-Context-Music,* ed. J. T. Jensen (Copenhagen, forthcoming).

12. Meritt and Vernon, "Epigraphic Notes of Francis Vernon," 213.

13. See Ridgway, *Prayers in Stone,* 128, for a discussion of the role of the Ionic frieze as a *taenia,* meaning "fillet" or "band." Painted with a blue background or made from bluish stone, the Ionic frieze serves to visually bind together or "fasten" the prostyle columns of the temple to the cella.

14. Vernon's perception of "triumph" in the chariots following behind the sacrificial procession concurs with our understanding of the frieze as a depiction of a victory sacrifice following the battle of Erechtheus and Eumolpos.

15. Pausanias, *Description of Greece* 1.24.5–7.

16. Summarized by Marconi, "Degrees of Visibility." See R. Stillwell, "The Panathenaic Frieze: Optical Relations," *Hesperia* 38 (1969): 231–41, esp. 232, fig. 1; Osborne, "Viewing and Obscuring." For objections to Stillwell's premise, see Ridgway, *Fifth Century Styles*, 75n8, 75–76. On November 9–10, 2012, an experiment was carried out on the replica of the Parthenon in Centennial Park, Nashville, Tennessee. The west frieze was re-created in full color with painted canvas stretched atop panels of insulation foam. The panels were installed in the original setting of the frieze within the colonnade, and the general public was invited to view it from a number of station points on the ground to assess its visibility. The project, directed by Bonna Wescoat, professor of Greek art and architecture at Emory University, found that added color greatly increases the visibility of the frieze from below. Results of the experiment are presented in a video: "Seeing Is Believing: Emory Students Shed New Light on the Parthenon Frieze."

17. Ridgway, *Prayers in Stone*, 117, drawing upon the observations of A. L. Millin, *Monuments antiques inédits ou nouvellement expliqués* (Paris: Imprimerie Impériale, 1806), 2:48. See also L. von Klenze, *Aphoristische Bemerkungen gesammelt auf seiner Reise nach Griechenland* (Berlin: G. Reiner, 1838), 253, for blue on the background of the frieze; Neils, *Parthenon Frieze*, 88–93. For a full discussion of polychromy on the Parthenon, see chapter 9.

18. Marconi, "Degrees of Visibility," 160n14; Hölscher, "Architectural Sculpture," 54–56.

19. Stillwell, "Optical Relations," 232–33, calculates an observation zone of 30 feet (9 meters) from the stylobate. See Lawrence, *Greek and Roman Sculpture*, 139: "To those who walked inside the colonnade only a distorted view was possible and by much craning of the neck." And new findings by Manolis Korres show that the frieze, in fact, was not carved in slightly higher relief at the top than at the bottom, as was previously believed; see Korres, "Überzählige Werkstücke des Parthenonfrieses," fig. 5. This had been seen as an adjustment calculated to give it better visibility from below; Boardman, "Closer Look," 306–7.

20. In referring to architectural sculpture on temple buildings as "prayers in stone," Ridgway means that the beauty of the decorative program is meant to bring pleasure and honor to the gods, just like sacrifice, libation, votive statues, paintings, song-dances, and any performed ritual that might be offered to divinities to establish communication with them.

21. Marconi, "Degrees of Visibility," 159–66; G. Rodenwaldt, *Die Akropolis*, 5th ed. (Berlin: Deustcher Kunstverlag, 1956), 41; Robertson, *History of Greek Art*, 310.

22. Euripides, *Ion* 190, 192, 211. See F. Zeitlin, "The Artful Eye: Vision, Ekphrasis, and Spectacle in Euripidean Theater," in *Art and Text in Ancient Greek Culture*, ed. S. Goldhill and R. Osborne (Cambridge, U.K.: Cambridge University Press, 1994), 139, 144; R. R. Holloway, "Early Greek Architectural Decoration as Functional Art," *AJA* 92 (1988): 178; Ridgway, *Prayers in Stone*, 9; Marconi, "Degrees of Visibility," 168. For the ancient experience of viewing art, see also J. B. Connelly, "Hellenistic Alexandria," in *The Coroplast's Art: Terracottas of the Hellenistic World*, ed. J. Uhlenbrock (New Rochelle, N.Y.: Aristide D. Caratzas, 1990), 94–101.

23. It comes from the verb *agallo*, "to honor" or "to take glory or delight in," see *Neue Pauly* (2002), s.v. "Agalma." See Marconi, "Degrees of Visibility," 172–74; T. B. L. Webster, "Greek Theories of Art and Literature down to 400 B.C.," *CQ* 33 (1939): 166–79; H. Philipp, *Tektonon Daidala* (Berlin: B. Hessling, 1968), 103–6; Sourvinou-Inwood, *"Reading" Greek Death*, 143–47; K. Keesling, *Votive Statues of the Athenian Acropolis* (Cambridge, U.K.: Cambridge University Press, 2003), 10.

24. Manuscript in the Bibliothèque Nationale, Paris. J. M. Patton, *Chapters on Mediaeval and Renaissance Visitors to Greek Lands* (Princeton, N.J.: American School of Classical Studies at Athens, 1951); Beard, *Parthenon*, 60–61.

25. Kaldellis, *Christian Parthenon*, 143.

26. Bodnar, *Cyriacus of Ancona*, letter 3, pages 14–21; C. Mitchell, "Ciriaco d'Ancona: Fifteenth Century Drawings and Descriptions of the Parthenon," in V. J. Bruno, *The Parthenon* (New York: W. W. Norton, 1974), 111–23; M. Beard has an interesting discussion of this in *Parthenon*, 65–68. See also Mallouchou-Tufano, "From Cyriacus to Boissonas," 164–65.

27. A copy of Cyriacus's drawing in silverpoint is illustrated in Bodnar, *Cyriacus of Ancona*, plate 2; letter 3 is reproduced on pages 14–21. See Bodnar, plate 1, for another drawing of the Parthenon by Cyriacus (from letter 3.5–10) that shows some of the south metopes curiously superimposed above the west pediment.

28. Ibid., letter 3.5 and 3.8, pages 16–19.

29. Ibid., letter 3.9, pages 18–19.

30. As observed also by Beard, *Parthenon*, 67.

31. Bodnar, *Cyriacus of Ancona*, letter 3.8 and 3.9, pages 18–19.

32. Dankoff and Kim, *Ottoman Traveller*, ix, book 8: "Athens," 278–86. See also R. Dankoff, *An Ottoman Mentality: The World of Evliya Çelebi* (Leiden: Brill, 2004); M. van Bruinessen and H. Boeschoten, eds. and trans., *Evliya Çelebi in Diyarbekir: The Relevant Section of "The Seyahatname"* (Leiden: Brill, 1988).

33. Dankoff and Kim, *Ottoman Traveller*, 281–82.

34. Dankoff and Kim, *Ottoman Traveller*, 285.

35. Ibid.

36. Stuart and Revett, *The Antiquities of Athens*, was published in four volumes dating from the first, in 1762, to the last, in 1816. See B. Redford, *Dilettanti: The Antic and the Antique in Eighteenth-Century England* (Los Angeles: J. Paul Getty Museum, 2008), 52–72; F. Salmon, "Stuart as Antiquary and Archaeologist in Italy and Greece," in Soros, *James "Athenian" Stuart*, 103–45.

37. Stuart and Revett, *Antiquities of Athens*, 2:12.

38. Ibid., 2:12–13. For a summary of early interpretations of the Parthenon frieze see Michaelis, *Parthenon*, 218, 262; Brommer, *Der Parthenonfries*, 147–50.

39. Stuart and Revett, *Antiquities of Athens*, 2:12. Writing of the east frieze they observe: "On it are a God and a Goddess, perhaps Neptune and Ceres, and two other figures, one of which is a man who appears to examine with some attention a piece of cloth folded several times double; the other is a young girl who assists in folding it: may we not suppose this folded cloth to represent the peplos?"

40. For this central panel see, among others, Sourvinou-Inwood, *Athenian Myths and Festivals*, 284–307; Hurwit, *Age of Pericles*, 146, 230, 236; Dillon, *Girls and Women*, 45–47; Neils, *Parthenon Frieze*, 67–70, 166–71, 184–85; Shear, "Polis and Panathenaia," 752–55; Hurwit, *Athenian Acropolis*, 179–86, 222–28; Connelly, "Parthenon and *Parthenoi*," 53–72; Harrison, "Web of History," 198; Wesenberg, "Panathenäische Peplosdedikation und Arrephorie"; Mansfield, "Robe of Athena," 289–95; Connelly, "Sacrifice of the Erechtheids"; Simon, "Die Mittelszene im Ostfries"; Jeppesen, "A Fresh Approach," 108, 127–129; B. Nagy, "The Ritual in Slab V."

41. Harrison, "Web of History," 198–202, and Wesenberg, "Panathenäische Peplosdedikation und Arrhephorie," see this as the folding up of the old peplos rather than the presentation of the new one at the Panathenaia.

42. Inconsistencies between the *testimonia* and the images on the frieze were first noted by Petersen, *Die Kunst des Pheidias*, cited by Michaelis, *Parthenon*, 209. See S. Rotroff, "The Parthenon Frieze and the Sacrifice to Athena," *AJA* 81 (1977): 379–80; Holloway, "Archaic Acropolis"; Boardman, "Parthenon Frieze," 214; Connelly, "Parthenon and *Parthenoi*," 54.

43. For *kanephoroi*, see Connelly, *Portrait of a Priestess*, 33–39, with bibliography.

44. Efforts to find a basket bearer in the east frieze come up short, though some have seen the tray-like object held in the hands of a "marshal" on the east frieze (E49

in the Louvre) as a basket. It is imagined that the girls before him, E50–51, have just handed him a *kanoun,* making one of the girls a *kanephoros:* Brommer, *Der Parthenonfries,* 148; J. Schelp, *Das Kanoun: Der griechische Opferkorb* (Würzburg: K. Tritsch, 1975), 55ff.; L. J. Roccos, "The Kanephoros and Her Festival Mantle in Greek Art," *AJA* 99 (1995): 641–66; Neils, *Parthenon Frieze,* 157.

45. Mansfield, "Robe of Athena," 68–78; Norman, "The Panathenaic Ship." The hoisting of the great tapestry peplos as the "sail" of the Panathenaic ship pulled on a wheeled cart during the Panathenaic procession is first attested in the third quarter of the fourth century B.C. See Plutarch, *Life of Demetrios* 10.5, 12.3. Elizabeth Barber suggests the practice might have begun much earlier, possibly just after the Persian Wars when one of the ships from the Battle of Salamis might have been lifted from the water and paraded before the citizenry to remind them of how Athens was saved from the Persian foe; see Barber, "*Peplos* of Athena," 114. A fourth-century marble relief found in the Athenian Plaka shows the Panathenaic ship-cart; see A. Spetsieri-Choremi, "Θραύσμα αναθηματικού αναγλύφου από την περιοχή του αθηναϊκού Ελευσινίου," *ArchEph* 139 (2000): 1–18.

46. See Thucydides, *Peloponnesian War* 6.58. For the omission of hoplites on the frieze, see Michaelis, *Parthenon,* 214; Boardman, "Parthenon Frieze," 210–11; Boardman, "Another View," 43–44; Connelly, "Parthenon and *Parthenoi,*" 69.

47. Boardman, "Another View," 42–45, and Boardman, "Parthenon Frieze," 215.

48. There is a double anachronism here, in that we would not expect to see soldiers riding astride horses in the Late Bronze Age, when horses were used for pulling wheeled carts and chariots but not for riding. I thank Nicola Di Cosmo for this observation.

49. The question is raised by M. Robertson in "Sculptures of the Parthenon," 56; Boardman, "Parthenon Frieze," 211; Holloway, "Archaic Acropolis," 223; Kroll, "Parthenon Frieze as Votive Relief"; and, of course, Lawrence, *Greek and Roman Sculpture,* 144.

50. Lissarrague, "Fonctions de l'image"; Lissarrague and Schnapp, "Imagerie des Grecs"; Connelly, "Parthenon and *Parthenoi,*" 55; Connelly, *Portrait of a Priestess,* 20–21; Ferrari, *Figures of Speech,* 17–25; Webster, "Greek Theories of Art and Literature"; Marconi, "Degrees of Visibility," 172; J. Svenbro, *La parole et le marbre* (Lund: Studentlitteratur, 1976); Sourvinou-Inwood, "*Reading*" *Greek Death,* 140–43; Steiner, *Images in Mind,* 252–59.

51. Lawrence, "Acropolis and Persepolis," 118.

52. Lawrence, *Greek and Roman Sculpture,* 144.

53. Kardara, "Glaukopis," 119–29.

54. Jeppesen, "Bild und Mythus an dem Parthenon."

55. For a reading of the frieze as a "general display of religiosity," see Ridgway, *Fifth Century Styles,* 77–78; for multiple meanings, see Jenkins, *Parthenon Frieze,* 31–42; for the frieze as "evocation of all the ceremonies, contests, and forms of training that made up the cultural and religious life of Classical Athens," see Pollitt, "Meaning of the Parthenon Frieze," 63.

56. Fehr, *Becoming Good Democrats and Wives,* especially 7–8, and 104–11, for the central scene on the east frieze.

57. First presented in a talk at Bryn Mawr College (December 11, 1991) on the occasion of the retirement of Phyllis Pray Bober, dean of the Graduate School of Arts and Sciences; followed by a lecture at New York University on November 21, 1992, "Parthenon and *Parthenoi:* A Mythological Interpretation of the Parthenon Frieze," at the symposium "Athens: Cradle of Democracy," held in honor of Homer A. Thompson and sponsored by the Alexander S. Onassis Center of Hellenic Studies. Later that year (December 28, 1992), I presented "The Parthenon Frieze and the Sacrifice of the Erechtheids: Reinterpreting the 'Peplos Scene'" at the Archaeological Institute of America's annual meeting in New Orleans; abstract published in *AJA* 97 (1993): 309–10. In 1996,

I published a full treatment of the reinterpretation in "Parthenon and *Parthenoi:* A Mythological Interpretation of the Parthenon Frieze," *AJA* 100 (1996): 53–80. See Chaniotis, "Dividing Art–Divided Art," 43; Deacy, *Athena,* 117; Jouan and Van Looy, *Fragments: Euripides,* 95–132; Ridgway, *Prayers in Stone,* 201; Spivey, *Understanding Greek Sculpture,* 146–47.

58. Noted by Boardman in "Another View," 41, and in "Naked Truth."

59. Connelly, "Sacrifice of the Erechtheids"; Connelly, "Parthenon and *Parthenoi,*" 58–66.

60. J. Barringer, "The Temple of Zeus at Olympia, Heroic Models, and the Panhellenic Sanctuary," in Barringer, *Art, Myth, and Ritual,* 8–58; J. Hurwit, "Narrative Resonance in the East Pediment of the Temple of Zeus at Olympia," *Art Bulletin* 69 (1987): 6–15; Säflund, *East Pediment of the Temple of Zeus at Olympia.*

61. Schnapp, "Why Did the Greeks Need Images?" For recent scholarship on divine images, see M. Gaifman, *Aniconism in Greek Antiquity* (Oxford, U.K.: Oxford University Press, 2012); P. Eich, *Gottesbild und Wahrnehmung: Studien zu Ambivalenzen früher griechischer Götterdarstellungen (ca. 800 v. Chr.–ca. 400 v. Chr.)* (Stuttgart: Franz Steiner, 2011); V. Platt, *Facing the Gods: Epiphany and Representation in Graeco-Roman Art, Literature, and Religion* (Cambridge, U.K.: Cambridge University Press, 2011); I. Mylonopoulos, "Divine Images Behind Bars: The Semantics of Barriers in Greek Temples," in *Current Approaches to Religion in Ancient Greece,* ed. J. Wallensten and M. Haysom (Stockholm: Svenska Institutet i Athen, 2011), 269–91; I. Mylonopoulos, ed., *Divine Images and Human Imaginations in Ancient Greece and Rome* (Leiden: Brill, 2010); S. Bettinetti, *La statua di culto nella pratica rituale greca* (Bari: Levante, 2001); Lapatin, *Chryselephantine Statuary;* Steiner, *Images in Mind;* T. S. Scheer, *Die Gottheit und ihr Bild: Untersuchungen zur Funktion griechischer Kultbilder in Religion und Politik* (Munich: Beck, 2000); D. Damaskos, *Untersuchungen zu hellenistischen Kultbildern* (Stuttgart: Franz Steiner, 1999); Donohue, *Xoana;* I. B. Romano, "Early Greek Cult Images and Cult Practices," in Hägg, Marinatos, and Nordquist, *Early Greek Cult Practice,* 127–34.

62. Contra Shear, "Polis and Panathenaia," 729–61; Osborne, "Viewing and Obscuring," 99–101.

63. Simon, *Festivals of Attica,* 67; Parke, *Festivals of the Athenians,* 40; Mansfield, "Robe of Athena," 291; Dillon, *Girls and Women,* 45–47; Marconi, "Degrees of Visibility," 167; Neils, *Parthenon Frieze,* 16; Sourvinou-Inwood, *Athenian Myths and Festivals,* 294; Hurwit, *Age of Pericles,* 230, and Hurwit, *Athenian Acropolis,* 225, who identifies the woman as either the priestess of Athena Polias or as the *basilinna.*

64. Mantis, Προβλήματα της εικονογραφίας, 28–65; Connelly, *Portrait of a Priestess,* 92–104.

65. Berlin, Staatliche Museen, Antikensammlung K 104. Connelly, *Portrait of a Priestess,* 95–96.

66. Mansfield, "Robe of Athena," 291, 346; Simon, *Festivals of Attica,* 66; Boardman, "Another View," 41; Mantis, Προβλήματα της εικονογραφίας, 78, 80–96. Sourvinou-Inwood, *Athenian Myths and Festivals,* 296, suggests that he is the priest of Zeus Polieus. Steinhart, "Die Darstellung der Praxiergidai," 476–77, argues he is neither a priest nor the archon basileus but that he and the child are members of the Praxiergidai clan, the *genos* closely connected with the peplos.

67. Robertson, *Shorter History of Greek Art,* 100; Connelly, "Parthenon and *Parthenoi,*" 60; Connelly, *Portrait of a Priestess,* 187ff.; Boardman and Finn, *Parthenon and Its Sculptures,* 222–23.

68. Images listed by Brommer, *Der Parthenonfries,* 268; Mantis, Προβλήματα της εικονογραφίας, 78, 80, 82–96.

69. Athens National Museum 772; Mantis, Προβλήματα της εικονογραφίας, plate 38a; Connelly, "Parthenon and *Parthenoi,*" 59, fig. 2; A. Conze, *Attischen Grabreliefs* (Berlin: Spemann, 1893), 197, no. 920, plate 181.

70. Stuart and Revett, *Antiquities of Athens*, 2:12.

71. Robertson and Frantz, *Parthenon Frieze*, 308. For Venus rings, see Boardman, "Notes on the Parthenon Frieze," 9–10.

72. Boardman, "Notes on the Parthenon Frieze," 9–11. See also Boardman, "Parthenon Frieze," 214; Boardman, "Another View," 41; Boardman, "Naked Truth."

73. Those who believe the child is a boy: Fehr, *Becoming Good Democrats and Wives*, 104–6; J. Neils, "The Ionic Frieze," in Neils, *Parthenon*, 203; Hurwit, *Age of Pericles*, 230; Neils, *Parthenon Frieze*, 168–71; Steinhart, "Die Darstellung der Praxiergidai," 476; Jenkins, *Parthenon Frieze*, 35; Clairmont, "Girl or Boy?"; Harrison, "Time in the Parthenon Frieze," 234; Simon, *Festivals of Attica*, 66–67; Brommer, *Der Parthenonfries*, 269–70n137, 264, table; Parke, *Festivals of the Athenians*, 41; Kardara, "Glaukopis." Those who identify the child as a girl: Dillon, *Girls and Women*, 45–47; Boardman, "Closer Look," 314–21; Connelly, "Parthenon and *Parthenoi*," 60; Connelly, "Sacrifice of the Erechtheids"; J. Pedley, *Greek Art and Archaeology* (London: Cassell, 1992), 246; Boardman, "Naked Truth"; Stewart, *Greek Sculpture*, 155, 157; Boardman, "Notes on the Parthenon Frieze," 9–10; Mansfield, "Robe of Athena," 293–94; Boardman, "Parthenon Frieze"; Robertson and Frantz, *Parthenon Frieze*, 34. For a summary, see Berger and Gisler-Huwiler, *Fries des Parthenon*, 158–59, 172–74; Ridgway, *Fifth Century Styles*, 76–83; and Sourvinou-Inwood, *Athenian Myth and Festivals*, 284–307 and 307–11.

74. Red-figured krater in Bari, Museo Civico 4979, *ARV*² 236.4, from Rutigliano. C. Bérard, "L'ordre des femmes," in Bérard et al., *La cité des images*, fig. 127.

75. Brommer, *Der Parthenonfries*, 269–70, sees the child as the temple boy responsible for the holy snake. See Simon, *Festivals of Attica*, 66; Hurwit, *Age of Pericles*, 230. Jenkins, *Parthenon Frieze*, 35, points to the example of Ion, who acts as temple servant to Apollo in Euripides's tragedy. As a male deity Apollo would, of course, be served by male temple servants with the exception of his female prophetesses. But the idea that the virgin goddess Athena would similarly be served by a little boy is wholly out of keeping with Greek cult practice, which would demand that she, as a virgin goddess, be attended by girls and women; see Connelly, *Portrait of a Priestess*, 73–74.

76. Connelly, "Parthenon and *Parthenoi*," 60; Robertson, *Shorter History of Greek Art*, 100; Mansfield, "Robe of Athena," 243.

77. Connelly, *Portrait of a Priestess*, 39.

78. Homer, *Iliad* 6.297–310; see Connelly, *Portrait of a Priestess*, 173.

79. Mansfield, "Robe of Athena," 294; Connelly, *Portrait of a Priestess*, 31–32, with bibliography.

80. W. Burkert, "Kekropidensage und Arrhephoria," *Hermes* 94 (1966): 1–25; Robertson, "Riddle of the Arrephoria at Athens."

81. Harpokration A 239 Keaney (quoting Dinarchus, frag. VI 4 Conomis) speaks of four *arrephoroi*. Pausanias, *Description of Greece* 1.27.3, speaks of two *arrephoroi*.

82. Apollodoros, *Library* 3.15.4.

83. Clairmont, "Girl or Boy?"; Connelly, "Parthenon and *Parthenoi*," 60–61.

84. See A. M. Snodgrass, *Narration and Allusion in Archaic Greek Art: A Lecture Delivered at New College Oxford, on 29th May, 1981* (London: Leopard's Head Press, 1982), 5–10; N. Himmeman-Wildschutz, "Erzählung und Figur in der archaischen Kunst," *AbhMainz* 2 (1967): 73–101; P. G. P. Meyboom, "Some Observations on Narration in Greek Art," *Mededelingen van het Nederlands Historisch Instituut te Rome* 40 (1978): 55–82; Connelly, "Narrative and Image in Attic Vase Painting," 107–8.

85. Ensuring that they will be in perpetuity the brides of Hades? See M. Alexiou, *The Ritual Lament in Greek Tradition* (Cambridge, U.K.: Cambridge University Press, 1974), 5, 27, 39, 120. For a broader discussion of the similarities in marriage and funeral rituals, see R. Rehm, *Marriage to Death: The Conflation of Marriage and Funeral Rituals in Greek Tragedy* (Princeton, N.J.: Princeton University Press, 1994).

86. Euripides, *Trojan Women* 309–460.
87. Euripides, *Iphigeneia at Aulis* 1080–87, 1577.
88. Aeschylus, *Agamemnon* 228–43.
89. Euripides, *Children of Herakles* 562.
90. Sophokles, Fr. 483 Nauck = 526 Radt. See A. C. Pearson, *The Fragments of Sophocles* (Cambridge, U.K.: Cambridge University Press, 1917), 167–68; A. H. Sommerstein, D. Fitzpatrick, and T. Talboy, *Sophocles: Selected Fragmentary Plays*, vol. 1 (London: Aris and Phillips, 2006), 81.
91. London, British Museum 1897.7-27.2; *ABV* 97.27; *Para.* 37; *Addenda*[2] 26; *LIMC* 7, s.v. "Polyxena," no. 26. Tyrrhenian amphora by the Timiades Painter, ca. 570–560 B.C.
92. See the amphora in Viterbo showing the sacrifice of a bull held in a similar position, horizontally and high in the air: J.-L. Durand and A. Schnapp, "Boucherie sacrificielle et chasses initiatiques," in Bérard et al., *La cité des images,* 55, fig. 83; Connelly, "Parthenon and *Parthenoi*," 63, fig. 6. We are reminded of Aeschylus, *Agamemnon* 213–33, where Iphigeneia is held high like "a kid, above the altar." A marble sarcophagus, dated ca. 520–500 B.C., found in 1994 during salvage excavations at Gümüşçay, Turkey, near the site of ancient Troy, shows the sacrifice of Polyxena in which she is held up in the same position while Neoptolemos slits her neck. See N. Sevinç, "A New Sarcophagus of Polyxena from the Salvage Excavation at Gümüşçay," *Studia Troica* 6 (1996): 251–64.
93. As Shear, "Polis and Panathenaia," 744, and Hurwit, *Athenian Acropolis,* 233, would have it.
94. Museo Archeologico Regionale di Palermo, NI 1886. Attic white-ground lekythos (500/490 B.C.). Attributed to Douris. *ARV*[2] 446.226; *Addenda*[2] 241; *LIMC* 5, s.v. "Iphegeneia," no. 3.
95. It is not until the fourth century B.C., in South Italian vase painting, that scenes of virgin sacrifice (especially of Iphigeneia) occur in significant numbers. These not only postdate the Parthenon by a century but also are highly influenced by the stagecraft of Greek theater, which, by then, had established a somewhat "standard" iconography for the subject.
96. Stewart, *Greek Sculpture,* 81, 148.
97. Pausanias, *Description of Greece* 5.10.6–7.
98. See the divine family group from Brauron. L. Kahil, "Le relief des dieux du sanctuaire d'Artémis à Brauron: Essai d'interprétation," in *Eumousia: Ceramic and Iconographic Studies in Honour of Alexander Cambitoglou,* ed. J.-P. Descœudres, Mediterranean Archaeology Supplement 1 (Sydney: Meditarch, 1990), 113–17. And, indeed, viewed as a royal family group, the central figures of the Parthenon east frieze may provide a further parallel to the sculptural program of the Apadana at Persepolis, where the king and crown prince appear at the very center of the relief composition; see M. C. Root, "The Parthenon Frieze and the Apadana Reliefs at Persepolis: Reassessing a Programmatic Relationship," *AJA* 89 (1985): 103–20.
99. For readings of the two girls as *arrephoroi,* see Sourvinou-Inwood, *Athenian Myths and Festivals,* 300–302 (where it is further suggested that the small child at far right may be a third *arrephoros*); Dillon, *Girls and Women,* 45–47; Neils, *Parthenon Frieze,* 168; Wesenberg, "Panathenäische Peplosdedikation und Arrephorie," 151–64; H. Rühfel, *Kinderleben im klassischen Athen: Bilder auf klassischen Vasen* (Mainz: Philipp von Zabern, 1984), 98; Simon, *Festivals of Attica,* 67; Simon, "Die Mittelszene im Ostfries," 128; Deubner, *Attische Feste,* 12–13; Stuart and Revett, *Antiquities of Athens,* 2:12. Hurwit, *Age of Pericles,* 230, and *Athenian Acropolis,* 225, says the girls could be *diphrophoroi* (stool carriers) or, possibly, *arrephoroi.* Sourvinou-Inwood, *Studies in Girls' Transitions: Aspects of the Arkteia and Age Representation in Attic Iconography* (Athens: Kardamitsa, 1988), 58–59 and 100–101n285, suggests the two

girls at the left could, in fact, be a ten-year-old and her slightly younger counterpart, but neither older than eleven.

100. See Boardman, "Parthenon Frieze," 213, for the importance of costume as a pointer to age, and Boardman, "Another View." For peplos as a costume worn by prepubescent girls, see Connelly, *Portrait of a Priestess,* 150–53.

101. Boardman, "Parthenon Frieze," 213; Boardman, "Closer Look," 312–13. Wesenberg sees these objects as trays and reads the stool legs as torches; Wesenberg, "Panathenäische Peplosdedikation und Arrephorie."

102. Furtwängler, *Meisterwerke,* 427–30, where he suggests the stools are meant for Pandrosos and Ge Kourotrophos to join the Theoxenia. B. Ashmole questioned this view, allowing that, "though possible," it "is not entirely satisfactory and a little strange"; see B. Ashmole, *Architect and Sculptor in Classical Greece* (New York: New York University Press, 1972), 143. See also Simon, *Festivals of Attica,* 68, and Simon, "Die Mittelszene im Ostfries," 142–43. Boardman, "Closer Look," 321, sees the two girls as *diphrophoroi* bringing stools.

103. Holloway, "Archaic Acropolis," 224, points out "the difficult problem of a divine audience in the midst of a human festival."

104. Vatican Museum 344; *ABV* 145.13; J. D. Beazley, *The Development of Attic Black-Figure,* rev. ed., ed. D. von Bothmer and M. B. Moore (1951; Berkeley: University of California Press, 1986), 61. See Connelly, "Parthenon and *Parthenoi,*" 63. H. von Heintze, "Athena Polias am Parthenon als Ergane, Hippia, Parthenos," *Gymnasium* 100 (1993): 385–418, similarly sees the bundles carried on stools by the girls on the Parthenon frieze as clothing rather than as seat cushions.

105. Metropolitan Museum of Art 75.2.11, *ARV²* 1313.11; *Para.* 477; *Addenda²* 180. L. Burn, *The Meidias Painter* (Oxford: Clarendon Press, 1987), 98, M 12, plate 52b; Connelly, "Parthenon and *Parthenoi,*" 63–64.

106. J. Scheid and J. Svenbro, *Le métier de Zeus: Mythe du tissage et du tissu dans le monde gréco-romain* (Paris: Errance, 1994), 26–29; Mansfield, "Robe of Athena," 50–59; Barber, "*Peplos* of Athena," 112–15; Barber, *Prehistoric Textiles,* 361–63.

107. For the Shroud of Turin, see A. Nicolotti, *Dal Mandylion di Edessa alla Sindone di Torino: Metamorfosi di una leggenda* (Alessandria: Edizioni dell'Orso, 2011); F. T. Zugibe, *The Crucifixion of Jesus: A Forensic Inquiry,* rev. ed. (New York: M. Evans, 2005); I. Wilson, *The Blood and the Shroud: New Evidence That the World's Most Sacred Relic Is Real* (New York: Free Press, 1998); H. E. Gove, *Relic, Icon, or Hoax? Carbon Dating the Turin Shroud* (Philadelphia: Institute of Physics, 1996).

108. Demaratus, *FGrH* 42 F 4; Apollodoros, *Library* 3.15.4.

109. D. B. Thompson first recognized the lion's paw: "The Persian Spoils in Athens," in *The Aegean and the Near East: Studies Presented to Hetty Goldman on the Occasion of Her Seventy-Fifth Birthday,* ed. S. S. Weinberg (Locust Valley, N.Y.: J. J. Augustin, 1956), 290.

110. Petersen, *Die Kunst des Pheidias,* 247 and n1, first identified this object as a footstool. See Furtwängler, *Meisterwerke,* 186; followed by Jeppesen, "Bild und Mythus an dem Parthenon," 27, 31, fig. 7; Boardman, "Another View," 41, plate 16.4; Boardman, "Closer Look," 307–12; Neils, *Parthenon Frieze,* 167.

111. For interpretation of this object as an incense box, see Simon, *Festivals of Attica,* 67; Simon, "Die Mittelszene im Ostfries," 141; as a jewelry box, see Connelly, "Parthenon and *Parthenoi,*" 64–66. For similar boxes showing lion's paws, see E. Brummer, "Griechische Truhenbehälter," *JdI* 100 (1985): 1–162.

112. Aelius Aristides, *Panathenaic Oration* 87 (Lenz and Behr).

113. Paris, Musée du Louvre CA 587. Connelly, "Parthenon and *Parthenoi.*"

114. London, British Museum 1843.11-3.24; *LIMC* 1, s.v. "Andromeda," nos. 3 and 17. London, British Museum E 169; *ARV²* 1062.1681.

115. Boston, Museum of Fine Arts 63.2663; *Para.* 448; *LIMC* 1, s.v. "Andromeda," no. 2. See H. Hoffmann, "Some Recent Accessions," *Bulletin of the Museum of Fine*

Arts 61 (1963): 108–9, who suggests that the box represents Andromeda's "wedding trousseau."

116. Neils, *Parthenon Frieze,* 164–66.

117. Simon, followed by Neils, *Parthenon Frieze,* 189–90, sees the gods at the north side of the east frieze as having a primary connection with the sea and those at the south with the land, and further associates the Panathenaic procession with Athenian victories on land and sea during the Persian Wars. Also, J. Neils, "Reconfiguring the Gods on the Parthenon Frieze," *Art Bulletin* 81 (1999): 6–20; Jeppesen, "A Fresh Approach," 123–25; I. S. Mark, "The Gods on the East Frieze of the Parthenon," *Hesperia* 53 (1984): 289–342; E. G. Pemberton, "The Gods of the East Frieze," 114; G. W. Elderkin, "The Seated Deities of the Parthenon Frieze," *AJA* 40 (1936): 92–99.

118. J. E. Harrison, "Some Points in Dr. Furtwängler's Theories on the Parthenon and Its Marbles," *CR* 9 (1895): 91.

119. I thank Angelos Chaniotis for making this point and for providing further references for gods turning their gaze away from certain deeds: Euripides, *Iphigeneia in Tauris* 1165–67; Herakleides Pontikos frag. 49 ed. Wehrli; Lykophron 984; Kallimachos frag. 35 ed. Pfeiffer; Apollodoros, *Library* 5.22; and Quintus Smyrnaeus 13.425–29.

120. Euripides, *Alkestis* 122; Euripides, *Hippolytos* 1437–39. I am indebted to Emily Vermeule for drawing this to my attention.

121. Frag. 11 H = Philemo, test. 6 Kassel-Austin. Colin Austin kindly provided this reference.

122. C. C. Picard, "Art archaïque: Les trésors 'ionique,'" *Fouilles de Delphes: Monuments Figurés: Sculpture* 4, no. 2 (1927), 57–171; R. Neer, "Framing the Gift: The Politics of the Siphnian Treasury at Delphi," *ClAnt* 20 (2001): 297–302, gives details of the east frieze. V. Brinkmann, "Die aufgemalten Namenbeischriften an Nord- und Ostfries des Siphnierschatzhauses," *BCH* 109 (1985): 77–130; L. V. Watrous, "The Sculptural Program of the Siphnian Treasury at Delphi," *AJA* 86 (1982): 159–72.

123. V. Brinkmann, "Die aufgemalten Namensbeischriften an Nord- und Ostfries des Siphnierschatzhauses," *BCH* 109 (1985): 79, 84–85, 87–88, 118–20.

124. Barringer, *Art, Myth, and Ritual,* 112–13n2, 223–24, gives a summary of the dating: J. S. Boersma, "On the Political Background of the Hephaisteion," *Bulletin van de Vereeniging tot Bevordering der Kennis van de Antieke Beschaving* 39 (1964): 102–6, claims that the temple was part of the Kimonian building program (ca. 460 B.C.); this position is followed by M. Cruciani and C. Fiorini, *I modelli del moderato: La stoà poikile e l'Hephaisteion di Atene nel programma edilizio cimoniano* (Naples: Scientifiche Italiane, 1998), 84; Camp, *Archaeology of Athens,* 103, places the start of construction around 460–450 B.C.; C. H. Morgan, "The Sculptures of the Hephaisteion II: The Friezes," *Hesperia* 31 (1962): 221–35, dates it to ca. 450; Thompson and Wycherley, *Agora of Athens,* 142–43; Ridgway, *Fifth Century Styles,* 26–27, places it at 450 or shortly thereafter; Dinsmoor, *Architecture of Ancient Greece,* 179–81, is for dating the beginning of construction to 449.

125. For Theseus versus Pallas, see K. O. Müller, "Die erhobenen Arbeiten am Friese des Pronaos von Theseustempel zu Athen, erklärt aus dem Mythus von den Pallantiden," in *Kunstarchaeologische Werke,* ed. K. O. Müller (1833; Berlin: S. Calvary, 1873), 4:1–19, followed by E. B. Harrison, "Athena at Pallene and in the Agora of Athens," in Barringer and Hurwit, *Periklean Athens,* 121–23. For the frieze as a mythological analogue of the Athenian people's expulsion of the aristocracy and tyrants, see K. Reber, "Das Hephaisteion in Athen: Ein Monument für die Demokratie," *JdI* 113 (1998): 41–43. See also E. Simon, *Die Götter der Griechen,* 4th ed. (Munich: Hirmer, 1998), 197–201; A. Delivorrias, "The Sculpted Decoration of the So-Called Theseion: Old Answers, New Questions," in Buitron-Oliver, *Interpretation of Architectural Sculpture,* 84, 89–90; F. Felten, *Griechische tektonische Friese archaischer und klassischer Zeit* (Waldsassen-Bayern: Stiftland, 1984), 60–64.

126. Plato, *Timaeus* 24e–25d. J. M. Barringer, "A New Approach to the Hephaisteion," in Schultz and Hoff, *Structure, Image, Ornament,* 105–20, esp. 116–17; Barringer, *Art, Myth, and Ritual,* 138–41.

127. Palagia, "Interpretations of Two Athenian Friezes," 184–90; Hurwit, *Age of Pericles,* 184–87; Pemberton, "Friezes of the Temple of Athena Nike," 303–10; Harrison, "South Frieze of the Nike Temple"; E. B. Harrison, "Notes on the Nike Temple Frieze," *AJA* 74 (1970): 317–23; A. Furtwängler, *Masterpieces of Greek Sculpture: A Series of Essays on the History of Art* (Chicago: Argonaut, 1964), 445–49; C. Blümel, "Der Fries des Tempels der Athena Nike," *JdI* 65–66 (1950–1951): 135–65.

128. Palagia, "Interpretations of Two Athenian Friezes," 189–90, identifies the east frieze as a depiction of the birth of Athena.

129. Kardara, "Glaukopis," 84–91. See also Jeppesen, "Bild und Mythus an dem Parthenon."

130. Those identifying the scene as the Battle of Marathon include: Palagia, "Interpretations of Two Athenian Friezes," 184–90; Hurwit, *Age of Pericles,* 184–87; Harrison, "South Frieze of the Nike Temple."

131. Euripides, *Erechtheus* F 370.75–90 Kannicht.

132. Aristotle, *Politics* 1297b, 16–22, tells us that it was in days of old that the cavalry dominated the army. I thank John Marr for this reference.

133. Cicero, *On the Nature of the Gods* 3.19, 49–50.

134. Generally identified as the ten Eponymous Heroes, counted as six men on the south side of the gods (E18–23) and four men on the north (E43–46), with the "left over" men identified as marshals. For a summary of discussion and bibliography, see Brommer, *Der Parthenonfries,* 255–56, nos. 14 and 19. See S. Woodford, "Eponymoi or anonymoi," *Source Notes on the History of Art* 6 (1987): 1–5; Kron, "Die Phylenheroen am Parthenonfries"; Harrison, "Eponymous Heroes"; see, however, Jenkins, "Composition of the So-Called Eponymous Heroes."

135. Four men at north: E47–49, E52; man at south corner: E1.

136. Figures numbered as E47 and E48 on block 6. For marshals in the Panathenaia procession, see Shear, "Polis and Panathenaia," 124–26.

137. Brommer, *Der Parthenonfries,* 255–56; Harrison, "Eponymous Heroes"; Kron, *Die zehn attischen Phylenheroen,* 202–14; Kron, "Die Phylenheroen am Parthenonfries"; Neils, *Parthenon Frieze,* 158–61.

138. Jenkins, "Composition of the So-Called Eponymous Heroes"; Jenkins, *Parthenon Frieze,* 33–34.

139. Nagy, "Athenian Officials," 67–69.

140. A. E. Raubitschek, *Opus Nobile* (Wiesbaden: F. Steiner, 1969), 129; Ridgway, *Fifth Century Styles,* 79, sees them as Athenian citizens. Berger and Gisler-Huwiler, *Fries des Parthenon,* 179, summarize the various interpretations.

141. Aristotle, *Athenian Constitution* 26.4: "It was decreed, on a motion of Perikles, that a person should not have the rights of citizenship unless both of his parents had been citizens." Plutarch, *Life of Perikles* 37.3: "He [Perikles] proposed a law that only those who could claim Athenian parentage on both sides could be counted as Athenian citizens." E. Carawan, "Pericles the Younger and the Citizenship Law," *CJ* 103 (2008): 383–406; K. R. Walters, "Perikles' Citizenship Law," *ClAnt* 2 (1983): 314–36; C. Patterson, *Pericles' Citizenship Law of 451–50 B.C.* (New York: Arno Press, 1981); Boegehold, "Perikles' Citizenship Law."

142. I agree with Fehr, *Becoming Good Democrats and Wives,* 81, 112–13, in seeing these *parthenoi* as the equivalent of the young, beardless men on the flanks and west side of the frieze. Together, they show the youths and maidens of early Athens as socialized into their future civic and domestic roles, as citizens and members of the military and as citizen wives and mothers, and as a community of ideal members fully engaged in local cult ritual. See Jeppesen, "A Fresh Approach," 129–33, for reading of

these maidens as *epikleroi,* heiresses who lost their fathers and inherited property in the absence of male heirs. Since these women were not allowed to hold property in their own rights, they were required to marry one of their male kin, to keep resources within the family.

143. Euripides, *Erechtheus* F 370.77–80 Kannicht.

144. Euripides, *Children of Herakles* 781.

145. Homer, *Iliad* 2.550.

146. Euripides, *Erechtheus* F 370.92–94 Kannicht, where the fragmentary text reads: "[ox] or bull and a [ram]."

147. *IG* II² 1146; *IG* II² 1357.

148. Simon, *Festivals of Attica,* 64, sees the water bearers not as participants in the ritual but as victors in the torch races, carrying their prize *hydriai.*

149. Photios, s.v. σκάφας, bases his definition on Menander fr. 147 (*PCG*). See *RE* (1949), s.v. "Panathenaia"; Shear, "Polis and Panathenaia," 134–36; Simon, *Festivals of Attica,* 65, 69–70; Deubner, *Attische Feste,* 28.

150. I thank Dr. Tomas Lochman, curator of the Skulpturhalle Basel des Antikenmuseums, for his kindness in facilitating my research on the casts of the Parthenon sculptures. I am also indebted to Prof. Dr. Anton Bierl for inviting me as visiting professor, Departement Altertumswissenschaften der Universität Basel. The tray bearer shown on page 192, bottom, is molded from north frieze, figure N15, a fragment that is in the Vatican. See Jenkins, *Parthenon Frieze,* 86; Connelly, "Parthenon and *Parthenoi*," 69. On *skaphephoroi* in general, see Berger and Gisler-Huwiler, *Fries des Parthenon,* 195–96; Brommer, *Der Parthenonfries,* 214.

151. F. Graf, "Milch, Honig und Wein: Zum Verständnis der Libation im griechischen Ritual," in *Perennitas: Studi in onore di Angelo Brelich,* ed. M. Eliade (Rome: Ateneo, 1980), 209–21; Simon, *Festivals of Attica,* 70, has suggested that the honey is meant for Gaia, who might somehow have been worshipped in the Panathenaia.

152. Euripides, *Erechtheus* F 370.83–86 Kannicht.

153. Ibid., F 370.87–89 Kannicht.

154. J. G. Pedley, *Paestum: Greeks and Romans in Southern Italy* (London: Thames and Hudson, 1990), 36–39, figs. 11–13; P. C. Sestieri, "Iconographie et culte d'Hera à Paestum," *Revue des Artes* 5 (1955): 149–58.

155. Demaratus, *FGrH* 42 F 4; Euripides, *Erechtheus* F 370.102 Kannicht.

156. Euripides, *Erechtheus* F 370{–369d}5–9 Kannicht.

157. Berger and Gisler-Huwiler, *Fries des Parthenon,* 67–69. Others disagree: Simon, *Festivals of Attica,* 62; Boardman, "Closer Look," 322–23. Von Heintze, "Athena Polias am Parthenon," sees the men as members of a male chorus for the *prosodion* (processional song performed en route to the altar of the divinity); Fehr, *Becoming Good Democrats and Wives,* 80, sees the men as symbols of the "meritorious older generation of Athenian citizens." See Shear, "Polis and Panathenaia," 134–35.

158. Xenophon, *Symposium* 4.17.

159. Boardman, "Closer Look," 324–25.

160. Thucydides, *Peloponnesian War* 6.58.1.

161. Parian Marble, *IG* XII 5 444, 17–18. Harpokration, s.v. "apobates"; Pseudo-Eratosthenes, *Constellations* 13. See Kyle, *Athletics in Ancient Athens,* 63–64, 188–89, 205 (A37), and 213 (A70).

162. Nonnus, *Dionysiaca* 37.155ff.

163. See Neils and Schultz, "Erechtheus and the Apobates"; also Fehr, *Becoming Good Democrats and Wives,* 52–67; C. Ellinghaus, *Die Parthenonskulpturen: Der Bauschmuck eines öffentlichen Monumentes der demokratischen Gesellschaft Athens zur Zeit des Perikles, Techniken in der bildenden Kunst zur Tradierung von Aussagen* (Hamburg: Dr. Kovač, 2011), 109–71; P. Schultz, "The Iconography of the

Athenian Apobates Race," in Schultz and Hoff, *Structure, Image, and Ornament*, 64–69; Neils, *Parthenon Frieze*, 97–98, 138–86; Shear, "Polis and Panathenaia," 299–310; Berger and Gisler-Huwiler, *Der Fries des Parthenon*, 169–86.

164. Plutarch, *Life of Phokion* 20.1.

165. *IG* II² 2316.16 and *IG* II² 2317 + *SEG* 61.118.49. See discussion in Shear, "Polis and Panathenaia," 313–314. For the City Eleusinion, see M. M. Miles, *The City Eleusinion*, Athenian Agora 31 (Princeton, N.J.: American School of Classical Studies at Athens, 1998).

166. Marble base, Agora S399. See T. L. Shear, "The Sculpture Found in 1933: Relief of an Apobates," *Hesperia* 4 (1935): 379–81.

167. Tracy and Habicht, "New and Old Panathenaic Victor Lists," 198; Kyle, *Athletics in Ancient Athens*, 63–64.

168. Thucydides, *Peloponnesian War* 6.56–58; Demosthenes, *Against Phormio* 39; Pausanias, *Description of Greece* 1.2.14.

169. Demosthenes, *Erotikos* 24–25.

170. Boardman, "Parthenon Frieze," 210.

171. For the ranks of horsemen, see Jenkins, *Parthenon Frieze*, 55–63; Jenkins, "South Frieze," 449; Harrison, "Time in the Parthenon Frieze," 230–33; Berger and Gisler-Huwiler, *Fries des Parthenon*, 110–11; L. Beschi, "Il fregio del Partenone: Una proposta lettura," *RendLinc*, ser. 8, 39 (1985): 176, 183, 185.

172. For ten groups of riders on the south frieze as evoking the ten Kleisthenic tribes, see Harrison, "Time in the Parthenon Frieze," 232; T. Osada, "Also Ten Tribal Units: The Grouping of the Cavalry on the Parthenon North Frieze," *AJA* 115 (2011): 537–48; T. Stevenson, "Cavalry Uniforms on the Parthenon Frieze?," *AJA* 107 (2003): 629–54; Pollitt, "Meaning of the Parthenon Frieze," 55; Jenkins, *Parthenon Frieze*, 99; S. Bird, I. Jenkins, and F. Levi, *Second Sight of the Parthenon Frieze* (London: British Museum Press, 1998), 18–19; I. Jenkins, "The Parthenon Frieze and Perikles' Cavalry of a Thousand," in Barringer and Hurwit, *Periklean Athens*, 147–61; Jenkins, "South Frieze," 449; Harrison, "Time in the Parthenon Frieze," 230–32; E. B. Harrison, review of *Der Parthenonfries*, by Brommer, *AJA* 83 (1979): 490. Some see the ranks of riders as associated with the brotherhood groups called *phratries*.

173. Fehr, *Becoming Good Democrats and Wives*, 146–47, sees in the cavalry and chariot groups *sophrosune* (healthy-mindedness, self-control guided by knowledge and balance), *arete* (excellence), and *philia* (friendship among fellow soldiers).

174. Aristotle, *Politics* 1297b16–22. On the other hand, many ancient traditions, like the trooping of the colors, involved staged anachronisms.

175. Xenophon, *On Horsemanship* 11.8.

176. Connelly, "Parthenon and *Parthenoi*," 69–71; G. R. Bugh, *Horsemen of Athens* (Princeton, N.J.: Princeton University Press, 1988), 34–35, notes that the horsemen on the frieze are too old to be ephebes. See Brommer, *Der Parthenonfries*, 151–53; Castriota, *Myth, Ethos, and Actuality*, 202–26.

177. For the three red-figured cups in Berlin and Basel, see H. Cahn, "Dokimasia," *RA* (1973): 3–22; Connelly, "Parthenon and *Parthenoi*," 70–71. See G. Adeleye, "The Purpose of the Dokimasia," *GRBS* 24 (1983): 295–306.

178. Aristotle, *Athenian Constitution* 49.

179. Ibid., 42.

180. Herodotos, *Histories* 8.53; Demosthenes, *On the False Embassy* 303.

181. Fehr, *Becoming Good Democrats and Wives*, esp. 35–40, sees in the west frieze the testing and training of young men and horses, emphasizing equality, discipline, and collectiveness within the group. The bearded figures are seen as role models for the young trainees.

182. For the genealogical function of architectural sculpture, see T. Hölscher, "Immagini mitologiche e valori sociali nella Grecia arcaica," in *Im Spiegel des Mythos: Bilderwelt und Lebenswelt Symposium, Rom 19.–20. Februar 1998 = Lo Specchio del*

Mito, ed. F. de Angelis and S. Muth (Weisbaden: Ludwig Reichert, 1999), 11–30; Connelly, "Parthenon and *Parthenoi,*" 66; Marconi, "Kosmos," 222–24. We have already noted the depiction of the royal family of Elis on the east pediment of Zeus's temple at Olympia (470–456 B.C.). The genealogical emphasis can be seen even earlier in the sculptures of the temple of Aphaia at Aegina (ca. 500–480 B.C.), where a localized "take" on the Trojan Wars is shown in the pediments. Here, two of its native sons (King Telamon on the east gable and his grandson Ajax on the west) fight in two successive Trojan Wars, separated by a generation. The first Trojan War is fought against Trojan King Laomedon and the second against King Priam. See E. Simon, *Aias von Salamis als mythische Persönlichkeit* (Stuttgart: F. Steiner, 2003), 20ff. But, of course, we have already tracked this genealogical function for architectural sculpture as far back as the Bluebeard pediment of the Hekatompedon.

183. Summarized by Castriota, *Myth, Ethos, and Actuality,* 134–38.

184. Chaniotis, "Dividing Art–Divided Art," 43.

185. Pausanias, *Description of Greece* 1.27.4; 9.30.1. See C. Ioakimidou, *Die Statuenreihen griechischer Poleis und Bünde aus spätarchaischer und klassischer Zeit* (Munich: Tuduv-Verlagsgesellschaft, 1997), 99–100, 262–73 (interpreted as a state monument for the fallen); R. Krumeich, *Bildnisse griechischer Herrscher und Staatsmänner im 5. Jahrhundert v. Chr.* (Munich: Biering & Brinkmann, 1997), 109–11, 244, no. A58. See M. Korres, *Melete Apokatastaseos tou Parthenonos* 4 (Athens, 1994) 124, for discovery of blocks from the base of this statue group, built into the repaired west door of the Parthenon. Korres, *Study for the Restoration of the Parthenon,* 86–87, 124, argues that supports from three surviving blocks of the statue base indicate that the images of Erechtheus, Eumolpos, Tolmides, and the Theainetos all stood together on the same base.

186. Policoro, Museo Nazionale della Siritide 35304; Proto-Italiote, ca. 400 B.C., *LIMC* 2, s.v. "Athena," no. 177; *LIMC* 4, s.v. "Eumolpos," no. 19; L. Weidauer, "Poseidon und Eumolpos auf einer Pelike aus Policoro," *AntK* 12 (1963): 91–93, plate 41; Clairmont, "Euripides' Erechtheus and the Erechtheum," 492, plates 4 and 5; *LCS* 55, no. 282; M. Treu, "Der Euripideischer Erechtheus als Zeugnis seiner Zeit," *Chiron* 1 (1971): 115–31.

187. For earliest references to Poseidon Hippios, see P. Siewert, "Poseidon Hippios am Kolonos und die athenischen Hippeis," in *Arktouros: Hellenic Studies Presented to Bernard M. W. Knox,* ed. G. Bowersock, W. Burkert, and M. C. J. Putnam (Berlin: W. de Gruyter, 1979), 280–89.

188. Hurwit, *Athenian Acropolis,* 223.

189. A research model long examined by the so-called French School associated with the Centre Louis Gernet. See, for example, F. Lissarrague, *Vases Grecs: Les Athéniens et leurs images* (Paris: Hazan, 1999); A. Schnapp, "De la cité des images à la cité dans l'image," *Métis* 9 (1994): 209–18; and the collection of essays in Bérard et al., *La cité des images.*

190. Euripides, *Ion* 184–218.

191. Sourvinou-Inwood, *Tragedy and Athenian Religion* (Lanham, Md.: Lexington Books, 2003), 25–30; Sourvinou-Inwood, "Tragedy and Anthropology," in *A Companion to Greek Tragedy,* ed. J. Gregory (Oxford: Blackwell, 2005), 297–302.

192. Euripides, *Erechtheus* F 351 Kannicht. Translation: Collard and Cropp, *Euripides VII: Fragments,* 371.

193. Euripides, *Erechtheus* F 360.46–49 Kannicht.

194. *Euripides, Erechtheus* F 369.2–5 Kannicht. Translation: Collard and Cropp, *Euripides VII: Fragments,* 387, 389.

195. Translation: Collard and Cropp, *Euripides VII: Fragments,* 387.

196. Euripides, *Erechtheus* F 370{–369d} 9–10 Kannicht. Translation: Collard and Cropp, *Euripides VII: Fragments,* 389.

197. Marconi, "Degrees of Visibility," 166–67.

198. Ibid., 157–73. Marconi tracks Athenian taste for excess in sculptural decoration back to the Athenian Treasury at Delphi, probably built in the 480s B.C.

199. Language that is *enargês* ("vivid" and "with life-giving clarity") generates a surplus of linguistic power that can be deployed in politics alongside other forms of power. See Allen, *Why Plato Wrote*, 26, 36, 43, 58–61, 63, 81, 89, 90, 105, 106, 139, 173, 179, 192.

6 WHY THE PARTHENON

1. Carroll, *Parthenon Inscription*, 1; Andrews, "How a Riddle of the Parthenon Was Unraveled." Andrews (303) remarks that, from a perspective of some 45 feet (13.7 meters) below, the architrave looked like the top of a pepperbox, riddled with nail holes from the attached letters. They were hard to distinguish from old bullet holes left from the Ottoman period.

2. Andrews remarks that each morning when he awoke in his room at the American School of Classical Studies (on the slopes of Mount Lykabettos), he would rush to his window with field glasses, looking out at the Acropolis to see if his squeezes had survived the night. Andrews, "How a Riddle of the Parthenon Was Unraveled," 304.

3. In a letter to his sister Andrews writes: "The inscription proved to be a dedication to Nero, whereat I'm much disgusted." See Carroll, *Parthenon Inscription*, 7.

4. Arrian, *Anabasis* 1.16.7; Plutarch, *Life of Alexander* 16.8.

5. Plutarch, *Life of Alexander* 16.17; Pritchett, *Greek State at War*, 3:288.

6. *SEG* 32 251. Translation by S. Dow, "Andrews of Cornell," *Cornell Alumni News* 75 (1972): 13–21, who made some additions to Andrews's reconstruction of the text. See Carroll, *Parthenon Inscription*, 12–15, fig. 5.

7. See paper given by G. Alföldy, "Der Glanz der römischen Epigraphik: litterae aureae," at the conference *Festvortrag des Ehrendoktors der Universität Wien emer. Prof. Dr. Dr. h. c. mult. Géza Alföldy*, University of Heidelberg, June 28, 2011, forthcoming. For Augustus's introduction of such "golden letters" on attached metal dedications, see G. Alföldy, "Augustus und die Inschriften: Tradition und Innovation: Die Geburt der imperialen Epigraphik," *Gymnasium* 98 (1991): 289–324. Like Eugene Andrews, Alföldy has similarly examined dowel holes to decipher lost dedicatory inscriptions, including those on the Colosseum: G. Alföldy, "Eine Bauinschrift aus dem Colosseum," *ZPE* 109 (1995): 195–226, as well as on the Roman aqueduct at Segovia on the Iberian peninsula: Alföldy, "Inschrift des Aquädukts von Segovia: Ein Vorbericht," *ZPE* 94 (1992): 231–48. I am indebted to Angelos Chaniotis and Michael Peachin for these references.

8. Carroll, *Parthenon Inscription*, 7.

9. Translation: Collard and Cropp, *Euripides VII: Fragments*, 387.

10. Plutarch, *Life of Nikias* 9.5.

11. Pritchett, *Greek State at War*; Pritchard, *War, Democracy, and Culture*; A. Chaniotis, *War in the Hellenistic World* (Malden, Mass.: Blackwell, 2005); H. van Wees, *Greek Warfare: Myths and Rituals* (London: Bristol Classical Press, 2004); K. Raaflaub, "Archaic and Classical Greece," in *War and Society in the Ancient and Medieval Worlds: Asia, the Mediterranean, Europe, and Mesoamerica*, ed. K. Raaflaub and N. Rosenstein (Cambridge, Mass.: Harvard University Press, 1999), 129–61; Whitley, "Monuments That Stood Before Marathon"; Rich and Shipley, *War and Society in the Greek World*; B. Lincoln, *Death, War, and Sacrifice: Studies in Ideology and Practice* (Chicago: University of Chicago Press, 1991); E. Vermeule, *Aspects of Death in Early Greek Art and Poetry* (Berkeley: University of California Press, 1979).

12. Plato, *Laws* 1.626a.

13. D. Kagan, *The Outbreak of the Peloponnesian War* (Ithaca, N.Y.: Cornell University Press, 1969); D. Kagan, *The Archidamian War* (Ithaca, N.Y.: Cornell

University Press, 1974); D. Kagan, *The Peace of Nicias and the Sicilian Expedition* (Ithaca, N.Y.: Cornell University Press, 1981); D. Kagan, *The Fall of the Athenian Empire* (Ithaca, N.Y.: Cornell University Press, 1987); D. Kagan, *The Peloponnesian War* (New York: Viking Press, 2003); Hanson, *A War Like No Other*; V. D. Hanson, *Warfare and Agriculture in Classical Greece* (Berkeley: University of California Press, 1983).

14. Xenophon, *Agesilaus* 2.14.

15. Herodotus, *Histories* 7.9. Translation: Godley, *Herodotus: Histories*, 315.

16. P. Vaughn, "The Identification and Retrieval of the Hoplite Battle-Dead," in Hanson, *Hoplites*, 38–62.

17. Polyainos, *Strategies* 1.17; Diodoros Siculus, *Library* 8.27.2; Pritchett, *Greek State at War*, 4:243–46; J. H. Leopold, "De scytala laconica," *Mnemosyne* 28 (1900): 365–91.

18. Pausanias, *Description of Greece* 1.29. N. Arrington, "Inscribing Defeat: The Commemorative Dynamics of the Athenian Casualty Lists," *ClAnt* 30 (2011): 179–212.

19. Thucydides, *Peloponnesian War* 2.34.1–5.

20. Nathan Arrington has plotted all excavated remains associated with the public cemetery along the Academy Road; see Arrington, "Topographic Semantics," and his forthcoming monograph *Ashes, Images, and Memories: The Presence of the War Dead in Fifth-Century Athens*.

21. For the excavations, see T. Karagiorga-Stathakopoulou, "Γ´ Εφορεία Προϊστορικών και Κλασικών Αρχαιοτήτων," *ArchDelt* 33 (1978): B 1, 10–42, esp. 18–20. For the inscriptions, see A. P. Matthaiou, "Ηρίον Λυκούργου Λυκόφρονος Βουτάδου," *Horos* 5 (1987): 31–44 (*SEG* 37.160–62); Arrington, "Topographic Semantics," 520; Pausanias, *Description of Greece* 1.29.15, sees the tomb of Lykourgos near the Academy during his visit to the public cemetery.

22. As Onassander, *Strategikos* 36.1–2, put it: "For if the dead are not buried, each soldier believes that no care will be taken of his own body, should he chance to fall." See P. Low, "Commemoration of the War Dead in Classical Athens: Remembering Defeat and Victory," in Pritchard, *War, Democracy, and Culture*, 342–58.

23. V. D. Hanson, *The Western Way of War: Infantry Battle in Classical Greece* (Berkeley: University of California Press, 1989).

24. V. D. Hanson, *A War Like No Other*, 252; Hale, *Lords of the Sea*, 95, 120–21, 208.

25. Thucydides, *Peloponnesian War* 8.1.2–4. Translation: Jowett, *Thucydides*, with changes.

26. Snodgrass, *Archaic Greece*, 53–54; A. Snodgrass, *Early Greek Armor and Weapons from the End of the Bronze Age to 600 B.C.* (Edinburgh: Edinburgh University Press, 1964).

27. Snodgrass, "Interaction by Design"; Snodgrass, *Archaic Greece*, 131ff.; Morgan, *Athletes and Oracles*, 16–25, 233–34.

28. The traditional date for the founding of the Olympics is 776 B.C., the Pythian Games in 586, the Isthmian Games in 582, and the Nemean Games in 573. Morgan, *Athletes and Oracles*, 16–20, 212–14.

29. Snodgrass, "Interaction by Design"; Morgan, *Athletes and Oracles*, 16–25, 203.

30. Snodgrass, *Archaic Greece*, 131.

31. A. H. Jackson, "Hoplites and the Gods: The Dedication of Captured Arms and Armour," in Hanson, *Hoplites*, 228–49, esp. 244–45.

32. A. Jackson, "Arms and Armour in the Panhellenic Sanctuary of Poseidon at Isthmia," in Coulson and Kyrieleis, *Proceedings of an International Symposium on the Olympic Games.* Jackson will further discuss this material in his volume on arms and armor.

33. Pausanias, *Description of Greece* 10.8.7. P. Kaplan, "Dedications to Greek

Sanctuaries by Foreign Kings in the Eighth Through Sixth Centuries BCE," *Historia* 55 (2006): 129–52.

34. Herodotos, *Histories* 8.27. The other two thousand shields seized from this battle were dedicated at the shrine of Abai (Kalapodi). Pritchett, *Greek State at War,* 3:285.

35. Aeschines 3.116.

36. Pausanias, *Description of Greece* 10.19.3–4.

37. Scott, *Delphi and Olympia,* 169–75.

38. Pausanias, *Description of Greece* 10.11.5, which would put its construction sometime in the 480s. This dating has been disputed by some scholars who think the building looks earlier than this, though Richard Neer defends the date given by Pausanias; R. Neer, "The Athenian Treasury at Delphi and the Material of Politics," *ClAnt* 23 (1982): 67.

39. Ober, *Democracy and Knowledge,* 178.

40. As explained by Morgan, *Athletes and Oracles,* 18.

41. Pausanias, *Description of Greece* 5.10.4.

42. D. White, "The Cyrene Sphinx, Its Capital, and Its Column," *AJA* 75 (1971): 47–55.

43. Pausanias, *Description of Greece* 1.15.5.

44. T. L. Shear, "A Spartan Shield from Pylos," *ArchEph* 76 (1937): 140–43; T. L. Shear, "The Campaign of 1936," *Hesperia* 6 (1937): 331–51.

45. Lippman, Scahill, and Schultz, "Nike Temple Bastion."

46. I. S. Mark, *Sanctuary of Athena Nike in Athens: Architectural Stages and Chronology* (Princeton, N.J.: Princeton University Press, 1993).

47. E. Petersen, "Nachlese in Athen," *JdI* 23 (1908): 12–44.

48. Aristophanes, *Knights* 843–59.

49. Lippman, Scahill, and Schultz, "Nike Temple Bastion." I thank Richard Anderson for helpful discussions of this material.

50. N. C. Loader, *Building in Cyclopean Masonry: With Special Reference to the Mycenaean Fortifications on Mainland Greece* (Jønsered: Paul Åström, 1998), 84–85.

51. Pausanias, *Description of Greece* 2.16.5, 2.25.8. J. A. Bundgaard, *Parthenon and the Mycenaean City on the Heights* (Copenhagen: National Museum of Denmark, 1976), 43–46. I thank Benjamin Schwaid, my former student at New York University, for his insights on the deliberate placing of the Nike temple upon the Mycenaean bastion.

52. R. Carpenter, *The Sculptures of the Nike Temple Parapet* (Cambridge, Mass.: Harvard University Press, 1929).

53. Pausanias, *Description of Greece* 9.4.1; Pausanias, *Description of Greece* 1.28.2, refers to the statue as the "Bronze Athena," as does Demosthenes, *On the False Embassy* 272. It is a scholiast to Demosthenes, *Against Androtion* 12–15, who first calls the statue Promachos, "She Who Fights in the Front of Battle," though no surviving sources of the classical period refer to it in this way. For the traditional date of 460–450 see Harrison, "Pheidias," 28–30; Hurwit, *Athenian Acropolis,* 151–52; Djordjevitch, "Pheidias's Athena Promachos Reconsidered," 323. For the financing and dating of the statue, see *IG* I³ 435, though this inscription's relevance to the Bronze Athena has been put in question; for a summary of the issues see O. Palagia, "Not from the Spoils of Marathon," 117–37, where there is also a nice critique of the various reconstruction drawings that have been made for the statue, including the (not perfect) rendering by G. P. Stevens shown here on page 227. For the statue in late antiquity, see Frantz, *Late Antiquity,* 76–77.

54. A. E. Raubitschek and G. P. Stevens, "The Pedestal of the Athena Promachos," *Hesperia* 15 (1946): 107–14. Dinsmoor, in "The Pedestal of the Athena Promachos," *AJA* 25 (1921): 128, restored the statue's height at 16.40 meters (including

base); Stevens, in "The Periclean Entrance Court to the Acropolis," *Hesperia* 5 (1936): 495–99, restored the statue at 9 meters (including base).

55. Palagia, "Not from the Spoils of Marathon," 18–19, 124–25, 127.

56. *IG* I³ 435; Dinsmoor, "Statue of Athena Promachos."

57. Martin-McAuliffe and Papadopoulos, "Framing Victory," 345–46.

58. *IG* I³ 427–31, 435; Harrison, "Pheidias," 28–34; Mattusch, *Greek Bronze Statuary,* 169–72; Hurwit, *Athenian Acropolis,* 24–25; Linfert, "Athenen des Phidias," 66–71; Robertson, *History of Greek Art,* 294; Dinsmoor, "Two Monuments on the Athenian Acropolis"; Dinsmoor, "Statue of Athena Promachos." B. D. Meritt, "Greek Inscriptions," *Hesperia* 5 (1936): 362–80.

59. Pausanias, *Description of Greece* 1.28.2.

60. See B. Lundgreen, "A Methodological Enquiry: The Great Bronze Athena by Pheidias," *JHS* 117 (1997): 190–97; Harrison, "Pheidias," 28–34; Ridgway, "Images of Athena," 127–31; Linfert, "Athenen des Phidias," 66–71; Mattusch, *Greek Bronze Statuary,* 170; E. Mathiopoulos, "Zur Typologie der Göttin Athena im fünften Jhr. v. Chr." (Ph.D. diss., University of Bonn, 1961–1968); B. Pick, "Die 'Promachos' des Phidias und die Kerameikos-Lampen," *AM* 56 (1931): 59–74.

61. F. W. Imhoof-Blumer, P. Gardner, and A. N. Oikonomides, *Ancient Coins Illustrating Lost Masterpieces of Greek Art* (Chicago: Argonaut, 1964), 128–29, plate Z i–viii; J. Boardman, *Greek Sculpture: The Classical Period* (London: Thames and Hudson, 1985), 203, fig. 180; Djordjevitch, "Pheidias's Athena Promachos Reconsidered," 323.

62. G. P. Stevens, "Dedication of Spoils in Greek Temples," *Hesperia Supplement* 3 (1940).

63. Herodotus, *Histories* 9.13, 22; Pausanias, *Description of Greece* 1.27.1; Demosthenes, *Against Timokrates* 129. For archaeological evidence of the Persian sack, see T. L. Shear, "The Persian Destruction of Athens: Evidence from Agora Deposits," *Hesperia* 62 (1993): 383–482.

64. Herodotus, *Histories* 9.20–25.

65. All listed in Harris, *Treasures of the Parthenon and Erechtheion,* with epigraphical citations and bibliography.

66. Ibid., 234.

67. Ibid., 81–103.

68. Roux, "Pourquoi le Parthénon?," and Tréheux, "Pourquoi le Parthénon?" I thank Patricia D. Connelly and Louise Connelly for their kind assistance with these texts.

69. Furtwängler, *Meisterwerke,* 172–74.

70. W. Dörpfeld, "Das Alter des Heiligtums von Olympia," *AM* 31 (1906): 170. Solomon Reinach followed in 1908, arguing that "Parthenon" signals a multiplicity of virgins; see S. Reinach, "ΠΑΡΘΕΝΟΝ," *BCH* 32 (1908): 499–513. For a summary of the scholarship up to 1984, see Roux, "Pourquoi le Parthénon?," 301–6, and Tréheux, "Pourquoi le Parthénon?," 238–42.

71. Tréheux, "Pourquoi le Parthénon?," 238, points out that Böckh, Bötticher, Stark, and Michaelis preceded Roux in locating the Parthenon within the eastern cella and in linking the word to the virginity of Athena. He cites A. K. Orlandos, H ἀρχιτεκτονικ του Παρθενου, *I–III* (Athens: Archaeological Society of Athens, 1977), 143, for complete bibliography.

72. For inventories referring to the chamber called Parthenon see chapter 3, note 52.

73. Harris, *Treasures of the Parthenon and Erechtheion,* 4–5, 40–80; see also T. Linders, "The Location of the Opisthodomos: Evidence from the Temple of Athena Inventories," *AJA* 111 (2007): 777–82.

74. *IG* II² 1407.

75. Harpokration; see Roux, "Pourquoi le Parthénon?," 304–5; Hurwit, *Athenian Acropolis,* 161–62.

76. *IG* I³ 343 4 (ca. 434/433 B.C.); *IG* I³ 376.14 (ca. 409/408 B.C.).

77. Roux, "Pourquoi le Parthénon?," 304–5; Tréheux, "Pourquoi le Parthénon?," 233; Hurwit, *Athenian Acropolis,* 161–62.

78. Demosthenes, *Against Androtion* 76 and 184. Existence of a "Parthenon" on the Acropolis is attested in *IG* II² 1407, dating to 385 B.C.

79. Plutarch, *Life of Perikles* 13.7. In his *Life of Cato* 5.3, however, Plutarch calls it simply Hekatompedon.

80. Pausanias, *Description of Greece* 1.24.5.

81. Tréheux, 238–40; Brauron, *SEG* 46.13; Magnesia on the Maeander, *SEG* 15.668; and Kyzikos, IMT Kyz Kapu Dağ 1433.

82. As pointed out by I. Mylonopoulos, "Buildings, Images, and Rituals in the Greek World," in *The Oxford Handbook of Greek and Roman Architecture,* forthcoming.

83. Roux, "Pourquoi le Parthénon?," 311–12.

84. Hurwit, *Athenian Acropolis,* 36, fig. 32, cites *IG* I³ 728, 745 as possibly giving the earliest appearance of the words "Athena Parthenos," inscribed on a base dedicated on the Acropolis (no. 6505) by one Telesios sometime between 500 and 480 B.C.

85. Whatever its primary meaning, as comparative philologist and linguist Anna Morpurgo Davies observed, the word "Parthenon" is unlikely to have been formed with the meaning of a single maiden in mind. I am indebted to Professor Davies for a very helpful discussion of the word *parthenon* in 1996.

86. Euripides, *Iphigeneia at Tauris* 1452–53; Pausanias, *Description of Greece* 9.17.1.

87. Pedersen, *Parthenon and the Origin of the Corinthian Capital,* 11–22. He points to the circular lines inscribed on the floor of the room which indicate the placement of these columns and clearly show that they were not Doric. This leaves two possibilities: Ionic and Corinthian. The use of Ionic capitals here is problematic, since they have distinctive "front" and "side" faces. Since this room is longer on its north–south axis than on its east–west axis, it forms what is called a "center-space room" in which the main corridor lies on a different axis from the rest of the building. This introduces a problem vis-à-vis which way the Ionic volutes faced: Would they have been aligned on the long axis of the Parthenon temple or on the shorter axis of the *parthenon* room? The introduction of Corinthian capitals here would solve this design problem, since akanthos leaves would completely encircle the crown of the columns, spreading equally on all sides and therefore specifying no "front" or "back" faces.

88. Ibid., 16–20.

89. Rykwert, *Dancing Column,* 317–27; Vitruvius, *Ten Books of Architecture* 4.1.

90. H. Gropengiesser, *Die pflanzlichen Akrotere klassischer Tempel* (Mainz: Philipp von Zabern, 1961), 2–17; P. Danner, *Griechische Akrotere der archaischen und klassischen Zeit* (Rome: G. Bretschneider, 1989), 13–14, no. 77; Korres, "Architecture of the Parthenon."

91. Pedersen, *Parthenon and the Origin of the Corinthian Capital,* 32–36.

92. Euripides, *Erechtheus* F 370.85 Kannicht.

93. Kyle, *Athletics in Ancient Athens,* 41–43.

94. Zeus-Agamemnon: *RE* (1972), s.v. "Zeus"; A. Momigliano, "Zeus Agamemnone e il capo Malea," *Studi Italiani di Filologia Classica,* n.s., 8 (1930): 317–19. Apollo-Hyakinthos: Aristotle, *Politics* 8.28; C. Christou, "Ἀνασκαφή Ἀμυκλῶν," *Praktika tes en Athenais Archaiologikis Etaireias* (1960): 228–31; C. Christou, "Ἀρχαιότητες Λακωνίας-Ἀρκαδίας: Ἀμύκλαι," *ArchDelt* 16 (1960): 102–3; J. M. Hall, "Politics and Greek Myth," in *The Cambridge Companion to Greek Mythology,* ed. R. D. Woodard (Cambridge, U.K.: Cambridge University Press, 2007), 331–54. Artemis-Iphigeneia at Brauron: J. Papadimitriou, "Excavations in Vravron Attica," *Praktika tes en Athenais*

Archaiologikis Etaireias 42 (1948): 81–90; J. Papadimitriou, "The Sanctuary of Artemis at Brauron," *Scientific American* 208 (1963): 110–20.

95. The bibliography on hero cult is large and ever growing: Albersmeier, *Heroes;* Ekroth, "Cult of Heroes"; J. Bravo, "Recovering the Past: The Origins of Greek Heroes and Hero Cult," in Albersmeier, *Heroes,* 10–29; G. Ekroth, "Heroes and Hero-Cults," in Ogden, *Companion to Greek Religion,* 100–114; H. van Wees, "From Kings to Demigods: Epic Heroes and Social Change, c. 750–600 B.C.," in *Ancient Greece: From the Mycenaean Palaces to the Age of Homer,* ed. S. Deger-Jalkotzy and I. S. Lemos (Edinburgh: Edinburgh University Press, 2006), 363–79; Pache, *Baby and Child Heroes;* Ekroth, *Sacrificial Rituals of Greek Hero-Cults;* J. Boardman, *The Archaeology of Nostalgia: How the Greeks Re-created Their Mythical Past* (London: Thames and Hudson, 2002); D. Boehringer, *Heroenkulte in Griechenland von der geometrischen bis zur klassischen Zeit: Attika, Argolis, Messenien* (Berlin: Akademie, 2001); A. Mazarakis Ainian, "Reflections on Hero Cults in Early Iron Age Greece," in Hägg, *Ancient Greek Hero Cult,* 9–36; Antonaccio, *Archaeology of Ancestors;* Larson, *Greek Heroine Cults;* Whitley, "The Monuments That Stood Before Marathon"; D. Boedeker, "Hero Cult and Politics in Herodotus: The Bones of Orestes," in *Cultural Poetics in Archaic Greece: Cult, Performance, Politics,* ed. C. Dougherty and L. Kurke (Oxford: Oxford University Press, 1993), 164–77; S. E. Alcock, "Tomb Cult and the Post-Classical Polis," *AJA* 95 (1991): 447–67; Kearns, *Heroes of Attica;* J. Whitley, "Early States and Hero Cults: A Re-appraisal," *JHS* 108 (1988): 173–82; M. Visser, "Worship Your Enemy: Aspects of the Cult of Heroes in Ancient Greece," *HTR* 74 (1982): 403–28; A. Snodgrass, "Les origines du culte des héros dans la Grèce antique," in *La mort: Les morts dans les sociétés anciennes,* ed. G. Gnoli and J.-P. Vernant (Cambridge, U.K.: Cambridge University Press, 1982), 107–19; H. Abramson, "Greek Hero Shrines" (Ph.D. diss., University of California, Berkeley, 1978); J. N. Coldstream, "Hero-Cults in the Age of Homer," *JHS* 96 (1976): 8–17; T. Hadzisteliou-Price, "Hero-Cult and Homer," *Historia* 22 (1973): 129–44; L. R. Farnell, *Greek Hero Cults and Ideas of Immortality* (Oxford: Clarendon Press, 1921).

96. It has been dated to the Late Helladic III period (1300–1190 B.C.) and is one of only four Mycenaean bridges of this type to survive. See R. Hope Simpson and D. K. Hagel, *Mycenaean Fortifications, Highways, Dams, and Canals* (Sävedalen: Paul Åström, 2006); R. Hope Simpson, "The Mycenaean Highways," *Classical Views* 42 (1998): 239–60; A. Jansen, "Bronze Age Highways at Mycenae," *Classical Views* 41 (1997): 1–16.

97. Morgan, *Athletes and Oracles,* 209.

98. Ibid.

99. W. J. Slater, "Pelops at Olympia," *GRBS* 30 (1989): 485–501; H. Kyrieleis, *Anfänge und Frühzeit des Heiligtums von Olympia: Die Ausgrabungen am Pelopion, 1987–1996* (Berlin: Walter de Gruyter, 2006); Barringer, "Temple of Zeus at Olympia"; D. E. Gerber, *Pindar's Olympian One: A Commentary* (Toronto: University of Toronto Press, 1982); H.-V. Hermann, *Olympia: Heiligtum und Wettkampfstätte* (Munich: Hirmer, 1972), 53–56.

100. Miller, "Excavations at Nemea, 1983"; S. G. Miller, "Excavations at Nemea, 1973–1974," *Hesperia* 44 (1975): 143–72; Miller, *Nemea;* S. G. Miller, "The Stadium at Nemea and the Nemean Games," in Coulson and Kyrieleis, *Proceedings of an International Symposium on the Olympic Games,* 81–86; D. G. Romano, "An Early Stadium at Nemea," *Hesperia* 46 (1977): 27–31.

101. First extant mention of Opheltes-Archemoros is in Simonides, preserved by Athenaeus: *PMG* 553, Athenaeus 9.396e. See also Bachyllides 9.10–14; Pindar, *Nemean Ode* 9.6–15; Euripides, *Hypsipyle;* and Apollodoros, *Library* 3.6; E. Simon, "Archemoros," *AA* 94 (1979): 31–45. For the myth, as told by Euripides, see W. E. H. Cockle, *Euripides Hypsipyle: Text and Annotation Based on a Re-examination of the Papyri* (Rome: Ateneo, 1987).

102. Pausanias, *Description of Greece* 2.15.2–3.

103. Miller, *Nemea*, 20; Miller, "Excavations at Nemea, 1983," 173.

104. Miller, *Nemea*, 12.

105. D. E. Birge, L. H. Kranack, and S. G. Miller, *Excavations at Nemea: Topographical and Architectural Studies: The Sacred Square, the Xenon, and the Bath, Nemea I* (Berkeley: University of California Press, 1992), 93.

106. Pausanias, *Description of Greece* 2.10.

107. E. R. Gebhard, "Rites for Melikertes-Palaimon in the Early Roman Corinthia," in *Urban Religion in Roman Corinth: Interdisciplinary Approaches*, ed. D. N. Schowalter and S. J. Friesen (Cambridge, Mass.: Harvard Divinity School, 2005); E. R. Gebhard and M. W. Dickie, "The View from the Isthmus, ca. 200 to 44 B.C.," *Corinth* 20 (2003): 261–78; E. R. Gebhard and M. W. Dickie, "Melikertes-Palaimon, Hero of the Isthmian Games," in Hägg, *Ancient Greek Hero Cult*, 159–65; E. R. Gebhard and F. P. Hemans, "University of Chicago Excavations at Isthmia, 1989: III," *Hesperia* 67 (1998): 405–56; E. R. Gebhard and F. P. Hemans, "University of Chicago Excavations at Isthmia: II," *Hesperia* 67 (1998): 1–63; E. R. Gebhard, "The Evolution of a Pan-Hellenic Sanctuary: From Archaeology Towards History at Isthmia," in *Greek Sanctuaries: New Approaches*, ed. N. Marinatos and R. Hägg (New York: Routledge, 1993), 154–77; E. R. Gebhard, "The Early Sanctuary of Poseidon at Isthmia," *AJA* 91 (1987): 475–76; D. W. Rupp, "The Lost Classical Palaimonion Found?," *Hesperia* 48 (1979): 64–72; Broneer, *Isthmia*, 2:99–112. I thank Elizabeth Gebhard for her kindness in providing information and bibliography.

108. A. Chaniotis, "Hyakinthia," *ThesCRA*, vol. 7, V.2, 164–67; S. Vlizos, "The Amyklaion Revisited: New Observations on a Laconian Sanctuary of Apollo," in *Athens-Sparta: Contributions to the Research on the History and Archaeology of the Two City-States*, ed. N. Kaltsas (New York: Alexander S. Onassis Public Benefit Foundation, 2007), 11–23; P. G. Calligas, "From the Amyklaion," in *Philolakon: Lakonian Studies in Honour of Hector Catling*, ed. J. M. Sanders (London: British School at Athens, 1992), 31–48; Pettersson, "Cults of Apollo at Sparta"; Amykles Research Project, http://amykles-research-project-en.wikidot.com.

109. Pausanias, *Description of Greece* 3.18.9–3.195. See I. Margreiter, *Die Kleinfunde aus dem Apollon-Heiligtum* (Mainz: Philipp von Zabern, 1988); J. G. Milne, "The Throne of Apollo at Amyklae," *CR* 10 (1896): 215–20; Pettersson, "Cults of Apollo at Sparta," 9.

110. By around 500 B.C., the sculptor Bathykles of Magnesia was brought in to build a huge marble throne around the statue. Delivorrias, "Throne of Apollo at the Amyklaion"; E. Georgoulaki, "Le type iconographique de la statue cultuelle d'Apollon Amyklaios: Un emprunt oriental?," *Kernos* 7 (1994): 95–118; A. Faustoferri, "The Throne of Apollo at Amyklai: Its Significance and Chronology," in *Sculpture from Arcadia and Laconia*, ed. O. Palagia and W. Coulson (Oxford: Oxbow, 1993), 159–66.

111. Pausanias, *Description of Greece* 3.18.6–8.

112. A. Chaniotis, "Hyakinthia," *ThesCRA*, vol. 7, V.2, 164–67; A. Brelich, *Paides e Parthenoi* (Rome: Ateneo, 1969), 1, 139–54, 171–91; Pettersson, "Cults of Apollo at Sparta."

113. C. Dietrich, "The Dorian Hyacinthia: A Survival from the Bronze Age," *Kadmos* 14 (1975): 133–42. M. J. Mellink, *Hyakinthos* (Utrecht: Kemink, 1943).

114. K. Demakopoulou, "Τό μυκηναϊκό ἱερό στο Ἀμυκλαῖο:μια νέα προσέγγιση," *British School at Athens Studies* 16 (2009): 95–104; K. Demakopoulou, Τό μυκηναϊκό ἱερό στό Ἀμυκλαῖο καιἡ ΥΕ ΙΙΙ Γ περίοδος στη Λακωνία (Athens, 1982).

115. Herodotus, *Histories* 9.7; Thucydides, *Peloponnesian War* 5.23.4–5; Xenophon, *Hellenika* 4.5.11.

116. Pettersson, "Cults of Apollo at Sparta"; A. Chaniotis, "Hyakinthia," *ThesCRA*, vol. 7, V.2, 164–67.

117. Euripides, *Erechtheus* F 370.71–74 Kannicht; Demosthenes, *Funeral Speech* 27.

118. Lucian, *Dialogues of the Gods*, 16; *Clement of Alexandria*, 10.26; Philostratos, *Imagines* 1.24; Ovid, *Metamorphoses* 10.162–219, 13.395; Ovid, *Fasti* 5.22.

119. Phanodemos, *FGrH* 325 F 4. Some have taken this to be at Sphendonai; others see it as a hill of purple color.

120. See Harpokration and *Suda*, s.v. Ὑακινθίδες. According to Apollodoros, *Library* 3.15.8, the names of the daughters of Hyakinthos were Antheis, Aigle, Lytaia, and Orthaia; they are said to have been sacrificed to save Athens from an attack led by Minos. According to yet another version of the story (Hyginus, *Fabulae* 238.2), Hyakinthos sacrificed Antheis alone in response to an oracle.

121. J. Fontenrose, *Python: A Study of Delphic Myth and Its Origins* (Berkeley: University of California Press, 1959); Ogden, *Drakon*, 40–48; C. Watkins, *How to Kill a Dragon* (Oxford: Oxford University Press, 1995); J. Katz, "To Turn a Blind Eel," *Proceedings of the Sixteenth Annual UCLA Indo-European Conference* 16 (2005): 259–96; Morgan, *Athletes and Oracles*.

122. Nagy, *Best of the Achaeans*, 121–24; E. Suárez de la Torre, "Neoptolemos at Delphi," *Kernos* 10 (1997): 153–76; L. Muellner, *The Anger of Achilles: Mēnis in Greek Epic* (Ithaca, N.Y.: Cornell University Press, 1996); I. Rutherford, *Pindar's Paeans: A Reading of the Fragments with a Survey of the Genre* (Oxford: Oxford University Press, 2001); M. Stansbury-O'Donnell, "Polygnotos's Iliupersis: A New Reconstruction," *AJA* 93 (1989): 203–15; L. Woodbury, "Neoptolemus at Delphi: Pindar, *Nem.* 7.30 ff.," *Phoenix* 33 (1979): 95–133; J. Fontenrose, *The Cult and Myth of Pyrros at Delphi* (Berkeley: University of California Press, 1960), 191–266, plates 18–19.

123. Scholiast on Pindar, *Nemean Ode* 7.62.

124. Strabo, *Geography* 9.421; Pausanias, *Description of Greece* 10.24.6.

125. Scott, *Delphi and Olympia*, 94, 119–120, 127, fig. 5.5; A. Jacquemin, *Offrandes monumentales à Delphes* (Paris: De Boccard, 1999); J. Pouilloux, *Fouilles de Delphes II: Topographe et architecture: La région nord du sanctuaire de l'époque archaïque à la fin du sanctuaire* (Paris: De Boccard, 1960).

126. Heliodoros, *Aethiopika* 2.34.3. For *Aethiopika*, see B. P. Reardon, *Collected Ancient Greek Novels* (1989; Berkeley: University of California Press, 2008), 349–588. See also J. Pouilloux and G. Roux, *Énigmes à Delphes* (Paris: E. de Boccard, 1963).

127. Ferrari, *Alcman*, 146–47.

128. Rykwert, *Dancing Column*, 327–31; Ferrari, *Alcman*, 146–47; J. Bousquet, "Delphes et les Aglaurides d'Athènes," *BCH* 88 (1964): 655–75; J. L. Martinez, "La colonne des danseuses de Delphes," *CRAI* (1997): 35–46; Louvre Museum and Insight Project, "Reconstruction of Acanthus Column in Delphi," http://www.insightdigital .org/entry/index.php?option=com_content&view=article&id=146&Itemid=438 (accessed April 26, 2013).

129. For a discussion of the importance of Pyrrhos and his death at Delphi, see Nagy, *Best of the Achaeans*, 118–41. Pindar, *Nemean* 7.44–47, refers to Pyrrhos as the one who will "preside over the Heroes' processions."

130. R. Balot, "Democratizing Courage in Classical Athens," in Pritchard, *War, Democracy, and Culture*, 88–108.

7 THE PANATHENAIA

1. Duncan, *My Life*, 95–100, quotation from 98. P. Kurth, *Isadora: A Sensational Life* (Boston: Little, Brown and Company, 2001), 109–16.

2. Duncan, *My Life*, 100–103.

3. I. Duncan, "The Art of the Dance," *Theatre Arts Monthly* (1928), republished as "The Parthenon," in *The Art of the Dance*, ed. S. Cheney (New York: Theatre Arts Books, 1969), 65. I am grateful to Lori Belilove, director of the Isadora Duncan Dance Foundation, for her kindness in helping with my research.

4. I thank Rob Lancefield of the Davison Art Gallery at Wesleyan University for

making a new scan of this image from their collection. See *Edward Steichen: The Early Years Portfolio, 1900–1927* (Gordonsville, Ga.: Aperture, 1991).

5. Shear, "Polis and Panathenaia," 556–660; Frantz, *Late Antiquity,* 51–56. Theodosios's edict of February 21, A.D. 391, banned sacrifices and closed temples; another of November 8, 392, banned sacrifices and divination and burning incense. There is no surviving evidence for the Panathenaia after 391.

6. See Shear, "Polis and Panathenaia," 5–7; for the Small, or Lesser, Panathenaia, 72–119; for the Great, or Greater, Panathenaia, 120–385, 505–660. The Great Panathenaia was quadrennial, that is, it took place every fourth year, if one counts by starting with zero. The Greeks, however, had no zero and started counting from the number one. They therefore thought of their Great Panathenaia as occurring in the fifth year, making it penteteric.

7. Sourvinou-Inwood, *Athenian Myths and Festivals,* 263–311; Simon, *Festivals of Attica,* 55–72; Parker, *Polytheism and Society,* 253–69; Shear, "Polis and Panathenaia," 75–76, 87–90, 120–66; Parker, *Athenian Religion,* 91; Deubner, *Attische Feste,* 22–35.

8. Davies, "Athenian Citizenship," 106–7; J. S. Traill, *The Political Organization of Attica: A Study of the Demes, Trittyes, and Phylai, and Their Representation in the Athenian Council,* Hesperia Supplement 14 (Princeton, N.J.: American School of Classical Studies at Athens, 1974).

9. B. Nagy, "The Athenian Athlothetai," *GRBS* 19 (1978): 307–13; Shear, "Polis and Panathenaia."

10. Aristotle, *Athenian Constitution* 60; B. Nagy, "The Athenian Athlothetai," *GRBS* 19 (1978): 307–13; Shear, "Polis and Panathenaia," 455–463.

11. The earliest evidence for the annual peplos at the Small Panathenaia dates to 108/107 B.C.; see *IG* II² 1036 + 1060 (*SEG* 28.90, *SEG* 52.117, *SEG* 53.143). See B. Nagy, "The Ritual in Slab V," and Shear, "Polis and Panathenaia," 97–103. For a summary of scholarship and bibliography on the peplos, see Mansfield, "Robe of Athena," 39–355; for the argument that there were two peploi, see 2–118. Shear, "Polis and Panathenaia," 97–103 and 173–86, is unconvinced by Mansfield's argument (174).

12. Boutsikas, "Timing of the Panathenaia."

13. See Connelly, "Towards an Archaeology of Performance," 313–39. For ritual dynamics in the Greek world, see Chaniotis, *Ritual Dynamics in the Ancient Mediterranean;* Chaniotis, "Ritual Dynamics in the Eastern Mediterranean"; Chaniotis, "Rituals Between Norms and Emotions"; A. Chaniotis, "Theater Rituals," in *The Greek Theatre and Festivals: Documentary Studies,* ed. P. Wilson (Oxford: Oxford University Press, 2007), 48–66; Chaniotis, "From Woman to Woman"; Chaniotis, "Dynamics of Ritual Norms in Greek Cult"; Chaniotis, "Dynamic of Emotions"; Mylonopoulos, "Greek Sanctuaries"; I. Mylonopoulos, "The Dynamics of Ritual Space in the Hellenistic and Roman East," *Kernos* 21 (2008): 9–39; Connelly, *Portrait of a Priestess,* 29–31, 153–57. For aesthetics and multimedia aspects of rituals and festivals, see Bierl, *Ritual and Performativity;* A. Bierl, "Prozessionen auf der griechischen Bühne: Performativität des einziehenden Chors als Manifestation des Dionysos in der Parodos der Euripideischen Bakchen," in *Medialität der Prozession: Performanz ritueller Bewegung in Texten und Bildern der Vormoderne—Médialité de la procession: performance du movement rituel en textes et en images à l'époque pré-moderne,* ed. K. Gvozdeva (Heidelberg: Winter, 2011), 35–61; A. Bierl, "Pädramatik auf der antiken Bühne: Das attische Drama als Spiel und ästhetischer Diskurs," in *Lücken sehen: Beiträge zu Theater und Performanz: Festschrift für Hans-Thies Lehmann zum 66. Geburtstag,* ed. M. Gross and P. Primavesi (Heidelberg: Winter, 2010), 69–82; A. Kavoulaki, "Choral Self-Awareness: On the Introductory Anapaests of Aeschylus' *Supplices,*" in *Archaic and Classical Choral Song: Performance, Politics, and Dissemination,* ed. L. Athanassaki and E. Bowie (Berlin: De Gruyter, 2011), 365–90. I thank Darby English for helpful discussions of this material.

14. Smith, *Athens,* 26–27; L. E. Pearce, "Sacred Texts and Canonicity: Mesopotamia," in *Religions of the Ancient World: A Guide,* ed. S. I. Johnston (Cambridge, Mass.: Belknap Press, 2004), 627–28.

15. S. D. Houston, "Impersonation, Dance, and the Problem of Spectacle Among the Classic Maya," in Inomata and Coben, *Archaeology of Performance,* 139, 144; N. Grube, "Classic Maya Dance: Evidence from Hieroglyphs and Iconography," *Ancient Mesoamerica* 3 (1992): 201–18.

16. R. C. T. Parker, "Greek Religion," in J. Boardman, J. Griffin, and O. Murray, *Oxford History of the Classical World* (New York: Oxford University Press, 1986), 254–74; Parker, *Polytheism and Society;* Bremmer, *Greek Religion;* Kearns, "Order, Interaction, Authority"; Connelly, *Portrait of a Priestess,* 6.

17. Connelly, *Portrait of a Priestess,* 2–5, 24–55, 85–87, 90–92, 197–215.

18. J. Blok, "Virtual Voices: Towards a Choreography of Women's Speech in Classical Athens," in *Making Silence Speak: Women's Voices in Greek Literature and Society,* ed. A. P. M. H. Lardinois and L. McClure (Princeton, N.J.: Princeton University Press, 2001), 112–14; Kyle, *Sport and Spectacle,* 167; Ober, *Democracy and Knowledge,* 195–96; R. Osborne, *The World of Athens: An Introduction to Classical Athenian Culture* (Cambridge, U.K.: Cambridge University Press, 1984), 116–17, who says there are 130 datable festivals plus more that are not datable.

19. Hesiod, *Theogony* 535–65, and Pseudo-Hyginus, *Astronomica* 2.15, tell the story of how Prometheus, having stolen fire, prepared an animal sacrifice for Zeus. He divided the portions of the slaughtered animal into two groups: one with ox meat and juicy innards wrapped up in stomach lining and the other with ox bones wrapped up in their own rich fat. Prometheus offered Zeus a choice between the two, and Zeus took the bundle of inedible bones in fat, since it looked tastier. Thereafter gods always received the inedible parts of the sacrificial victim while the tasty cuts were reserved for humankind.

20. J. Swaddling, *The Ancient Olympic Games* (Austin: University of Texas Press, 1999), 11; Kyle, *Sport and Spectacle,* 8.

21. Shear, "Polis and Panathenaia," 490–93.

22. P. Themelis, "Panathenaic Prizes and Dedications," in Palagia and Choremi-Spetsieri, *Panathenaic Games,* 21–32; Kyle, "Gifts and Glory"; Tracy and Habicht, "New and Old Panathenaic Victor Lists."

23. Athenian colonists at Brea sent a cow and panoply to the Great Panathenaia in the third quarter of the fifth century. *IG* I³ 46.15–16.

24. J. Shear, "Prizes from Athens: The List of Panathenaic Prizes and the Sacred Oil," *ZPE* 142 (2003): 87–108; P. Siewert, "Zum historischen Hintergrund der frühen Panathenäen und Preisamphoren," in *Panathenaïka: Symposion zu den Panathenäischen Preisamphoren, Rauischholzhausen 25.11.–29.11. 1998,* ed. M. Bentz and N. Eschbach (Mainz: Philipp von Zabern, 2001); M. Bentz, *Panathenäische Preisamphoren: Eine athenische Vasengattung und ihre Funktion vom 6.–4. Jahrhundert v. Chr.* (Basel: Vereinigung der Freunde Antiker Kunst, 1998); Kyle, "Gifts and Glory"; R. Hamilton, "Panathenaic Amphoras: The Other Side," in Neils, *Worshipping Athena,* 137–62; J. Neils, "Panathenaic Amphoras: Their Meaning, Makers, and Markets," in Neils, *Goddess and Polis,* 29–51; R. Hampe, "Zu den panathenäische Amphoren," in *Antikes und modernes Griechenland,* ed. R. Hampe (Mainz: Philipp von Zabern, 1984), 145–49; J. R. Brandt, "Archaeologica Panathenaica I: Panathenaic Prize-Amphorae from the Sixth Century B.C.," *Acta ad Archaeologiam et Artium Historiam Pertinentia* 8 (1978): 1–23; E. von Brauchitsch, *Die Panathenäischen Preisamphoren* (Leipzig: B. G. Teubner, 1910).

25. C. Hadziaslani, ΤΩΝ ΑΘΗΝΗΘΕΝ ΑΘΛΩΝ (Athens: Acropolis Restoration Service, Department of Information and Education, 2003).

26. British Museum GR 1842.0728.834, Burgon Group (B130). *ABV* 89; *Para.* 33, no. 1; *Addenda*² 24; Neils, *Goddess and Polis,* 30, 93; Bentz, *Panathenäische Preisamphoren,* 123.

27. Metropolitan Museum of Art 1989.21.89; 540–30 B.C. The reduced size of this vase and absence of the official inscription ("from the games at Athens") indicate that this was not actually a prize amphora but modeled on one. M. B. Moore, "The Princeton Painter in New York," *MMAJ* 42 (2007): 26, 28, 30, 42, 45; E. J. Milleker, "Ancient Art: Gifts from the Norbert Schimmel Collection," *MMAB* 49 (1992): 40–41; M. Popkin, "Roosters, Columns, and Athena on Early Panathenaic Prize Amphoras: Symbols of a New Athenian Identity," *Hesperia* 81 (2012): 207–35.

28. Mikalson, *Sacred and Civil Calendar,* 34 and 199, summarizes the various reconstructions of the time span of the festival, some of which have it starting as early as the twenty-first of Hekatombaion. See also Neils, *Goddess and Polis;* J. Neils, "The Panathenaia: An Introduction," in Neils, *Goddess and Polis,* 13–27; J. Neils, "The Panathenaia and Kleisthenic Ideology," in Coulson et al., *Archaeology of Athens and Attica Under the Democracy,* 151–60; Shear, "Polis and Panathenaia," 7–8; Simon, *Festivals of Attica,* 55.

29. Kallisthenes, *FGrH* 124 F 52.

30. *IG* II² 2311; *SEG* 37.129, with large bibliography. See Tracey and Habicht, "New and Old Panathenaic Victor Lists," 187–236; Neils, *Goddess and Polis,* 15–17, fig. 1; Shear, "Polis and Panathenaia," 237, 389, 1056–59, 1162–66.

31. See Shear, "Polis and Panathenaia," 83–84.

32. See Hurwit, *Age of Perikles,* 214–16, 243; Goette, *Athens, Attica, and the Megarid,* 53–54. The building identified as the Odeion of Perikles measures roughly 62.4 by 68.6 meters (200 by 225 feet) and is believed to have held four thousand to five thousand people. Plutarch, *Life of Perikles* 13.5–6, describes it: "The Odeion, or music room, which in its interior was full of seats and ranges of pillars, and outside had its roof made to slope and descend from one single point at the top, was constructed, we are told, in imitation of the king of Persia's pavilion [*skênê*]. This was done by Perikles's order." Pausanias, *Description of Greece* 1.20.4, also mentions that the Odeion looked like Xerxes's tent. Excavations on the site have revealed an arrangement of internal pillars, set in nine rows of ten, supporting the roof in a manner reminiscent of poles in a tent. We are told by Vitruvius, *Ten Books of Architecture* 5.9.1, that the building was covered with timber from captured Persian ships. Its function as a music hall, however, is contested and some think it was a school or lecture hall.

33. The "Hephaestia inscription" of 421 B.C., *IG* I³ 82, mentions a *penteteris,* the Agora, and a musical contest for Athena and Hephaistos; *SEG* 54.46, with bibliography.

34. E. Csapo and W. J. Slater, eds., *The Context of Athenian Drama* (Ann Arbor: University of Michigan Press, 1995), 79–80, 109–10; Hurwit, *Athenian Acropolis,* 216–17.

35. T. Inomata and L. Coben have explored this phenomenon in Classic Maya and Inka contexts; see *Archaeology of Performance.*

36. Lykourgos, *Against Leokrates* 102. Translation: Burtt, *Minor Attic Orators.*

37. For discussion of the Panathenaic Regulation see G. Nagy, "Performing and Reperforming of Masterpieces," 4.6–11, and *Plato's Rhapsody and Homer's Music,* 36–37. See also H. A. Shapiro, "Hipparchos and the Rhapsodes," in *Cultural Poetics in Archaic Greece: Cult, Performance, Poetics,* ed. C. Dougherty and L. Kurke (Cambridge, U.K.: Cambridge University Press, 1993), 92–107.

38. In the pseudo-Platonic dialogue known as the *Hipparchos* 228b–c, Sokrates says that Hipparchos was "the first to bring over to this land the verses of Homer, and he required the rhapsodes at the Panathenaia to go through these verses in sequence, by relay, just as they do even nowadays"; translation by G. Nagy, "Performing and Reperforming of Masterpieces," 19. For rhapsodic events, see Shear, "Polis and Panathenaia," 365–68.

39. See victors' list, *SEG* 41.115, col. 3.39–43, dating to 162/161 B.C.

40. Plutarch, *Life of Perikles* 13.6.

41. H. A. Shapiro, "Les rhapsodes aux Panathénées et la céramique à Athènes à

l'époque archaïque," in *Culture et cité: L'avènement d'Athènes à l'époque archaïque,* ed. A. Verbanck-Piérard and D. Viviers (Brussels: De Bouccard, 1995), 127–37; H. A. Shapiro, "Mousikoi Agones: Music and Poetry at the Panathenaia," in Neils, *Goddess and Polis,* 53–75; H. Kotsidu, *Die musischen Agone der Panathenäean in archaischer und klassischer Zeit: Eine historisch-archäologische Untersuchung* (Munich: Tuduv, 1991). For the aulos, see West, *Ancient Greek Music,* 1–2, 50–56, 61–70, 81–109; P. Wilson, "The Aulos in Athens," in Goldhill and Osborne, *Performance Culture and Athenian Democracy,* 58–95, 69–79; C. Schafter, "Musical Victories in Early Classical Vase Painting," *AJA* 95 (1991): 333–34; M. F. Vos, "Aulodic and Auletic Contests," in *Enthousiasmos: Essays in Greek and Related Pottery Presented to J. M. Hemelrijk,* ed. H. A. G. Brijder, A. A. Drukker, and C. W. Neeft (Amsterdam: Allard Pierson Museum, 1986), 122–30.

42. Shear, "Polis and Panathenaia"; for aulos and kythara competitions, see 352–65; for rhapsodic contests, see 365–68.

43. West, *Ancient Greek Music,* 53–56.

44. Shear, "Polis and Panathenaia," 352–65.

45. Boegehold, "Group and Single Competitions at the Panathenaia"; Kyle, "Gifts and Glory"; D. Kyle, "The Panathenaic Games: Sacred and Civic Athletics," in Neils, *Goddess and Polis,* 77–101; Kyle, *Athletics in Ancient Athens;* N. B. Crowther, "Studies in Greek Athletics, Part II," *CW* 79 (1985–1986): 73–135; N. B. Crowther, "Studies in Greek Athletics, Part I," *CW* 78 (1984–1985): 497–558; Shear, "Polis and Panathenaia," 244–54; A. J. Papalas, "Boy Athletes in Ancient Greece," *Stadion* 17 (1991): 165–92.

46. Shear, "Polis and Panathenaia," 244–54.

47. G. Waddell, "The Greek Pentathlon," in *Greek Vases in the J. Paul Getty Museum 5* (Malibu, Calif.: J. Paul Getty Museum, 1991), 99–106; Shear, "Polis and Panathenaia," 254–57.

48. New York, Metropolitan Museum of Art 1916.16.71; *ABV* 404, no. 8; *Para.* 175, no. 8; Bentz, *Panathenäische Preisamphoren,* 139, no. 5.009, 44–45.

49. Pliny, *Natural History* 34.59; Pausanias, *Description of Greece* 6.4.1–3.

50. N. B. Crowther, "Reflections on Greek Equestrian Events, Violence, and Spectator Attitudes," *Nikephoros* 7 (1994): 121–33; D. Bell, "The Horse Race κέλης in Ancient Greece from the Pre-classical Period to the First Century B.C.," *Stadion* 15 (1989): 167–90; Shear, "Polis and Panathenaia," 279–89; J. McK. Camp, *Horses and Horsemanship in the Athenian Agora,* Agora Picture Book 24 (Princeton, N.J.: American School of Classical Studies at Athens, 1998); V. Olivová, "Chariot Racing in the Ancient World," *Nikephoros* 2 (1989): 65–88.

51. Plato, *Laws* 7.815a; E. L. Wheeler, "Hoplomachia and Greek Dances in Arms," *GRBS* 23 (1982): 223–33; J.-C. Pousat, "Une base signée du Musée National d'Athènes: Pyrrhichistes victorieux," *BCH* 91 (1967): 102–10; Ferrari Pinney, "Pallas and Panathenaea," 468–73; Shear, "Polis and Panathenaia," 323–30.

52. Dionysios of Halikarnassos, *Roman Antiquities* 7.72.7; see Ferrari Pinney, "Pallas and Panathenaea"; Shear, "Polis and Panathenaia," 38–43 (for *pyrrhike* as victory dance following Gigantomachy) and 323–31 (for Panathenaic event); P. Ceccarelli, *La pirrica nell'antichità greco romana: Studi sulla danza armata* (Pisa: Istituti Editoriali e Poligrafici Internazionali, 1998).

53. E. Vanderpool, "Victories in the Anthippasia," *Hesperia* 43 (1974): 311–13; Xenophon, *Hipparchikos* 3.10–131; Shear, "Polis and Panathenaia," 315–18.

54. Shear, "Polis and Panathenaia," 340–45.

55. Crowther, "Male Beauty Contests"; Shear, "Polis and Panathenaia," 331–34; Boegehold, "Group and Single Competitions at the Panathenaia," 95–103.

56. Aristotle, *Athenian Constitution* 60.3; *IG* II2 2311; Crowther, "Male Beauty Contests," 286.

57. We do hear of three other sites (Rhodes, Sestos, and Sparta) where male beauty

contests took place. Crowther, "Male Beauty Contests," 286–88. Crowther mentions *euandria* at five festivals (including the Panathenaia and the Theseia at Athens).

58. Pseudo-Andokides, *Against Alkibiades* 4.42.

59. See scholiast on Plato, *Phaidros* 231e, for references to ephebes and altar of Eros; and Plutarch, *Life of Solon* 1.4, again, for altar of Eros. See Shear, "Polis and Panathenaia," 335–39; J. R. S. Sterrett, "The Torch-Race: A Commentary on the Agamemnon of Aeschylus vv. 324–326," *AJP* 22 (1901): 393–419; Graf, "Lampadedromia"; Kyle, *Athletics in Athens,* 190–93; Deubner, *Attische Feste,* 211–13; Simon, *Festivals of Attica,* 53–54, 63–64; Parke, *Festivals of the Athenians,* 45–46, 150–51, 171–73.

60. *IG* II² 2311.88–89; Shear, "Polis and Panathenaia," 335–39.

61. For night festivals, see C. Trümpy, "Feste zur Vollmondszeit: Die religiösen Feiern Attikas im Monatlauf und der vorgeschichtliche attische Kultkalendar," *ZPE* (1998): 109–15. For *pannychis* at the Small Panathenaia, see Shear, "Polis and Panathenaia," 83–84, who argues that the pannychis was held, in fact, later in the week and after the sacrifices on 28 Hekatombaion. It does seem plausible that all-night dancing might take place after the feast, rather than before it. Shear points to the Bendideia (Plato, *Republic* 1.328a) as a festival that concluded with a *pannychis.*

62. Plato, *Laws* 672e. See Calame, *Choruses of Young Women,* 222–38, on the socializing function of the chorus; Connelly, "Towards an Archaeology of Performance," 324–39.

63. Connelly, "Towards an Archaeology of Performance," 331–33.

64. L. B. Holland, "Erechtheum Paper II: The Strong House of Erechtheus," *AJA* 28 (1924): 142–69; L. B. Holland, "Erechtheum Papers III: The Post-Persian," *AJA* 28 (1924): 402–25; L. B. Holland, "Erechtheum Papers IV: The Building Called the Erechtheum," *AJA* 28 (1924): 425–34; Lesk, "Erechtheion and Its Reception," 88, 114, 115, 225, 226. For discussion of staircases and performance space, see I. Nielsen, *Cultic Theatres and Ritual Drama: A Study in Regional Development and Religious Interchange Between East and West in Antiquity* (Aarhus: Aarhus University Press, 2002), 69–73, 86–128, 167–74; Mylonopoulos, "Greek Sanctuaries," 94–99.

65. Euripides, *Ion* 492–505.

66. For Kekropids, see Apollodoros, *Library* 3.14.6. For Erechtheids, see Apollodoros, *Library* 3.15.4; Euripides, *Ion* 277–82; Hyginus, *Fabulae* 46. A few fragmentary phrases from the *Erechtheus,* translated in Collard and Cropp's Loeb edition, *Euripides VII: Fragments,* 388–393, might possibly allude to the suicide of the older daughters in jumping off the Acropolis. See *Erechtheus* F 370.37, "to you the dear one of my daughters"; F 370.38–39, "funeral rite" . . . "I have looked upon your . . . limbs(?)"

67. Translation: Kovacs, *Euripides: Children of Heracles,* 84–87, with minor changes. J. Wilkins offers a commentary on these lines, Euripides, *Heraclidae* (Oxford: Clarendon Press, 1993), 151–52.

68. C. Seltmann, *"Group H" in Athens: Its History and Coinage* (Cambridge, U.K.: Cambridge University Press, 1924), 72–78, 189–92. I am grateful to Dr. Peter van Alfen for helpful discussions of this material.

69. C. M. Kraay, *Archaic and Classical Greek Coins* (Berkeley: University of California Press, 1976), 63–77.

70. Euripides, *Erechtheus* F 350 Kannicht.

71. Euripides, *Erechtheus* F 351 Kannicht.

72. See G. Nagy, *Homer the Preclassic* (Berkeley: University of California Press, 2010), 239, for women of Troy ululating as they extend their hands in a choreographed ritual gesture to Athena: "with a cry of ololu! all of them lift up their hands to Athena" (*Iliad* 6.301). Nagy points out that *ololuzein* is characteristic of female choruses on Lesbos (and elsewhere); in Alkaios, the word *ololuge* is described as *hiere,* "sacred." I thank Greg Nagy for very helpful conversations and for sharing bibliographical references.

73. *American Heritage Dictionary,* 4th ed., s.v. "ululate"; *Online Etymology Dictionary,* s.v. "ululation," http://www.etymonline.com/index.php?term=ululation.

74. Pliny, *Natural History* 10.33. I thank David S. Levene for drawing this to my attention.

75. For ululation in Greek antiquity, see Diggle, *Euripidea,* 477–80; E. Calderón, "A propósito de ὀλολυγών (Arato, Phaenomena 948)," *Quaderni Urbinati di Cultura Classica* 67 (2001): 133–39; L. Gernet, *Les grecs sans miracle* (Paris: La Découverte, 1983), 247–57; L. Deubner, *Kleine Schriften zur klassischen Altertumskunde* (Hain: Königstein/Ts, 1982), 607–34; J. Rudhardt, *Notions fondamentales de la pensée religieuse et actes constitutifs du culte dans la Grèce classique* (1958; Paris: Picard, 1992), 178–80. I am grateful to Jan Bremmer for sharing bibliographical references and for helpful discussions of this material.

76. I am indebted to Anton Bierl for making this point.

77. Boutsikas, "Astronomical Evidence for the Timing of the Panathenaia," 307.

78. Boutsikas writes: "If observed from the north porch of the Erechtheion or nearby, these movements of Draco would have been an impressive sight as the constellation is one of the largest in the sky. The constellation, although not particularly bright today, would have been extremely prominent in an era before widespread light pollution."

79. Boutsikas and Hannah, "Aitia, Astronomy, and the Timing of the Arrhēphoria," 238.

80. A. Choisy takes up the ancient experience of space on the Acropolis, discussing circulation patterns and directions of movement in *Histoire de l'architecture* (Geneva: Slatkine Reprints, 1899), 327–34, 409–22, especially in a long paragraph subtitled: "Le pittoresque dans l'art grec: Partis dissymétriques, pondération des masses: Exemple de l'Acropole d'Athènes." I thank Yves-Alain Bois for drawing this to my attention. See also T. Mandoul, *Entre raison et utopie: L'histoire de l'architecture d'Auguste Choisy* (Wavre: Mardaga, 2008), 222–28, 234–47.

81. Deubner, *Attische Feste,* 22–35; Simon, *Festivals of Attica,* 55–72; Parker, *Athenian Religion,* 91; Shear, "Polis and Panathenaia," 75–76, 87–90, 120–66; Parker, *Polytheism and Society,* 253–69; Sourvinou-Inwood, *Athenian Myths and Festivals,* 263–311; L. Maurizio, "'The Panathenaic Procession: Athens' Participatory Democracy on Display?,'" in *Democracy, Empire, and the Arts in Fifth-Century Athens,* ed. D. Boedeker and K. A. Raaflaub (Cambridge, Mass.: Harvard University Press, 1998), 297–317; Connolly and Dodge, *Ancient City;* Graf, "Pompai in Greece."

82. Connolly, *Portrait of a Priestess,* 33–39.

83. Stavros Nearchos Collection, ca. 560–550 B.C. *LIMC* 2, s.v. "Athena," no. 574; L. I. Marangou, *Ancient Greek Art from the Collection of Stavros S. Niarchos* (Athens: N. P. Goulandris Foundation, Museum of Cycladic Art, 1995), 86–93, no. 12, with full bibliography. Of course, this cannot represent a historical Panathenaic procession, as we see no hecatomb of cattle but a sow and a pig instead, unheard-of at the Panathenaia. For full discussion, see Connolly, *Portrait of a Priestess,* 187–89.

84. Connolly, "Towards an Archaeology of Performance," 320–24.

85. Karyatids of even earlier date, ca. 540–530 B.C. (Delphi inv. 1203), are sometimes attributed to the Knidian Treasury; see Ridgway, *Prayers in Stone,* 145–50; Croissant, *Les protomés féminines archaïques,* 71–82. For the Siphnian Treasury karyatids, ca. 530–525 B.C., see Ridgway, *Prayers in Stone,* 147–48, 168–69n11; Croissant, *Les protomés féminines archaïques,* 106–8.

86. Connolly, *Portrait of a Priestess,* 124–25; Connolly, "Towards an Archaeology of Performance," 320-21.

87. Connolly, *Portrait of a Priestess,* 125; Connolly, "Towards an Archaeology of Performance," 321–23.

88. As Angelos Chaniotis has pointed out (personal communication), this same strategy can be seen in the Nike Apteros, or "Wingless Victory," whose wings

424 / Notes to Pages 270–275

were clipped to keep it from flying away, rendering Victory ever present within the sanctuary.

89. See, for example, in the Victoria and Albert Museum, *A Temple Procession at Night*, Company School, Tanjavur (Tanjore), Tamil Nadu, ca. 1830.

90. See C. Branfoot, "Approaching the Temple in Nayaka-Period Madurai: The Kūṭal Alakar Temple," *Artibus Asiae* 60 (2000): 197–221; C. Branfoot, *Gods on the Move: Architecture and Ritual in the South Indian Temple* (London: Society for South Asian Studies, 2007). I thank Tamara Sears for alerting me to helpful bibliography.

91. Demosthenes, *Erotikos* 23–29. N. B. Crowther, "The Apobates Reconsidered (Demosthenes lxi 23–9)," *JHS* 111 (1991): 174–76; M. Gisler-Hurwiler, "À propos des apobates et de quelques cavaliers de la frise nord du Parthénon," in Schmidt, *Kanon*, 15–18; Shear, "Polis and Panathenaia," 299–310; Neils and Schultz, "Erechtheus and the Apobates." Thompson, "Panathenaic Festival," 227, suggests that the *apobates* event dates back as early as the eighth or seventh century B.C. on the basis of late Geometric vases showing armed chariot riders.

92. Plato Comicus, F 199 Kassel-Austin; Plutarch, *Life of Themistokles* 32–35.

93. Shear, "Polis and Panathenaia," 339–40.

94. S. R. F. Price, *Rituals and Power: The Roman Imperial Cult in Asia Minor* (Cambridge, U.K.: Cambridge University Press, 1984), 3–4.

95. Based on Kallisthenes, *FGrH* 124 F 52. The first identification of the Panathenaia as a celebration of Athena's birthday was advanced by L. Preller and C. Robert, *Griechische Mythologie I: Theogonie und Götter*, 4th ed. (1894; Berlin: Weidmann, 1967), 212n2; W. Schmidt, *Geburtstag im Altertum* (Giessen: A. Töpelmann, 1908), 98–101; Deubner, *Attische Feste*, 23n10, summarized by Shear, "Polis and Panathenaia," 29–30. See also Parke, *Festivals*, 33; Simon, *Festivals of Attica*, 55; Neils, *Goddess and Polis*, 14–15; V. Wohl, "Εὐσεβείας ἕνεκα καὶ φιλοτιμίας: Hegemony and Democracy at the Panathenaia," *ClMed* 47 (1996): 25.

96. A. Mommsen, *Feste der Stadt Athen im Altertum: Geordnet nach Attischem Kalendar*, 2nd ed. (Leipzig: B. G. Teubner, 1898), 158. For a review of relevant ancient testimonia see Mikalson, *Sacred and Civil Calendar*, 23, and Shear, "Polis and Panathenaia," 37. It should be said that the practice of marking birthdays is much more popular in late Hellenistic and Roman times than in the Archaic or classical Greek periods.

97. See W. Burkert, *Homo Necans: The Anthropology of Ancient Greek Sacrificial Ritual and Myth*, trans. P. Bing (Berkeley: University of California Press, 1983), 154–58, for New Year's festival; see Robertson, "Origin of the Panathenaea," 240–81, for celebration of new fire.

98. Robertson, "Origin of the Panathenaia," 232.

99. See Vian, *La guerre des géants*, 246–59; Ferrari Pinney, "Pallas and Panathenaea"; Shear, "Polis and Panathenaia," 29–33. Aristotle, frag. 637 (Rose); quoted by the scholiast to Aristides, *Panathenaic Oration* 362 (Lenz and Behr) = Dindorf 3:323 = Jebb 189, 4; cf. scholiast to Aristophanes, *Knights* 566a (II); repeated by *Suda*, s.v. πέπλος.

100. Homer, *Iliad* 3.257–897.

101. See W. Raschke, ed., *The Archaeology of the Olympic Games* (Madison: University of Wisconsin Press, 1988).

102. Thompson, "Panathenaic Festival," 227.

103. Cicero, *On the Nature of the Gods* 3.19, 49–50.

104. Wesenberg, "Panathenäische Peplosdedikation und Arrhephorie"; Barber, "*Peplos* of Athena"; Ridgway, "Images of Athena"; Barber, *Prehistoric Textiles;* Mansfield, "Robe of Athena"; B. Nagy, "The Peplotheke: What Was It?," in *Studies Presented to Sterling Dow on His Eightieth Birthday*, ed. K. J. Rigsby (Durham, N.C.: Duke University Press, 1984), 227–32; W. Gauer, "Was geschieht mit dem Peplos?,"

in Berger, *Parthenon-Kongreß Basel,* 220–29; D. M. Lewis, "Athena's Robe," *Scripta Classica Israelica* 5 (1979–1980): 28–29.

105. H. Goldman, "The Acropolis of Halae," *Hesperia* 9 (1940): 478–79; H. Goldman, "Inscriptions from the Acropolis of Halae," *AJA* 19 (1915): 448; S. J. Wallrodt, "Ritual Activity in Late Classical Ilion: The Evidence from a Fourth Century B.C. Deposit of Loomweights and Spindlewhorls," *Studia Troica* 12 (2002): 179–96. S. J. Wallrodt, "Late Classical Votive Loomweights from Ilion," *AJA* 105 (2001): 303 (abstract); L. Surtees, "Loomweights," in *Stymphalos: The Acropolis Sanctuary,* ed. G. P. Schaus (Toronto: University of Toronto Press, forthcoming); L. Surtees, "The Loom as a Symbol of Womanhood: A Case Study of the Athena Sanctuary at Stymphalos" (master's thesis, University of Alberta, 2004), 68–85. I am indebted to Laura Surtees for sharing information and bibliography on ritual weaving with me.

106. Alkman, *Parthenion* 61; Pausanias, *Description of Greece* 3.16.2, 5.16.2, 6.24.10; Hesychios, *Lexicon,* s.v. γεραράδες. The *Palatine Anthology* (6.286) records in its inventory lists dedications of clothing to the gods. Homer, *Iliad* 6.269–311, describes the ritual offering of a peplos placed on the knees of Athena's cult statue.

107. Norman, "The Panathenaic Ship," 41–46; Barber, *"Peplos* of Athena," 114; Hurwit, *Athenian Acropolis,* 45; Mansfield, "Robe of Athena," 51–52, 68. Shear, "Polis and Panathenaia," 145–46, discusses the fragment of Strattis (writing around 400 B.C.): "and ths peplos, the men without number, hauling with the rigging, drag to the top, just like the sail on a mast," Strattis frag. 31 *(PCG),* quoted by Harpokration s.v. τοπεῖον. For a full discussion of the Panathenaic ship, see Shear, "Polis and Panathenaia," 143–55.

108. Scholia on Aristophanes's *Knights* 566a (II).

109. Plutarch, *Life of Demosthenes* 10.5 and 12.3.

110. Ridgway, "Images of Athena on the Acropolis," 124.

111. Heliodoros, *Aethiopika* 5.31.

112. For full discussion see I. Mylonopoulos, ed., *Divine Images and Human Imaginations in Ancient Greek and Rome* (Leiden: Brill, 2010); I. Mylonopoulos, "Divine Images Versus Cult Images: An Endless Story About Theories, Methods, and Terminologies," in ibid., 1–19.

113. More precisely, 11.54 meters, or 37 feet 10 inches.

114. The statue is cast from a composite of gypsum cement and ground fiberglass from multiple molds that were assembled inside the Parthenon by A. LeQuire in 1982–1990. The statue was gilded in 2002. A. LeQuire, "Athena Parthenos: The Re-creation in Nashville," in Tsakirgis and Wiltshire, *Nashville Athena,* 8–10. B. Tsakirgis and S. F. Wiltshire, eds., *The Nashville Athena: A Symposium* (Nashville, 1990); Ridgway, "Parthenon and Parthenos."

115. Pliny, *Natural History* 36.18; Pausanias, *Description of Greece* 1.24.5–7; Plutarch, *Life of Perikles* 31.4; Ridgway, "Images of Athena," 131–35; Ridgway, "Parthenon and Parthenos," 297–99; Lapatin, *Chryselephantine Statuary;* K. D. S. Lapatin, "Pheidias ἐλεφαντουργός," *AJA* 101 (1997): 663–82; Lapatin, "Ancient Reception of Pheidias' Athena Parthenos and Zeus Olympios."

116. Farnell, *Cults of the Greek States,* 1:361, maintained that Pliny's text is corrupt and that he probably never saw the statue. See L. Berczelly, "Pandora and Panathenaia: The Pandora Myth and the Sculptural Decoration of the Parthenon," *Acta ad Archaeologiam et Atrium Historiam Pertinentia* 8 (1992): 53–86; A. Kosmopoulou, *The Iconography of Sculptured Statue Bases in the Archaic and Classical Periods* (Madison: University of Wisconsin Press, 2002), 112–17. Hurwit, "Beautiful Evil," 173, 175; Jeppesen, "Bild und Mythus an dem Parthenon," 59; J. J. Pollitt, *Art and Experience in Classical Greece* (Cambridge, U.K.: Cambridge University Press, 1972), 98–99; J. J. Pollitt, "The Meaning of Pheidias' Athena Parthenos," in Tsakirgis and Wiltshire, *Nashville Athena,* 1–23; Loraux, *Children of Athena,* 114–15.

117. Hesiod (*Works and Days* 80; *Theogony* 560–71) tells us that when Pro-

metheus stole fire from heaven, Zeus took revenge by causing Hephaistos to make a woman out of earth, a terrible woman who by her charms and beauty would bring misery upon the human race. According to some mythographers, Pandora and Epimetheus had two children, Pyrrha and Deukalion (Hyginus, *Fabulae* 142; Apollodoros, *Library* 1.7.2; Proklos, *On Hesiod's "Works and Days";* Ovid, *Metamorphoses* 1.350). But according to others, Pandora was the daughter of Pyrrha and Deukalion (Eustathios, *Commentary on Homer* 23).

118. Jane Harrison stressed that this Attic Pandora is an Earth-Goddess in the kore form, entirely humanized and vividly personified in myth; see Harrison, "Pandora's Box," and Harrison, *Prolegomena*, 281–85. For the two distinct aspects of Pandora, see Hurwit, "Beautiful Evil," 177. Significant differences also can be found between the Attic version of the Prometheus story and Hesiod's account of it.

119. West, *Hesiodic Catalogue of Women*, F2/4, F5n20; for date of catalog, see 130–37.

120. Hesiod, F2/4 and F5; West, *Hesiodic Catalogue of Women*, 50–56.

121. In fact, a scholiast to Aristides, *Panathenaic Oration* 85–87 (Lenz and Behr) = Dindorf 3:110, line 9, and 3:12, lines 10–15, identifies Aglauros, Herse, and Pandrosos as the daughters of Erechtheus, rather than as the daughters of Kekrops.

122. See Ridgway, *Prayers in Stone*, 196–98.

123. G. P. Stevens suggested a height of ca. 0.90 meters for the Athena Parthenos base; see "Remarks upon the Colossal Chryselephantine Statue of Athena in the Parthenon," *Hesperia* 24 (1955): 260.

124. Pliny, *Natural History* 36.18. See Leipen, *Athena Parthenos*, 24–27, plate 86C; see also W.-H. Schuchhardt, "Zur Basis der Athena Parthenos," in *Wandlungen: Studien zur antiken und neueren Kunst: Ernst Homann-Wedeking gewidmet* (Waldsassen-Bayern: Stiftland, 1975), 120–30, plates 26–27; C. Praschniker, "Das Basisrelief der Parthenos," *JOAI* 39 (1952): 7–12; Becatti, "Il rilievo del Drago e la base della Parthenos"; Hurwit, "Beautiful Evil"; Hurwit, *Athenian Acropolis,* 187–88; A. Kosmopoulou, *The Iconography of Sculptured Statue Bases in the Archaic and Classical Periods* (Madison: University of Wisconsin Press, 2003), 113–24.

125. Leipen, *Athena Parthenos*, plate 86.

126. London, British Museum E 467, GR 1856.1213.1, by the Niobid Painter, ca. 460–450 B.C.; *ARV²* 601, 23; *Addenda²* 266; *LIMC* 7, s.v. "Pandora," no. 2.

127. Euripides, *Erechtheus* F 360.34–45 Kannicht.

128. London, British Museum D 4, *ARV²* 869, 55; *LIMC* 7, s.v. "Pandora," no. 1; ca. 460 B.C., from Nola. See Bremmer, "Pandora," 30–31; E. D. Reeder, *Pandora: Women in Classical Greece* (Baltimore: Walters Art Museum, 1995), 284–86. A fragment of a crocodile rhyton by the Sotades Painter (BM E 789; *ARV²* 764.9; *LIMC* 1, s.v. "Anesidora," no. 3), ca. 460–450 B.C., shows the lower portion of what seems to be a similar scene, with a girl standing frontally at center, flanked by Athena and a male figure.

129. The Anesidora/Pandora relationship is first discussed by Jane Harrison, "Pandora's Box"; Harrison, *Prolegomena*, 281–85; J. E. Harrison, *Themis: A Study of the Social Origins of Greek Religion* (Cambridge, U.K.: Cambridge University Press, 1912), 295, 298–99. See also West, *Works and Days*, 164–65; Bremmer, "Pandora," 30–31; Boardman and Finn, *Parthenon and Its Sculptures,* 249–50.

130. C. Bérard, *Anodoi: Essai sur l'imagerie des passages chthoniens* (Rome: Institut Suisse de Rome, 1974), 161–64. A chthonic nature is attested for Pandora in Hipponax 104.48 W, where she receives an offering of a potted plant at the Thargelia, as celebrated in Ephesos. The name Anesidora has been attested as an epithet for Demeter, since she sends up the fruits of the earth; see Sophokles, frag. 826, 1010, and discussion in Bremmer, "Pandora," 30–31. At the very end of the surviving fragments of Euripides's *Erechtheus*, Demeter's name appears, see F 370 102 Kannicht.

131. Harpokration A 239 Keaney 101 on E 85: Πανδρόσῳ ΚΜ, Πανδώρᾳ ερ QNP

(var. lect. KM). *FGrH* 3 B I 276–77. For sacrifices to Pandora see Farnell, *Cults of the Greek States,* 1:290; *RE* (1949), s.v. "Pandora."

132. Aristophanes, *Birds* 971.

133. In Homer, *Odyssey* 3.371.2, Athena metamorphoses into a sea eagle or vulture.

134. Aristophanes, *Wasps* 1086.

135. Plutarch, *Life of Themistokles* 12.1.

136. See Kroll, *The Greek Coins,* no. 182, A.D. 120–150.

137. Ferrari, *Figures of Speech,* 7–8, 55, 72–73; G. Ferrari, "Figure of Speech: The Picture of Aidos," *Métis* 5 (1990): 186–91.

138. Homer, *Iliad* 17.567; Hesiod, *Theogony* 886–900.

139. See Korshak, *Frontal Face in Attic Vase Painting,* for a full treatment of the subject.

140. London, British Museum 2003, 07180.10. H. Frankfort, "The Burney Relief," *Archiv für Orientforschung* 12 (1937): 128–35; E. G. Kraeling, "A Unique Babylonian Relief," *Bulletin of the American Schools of Oriental Research* 67 (1937): 16–18; E. Porada, "The Iconography of Death in Mesopotamia in the Early Second Millennium B.C.," in *Death in Mesopotamia: Papers Read at the XXVIᵉ Rencontre Assyriologique Internationale,* ed. B. Alster, Mesopotamia 8 (Copenhagen: Akademisk, 1980), 259–70. For the view that the relief is a modern forgery, see P. Albenda, "The 'Queen of the Night' Plaque: A Revisit," *Journal of the American Oriental Society* 125 (2005): 171–90; and rebuttal, D. Collon, "The Queen Under Attack—a Rejoinder," *Iraq* 69 (2007): 43–51.

141. London, British Museum E 477, GR 1772, 0320.36, by the Hephaistos Painter. *ARV²* 1114; *Addenda²* 331; *LIMC* 6, s.v. "Kephalos," no. 26. Harrison, *Mythology and Monuments of Ancient Athens,* lxix, fig. 14.

142. Translation: G. Ferrari, *Alcman, First Parthenion,* 70–71, 156. The bibliography is vast. See C. Calame, ed., *Alcman: Introduction, Texte critique, témoinage, traduction, et commentaire* (Rome: 1983), Calame, *Les choeurs des jeunes filles.*

143. G. Ferrari, *Alcman,* 90-92, 121. See N. Loraux, *The Mourning Voice* (Ithaca, N.Y.: Cornell University Press, 2002).

144. Euripides, *Erechtheus* F 370.107–8 Kannicht. For catasterized Erechtheids as Hyades, see scholiast to Aratus, *Phaenomena* 172, 107.

145. Kansas City, Mo., Nelson-Atkins Museum of Art, Nelson Fund 34.289. By the Athena Painter. See Haspels, *ABL* 257, no. 74; *Para.* 260, no. 74; Neils, *Goddess and Polis,* 148–49n7.

146. Ferrari suggested this in a talk given at the symposium "Parthenon and Panathenaia" at Princeton University, on September 18, 1993; see S. Peirce and A. Steiner, *Bryn Mawr Classical Review,* March 9, 1994. Ferrari made the case that owls appearing on Athenian coins, state stamps, owl skyphoi, and other objects represent the daughters of Kekrops.

147. Uppsala, Uppsala University 352. Douglas, "Owl of Athena"; Farnell, *Cults of the Greek States,* 1:290.

148. See note 119, page 426.

149. Paris, Musée du Louvre CA 2192. *ARV²* 983.14; *Addenda²* 311. Ca. 475–450 B.C.

150. For owl skyphoi, see *ARV²* 982–84 with bibliography; F. P. Johnson, "An Owl Skyphos," in *Studies Presented to David Moore Robinson on His Seventieth Birthday,* ed. G. Mylonas and D. Raymond (St. Louis: Washington University, 1953), 96–105; F. P. Johnson, "A Note on Owl Skyphoi," *AJA* 59 (1955): 119–24.

151. Bryn Mawr, Pa., Bryn Mawr College, Art and Artifact collection, T-182, ca. 300 B.C. G. Ferrari Pinney and B. S. Ridgway, eds., *Aspects of Ancient Greece* (Allentown, Pa.: Allentown Art Museum, 1979), 291n148; Neils, *Goddess and Polis,* 151n12; H. Herdejürgen, *Die Tarentinischen Terrakotten des 6. bis. 4. Jahrhunderts v. Chr. im Antikenmuseum Basel* (Mainz: Philipp von Zabern, 1971), 73–74.

152. The image shown on page 290 is American Numismatic Society, 1977, 158.834. P. van Alfen, "The Coinage of Athens, Sixth to First Century B.C.," in *The Oxford Handbook of Greek and Roman Coinage,* ed. W. E. Metcalf (Oxford: Oxford University Press, 2012), 88–104, dates their beginning to around 515 B.C.; Douglas, "Owl of Athena"; E. D. Tai, "'Ancient Greenbacks': Athenian Owls, the Law of Nikophon, and the Greek Economy," *Historia* 54 (2005): 359–81; Kroll and Waggoner, "Dating the Earliest Coins of Athens, Corinth, and Aegina." I thank Dr. Peter van Alfen of the American Numismatic Society for providing the image.

153. Aristophanes, *Birds* 301.

154. Davies, "Athenian Citizenship," 106.

155. Rosivach, "Autochthony," 303.

156. Davies, "Athenian Citizenship," 106.

157. Translation is my own.

158. Euripides, *Erechtheus* F 359 Kannicht. Translation: Collard and Cropp, *Euripides VII: Fragments,* 375.

159. Euripides, *Erechtheus* F 366 Kannicht. Translation: Collard and Cropp, *Euripides VII: Fragments,* 385.

160. Rosivach, "Autochthony," 302–3.

161. Ibid.

162. Fehr, *Becoming Good Democrats and Wives,* 145–49.

163. N. Loraux, *The Invention of Athens: The Funeral Oration in the Classical City* (Cambridge, Mass.: Harvard University Press, 1986), 15–24.

164. Euripides, *Erechtheus* F 360a Kannicht, and F 360.53–55 Kannicht.

165. Thucydides, *Peloponnesian War,* trans. R. Crawley (New York: J. M. Dent, 1903).

8 THE WELL-SCRUBBED LEGACY

1. R. Fry, "The Case of the Late Sir Lawrence Alma Tadema," in *A Roger Fry Reader,* ed. C. Reed (Chicago: University of Chicago Press, 1996), 147–49, reprinted from *Nation,* January 18, 1913, 666–67.

2. R. Ash, *Alma-Tadema* (Aylesbury: Shire, 1973); V. Swanson, *Alma-Tadema: The Painter of the Victorian Vision of the Ancient World* (London: Ash & Grant, 1977); R. Ash, *Sir Lawrence Alma-Tadema* (London: Pavilion Books, 1989; New York: Harry N. Abrams, 1990); V. Swanson, *The Biography and Catalogue Raisonné of the Paintings of Sir Lawrence Alma-Tadema* (London: Garton, 1990); J. G. Lovett and W. R. Johnston, *Empires Restored, Elysium Revisited: The Art of Sir Lawrence Alma-Tadema* (Williamstown, Mass.: Sterling and Francine Clark Art Institute, 1995), exhibition catalog; E. Becker and E. Prettejohn, *Sir Lawrence Alma Tadema* (Amsterdam: Van Gogh Museum, 1996), exhibition catalog.

3. Barrow, *Lawrence Alma-Tadema,* 192; E. Swinglehurst, *Lawrence Alma-Tadema* (San Diego: Thunder Bay Press, 2001); R. Tomlinson, *The Athens of Alma Tadema* (Stroud: Sutton, 1991).

4. Buying-in reported in G. Reitlinger, *The Economics of Taste,* vol. 1: *The Rise and Fall of Picture Prices, 1760–1960* (London: Barrie and Rockliffe, 1961), 243–44.

5. Barrow, *Lawrence Alma-Tadema,* 43–44.

6. *Athenaeum,* December 8, 1882, 779.

7. Newton and Pullan, *Halicarnassus, Cnidus, and Branchidae,* 72–264 (description of monument), 78 (as one of the seven wonders of the ancient world), 185 (colors on its architectural members), and 238–39 (colors on the reliefs). See I. Jenkins, C. Gratziu, and A. Middleton, "The Polychromy of the Mausoleum," in *Sculptors and Sculpture of Caria and the Dodecanese,* ed. I. Jenkins and G. Waywell (London: British Museum, 1997).

8. Newton and Pullan, *Halicarnassus, Cnidus, and Branchidae,* 238–39.

9. This continued straight to the end of the nineteenth century. See R. R. R. Smith and R. Frederiksen, *The Cast Gallery of the Ashmolean Museum: Catalogue of Plaster Casts of Greek and Roman Sculptures* (Oxford: Ashmolean Museum, 2013); R. Frederiksen, ed., *Plaster Casts: Making, Collecting, and Displaying from Classical Antiquity to the Present,* Transformationen der Antike (Berlin: De Gruyter, 2010); D. C. Kurtz, *The Reception of Classical Art in Britain: An Oxford Story of Plaster Casts from the Antique* (Oxford: British Archaeological Reports, 2000); Yalouri, *Acropolis,* 176–83.

10. Winckelmann, *Geschichte der Kunst des Alterthums,* 147–48.

11. Stuart and Revett, *Antiquities of Athens,* 2: plate 6; 3: plate 9. For metal attachments on the Parthenon frieze, see Stuart and Revett's *Antiquities of Athens,* 2:14.

12. M. J. Vickers and D. Gill, *Artful Crafts: Ancient Greek Silverware and Pottery* (Oxford: Clarendon Press, 1994), 1–32; M. J. Vickers, "Value and Simplicity: Eighteenth-Century Taste and the Study of Greek Vases," *Past and Present* 116 (1987): 98–104.

13. J.-I. Hittorff, *Restitution du Temple d'Empédocle à Sélinonte* (Paris: Firmin Didot Frères, 1851).

14. M. Fehlmann, "Casts and Connoisseurs: The Early Reception of the Elgin Marbles," *Apollo* 544 (2007): 44–51. In 1811, the sculptor John Henning objected when the marbles were about to be cleaned with dilute sulfuric acid by Joseph Nollekens's men. See Jenkins, *Cleaning and Controversy,* 4.

15. Jenkins, *Cleaning and Controversy,* 16–19; Jenkins, "Casts of the Parthenon Sculptures"; Jenkins and Middleton, "Paint on the Parthenon Sculptures," 202–5.

16. Jenkins, *Cleaning and Controversy,* 16; Jenkins and Middleton, "Paint on the Parthenon Sculptures," 185–86.

17. Faraday's findings are questioned by Jenkins, *Cleaning and Controversy,* 4–5, 16–17.

18. Ibid., 4.

19. J. Goury and O. Jones, *Plans, Elevations, Sections, and Details of the Alhambra* (London: Jones, 1836–1845).

20. O. Jones, "An Apology for the Colouring of the Greek Court in the Crystal Palace," *Papers Read at the Royal Institute of British Architects* (1854): 7. For a useful overview of early scholarship on the Parthenon's polychromy, see Vlassopoulou, "New Investigations into the Polychromy of the Parthenon," 219–20; Jenkins and Middleton, "Paint on the Parthenon Sculptures."

21. G. H. Lewes, "Historical Evidence," *Papers Read at the Royal Institute of British Architects* (1854): 19.

22. F. C. Penrose, *An Investigation of the Principles of Athenian Architecture; or, The Results of a Recent Survey Conducted Chiefly with Reference to the Optical Refinements Exhibited in the Constructions of the Ancient Buildings of Athens* (London: Society of the Dilettanti, 1851), 55. See Jenkins and Middleton, "Paint on the Parthenon Sculptures," where they argue for ancient base coatings on the sculptures applied in advance of the application of color.

23. On June 18, 1858, a writer who signed as "Marmor" railed, "Sir, they are scrubbing the Elgin Marbles!" Westmacott's method of cleaning with fuller's earth was contrary to the advice of the keeper of antiquities, Edward Hawkins (employed in the post since 1826), who had advised a gentler cleaning with "clay water." See Jenkins, *Cleaning and Controversy,* 5–6.

24. Ibid., 6; Officers Report: The Reports of the Keepers of the Antiquities Departments to the Trustees, June 25, 1868 (British Museum).

25. Newton recommended that the pedimental sculptures be similarly protected. See Jenkins, *Cleaning and Controversy,* 6; Officers Report: The Reports of the Keepers of the Antiquities Departments to the Trustees, October 8, 1873 (British Museum).

26. Jenkins, *Cleaning and Controversy*, 6.

27. Ibid.; Officers Report: The Reports of the Keepers of the Antiquities Departments to the Trustees, January 23, 1933 (British Museum).

28. David Lindsay, Earl of Crawford, *The Crawford Papers: The Journals of David Lindsay, Twenty-Seventh Earl of Crawford and Tenth Earl of Balcarres, 1871–1940, During the Years 1892 to 1940*, ed. J. Vincent (Manchester: Manchester University Press, 1984). See Jenkins, *Cleaning and Controversy*, 6.

29. Jenkins, *Cleaning and Controversy*, 8, 37–39, gives the First Interim Report to the Trustees, November 7, 1938, in which Lord Duveen's foreman, a man named Daniel, is said to have "expressed Lord Duveen's desire that the sculptures be made as clean and white as possible."

30. The Second Interim Report, December 8, 1938, contains the testimony of two laborers who had used copper tools in cleaning from June 1937 on. See Jenkins, *Cleaning and Controversy*, 46–47, 24–25, and plate 10, for discussion and illustration of tools used in the cleaning. Dr. R. D. Barnett, retired keeper of Western Asiatic antiquities at the museum, stated in a letter to the museum's director (February 9, 1984) that he had been puzzled as to why an elderly laborer had been allowed to sit "day after day using hammer and chisel and wire brushes" on the Parthenon's metopes and frieze slabs. See Jenkins, *Cleaning and Controversy*, 7, for background context to this document, which Jenkins sees as "artfully designed" to discredit all but Barnett himself. The full document (marked "Strictly Private and Confidential") is published in Jenkins, *Cleaning and Controversy*, as app. 5, 45.

31. Letter of Plenderleith, dated September 26, 1938, published in Jenkins, *Cleaning and Controversy*, 36.

32. Jenkins, *Cleaning and Controversy*, app. 2; First Interim Report, 27, 37–39.

33. All press clippings are published in Jenkins, *Cleaning and Controversy*, 9, 57–65.

34. St. Clair, *Lord Elgin and the Marbles*, 280–313; W. St. Clair, "The Elgin Marbles: Questions of Stewardship and Accountability," *International Journal of Cultural Property* 8 (1999): 397–521. Jenkins, *Cleaning and Controversy*, presents a wonderfully thorough account of the history of the cleaning of the Parthenon sculptures with all relevant documentation and archival materials.

35. Vlassopoulou, "New Investigations into the Polychromy of the Parthenon"; C. Vlassopoulou, "Η πολυχρωμία στον Παρθενώνα," in Πολύχρωμοι Θεοί: Χρώματα στα αρχαία γλυπτά, ed. V. Brinkmann, N. Kaltsas, and R. Wünsche (Athens: National Archaeological Museum, 2007), 98–101. I thank Christina Vlassopoulou for her kindness in sharing this information with me.

36. Blue pigment has been found on the fillet of the metopes and triglyphs and on the three vertical bars (*meroi*) of the triglyphs themselves. X-ray diffraction analysis and electron beam microanalysis shows that the blue paint is "Egyptian blue" ($CaCuSi_4O_{10}$) and the red is ferric oxide (hematite, Fe_2O_3). See Vlassopoulou, "Η πολυχρωμία στον Παρθενώνα" (note 35, above), who cites K. Kouzeli et al., "Monochromatic layers with and without oxalates on the Parthenon," in *The Oxalate Films: Origins and Significance in the Conservation of Works of Art* (Milan: Centro CNR Gino Bozza, 1989), 198–202, esp. 199, figs. 30–32.

37. By the Acropolis Ephorate and the Organization for the Construction of the New Acropolis Museum in direct collaboration with the Institute of Electronic Structure and Laser. For the history of research on polychromy and pigments used on sculptures from the Athenian Acropolis, see D. Pandermalis, ed., *Archaic Colors* (Athens: Acropolis Museum, 2012).

38. West frieze, rider 17 (slab 9), pigment on the left arm and on the folds hanging down behind the figure's back; rider 21 (slab 11), on the *chitoniskos*. The conservation of the east metopes has revealed paint on the fillet (*taenia*) and the band with the astragal.

39. Traces of tool marks used in carving the sculpture, as well as original monochromatic layers of paint on its surface, were also revealed. See Vlassopoulou, "New Investigations into the Polychromy of the Parthenon," 221–23.

40. R. Brooks, "High-Tech Athens Museum Challenges UK over Marbles," *Sunday Times,* June 21, 2009, 8.

41. Thompson, "Architecture as a Medium of Public Relations"; H. A. Thompson, "Athens and the Hellenistic Princes," *Proceedings of the American Philological Society* 97 (1953): 254–61; C. Habicht, "Athens and the Attalids in the Second Century B.C.," *Hesperia* 59 (1990): 561–77; C. Habicht, *The Hellenistic Monarchies: Selected Papers* (Ann Arbor: University of Michigan Press, 2006), 177–84.

42. E. S. Gruen, "Culture as Policy: The Attalids of Pergamon," in De Grummond and Ridgway, *From Pergamon to Sperlonga,* 17–31; Webb, "Functions of the Sanctuary of Athena and the Pergamon Altar"; R. A. Tomlinson, "Pergamon," in *From Mycenae to Constantinople: The Evolution of the Ancient City* (New York: Routledge, 1992), 111–21; Radt, *Pergamon,* 179–206, 216–24; J. Onians, *Art and Thought in the Hellenistic Age: The Greek World View, 350–50 B.C.* (London: Thames and Hudson, 1979), 62–63; Hurwit, *Athenian Acropolis,* 264–66.

43. P. Thonemann, *Attalid Asia Minor: Money, International Relations, and the State* (Oxford: Oxford University Press, 2013); H.-J. Gehrke, "Geschichte Pergamons—ein Abriss," in Antikensammlung der Staatlichen Museen zu Berlin, *Pergamon: Panorama,* 13–20; Radt, *Pergamon,* 24–26.

44. Diogenes Laertius, *Lives of the Philosophers* 4.6. For an overview of philosophers of the period, see C. Habicht, *Hellenistic Athens and Her Philosophers* (Princeton, N.J.: Princeton University Press, 1988); J. Dillon, *The Heirs of Plato: A Study of the Old Academy, 347–274 B.C.* (Oxford: Oxford University Press, 2003).

45. Pausanias, *Description of Greece* 1.8.1; Livy, *History of Rome* 38.16; Hansen, *Attalids of Pergamon,* 28, 59, 306–14.

46. Camp, *Athenian Agora,* 16; J. McK. Camp, *Gods and Heroes in the Athenian Agora* (Princeton, N.J.: American School of Classical Studies at Athens, 1980), 24–25; T. L. Shear, *The Monument of the Eponymous Heroes in the Athenian Agora* (Princeton, N.J.: American School of Classical Studies at Athens, 1970).

47. Stewart, *Attalos, Athens, and the Akropolis,* with full bibliography; Ridgway, *Hellenistic Sculpture I,* 284–85; J. J. Pollitt, *Art in the Hellenistic Age* (Cambridge, U.K.: Cambridge University Press, 1986), 83–95.

48. Pausanias, *Description of Greece* 1.25.2.

49. M. Korres, "The Pedestals and the Akropolis South Wall," in Stewart, *Attalos, Athens, and the Akropolis,* 242–85.

50. L. Mercuri, "Programmi pergameni ad Atene: La stoa di Eumene," *Annuario della Scuola Archeologica di Atene e delle Missioni Italiane in Oriente* 82 (2004): 61–80; Camp, *Athenian Agora,* 171–72; E.-L. Schwandner, "Beobachtungen zur hellenistischen Tempelarchitektur von Pergamon," in *Hermogenes und die hochhellenistische Architektur: Kolloquium Berlin 1988,* ed. W. Hoepfner and E.-L. Schwandner (Mainz: Philipp von Zabern, 1990), 93–102; Radt, *Pergamon,* 286–92; Thompson, "Architecture as a Medium of Public Relations," 182–83.

51. *IG* II² 3781, see Thompson and Wycherley, *Agora of Athens,* 107; H. A. Thompson, "Excavations in the Athenian Agora, 1949," *Hesperia* 19 (1950): 318ff.; Thompson, "Architecture as a Medium of Public Relations," 186. It should be noted, however, that the dedicants could be Athenians named after the kings, see H. Mattingly, "Some Problems in Second Century Attic Prosopography," in *Historia* 20 (1971): 24–46, especially 29–32.

52. Athenaios, *Deipnosophists* 5.212e–f.

53. N. Sakka, "'A Debt to Ancient Wisdom and Beauty': The Reconstruction of the Stoa of Attalos in the Ancient Agora of Athens," in *Philhellenism, Philanthropy, or Political Convenience? American Archaeology in Greece, Hesperia Special Issue*

82 (2013):203–27; M. Kohl, "La genèse du portique d'Attale II: Origine et sens des singularités d'un bâtiment construit dans le cadre de la nouvelle organisation de l'agora d'Athènes au II^e siècle av. J.-C.," in *Constructions publiques et programmes édilitaires en Grèce entre le II^e siècle av. J.-C. et le I^{er} siècle ap. J.-C.*, ed. J.-Y. Marc and J.-C. Moretti (Athens: École Française d'Athènes, 2001), 237–66; H. A. Thompson, *The Stoa of Attalos II in Athens* (Princeton, N.J.: American School of Classical Studies at Athens, 1992); Camp, *Athenian Agora*, 172–75, and plate 140; J. J. Coulton, *The Architectural Development of the Greek Stoa* (Oxford: Clarendon Press, 1976), 69, 219; Travlos, *Pictorial Dictionary*, 505–19; J. Travlos, "Restauration de la Stoa (portique) d'Attale," *Bulletin de l'Union des Diplômés des Universités et des Écoles de Hautes Études de Belgique* 7 (1955): 1–16; H. A. Thompson, "Stoa of Attalos," *Archaeology* 2 (1949): 124–30.

54. For full discussion see Shear, "Polis and Panathenaia," 873–78; J. Shear, "Royal Athenians: The Ptolemies and Attalids at the Panathenaia," in Palagia and Spetsieri-Choremi, *Panathenaic Games*, 135–45. See Hurwit, *Athenian Acropolis*, 271–72, for the possibility of victories at the Panathenaia of 182 B.C. or 186 B.C.

55. M. Korres, "Ἀναθηματικά καὶ τιμητικὰ τέθριππα στὴν Ἀθήνα καὶ τοὺς Δελφούς," in *Delphes cent ans après la grande fouille: Essai de bilan*, ed. A. Jacquemin (Athens: École Française d'Athènes, 2000), 293–329.

56. See Shear, "Polis and Panathenaia," 876–77.

57. Korres, "Architecture of the Parthenon," in *Acropolis Restoration*, 47, 177; Korres, "Recent Discoveries on the Acropolis," 177, 179; Korres, "Parthenon from Antiquity to the 19th Century," 139; Hurwit, *Athenian Acropolis*, 271–72.

58. Pausanias, *Description of Greece*, 1.27.4; 9.30.1.

59. S. Agelides, "Kulte und Heiligtümer in Pergamon," in Antikensammlung der Staatlichen Museen zu Berlin, *Pergamon: Panorama*, 174–83; Webb, "Functions of the Pergamon Altar and the Sanctuary of Athena," 241–44; Radt, *Pergamon*, 179–90; R. Bohn, *Das Heiligtum der Athena Polias Nikephoros* (Berlin: Spemann, 1885).

60. The hypothetical visualization of the south slope of the Acropolis shown on page 305 is not a scientific reconstruction but is merely meant to help the reader visualize the Acropolis at this time. For the Pergamene theater, see M. Maischberger, "Der Dionysos-Tempel auf der Theaterterrasse," in Antikensammlung der Staatlichen Museen zu Berlin, *Pergamon: Panorama*, 242–47.

61. V. Kästner, "Das Heiligtum der Athena," in Antikensammlung der Staatlichen Museen zu Berlin, *Pergamon: Panorama*, 184–93.

62. Queyrel, *L'autel de Pergame*; Ridgway, *Hellenistic Sculpture II*, 19–102; Stewart, "Pergamo Ara Marmorea Magna"; V. Kästner, "The Architecture of the Great Altar of Pergamon," in *Pergamon: Citadel of the Gods*, ed. H. Koester (Harrisburg, Pa.: Trinity Press International, 1998), 137–61; W. Hoepfner, "The Architecture of Pergamon," in Dreyfus and Schraudolph, *Pergamon*, 2:23–67 and 168–82; Kästner, "Architecture of the Great Altar and the Telephos Frieze."

63. Summarized and analyzed by Stewart, "Pergamo Ara Marmorea Magna," 32–33; Andreae, "Dating and Significance of the Telephos Frieze"; A. Scholl, "Der Pergamonaltar—ein Zeuspalast mit homerischen Zügen?," in Antikensammlung der Staatlichen Museen zu Berlin, *Pergamon: Panorama*, 212–18. For the identification of the Great Altar with the hero shrine of Telephos, see Ridgway, *Hellenistic Sculpture II*, 67–102; Webb, "Functions of the Sanctuary of Athena and the Pergamon Altar"; Kästner, "Architecture of the Great Altar and the Telephos Frieze"; Webb, *Hellenistic Architectural Sculpture*, 12–13, 61–66; Radt, *Pergamon*, 55. For interpretation of the Great Altar as victory monument, see W. Hoepfner, "Von Alexandria über Pergamon nach Nikopolis: Städtebau und Stadtbilder hellenistischer Zeit," *Akten* 13 (1990): 275–85. For the Great Altar as "Palace of Zeus," see Scholl, "Der Pergamonaltar—ein Zeuspalast mit homerischen Zügen?"

64. On the strength of his study of the context pottery from the 1961 excava-

tions (which he dates to ca. 172/171 B.C.), P. J. Callaghan down dates the beginning of construction on the Pergamon Altar to ca. 165 B.C. and associates it with Eumenes II's victories over the Gauls in 167–166 B.C. Since the Attalids would have been directing all of their financial resources before this date to the wars, Callaghan argues that construction on the altar is likely to have started only after these victories; that is, ca. 166–156 B.C. P. J. Callaghan, "On the Date of the Great Altar of Pergamon," *BICS* 28 (1981): 115–21. De Luca and Radt opened new soundings in 1994 that yielded pottery they dated to just after 172 B.C., with certain styles dating as late as 157–150 B.C.; see G. De Luca and W. Radt, "Sondagen im Fundament des Grossen Altars," *AJA* 105 (2001): 129–30. B. S. Ridgway suggests that construction began in 159 B.C., shortly before Eumenes II's death and during his co-regency with Attalos II, and ended with the death of Attalos III in 133 B.C.; see Ridgway, *Hellenistic Sculpture II,* 19–76; Webb, *Hellenistic Architectural Sculpture,* 21–22, 62–63. See also Andreae, *Phyromachos-Probleme;* Andreae, "Dating and Significance of the Telephos Frieze"; F. Rumscheid, *Untersuchungen zur Kleinasiatischen Bauornamentik des Hellenismus,* 2 vols. (Mainz: Philipp von Zabern, 1994), 1:3–39.

65. Hesiod, *Theogony* 105–7; see Simon, *Pergamon und Hesiod.* For philosophical, astronomical, and cosmological aspects of the Gigantomachy frieze, see F.-H. Massa-Pairault, *La gigantomachie de Pergame ou l'image du monde* (Athens: École Française d'Athènes, 2007); F.-H. Massa-Pairault, "Sur quelques motifs de la frise de la gigantomachie: Définition et interprétation," in *Pergame: Histoire et archéologie d'un centre urbain depuis ses origines jusqu'à la fin de l'antiquité,* ed. M. Kohl (Villeneuve-d'Ascq: Université Charles de Gaulle–Lille III, 2008), 93–120.

66. Interestingly, the cornice of the sacrificial altar within the raised court shows a distinctive molding that quotes the decoration on the altar of Athena at Tegea, establishing a direct link with the "home" sanctuary on the Greek mainland, where Auge herself was understood to have served as priestess. See E. Schraudolph, "Cornice of the Sacrificial Altar (cat. n. 34)," in Dreyfus and Schraudolph, *Pergamon,* 1:100: "The two-fascia architrave is completed by a string of beads, a Lesbian kymation, an egg-and-dart pattern, and a groove with a floral frieze. This extraordinarily varied decoration closely resembles the pilaster molding with a nearly identical sequence from the altar of the temple of Athena at Tegea, which dates to the later fourth century B.C." See also Kästner, "Architecture of the Great Altar and the Telephos Frieze," 78–80 and fig. 7; N. J. Norman, "The Temple of Athena Alea at Tegea," *AJA* 88 (1984): 190–91 and plate 30, figs. 8a–b. Kästner notes, in addition, that the altar's anthemion frieze goes back to the architecture of the Erechtheion and, if Hans Möbius's hypothesis is correct, to the altar of Athena as well. Kästner therefore proposes, "The famous sanctuary on the Athenian Acropolis—recalling the good relations of the Attalids with Athens—could well have been the model for an ornamentation that was unusual in Asia Minor." H. Möbius, "Attische Architekturstudien, II: Zur Ornamentik des Erechtheions," in *Studia varia,* ed. W. Schiering (Wiesbaden: Franz Steiner, 1967), 83–91. I thank Michael Anthony Fowler for kindly alerting me to these references.

67. Those who interpret this figure as Nyx include L. Robert, "Archäologische Nachlese, XX: Die Götter in der pergamenischen Gigantomachie," *Hermes* 46 (1911): 232–35, and Simon, *Pergamon und Hesiod.* M. Pfanner sees her as Persephone, based on the ribbons behind her head, which terminate in pomegranate flowers; see M. Pfanner, "Bemerkungen zur Komposition und Interpretation des Grossen Frieses von Pergamon," *AA* 94 (1979): 53–55. H. Winnefeld thought the figure was Demeter; see H. Winnefeld, *Die Friese des grossen Altars* (Berlin: G. Reimer, 1910), 146. V. Kästner, "Restaurierung der Friese des Pergamonaltars—zum Abschluss der Arbeiten am Nordfries," *Jahrbuch Preußischer Kulturbesitz* 37 (2000): 159, 170, suggests that the figure is one of the three Fates; Queyrel, *L'autel de Pergame,* 71–73, agrees with Kästner's general identification as a Fate but proposes further that she is Atropos.

68. For metope 14, see Schwab, "New Evidence for Parthenon East Metope 14."

69. M. Kunze, "Neue Beobachtungen zum Pergamonaltar," in Andreae, *Phyromachos-Probleme*, 123–39. For Tritons, see S. Lattimore, *The Marine Thiasos in Greek Sculpture* (Los Angeles: Institute of Archaeology, University of California, 1976); Webb, *Hellenistic Architectural Sculpture*, 65–66.

70. The Parthenon frieze measures 160 meters (525 feet) long and just over a meter (3.3 feet) in height, while the Telephos frieze measures 58 meters (190 feet) in length and 1.58 meters (5.1 feet) in height.

71. Collard, Cropp, and Lee, *Euripides: Selected Fragmentary Plays;* for Telephos, see 17–52; for the Erechtheus, see 148–94.

72. Brunilde Ridgway emphasizes the role of architectural sculpture as a permanent public statement comparable to "the recitation of a bard or the performance of a play." Ridgway, *Prayers in Stone*, 8, 82.

73. A. Scholl, "Zur Deutung des Pergamonaltars als Palast des Zeus," *JdI* 124 (2009): 257–64. I am grateful to Prof. Dr. Scholl for his kind help and hospitality during my study visit to the Pergamon Museum.

74. Dreyfus and Schraudolph, *Pergamon*, 1:60, no. 5, panel 12.

75. See Connelly, *Portrait of a Priestess*, 59–64.

76. V. Käster, "Die Altarterrasse," in Antikensammlung der Staatlichen Museen zu Berlin, *Pergamon: Panorama*, 199–211; Hansen, *Attalids of Pergamon*, 239–40; Ridgway, *Hellenistic Sculpture II*, 38.

77. For interpretation of the Great Altar as the *heroön* of Telephos, see Radt, *Pergamon*, 55; K. Stähler, "Überlegungen zur architecktonischen Gestalt des Pergamonaltares," in *Studien zur Religion und Kultur Kleinasiens: Festschrift für Friedrich K. Dörner zum 65. Geburtstag am 28. Februar 1976*, ed. S. Şahin, E. Schwertheim, and J. Wagner (Leiden: Brill, 1978), 838–67; Ridgway, *Hellenistic Sculpture II*, 27–32; Webb, *Hellenistic Architectural Sculpture*, 12–13.

78. Pausanias, *Description of Greece* 5.13.3, 3.26.10.

79. Pausanias, *Description of Greece* 8.4.9.

80. A. Stewart, "Telephos/Telepinu and Dionysos: A Distant Light on an Ancient Myth," in Dreyfus and Schraudolph, *Pergamon*, 2:109–20.

81. S. Brehme, "Die Bibliothek von Pergamone," in Antikensammlung der Staatlichen Museen zu Berlin, *Pergamon: Panorama*, 194–97; W. Hoepfner, "Die Bibliothek Eumenes' II in Pergamon" and "Pergamon—Rhodos—Nysa—Athen: Bibliotheken in Gymnasien und anderen Lehr- und Forschungsstätten," in *Antike Bibliotheken*, ed. W. Hoepfner (Mainz: Philipp von Zabern, 2002), 41–52, 67–80; G. Nagy, "The Library of Pergamon as a Classical Model," in H. Koester, ed., *Pergamon: Citadel of the Gods* (Harrisburg, Pa.: Trinity Press International, 1998), 185–232; L. Casson, *Libraries in the Ancient World* (New Haven, Conn.: Yale University Press, 2001).

82. Hurwit, *Athenian Acropolis*, 264–66.

83. *RC* 23 (*OGIS* 267). The inscription was found in 1883 built into a Turkish gateway on the citadel. J. Muir, *Life and Letters in the Ancient Greek World* (New York: Routledge, 2009), 98–99; Hansen, *Attalids of Pergamon*, 448; Ridgway, *Hellenistic Sculpture II*, 38.

84. Dreyfus and Schraudolph, *Pergamon*, 1:112, no. 54.

85. Camp, *Athenian Agora*, 26–27, 35, 202; J. McK. Camp, *The Athenian Agora: A Short Guide to the Excavations*, Agora Picture Book 16 (Princeton, N.J.: American School of Classical Studies at Athens, 2003), 35.

86. Lesk, "Erechtheion and Its Reception," 43.

87. Ibid., 126–29.

88. A. L. Lesk, "'Caryatides probantur inter pauca operum': Pliny, Vitruvius, and the Semiotics of the Erechtheion Maidens at Rome," *Arethusa* 40 (2007): 25–42;

E. Perry, *The Aesthetics of Emulation in the Visual Arts of Ancient Rome* (Cambridge, U.K.: Cambridge University Press, 2005), 92–93.

89. J. N. Svoronos, *Les monnaies d'Athènes* (Munich: F. Bruckmann, 1923–1926), 19–20.

90. Allen, *Why Plato Wrote*, 44. For Plato's aesthetics, see N. Pappas, *Stanford Encyclopedia of Philosophy*, http://plato.stanford.edu/entries/plato-aesthetics/, esp. sec. 2.4. For mimesis in poetry and the visual arts, see Pollitt, *Ancient View of Greek Art*, 37–41.

91. Thucydides, *Peloponnesian War* 2.37.1.

92. Ibid., 2.51.2; Hermann, *Morality and Behaviour*, 52, 395–414; Hermann, "Reciprocity, Altruism, and the Prisoner's Dilemma."

93. Euripides, *Erechtheus* F 360.10–50 Kannicht = Lykourgos, *Against Leokrates* 100.

94. Hermann, *Morality and Behaviour*, 342.

EPILOGUE

1. V. Woolf, *The Diary of Virgina Woolf,* vol. 4, 1931–35 (New York: Harcourt Brace & Company, 1983), 90–91.

2. Balanos, *Les monuments de l'Acropole*. On Balanos's restoration work, see Mallouchou-Tufano, "History of Interventions on the Acropolis," 81, and "Restoration of Classical Monuments."

3. Sourvinou-Inwood, *"Reading" Greek Culture,* 10–13; C. Sourvinou-Inwood, "Reading a Myth, Reconstructing Its Constructions," in *Myth and Symbol 2: Symbolic Phenomena in Ancient Greek Culture,* ed. S. des Bouvrie (Bergen: Norwegian Institute at Athens, 2004), 141, 146–47.

4. For the history of CCAM, see Mallouchou-Tufano, "Restoration Work on the Acropolis," in *Proceedings of the Fifth International Meeting.*

5. Korres, *Study of the Restoration of the Parthenon;* Mallouchou-Tufano, H Αναστύλωση των Αρχαίων Μνημείων; Toganidis, "Parthenon Restoration Project," 27–38.

6. Korres, *From Pentelicon to the Parthenon;* Korres, *Stones of the Parthenon.*

7. Korres, "Recent Discoveries on the Acropolis"; Korres, "Architecture of the Parthenon"; Korres, "History of the Acropolis Monuments"; Korres, "Parthenon from Antiquity to the 19th Century"; Korres, Panetsos, and Seki, *Parthenon,* 68–73; Korres, "Der Pronaos und die Fenster des Parthenon"; Korres, "Die klassische Architektur und der Parthenon."

8. Vlassopoulou, *Acropolis and Museum;* Bernard Tschumi Architects, *New Acropolis Museum;* K. Servi, *The Acropolis: The Acropolis Museum* (Athens: Ekdotike Athenon SA, 2011); Tschumi, Mauss, and Tschumi Architects, *Acropolis Museum.* To be sure, the museum has been criticized by some for not showing the full multi-temporal and multicultural life of the Acropolis, including the medieval and Ottoman periods; see Hamilakis, "Museums of Oblivion," and other criticisms by D. Plantzos, "Behold the Raking Geison: The New Acropolis Museum and Its Context-Free Archaeologies," *Antiquity* 85 (2011): 613–25.

9. Chaniotis, *Ritual Dynamics in the Ancient Mediterranean,* introduction, 9, sets out the challenges of the source materials and various biases that bedevil the study of ancient ritual in particular and ancient history in general.

10. Bremmer, *Strange World of Human Sacrifice,* esp. J. Bremmer, "Human Sacrifice: A Brief Introduction," 1–8.

11. A. Parpola, "Human Sacrifice in India in Vedic Times and Before," in Bremmer, *Strange World of Human Sacrifice,* 157–77.

12. Judges 11:31–40.

13. Genesis 22.

14. Euripides, *Iphigeneia in Aulis* 1585–94; Apollodoros, *Library* 3.21.

15. Kaldellis, *Christian Parthenon*, 34–35; Korres, "The Parthenon from Antiquity to the Nineteenth Century," 14–161.

16. Ibid., 40–41; G. Rodenwaldt, "Interpretatio Christiana," *AA* 48 (1933): 401–5.

17. Mokyr, *Gifts of Athena*, 218–83.

18. Mokyr, *Gifts of Athena*, 225–26. See also B. Barber, "Resistance by Scientists to Scientific Discovery," in *The Sociology of Science*, ed. B. Barber and W. Hirsch (New York: Macmillan, 1962), 539–56.

19. Mokyr, *Gifts of Athena*, 19, 266.

20. P. G. G. Joly de Lotbinière, "The Parthenon from the Northwest, 1839," in N. P. Lerebours, *Excursions daguerriennes: Vues et monuments les plus remarquables du globe* (Paris: H. Bossange, 1841–1842).

21. For an overview of the impact of nineteenth-century photography carried out on the Acropolis, see Hamilakis, "Monumental Visions," 5–12. During his first visit to Greece, Boissonnas shot a few thousand photographs published in his collections *La Grèce par monts et par vaux*, with D. Baud-Bovy (Geneva: F. Boissonnas, 1910), *L'Acropole d'Athènes*, with G. Fougères (Paris: Albert Morance, 1914), *La Grèce immortelle* (Geneva: Éditions d'Art Boissonnas, 1919), and *Dans le sillage d'Ulysse*, with V. Bérard (Paris: A. Colin, 1933). He traveled to Egypt, Nubia, the Sinai Peninsula, and Mount Athos and published fifty collections of photographs in all. For the work of Mavrommatis, see A. Delivorrias and S. Mavrommatis, *The Parthenon Frieze: Problems, Challenges, Interpretations* (Athens: Melissa, 2004); A. Choremi, C. Hadziaslani, S. Mavrommatis, and E. Kaimara, *The Parthenon Frieze*, CD-ROM (Athens: Acropolis Restoration Service in collaboration with the National Documentation Centre, National Research Foundation, 2003); S. Mavrommatis, *Photographs, 1975–2002, from the Works on the Athenian Acropolis* (Athens: Acropolis Restoration Service, 2002); C. Bouras, K. Zambas, S. Mavrommatis, and C. Hadziaslani, *The Works of the Committee for the Preservation of the Acropolis Monuments on the Acropolis of Athens* (Athens: Ministry of Culture, Archaeological Receipts Fund, 2002); S. Mavrommatis and C. Hadziaslani, *The Parthenon Frieze, Photographic Reconstruction at Scale 1:20* (Athens: Acropolis Restoration Service, 2002); C. Hadziaslani and S. Mavrommatis, *Promenades at the Parthenon*. Films by S. Mavrommatis: *The Works on the Athenian Acropolis: The People and the Monuments; The Parthenon West Frieze, Conservation and Cleaning (2003–2004); The Restoration Works on the Acropolis Monuments (2003–2004).*

22. Lissarrague, "Fonctions de l'image"; F. Lissarrague, lectures, delivered at the Swedish Institute at Athens; Lissarrague and Schnapp, "Imagerie des Grecs"; Connelly, "Parthenon and *Parthenoi*," 55; Connelly, *Portrait of a Priestess*, 20–21; Marconi, "Degrees of Visibility," 172; Ferrari, *Figures of Speech*, 17–25; Sourvinou-Inwood, *"Reading" Greek Death*, 140–43.

23. Hitchens, *Parthenon Marbles;* D. King, *The Elgin Marbles* (London: Hutchinson, 2006); Cosmopoulos, *Parthenon and Its Sculptures;* D. William, "'Of Publick Utility and Publick Property': Lord Elgin and the Parthenon Sculptures," in *Appropriating Antiquity*, ed. A. Tsingarida and D. Kurtz (Brussels: Le Livre Timperman, 2002), 103–64; St. Clair, *Lord Elgin and the Marbles;* Vrettos, *Elgin Affair;* C. Hitchens, *Imperial Spoils: The Curious Case of the Elgin Marbles* (New York: Hill and Wang, 1988); T. Vrettos, *A Shadow of Magnitude: The Acquisition of the Elgin Marbles* (New York: G. P. Putnam, 1974).

24. D. Rudenstine, "The Legality of Elgin's Taking: A Review Essay of Four Books on the Parthenon Marbles," *International Journal of Cultural Property* 8 (1999): 356–76; J. H. Merryman, "Thinking About the Elgin Marbles," *Michigan Law Review* 83 (1985): 1898–99; J. H. Merryman, "Whither the Elgin Marbles?," in

Imperialism, Art, and Restitution, ed. J. H. Merryman (Cambridge, U.K.: Cambridge University Press, 2006); C. Hitchens, *The Elgin Marbles: Should They Be Returned to Greece?* (London: Verso Books, 1998).

25. St. Clair, *Lord Elgin and the Marbles,* 338–41. Photographs and full translation at http://www.britishmuseum.org/explore/highlights/article_index/t/translation _of_elgins_firman.aspx.

26. Nagel, *Mistress of the Elgin Marbles,* 134–35.

27. Ibid., 136.

28. Extracts given in Nagel, *Mistress of the Elgin Marbles,* 134–39, as transcribed from letters and diaries of Mary Hamilton Nisbet, Bruce Ferguson, and Thomas Bruce, Earl of Elgin (now in the possession of Andrew, eleventh Earl of Elgin and fifteenth Earl of Kincardine, Mr. Julian Brooke, and Mr. Richard Blake). See also R. Stoneman, *A Literary Companion to Travel in Greece* (Harmondsworth: Penguin, 1994), 139.

29. E. D. Clarke, *Travels in Various Countries of Europe, Asia, and Africa* (London: T. Cadell and W. Davies, 1810), sec. 2, 484.

30. Vrettos, *Elgin Affair;* F. S. N. Douglas, *An Essay on Certain Points of Resemblance Between the Ancient and Modern Greeks* (London: J. Murray, 1813), 89; Dodwell, *Classical and Topographical Tour Through Greece,* vol. 1, 322–24; T. S. Hughes, *Travels in Sicily, Greece, and Albania* (London: J. Mawman, 1820), sec. 1, 261; F.-A.-R. Chateaubriand, *Travels to Jerusalem and the Holy Land Through Egypt* (London: H. Colburn, 1835), sec. 1, 187.

31. Lord Byron, *Childe Harold's Pilgrimage* (1812), canto 2, stanzas 11–15.

32. A. Chaniotis, "Broken Is Beautiful: The Aesthetics of Fragmentation and the Cult of Relics," in Mylonopoulos and Chaniotis, *New Acropolis Museum,* 44.

33. Bernard Tschumi Architects, *New Acropolis Museum;* Tschumi, Mauss, and Tschumi Architects, *Acropolis Museum.*

34. D. Pandermalis and S. Eleftheratou, *Acropolis Museum Short Guide* (Athens: New Acropolis Museum, 2009); Vlassopoulou, *Acropolis and Museum*; M. Caskey, "Perceptions of the New Acropolis Museum," *AJA* 115 (2011), http://www.ajaonline .org/online-review-museum/911.

35. Some, however, have seen this offer very differently. See Y. Hamilakis, "Nostalgia for the Whole: The Parthenon (or Elgin) Marbles," in *Nation and Its Ruins,* pages 243–86, for the opinion that this approach only continues a submissive, subservient posture that exists within the logic of colonialism.

36. "Students, Supported by Marbles Reunited, Stage a Peaceful Protest at the British Museum," PRNewswire, May 6, 2009, http://www.elginism.com/20090506/1942/. Students and teachers traveled to London from the second General Lyceum in Argostoli, Kephalonia.

37. For the eighth Earl of Elgin and the burning of the Summer Palace, see W. T. Hanes and F. Sanello, *The Opium Wars: The Addiction of One Empire and the Corruption of Another* (Naperville, Ill.: Sourcebooks, 2002).

38. For the "universal museum," see the Declaration on the Importance and Value of the Universal Museum, signed by eighteen European and American museums in December 2003, http://icom.museum/fileadmin/user_upload/pdf/ICOM_News/ 2004-1/ENG/p4_2004-1.pdf. For cosmopolitanism and the defense of the universal museum, see K. A. Appiah, *Cosmopolitanism* (New York: W. W. Norton, 2006); J. Cuno, *Museums Matter: In Praise of the Encyclopedic Museum* (Chicago: University of Chicago Press, 2012); J. Cuno, *Who Owns Antiquity?* (Princeton, N.J.: Princeton University Press, 2008); J. Cuno, ed., *Whose Culture? The Promise of Museums and the Debate over Antiquities* (Princeton, N.J.: Princeton University Press, 2009). For an interesting discussion of cosmopolitanism and particularism, see D. Gillman, *The Idea of Cultural Heritage,* 49–55. For critiques of the universal museum, see G. Abungu, "The Declaration: A Contested Issue," *ICOM News* 1 (2004): 4; G. W. Curtis, "Universal Museums, Museum Objects, and Repatriation:

The Tangled Stories of Things," *Museum Management and Curatorship* 21 (2006): 117–28.

39. C. Calhoun, *Nations Matter: Culture, History, and the Cosmopolitan Dream* (New York: Routledge, 2007); C. Calhoun, "Imagining Solidarity: Cosmopolitanism, Constitutional Patriotism, and the Public Sphere," *Public Culture* 14 (2002): 147–71; C. Calhoun, "Cosmopolitanism in the Modern Social Imaginary," *Daedalus* 137 (2008): 105–14. For further critique of cosmopolitanism, see A. González-Ruibal, "Vernacular Cosmopolitanism: An Archaeological Critique of Universalistic Reason," in *Cosmopolitan Archaeologies,* ed. L. Meskell (Durham, N.C.: Duke University Press, 2009), 113–39.

40. A television poll conducted in 1996, reported in Hitchens, *Parthenon Marbles,* xxi, shows a very similar figure. For a poll taken by *The Guardian* in 2009 see http://www.guardian.co.uk/culture/poll/2009/jun/24/elgin-marbles. It should be said that these polls represent somewhat "loaded" samples and, in the case of the *Guardian* poll, reflect the opinions of those choosing to send in their vote. The true figure is hard to ascertain because of the large number of "don't know/never heard of them" responses. A debate on the return of the Parthenon sculptures to Athens, sponsored by Intelligence Squared and televised by the BBC, was held at Cadogan Hall in London on June 11, 2012. The actor Stephen Fry and Andrew George, Liberal Democrat MP for St. Ives, spoke for the motion, while Tristram Hunt, Labour MP for Stoke-on-Trent, and Felipe Fernández-Armesto, professor of history at the University of Notre Dame, spoke against it. A vote by the audience showed the motion to return the sculptures carried by 384 to 125.

41. This figure is extrapolated from the annual visitor totals claimed by the British Museum and the average proportion observed entering the Duveen Gallery. http://www.bbc.co.uk/news/uk-18373312.

42. Lords Debates, "The Parthenon Sculptures," May 19, 1997.

43. Lord Renfrew has argued for the preservation of archaeological material within its stratigraphic and cultural contexts, see C. Renfrew, *Loot, Legitimacy, and Ownership: The Ethical Crisis in Archaeology* (London: Duckworth, 2000); C. Renfrew, "Museum Acquisitions: Responsibilities for the Illicit Traffic in Antiquities," in *Archaeology, Cultural Heritage, and the Antiquities Trade,* ed. N. Brodie, M. Kersel, C. Luke, and K. W. Tubb (Gainesville: University of Florida Press, 2008), 245–57; N. Brodie and C. Renfrew, "Looting and the World's Archaeological Heritage: The Inadequate Response," *Annual Review of Anthropology* 34 (2005): 343–61; N. Brodie, J. Doole, and C. Renfrew, eds., *Trade in Illicit Antiquities: The Destruction of the World's Archaeological Heritage* (Cambridge, U.K.: McDonald Institute for Archaeological Research, 2001); C. Renfrew, "The Fallacy of the 'Good Collector' of Looted Antiquities," *Public Archaeology* 1 (2000): 76–78.

44. http://www.bbc.co.uk/news/uk-18373312.

45. M. Anderson, "Ownership Isn't Everything: The Future Will Be Shared," *Art Newspaper,* September 15, 2010.

46. By Robert A. McCabe, whom I warmly thank for his kindness in allowing his beautiful photographs to be published throughout this book.

Selected Bibliography

Albersmeier, S., ed. *Heroes: Mortals and Myths in Ancient Greece*. Baltimore: Walters Art Museum, 2009.

Alcock, S. "Archaeologies of Memory." In S. Alcock, *Archaeologies of the Greek Past: Landscapes, Monuments, and Memories*, 1–35. Cambridge, U.K.: Cambridge University Press, 2002.

Allen, D. *Why Plato Wrote*. Chichester: Wiley-Blackwell, 2010.

Andreae, B. "Dating and Significance of the Telephos Frieze in Relation to the Other Dedications of the Attalids of Pergamon." In Dreyfus and Schraudolph, *Pergamon*, 2:120–26.

———, ed. *Phyromachos-Probleme: Mit einem Anhang zur Datierung des grossen Altars von Pergamon*. Mitteilungen des Deutschen Archäologischen Instituts, Römische Abteilung, Supplement 31. Mainz: Philipp von Zabern, 1990.

Andrews, E. "How a Riddle of the Parthenon Was Unraveled." *Century Illustrated Monthly Magazine*, June 1897, 301–9.

Antikensammlung der Staatlichen Museen zu Berlin. *Pergamon: Panorama der antiken Metropole: Begleitbuch zur Ausstellung*. Berlin: Michael Imhof, 2011.

Antonaccio, C. *An Archaeology of Ancestors: Tomb Cult and Hero Cult in Early Greece*. Lanham, Md.: Rowman & Littlefield, 1995.

Arrington, N. "Topographic Semantics: The Location of the Athenian Public Cemetery and Its Significance for the Nascent Democracy." *Hesperia* 79 (2010): 499–539.

Ataç, A. M. *The Mythology of Kingship in Neo-Assyrian Art*. Cambridge, U.K.: Cambridge University Press, 2010.

Austin, C. *Nova fragmenta Euripidea in papyris reperta*. Kleine Texte 187. Berlin: Walter de Gruyter, 1968.

———. "De nouveaux fragments de l'*Érechthée* d'Euripide." *Recherches de Papyrologie* 4 (1967): 11–67.

Balanos, G. *Les monuments de l'Acropole: Relèvement et conservation*. Paris: Charles Massin et Albert Lévy, 1938.

Bancroft, S. "Problems Concerning the Archaic Acropolis at Athens." Ph.D. diss., Princeton University, 1979.

Barber, E. J. W. "The *Peplos* of Athena." In Neils, *Goddess and Polis*, 103–17.

———. *Prehistoric Textiles: The Development of Cloth in the Neolithic and Bronze Age*. Princeton, N.J.: Princeton University Press, 1991.

Barletta, B. "The Architecture and Architects of the Classical Parthenon." In Neils, *Parthenon*, 67–99.

Barringer, J. M. *Art, Myth, and Ritual in Classical Greece*. Cambridge, U.K.: Cambridge University Press, 2008.

————. "The Temple of Zeus at Olympia: Heroes and Athletes." *Hesperia* 74 (2005): 211–41.

Barringer, J. M., and J. M. Hurwit, eds. *Periklean Athens and Its Legacy: Problems and Perspectives*. Austin: University of Texas Press, 2005.

Barrow, R. J. *Lawrence Alma-Tadema*. London: Phaidon Press, 2001.

Bastea, E. *The Creation of Modern Athens: Planning the Myth*. Cambridge, U.K.: Cambridge University Press, 1999.

Beard, M. *The Parthenon*. Cambridge, Mass.: Harvard University Press, 2002.

Becatti, G. "Il rilievo del Drago e la base della Parthenos." In *Problemi Fidiaci,* edited by G. Becatti, 53–70. Milan: Electa, 1951.

Bérard, C., et al., eds. *La cité des images: Religion et société en Grèce antique*. Paris: Fernand Nathan—L.E.P., 1984 = *A City of Images: Iconography and Society in Ancient Greece*. Princeton, N.J.: Princeton University Press, 1989.

Berger, E., ed. *Parthenon-Kongreß Basel: Referate und Berichte, 4. bis 8. April 1982*. Mainz am Rhein: Philipp von Zabern, 1984.

Berger, E., and M. Gisler-Huwiler, eds. *Der Parthenon in Basel: Dokumentation zum Fries des Parthenon*. Studien der Skulpturhalle Basel 3. Mainz: Philipp von Zabern, 1996.

Bernard Tschumi Architects, ed. *The New Acropolis Museum*. New York: Skira Rizzoli, 2009.

Beyer, I. "Die Reliefgiebel des alten Athena-Tempels der Akropolis." *AA* (1974): 639–51.

Bierl, A. *Ritual and Performativity: The Chorus of Old Comedy*. Translated by A. Hollmann. Washington, D.C.: Center for Hellenic Studies, 2009.

Blok, J. "Gentrifying Genealogy: On the Genesis of the Athenian Autochthony Myth." In *Antike Mythen: Medien, Transformationen und Konstruktionen,* edited by U. Dill and C. Walde, 251–75. New York: Walter de Gruyter, 2009.

————. "Perikles' Citizenship Law: A New Perspective." *Historia* 58 (2009): 141–70.

Boardman, J. "A Closer Look." *RA* (1999): 305–30.

————. "The Naked Truth." *OJA* 10 (1991): 119–21.

————. "Notes on the Parthenon Frieze." In Schmidt, *Kanon,* 9–14.

————. "The Parthenon Frieze." In Berger, *Parthenon-Kongreß Basel,* 210–15.

————. "Herakles, Peisistratos, and Sons." *RA* (1972): 57–72.

————. "The Parthenon Frieze: Another View." In *Festschrift für Frank Brommer,* 39–49. Mainz: Philipp von Zabern, 1970.

Boardman, J., and D. Finn. *The Parthenon and Its Sculptures*. Austin: University of Texas Press, 1985.

Bodnar, E. *Cyriacus of Ancona and Athens*. Collection Latomus, vol. 43. Brussels: Latomus, 1960.

Boegehold, A. L. "Group and Single Competitions at the Panathenaia." In Neils, *Worshipping Athena,* 95–105.

————. "Perikles' Citizenship Law of 451/0 B.C." In *Athenian Identity and Civic Ideology,* edited by A. L. Boegehold and A. C. Scafuro, 57–66. Baltimore: Johns Hopkins University Press, 1994.

Boegehold, A. L., and A. C. Scafuro, eds. *Athenian Identity and Civic Ideology*. Baltimore: Johns Hopkins University Press, 1994.

Boersma, J. S. *Athenian Building Policy from 561/0 to 405/4 B.C.* Groningen: Wolters-Noordhoff, 1970.

Borgeaud, P. *The Cult of Pan in Ancient Greece*. Chicago: University of Chicago Press, 1988.

Boutsikas, E. "Greek Temples and Rituals." In Ruggles, *Handbook of Archaeoastronomy and Ethnoastronomy,* 2014.

————. "Astronomical Evidence for the Timing of the Panathenaia." *AJA* 115 (2011): 303–9.

————. "Placing Greek Temples: An Archaeoastronomical Study of the Orientation of Ancient Greek Religious Structures." *Archaeoastronomy: The Journal of Astronomy in Culture* 21 (2009): 4–16.

Boutsikas, E., and R. Hannah. "Aitia, Astronomy, and the Timing of the Arrhēphoria." *BSA* 107 (2012): 233–45.

————. "Ritual and the Cosmos: Astronomy and Myth in the Athenian Acropolis." In Ruggles, *Archaeoastronomy and Ethnoastronomy,* 342–48.

Boutsikas, E., and C. Ruggles. "Temples, Stars, and Ritual Landscapes: The Potential for Archaeoastronomy in Ancient Greece." *AJA* 115 (2011): 55–68.

Bremmer, J. N. *The Strange World of Human Sacrifice.* Leuven: Peeters, 2007.

————. "Pandora and the Creation of a Greek Eve." In *The Creation of Man and Woman in Jewish and Christian Interpretations,* edited by G. Luttikhuizen, 19–34. Leiden: Brill, 2000.

————. *Greek Religion.* Oxford: Oxford University Press, 1994.

————, ed. *Interpretations of Greek Mythology.* London: Croom Helm, 1988.

Brommer, F. *Der Parthenonfries: Katalog und Untersuchung.* Mainz: Philipp von Zabern, 1977.

————. *Die Skulpturen der Parthenon-Giebel: Katalog und Untersuchung.* Mainz: Philipp von Zabern, 1963.

Broneer, O. *Isthmia: Topography and Architecture.* Vol. 2. Princeton, N.J.: Princeton University Press, 1973.

————. "Eros and Aphrodite on the North Slope of the Acropolis in Athens." *Hesperia* 1 (1932): 31–55.

Brown, K. S., and Y. Hamilakis, eds. *The Usable Past: Greek Metahistories.* New York: Lexington Books, 2003.

Burford, A. "The Builders of the Parthenon." In *Parthenos and Parthenon,* 23–35. Greece and Rome Supplement 10. Oxford: Clarendon Press, 1963.

Burtt, J. O. *Minor Attic Orators, II: Lycurgus, Demades, Dinarchus, Hyperides.* Cambridge, Mass.: Harvard University Press, 1982.

Buitron-Oliver, D., ed. *The Interpretation of Architectural Sculpture in Greece and Rome.* Washington, D.C.: National Gallery of Art, 1997.

Buxton, R. G. A., ed. *Oxford Readings in Greek Religion.* Oxford: Oxford University Press, 2000.

Calame, C. *Choruses of Young Women in Ancient Greece: Their Morphology, Religious Role, and Sacred Functions.* Lanham, Md.: Rowman & Littlefield, 1997.

Calder, W. M. "Prof. Calder's Reply." *GRBS* 12 (1971): 493–95.

————. "The Date of Euripides' *Erechtheus*." *GRBS* 10 (1969): 147–56.

Camp, J. McK. *The Archaeology of Athens.* New Haven, Conn.: Yale University Press, 2001.

————. "Before Democracy: Alkmaionidai and Peisistratidai." In Coulson, Palagia, Shear, Shapiro, and Frost, *Archaeology of Athens and Attica Under the Democracy,* 9–11.

————. *The Athenian Agora.* London: Thames and Hudson, 1986.

————. "Water and the Pelargikon." In *Studies Presented to Sterling Dow on His Eightieth Birthday,* edited by K. J. Rigsby, 37–41. Durham, N.C.: Duke University Press, 1984.

Carpenter, R. *The Architects of the Parthenon.* Harmondsworth: Penguin Books, 1970.

Carrara, P. *Euripide: Eretteo.* Papyrologica Florentina 3. Florence: Gonnelli, 1977.

Carroll, K. K. *The Parthenon Inscription.* Durham, N.C.: Duke University Press, 1982.

Castriota, D. *Myth, Ethos, and Actuality: Official Art in Fifth-Century B.C. Athens.* Madison: University of Wisconsin Press, 1992.

Chaniotis, A. *Unveiling Emotions: Sources and Methods for the Study of Emotions in the Greek World.* Stuttgart: Franz Steiner, 2012.

————, ed. *Ritual Dynamics in the Ancient Mediterranean: Agency, Emotion, Gender, Representation.* Heidelberger althistorische Beiträge und epigraphische Studien 49. Stuttgart: Franz Steiner, 2011.

————. "Dynamic of Emotions and Dynamic of Rituals: Do Emotions Change Ritual Norms?" In *Ritual Matters: Dynamic Dimensions in Practice,* edited by C. Brosius and U. Hüsken, 208–33. London: Routledge, 2010.

————. "Dividing Art–Divided Art: Reflections on the Parthenon Sculpture." In Mylonopoulos and Chaniotis, *New Acropolis Museum,* 1:41–48.

————. "The Dynamics of Ritual Norms in Greek Cult." In *La norme en matière religieuse en Grèce antique,* edited by P. Brulé, 91–105. *Kernos* Supplement 21. Liège: Centre International d'Étude de la Religion Grecque Antique, 2009.

————. "From Woman to Woman: Female Voices and Emotions in Dedications to Goddesses." In *Le donateur, l'offrande et la déesse,* edited by C. Prêtre, 51–68. *Kernos* Supplement 23. Liège: Centre International d'Étude de la Religion Grecque Antique, 2009.

————. "Theater Rituals." In *The Greek Theatre and Festivals: Documentary Studies,* edited by P. Wilson, 48–66. Oxford: Oxford University Press, 2007.

————. "Rituals Between Norms and Emotions: Ritual as Shared Experience and Memory." In *Ritual and Communication in the Graeco-Roman World,* edited by E. Stavrianopoulou, 211–38. *Kernos* Supplement 16. Liège: Centre International d'Étude de la Religion Grecque Antique, 2006.

————. "Ritual Dynamics in the Eastern Mediterranean: Case Studies in Ancient Greece and Asia Minor." In *Rethinking the Mediterranean,* edited by W. V. Harris, 141–66. Oxford: Oxford University Press, 2005.

Childs, W. A. P. "The Date of the Old Temple of Athena on the Athenian Acropolis." In Coulson, Palagia, Shear, Shapiro, and Frost, *Archaeology of Athens and Attica Under the Democracy,* 1–6.

Clairmont, C. "Girl or Boy? Parthenon East Frieze 35." *AA* (1989): 495–96.

————. "Euripides' *Erechtheus* and the Erechtheum." *GRBS* 12 (1971): 485–93.

Cohen, A. "Mythic Landscapes of Greece." In *Greek Mythology,* edited by R. D. Woodland, 305–30. Cambridge, U.K.: Cambridge University Press, 2007.

Collard, C., and M. Cropp. *Euripides VII: Fragments.* Loeb Classical Library 504. Cambridge, Mass.: Harvard University Press, 2008.

Collard, C., M. Cropp, and K. Lee, eds. *Euripides: Selected Fragmentary Plays.* Warminster: Aris & Phillips, 1995.

Connelly, J. B. "Ritual Movement Through Greek Sacred Space: Towards an Archaeology of Performance." In Chaniotis, *Ritual Dynamics in the Ancient Mediterranean,* 313–46.

————. *Portrait of a Priestess: Women and Ritual in Ancient Greece.* Princeton, N.J.: Princeton University Press, 2007.

————. "Parthenon and *Parthenoi*: A Mythological Interpretation of the Parthenon Frieze." *AJA* 100 (1996): 53–80.

————. "Narrative and Image in Attic Vase Painting: Ajax and Kassandra at the Trojan Palladion." In *Narrative and Event in Ancient Art,* ed. P. J. Holliday, 88–129. Cambridge, U.K.: Cambridge University Press, 1993.

————. "The Parthenon Frieze and the Sacrifice of the Erechtheids: Reinterpreting the 'Peplos Scene.'" *AJA* 97 (1993): 309–10.

Connerton, P. *How Societies Remember.* Cambridge, U.K.: Cambridge University Press, 1989.

Connolly, P., and H. Dodge. *The Ancient City: Life in Classical Athens and Rome.* Oxford: Oxford University Press, 1998.

Cook, R. M. *Greek Art: Its Development, Character, and Influence.* New York: Farrar, Straus and Giroux, 1973.

Cosmopoulos, M. B., ed. *The Parthenon and Its Sculptures*. Cambridge, U.K.: Cambridge University Press, 2004.

Coulson, W., and H. Kyrieleis, eds. *Proceedings of an International Symposium on the Olympic Games*. Athens: Deutsches Archäologisches Institut Athen, 1992.

Coulson, W., O. Palagia, T. L. Shear Jr., H. A. Shapiro, and F. J. Frost, eds. *The Archaeology of Athens and Attica Under the Democracy*. Oxford: Oxford University Press, 1994.

Croissant, F. "Observations sur la date et le style du fronton de la gigantomachie, Acr. 631." *RÉA* 95 (1993): 61–77.

———. *Les protomés féminines archaïques: Recherches sur les représentations du visage dans la plastique grecque de 550 à 480 av. J.-C.* Vol. 1. Paris: Écoles Françaises d'Athènes, 1983.

Crowther, N. B. "Male Beauty Contests in Greece: The *Euandria* and *Euexia*." *L'Antiquité Classique* 54 (1985): 285–91.

D'Alessio, G. B. "Textual Fluctuations and Cosmic Streams: Ocean and Acheloios." *JHS* 124 (2004): 16–37.

Damaskos, D., and D. Plantzos, eds. *A Singular Antiquity: Archaeology and Hellenic Identity in Twentieth-Century Greece*. Athens: Benaki Museum, 2008.

Dankoff, R., and S. Kim. *An Ottoman Traveller: Selections from the Book of Travels of Evliya Çelebi*. London: Eland, 2010.

Davies, J. K. "Athenian Citizenship: The Descent Group and the Alternatives." *CJ* 73 (1977): 105–21.

Deacy, S. *Athena: Gods and Heroes of the Ancient World*. New York: Routledge, 2008.

De Grummond, N. T., and B. S. Ridgway, eds. *From Pergamon to Sperlonga: Sculpture and Context*. Berkeley: University of California Press, 2000.

Delivorrias, A., "The Throne of Apollo at the Amyklaion: Old Proposals, New Perspectives." *British School at Athens Studies* 16 (2009): 133–35.

Delivorrias, A. and S. Mavromatis. Η Ζωοφόρος του Παρθενώνα. Athens: Melissa Publications, 2004.

Deubner, L. *Attische Feste*. Berlin: Keller, 1932.

Diggle, J. *Tragicorum Graecorum Fragmenta Selecta*. Oxford: Oxford Classical Texts, 1998.

———. *Euripidea: Collected Essays*. Oxford: Oxford University Press, 1994.

Dillon, M. *Girls and Women in Classical Greek Religion*. New York: Routledge, 2002.

Dinsmoor, W. B. *The Architecture of Ancient Greece: An Account of Its Historical Development*. 3rd ed. New York: W. W. Norton, 1975.

———. "Two Monuments on the Athenian Acropolis." In *Charisterion eis Anastasion K. Orlandon 4*, 145–53, 155. Athens: Library of the Archaeological Society at Athens, 1967–1968.

———. "New Evidence for the Parthenon Frieze." *AJA* 58 (1954): 144–45.

———. "The Hekatompedon on the Athenian Acropolis." *AJA* 51 (1947): 109–51.

———. "The Older Parthenon, Additional Notes." *AJA* 39 (1935): 508–9.

———. "The Date of the Older Parthenon." *AJA* 38 (1934): 408–48.

———. "The Burning of the Opisthodomus at Athens I: The Date." *AJA* 36 (1932): 143–172.

———. "The Burning of the Opisthodomus at Athens II: The Site." *AJA* 36 (1932): 307–326.

———. "Attic Building Accounts, IV: The Statue of Athena Promachos." *AJA* 25 (1921): 118–29.

Djordjevitch, M. "Pheidias's Athena Promachos Reconsidered." *AJA* 98 (1994): 323.

Dodwell, E. A. *A Classical and Topographical Tour Through Greece, During the Years 1801, 1805, and 1806*. 2 vols. London: Rodwell & Martin, 1819.

Donohue, A. A. *Xoana and the Origins of Greek Sculpture*. Atlanta: Scholars Press, 1988.

Dontas, G. "The True Aglaurion." *Hesperia* 52 (1983): 48–63.

Dörig, J., and O. Gigon. *Der Kampf der Götter und Titanen*. Otlen: Graf, 1961.

Dörpfeld, W. "Parthenon I, II und III." *AJA* 39 (1935): 497–507.

Douglas, E. M. "The Owl of Athena." *JHS* 32 (1912): 174–78.

Dreyfus, R., and E. Schraudolph, eds. *Pergamon: The Telephos Frieze from the Great Altar*. 2 vols. San Francisco: Fine Arts Museums of San Francisco, 1996.

Duncan, I. *My Life*. 1927. New York: Liveright, 1995.

Economakis, R., ed. *Acropolis Restoration: The CCAM Intervention*. London: Academy Editions, 1994.

Ehrhardt, W. "Zu Darstellung und Deutung des Gestirngötterpaares am Parthenon." *Jdl* 119 (2004): 1–39.

Ekroth, G. "The Cult of Heroes." In Albersmeier, *Heroes*, 120–43.

———. *The Sacrificial Rituals of Greek Hero-Cults: From the Archaic to the Early Hellenistic Periods*. Liège: Centre International d'Étude de la Religion Grecque Antique, 2002.

Evelyn-White, H. G., ed. *First Homeric Hymn to Athena*. Cambridge, Mass.: Harvard University Press, 1924.

Farnell, L. R. *The Cults of the Greek States*. Oxford: Oxford University Press, 1896.

Fehr, B. *Becoming Good Democrats and Wives: Civic Education and Female Socialization on the Parthenon Frieze*. Berlin: LIT Verlag, 2012.

Ferrari, G. *Alcman and the Cosmos of Sparta*. Chicago: University of Chicago Press, 2008.

———. "The Ancient Temple on the Acropolis at Athens." *AJA* 106 (2002): 11–35.

———. *Figures of Speech: Men and Maidens in Ancient Greece*. Chicago: University of Chicago Press, 2002.

Ferrari Pinney, G. "Pallas and Panathenaea." In *Proceedings of the Third Symposium on Ancient Greek and Related Pottery: Copenhagen, August 31–September 4, 1987*, edited by J. Christiansen and T. Melander, 465–77. Copenhagen: Nationalmuseet, Ny Carlsberg Glyptotek & Thorvaldsens Museum, 1988.

Fisher, N. R. E., and H. van Wees, eds. *Archaic Greece: New Approaches and New Evidence*. London: Duckworth, 1997.

Frantz, A. *Late Antiquity, A.D. 267–700*. Athenian Agora 24. Princeton, N.J.: Princeton University Press, 1988.

Fuchs, W. "Zur Rekonstruktion des Poseidon im Parthenon-Westgiebel." *Boreas* 6 (1983): 79–80.

Furtwängler, A. *Meisterwerke der griechischen Plastik*. Leipzig: Geisecke & Devrient, 1893.

Gilman, D. *The Idea of Cultural Heritage*. Rev. ed. Cambridge, U.K.: Cambridge University Press, 2010.

Glowacki, K. "The Acropolis of Athens Before 566 B.C." In *Stephanos: Studies in Honor of Brunilde Sismondo Ridgway*, edited by K. J. Hartswick and M. C. Sturgeon, 79–88. Philadelphia: University Museum, University of Pennsylvania, for Bryn Mawr College, 1998.

———. "Topics Concerning the North Slope of the Acropolis of Athens." Ph.D. diss., Bryn Mawr College, 1991.

Godley, A. D. *Herodotus: Histories*. Loeb Classical Library. Cambridge, Mass.: Harvard University Press, 1924.

Goette, H. R. *Athens, Attica, and the Megarid: An Archaeological Guide*. Rev. ed. New York: Routledge, 2001.

Goldhill, S., and R. Osborne, eds. *Performance Culture and Athenian Democracy*. Cambridge, U.K.: Cambridge University Press, 2004.

Graf, F. "Lampadedromia." In Brill's New Pauly: Encyclopaedia of the Ancient World, 7:186–87. Leiden: Brill, 2003.

———. "Pompai in Greece: Some Considerations About Space and Ritual in the Greek Polis." In The Role of Religion in the Early Greek Polis, edited by R. Hägg, 55–65. Stockholm: Svenska Institutet i Athens, 1996.

Guarducci, M. "L'offerta di Xenokrateia nel santuario di Cefiso al Falero." In Phoros: Tribute to Benjamin Dean Meritt, edited by D. W. Bradeen and M. F. McGregor, 57–66. Locust Valley, N.Y.: J. J. Augustin, 1974.

Habicht, C. Athens from Alexander to Antony. Translated by D. L. Schneider. Cambridge, Mass.: Harvard University Press, 1997.

Hadziaslani, C. ΤΩΝ ΑΘΗΝΗΘΕΝ ΑΘΛΩΝ. Athens: Acropolis Restoration Service, Department of Information and Education, 2003.

———. Promenade at the Parthenon. Athens: Hellenic Ministry of Culture, 2000.

Hägg, R. Ancient Greek Hero Cult. Stockholm: Svenska Institutet i Athen, 1999.

———. Ancient Greek Cult Practice from the Archaeological Evidence. Stockholm: Svenska Institutet i Athen, 1998.

Hägg, R., N. Marinatos, and G. Nordquist, eds. Early Greek Cult Practice. Stockholm: Svenska Institutet i Athen, 1988.

Hale, J. R. Lords of the Sea: The Epic Story of the Athenian Navy and the Birth of Democracy. New York: Penguin, 2010.

Hamilakis, Y. "Museums of Oblivion." Antiquity 85 (2011): 625–29.

———. "Decolonizing Greek Archaeology: Indigenous Archaeologies, Modernist Archaeology, and the Post-colonial Critique." In A Singular Antiquity: Archaeology and Hellenic Identity in Twentieth-Century Greece, edited by D. Damaskos and D. Plantzos, 273–84.

———. "Monumentalising Place: Archaeologists, Photographers, and the Athenian Acropolis from the 18th Century to the Present." In Monuments in the Landscape, edited by P. Rainbird, 190–98. Stroud: Tempus, 2008.

———. The Nation and Its Ruins: Antiquity, Archaeology, and National Imagination in Greece. Oxford: Oxford University Press, 2007.

———. "Monumental Visions: Bonfils, Classical Antiquity, and 19th Century Athenian Society." History of Photography 25, no. 1 (2001): 5–12, 23–43.

———. "Cyberpast/Cyberspace/Cybernation: Constructing Hellenism in Hyperreality." European Journal of Archaeology 3 (2000): 241–64.

———. "Sacralising the Past: The Cults of Archaeology in Modern Greece." Archaeological Dialogues 6 (1999): 115–35, 154–60.

Hamilakis, Y., and E. Yalouri. "Antiquities as Symbolic Capital in Modern Greek Society." Antiquity 70 (1996): 117–29.

Hansen, E. V. The Attalids of Pergamon. Ithaca, N.Y.: Cornell University Press, 1971.

Hanson, V. D. A War Like No Other: How the Athenians and the Spartans Fought the Peloponnesian War. New York: Random House, 2006.

———, ed. Hoplites: The Classical Greek Battle Experience. New York: Routledge, 1991.

Harris, D. Treasures of the Parthenon and Erechtheion. Oxford: Clarendon Press, 1995.

Harrison, E. B. "Pheidias." In Personal Styles in Greek Sculpture, edited by O. Palagia and J. J. Pollitt, 16–65. Cambridge, U.K.: Cambridge University Press, 1996.

———. "The Web of History: A Conservative Reading of the Parthenon Frieze." In Neils, Worshipping Athena, 198–214.

———. "Time in the Parthenon Frieze." In Berger, Parthenon-Kongreß Basel, 230–34.

———. "The Iconography of the Eponymous Heroes on the Parthenon and in the Agora." In Greek Numismatics and Archaeology: Essays in Honor of Margaret Thompson, edited by O. Mørkholm and N. Waggoner, 71–85. Belgium: Cultura Press, 1979.

———. "The South Frieze of the Nike Temple and the Marathon Painting in the Painted Stoa." *AJA* 76 (1972): 353–78.

———. "Athena and Athens in the East Pediment of the Parthenon." *AJA* 71 (1967): 27–58.

Harrison, J. E. *Ancient Art and Ritual*. New York: Greenwood Press, 1913.

———. *Primitive Athens as Described by Thucydides*. Cambridge, U.K.: Cambridge University Press, 1906.

———. *Prolegomena to the Study of Greek Religion*. Cambridge, U.K.: Cambridge University Press, 1903.

———. "Pandora's Box." *JHS* 20 (1900): 99–144.

———. *Mythology and Monuments of Ancient Athens: Being a Translation of a Portion of the "Attica" of Pausanias*. New York: Macmillan, 1890.

Heberdey, R. *Altattische Porosskulptur: Ein Beitrag zur Geschichte der archaischen griechischen Kunst*. Vienna: A. Hölder, 1919.

Henrichs, A. "Human Sacrifice in Greek Religion: Three Case Studies." In *Le sacrifice dans l'antiquité*, edited by J. Rudhardt and O. Reverdin, 195–235. Geneva: Entretiens Hardt, 1981.

Hermann, G. *Morality and Behaviour in Democratic Athens: A Social History*. Cambridge, U.K.: Cambridge University Press, 2006.

———. "Reciprocity, Altruism, and the Prisoner's Dilemma: The Special Case of Classical Athens." In *Reciprocity in Ancient Greece*, edited by C. Gill, N. Postlethwaite, and R. Seaford, 199–225. Oxford: Oxford University Press, 1998.

Hintzen-Bohlen, B. *Die Kulturpolitik des Euboulos und des Lykurg: Die Denkmäler und Bauprojeckte in Athen zwischen 355 und 322 v. Chr.* Berlin: Akademie, 1997.

Hitchens, C. *The Parthenon Marbles: The Case for Reunification*. London: Verso, 2008.

Holloway, R. "The Archaic Acropolis and the Parthenon Frieze." *Art Bulletin* 48 (1966): 223–26.

Hölscher, T. "Architectural Sculpture: Messages? Programs?" In Schultz and Hoff, *Structure, Image, Ornament*, 54–67.

Hughes, D. *Human Sacrifice in Ancient Greece*. New York: Routledge, 1991.

Humphreys, S. C. *The Strangeness of Gods: Historical Perspectives on the Interpretation of Athenian Religion*. Oxford: Oxford University Press, 2004.

Hurwit, J. M. *The Acropolis in the Age of Pericles*. Cambridge, U.K.: Cambridge University Press, 2004.

———. *The Athenian Acropolis: History, Mythology, and Archaeology from the Neolithic Era to the Present*. Cambridge, U.K.: Cambridge University Press, 1999.

———. "Beautiful Evil: Pandora and the Athena Parthenos." *AJA* 99 (1995): 171–86.

Iakovidis, S. E. *The Mycenaean Acropolis of Athens*. Archaeological Society at Athens Library. Athens: Archaeological Society at Athens, 2006.

———. *Late Helladic Citadels on Mainland Greece*. Leiden: E. J. Brill, 1983.

Immerwahr, S. A. *The Neolithic and Bronze Ages*. Athenian Agora 13. Princeton, N.J.: American School of Classical Studies at Athens, 1971.

Inomata, T., and L. Coben, eds. *Archaeology of Performance: Theaters of Power, Community, and Politics*. New York: Altamira Press, 2006.

Isager, S., and J. E. Skydsgaard. *Ancient Greek Agriculture: An Introduction*. New York: Routledge, 1992.

Jenkins, I. D. *Cleaning and Controversy: The Parthenon Sculptures, 1811–1939*. London: British Museum Press, 2001.

———. "The South Frieze of the Parthenon: Problems in Arrangement." *AJA* 99 (1995): 445–56.

———. *The Parthenon Frieze*. London: British Museum Press, 1994.

———. "Acquisition and Supply of Casts of the Parthenon Sculptures by the British Museum, 1835–1939." *BSA* 85 (1990): 89–114.

———. "The Composition of the So-Called Eponymous Heroes on the East Frieze of the Parthenon." *AJA* 89 (1985): 121–27.

Jenkins, I. D., and A. P. Middleton. "Paint on the Parthenon Sculptures." *BSA* 83 (1988): 183–207.

Jeppesen, K. K. "A Fresh Approach to the Problems of the Parthenon Frieze." In E. Hallager and J. T. Jensen, *Proceedings of the Danish Institute at Athens V*. Athens: Aarhus University Press, 2007, 101–72.

———. "Bild und Mythus an dem Parthenon: Zur Ergänzung und Deutung der Kultbildausschmückung des Frieses, der Metopen und der Giebel." *Acta Archaeologica* 34 (1963): 23–33.

Jouan, F., and H. Van Looy, eds. *Fragments: Euripides*, vol. 8.2: *De Bellérophon à Protésilas*. Paris: Belles Lettres, 2002.

Jowett, B. *Thucydides: History of the Peloponnesian War*. New York: Bantam, 1963. (Original publication Oxford: Clarendon Press, 1881.)

Kagan, D. *Pericles of Athens and the Birth of Democracy*. New York: Free Press, 1991.

Kaldellis, A. *The Christian Parthenon: Classicism and Pilgrimage in Byzantine Athens*. Cambridge, U.K.: Cambridge University Press, 2009.

Kannicht, R. *Tragicorum Graecorum Fragmenta*, vol. 5: *Euripides*. Göttingen: Vandenhoeck & Ruprecht, 2004, 390–418.

Kardara, K. "Glaukopis, the Archaic Naos, and the Theme of the Parthenon Frieze." *ArchEph* 1961 (1964): 61–158.

Kästner, V. "The Architecture of the Great Altar and the Telephos Frieze." In Dreyfus and Schraudolph, *Pergamon*, 2:68–82.

Kavvadias, G., and E. Giannikapani. *North, East, and West Slopes of the Acropolis: Brief History and Tour*. Athens: Hellenic Ministry of Culture, 2004.

———. *South Slope of the Acropolis: Brief History and Tour*. Athens: Hellenic Ministry of Culture, 2004.

Keane, J. "Does Democracy Have a Violent Heart?" In Pritchard, *War, Democracy, and Culture in Classical Athens*, 378–408.

Kearns, E. *Ancient Greek Religion: A Sourcebook*. Oxford: Wiley-Blackwell, 2009.

———. "Order, Interaction, Authority: Ways of Looking at Greek Religion." In *The Greek World*, edited by A. Powell, 511–29. London: Routledge, 1995.

———. "Saving the City." In *The Greek City: From Homer to Alexander*, edited by O. Murray and S. R. F. Price, 323–44. Oxford: Oxford University Press, 1990.

———. *The Heroes of Attica*. London: University of London, Institute of Classical Studies, 1989.

Kissas, K. *Archaische Architektur der Athener Akropolis: Dachziegel, Metopen, Geisa, Akroterbasen*. Wiesbaden: Reichert, 2008.

Knell, H. *Mythos und Polis: Bildprogramme griechischer Bauskulptur*. Darmstadt: Wissenschaftliche Buchgesellschaft, 1990.

Kondaratos, S. "The Parthenon as Cultural Ideal." In Tournikiotis, *Parthenon and Its Impact in Modern Times*, 18–53.

Korres, M. "Athenian Classical Architecture." In *Athens: From the Classical Period to the Present Day*, edited by M. Korres and C. Bouras, 2–45. New Castle, Del.: Oak Knoll Press, 2003.

———. "Die klassische Architektur und der Parthenon." In *Die griechische Klassik: Idee oder Wirklichkeit*, edited by M. Maischberger and W.-D. Heilmeyer, 364–84. Mainz am Rhein: Philipp von Zabern, 2002.

———. "On the North Acropolis Wall." In *Excavating Classical Culture: Recent Archaeological Discoveries in Greece*, edited by M. Stamatopoulou and M. Yeroulanomou, 179–86. Oxford: Oxford University Press, 2002.

————. *The Stones of the Parthenon.* Los Angeles: J. Paul Getty Museum, 2000.

————. "Die Athena-Tempel auf der Akropolis." In *Kult und Kultbauten auf der Akropolis,* edited by W. Hoepfner, 218–43. Berlin: Archäologisches Seminar der Freien Universität Berlin, 1997.

————. "The Parthenon." In Korres, Panetsos, and Seki, *Parthenon,* 12–73.

————. *From Pentelicon to the Parthenon.* Athens: Melissa, 1995.

————. "The Architecture of the Parthenon." In Tournikiotis, *Parthenon and Its Impact in Modern Times,* 54–97.

————. "The History of the Acropolis Monuments." In Economakis, *Acropolis Restoration,* 34–51.

————. "The Parthenon from Antiquity to the 19th Century." In Tournikiotis, *Parthenon and Its Impact in Modern Times,* 137–61.

————. "Der Plan des Parthenon." *AM* 109 (1994): 53–120.

————. "Recent Discoveries on the Acropolis." In Economakis, *Acropolis Restoration,* 174–79.

————. "The Restoration of the Parthenon." In Economakis, *Acropolis Restoration,* 110–33.

————. "The Sculptural Adornment of the Parthenon." In Economakis, *Acropolis Restoration,* 29–33.

————. *Study for the Restoration of the Parthenon.* Vol. 4. Athens: Ministry of Culture, Committee for the Preservation of the Acropolis Monuments, 1994.

————. "Überzählige Werkstücke des Parthenonfrieses." In Schmidt, *Kanon,* 19–27.

————. "Der Pronaos und die Fenster des Parthenon." In Berger, *Parthenon-Kongreß Basel,* 47–54.

Korres, M., and C. Bouras, eds. *Studies for the Restoration of the Parthenon* (in Greek). Vol. 1. Athens: Ministry of Culture and Sciences, 1983.

Korres, M., G. A. Panetsos, and T. Seki, eds. *The Parthenon: Architecture and Conservation.* Athens: Foundation for Hellenic Culture, Committee for the Conservation of the Acropolis Monuments, 1996.

Korshak, Y. *Frontal Face in Attic Vase Painting in the Archaic Period.* Chicago: Ares, 1987.

Koutsadelis, C., ed. *Dialogues on the Acropolis: Scholars and Experts Talk on History, Restoration, and the Acropolis Museum.* Athens: Skai Books, 2010.

Kovacs, D. *Euripides: Children of Heracles. Hippolytus. Andromache. Hecuba.* Loeb Classical Library. Cambridge, Mass.: Harvard University Press, 1995.

Kretschmer, P. "Pelasger und Etrusker." *Glotta* 11 (1921): 276–85.

Kroll, J. H. *The Greek Coins.* Athenian Agora 26. Princeton, N.J.: American School of Classical Studies at Athens, 1993.

————. "The Parthenon Frieze as a Votive Relief." *AJA* 83 (1979): 349–52.

Kroll, J. H., and N. M. Waggoner. "Dating the Earliest Coins of Athens, Corinth, and Aegina." *AJA* 88 (1984): 325–40.

Kron, U. "Die Phylenheroen am Parthenonfries." In Berger, *Parthenon-Kongreß Basel,* 235–44.

————. *Die zehn attischen Phylenheroen: Geschichte, Mythos, Kult und Darstellungen.* Berlin: Mann, 1976.

Kyle, D. *Sport and Spectacle in the Ancient World.* Malden, Mass.: Blackwell, 2007.

————. "Gifts and Glory: Panathenaic and Other Greek Athletic Prizes." In Neils, *Worshipping Athena,* 106–36.

————. *Athletics in Ancient Athens.* Leiden: Brill, 1987.

Lang, M. *Waterworks in the Athenian Agora.* Agora Picture Book 11. Princeton, N.J.: American School of Classical Studies at Athens, 1968.

Lapatin, K. *Chryselephantine Statuary in the Classical World.* Oxford: Oxford University Press, 2001.

————. "The Ancient Reception of Pheidias' Athena Parthenos and Zeus Olympios:

The Visual Evidence in Context." In *The Reception of Texts and Images,* edited by L. Hardwick and S. Ireland. 2 vols. Open University, 1996, and at http://www2 .open.ac.uk/ClassicalStudies/GreekPlays/conf96/lapatinabs.htm.

Larson, J. *Greek Nymphs: Myth, Cult, Lore.* Oxford: Oxford University Press, 2001.

———. *Greek Heroine Cults.* Madison: University of Wisconsin Press, 1995.

Lavelle, B. M. *Fame, Money, and Power: The Rise of Peisistratos and "Democratic" Tyranny at Athens.* Ann Arbor: University of Michigan Press, 2005.

Lawrence, A. W. *Greek and Roman Sculpture.* London: J. Cape, 1972.

———. "The Acropolis and Persepolis." *JHS* 71 (1951): 116–19.

Leipen, N. *Athena Parthenos: A Reconstruction.* Ontario: Royal Ontario Museum, 1972.

Lesk, A. "A Diachronic Examination of the Erechtheion and Its Reception." Ph.D. diss., University of Cincinnati, 2004.

Linfert, A. "Athenen des Phidias." *AM* 97 (1982): 57–77.

Lippman, M., D. Scahill, and P. Schultz. "*Knights* 843–859, the Nike Temple Bastion, and Cleon's Shields from Pylos." *AJA* 110 (2006): 551–63.

Lissarrague, F. "La Grèce antique. Civilization I: Fonctions de l'image." In *Encyclopaedia universalis,* 874–77. Paris: Encyclopaedia Universalis France, 1991.

Lissarrague, F., and A. Schnapp, "Imagerie des Grecs ou Grèce des imagiers." *Le Temps de la Réflexion* 2 (1981): 286–97.

López-Ruiz, C. *When the Gods Were Born: Greek Cosmogonies and the Near East.* Cambridge, Mass.: Harvard University Press, 2010.

Loraux, N. *The Children of Athena.* Princeton, N.J.: Princeton University Press, 1993.

Maass, M. *Das antike Delphi.* Munich: C. H. Beck, 2007.

Mallouchou-Tufano, F., ed. *Dialogues on the Acropolis.* Athens: SKAI editions, 2010.

———. "The Restoration of Classical Monuments in Modern Greece: Historic Precedents, Modern Trends, Peculiarities." *Conservation and Management of Archaeological Sites* 8.3 (2007): 154–73.

———. "Thirty Years of Anastelosis Works on the Athenian Acropolis, 1975–2005." In *Conservation and Management of Archaeological Sites* 8 (2006): 27–38.

———, ed. *Proceedings of the Fifth International Meeting for the Restoration of the Acropolis Monuments.* Athens: Acropolis Restoration Service, 2004.

———. Η Αναστύλωση των Αρχαίων Μνημείων στην Σύγχρονη Ελλάδα [The restoration of ancient monuments in modern Greece]. Athens: Archaeological Society at Athens, 1998.

———. "The History of Interventions on the Acropolis." In Economakis, *Acropolis Restoration,* 68–85.

———. "The Parthenon from Cyriacus of Ancona to Frédéric Boissonas: Description, Research, and Depiction." In Tournikiotis, *The Parthenon and Its Impact in Modern Times,* 164–99.

———. "Restoration Work on the Acropolis (1975–1994)." In Economakis, *Acropolis Restoration,* 12–15.

Mallouchou-Tufano, F., Ch. Bouras, M. Ioannidou, and I. Jenkins, eds. *Acropolis Restored.* London: The Trustees of The British Museum, 2012.

Mansfield, J. "The Robe of Athena and the Panathenaic Peplos." Ph.D. diss., University of California, Berkeley, 1985.

Mantis, A. Προβλήματα της εικονογραφίας των ιερέων στην αρχαία ελληνική τέχνη. *Arch-Delt* Supplement 42 (1990).

Marcadé, J. "Hélios au Parthenon." *Monuments et mémoires de la Fondation Eugène Piot* 50 (1958): 11–47.

Marconi, C. "The Parthenon Frieze: Degrees of Visibility." *Res: Anthropology and Aesthetics* 55–56 (2009): 157–73.

———. "Kosmos: The Imagery of the Archaic Greek Temple." *Res: Anthropology and Aesthetics* 45 (2004): 211–24.

Martin, R. "Bathyclès de Magnésie et le 'thrône' d'Apollon à Amyklae." *RA* (1976): 205–18.

Martínez Díez, A. *Euripides, Erecteo: Introduccion, Texto Critico, Traducción y Comentario.* Granada: Universidad de Granada, 1976.

Martin-McAuliffe, S., and J. Papadopoulos. "Framing Victory: Salamis, the Athenian Acropolis, and the Agora." *Journal of the Society of Architectural Historians* 71 (2012): 332–61.

Mattusch, C. *Greek Bronze Statuary.* Ithaca, N.Y.: Cornell University Press, 1988.

Mavrommatis, S., and C. Hadziaslani. *The Parthenon Frieze.* Athens: Hellenic Ministry of Culture and Sport, 2002.

Meineck, P. "The Embodied Space: Performance and Visual Cognition at the Fifth Century Athenian Theatre." *New England Classical Journal* 39 (2012): 3–46.

Meritt, B. D., and F. Vernon. "The Epigraphic Notes of Francis Vernon." *Hesperia Supplement* 8 (1949): 213–27.

Michaelis, A. *Der Parthenon.* Leipzig: Breitkopf und Härtel, 1871.

Mikalson, J. D. "Erechtheus and the Panathenaia." *AJP* 97 (1976): 141–53.

———. *The Sacred and Civil Calendar of the Athenian Year.* Princeton, N.J.: Princeton University Press, 1975.

Miles, M. "The Lapis Primus and the Older Parthenon." *Hesperia* 80 (2011): 657–75.

Miller, S. G., ed. *Nemea: A Guide to the Museum and the Site.* Berkeley: University of California Press, 1990.

———. "Excavations at Nemea, 1983." *Hesperia* 53 (1984): 171–92.

Mokyr, J. *The Gifts of Athena: Historical Origins of the Knowledge Economy.* Princeton, N.J.: Princeton University Press, 2002.

Morgan, C. *Athletes and Oracles.* Cambridge, U.K.: Cambridge University Press, 2007.

Mountjoy, P. A. *Mycenaean Athens.* Jonsered: Paul Åströms, 1995.

Mylonas, G. E. *Eleusis and the Eleusinian Mysteries.* Princeton, N.J.: Princeton University Press, 1961.

Mylonopoulos, I. "Greek Sanctuaries as Places of Communication Through Rituals: An Archaeological Perspective." In *Ritual and Communication in the Graeco-Roman World*, edited by E. Stavrianopoulou, 69–110. Kernos Supplement 16. Liège: Centre International d'Étude de la Religion Grecque Antique, 2006.

Mylonopoulos, I., and A. Chaniotis, eds. *The New Acropolis Museum.* Vol. 1. New York: Miriam and Ira D. Wallach Art Gallery, Columbia University, 2009.

Nagel, S. *Mistress of the Elgin Marbles: A Biography of Mary Nisbet, Countess of Elgin.* New York: William Morrow, 2004.

Nagy, B. "Athenian Officials on the Parthenon Frieze." *AJA* 96 (1992): 62–69.

———. "The Ritual in Slab V-East on the Parthenon Frieze." *CP* 73 (1978): 136–41.

Nagy, G. *The Ancient Greek Hero in Twenty-four Hours.* Cambridge, Mass.: The Belknap Press, 2013.

———. *Homer the Classic.* Washington, D.C.: Center for Hellenic Studies, 2010.

———. "The Performing and the Reperforming of Masterpieces of Verbal Art at a Festival in Ancient Athens." *Athens Dialogues*, 2010, http://athensdialogues.chs .harvard.edu/cgi-bin/WebObjects/athensdialogues.woa/wa/dis?dis=48.

———. *Plato's Rhapsody and Homer's Music: The Poetics of the Panathenaic Festival in Classical Athens.* Washington, D.C.: Center for Hellenic Studies, 2002.

———. *Poetry as Performance: Homer and Beyond.* Cambridge: Cambridge University Press, 1996.

———. *Pindar's Homer: The Lyric Possession of an Epic Past.* Baltimore: Johns Hopkins University Press, 1990.

———. *The Best of the Achaeans.* Baltimore: Johns Hopkins University Press, 1979.

Nehamas, A., and P. Woodruff. *Phaedrus.* Indianapolis: Hackett, 1995.

Neils, J. *The Parthenon Frieze*. Cambridge, U.K.: Cambridge University Press, 2001.
———, ed. *The Parthenon: From Antiquity to the Present*. Cambridge, U.K.: Cambridge University Press, 2005.
———, ed. *Worshipping Athena: Panathenaia and Parthenon*. Madison: University of Wisconsin Press, 1996.
———, ed. *Goddess and Polis: The Panathenaic Festival in Ancient Athens*. Princeton, N.J.: Princeton University Press, 1992.
Neils, J., and P. Schultz. "Erechtheus and the Apobates Race on the Parthenon Frieze (North XI–XII)." *AJA* 116 (2012): 195–207.
Newton, C. T., and R. Popplewell Pullan. *A History of Discoveries at Halicarnassus, Cnidus, and Branchidae*. London: Day, 1862.
Norman, N. J. "The Panathenaic Ship." *Archaeological News* 12 (1983): 41–46.
Ober, J. *Democracy and Knowledge: Innovation and Learning in Classical Athens*. Princeton, N.J.: Princeton University Press, 2010.
O'Connor-Visser, E. A. M. E. *Aspects of Human Sacrifice in the Tragedies of Euripides*. Amsterdam: B. R. Grüner, 1987.
Ogden, D. *Drakon: Dragon Myth and Serpent Cult in the Greek and Roman Worlds*. Oxford: Oxford University Press, 2013.
———, ed. *A Companion to Greek Religion*. Malden, Mass.: Wiley-Blackwell, 2007.
Osborne, R. "The Viewing and Obscuring of the Parthenon Frieze." *JHS* 107 (1987): 98–105.
Pache, C. O. *Baby and Child Heroes in Ancient Greece*. Urbana: University of Illinois Press, 2004.
Palagia, O. "Not from the Spoils of Marathon: Pheidias' Bronze Athena on the Acropolis." In *Marathon: The Day After,* edited by K. Buraselis and E. Koulakiotis. Athens: European Cultural Center of Delphi, 2013, 117–37.
———. "Fire from Heaven: Pediments and Akroteria of the Parthenon." In Neils, *Parthenon,* 225–59.
———. "Interpretations of Two Athenian Friezes." In Barringer and Hurwit, *Periklean Athens and Its Legacy,* 177–92.
———. "First Among Equals: Athena in the East Pediment of the Parthenon." In Buitron-Oliver, *Interpretation of Architectural Sculpture,* 31–45.
———. *The Pediments of the Parthenon*. Monumenta Graeca et Romana 7. Leiden: Brill, 1992.
Palagia, O., and A. Spetsieri-Choremi. *The Panathenaic Games*. Oxford: Oxbow, 2007.
Pantelidou, M. Ἀι Προϊστορικἀι Ἀθῆναι: Διατριβή ἐπί διδακτορία. Athens: Pantelidou, 1975.
Pappas, N. "Autochthony in Plato's *Menexenus*." *Philosophical Inquiry* 34 (2011): 66–80.
Parke, H. W. *Festivals of the Athenians*. Ithaca, N.Y.: Cornell University Press, 1977.
Parker, R. C. T. *Polytheism and Society at Athens*. Oxford: Oxford University Press, 2005.
———. *Athenian Religion*. Oxford: Oxford University Press, 1996.
———. "Myths of Early Athens." In Bremmer, *Interpretations of Greek Mythology,* 184–214.
Parlama, L., and N. Stampolidis. *Athens, the City Beneath the City: Antiquities from the Metropolitan Railway Excavations*. Athens: Ministry of Culture, Museum of Cycladic Art, 2000.
Parsons, A. "Klepsydra and the Paved Court of the Pythion." *Hesperia* 12 (1943): 191–267.
Pasztor, E., ed. *Archaeoastronomy in Archaeology and Ethnography*. BAR International Series 1647. Oxford: Archaeopress, 2007.
Paton, J. M., L. D. Caskey, H. N. Fowler, and G. P. Stevens. *The Erechtheum*. Cambridge, Mass.: Harvard University Press, 1927.

Pedersen, P. *The Parthenon and the Origin of the Corinthian Capital.* Odense University Classical Studies. Oxford: Oxford University Press, 1989.

Pemberton, E. G. "The Gods of the East Frieze of the Parthenon." *AJA* 80 (1976): 113–24.

———. "The East and West Friezes of the Temple of Athena Nike." *AJA* 76 (1972): 303–10.

Petersen, E. *Die Kunst des Pheidias am Parthenon und zu Olympia.* Berlin: Weidmann, 1873.

Pettersson, M. "Cults of Apollo at Sparta: The Hyakinthia, the Gymnopaidiai, and the Kerneia." Ph.D. diss., Göteborg University, 1992.

Pierce, N. "The Placement of Sacred Caves in Attica." Ph.D. diss., McGill University, 2006.

Plommer, W. H. "The Archaic Acropolis: Some Problems." *JHS* 80 (1960): 127–59.

Podlecki, A. J. *Perikles and His Circle.* New York: Routledge, 1998.

Pollitt, J. J. "The Meaning of the Parthenon Frieze." *Studies in the History of Art* 49 (1995): 50–65.

———. *The Ancient View of Greek Art: Criticism, History, and Terminology.* Yale Publications in the History of Art 26. New Haven, Conn.: Yale University Press, 1974.

Powell, B. *Athenian Mythology.* Chicago: Ares, 1976.

Preisshofen, F. *Untersuchungen zur Darstellung des Greisenalters in der frühgriechischen Dichtung.* Wiesbaden: Steiner, 1977.

Pritchard, D. M., ed. *War, Democracy, and Culture in Classical Athens.* Cambridge, U.K.: Cambridge University Press, 2010.

Pritchett, W. K. *The Greek State at War.* 5 vols. Berkeley: University of California Press, 1974.

Queyrel, F. *Le Parthénon: Un monument dans l'histoire.* Paris: Bartillat, 2008.

———. *L'autel de Pergame: Images et pouvoir en Grèce d'Asie.* Paris: A. et J. Picard, 2005.

Radt, W. *Pergamon: Geschichte und Bauten, Funde und Erforschung einer antiken Metropole.* Cologne: DuMont, 1988.

Rich, J., and G. Shipley, eds. *War and Society in the Greek World.* New York: Routledge, 1993.

Ridgway, B. S. *Hellenistic Sculpture I: The Style of ca. 331–200 B.C.* Madison: University of Wisconsin Press, 2001.

———. *Hellenistic Sculpture II: The Styles of ca. 200–100 B.C.* Madison: University of Wisconsin Press, 2000.

———. *Prayers in Stone: Greek Architectural Sculpture ca. 600–100 B.C.E.* Berkeley: University of California Press, 1999.

———. *The Archaic Style in Greek Sculpture.* 2nd ed. Chicago: Ares, 1993.

———. "Images of Athena on the Akropolis." In Neils, *Goddess and Polis,* 119–42.

———. *Hellenistic Sculpture.* 2 vols. Madison: University of Wisconsin Press, 1990.

———. "Parthenon and Parthenos." In *Festschriften für Jale Inan Armagani,* edited by N. Basgelen, 295–305. Istanbul: Arkeoloji ve Sanat Yayinlari, 1989.

———. *Fifth Century Styles in Greek Sculpture.* Princeton, N.J.: Princeton University Press, 1981.

Robertson, M. *A Shorter History of Greek Art.* Cambridge, U.K.: Cambridge University Press, 1981.

———. *A History of Greek Art.* Cambridge, U.K.: Cambridge University Press, 1975.

———. *The Parthenon Frieze.* London: Oxford University Press, 1975.

———. "The Sculptures of the Parthenon." In *Parthenos and Parthenon,* edited by G. T. W. Hooker, 46–60. Oxford: Clarendon Press, 1963.

Robertson, M., and A. Frantz. *The Parthenon Frieze.* New York: Oxford University Press, 1975.

Robertson, N. "The Origin of the Panathenaea." *RhM* 128 (1985): 231–95.
————. "The Riddle of the Arrephoria at Athens." *HSCP* 87 (1983): 273–74.
Rosenzweig, R. *Worshipping Aphrodite: Art and Cult in Classical Athens.* Ann Arbor: University of Michigan Press, 2004.
Rosivach, V. J. "Autochthony and the Athenians." *CQ* 37 (1987): 294–306.
Roux, G. "Pourquoi le Parthénon?" *RÉG* (1984): 301–17.
Ruggles, C. L. N., ed. *Handbook of Archaeoastronomy and Ethnoastronomy.* New York: Springer Science and Business Media, 2014.
————, ed. *Archaeoastronomy and Ethnoastronomy: Building Bridges Between Cultures.* Cambridge, U.K.: Cambridge University Press, 2011.
Rykwert, J. *The Dancing Column: On Order in Architecture.* Cambridge, Mass.: MIT Press, 1999.
Säflund, M.-L. *The East Pediment of the Temple of Zeus at Olympia: A Reconstruction and Interpretation of Its Composition.* Studies in Mediterranean Archaeology 27. Göteborg: Paul Åströms, 1970.
Salt, A., and E. Boutsikas. "When to Consult the Oracle at Delphi." *Antiquity* 79 (2005): 564–72.
Sanders, E. "Beyond the Usual Suspects: Literary Sources and the Historian of Emotions." In Chaniotis, *Unveiling Emotions,* 151–73.
Santi, F. *I frontoni arcaici dell'Acropoli di Atene.* Rome: L'Erma Brentschneider, 2010.
Schmidt, M., ed. *Kanon: Festschrift Ernst Berger zum 60. Geburtstag am 26. Februar 1988 gewidmet.* Basel: Vereinigung der Freunde antiker Kunst, 1988.
Schnapp, A. "Why Did the Greeks Need Images?" In *Proceedings of the Third Symposium on Ancient Greek and Related Pottery: Copenhagen, August 31–September 4, 1987,* edited by J. Christiansen and T. Melander, 568–74. Copenhagen: Nationalmuseet, Ny Carlsberg Glyptotek & Thorvaldsens Museum, 1988.
Schultz, P., and R. von den Hoff, eds. *Structure, Image, Ornament: Architectural Sculpture in the Greek World.* Oxford: Oxbow Books, 2009.
Schwab, K. "New Evidence for Parthenon East Metope 14." In Schultz and Hoff, *Structure, Image, Ornament,* 79–86.
Scodel, R. "The Achaean Wall and the Myth of Destruction." *HSCP* 86 (1982): 33–50.
Scott, M. *Delphi and Olympia: The Spatial Politics of Panhellenism in the Archaic and Classical Periods.* Cambridge, U.K.: Cambridge University Press, 2010.
Shapiro, H. A. *Art and Cult Under the Tyrants in Athens.* Mainz: Philipp von Zabern, 1989.
Shear, J. "Polis and Panathenaia: The History and Development of Athena's Festival." Ph.D. diss., University of Pennsylvania, 2001.
Shipley, G., and J. Salmon, eds. *Human Landscapes in Classical Antiquity.* New York: Routledge, 1996.
Siewert, P. "The Ephebic Oath in Fifth Century Athens." *JHS* 97 (1977): 102–11.
Simon, E. *Festivals of Attica.* Madison: University of Wisconsin Press, 1983.
————. "Die Mittelszene im Ostfries des Parthenon." *AM* 97 (1982): 127–44.
————. *Pergamon und Hesiod.* Mainz: Philipp von Zabern, 1975.
Smith, M. L. *Athens: A Cultural and Literary History.* Northampton, Mass.: Interlink Books, 2004.
Smoot, G. "The Poetics of Ethnicity in the Homeric *Iliad.*" Ph.D. diss., Harvard University, in progress.
Snodgrass, A. "Interaction by Design: The Greek City State." In *Peer Polity Interaction and Socio-political Change,* edited by C. Renfrew and J. Cherry, 47–58. Cambridge, U.K.: Cambridge University Press, 1986.
————. *Archaic Greece: The Age of Experiment.* London: J. M. Dent, 1980.
Sojc, N. *Trauer auf attischen Grabreliefs.* Berlin: Reimer, 2005.
Sonnino, M. *Euripidis Erechthei quae exstant.* Florence: F. Le Monnier, 2010.

Soros, S. W. *James "Athenian" Stuart, 1713–1788: The Rediscovery of Antiquity.* New Haven, Conn.: Yale University Press, 2006.

Sourvinou-Inwood, C. *Athenian Myths and Festivals: Aglauros, Erechtheus, Plynteria, Panathenaia, Dionysia.* Edited by R. Parker. Oxford: Oxford University Press, 2011.

———. *Tragedy and Athenian Religion.* Lanham, Md.: Lexington Books, 2003.

———. *"Reading" Greek Death: To the End of the Classical Period.* Oxford: Clarendon Press, 1995.

———. *"Reading" Greek Culture: Texts and Images, Rituals and Myths.* Oxford: Clarendon Press, 1991.

Spaeth, B. S. "Athenians and Eleusinians in the West Pediment of the Parthenon." *Hesperia* 60 (1991): 331–62.

Spivey, N. *Greek Sculpture.* Cambridge: Cambridge University Press, 2013.

———. *Understanding Greek Sculpture: Ancient Meanings, Modern Readings.* New York: Thames and Hudson, 1996.

Squire, M. *The Art of the Body.* New York: Oxford University Press, 2011.

St. Clair, W. *Lord Elgin and the Marbles: The Controversial History of the Parthenon Sculptures.* 3rd ed. Oxford: Oxford University Press, 1998.

Steinbock, B. "A Lesson in Patriotism: Lycurgus' *Against Leocrates,* the Ideology of the Ephebeia and Athenian Social Memory." *Classical Antiquity* 30 (2011): 269–317.

Steiner, D. T. *Images in Mind: Statues in Archaic and Classical Greek Literature and Thought.* Princeton, N.J.: Princeton University Press, 2001.

Steinhart, M. "Die Darstellung der Praxiergidai im Ostfries des Parthenon." *AA* (1997): 475–78.

Stewart, A. Review of *I frontoni arcaici dell'Acropoli di Atene,* by F. Santi. *AJA* 116 (2012). www.ajaonline.org/sites/default/files/1162_Stewart.pdf.

———. "The Persian and Carthaginian Invasions of 480 B.C.E. and the Beginning of the Classical Style: Part 1, The Stratigraphy, Chronology, and Significance of the Acropolis Deposits." *AJA* 112 (2008): 377–412.

———. *Attalos, Athens, and the Akropolis: The Pergamene "Little Barbarians" and Their Roman and Renaissance Legacy.* Cambridge, U.K.: Cambridge University Press, 2004.

———. "Pergamo Ara Marmorea Magna: On the Date, Reconstruction, and Functions of the Great Altar of Pergamon." In De Grummond and Ridgway, *From Pergamon to Sperlonga,* 32–57.

———. *Greek Sculpture: An Exploration.* Vol. 1. New Haven: Yale University Press, 1990.

Stuart, J., and N. Revett. *The Antiquities of Athens.* Vol. 4. Edited by Joseph Woods. London: T. Bensley for J. Taylor, 1816.

———. *The Antiquities of Athens.* Vol. 3. Edited by Willey Reveley. London: J. Nichols, 1794.

———. *The Antiquities of Athens.* Vol. 2. Edited by Willliam Newton. London: John Nichols, 1787. [Title page is dated 1787 but several plates are dated 1789; publication seems to have been backdated following Stuart's death in 1788.]

———. *The Antiquities of Athens.* Vol. 1. London: Haberkorn, 1762.

Thompson, D. B. *Garden Lore of Ancient Athens.* Agora Picture Book 8. Princeton, N.J.: American School of Classical Studies at Athens, 1963.

Thompson, H. A. "Architecture as a Medium of Public Relations Amongst the Successors of Alexander." In *Macedonia and Greece in Late Classical and Early Hellenistic Times.* Edited by E. N. Borza and B. Barr-Sharrar, 173–90. Studies in the History of Art 10. Washington, D.C.: National Gallery of Art, 1982.

———. "The Panathenaic Festival." *AA* 76 (1961): 224–31.

Thompson, H. A., and R. E. Wycherley. *The Agora of Athens: The History, Shape,*

and Uses of an Ancient City Center. Athenian Agora 14. Princeton, N.J.: American School of Classical Studies at Athens, 1972.

Tilley, C. *Phenomenology of Landscape: Places, Paths, and Monuments* (Oxford: Berg, 1994).

Toganidis, N. "Parthenon Restoration Project." *XXI International CIPA Symposium, 01–06 October 2007, Athens, Greece.* Athens: CIPA, 2007, http://www.isprs.org/proceedings/XXXVI/5-C53/papers/FP139.pdf.

Tournikiotis, P., ed. *The Parthenon and Its Impact in Modern Times.* Athens: Melissa, 1994.

Tracy, S. V., and C. Habicht. "New and Old Panathenaic Victor Lists." *Hesperia* 60 (1991): 187–236.

Travlos, J. *Bildlexikon zur Topographie des antiken Attika.* Tübingen: Ernst Wasmuth, 1988.

———. *Pictorial Dictionary of Ancient Athens.* New York: Praeger, 1971.

Tréheux, J. "Pourquoi le Parthénon?" *RÉG* 98 (1985): 233–42.

Tsakirgis, B., and S. F. Wiltshire, eds. *The Nashville Athena: A Symposium.* Nashville: Department of Classical Studies, Vanderbilt University, 1990.

Tschumi, B., P. Mauss, and B. Tschumi Architects, eds. *Acropolis Museum, Athens.* Barcelona: Polígrafa, 2010.

van Dyke, R. M., and S. E. Alcock, eds., *Archaeologies of Memory.* Malden, Mass.: Blackwell, 2003.

Vernant, J.-P. *Myth and Thought Among the Greeks.* London: Routledge & Kegan Paul, 1983.

———. *Myth and Society in Ancient Greece.* Translated by J. Lloyd. New York: Zone Books, 1980.

Vian, F. *La guerre des géants: Le mythe avant l'époque hellénistique.* Paris: Klincksieck, 1952.

Vlassopoulou, C. "New Investigations into the Polychromy of the Parthenon." In *Circumlitio: The Polychromy of Antique and Medieval Sculpture,* edited by V. Brinkmann and O. Primavesi, 219–23. Munich: Hirmer, 2010.

———. *Acropolis and Museum.* Athens: Hellenic Ministry of Culture, 2004.

Vlizos, S., ed. *E Athena kata te Romaike Epokhe: Prosphates anakalypseis, nees ereunes.* Athens: Benaki Museum, 2008.

Vrettos, T. *The Elgin Affair: The Abduction of Antiquity's Greatest Treasures and the Passions It Aroused.* New York: Arcade, 1997.

Waterfield, R. *Plato's Phaedrus.* Oxford: Oxford University Press, 2009.

———. *Timaeus and Critias.* Oxford: Oxford University Press, 2008.

———. *Plutarch: Greek Lives.* Oxford: Oxford University Press, 1998.

Webb, P. A. "The Functions of the Sanctuary of Athena and the Pergamon Altar (the Heroon of Telephos) in the Attalid Building Program." In *Stephanos: Studies in Honor of Brunilde Sismondo Ridgway,* edited by K. J. Hartswick and M. C. Sturgeon, 241–54. Philadelphia: University Museum, University of Pennsylvania, for Bryn Mawr College, 1998.

———. *Hellenistic Architectural Sculpture: Figural Motifs in Western Anatolia and the Aegean Islands.* Madison: University of Wisconsin Press, 1996.

Webster, T. B. L. "Greek Theories of Art and Literature Down to 400 B.C." *CQ* 33 (1939): 166–79.

Weidauer, L. "Poseidon und Eumolpos auf einer Pelike aus Policoro." *AntK* 12 (1969): 91–93.

Wesenberg, B. "Panathenäische Peplosdedikation und Arrephorie: Zur Thematik des Parthenonfrieses." *JdI* 110 (1995): 149–78.

West, M. L. *Indo-European Poetry and Myth.* Oxford: Oxford University Press, 2007.

————. *Homeric Hymns. Homeric Apocrypha. Lives of Homer.* Loeb Classical Library. Cambridge, Mass.: Harvard University Press, 2003.

————. *The East Face of Helicon: West Asiatic Elements in Greek Poetry and Myth.* Oxford: Clarendon Press, 1997.

————. *Ancient Greek Music.* Oxford: Oxford University Press, 1994.

————. *Hesiod: Theogony, Works and Days.* Oxford: Oxford University Press, 1988.

————. *The Hesiodic Catalogue of Women.* Oxford: Clarendon Press, 1985.

Whitley, J. "The Monuments That Stood Before Marathon: Tomb Cult and Hero Cult in Archaic Attica." *AJA* 98 (1994): 213–30.

Wickens, J. "The Archaeology and History of Cave Use in Attica, Greece, from Prehistoric Through Late Roman Times." Ph.D. diss., Indiana University, 1986.

Wilkins, J. *Euripides: Heraclidae.* Oxford: Clarendon Press, 1993.

————. "The State and the Individual: Euripides' Plays of Voluntary Self-Sacrifice." In *Euripides, Women, and Sexuality,* edited by A. Powell, 177–94. London: Routledge, 1990.

————. "The Young of Athens: Religion and Society in Herakleidai of Euripides." *CQ* 40 (1990): 329–35.

Will, W. *Perikles.* Reinbeck bei Hamburg: Rowohlt, 1995.

Winckelmann, J. J. *Geschichte der Kunst des Althertums.* Dresden: Walther, 1764.

Winkler, J. J. *The Constraints of Desire.* New York: Routledge, 1990.

Wood, A. *Athenae Oxonienses: An Exact History of All the Writers and Bishops Who Have Had Their Education in the University of Oxford, to Which Are Added the Fasti, or, Annals of Said University.* 2nd ed., with additions by P. Bliss. London: Printed for F. C. and J. Rivington, 1813.

Yalouri, E. "Between the Local and the Global: The Athenian Acropolis as Both National and World Monument." In *Archaeology in Situ: Sites, Archaeology, and Communities in Greece,* edited by A. Stroulia and S. Buck Sutton, 131–58. Lanham, Md.: Lexington Books, 2010.

————. *The Acropolis: Global Fame, Local Claim.* Oxford: Berg, 2001.

Zachariadou, O. "Syntagma Station." In Parlama and Stampolidis, *Athens, the City Beneath the City,* 148–61.

Index

Illustration Credits

Athens, Acropolis Museum NM 13050. © Acropolis Museum. Nikos Danilidis.

PAGE 72 Hypothetical visualization of Older Parthenon and Old Athena Temple in 480 B.C. D. Tsalkanis, www.ancientathens3d.com.

PAGE 73 Display of reused column drums, north fortification wall, Athenian Acropolis. Socratis Mavrommatis.

PAGE 74 Hypothetical visualization of surviving opisthodomos of Old Athena Temple with Erechtheion. D. Tsalkanis, www.ancientathens3d.com.

PAGE 83 Reconstruction drawing of Athenian Acropolis. Manolis Korres.

PAGE 84 Parthenon from northwest, 1987. Socratis Mavrommatis.

PAGE 90 Plan of Parthenon, showing outline of Older Parthenon beneath. Manolis Korres.

PAGE 91 Reconstruction drawing of Parthenon's north peristyle with *naiskos* and altar by Manolis Korres.

PAGE 93 Curvature of *krepidoma,* north side of Parthenon. Socratis Mavrommatis.

PAGE 98 Reconstruction drawing of northeast cornice of Parthenon by Manolis Korres.

PAGES 100–101 Battle of Lapiths and Centaurs, south metopes, Parthenon. Nointel Artist and S. Mavrommatis. After C. Hadziaslani and S. Mavrommatis, *Promenades at the Parthenon* (2000), 136–37.

PAGE 106 East pediment, figures K, L, M. London. British Museum. Socratis Mavrommatis.

PAGE 108 Erechtheion, from west, showing olive tree of Athena replanted by the American School of Classical Studies at Athens in 1952. © Robert A. McCabe, 1954–1955.

PAGE 109 Aperture in ceiling of north porch, Erechtheion. J. B. Connelly.

PAGE 111 Kephisos River, west pediment, Parthenon. London, British Museum. Socratis Mavrommatis.

PAGE 111 Kephisos River, west pediment, Parthenon. London, British Museum. Socratis Mavrommatis.

PAGE 112 Kekrops and Pandrosos, west pediment, Parthenon. Athens, Acropolis Museum. © Acropolis Museum. Socratis Mavrommatis.

PAGE 127 Pierre Jouguet. *La Revue du Caire* 13, no. 130 (1950).

PAGE 128 *Life,* November 15, 1963, 65. Professor André Bataille and Mlle Nicole Parichon with *Erechtheus* fragments. Copyright 1963. Time Inc. Reprinted with permission. All rights reserved. Photo: © Pierre Bouat/Ass. Pierre & Alexandra Boulat.

PAGE 130 The *Erechtheus* papyrus. Pap. Sorbonne 2328a.

PAGE 130 The *Erechtheus* papyrus. Pap. Sorbonne 2328b–d.

PAGE 133 Birth of Erichthonios, kylix by Kodros Painter. Berlin, Antikensammlung, Staatliche Museen F2537. bpk, Berlin/Antikensammlung, Staatliche Museen, Berlin, Germany/Art Resource, New York.

PAGE 134 Aglauros and King Erechtheus, kylix by Kodros Painter. Berlin, Antikensammlung, Staatliche Museen F2537. bpk, Berlin/Antikensammlung, Staatliche Museen, Berlin, Germany/Art Resource, New York.

PAGE 151 West portico of Parthenon, William J. Stillman, 1882. Special Collections, Schaffer Library, Union College.

PAGE 152 Parthenon's sculptural program: pediments, metopes, and frieze. After L. Schneider and C. Höcker, *Die Akropolis von Athen: Eine Kunst- und Kulturgeschichte* (2001), fig. 150.

PAGE 156 Cyriacos of Ancona, drawing of Parthenon's west façade. Staatliche Museen (MS Ham. 254, Blatt 85r.) bpk, Berlin/Antikensammlung, Staatliche Museen, Berlin, Germany/Art Resource, New York.

PAGE 158 Parthenon frieze, sequence and direction of procession. Angela Schuster after Robert M. Cook, 1973.

PAGES 160–161 North frieze, Parthenon. Nointel Artist and S. Mavrommatis. After C. Hadziaslani and

S. Mavrommatis, *Promenades at the Parthenon* (2000), 140–41.

PAGE 162 Erechtheus and family prepare for sacrifice, flanked by gods, east frieze, slab 5, Parthenon. London, British Museum. Socratis Mavrommatis.

PAGE 165 Erechtheus, Praxithea, and daughters preparing for sacrifice, east frieze, slab 5, Parthenon. London, British Museum. Socratis Mavrommatis.

PAGE 166 Royal family of Elis preparing for chariot race. Archaeological Museum, Olympia, Greece. Marie Mauzy/Art Resource, New York.

PAGE 167 Honorary relief, Athena with Victory crowning her priestess. Berlin, Antikensammlung, Staatliche Museen SK 881. bpk, Berlin/ Antikensammlung, Staatliche Museen, Berlin, Germany/Art Resource, New York.

PAGE 169 Funerary relief of priest named Simos. Athens, National Archaeological Museum 772 (photographer: Kostas Konstantopoulos). © Hellenic Ministry of Culture and Sports/ Archaeological Receipts Fund.

PAGE 170 Erechtheus and daughter displaying funerary dress, east frieze, slab 5, Parthenon. London, British Museum. Socratis Mavrommatis.

PAGE 171 Women exercising in palaistra. Bari, Museo Civico 4979. Provincia di Bari, Servizio Beni, Attivita Culturali, Biblioteca Orchestra, Sporte Turismo.

PAGE 173 Polyxena sacrificed by Neoptolemos at tomb of Achilles, Tyrrhenian amphora by Timiades Painter. London, British Museum 1897.0727.2. © The Trustees of the British Museum/Art Resource, New York.

PAGE 176 Serving boy bringing clean clothes to Kastor and Polydeukes, amphora by Exekias. Museo Gregoriano Etrusco, Vatican Museums 344, Vatican State. Scala/ Art Resource, New York.

PAGE 177 Women perfuming fabric on swinging stool, oinochoe by Meidias

Painter. New York, Metropolitan Museum of Art 75.2.11. Image copyright © Metropolitan Museum of Art. Image source: /Art Resource, New York.

PAGE 179 Bridal *kosmos* with dress and jewelry displayed before bride, pyxis by Painter of the Louvre Centauromachy. Paris, Musée du Louvre CA 587. Erich Lessing/Art Resource, New York.

PAGE 180 Andromeda dressed for sacrifice to sea dragon, pelike. Boston, Museum of Fine Arts 63.2663. © 2014, Museum of Fine Arts, Boston.

PAGE 181 King Kepheus oversees sacrifice of Andromeda, pelike. Boston, Museum of Fine Arts 63.2663. © 2014, Museum of Fine Arts, Boston.

PAGE 182 Poseidon, Apollo, and Artemis, east frieze, slab 6, Parthenon. Athens, Acropolis Museum. © Acropolis Museum. Socratis Mavrommatis.

PAGE 182 Erechtheus and daughter, Athena and Hephaistos, east frieze, slab 6, Parthenon. After J. Stuart and N. Revett, *The Antiquities of Athens* (1787), vol. 2, plate 24.

PAGE 183 Assembly of gods, east frieze, Siphnian Treasury, Delphi. Alison Frantz, American School of Classical Studies at Athens.

PAGE 185 East frieze, slabs 1–9, Parthenon. Nointel Artist and S. Mavrommatis. After C. Hadziaslani and S. Mavrommatis, *Promenades at the Parthenon* (2000), 138.

PAGE 187 Group of men, east frieze, slab 4, Parthenon. London, British Museum. Socratis Mavrommatis.

PAGE 187 Group of maidens, east frieze, slab 8, Parthenon. London, British Museum. Socratis Mavrommatis.

PAGE 190 Youths leading cattle to sacrifice, north frieze, slab 2, Parthenon. Athens, Acropolis Museum. © Acropolis Museum. Socratis Mavrommatis.

PAGE 191 Youths leading ewes to sacrifice, north frieze, slab 4, Parthenon. Athens, Acropolis

Museum. © Acropolis Museum. Socratis Mavrommatis.

PAGE 192 North frieze, Parthenon, reconstruction drawing by George Marshall Peters.

PAGE 192 Tray bearer carrying honeycombs, plaster cast of north frieze, slab 5, fig. 15, Skulpturhalle, Basel Antikensmuseum, original in Vatican Museum. J. B. Connelly.

PAGE 193 Tray bearer and men carrying water jars, north frieze, slab 6, Parthenon. Athens, Acropolis Museum. © Acropolis Museum. Socratis Mavrommatis.

PAGE 194 Elders, with one crowning himself, north frieze, slab 10, Parthenon. Athens, Acropolis Museum. © Acropolis Museum. Socratis Mavrommatis.

PAGES 196–197 South frieze, Parthenon. Nointel Artist and S. Mavrommatis. After C. Hadziaslani and S. Mavrommatis, *Promenades at the Parthenon* (2000), 142–43.

PAGE 198 Charioteer and armed rider, south frieze, slab 31, Parthenon. London, British Museum. Socratis Mavrommatis.

PAGE 198 Victory monument from *apobates* race, found near the City Eleusinion. Athens, Agora Excavations S399. American School of Classical Studies at Athens, Agora Excavations.

PAGE 199 Horse rider, north frieze, slab 41, fig. 114, Parthenon. London, British Museum. Socratis Mavrommatis.

PAGE 200 Horse riders and preparation for procession, west frieze, Parthenon. Socratis Mavrommatis. After C. Hadziaslani and S. Mavrommatis, *Promenades at the Parthenon* (2000), 139.

PAGE 203 Poseidon and Eumolpos ride into battle, Lucanian pelike. Policoro, Museo della Civiltà 35304. DAI Rome (68.1525).

PAGE 204 Athena and daughter of Erechtheus ride into battle, Lucanian pelike. Policoro Museo della Civiltà 35304. DAI Rome (68.1526).

PAGE 208 Nude male, horse rider,

adolescent, and boy, north frieze, slab 47, Parthenon. London, British Museum. Socratis Mavrommatis.

PAGE 211 Eugene Andrews taking squeeze of inscription on Parthenon's east architrave, 1895. Division of Rare and Manuscript Collections, Cornell University.

PAGE 218 Map of Greece. Matt Kania.

PAGE 224 Statue of Nike, Paionios, sanctuary of Zeus at Olympia. Alison Frantz, American School of Classical Studies at Athens.

PAGE 225 Athena Nike temple and bastion, from northwest. Alison Frantz, American School of Classical Studies at Athens.

PAGE 226 Seated Athena from Nike parapet. Athens, Acropolis Museum. © Acropolis Museum. Nikos Danilidis.

PAGE 227 Bronze Athena with other dedications on the Acropolis, reconstruction drawing by G. P. Stevens, 1936. American School of Classical Studies at Athens, Agora Excavations.

PAGE 231 Plan of classical Acropolis. Angela Schuster after John Travlos (1984).

PAGE 233 Western room of Parthenon with proto-Corinthian columns, reconstruction drawing by P. Pedersen, *The Parthenon and the Origin of the Corinthian Capital* (1989), 30.

PAGE 242 Shrine of Neoptolemos and Akanthos Column, sanctuary of Apollo, Delphi. Angela Schuster after M. Maass, *Das antike Delphi* (1993).

PAGE 243 Daughters of Erechtheus as dancing Hyakinthides/Hyades, Akanthos Column, Delphi Museum. Constantinos Iliopoulos.

PAGE 249 Isadora Duncan in peristyle of Parthenon. Gelatin silver print. Edward Steichen, 1920. Courtesy of the Davison Art Center, Wesleyan University. Copy photo: R. J. Phil.

PAGE 255 Athena brandishing spear and shield, accompanied by her owl, krater of Panathenaic shape by the Princeton Painter. New York, Metropolitan Museum of Art 1989.281.89. Image copyright ©

Metropolitan Museum of Art. Image source: Art Resource, New York.
PAGE 256 Panathenaic prize amphora of Burgon type, showing Athena, with siren on neck. London, British Museum B 130. The Trustees of the British Museum/Art Resource, New York.
PAGE 261 *Pankration* competition, Panathenaic prize amphora by the Kleophrades Painter. Metropolitan Museum of Art, 1916 (16.71). Image copyright © Metropolitan Museum of Art. Image source: Art Resource, New York.
PAGE 265 Plan of Erechtheion with foundations of Old Athena Temple. After H. Berve and G. Gruben, *Griechische Tempel und Heiligtümer* (1961), 182, fig. 69.
PAGE 271 Erechtheion, karyatid porch, from southeast. © Robert A. McCabe, 1954–1955.
PAGE 280 Reconstruction drawing of base of Athena Parthenos statue by George Marshall Peters after Neida Leipen, *Athena Parthenos,* 1971, plate 6.
PAGE 280 Athena crowning daughter of Erechtheus, in the company of gods, calyx krater by the Niobid Painter. London, British Museum GR 1856,1213.1. © The Trustees of the British Museum/Art Resource, New York.
PAGE 281 Anesidora crowned by Athena and Hephaistos, Tarquinia Painter, London, British Museum D 4. © The Trustees of the British Museum.
PAGE 284 "Queen of the Night," terra-cotta relief, Old Babylonian period. London, British Museum GR 2003,0718.10. © The Trustees of the British Museum/Art Resource, New York.
PAGE 285 Death of Prokris, column krater by Hephaistos Painter. London, British Museum GR 1772,0320.36. © The Trustees of the British Museum/Art Resource, New York.
PAGE 287 Athena seated in her sanctuary with three owls, white-ground lekythos by Athena Painter. Kansas

City, Mo., Nelson-Atkins Museum of Art (34.289). © Nelson-Atkins Museum of Art.
PAGE 288 Warrior owl, with spear, shield, and crested helmet, ca. 475–450 B.C. Paris, Musée du Louvre CA 2192. © RMN–Grand Palais/Art Resource, New York.
PAGE 289 Anthropomorphized owl shown spinning, terra-cotta loom weight. Bryn Mawr, Pa., Bryn Mawr College, T-182. © Bryn Mawr College Special Collections.
PAGE 290 Athenian silver tetradrachm, ca. 454–449 B.C. American Numismatic Society, 1935.117.226.rev.
PAGE 304 Reconstruction model of fortified acropolis at Pergamon, view from west. Berlin, Antikensammlung, Staatliche Museen. bpk, Berlin/Antikensammlug, Staatliche Museen, Berlin Germany/Art Resource, New York.
PAGE 305 South slope of Athenian Acropolis, hypothetical 3-D visualization. D. Tsalkanis, www.ancientathens3d.com.
PAGE 310 Reconstruction drawing of victory monument of Attalos II, set at northeast corner of the Parthenon, by Manolis Korres.
PAGE 312 Pergamon Altar. Berlin, Antikensammlung, Staatliche Museen. bpk, Berlin/Antikensammlung, Staatliche Museen, Berlin, Germany/Art Resource, New York.
PAGE 313 Plan of Pergamon Altar showing disposition of Gigantomachy and Telephos friezes, A. Schuster after V. Kastner (1988).
PAGE 314 Athena (crowned by Nike) fights winged giant; Ge emerges from below, east frieze, Pergamon Altar. Berlin, Antikensammlung, Staatliche Museen. bpk, Berlin/Antikensammlung, Staatliche Museen, Berlin, Germany/Erich Lessing/Art Resource, New York.
PAGE 315 Zeus battles Giants, east frieze, Pergamon Altar. Berlin, Antikensammlung, Staatliche Museen. bpk, Berlin/Antikensammlung, Staatliche

Museen, Berlin, Germany/Erich
Lessing/Art Resource, New York.
PAGE 316 "Nyx" hurls orb encircled
by serpent, north frieze, Pergamon
Altar. Berlin, Antikensammlung,
Staatliche Museen. bpk, Berlin/
Antikensammlung, Staatliche
Museen, Berlin, Germany/Erich
Lessing/Art Resource, New York.
PAGE 317 Serpent attacking eagle,
monstrous fish (inset), Gigantomachy
frieze, Pergamon Altar, Pergamon.
Berlin, Antikensammlung, Staatliche
Museen, Berlin, Germany. J. B.
Connelly.
PAGE 318 Athena akroteria, Pergamon
Altar. Berlin, Antikensammlung,
Staatliche Museen. bpk, Berlin/
Antikensammlung, Staatliche
Museen/Art Resource, New York.
PAGE 318 Poseidon akroteria, Pergamon
Altar. Berlin, Antikensammlung,
Staatliche Museen. bpk, Berlin/
Antikensammlung, Staatliche
Museen/Art Resource, New York.
PAGE 318 Triton akroteria, Pergamon
Altar. Berlin, Antikensammlung,
Staatliche Museen. bpk, Berlin/
Antikensammlung, Staatliche
Museen/Art Resource, New York.
PAGE 320 Herakles and the infant
Telephos, Telephos frieze, Pergamon
Altar. Berlin, Antikensammlung,
Staatliche Museen. bpk, Berlin/
Antikensammlung, Staatliche
Museen/Art Resource, New York.
PAGE 322 Telephos welcomed in
Mysia, receiving arms from
Auge, Telephos frieze, Pergamon
Altar. Berlin, Antikensammlung,

Staatliche Museen. bpk, Berlin/
Antikensammlung, Staatliche
Museen/Art Resource, New York.
PAGE 333 Parthenon during
reconstruction work, from east,
1987. Socratis Mavrommatis.
PAGE 334 Manolis Korres atop northeast
cornice of Parthenon, 1986. Socratis
Mavrommatis.
PAGE 337 Reconstruction drawing of
east end of twelfth-century
Parthenon as church with apse,
by Manolis Korres.
PAGE 338 Daguerreotype, P. G. G. Joly
de Lotbinière, 1839, *Excursions
daguerriennes* (1842). © Rheinisches
Bildarchiv Köln.
PAGE 339 Frédéric Boissonnas
photographing Parthenon, 1907.
© Hellenic Culture Organisation
S.A./Depository: Museum of
Photography Thessaloniki.
PAGE 339 Socratis Mavrommatis
photographing Parthenon, 1988, by
Tina Skar.
PAGE 341 U.S. Custom House, New
York, 1833–1842. Ithiel Town and
Alexander Jackson Davis, architects.
© Lawrence A. Martin/Artifice
Images.
PAGE 348 Parthenon frieze and plaster
casts of frieze. Athens, Acropolis
Museum. © Acropolis Museum.
PAGE 348 Parthenon frieze in Duveen
Gallery. London, British Museum.
Public domain, Wikimedia
Commons.
PAGE 352 Acropolis, view from
Monastiraki Square. © Robert A.
McCabe, 1954–1955.

COLOR INSERT

PAGE 1 (top) Orthophotomosaic
of Acropolis, 2009. Acropolis
Restoration Service, Hellenic
Ministry of Education and Religious
Affairs, Culture and Sports.
PAGE 1 (bottom) Acropolis, east and
south slopes, east cave. Kevin T.
Glowacki, 2005.
PAGE 2 (top) Limestone snake from
Bluebeard Temple pediment

(Hekatompedon?). Athens,
Acropolis Museum. © Acropolis
Museum. Socratis Mavrommatis.
PAGE 2 (bottom) Hypothetical
visualization of Archaic Acropolis
with Hekatompedon and Old Athena
Temple. D. Tsalkanis, www
.ancientathens3d.com.
PAGE 3 (top) Bluebeard monster,
Bluebeard Temple pediment

(Hekatompedon?). Athens, Acropolis Museum. © Acropolis Museum. Socratis Mavrommatis.

PAGE 3 (bottom) Zeus battling Typhon, Chalkidean hydria, Munich, Staatliche Antikensammlung 596. Bibi Saint-Pol, 2007-02-09.

PAGE 4 (top) Herakles wrestling Triton, Bluebeard pediment (Hekatompedon?). Athens, Acropolis Museum. © Acropolis Museum. Socratis Mavrommatis.

PAGE 4 (bottom) Raking cornice with lotus flowers, Bluebeard Temple pediment (Hekatompedon?). Athens, Acropolis Museum. © Acropolis Museum. S. Mavrommatis.

PAGE 5 (left) Birth of Athena, east pediment, Parthenon. Nointel Artist and S. Mavrommatis. After C. Hadziaslani and S. Mavrommatis, *Promenades at the Parthenon* (2000), 132–33.

PAGE 5 (right) Contest of Athena and Poseidon, west pediment, Parthenon. Nointel Artist and S. Mavrommatis. After C. Hadziaslani and S.

Mavrommatis, *Promenades at the Parthenon* (2000), 134–35.

PAGE 6 (top) Sacrificial procession to altar of Athena, Attic kylix, private collection, London. Widmer 837.

PAGE 6 (bottom) Akanthos akroterion, Parthenon. Athens, Acropolis Museum. © Acropolis Museum. Nikos Danilidis.

PAGE 7 (top) Processional route along the Panathenaic Way. akg-images/ P. Connolly.

PAGE 7 (bottom) Replica of Athena Parthenos Statue by A. LeQuire, 1982–2002. Nashville, Tennessee, Parthenon. Metropolitan Government of Nashville/Gary Layda.

PAGE 8 (top) Man approaching altar on which owl is perched, sheep and bull await sacrifice, hydria. Uppsala, Uppsala University (352). © Uppsala University.

PAGE 8 (bottom) *Pheidias Showing the Frieze of the Parthenon to His Friends,* Sir Lawrence Alma-Tadema, 1868. Birmingham, Birmingham Museum and Art Gallery. © Birmingham Museum and Art Gallery.

A NOTE ON THE TYPE

The text of this book was set in Sabon, a typeface designed by Jan Tschichold (1902–1974), the well-known German typographer. Based loosely on the original designs by Claude Garamond (ca. 1480–1561), Sabon is unique in that it was explicitly designed for hot-metal composition on both the Monotype and Linotype machines as well as for filmsetting. Designed in 1966 in Frankfurt, Sabon was named for the famous Lyon punch cutter Jacques Sabon, who is thought to have brought some of Garamond's matrices to Frankfurt.

Composed by North Market Street Graphics,
Lancaster, Pennsylvania

Designed by Cassandra J. Pappas